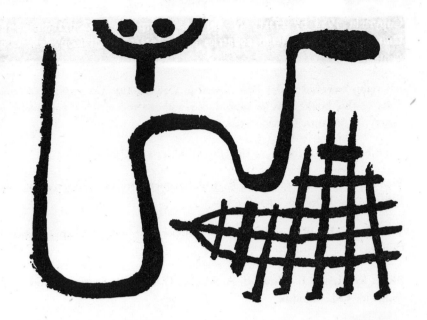

Will Grohmann

Paul Klee

Harry N. Abrams, Inc., Publishers

New York

Impressum

Published simultaneously in the United States and Canada.

Printed in association with W. Kohlhammer, Stuttgart, Germany, and Editions des Trois Collines, Geneva.

Typography by W. Kohlhammer in colloboration with François Lachenal, Geneva.

Blocks by Messrs. E. Schreiber, A. Schuler, G. Krämer, Stuttgart, and W. F. Sedgwick Ltd., London.

The Publishers are indebted to Mr. Felix Klee, Bern, to the *Klee-Stiftung*, Bern and to the owners of the pictures reproduced for the rights of the reproduction of the full color and single color plates. They have also received the rights of reprinting from letters, articles and publications of Paul Klee through the kindness of Mr. Felix Klee and of the *Klee-Stiftung*.

Drawing on page 1: *Fir-Tree* 1940

Drawing on page 3: *The Snake Goddes and Her Foe* 1940

Contents

Contents

For the convenience of the reader we have provided a *Chronological Catalogue* of all the illustrations, including color and black-and-white plates, and the drawings in the text.

The *Classified Catalogue* contains a selection of Klee's painted *œuvre*, arranged according to groups in roughly chronological sequence. Each entry is reproduced. The works illustrated elsewhere in the book are referred to by page number under the appropriate group headings. In the measurements, height precedes width. Until 1924, Klee used continuous numbering for each year's output in the record which he kept of his work. From 1925 on, he employed a special code of letters and numerals. The "signatures" (or opus designations) which we have used in the *Classified Catalogue* correspond with Klee's own record.

There are ten *Sketchbooks* by Klee, the smallest measuring $4^1/_2 : 6^7/_8''$, the largest $12^3/_4 : 8^1/_8''$. Their dates range from 1892 to 1899. All of them, as well as 64 sheets of studies done at the Munich Academy, are now in the archives of the Klee Foundation. Klee's own listing of his works does not include this material.

Quotations from Klee's published writings in the text are identified by year, as follows:

> 1918: *Creative Credo* (printed 1920)
> 1923: Essay in the *Bauhaus-Buch,* "Ways of Studying Nature"
> 1924: Lecture at the Jena *Kunstverein,* published *1945*
> under the title, "On Modern Art"
> 1928: Essay in the *Bauhaus-Zeitschrift* (II, 2–3), "Exact
> Experiment in the Field of Art"

In Itself 1938

Since Paul Klee's death at the age of sixty in 1940 his fame has rapidly grown. Today his work is recognized as one of the most important contributions to the art of the twentieth century. His influence on contemporary painters is widespread, and large retrospective exhibitions of his work have been organized in Europe and America. He is represented in museums and private collections throughout the world, particularly in Switzerland, his adopted fatherland, and in the United States, where some nine hundred of his pictures can be found. In Germany, where his reputation was first established, collectors now try to redeem those losses that occurred after 1933, when the Nazi regime showed official disfavor to his work. How successful these collectors will be, however, remains doubtful since most of his pictures formerly in German collections have left the country.

As Klee's fame has grown, so has the number of publications dealing with his work by writers of all nationalities. The present biography, based on hitherto unpublished material as well as on personal recollections, attempts to cover the whole of his *œuvre*, to describe his evolution and achievement, so that his work may be seen as one of the major artistic phenomena of our time. Although it sometimes seems as though Klee were still in our midst, the fourteen years since his death have put the whole of his work into perspective. In times to come, our views of the man and his work will undoubtedly be amended on the basis of new sources of information such as letters and memoirs which are not yet available for study or which cannot be published during the lifetime of people mentioned in them. Still, there is no need to delay any longer the publication of this first comprehensive biography.

Such an undertaking is amply justified by the vast amount of material which is now available: letters; a journal covering the years 1899 through 1918 (it opens with a brief backward glance into the preceding years); notes for courses at the Bauhaus School from 1920 through 1931; lectures and essays on art; records of private conversations and a few similar documents. Very important, too, is the manuscript catalogue of Klee's pictures which, although not begun until 1911, includes many of his earliest works. In addition, his statements about artistic matters are so revealing in relation to himself and his contemporaries that no biographer or art historian can afford to neglect them.

Klee himself suggested the first selection of illustrations made for this volume, and many works are published here for the first time – childhood drawings, early self-portraits, paintings on glass, sculptures. In most cases the name of the present owner is given, although this has not always been possible owing to frequent changes of ownership.

The three sections of this book – Life, Work, Pedagogics – correspond to the three aspects of Klee himself – the man, the painter, the teacher. All who knew him will agree that his professional activity was so essentially part of his personality that to all intents and purposes he had no life apart from his art. In fact, it is easier to draw conclusions about Klee as a person from his work than to follow the opposite

course. In later years, the external events of the artist's life were governed almost entirely by his work, so that what he experienced within himself tended to coincide completely with his pictorial creations. The biographer must therefore be on guard, particularly since Klee looked upon all biographies of artists with a skeptical eye. He wanted simply to know where good pictures could be found and why they were good. He had no interest in the historical approach to art. As he wrote in his journal in 1909, "Captivating though it may be to tackle problems of personality such as Van Gogh or Ensor, far too much biography gets muddled up with art. This is the fault of the critics, who are, after all, literary men."

Unless otherwise identified, statements by Klee have been taken from his unpublished journals or from diaries of his trips. In the preparation of this edition I wish to thank first of all Felix Klee, Paul Klee's son; Curt Valentin, R. Allen, William S. Liebermann, H. W. Janson, and Justin Kaplan. I also wish to express my thanks to all who have given me assistance, and especially to the many collectors of Klee's work in Europe and in America. W. G.

X-let 1938

Lebenslauf

Ich bin am 18 Dezember 1879 in München=
=buchsee geboren. Mein Vater war Musik=
lehrer am kantonalen Lehrerseminar Hofwyl,
und meine Mutter war Schweizerin. Als ich im Frühjahr
1886 in die Schule kam, wohnten wir in der
Länggasse in Bern. Ich besuchte die ersten vier
Klassen der dortigen Primarschule, Dann
schickten mich meine Eltern ans städtische
Progymnasium, dessen vier Klassen ich absolvierte,
um dann in die Literarschule derselben Anstalt
einzutreten. Den Abschluss meiner allgemeinen
Bildung bildete das kantonale Maturitätsexamen,
das ich im Herbst 1898 bestand.

Die Berufswahl ging äusserlich glatt
von Statten. Obwohl mir durch das Maturitäts-
zeugnis alles offen stand, wollte ich es wagen,
mich in der Malerei auszubilden und die Kunst=
= malerei als Lebensaufgabe zu wählen. Die
Realisierung führte damals — wie teilweise auch
heute noch — auf den Weg ins Ausland.
Man musste sich nur entscheiden zwischen Paris
oder Deutschland. Mir kam Deutschland

Gefühlsmässig mehr entgegen.

Und so begab ich mich dann auf den Weg nach der bayrischen Metropole, wo mich die Kunstakademie zunächst an die private Vorschule Knirr verwies. Hier übte ich Zeichnen und Malen, um dann in die Klasse Franz Stuck der Kunstakademie einzutreten.

Die drei Jahre meines Münchner Studiums erweiterte ich dann durch eine einjährige Studien= =reise nach Italien (hauptsächlich Rom)

Und nun galt es, in stiller Arbeit das Gewonnene zu verwerten und zu fördern. Dazu eignete sich die Stadt meiner Jugend, Bern, auf das beste, und ich kann heute noch als Früchte dieses Aufenthaltes eine Reihe von Radierungen aus den Jahren 1903 bis 1906 nachweisen, die schon damals nicht unbeachtet blieben.

Mannigfache Beziehungen, die ich in München angeknüpft hatte, führten auch zur ehelichen Verbindung mit meiner jetzigen Frau. Dass sie in München beruflich tätig war, war für uns ein wichtiger Grund, ein zweites Mal dorthin zu übersiedeln (Herbst 1906) Nach aussen setzte ich mich als Künstler langsam durch — und jeder Schritt vorwärts war

war an diesem damals kunstzentralen Platze von Bedeutung.

Mit einer Unterbrechung von drei Jahren während des Weltkriegs durch Garnisonsdienst in Landshut, Schleissheim und Gersthofen, blieb ich in München niedergelassen bis zum Jahre 1920. Die Beziehungen zu Bern brachen schon äusserlich nicht ab, weil ich alljährlich die Ferienzeit von 2-3 Monaten daselbst im Elternhaus verbrachte.

Das Jahr 1920 brachte mir die Berufung als Lehrer an das staatliche Bauhaus zu Weimar. Hier wirkte ich bis zur Übersiedelung dieser Kunsthochschule nach Dessau im Jahre 1926. Endlich erreichte mich im Jahr 1930 ein Ruf zum Leiter einer Malklasse an der preussischen Kunst-Akademie zu Düsseldorf. Dieses Kam meinen Wunsch entgegen, die Lehrtätigkeit ganz auf das mir eigentümlichste Gebiet zu beschränken, und so lehrte ich denn an dieser Kunsthochschule während der Jahre 1931 bis 1933.

Die neuen politischen Verhältnisse Deutschlands erstreckten ihre Wirkung auch auf das Gebiet der bildenden Kunst und hemmten nicht nur die Lehrfreiheit, sondern auch die Auswirkung des privaten künstlerischen Schaffens. Mein Ruf als Maler hatte im Laufe der Zeit sich

über die staatlichen, ja auch über die continentalen Grenzen hinaus ausgebreitet, so dass ich mich stark genug fühlte, ohne Amt im freien Beruf zu existieren.

Die Frage von welchem Orte aus das geschehen würde, beantwortete sich eigentlich ganz von selber. Dadurch, dass die guten Beziehungen zu Bern nie abgebrochen waren, spürte ich zu deutlich und zu stark die Anziehung dieses eigentlichen Heimatortes. Seitdem lebe ich wieder hier und es bleibt nur noch ein Wunsch offen, Bürger freier Stadt zu sein

Bern den 7 Januar 1940

Paul Klee

"I was born December 18, 1879, in Münchenbuchsee. My father was a teacher of music at the Cantonal Teachers' College of Hofwyl; my mother was Swiss. When I started school in the spring of 1886, we lived in the Länggasse, Berne. I attended the first four grades of the local primary school, followed by four years at the municipal *Progymnasium*. I then entered the *Literarschule* of the *Gymnasium*, and passed the Cantonal examinations, graduating in the fall of 1898. This concluded my general education.

Choosing my profession proved easy enough, outwardly at least. While every career was open to me by virtue of my graduation certificate, I decided to study painting and to devote my life to art. In order to realize this goal, I had to go abroad (the same would be true of many young Swiss artists today), either to Paris or to Germany. I felt more strongly drawn to Germany, and chose to go there.

That is how I came to the capital of Bavaria, where on the advice of the Art Academy I started out at the private Knirr Art School. I practiced drawing and painting there, and before long was able to enter the class of Franz Stuck at the Academy. After three years of study in Munich, I broadened my experience by a year of travel in Italy, which I spent mostly in Rome. And then I had to settle down to digesting what I had learned, and to make it the point of departure for independent work. For this program of quiet work I returned to Bern, the home of my youth; the fruits of my stay there were a number of etchings done between 1903 and 1906, which even then attracted some notice.

During my Munich years I had made many friends, including the woman who is my wife. Since she was professionally active there, I decided – for what seemed to me an important reason – to move back to Munich in the fall of 1906. I was slowly making a name for myself as an artist; and Munich, a center of art and artists at that time, offered significant prospects of professional advancement. Except for three years of military service, when I was stationed at Landshut, Schleissheim, and Gersthofen, I remained settled in Munich until 1920. At the same time, maintained my link with Bern, returning every year to the home of my parents for a summer holiday of two to three months.

In 1920 I was appointed to the faculty of the Bauhaus in Weimar. I taught there until 1926, moving then to Dessau, the new location of the school. Finally, in 1930, I received a call to the Prussian State Academy in Düsseldorf, to be in charge of a painting class. I welcomed this appointment; it permitted me to confine my teaching to the field I knew best. I taught at this Academy from 1931 to 1933.

The political upset in Germany had its impact on the fine arts, too, constricting not only my freedom to teach but the free exercise of my creative talent. Since I had by then achieved an international reputation as a painter, I felt enough assurance to give up my salaried position and to devote all my efforts to my own creative work.

The question of where to settle down for this new phase of my life answered itself. I never really lost touch with my home town; now I was strongly attracted to it again. I have been a resident here ever since. My one remaining wish is to become a citizen as well."

Bern, January 7, 1940 (signed) Paul Klee

(Translation of Klee's handwriting, pages 11–14)

Lost in Thought 1919
[Self-Portrait]

Paul Klee 1912, Postkarte des „Sturm"
Postcard from the „Sturm" / Carte postale du „Sturm"

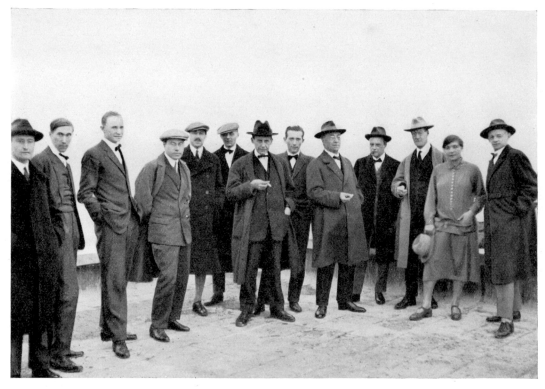

Mitglieder des Bauhauses Dessau (1926) / *Members of the Bauhaus at Dessau*
Membres du Bauhaus à Dessau
von l. nach r. / l. to r. / de g. à dr.: Albers, Scheper, Muche, Moholy-Nagy, Bayer,
Schmidt, Gropius, Breuer, Kandinsky, Klee, Feininger, Gunda Stölzl, Schlemmer

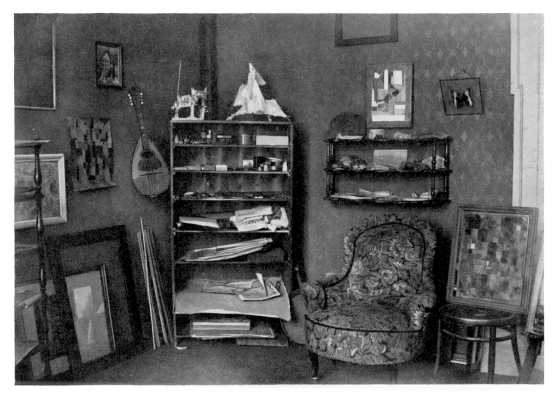

Atelier in Weimar (1924) / *The Artist's Studio at Weimar* / *L'Atelier de Weimar*

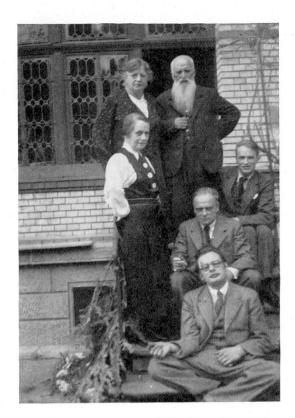

Bern / Berne (1935): Mathilde Klee, Hans Klee,
Will Grohmann, Gertrud Grohmann, Paul Klee, Felix Klee

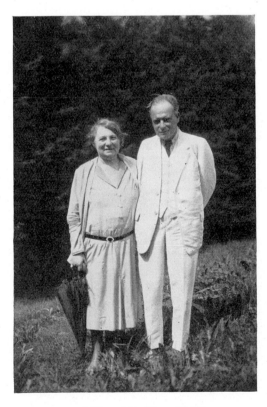

Paul Klee, Lily Klee (1930)

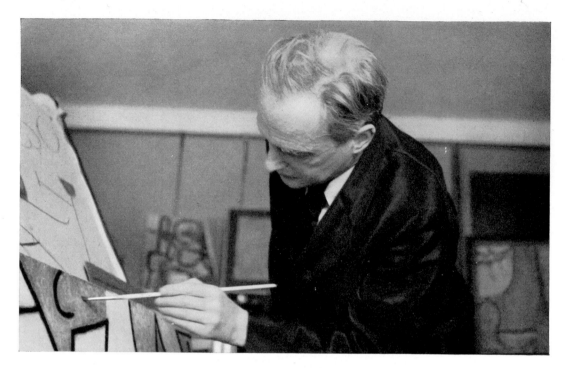

Paul Klee (1938)

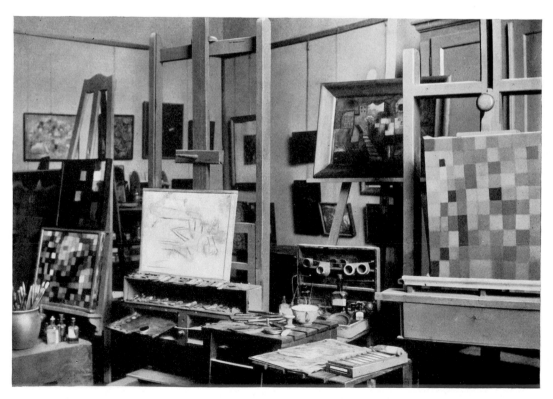

Atelier in Bern (1935) / *The Artist's Studio in Bern* / *L'Atelier de Berne*

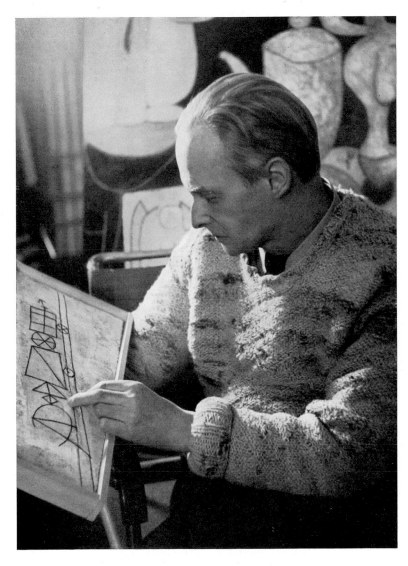

Paul Klee (1940)

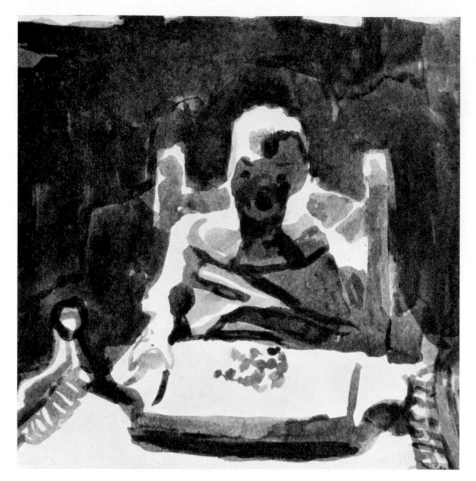

Kind im Klappstuhl (Felix Klee) (1908) / *Child in Folding Chair* / *Enfant sur une chaise pliante*

Rauchender Mann (Hans Klee) (1913) / *Man Smoking* / *Fumeur*

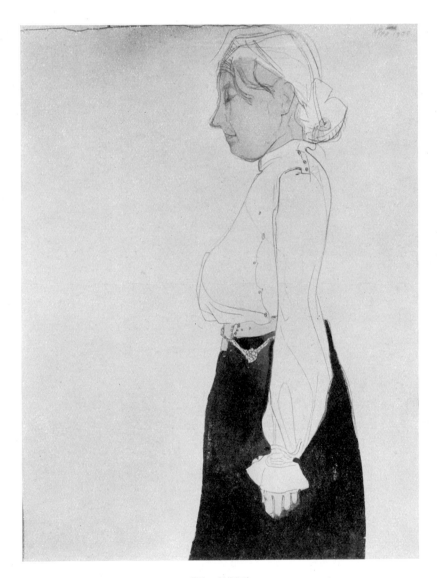

Lily (1905)

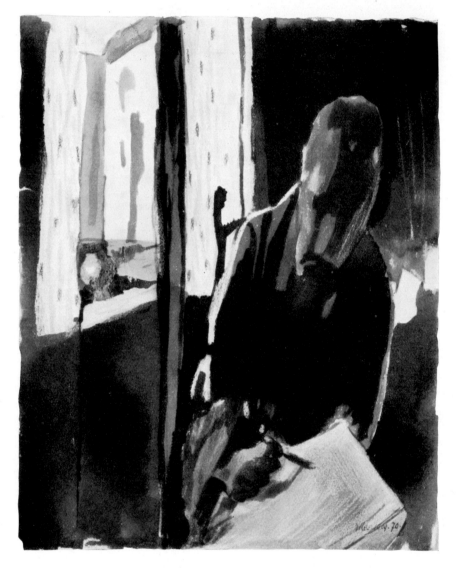

Der Zeichner am Fenster, Selbstbildnis (1909) / *The Artist at the Window*,
self-portrait / *L'Artiste à la fenêtre*, autoportrait

With or without reason, posterity often seizes upon the life of a great painter and turns it into a romance. Perhaps in the future some poet will attempt to interpret Klee's life, to draw conclusions about his existence from the indirect utterances contained in his art. Klee's life was so intricately involved with his pictorial work that even in his private letters the personality of the painter overshadows that of the man. For example, the letters which he wrote to his parents during his student days and those which he wrote later to his fiancée, contain no references to purely private affairs; instead, they discuss his experiences in art and music and how they help him to realize his own goals. There is no mention of what had occurred in his own life or in that of his friends, except during his stay at the Academy of Fine Arts in Munich, when he occasionally refers to unsuccessful love affairs or expresses some candid opinion about one of his contemporaries. In conversation he was slow to pass judgment. He discouraged friends and acquaintances from prying into his private life, and he made no attempt to pry into theirs.

His journals and letters do not record what Klee thought of Robert Delaunay, whom he met in Paris in 1912, though the French painter's researches into color and light had made a tremendous impression upon him. Similarly he has little to say about Kandinsky as a personality, although for thirty years they were intimate friends. There is nothing about his colleagues at the Bauhaus – Gropius, Feininger, and Schlemmer, for example – and nothing about his meeting with either Rilke or Stravinsky. The only exception seems to have been the painter Franz Marc, about whom Klee writes at some length, as though he felt a need to clarify his impressions of a man of very different temper. In his letters and journals, women are almost never mentioned. Indeed, it would even be impossible to discover anything about the relationship between Klee and his wife from these sources. Nor is there any indication of his feelings toward people who liked him or expressed admiration for his work, whether they were pupils, collectors, writers, musicians, or casual acquaintances.

No matter whom he happened to be with, Klee was always reserved; not deliberately, but because he could not be otherwise. Although intensely perceptive, he seemed to live in another world. Even on the occasion of festivities arranged in his honor, Klee remained his usual self. His withdrawal was so compellingly apparent that no one dared to trespass upon his private world. This was all the more remarkable as Klee's outward behavior was so modest and unassuming.

A direct approach was contrary to Klee's nature. For example, his letters written during the First World War contain scarcely any mention of the war itself or of the fact that he was in uniform. The repeated allusions to the Kaiser in his pictures are, like his paintings of the theater, transfigurations of reality; that is why he never permitted them to be reproduced for political ends. In the same way, erotic or sexual episodes that he happened to witness impressed him no more than similar manifestations in the animal or vegetable kingdoms; he accepted such things as natural phenomena and translated them pictorially into his own formal language. He was much more stimulated

by a good picture or concert, and never tired of taking solitary walks where he could be alone with nature, which for him was an inexhaustible source of experience.

Over the years, Klee changed little; even fame had no visible effect upon him. When he traveled, he never visited other famous painters. If they came to see him he would show his latest works as though he had nothing else to offer. Few words would be exchanged, yet the atmosphere he created was so comfortable that the visitor felt that he was in the presence of a sage who had overcome all passion. There was no means of knowing whether or not this was really true, but outwardly he appeared entirely calm. Klee would say something and then watch to see whether it had been understood; if so, he might add a sentence or two, but never more. He never ran after things any more than he ran after people; even where publicity for his own work was concerned, he was content to sit back and patiently wait. He wanted things to happen of their own accord. Not even Klee's closest friends could tell what manner of man he was, and this was as true in his childhood as in later years. Those who really understood his work knew most; the others saw only his integrity and the authenticity of his feelings.

Many pictures of Klee's blend cold and hot, the arctic and the tropic, and this combination of opposites corresponds to a fundamental trait in his character. The blend of hot and cold within himself never produced a discrepancy; on the contrary, it contributed to the richness of his talent. The mathematical and the fantastic, the visual and the musical, the human and the cosmic were reconciled within him; indeed, it was the interaction of these opposing forces that made his personality so difficult to grasp.

Klee could never accept the Faustian attitude toward the world. Growth and change seemed to him more natural than the idea of an individual pitting himself against the universe. He was sure of his own gradual evolution: hence, calm and certainty, rather than any dramatic turn of events. Once he had decided what his life was to be, Klee allowed nothing to upset it, no matter how perturbed he might be, nor how exciting the work he was producing. Since he himself saw everything in terms of similes, his life can best be elucidated through his work.

Klee's parents

Paul Klee came from a family of musicians. His paternal great-grandfather was an organist in Thuringia. His father, Hans Klee (1849–1940), also born in the homeland of Bach, had originally intended to become a singer. Circumstances, however, compelled him to accept a teaching position and for fifty years he taught at the Cantonal School for Teachers at Hofwyl near Bern. Intellectually his father was above average, but his career was not crowned with the success for which he hoped; disappointment probably showed itself in his sarcastic tongue which was often turned against his son. Hans Klee died on January 12, 1940, only a few months before his son.

Klee's mother, Ida Maria Frick (1855–1921) was from Basle. Some of her ancestors had come from southern France and, it was even said,

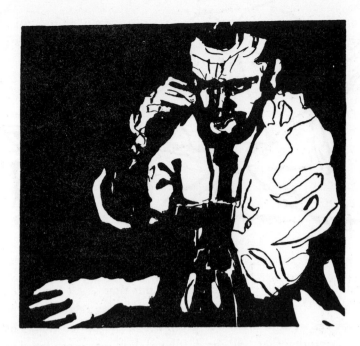

*Self-Portrait Drawing for a
Woodcut* 1909

from North Africa. Klee himself always had a strong affinity for the
Near East and felt at home when he arrived in Tunis in 1914; in 1928
he felt compelled to visit Egypt. Although his mother never entered
upon a professional career, she had been trained as a musician at the
Stuttgart Conservatory. She would have been delighted if her son had
adopted music as a profession. Indeed, for a time, Klee hesitated
between music and painting as a career. But, as he said in the 1920s, he
chose painting because it seemed to be lagging behind and he felt that
perhaps he could help to advance it.

Klee was thus Swiss on his mother's side and German on his father's.
He was born on December 18, 1879, at the village schoolmaster's house
in Münchenbuchsee near Bern, but grew up in the Swiss capital itself
where his father had been transferred. His parents finally settled in a
small house with a garden at Obstbergweg 6, on the outskirts of Bern.
It was here that Klee returned after completing his studies in Munich;
and it remained his home until his marriage in 1906.

Birth on December 18, 1879

Klee's attachment to his mother was close. She was a sensitive
woman, and, in his diary, Klee remembered that at the age of four he
used to rush to her for safety when the "evil spirits" he was drawing
became too real. She encouraged him, when he was seven, to learn to
play the violin. They went to concerts and the theater together, and he
was only ten when he heard his first performance of *Il Trovatore*.
At that time Klee showed the first signs of adolescense, but here his
mother was less understanding; she was morally outraged when she
found some "pornographic" drawings he had done after seeing a ballet
performance at the Municipal Theater in Bern.

Klee's mother became partially paralyzed about 1906 and her afflic-
tion imposed an air of isolation which increased their close bond of
sympathy. On the day of her death in 1921, he dreamt of a female
apparition passing through his studio. The large black borders painted

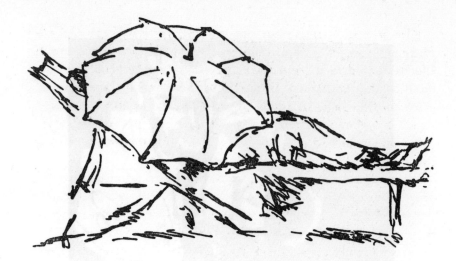

Young Woman on a Chaise
1909

Childhood Drawings p. 33

around his watercolors and gouaches at this time – *All Souls' Picture, The Gate of Hades,* and *The Gate of Night* – may relate to her death.

At the age of four Klee was given a box of colored chalks by his maternal grandmother, and the childhood drawings reproduced here – probably inspired by some fairy tale she had read to him – probably dates from this time. Grandmother Frick did needlework and drawings. She showed him piles of brightly colored prints of religious subjects, and generally devoted so much time to him that on her death he referred to himself as "an orphaned artist". Another relative who played an important role in his life was an uncle who owned a restaurant. The table tops of polished marble fascinated Klee. In the tangle of lines made by the veining in the marble he was able to see grotesque figures which he could copy in pencil. "I could not keep my eyes off the marble tops", he noted in his diary, "and this is yet another proof of my innate taste for the bizarre". One is reminded of Leonardo seeing faces in damp stains on walls. Through visits to this uncle who lived in Beatenberg, and to an aunt who lived in Hilterfingen and later in Oberhofen on the Lake of Thun, Klee knew the surrounding countryside of Bern. Klee's sister, Mathilde († 1953), was entirely different from her brother; she did not really understand his painting but never failed in times of need to give whatever support she could.

He was befriended by many of his father's close acquaintances, notably Hanni Bürgi who was to be among the first to buy his work. Like all his friends, Klee received a thorough schooling. He was sent to primary school in 1886, then, four years later, to preparatory school *(Progymnasium)*, and after that to the *Literarschule* where he studied Greek and Latin. He graduated in September 1898 and was happy that at last school was over. Among his closest friends were Hans Bloesch, who later became Municipal Librarian in Bern, and Fritz Lotmar, later a well-known brain specialist, both of whom he saw regularly after his return to Bern in 1933. In 1938, when he was already a very sick man, he attended a class reunion and was shown some drawings he had made forty years earlier in a student newspaper and some fictitious "for sale" advertisements signed Luap Elk – his own name spelled backwards.

Klee was an attentive but not an enthusiastic student. Only his study of Greek left a lasting impression upon him, for throughout his life he continued to read Greek poetry in the original. He drew busily – ten sketchbooks from this period survive – and played a great deal of music; at the age of eleven he was accepted as a super-numerary in the Municipal Orchestra of Bern. He was not at all stand-offish, however, and liked to join in the fun with youngsters of his own age.

Nothing extraordinary seems to have happened during his school years. He mentions an outing up the Grimsel, trips with his father up the St. Gotthard and to Fribourg, and two visits to relatives in Basle to hear *Figaro* and *Tannhäuser*. He wrote poems and stories which he tore up, and only a year before graduation he was still worrying over his love of music. However, in the summer of 1898, at the age of 19, he refers to himself as "a future painter", so by that time the great decision had been made.

During his life in Germany (1906–1933) he felt himself to be Ger-man. When he retired to Bern in 1933 he felt once again, as during his schooldays, the strength of his ties with Switzerland, the more so because he had never lost touch with many of his childhood friends.

From School Copybooks p. 34
From Sketchbooks pp. 36, 37

(below)
Sick Woman in Armchair
[The Artist's Mother] 1909

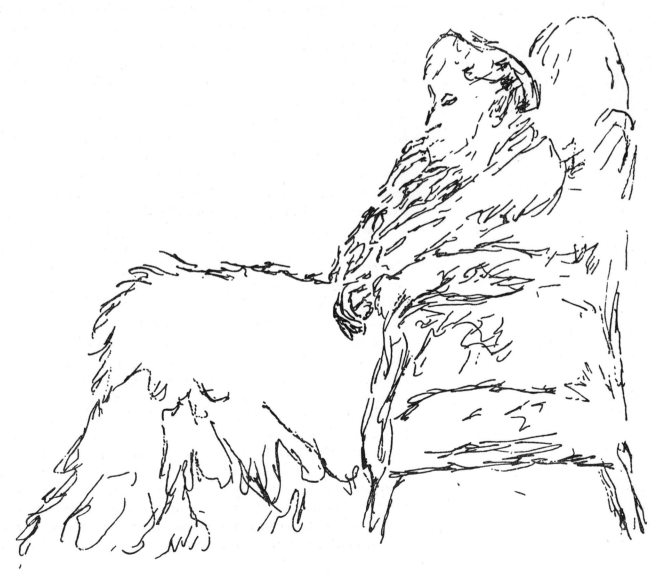

In January 1940 he applied for Swiss citizenship which, however, had not yet been granted when he died. The application for naturalization which he handed to the Federal authorities in Bern contains the following autobiographical statement: "Although after graduation every career was open to me, I wanted to try my luck at learning how to paint... Then, or for that matter nowadays, this meant leaving our country, and the only choice lay between Germany and Paris. Temperamentally I was more attracted by Germany, and so I set out for the Bavarian capital where the authorities of the Academy of Fine Arts recommended that I take private lessons at Knirr's school to begin with. I was taught to draw and paint, and afterwards I entered the class of Franz Stuck at the Academy." In the last year of his life, Klee, by then famous, could still describe what happened with the modesty of someone quite unknown.

Self-Portrait Cl. Cat. 1

Study with Knirr and Stuck

In October 1898 Klee began a three-year period of study in Munich. On the advice of Ludwig Löfftz, the Director of the Academy, he worked with Erwin Knirr, who was as enthusiastic about his new pupil as Klee was about the painting and teaching of his master. Knirr expressed the opinion that if Klee persevered the result might be extraordinary. Franz Stuck, whose class at the Academy he joined in October 1900, was also encouraging, and Klee refers to his "sharp and intelligent criticism". He studied the technique of etching under Ziegler, and wrote very self-important letters home to his parents. He does not seem to have thought much of Anton Azbé's School, and it was not until 1911 that he met the two Russians, Wassily Kandinsky and Alexey Jawlensky, who had been studying there since 1896. Actually Klee and Kandinsky had been pupils in Stuck's studio in 1900 but did not know each other at that time.

Klee's program of work was ambitious: he worked hard at drawing from the nude (often with considerable success as is proved by some studies now in the Klee Foundation); he also drew landscapes and illustrations, although he noted that his aim was to be "more than an illustrator". Among surviving works of this time are a sketch, *Nocturnal Ghost* (1899), strongly influenced by the *Jugendstil*, and *Joan of Arc*, "the product of a hot summer's afternoon", reminiscent of Gauguin whose pictures, however, he could not yet have seen. Klee attended lectures on art history and anatomy, and around 1900 he began modeling figures "for the sake of the form". When he left Stuck's class in March 1901 he wanted to join Ruemann's sculpture class. Perhaps he felt that he had not worked hard enough; at all events he did not pursue this project.

Sketchs pp. 38, 39

Klee found the atmosphere of Munich stimulating, but his journal and letters contain more references to music than to painting. He was fascinated by Wagner and Richard Strauss, though Mozart was his great love. He also had time for lighter diversions, and there are accounts of excursions, of evenings spent in riotous company, of flirtations and more serious affairs. He wanted to discover as much as possible about life, to stake out his own limits, to learn not to run away from any experience no matter how banal. Lacking money, Klee could not afford

to travel abroad, and he spent his holidays in Bern with his parents. In the summer of 1899, however, he returned home from Munich by a roundabout route through Salzburg and Innsbruck.

During these years women played a great part in his life, although none of his romances seem to have lasted. When he met the girl who was to become his wife – Lily Stumpf, the daughter of a Munich doctor – at a musical evening in the winter of 1899–1900, he was quick to recognize his good fortune. Their engagement was announced in 1902, and they were married in Bern on September 15, 1906.

From a visual point of view, Klee's artistic experiences during his three years of study in Munich were limited. He was of course familiar with *Jugendstil* (the German version of the *art nouveau* movement elsewhere in Europe). *Jugendstil* had originated in Munich in the 1890's with Obrist, Endell, and Eckmann, and the style had been popularized through periodicals such as *Insel, Pan, Jugend,* and *Simplizissimus.* The last Klee referred to as "the finest journal in the world". His only comment in a letter to his parents, on an exhibition of works by Ferdinand Hodler in 1898 was that Menzel had stood for half an hour in front of the painting *Night.*

He discussed his own work more frequently. "Without question painting is the most difficult of all the arts", he wrote to his parents in 1899. And in his journal he noted that for him the prerequisite of success was to cultivate his personality and produce a blend of art and morality; his duty, he says, is not "to reflect surface appearances" but "to penetrate within. . . . I mirror the very heart. I write words on the brow and around the corners of the mouth. My faces are truer than real ones".

In the spring of 1901 he decided on the following order of precedence: "First and foremost the art of living; then as ideals: art, poetry, and

Marriage to Lily Stumpf, 1906

Girls Playing Out-of-Doors
1910

Journey to Italy

Opinions on Renaissance art

philosophy; after that sculpture as an actual profession; and, finally, when money is short, illustration." He added to his parents: "At the moment only illustration is making progress. I feel that it may yet be my salvation."

While studying in Munich, Klee fluctuated between many things. However, his relationship with Lily Stumpf and his ever clearer insight into himself and his calling helped him to gain inner stability.

Klee left Munich on June 30, 1901, and spent a few months in Bern. For most of his contemporaries Paris was the immediate goal, but Klee preferred to postpone a visit to France until he was more sure of himself. In the autumn, he went to Italy for a holiday with his friend Hermann Haller, the Swiss sculptor. They arrived in Milan on October 22, and Klee was particulary struck by the Tintorettos in the Brera. The harbor of Genoa thrilled him; he took a boat to Leghorn and arrived in Rome on October 27. With Burckhardt's *Cicerone* in his hand, Klee visited the artistic monuments of Rome and frequently attended the theater: he mentions seeing Duse, Réjane, Loïe Fuller, and Sada Yaco, as well as a performance of *Meistersinger*. He read Tacitus' *Histories*, plays by Aristophanes and Plautus, and Xenophon's *Symposium*. He had also brought with him Goethe's *Italian Journey*, and in his journal Klee comments: "Goethe is the only tolerable German. Perhaps I would like to be such a German myself."

There were days when Klee did nothing but wait for the life of Rome to engulf him. He was not quite sure why, but waiting seemed an essential part of his nature and offered a better prospect than too much activity.

His judgments on Italian art were astonishingly mature and modern. He regretted the loss of so many works by Leonardo, as he wrote to Lily, because "all the greatest achievements in art derive from this man, at least so my spirit tells me." After Leonardo, he was most enthusiastic about Michelangelo's paintings in the Sistine Chapel and Raphael's *Stanze* – "Michelangelo acted like a lash on a pupil of Knirr and Stuck." Pinturicchio's frescoes in the Borgia apartments of the Vatican impressed him as "the most beautiful creation of the Renaissance", while Botticelli's *Birth of Venus* in the Uffizi appeared "the simplest and most complete piece of painting." Klee also mentions some early Christian mosaics in Rome, but without great enthusiasm, for it was not until much later that he became aware of their beauty and of the traces of oriental art in various churches and palaces. His admiration for classical sculpture was not wholehearted. He wrote to his parents, "The *Laocoön* is a great achievement only in terms of workmanship." On the other hand he felt strongly about the wall paintings of Pompeii and wrote in his journal: "I had a good idea in advance of this use of silhouettes and of the decorative color. This I take personally. They were made for me and excavated for me, they have given me courage." But on second thought: "Imitate nothing. I am suspicious of any attempt to try to do something not of one's own time." The result was that he felt embarrassed about his own work and turned to satire. "Perhaps I shall never become positive. At all events I shall struggle like a wild animal."

Christkind mit gelben Flügeln (1885)
Christ Child with Yellow Wings
Enfant Jésus aux ailes jaunes

Weihnachtsbaum mit Christkind und Eisenbahn
(1884) / *Christmas Tree with Christ Child and Toy*
Train / Arbre de Noël, Enfant Jésus et train

Kinderzeichnungen / Childhood Drawings / Dessins d'enfant

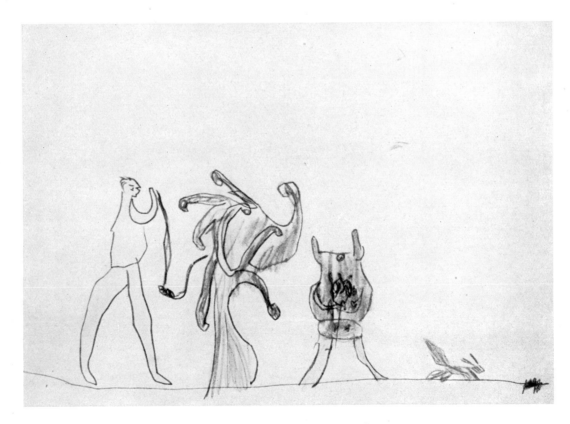

Mit dem Hasen (1884) / *Picture with Hare* / *Avec le lièvre*

Harzreise im Winter (1897) / *Winter Journey through the Harz Mountains*
Voyage dans le Harz en hiver

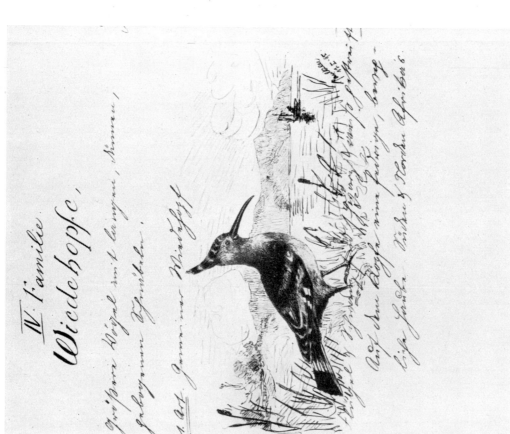

Wiedehopfe (1895) / *Hoopoes* / *Huppes*

Aus Schulheften / School copybooks / Cahiers d'école

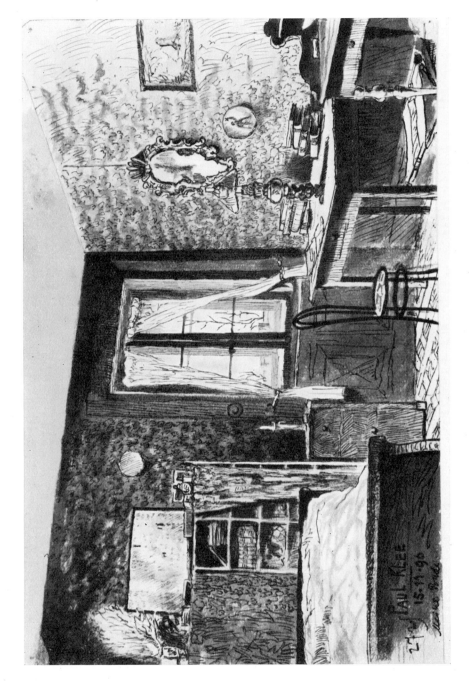

Meine Bude, Bern (1896) / *My Room* / *Ma cambuse*

1892

1896

1895

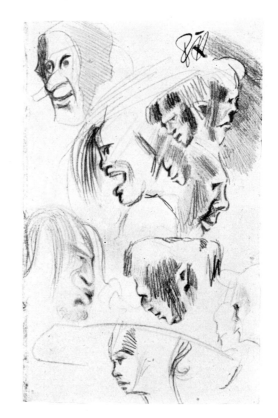

1897

Aus Skizzenbüchern / Sketchbooks / Cahiers d'esquisses

Elfenau, Bern / Berne (1897)

Basel / Basle / Bâle (1896)

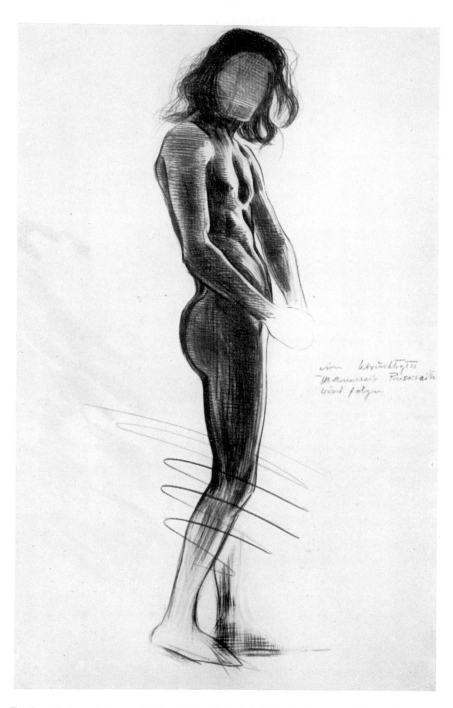

Ein berüchtigtes Mannweib (Studie bei Knirr) (1899) / *A Notorious Hermaphrodite*
(study at Knirr's) / *Une Femme-homme notoire* (étude chez Knirr)

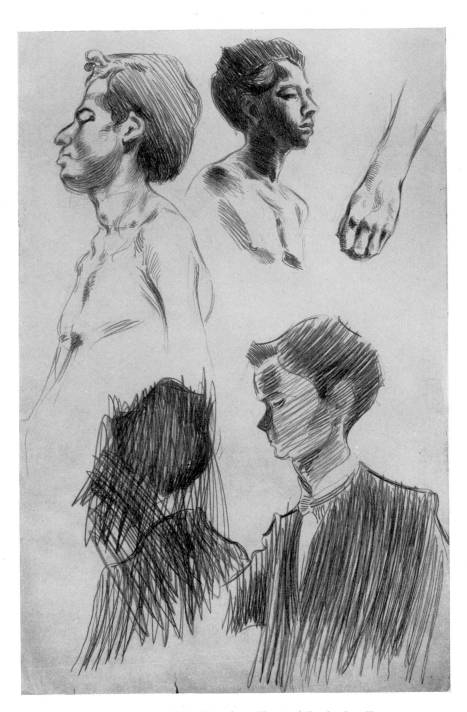

Studie bei Knirr (1899) / *Study at Knirr's* / *Etude chez Knirr*

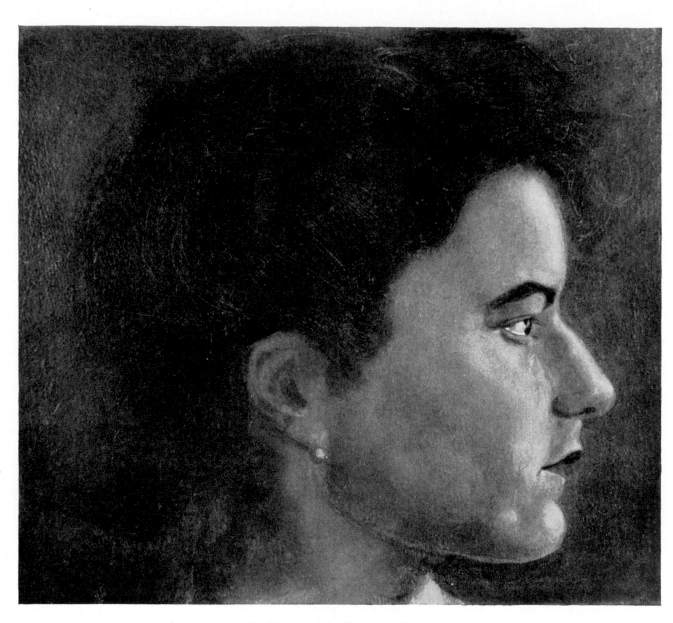

Die Schwester des Künstlers (1903)
The Artist's Sister / La Sœur de l'Artiste

At Eastertime Klee arrived in Naples. He found the frescoes by Hans von Marées in the Zoological Station "very close to my heart", but he was perhaps more attracted by the aquarium with its stock of fantastic marine animals which revealed to him an unsuspected world. Klee had a distinct taste for strange and exotic things such as the flora and fauna which inhabit the depths of the ocean; they suggested to him some unobtainable far-off realm. On his first visit to the aquarium, Klee was both surprised and amused: one of the octopuses resembled an art dealer who seemed to ogle and wonder "whether I was a second Böcklin."

Klee worked on figure studies in the studio, and also directly from nature out of doors. "One works more freely in the void, but it is easy to lose one's self-control that way." He inscribed one of his pictures, *The Epigone* (1902), in the style of the titles he gave later to his etchings. The linear structure of some trees suggested human bodies to him. This was one of the first signs of the development of his penetrating vision, and when he talks of "expressing many things at once by a single word", he anticipates the more complex conception of art which he evolved later. Klee used pencil and tempera, "mixed simply with water", to avoid technical complications. In his own catalogue of his work he included no experimental efforts, but the small watercolor, *A Grace, Floating, in Pompeian-Style*, was probably executed before he left for Italy. It is dated simply 1901 and bears the annotation "from imagination."

Klee returned to Bern on May 2, 1902 and by May 7 was already back at work. Though his friends found him changed – for one thing, he had grown a beard – his style of painting remained the same. During seven months of travel he had developed considerably; but this is most apparent in his journal, for his ideas are in advance of the few pictures he actually produced. Klee was not an artist who simply copied things he saw; instead he thought about them, wondered how they had been produced and why they had assumed one form rather than another. He applied his conclusions to his own work but resisted the temptation to strain after effect. "I have to disappoint at first. I am expected to do things a clever fellow could easily make. But my consolation must be that I am much more handicapped by my sincerity than by any lack of talent or ability. I have a feeling that sooner or later I'll arrive at something valid, only I must begin, not with hypotheses, but with specific instances, no matter how minute. For me it is very necessary to begin with minutiae, but it is also a handicap. I want to be as though newborn, knowing absolutely nothing about Europe; ignoring facts and fashions, to be almost primitive. Then I want to do something very modest, to work out by myself a tiny, formal motif, one that my pencil will be able to encompass without any technique . . . So far as I can see, pictures will more than fill the whole of my lifetime . . . it is less a matter of will than of fate."

First of all, he had to learn more about the techniques and laws of painting. He frequently attended lectures on anatomy by Prof. Strasser in Bern, drew regularly from the nude, experimented technically with

paints, and attempted satirical drawings, most of which he destroyed.

He became an avid reader, and to the end of his life he continued to read the literary masterpieces of several languages. His letters to his fiancée are full of discussions of books. Everything that people were reading is mentioned, from the Bible to Strindberg and Wedekind. The list of titles would make a long catalogue. It includes the French and Russian novelists, especially Tolstoy and Dostoievsky, as well as unfashionable and forgotten things such as the plays of Calderon, Schlegel's *Lucinde*, Lenau's *Don Juan*, Heinse's *Ardinghello*. He mentions, of course, the Greek tragedians as well as Aristophanes, whose satire he enjoyed. Klee's favorite authors were E. T. A. Hoffmann, Poe, Gogol, and Baudelaire, whom he felt to be kindred spirits. Since his own outlook was endowed with a blend of realism and fantasy, of scepticism and transcendentalism, he was stimulated by Cervantes and Rabelais, and, later, found inspiration in Voltaire's *Candide*. Goethe's *Elective Affinities* he read three times consecutively, each time reading the parts concerning Ottilie. His copy of Hebbel's *Journals* is full of critical, self-revelatory notes in the margin. Zola's *L'œuvre* he found sinister, but for the first time he felt the desire to go to Paris.

Lily, too, read a great deal and often sent him books which she had enjoyed or which he had requested. On one occasion he asked her to look up a quotation in Lessing's *Laocoön*, a quotation which he was later to challenge in his essay contributed to *Schöpferische Konfession*, an anthology of artists' writings. Although few of the books Klee read concerned art, he mentions volumes by Jacob Burckhardt and Taine, as well as monographs by Esswein on Toulouse-Lautrec and Munch, these last with approval.

Klee became a regular member of the Bern municipal orchestra; he even traveled with the orchestra, and once substituted for Jahn, the first violin, who had been his teacher. He went to Zürich to hear Richard Strauss, and his letters are full of comprehensive musical analyses and well-balanced criticisms. Once or twice a year Klee would visit Lily in Munich and would hear concerts and operas. Their

Music

Small Sketch – Children Out-of-Doors 1908

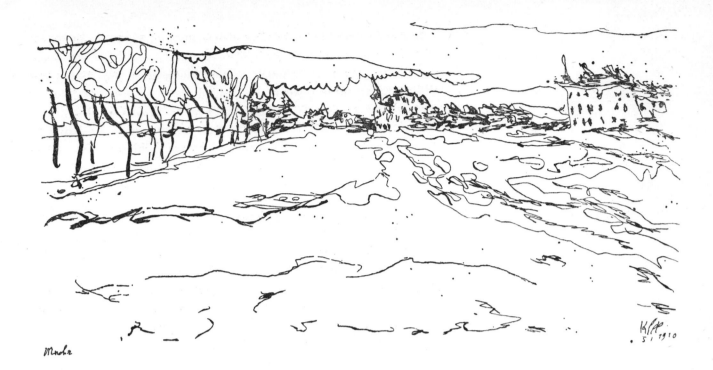

Mudz

musical standards were always very high, because from 1903 onwards they were set by Felix Mottl, the chief conductor at the Opera.

His trips to Munich enabled Klee to see a great many works of art. In October of 1904, he spent some time studying drawings in the Print Room. Aubrey Beardsley, about whom he had heard a great deal, did not appeal to him, and he was much more interested in the visionary works of William Blake. His greatest thrill were the *Proverbs,* the *Caprichos,* and the *Disasters of War* by Goya, which he adopted as the ideals which he was never likely to attain. In August Klee went with Lily to Geneva where he saw pictures by Corot which he decided were among the most beautiful in modern painting.

Apart from his tour of Italy, Klee's only other trip abroad was a short visit to Paris from May 31 through June 13, 1905. He traveled with his friends Hans Bloesch and Louis Moilliet. His diary of this visit contains a mere mention of the Whistler retrospective exhibition. Renoir, he comments, is "very nearly vulgar, yet so important." He seems to have seen nothing by painters of his own generation; Matisse, Derain, and even Cézanne escaped his notice. Perhaps he was not looking for such things. As in Rome, what interested him most was the life of the city, the past continuing into the present, the ever-changing spectacle of the boulevards. Klee knew what he wanted; everything had to originate within himself, and so no meeting with another artist could prove decisive.

In the Louvre, the artist whose work most impressed him was once again Leonardo, "the greatest pioneer in the handling of tonalities"; next in his esteem ranked the late works of Rembrandt and Goya. Klee went to the theater and mentions hearing Gluck's *Armida* at the Opera and *The Barber of Seville* at the Théâtre Sarah Bernhardt. He seems to have spent other evenings Chez Bullier, a well-known "bal de nuit" near the Halles.

First journey to Paris

In April 1906 Klee paid a short visit to Berlin to see Lily and discuss with the critic Heilbut the possibility of an exhibition of his work in the German capital. Although he sold one picture, no dealer was willing to accept his work. He visited the Centennial Exhibition organized by Hugo von Tschudi and went frequently to the Kaiser-Friedrich-Museum. On his return to Bern he stopped in Karlsruhe to look at pictures by Hans Thoma, which meant nothing to him; but he felt some degree of kinship with the Grünewald picture in the museum there.

Etchings pp. 105–108

Between his trip to Italy in 1901 and his arrival in Munich in 1906, Klee laid the foundations of his own art. Three of these years were devoted to printmaking, and he etched some fifteen plates. To this group must be added an etching of 1901 and two others of 1906 and 1907. Between 1910 and 1932 Klee made some forty more etchings, but in terms of stylistic development these lack the significance of the earlier group. They are simply extensions of pictorial ideas which he was pursuing simultaneously in other mediums.

Klee considered these etchings as his first successful achievement and was so pleased that he gave some away to friends and even hoped for a few sales. When the series of "Inventions" was completed, he sent a small portfolio to Lily in Munich, asking her to show them to his teacher, Franz Stuck, and to try to arrange for an exhibition: "I will have a prospectus printed like any traveling salesman, in which the marvelous qualities of my etchings shall be weighed in terms of gold. I shall also include some press criticisms." On April 26 he sent the portfolio to Munich to the jury of the *Sezession* exhibition, and he even suggested how his etchings should be hung: If space were limited, then all ten should be shown together in one large frame. His instructions were followed. His teacher, Franz Stuck was pleased; the critics less so. Gagliardi wrote in the *Berner Rundschau:* "It is very difficult to give any sort of clear picture of the crazy anatomy of these forms. Nothing like them appears even in one's wildest dreams and they could only

A Clearing in the Forest
1910

have been produced by someone who deliberately sets out to make a meaningless medley of part-human, part-animal fragments." Klee continued to consider himself a graphic artist, although by the end of the summer of 1906 he felt that he had got away from the "severe style" of these etchings.

On the plate of *Hero with a Wing* (1905), he wrote: "Specially provided by nature with only one wing, he took it into his head that he was intended to fly, and that was his undoing." There are similar inscriptions on nearly all these etchings, and they are also often described in his letters and journal. Of the *Virgin in a Tree* (1903) he wrote to Lily: "The idea that it is meant to convey is certainly a truism – the truism that virginity, though much-prized and carefully guarded, serves no purpose." Already Klee was moving away from the illustrative toward the creation of a pictorial style. The balance was beginning to shift.

Hero with a Wing p. 108

Virgin in a Tree p. 106

Klee's etchings represent the most direct expression of his insight into the world during these early years. They also reveal an astonishing command of anatomical detail. Those weaknesses which Stuck had not hesitated to point out to his pupil had been overcome. Klee had benefited from the lectures in anatomy and from the life classes which he had attended with Moilliet and "with lots of bourgeois painters, to draw the ugly *hetaerae* of the Matte quarter in Bern." "The naked body is an altogether admirable object. In art classes I have gradually learned something of it from every angle. But now I will no longer content myself with views of it, but will proceed so that all of its essentials, even those hidden due to optical perspective, will materialize."

Success banished the depression which Klee felt about painting "that never turns out right", and freed him from the gloomy ideas which his narrow, everyday life in Bern had nurtured. He started to work *"pour ne pas pleurer"*, as well as in the hope of achieving things which he only vaguely glimpsed but did not dare believe he could accomplish in the course of a lifetime.

Klee's self-criticism, especially after this first taste of success, is astonishing. In the summer of 1906 he still found it necessary to distinguish intellectual from pictorial projects. "Nobody will notice", he wrote to Lily, "but the flaw in my etchings is that, although pictorially conceived, they can be epigrammatically explained. They are a combination of pure painting and pure drawing (explicable in terms of my own personality), each of them pursued with the painstaking concentration which, to me, is unavoidable... At present, my whole mind is absorbed in an effort to separate painting from graphic art and to develop both. For painting I have turned toward Impressionism; and now graphic art is beginning to come into its own. Therefore my etchings suffer from the fault of all youthful works, namely that they attempt too much." Klee, the graphic artist, had still not found a final solution: there were other experiments to come. He had seen some prints by Munch and Toulouse-Lautrec in Paris; he also read Loga's book on Goya, which was sent to him by Heilbut, and was "knocked out" by a reproduction of an etching by Goya which he hung on a wall

of his studio in Bern. He dared not hope to compete with the many-sided genius of the Spanish master, but he could strive to cultivate an equal power of expression.

During his Italian trip he had already shown traces of considerable pessimism and a tendency toward satire. From Rome in 1902 he had written to his father: "Classical art is a sort of paradise for me. Culturally speaking, our art is very unimportant. That does not matter; we were born that way and must accept the situation. In order not to be laughed at, however, one must make others laugh, even at an image of themselves. That is one of the motives behind my present experiments." Klee reacted to Rome through satire, not through insolence, but through self-dissatisfaction when faced with something higher: ridiculous man – divine god. "Hatred of mediocrity out of respect for pure humanity." He justified the comic element in his etching, *Comedian,* by a quotation from Gogol's *Dead Souls:* "There is a laughter which may be classed with the higher lyrical emotions and which is as distant as heaven from the convulsions of a common jester." Klee even refers to "the world of visible laughter and invisible tears" as a characteristic of this novel.

Klee worked hard, much harder even than the number of his surviving works would lead one to suppose. He drew from life as well as from imagination, a distinction which he maintained until 1903. He drew portraits of his parents, his sister, and his fiancée. He attempted group compositions and, in short, was more concerned with figures than anything else. In 1903 he painted a very academic but competent head of his sister in oil; in 1906 he drew a portrait of his father in india ink on glass, which neatly balances psychological penetration and incisive draftsmanship; and finally, Frau von Sinner commissioned a portrait of herself, to be executed in watercolor on glass.

Painting on glass suddenly assumed great importance. In 1905 and 1906 Klee made twenty-six drawings and watercolors on glass and, until 1917, he continued occasionally to use this technique. Klee's paintings on glass were more naturalistic than his etchings, and satire was replaced by the grotesque: an almost impossible blend of humor based on contrast and distortion, which affects subject matter as much as form. In line, color, and content there is no great difference between these pictures and other drawings and watercolors of the same time. Accidents of technique, however, give them a slightly more ephemeral and fantastic appearance. *Comedy,* with its two strange women, one with red hair and a hoop skirt, the other with bright yellow hair and a long loose dress, is spectral but gay. The *Portrait of a Sentimental Lady* is almost absurd, with its enormous breasts. Only a few of Klee's glass paintings are as Impressionistic as *Garden Scene with a Watering Can* or as descriptive as the *Portrait of Frau von Sinner.*

The "old jog-trot" was nearing its end, "but what is the use of forcing oneself to do things beyond one's power?" he asked Lily in 1906. The period of his Impressionistic experiments was about to begin, and once again Klee thought more about the world around

Comedian p. 107

The Artist's Sister p. 40

Portrait of My Father
Cl. Cat. 18

Paintings on glass pp. 109–111

Portrait of a Sentimental Lady
p. 111

Garden Scene with a Watering Can p. 117

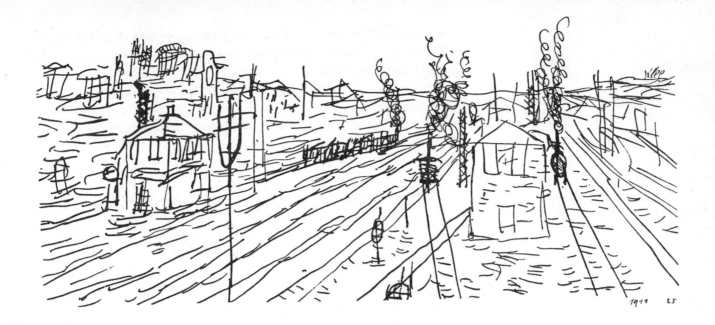

(above)
Munich, Main Station II
1911

him. "Imagine that you have been dead for many years and that at long last you are permitted one more look at the earth. All you can see is an old dog cocking a leg toward a lamppost, but still you can't help sobbing with emotion." Klee was avid for impressions and experiences; he worked hard from nature but paid little attention to whether or not he took liberties or copied exactly what he saw. He made little drawings and imagined that they were as good as those of the French Impressionists; in fact he was so pleased with these drawings from nature that he was convinced that they could help him to unbend. His aim was to find a direct route from visual experience to pictorial creation; he wanted to expand his range, "and not be beggared by orderliness." In 1903 Klee had cast out the poet in himself because he wanted to be a puritan, and because wherever he looked he saw nothing but lines and surface rhythms. Now this phase was over. He was searching for a bridge between nature, inspiration, and his own creative powers – the common denominator of which he had been dimly aware in 1903 but which now was his task to render visible.

Many of Klee's drawings of this time are of nudes in carefully observed attitudes, often quite obviously contrived to enable him to solve some problem of his own devising – for example, one is called *Female Nude Having Drunk, Pouring Out and Spitting as an Expression of Disgust* (1905) – though there are several examples of more mature thought, such as *Soothsayers Conversing* (1906).

Soothsayers Conversing p. 97

In the summer of 1906 Klee modeled a little figure in colored plasticine and was so pleased with it that he decided to attempt others, now in the Klee Foundation in Bern. They are small fetish-like objects, articulated by means of surface intaglio. "This receptive material has, incidentally, opened my eyes to what bores and idiots most German sculptors are," he wrote to Lily. "How few of them have ever tried to use color!"

Despite a few Swiss friends – Hermann Haller, Louis Moilliet, Bloesch, and Lotmar – who understood his aims, Klee had felt more and more alone in Bern. Not even his few short trips abroad could compensate for the lack of contact with other artists. Bern had proved too much of a small town. "I must find a place where there is nothing, but where I fall on my knees with emotion. I have had enough of bitter laughter over things the way they are, but which are not as they ought to be." It was a great relief to him to settle in Munich after his marriage to Lily Stumpf on September 15, 1906.

Their only child, Felix, was born on November 30, 1907, and they lived at Ainmillerstrasse 32, in the suburb of Schwabing where they remained until Klee was summoned to the Bauhaus. Lily had studied the piano with Ludwig Thuile, Ermannsdörfer, and Jedlitzka, and since Klee's earnings were still negligible, she kept the household in funds by giving music lessons. This remained their chief source of income until the end of the war, although Klee's pictures had begun to sell fairly steadily after the *Deutscher Herbstsalon* exhibition in Berlin in 1913. They lived economically. "The essence of happiness is to live unpretentiously", – and his attitude never changed. His final home on the Kistlerweg in Bern was to be no more sumptuous than the three-room apartment in Schwabing.

In spite of financial difficulties, Munich was a paradise for Klee. He was in contact with people, music, and art. Poverty seemed more tolerable in a city which, at least until 1914, was a cultural center and where he soon acquired a reputation as a serious artist. Munich offered good exhibitions and concerts. During his three years as a student in Munich, he had attended an incredible number of musical performances by a great variety of singers and conductors. Now again, between 1907 and 1914, he seems to have missed hardly any important performance. The chief conductor at the opera was Mottl, who was succeeded after his death in 1911 by Bruno Walter. Klee later immortalized two of the great soloists he had heard at this time in the pictures *Fiordiligi* and *The Voice Cloth of the Singer Rosa Silber*. His passion for Mozart grew, and he began to develop a taste for contemporary music. In 1909 he referred to Debussy's *Pelléas et Mélisande* as the most beautiful opera since Wagner; in 1913, Schönberg's *Pierrot Lunaire* evoked the pithy comment: "Burst, you stuffed shirt: your knell is ringing."

Klee's daily life consisted of housework, painting, shopping, and occasionally visiting friends. Until 1910 Klee cooked and looked after Felix while Lily was out giving music lessons. To make things easier he did most of his painting in the kitchen. When the weather was fine he sat with Felix on the apartment's little balcony and looked for something to paint. Such was the origin, for example, of the glass-painting *A Street with Carriage* (1907). Sometimes he would take a walk with Felix, the father taking his painting materials, the child his toys, many of them – a sailboat, a train, and a puppet theater – made by Klee himself. Some of these toys are still in Felix' possession.

Every day Klee and Lily and some of their friends would play music. He also read, though not nearly so much as in Bern. When

visitors came they were entertained in the living room where the grand
piano stood with the violin on top of it. The same room was also used
for showing his tiny pictures, which fortunately did not take up much
space. There were not many books in the apartment, and until Klee
inherited a few good Rococo and Empire pieces from his grandmother
in 1911, only a minimum of furniture.

Visitors to the Klee apartment were struck by the contrast between
the busy atmosphere, the bourgeois furniture, and the way of life.
Although there was no hint of bohemianism, the general effect was
somewhat odd. The pictures by Klee and others seemed to mock their
Biedermeier setting. Little carvings, pebbles, fossils, dried leaves and
flowers lay around on the tops of commodes, suggesting a witches'
kitchen rather than an average dwelling. Klee himself tended to dress
more like an alchemist than a Munich bourgeois.

Klee was particulary fond of cats, and he always had a cat, just
as his parents had in Bern. He liked the sense of peace and ordered
life which they contributed to a home, and he allowed the cat to
remain in the room while he worked. Bimbo, the cat Klee had at
the end of his life, was an essential part of the household. Klee's
admiration can be summed up in Baudelaire's lines, and many pictures
often touch on the same theme:

> C'est l'esprit familier du lieu;
> Il juge, il préside, il inspire
> Toutes choses dans son empire;
> Peut-être est-il fée, est-il dieu?

As soon as Klee began to earn money from the sale of pictures, he
rebelled against losing so much time when he ought to be at work.
He was thirty-one years old and, in a letter to Lily from Bern in
October 1910, he said that in the future he could devote only half
instead of the whole day to the household. He was working on the
series of illustrations for Voltaire's *Candide* (published in 1920); and
had just held his first one-man show of fifty-six items in the Bern
Museum where Hanni Bürgi made her first purchases. This exhibition
traveled to Basle, Winterthur, and Zürich. Klee received a favorable
review in the *Neue Zürcher Zeitung* and sold a watercolor for 200
Swiss francs. Even the smallest sale in Switzerland meant a great
deal to Klee, who had somewhat the feeling of the prophet without
honor in his own country. In Germany he had sent only a few works
to each exhibition: ten etchings shown at the Munich *Sezession* in 1906
and three pictures in 1908; seven pictures at the Berlin *Sezession* in

First one-man show

(below)
*Spectators at a Regatta, on a
Small Steamer* 1911

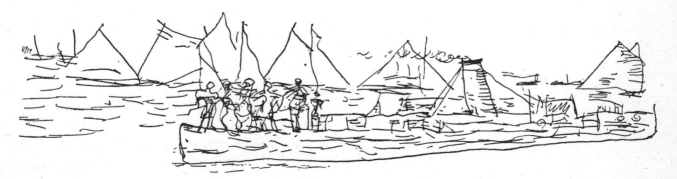

1908; one watercolor shown at the *Glaspalast* in Munich in 1909 and another at the Berlin *Sezession*. But in 1911 the entire Swiss exhibition went to Munich, where it was shown at the Thannhauser Gallery, and in the spring of 1912 Klee was represented at the second *Blaue Reiter* exhibition. After that, he was invited to contribute to the Cologne *Sonderbund* in 1912, to the *Deutscher Herbstsalon,* and to the *Sturm* Exhibition in Berlin in 1913, and subsequently to exhibitions in Munich, Hanover, Dresden, and elsewhere.

Before the First World War Munich had excellent art exhibitions, many of them at dealers' galleries. It would be difficult to exaggerate the importance of their influence on Klee. A shy man, he avoided lengthy discussions and unnecessary personal contacts, and these exhibitions enabled him to discover many things that he might otherwise have missed. When he looked at pictures in an artist's studio or in a gallery, Paul Klee was a forthright critic who made no concessions, even to friendship, in his judgment. Thus he found Hermann Haller's little sculptures "hackneyed", while Alfred Kubin's drawings were "lively in their destructiveness." His opinion of Kubin, one of his admirers, remains valid today: "He ran away from this world because he could no longer face up to it physically and got stuck halfway. He longed to attain to things crystalline but could not free himself from the mire of appearances." In general, however, Klee says little about the majority of his contemporaries: there is no mention of the painters of the *Brücke* group whom he met at the time of the second *Blaue Reiter* exhibition; there is very little about the Cubist painters, whose work he saw at Wilhelm Uhde's in Paris in 1912; but he admits that Delaunay's *peinture pure* had started his mind working. The Futurists, whose work he saw at the Thannhauser Gallery in 1912, made less of an impression on Klee than on Marc, although one cannot deny that Klee's work shows traces of their influence. But his letters and journals do not always exactly show how strongly he reacted to experiences which were silently absorbed. The *Blaue Reiter,* however, was a part of his own development.

Hugo von Tschudi, former Director of the National Gallery in Berlin, and one of the first in Germany to buy Impressionist and post-Impressionist paintings, had been appointed director of the Bavarian State Museums in 1909. He brought to Munich a private collection of Impressionist and post-Impressionist pictures which were acquired for the Neue Pinakothek between 1910 and 1913. The Impressionist painters, whose work Klee could see in Munich, seem to have presented no problem for him. In his journal, he refers to them by name but does not discuss their work. On the other hand two exhibitions of Van Gogh which he saw in 1908 had a tremendous effect: "Here one sees a mind consumed by a cosmic conflagration. On the eve of the catastrophe, he liberates himself through work." Three years later Klee applied his deeper understanding of the phenomenon that is Van Gogh to himself, becoming electrified by the Dutch painter's line, which seemed to him to draw on Impressionism, but at the same time to go beyond it. "Line in the progressive sense is permissible," he wrote in his journal. And Klee found confirmation in the work of

Influenced by Van Gogh

(above)
Young Man Resting
[Self-Portrait] 1911

Ensor, which fascinated him because line was used as "an independent pictorial element" to defeat naturalism. He studied Ensor's etchings and was delighted when in July 1909 his friend Ernst Sonderegger gave him a print of the Belgian master's *Skeletons Trying to Warm Themselves*. Klee, through Ensor, was able to escape from the blind alley of decoration. At the Munich *Sezession* in 1908 he saw eight pictures by Cézanne, who was immediately accepted by Klee as his master *par excellence*, though it was not until five years later that he began to understand the full importance of his "sensations." Klee also saw pictures by Matisse at the Thannhauser gallery, and their importance to him can be seen in a picture such as *Girl with Jugs*.

Girl with Jugs p. 119

As far as the old masters are concerned, it is difficult to be precise about what Klee saw and liked. He was certainly more interested in the primitives than in the painters of the High Renaissance, just as he was always more interested in the beginnings of a movement than in its final flowering. With the passage of time his taste undoubtedly changed. Goya finally yielded first place in Klee's esteem to El Greco, "whose works I would have liked to collect if I had had enough money." A magician like Klee himself.

His friend Bloesch and the Swiss painters Welti and Kreydolf were in Munich. Then in January 1911 Kubin came to see him to buy a picture. Louis Moilliet, too, paid him a visit in the company of August Macke, whom Klee had already met in the summer of 1911 at Moilliet's house in Gunten on the Lake of Thun. Macke in turn brought his

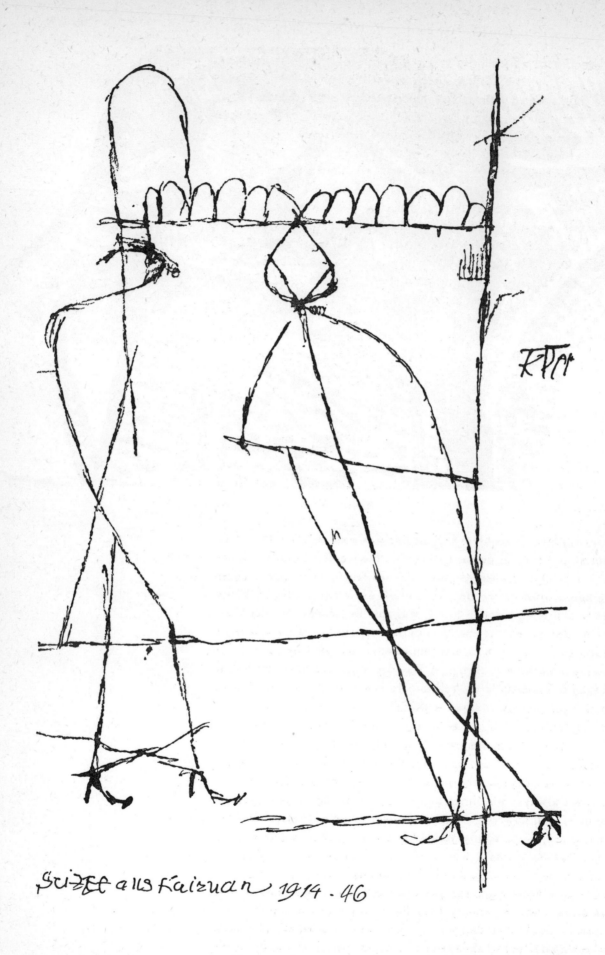

Suzee aus Kairuan 1914 . 46

neighbor Wassily Kandinsky to see Klee in the autumn of the same year. He "inspires a certain deep confidence in himself ... He is 'somebody,' and has an exceptionally handsome, open face," Klee wrote. Then, during the course of the winter, Klee met in rapid succession Franz Marc, Heinrich Campendonk, Alexey Jawlensky, Marianne von Werefkin, Gabriele Münter, and a little later, Hans Arp. Klee found himself in the society of painters who were his peers, who shared his views on the nature of art and confirmed his belief that he was on the right path. As he later confessed, he had often been much worried by the singular form of his art; but now at last he had friends who understood him, notably Kandinsky and Marc. They spent a great deal of time in each others' homes talking about their work, about the eternal problems of artistic representation, about the history of art, and about books such as Worringer's *Abstraction and Empathy*, published in 1908.

Kandinsky and Marc were more active than Klee. In 1909 Kandinsky had founded the *Neue Künstlervereinigung*, to which many "progressive" artists of all nationalities belonged, including Marc who joined in 1911. This society was rent by violent differences of opinion in the summer of 1911, and in December Kandinsky, Marc, Kubin, and Gabriele Münter resigned.

Kandinsky and Marc then founded the publication, *Der Blaue Reiter*. Under this title they issued the now-famous statement of artistic aims, and simultaneously organized – the first *Blaue Reiter* exhibition at the Thannhauser Gallery in December 1911. The second *Blaue Reiter* exhibition held at the Goltz Gallery in March 1912 included a section of graphic work and Klee was represented. The effect of these two exhibitions was revolutionary, and Klee, who had hitherto been a solitary figure, found himself involved in battles over modern art and a new conception of the world. The leaders of the battle were Marc and Kandinsky, the latter publishing *The Art of Spiritual Harmony* in 1912 (written in 1910), more or less contemporaneously with the *Blaue Reiter* volume. These volumes were the most discussed books of modern artistic theory in Germany until the outbreak of war. As one would expect, Klee did not play a very active part publicly; nevertheless, he did write a review of the exhibition of the *Moderner Bund* in the Kunsthaus at Zürich for the Bern periodical *Die Alpen*, in which he vigorously defended Marc and Kandinsky as well as Delaunay, one of whose essays – *On Light* – he translated later in the year for the periodical *Der Sturm*.

During a second trip to Paris in the spring of 1912 Klee had called on old friends and met various artists such as Le Fauconnier and Delaunay. He had also visited dealers such as Kahnweiler, Barbazanges, Bernheim-Jeune, and Durand-Ruel, but much of his time was spent with Wilhelm Uhde, in whose gallery he saw pictures by Braque, Picasso, and Henri Rousseau (who had died less than two years before). Klee was too modest to visit Braque and Picasso in their studios, and he did not meet them until many years later. Whenever he went to Bern, however, he had a chance to see and admire their pictures in the home of the collector Hermann Rupf, to whom he once admitted that

First "Blaue Reiter" Exhibition

Second journey to Paris

without this privilege, his own development might have been much less rapid.

After 1912 Klee's circle of friends in Munich grew to include poets, writers, publishers, and art dealers. Eliasberg tried to interest Karl Scheffler in his work; Franz Blei and Julius Meier-Graefe followed his development with interest; Reinhard Piper gave him books in exchange for drawings; Justin K. Thannhauser begged for his pictures; and Herwarth Walden began to buy. Klee was also invited to the most select intellectual salon of Munich, run by Karl Wolfskehl, a friend of Stefan George; there he met Hans Carossa. And one day Rainer Maria Rilke was brought to see him in his studio by the artlover Rudolf Probst. However, Klee never met Christian Morgenstern (who died in 1914) for whose *Galgenlieder* he had particular admiration. At last, too, the critics began to visit his studio. Fifteen years of hard work had not been in vain, and the words which he had written to Lily on February 22, 1903, were proving true: "My will-power is tough enough to enable me ultimately to achieve something which is really mine and mine alone."

Between 1906 and the outbreak of the war in 1914, Klee never stopped working, even when on holiday with his parents in Bern, or with his aunt in Beatenberg. His visit to Paris in 1912 lasted only sixteen days; the famous journey to Tunis in 1914 only seventeen. Yet during these short trips he continued to draw and paint.

In Munich his productive capacity rapidly increased. We can follow the change in pace through entries in the catalogue of his work which Klee began in February 1911. He listed everything he had done beginning, in retrospect, with the year 1899. (In 1906 he produced 33 works; in 1908, 74; in 1910, 124; in 1912, 171; in 1914, 220.) The proportion of drawings to paintings varies. For 1910 he listed 90 drawings as opposed to 21 watercolors; in 1914, 92 drawings to 111 watercolors. Under the classification "watercolor" he included tinted drawings. Beween 1906 and 1909 this was the only kind of watercolor he made, but between 1910 and 1912 drawings with a colored wash predominate. Not until 1913 did color as such become a feature of Klee's work; and only in 1914 could he really say "color has taken hold of me."

During his first years in Munich, Klee continued in the direction he had taken in Bern. He "worked pictorially from nature," and tried to find a method for transferring his visual experiences directly to paper. He accepted "any subject that offered itself," and produced a series of landscapes, nudes, heads, and genre pieces. During the summers in Bern and Beatenberg he drew a great many landscapes – in the quarries at Bentiger, which belonged to friends of his father; on the banks of the river Aare; on the Lake of Thun. The landscapes of 1907 such as *The Quarry at Ostermundigen* and the charcoal drawing *Road Lined with Trees*, are comparatively naturalistic. *Pregnant Woman*, one of three versions of a portrait of Lily, is pitiless in the accuracy of its observation. The still lifes and the views from his balcony, of the following year, are farther removed from naturalism by an emphasis

The Quarry at Ostermundigen
Cl. Cat. 21

Pregnant Woman Cl. Cat. 19

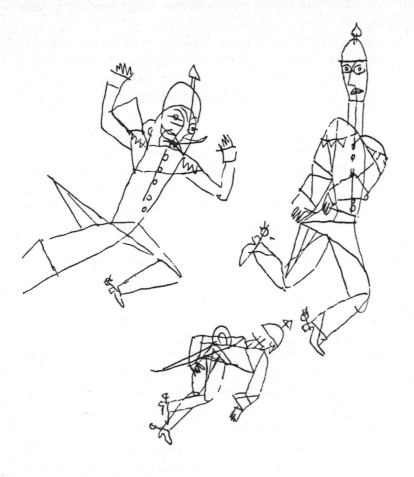

1913 55 *Die fliehenden Polizisten*

The Fleeing Policemen 1913

on tonalities. In his drawings, often of children, line functions freely. He became bored with nature and remarked that "perspective makes me yawn". He began again "to cultivate a pure use of the artistic means", and line and chiaroscuro become dominant elements. Drawings such as *A Clearing in the Forest* (1910) are less realistic, and his black-and-white watercolors are noticeably more "constructed". His "first offensive against painting" occurred in *Girl with Jugs*.

In 1911 Klee undertook the series of brilliant comic drawings for Voltaire's *Candide* which occupied him for over a year. These illustrations aroused the interest of several friends. Marc brought them to the attention of the firm of Piper; Arp to the Verlag der Weissen Bücher. The *Candide* illustrations, however, were not published until 1920, by Kurt Wolff. His approach to landscape became freer once more. Street scenes of Munich, *Main Station* or *Suburban Villas*, for example, are surprisingly loose and Impressionistic. Some pictures of 1912, however – *Head of a Young Pierrot*, *Apprehension*, and some drawings with stars – anticipate much that is to come, and their themes cannot be dealt with simply in terms of painting and drawing. "What a lot of things an artist must be . . . poet, naturalist, and philosopher."

A Clearing in the Forest p. 44

Girl with Jugs p. 119

"Candide" pp. 122, 123

Munich, Main Station II p. 47

Head of a Young Pierrot Cl. Cat. 25

His trip to Paris and his contact with the *Blaue Reiter*, reaffirmed his confidence in himself and the direction he wished to follow. "I am tough, but I always know to what purpose." He derived confidence and inspiration from the new and vital atmosphere around him; from Kandinsky's and Marc's overwhelming faith in the power of art; from the new conception of space and time developed by the Cubists and Delaunay; and from his own incipient success.

During the winter of 1912–1913, Klee first ventured into the realms of metaphysical conjunctions – man and his destiny, objects and their universe – and independent forms. His *Exciting Beasts* treats the surface cubistically, and the etching *Garden of Passion* already offers an independent formal conception corresponding to a subjective experience. *An Angel Handing Over the Object of Desire* formulates a method of expression which is to continue until the early Bauhaus period. The divisions between different categories of existence have been abolished; the universe has become ambiguous and transparent.

Even the titles, such as *Idols*, indicate the change which occurred, first in his drawings and etchings and, by 1914, in his approach to color.

He spent Christmas of 1913 in Bern where he was ill, and returned to Munich to assist at the founding of the *Neue Sezession*, "an array stretching from Püttner to Klee", as he said. Much to his regret, Kandinsky and Marc did not participate and it was "weak at the top".

Journey to Tunis

Early in 1914 Moilliet prepared for a second trip to Tunis where his friend Jäggi, a doctor from Bern, was living. Because Moilliet was "a good-hearted fellow toward people he likes", he agreed that Klee and Macke should accompany him. Klee sold a few pictures to defray expenses, and Dr. Jäggi agreed to put them up. On April 3, Klee traveled from Munich to Bern, and on April 5, he and Moilliet went via Geneva and Lyons to Marseille, where they met Macke and embarked.

They arrived in Tunis on April 7. "The sun has a dark force. The colorful clarity of the landscape is full of promise." In the evening they went down to the Arab quarter: "Reality and dream at the same time; and a third element – completely absorbed – myself. It has to turn out well ... Greenish-yellow, terracotta. The color harmonies penetrate and will remain with me whether or not I paint them on the spot." On Easter Sunday, they gathered at Dr. Jäggi's house at St. Germain, a seaside resort outside Tunis. They painted watercolors, and Moilliet challenged Klee to try painting the full moon. But Klee felt unable to approach nature in this way: "I must not hurry when I want to do so much. This evening has sunk deep inside me and will remain forever. Many a blond northern moonrise will incite me softly like a muted reflection of this, again and again. It shall be my beloved: my other 'self'! An incentive to find my 'self'. But I myself am the southern moonrise."

The next ports of call were at Sidi-bou-Said and Carthage, and at Hammamet, which is the subject of some of his finest watercolors. One evening he saw a blind minstrel led by a boy beating a tambourine – "a rhythm forever". On April 15 the party was in Kairouan,

the city of a hundred mosques, where they witnessed an Arab wedding: "Concentrated essence of the Arabian Nights, 99 percent pure reality. What atmosphere! Simultaneously permeating, intoxicating, and clarifying." The next morning was spent visiting mosques and painting, but Klee was overwhelmed by the effect of so many different impressions: "I shall stop working now. I can feel everything sinking deep inside me of its own accord, and this gives me great confidence because I do not have to do anything. Color has taken hold of me; no longer do I have to chase after it. I know that it has hold of me forever. That is the significance of this blessed moment. Color and I are one. I am a painter."

Since he wanted to get to work and digest his experiences, Klee was ready to depart. They returned to Tunis, and on April 19, Klee embarked alone, leaving his two friends, "Macke, light-hearted and radiant; Moilliet, lost in reverie", to remain a few more days. Arriving in Naples, about which he had been so enthusiastic in 1902, Klee realized that he had been in the East, and that he wanted to remain there: "That other music must not be confused. Here the influence is too dangerous." He returned via Rome, Florence, and Milan without stopping, and arrived on April 22 in Bern, which he left for Munich on April 25. Among the wonders of Tunisia itself, Klee had only spent twelve days, but this sufficed to open a new chapter in his life. He had begun to think about color, and found the distance between himself and nature growing even greater than in his drawing, until finally he accepted the idea of "creation as a genesis beneath the surface of the work" and "the chill romanticism of abstraction".

The year 1914 was enormously productive, and even the outbreak of war at the beginning of August did not stop him from work. At first he was not personally affected by events, except in so far as his friends were dispersed to all corners of Europe. Marc, Macke and Campendonk were called up. Kandinsky and Jawlensky, who were Russian subjects, had to leave Germany, and Gabriele Münter left for Scandinavia, where she remained five years.

On August 16 Macke, at the age of 27, was killed fighting in France. Klee's grief was almost as profound as that of Marc. He began to shut himself off from events: "In order to work my way out of my dreams, I had to learn to fly. And so I flew. Now, I dally in that shattered world only in occasional memories – the way one recollects things now and again. Thus I deal abstractly with memories." At the beginning of 1915 he recorded in his journal: "The more horrifying this world becomes (as it is these days) the more art becomes abstract; while a world at peace produces realistic art." He wondered whether he was turning into "the crystalline type", and his correspondence with Marc is full of discussions about artistic problems: for example, the negative attitude of the composer Heinrich Kaminsky (1886–1947) toward Kandinsky's work.

In the summer of 1915 the Munich recruiting depot granted Klee permission to visit Switzerland, though he had to promise to return to Germany. He felt he could promise in good faith because he had built

Outbreak of war, 1914

57

Death of Franz Marc, 1916

up an entirely new life for himself in Germany which he considered his home. At the end of the year Marc came home on leave. This was the last meeting between them. Marc was killed in the spring of 1916. "On the 4th of March my friend Franz Marc died near Verdun. On March 11, at the age of 35, I was called up." The fact that Klee used the word "friend" shows the intimacy of their relationship, for Klee was sparing in his use of the term. The first entry in his journal, written after he became a soldier at the recruiting depot of Landshut, runs: "The name Marc frequently comes to my mind, and then I am moved, for I seem to see something collapsing." However, friendship did not prevent Klee from evaluating precisely his artistic relationship to Marc and underlining the difference between them. In July 1916 when Klee was on leave in Munich, he wrote the foreword to the catalogue of the Franz Marc Memorial Exhibition. A year and a half later, he heard that Marc's painting *Happenings in the Animal World* had been burnt; luckily, however, things were not quite so bad as had been feared, and he was able to make the necessary restorations with the help of Marc's preliminary sketch.

Klee's first taste of military service was tolerable. Privately billeted, he was occasionally able to visit his family in Munich. The army seemed no more than a "fantastic dream" and he attempted insofar as possible to live normally. He even played first violin at a performance of Haydn's *Creation* in Landshut, and he painted in his spare time. His work was beginning to sell at last, and he proudly noted that the art dealer Herwarth Walden had sold 420 marks worth of pictures in 1915, while in the following year the figure rose to 3460 marks.

On November 9, 1916, Klee was posted to Schleissheim as a member of an air force reserve workshop company – "a factory worker; how

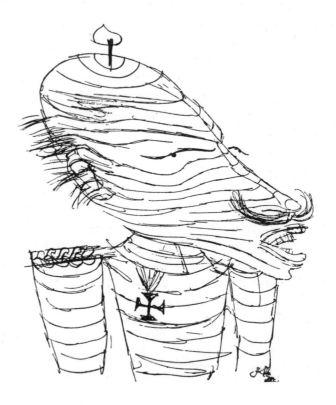

The Angry Kaiser 1920

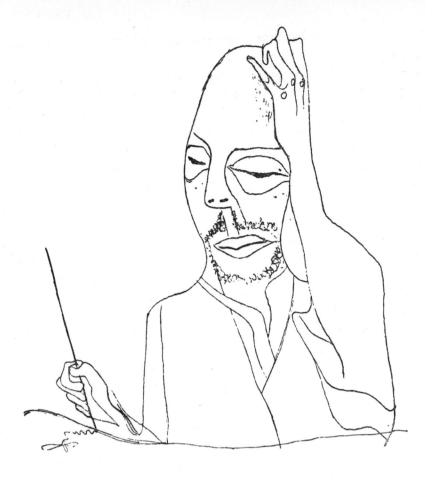

An Artist
[Self-Portrait] 1919

adventurous!" – which among other things painted airplanes. He also escorted convoys to the front, going to Cambrai on November 13, to St. Quentin on November 30, and to Nordholz near Cuxhaven on January 5, 1917. But art was not forgotten, and every opportunity was turned to profit. Thus in Cologne he saw the Zeppelin flying over the Cathedral by night, a spectacle which he called "a truly festive scene of evil"; in the museum he studied the pictures of Hieronymus Bosch and Pieter Bruegel. On his way back from Cuxhaven Klee visited the collector Bernhard Köhler in Berlin and Herwarth Walden, who was then preparing a volume of reproductions of his drawings for the *Sturm Bilderbuch*. He took with him on the journey a volume of stories and poems translated from the Chinese by Klabund.

After his return to Schleissheim on January 15, Klee was transfered to Gersthofen near Augsburg as a clerk in the accounting department. It would seem that his superior officers showed some consideration for a painter whose work had been acclaimed by the critics of the Berlin daily *Börsenkurier* (Theodor Däubler) and of the magazine *Weisse Blätter* (Adolf Behne). He had some free time and sometimes even continued to work when on duty – "under cover", of course, so as not to be caught. He drew rather than painted because for the moment color, it seemed, "had somewhat exhausted itself"; nevertheless he lists five watercolors, three of which particularly pleased him. He wanted to experiment again with sculpture but there was no opportunity in Gersthofen, and he doubted whether later on he would be able to make up for lost time. (In Bern, at the Klee Foundation and in Felix Klee's

Souvenir of Gersthofen p. 217

Sculptures p. 112

possession, are some small sculptures which date from 1915–1920, and 1932.)

Klee spent an increasing amount of time in meditation, and the entry in his diary for July 17, 1917, reads: "Everything transient is only comparative. What we see before us is but a suggestion, a possibility, a makeshift. True reality is at first buried and invisible." He became preoccupied with the conflict of good and evil in his artistic creations; with the relationship of forms to ideas; with the problem of time in the polyphony of painting and music. Klee hated vagueness, and he did not hesitate to reject the anthroposophic books by Rudolf Steiner which had been sent to him by a friend. "It is either false or a piece of self-deception. The basis is autosuggestion. But absence of resistance is not a prerequisite to the triumph of truth." When Oskar Schlemmer asked him in 1919 about the anthroposophic movement, Klee replied that he had never studied it.

During the last year of the war Klee read Rousseau's *Confessions*, and Goethe's *Wilhelm Meister*. He read these books to find out more about life, and the knowledge gained imperceptibly permeated his work. The only modern authors he mentions are Theodor Däubler, Walter Mehring's poems, and Curt Corrinth's *Potsdamer Platz*, for which he made a series of ten illustrations. These drawings were reproduced by photo-lithography, and the book was published in Berlin in 1921. He also began to illustrate Däubler's *Silberne Sichel*: "It must be done, no matter what it costs me." Klee also toyed with the idea of illustrating an anthology of poems, including poems from the Chinese; it was perhaps in connection with this project that he sent for a copy of *Des Knaben Wunderhorn*, "youth's magic horn", the best collection of German folk songs. Nothing came of these projects because he eventually became bored with illustration, and in later years, whenever he was asked to illustrate a book, Klee always refused but told the author to choose any existing drawings which seemed appropriate. In 1918 Walden's *Sturm* press published their volume of Klee's drawings. Soon after, two important critical articles on his work appeared: one by Hausenstein in the *Münchner Neueste Nachrichten*, the other by Däubler in the *Neue Blätter für Kunst und Dichtung* in Dresden. "The miracle has happened. My work is appreciated", Klee wrote after reading Hausenstein's article. At the same time Klee himself began to write for publication. The article contributed to the anthology *Schöpferische Konfession* (*Creative Credo*, Berlin, 1920),

Up, Away, and Out p. 100

First appreciation

Rooster and Pig 1920

deals predominantly with graphic problems and affords a deep insight into the progress of his artistic development.

As early as 1916 Klee had realized that Germany was defeated, and began to make plans. The dealers Walden, Goltz, and Richter (of Dresden) had been sellings his work relatively well. His letters to Lily, who was in Bern, were full of optimism, and he could think of renting a studio and even of employing a charwoman. Every year Lily and Felix summered in Bern, and Klee was relieved to know that for these months they were well looked after by his parents. When he had leave on a Sunday he would go off to the empty flat in Munich, look at his own pictures, work on his catalogue, play the violin, or paint. If Lily and Felix were in Munich they would "celebrate". Klee was fascinated watching Felix grow up, and took a great interest in his first attempts at painting; he proudly wrote his parents that they were "real gems."

In December 1918 Klee applied for demobilization. "I want to do it gracefully and not run away, so I shall get the authorities to grant me Christmas leave, and then I'll pull a Leporello." To Lily he wrote: "I am obeying some inner compulsion . . . It feels good to be led by one's own faith, and it will turn out well. This is the end. After the die of fate is cast, it is pointless to continue doing inferior things." Klee was home for Christmas.

Between 1914 and 1921, with the exception of the year 1916, Klee was as productive as ever. Several pictures painted during 1915 are closely related to the Tunis watercolors of the previous year – *The Niesen,* a mountain behind the Lake of Thun, for example. Others have drawing superimposed over a colored ground, and some are architectural or abstract. In 1916 he produced a few delicate little compositions such as *Blue Roof – Orange Moon,* inspired by classic Chinese poems and romantic works, which were snapped up so eagerly by collectors that Klee was left with almost none. The *"Nightingale"* pictures of 1917 and *Invention with the Dovecot* belong to the same series.

The year 1918 was particularly productive, although Klee was not demobilized until Christmastime. Now the atmosphere of artistic revolution in Munich, his North African experience, and his long period of intensive preparation were about to bear fruit, particularly in his handling of color. Klee produced far more paintings and watercolors than before, and simultaneously the character of his drawing changed. He alternated between the two mediums; sometimes he felt that in drawing, his hand was merely "a tool obeying the orders of a force outside himself"; sometimes he lost himself so completely in the world of color that he was able to reach hitherto undreamed – of insights.

His attitude toward reality was marked by the same sort of ambivalence. Sometimes he felt that the only link between himself and material objects was through memory; at other times he rejected the idea that there is any such thing as an art of abstraction: "The only remaining abstraction was that which is crystallized out of the transitory. Reality was everything, even though it was not the everyday kind

Demobilization

Works 1914–1920

The Niesen p. 127

Blue Roof – Orange Moon
Cl. Cat. 35
Trilling Nightingale Cl. Cat. 36
Invention with the Dovecot
p. 147

of reality." There is no doubt that after 1915 Klee "cannot be interpreted in terms of this world"; either he looked right through things or, as many of his friends have asserted, he did not see them at all.

In 1918 Klee, for the first time, was fully master of his materials and therefore able to realize completely what he had in mind, as in *Ship, Review, The Descent of the Dove*, and *Dream*, the latter being characterized by Klee himself as "a strictly organic composition" – contrary to Hausenstein's criticism.

In 1919 Klee turned to painting in oil. As though to disprove the criticism that he was no more than a miniaturist, he produced the well-known *Villa R*, now in the Kunstmuseum in Basle, *Composition with a B*, *Picture with Cock and Grenadier*, and *Landscape with Rocks*, the latter two in a private collection in Bern. Klee had struggled to master the technique of oil painting and used this more laborious process to intensify his pictorial presentation. In 1920 he painted a group of pictures – *Arctic Thaw, The Bud, Rosa,* and a series of rhythmic landscapes with trees – in which he was able to represent, calmly but firmly, his vision of the world through analogous forms. Pictures such as *Greeks and Barbarians* or *Message of the Air Spirit* prove that he was also able to "illustrate" an idea.

During 1919 and 1920 he felt in need of rest and relaxation and spent a great deal of time in Switzerland. However, he concentrated all the harder on his work in order to make up for lost time. He rented a small studio in Schlösschen Suresnes in the Werneckstrasse in Munich. Baumeister and Schlemmer tried to persuade him to move to Stuttgart but, since there was disagreement among the members of the staff of its Academy of Fine Arts, Klee stayed in Munich. On October 1, 1919, he signed a three-year contract with Goltz for the purchase of all his work, and later extended this contract through October 1, 1925. He also received a request for some watercolors from Hermann Rupf, a Bern collector who was acting for himself and the Paris dealer Daniel-Henry Kahnweiler. In the spring of 1920 Goltz organized a retrospective show of Klee's work which included 38 paintings, 212 watercolors, 79 drawings, the whole of his etched works and a few sculptures. The exhibition created something of a sensation in Munich. Soon afterwards H. von Wedderkop published a small monograph on Klee, as did Leopold Zahn; Klee's own article in *Creative Credo* appeared at this time, as well as his illustrations to *Candide*. These were followed at the beginning of 1921 by Wilhelm Hausenstein's book *Kairuan, oder eine Geschichte vom Maler Klee*.

Year by year Klee expanded his spiritual and psychic horizons, and the subjective elements of his vision became more precisely defined. His pictures, which began to have significance on more levels than one were marked by a new expressive intensity, and it is reasonable to maintain that at last Klee had achieved what he had set out to accomplish (consciously or unconsciously) when he arrived in Munich.

Klee was becoming famous. Then on November 25, 1920, Walter Gropius sent him the following telegram from the newly founded Bauhaus in Weimar: "Dear Paul Klee: We are unanimous in asking you to

First Sketch for the Spectre of a Genius
[Self-Portrait] 1922

come and join us as a painter at the Bauhaus – Gropius, Feininger, Engelmann, Marcks, Itten, Klemm." Klee was in the Ticino visiting Jawlensky and Marianne von Werefkin, whom he had not seen for six years, when he received the telegram. He realized at once that this was an offer he could not refuse. He had reached a stage where he could hold his own in such an exacting community as the Bauhaus, where he was expected to explain and discuss his aims and experiences. In January 1921, with full confidence in his ability to carry out his assignment, Klee, at the age of 41, left Munich for Weimar, to be followed by his family in October. With his arrival at the Bauhaus there begins the third, and possibly the happiest, period in his life.

The program of the Bauhaus was strenuous. It initiated a long period during which Klee divided his time and energy between creative work and teaching. This dual activity imposed a great physical strain on him. For thirteen years the disadvantages of this situation were outweighed by the guarantee of a living wage and by the necessity of clarifying in his own mind (in order to be able to explain them to the students) artistic procedures which he had hitherto adopted almost unconsciously. Various quotations from his letters and journal have already demonstrated that Klee always thought about the why and wherefore of his art. But, at the Bauhaus, he had to formulate a theory – consistent, communicable, and intelligible – concerning the use of

63

pictorial elements for those who wanted "to get their bearings on the formal plane." After his regularly scheduled and carefully prepared lectures, Klee would assign problems to the students to work out on their own, and then, a week later, they would discuss the results.

Klee was often cross at being dragged into bitter controversies over principles of artistic education and the coordination of the various types of creative activity. After one particularly heavy session, in December 1921, he wrote to Gropius: "I welcome the fact that forces so diversely inspired are working together at our Bauhaus. I approve of the conflict between them if the effect is evident in the final product. To tackle an obstacle is a good test of strength, if it is a real obstacle . . . On the whole, there is no such thing as a right or a wrong; the work lives and develops through the interplay of opposing forces, just as in nature good and bad work together productively in the long run."

Klee kept aloof from personal disputes and jealousies, although within the Bauhaus he became, as Gropius said, "the authority on all moral questions". The students and the teaching staff had great respect for his reserve, and he was even jokingly referred to as "the heavenly Father". Klee and the other masters discovered that the most difficult and wearisome task was the necessity of establishing a completely new system of instruction. They had no previous experience and were obliged to write their own textbooks. Such was the origin of the fourteen volumes of the *Bauhausbücher*, one of which was Klee's own *Pedagogical Sketchbook*, written in 1924. He was naturally sympathetic to the idea of beginning from scratch, for, as he had written in 1902, he himself approached the problems of artistic creation by "beginning with the smallest things".

First Proclamation of the Bauhaus

Unlike most art-revolutionaries, Gropius said nothing about the sanctity of art, but talked of craftsmanship in his *First Proclamation of the Bauhaus*. "The artist is a superior craftsman. In rare moments of inspiration, moments beyond the control of his will, the grace of heaven may cause his work to blossom unconsciously into art. But proficiency in his craft is essential for every artist. Therein lies the source of all creative activity." Klee fully agreed with this point of view. He considered himself a craftsman; in Bern his studio had been an etcher's workshop, and his studio always remained a modest workroom.

No "arrogant barrier between artists and craftsmen" existed at the Bauhaus, which was organized on a basis of masters, journeymen, and apprentices. Masters and students worked closely together with only one aim: to achieve the "artistic synthesis", the blending of craftsmanship with the formal requirements of art. The curriculum was divided into a course of instruction in the crafts (working in a variety of different materials) and a course of instruction in formal problems of observation, representation, and composition. The Bauhaus student started with a preliminary course in which he was introduced, by practical experiment, to the creative possibilities of different materials. Then he received instruction in a craft during which he was taught by two masters, a craftsman and an artist, both working in close cooperation. This new, unified conception of work culminated in building,

for architecture is an indivisible union of all the creative, formative processes: the individual becomes a part of a whole, yet retains the consciousness of his significance as an individual ("social synthesis").

In so far as Klee had any political views, this type of organization corresponded with his conception of society, and, although he was a solitary figure, he took his place quite happily within the Bauhaus community. Given the necessary safeguards, it did not matter to him that the whole organization was directed toward architecture, for he was conscious of being an essential part of the whole. As a "Master of Form" he was entrusted first of all with a class in stained glass, then with a class in weaving. Only later did Klee, like Kandinsky and Feininger, take charge of a class in painting, which had not been included as part of the original curriculum but which developed because of the number and importance of artists on the staff, and to meet the demands of the students.

Everything at the Bauhaus was based on continual give-and-take, and Klee learned a lot, not only from his colleagues but from his students. He derived new ideas and spiritual nourishment for his painting from the courses he taught; while conversations with architects led to the series of perspective pictures. He participated in everything, even in the students' festivities, when he would become genial and talkative although he could never entirely shake off his reserve.

(below)
Home of the Opera-Bouffe
1925

Relations between the members of the teaching staff were very friendly, and they met regularly at each others' houses. If one or the other of them had an important visitor, he was sure to be introduced to all the others.

Klee took a special interest in the introductory course, conducted by Johannes Itten until 1923, and then by Moholy-Nagy and Josef Albers. The experiments with different textures and materials appealed to his curiosity and to his desire to find out what makes things tick. He loved to see what grows out of playful impulse; to be amazed; to create new relationships between the internal and the external; to analyze, construct, and transform. The principles which inspired the preliminary course had already been exploited by the Dada and Constructivist movements, although for them the means had been accepted as synonymous with the end. Klee, on the other hand, started with next to nothing and worked gradually and logically toward a metaphysical conception. The result had nothing in common with the Italian metaphysical painters such as de Chirico, who carefully calculated the element of surprise by contrasting the banal with the heroic. Klee was able to substantiate much of what he had anticipated in his little essay in *Creative Credo,* since the materials for research, human and otherwise, were at hand.

Kandinsky at the Bauhaus

Kandinsky began to teach at the Bauhaus in 1922, having been summoned there by the Bauhaus Council after his return from Moscow in the previous year. Klee had made frequent inquiries about him, for he regarded him as particularly congenial. Now a closer friendship developed between them, based on past experiences and day-to-day collaboration as colleagues. In 1932, when they parted, Klee wrote to Lily: "Ours is a friendship which can withstand all sort of setbacks because it is firmly and positively established, especially since it is rooted in the creative period of my youth. Everything one acquires in later life is of less importance." Klee and Kandinsky were often played off against each other, even within the Bauhaus. Too few people realized how little they had in common: Kandinsky, the older man, was a Russian with an unquestioning temperament whose artistic ideas were colored by the Far East; Klee's

(below) *Fishing Smacks* 1924

c56/2Kl

ideas, on the other hand, were colored by Arab or Islamic examples, and his sensibility was attuned to every realm of nature. The contrast made possible their fruitful collaboration though, of course, no one could ever confuse their work. Their methods of instruction in formal problems offered a perfect complement to each other, to such a point that the best students in painting worked under both Klee and Kandinsky. It is not generally known that Kandinsky's theory of form had a strong philosophical basis, and that Klee would lecture his students for months on end about the most complicated aspects of descriptive geometry and spherical trigonometry.

For four years – until the famous Bauhaus Exhibition in 1923 and the no less famous Bauhaus Festival – Weimar was a center of modern artistic creation. The tremendous success of the Bauhaus Exhibition revealed for the first time how extensively this little group of artists had worked to revolutionize artistic theories. Fifteen thousand people visited the exhibition, which was also the occasion for special concerts and theatrical performances such as Schlemmer's *Triadic Ballet*. Hindemith, Busoni, and Stravinsky all participated and Klee had the opportunity to meet and talk with them. Indeed, through his association with the Bauhaus Klee, by nature retiring, met many other creative artists – Adolf Busch and Serkin, Erdmann and Edwin Fischer, Driesch and Ostwald, Ozenfant and Gleizes – whom he would not otherwise have known. Whether they came to give concerts or to lecture, they were soon involved in discussion with the teaching staff and the students. Klee found himself arguing on all sorts of subjects, scientific as well as artistic, and this particularly appealed to him.

On one occasion Léon-Paul Fargue visited Weimar. Klee had a high opinion of his poetry because he felt that, in its attempt to create a private world, it resembled his own painting. The two men discussed the possibility of collaborating on an edition of Fargue's poems to be translated into German and illustrated with drawings by Klee, chosen from among those in his studio. But no publisher could be found and the intention came to naught. *Intention* – at the end of his life Klee exe-

(above) *Migratory Bird* 1925

Bauhaus Exhibition in 1923

cuted a large oil painting to which he gave this title. The picture suggests a host of missed opportunities such as this one. In the center is the figure of a man lost in thought and wondering who is directing him. The parallelogram of forces is opaque, and the more pleasing half of the picture is lost in shadow.

It was in connection with publishing something about his drawings that I first met Klee soon after he had arrived at the Bauhaus. He set great store by his drawings, which were not then appreciated, and we found a basis for a mutual understanding. After several visits we became lifelong friends.

Klee still had a beard and wore clothes of an unusual cut, as well as the fur cap which had caused a great stir in Munich. People with an eye for the unusual always stared at him. With his high forehead, dark brown eyes, hair combed forward like a Roman, and skin yellowish like an Arab's, Klee made a strange impression. He walked slowly and spoke with deliberation. There was something in his composure and easy movements, his thoughtfulness and economy with words, that reminded one of the legend of his mother's Algerian origins. This impression grew stronger as conversation proceeded, especially if one were looking at pictures with him. He frequently spoke a single word instead of a whole sentence, and, in true Eastern style, he might use an entire sentence as a parable.

When Klee examined his own work, he would discuss it with such complete detachment that he might have been examining the work of someone else. Never easily satisfied, he would occasionally hint at some mistake and, with a roguish laugh, defy you to discover it. But when for some reason or other he was particularly pleased with a picture, he did not hesitate to say so. His friends' visits were an excuse for looking at his latest productions, and as the pictures were passed in review he would remain silent, hoping for some objective criticism or at least a sign that they had been understood. To his regret, most people hesitated to express their pleasure or gratitude in words — "they contributed nothing". He longed to know how his pictures affected others, whether they found them exciting and what sort of ideas they provoked.

He felt the need to check upon himself and was never upset if the reactions of others differed from his own. They might be right and he would say: "I am surprised; but your interpretation is as valid as mine, perhaps even more so." Differences in interpretation occurred most frequently when he was deciding on titles for his pictures. As a rule he stuck to his own interpretation, but sometimes he would accept a suggestion, though after writing it down he would often find a better way to express it in his own poetic language. Thus *Calypso's Isle* became *Insula Dulcamara*, just as *Desert Father* became *Penitent*.

Klee's home in Weimar, on the top floor of No. 53 Am Horn, was modest, but it had a beautiful view over the park. The furniture was the same that had decorated his apartments in Bern and Munich; a grand piano stood in the living room, and on the walls hung pictures by himself and his friends. There was, of course, also a cat.

Every morning Klee walked through the park to the Bauhaus, passing close to Goethe's house. He enjoyed the walk because it gave

Insula Dulcamara Cl. Cat. 182

Christ 1926

him an opportunity to observe nature, and contact with nature was a *sine qua non* of his daily life. He lingered to marvel at every bird he saw or to ponder on the parallel between the ages of man and the changes of season. He might talk to a snake that happened to cross his path, as if it were a human being, because after all snakes, too, form part of the cosmos, and there was nothing strange to him about the fact that serpents had been worshipped in ancient Egypt; they frequently recur in his own work. *Wintry* (1923), one of his pictures of this period, consists of signs such as he drew with his stick in the snow to amuse Felix, who would follow the same path a little later and might chance to read them. Klee's art was so closely bound up with his everyday life and reality that he could dare to search for their ultimate meaning.

At the Bauhaus, for the first time in his life, Klee had a large studio. It was a colorful one, and here he sat and worked, smoking a pipe. About a dozen easels stood in the middle of the room, each with a picture, some just begun, some almost finished. In among the easels was a low wooden stool. On the floor and on little tables were pots of paint, boxes of watercolors, tubes, bottles, and brushes, clean and neatly

Klee's studio in Weimar p. 18

arranged. The few pieces of furniture and the bookshelves were laden with objects of all sorts which he had either collected or invented – butterflies, shells, tree roots, pressed leaves, masks, toy boats, models, painted statuettes, and piles of drawings and paintings.

His method of work was simple: he would study his picture, add a few brush strokes, think about it and then go on painting. Indeed, having seen him work in such a leisurely manner, it was difficult to believe that he could have produced such an enormous quantity of pictures. Klee never hurried; he was always calm. His achievement was entirely the result of perseverance, and even on holiday he would never let a day go by without work.

Music was an inevitable part of daily life, and after supper he and Lily would usually play, particularly if guests had been invited. Later in Dessau, however, Klee played only on special occasions, for it became his habit to practice on the violin in the early morning and to play in a quartet once a week. After the onset of his mysterious illness in 1935, he rarely played at all.

When playing the violin, Klee surrendered himself to music. His eyes became transfixed, and he appeared to lose all awareness of his surroundings. His understanding of music was not merely technical; it was above all spiritual, and he had his own firm ideas about each composer. He did not try to make a contribution of his own; on the contrary, he was concerned only with trying to play as he imagined Mozart, for example, might have done. He knew the score of *Don Giovanni* by heart, and in 1926 it was suggested that he provide a new décor for a production at the Dresden Opera House, then under the direction of Fritz Busch. Klee was delighted with the suggestion, but at the last minute the management lost courage and instead commissioned Max Slevogt. An opportunity to make theatrical history was thus lost; Klee might have been able to create a décor inspired by Mozart's music as successfully as he was able to incorporate musical themes into pictures.

Klee loved classical music above all – Bach, Mozart, the late works of Beethoven, and Haydn, whose genius he did not recognize until comparatively late. He was frequently asked why he always played classical rather than modern music, for he regularly attended concerts of modern music, which he understood and criticized intelligently. He liked Stravinsky's work, in which he detected a link with Weber, and he had a very high opinion of Hindemith, whose intellectual control he admired. Klee had a large collection of gramophone records and would organize musical evenings with a carefully chosen program in the middle of which he would offer a symphonic work, perhaps Stravinsky's *L'Histoire d'un Soldat*. But when Klee listened by himself, he chose only classical music, because he found that it stimulated his sense of form and provided him with a sure guide through the labyrinth of his own formal invention. He did not really believe in parallels between contemporary music and painting. He thought that each was too much wrapped up in its own problems to be clearly aware of the goal at which the other aimed. But Bach and Mozart, he felt, could probably help him to formulate certain fundamental

Stage Landscape Cl. Cat. 99
Home of the Opera-Bouffe p. 65

Child and Dog 1929

principles governing painting, whose lack Goethe had felt —
principles around which everything else would fall into place. Klee
considered that modern music was more advanced than modern
painting. Somewhat paradoxically he remarked that perhaps it had
been his good fortune to develop painting, at least on the formal plane,
to the stage reached in music by Mozart.

Inflation gripped Germany until the end of 1923, and this often
meant that money earned in the morning was valueless by nightfall.
Foreign travel was impossible because no currency was available, and
Klee, who liked to travel during the summer in search of relaxation
and artistic stimulation, was obliged to spend his holidays in Germany.
In 1923 he stayed for a while on the island of Baltrum in the North
Sea, stopping on his way back at Bremen and Hanover to visit Kurt
Schwitters and El Lissitzky. Some of the watercolors painted during
this holiday by the sea — *Tideland at Baltrum* or *Dune Flora* — are
curious, related in color and form to those done in St. Germain near
Tunis in 1914.

Not until the summer of 1924 was Klee again able to travel abroad.
He spent six weeks in Sicily at Taormina and Mazzaró. Despite the
heat he hoped to proceed to Tunis; however, he remained and painted
a few "pseudo-Tunisian" landscapes such as *Near Taormina* and the
more naturalistic *Mazzaró*. Klee, already well acquainted with
classical art and literature, took the opportunity to visit several of the
ruins and archaeological sites in the neighborhood ("excavations" is a
subject that recurs frequently in his work). He was tremendously
impressed by the Greek theater in Syracuse where plays by Aeschylus
had been performed. One day, he found himself in Gela, where
Aeschylus had died; Klee stopped the car and walked reverently
through the village. He was always fascinated by a landscape with
historical associations, and like Däubler, his contemporary, had visions
of history and geography overlapping in terms of space. After his
return to Weimar he thought of Sicily "as pure landscape in the
abstract", and something of this found its way into pictures. "I have

(above) *Porto Ferraio* 1927

Exhibitions in 1923, 1924

Closing of the Bauhaus at Weimar

Bauhaus, Dessau

Members of the Bauhaus p. 18

the mountains of Sicily within me and also its sunshine. Beside these, everything is insipid."

Two important exhibitions of Klee's work were held during these years, one at the Kronprinzenpalais in Berlin in 1923, the other in New York (Société Anonyme) in 1924. Both exhibitions contributed greatly to his reputation, although the officialdom of art continued to ignore him. Private collectors eagerly bought his work, but the museums still hesitated. It was therefore an event of great significance when the National Gallery in Berlin bought the painting *The Goldfish* of 1925.

The closing of the Bauhaus in Weimar was a sad period. In addition, bourgeois reaction and envy provoked all sorts of artificially aroused antagonisms. All the leading intellectuals of Germany – from Hans Thoma to Kokoschka, Gerhart Hauptmann to Franz Werfel, Van de Velde to Van der Rohe – tried to come to its rescue and protested against its enforced dissolution. But their efforts were in vain, and on December 26, 1924, both masters and students packed their belongings and ceased work.

When the Bauhaus reopened in Dessau in April 1925, everything remained on a provisional basis. The City Council headed by the mayor, Dr. Fritz Hesse, however, proved extremely generous and agreed to erect a modern building designed by Gropius. An appropriation was approved for seven houses with studios for former Weimar masters and for a new building to house both the Bauhaus and the Municipal Arts and Crafts School. The unit of buildings was inaugurated on December 4, 1926.

The curriculum underwent several modifications. The departments of architecture and design were greatly enlarged. Joint instruction by a craftsman and an artist was abandoned, and five former students who had been trained in both craft and theory were appointed masters.

Klee, Lily, and Felix moved into the new house at No. 7 Burgkühnauer Allee which had been assigned to them, in July 1926. It was a

semi-detached villa, the other half of which was shared by the Kandinskys. All the familiar Klee furniture was soon in place, and only the bright, spacious studio with its built-in picture racks and large drawing board retained a distinctly Bauhaus look.

'The Masters' houses were situated on the edge of a wood, and Klee had every encouragement to go for long walks down to the Elbe valley. With fine disregard for trespassing, he strode along his "criminal" way. He liked the neighborhood, especially Oranienbaum and Wörlitz, with its castles and English park. Nor did he overlook the charm of Dessau itself with its ducal castle. Ever since his first visit to Italy, Klee had cultivated an interest in historical monuments. "When, in Italy, I learned to understand architectural monuments, I chalked up at once a remarkable advance in knowledge. Though they serve a practical purpose, the principles of art are more clearly expressed in them than in any other works of art."

Close to the Bauhaus in Dessau stood the Junkers airplane works, and it was not long before the aeronautical engineers at the factory and the Masters of Form at the school struck up a friendship of great mutual benefit. This close association showed itself during the celebration of Klee's fiftieth birthday, when some pilots from the factory flew over and dropped flowers and presents onto Klee's roof garden.

(below) *Suburb of Beride*
1927

Many people were upset by the idea of the Bauhaus moving to such a small town, but their fears were without foundation, for Dessau is within easy reach of Berlin. But no matter where it might have been situated, it would not have been far enough to avoid the fate in store after the Nazis came into power in 1932.

The years 1927 and 1928 were years of hard work for Klee in both studio and classroom. At first everything went well, and he was able to work hard. The unfortunate turn of events in Weimar had produced a deepening of communal feeling, so that life in Dessau was rather like life on an island with connections to all four corners of the earth. Klee's financial situation was satisfactory, but by no means brilliant. He was therefore delighted when, in November 1925, an admirer formed a society of fellow collectors, each of whom guaranteed to buy at least one or two pictures a year, usually water-colors.

Music

At this time music seems to have meant more to Klee than ever before. He referred to Mozart's *Jupiter Symphony* as "the highest attainment in art", describing its fast movement as "the summit of all daring. This movement is decisive for all subsequent musical history". The concerts and operatic performances at Dessau were good; the two principal conductors, Franz von Hoesslin and Arthur Rother, both included modern music in their programs. But, with the exception of Stravinsky and Hindemith, Klee esteemed no contemporary composer highly. Kodaly seemed a composer of mere *genre* music; Ravel, too often coarse. Klee remembered particularly a Hindemith concert and a performance of his opera *Neues vom Tage* (1929). "A certain starkness toward spiritual matters is deeply rooted in his personality", Klee wrote to Lily on May 15, 1930, after Hindemith had visited his studio. This provided a bond of understanding between them because Klee's own reserve was always mistaken for coldness. He admired Hindemith for his wonderful sense of rhythm, his economy of means, the vigorous sound and carefully controlled expression of his chamber music. Klee did not, however, accept Hindemith's opera so wholeheart-edly: he felt that the text was poor and that, in order to compensate, the music made too many concessions. It was as though Bach had undertaken a musical comedy: a tension existed between the two opposing elements, and the performance seemed "to throw sarcastic spotlights on the entire history of music between Bach and the present-day." The production of Moussorgsky's *Pictures at an Exhibition* in settings by Kandinsky (1928) was a more memorable experience for Klee.

No one came to see the Bauhaus without also visiting its Masters, and Klee met people from all over the world. Artists and intellectuals flocked to the series of special lectures and concerts. Indeed, there were so many visitors and invitations that, after a performance of Pfitzner's *Palestrina*, Klee wrote to Lily that he could not continue with so many distractions.

The first number of the publication *Bauhaus* appeared in 1926. The periodical continued until the institution closed in 1932, and naturally Klee was among its contributors. A society of "Friends of

(page 75) *Afraid on the Beach* 1929

the Bauhaus" was also founded to propagate the new ideas, and the contact between industry and the Bauhaus workshops became increasingly close. To all appearances, the Bauhaus had become the international center of artistic creation and practical experiment. But in 1928 Gropius resigned from the directorship in order to concentrate entirely on his own work. With him Moholy-Nagy, Marcel Breuer, and Herbert Bayer also resigned. In 1929 Oscar Schlemmer accepted a position at the Academy of Fine Arts in Breslau and, within two years, the Bauhaus had assumed a different aspect.

Journeys to Italy, Corsica, and France

As far as extracurricular events during this period are concerned, Klee was most profoundly affected by certain trips away from Dessau. Just as he was keenly aware of the changes in color and form which accompany the changes of season, so he was keenly aware of the differences in color and structure between one landscape and another. In 1926 he returned to Italy, visiting Florence, Pisa, Ravenna, and Elba. In the following year he visited the Porquerolles Islands and Corsica, hoping that the Mediterranean would more directly affect him than in the previous year. He was not disappointed. "Once again I went in search of something to stimulate harmonies lying dormant within myself, small or big adventures in color." Ajaccio he described as "the Geneva of Corsica". Calvi he liked more each day and wrote Lily that "the way it is built into the heroic landscape is so fantastic that one is confronted by a puzzle. Granite in every sense". On his way back to Dessau he stopped at Avignon.

In 1928 Klee went to Brittany. He stayed on the coast, between Nantes and Quimper, in Belle-Ile, and in small harbor towns such as Concarneau and Auray. He went on excursions to Pont-Aven and Le Pouldu, made famous by Gauguin, as well as to the megalithic remains at Carnac.

Journey to Egypt

At the end of 1928 Klee decided to visit Egypt and, in relation to his work, this trip became the greatest single source of inspiration in his later years. He was aware of the living presence of a culture 6000 years old, a span in the history of the world transfixed in the landscape as well as in the creations of man himself. The Acropolis

Mechanics of a Part of Town
1928

Saint A in B 1929

or a glimpse of ancient Attica could not have influenced his work as much. Classic Greece belonged to a definite period and seemed to him irrevocably in the past. Egypt, on the other hand, seemed more exciting, at once eternal and alive. He felt that every monument and every mound of sand proclaimed its origins, reflected the present, and foretold the end.

A small diary records Klee's journey day by day. On December 20 he embarked at Genoa, then sailed past Syracuse and Crete, and arrived in Alexandria on the morning of December 24. That evening he reached Cairo and strolled through the native quarter. During the next few days he visited the Museum of Antiquities, the tombs of the Caliphs, and the pyramids at Gizeh. On December 31 he was in Luxor; on January 1, in Karnak; on January 3 he saw the Valley of the Kings and Thebes; on January 7 he was in Assouan, where he visited Elephantine Island. "As far as I am concerned this journey could go on and on for as long as possible." But Klee had to return. He stopped briefly in Syracuse where he saw the Greek and Roman amphitheaters and the quarry prisons of Dionysius the Tyrant.

The trip was short. Klee spent only a little more time in Egypt than he had fifteen years previously in Tunis. Although he was not entirely unprepared for what he saw, the impression was profound. It proved as decisive for the work of his last years as the experience of Tunis had been for his middle period. Egypt gave him the courage to simplify still further and to escape from the fixed poles which limit our European vision. Klee's Egyptian pictures, in short, are his equivalent of Goethe's *West-Oestlicher Divan.* In Tunis the southern moon had impressed him most; but in Egypt it was the sun, the light, "that great God which created itself" *(Book of the Dead).*

In the summer of 1929 he went South again, this time to Bidart near Biarritz; Kandinsky was in the neighboring village of Guéthary. Klee also visited Carcassonne and Bayonne, with its well known Musée Bonnat. The summer of 1930, his last year at the Bauhaus, was spent at Viareggio, in addition to a fortnight's rest in the Engadine.

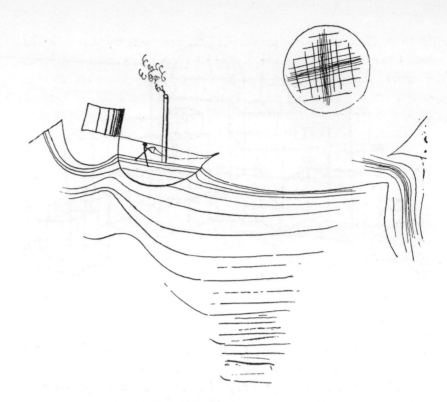

Countercurrent by Full Moon
1928

Porto Ferraio p. 72
Côte de Provence Cl. Cat. 124
View of G. p. 269

Fiftieth birthday

Klee's immediate pictorial records of his journeys were never numerous. Now and again he would produce a picture to recall some particular place or event such as *Porto Ferraio*, the landscape entitled *Côte de Provence* or *View of G.*, inspired by Corsica. But what he absorbed for his art were generalizations and particular color effects on which he could base future pictures.

As far as Klee's work was concerned, the year 1929 was not only very productive but also successful in the worldly sense. To celebrate his fiftieth birthday the Flechtheim Gallery in Berlin organized a large exhibition which was much discussed. This exhibition was originally scheduled to be shown in New York at J. B. Neumann's Gallery. The available wall space, however, was limited, and the Museum of Modern Art offered, as a mark of special respect, to put their galleries at Klee's disposal in 1930. Exhibitions of Klee's work were also held in Dresden at the Neue Kunst Fides Galerie in 1929; in Düsseldorf at the Kunstverein für die Rheinlande und Westfalen, in 1931; and in Saarbrücken. Several museums bought pictures, and laudatory articles appeared in a number of daily papers and periodicals. In Paris the magazine *Cahiers d'Art* commissioned a volume of reproductions with the introductory text by Will Grohmann, and when Klee read the prospectus he wrote that "the sight of [his] name in such large letters seemed quite frightening".

Alfred Flechtheim had now taken over Goltz's contract with Klee, and it was largely thanks to his efforts that Klee's reputation rose so rapidly. Hitherto his pictures had been exhibited only once in Paris – at the little Galerie Vavin-Raspail in October 1925 – but now, in 1929 Flechtheim persuaded his friend Kahnweiler to interest himself in his work, and a second exhibition was arranged at Bernheim-Jeune's.

In 1934, again at the instigation of Flechtheim, who by that time had
been forced to leave Germany, Kahnweiler made a contract with Klee.
Flechtheim also encouraged museum directors and private collectors in
in Belgium, Holland, and elsewhere to buy Klee's work; and in America
he joined forces with J. B. Neumann and Galka Scheyer. The first
exhibition of Klee's work in England was held in January 1934.

Gropius' successor at the Bauhaus was the Swiss architect Hannes
Meyer, whose sociological approach to art was violently disputed, not
only within the school, but also outside, especially by the City Council
of Dessau. Meyer was succeeded in 1930 by Mies van der Rohe who
took over this heavy legacy, only to watch the whole institution
collapse for a second time under political pressure. The Bauhaus closed
first in Dessau in October 1932, and finally in Berlin in April 1933.

Before the school closed Klee had already ceased to be a member
of the teaching staff. The troubled atmosphere had a disruptive
effect on his work, and he felt that he could not continue teaching.
He complained of "losing the greater part of these precious years of
productivity. I should perhaps be able to seize freedom as my right,
and for a while do nothing at all. But everywhere I have responsibilities
and dealers; and then there is the problem of daily bread, of my
reputation – it is all wrong."

When the city of Düsseldorf offered him a part-time professorship
at its Academy of Fine Arts, he accepted at once and resigned from
the Bauhaus in April, 1931. The new appointment, he wrote, "was
exactly what I wanted, as I was free to confine my teaching to my
own subject".

By 1930 Klee's income from the sale of his pictures sufficed for his
needs. Although it was no longer essential that he teach, he accepted
the position at Düsseldorf because he felt the need for discussion with
the younger students, and because his academic duties would be much
less onerous than at Dessau. Since he could not find any suitable living
accommodations, he retained his Master's house and shuttled back and

Professorship at the State
Academy, Düsseldorf

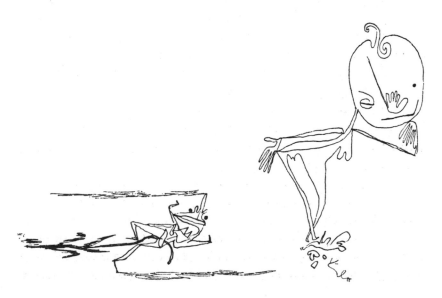

Please! 1932

79

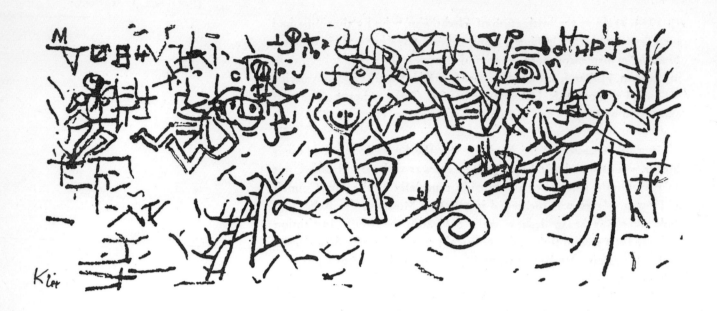

forth between Dessau and Düsseldorf until he was at last able to move in the spring of 1933. However, this interlude in the Rhineland was not destined to last long; on April 21, before Klee was installed in his new home, he received a telegram from Felix saying that his enforced resignation had been decided upon. And so at last he was able to enjoy that "complete freedom" which he had been longing for since 1929.

Klee's two years in Düsseldorf were much less dominated by teaching than those spent in Weimar and Dessau. He seemed more like a visiting lecturer, and he arranged to go to Düsseldorf only for regular periods. Nevertheless, he strictly fulfilled his academic obligations until the moment of his dismissal. He began with only four pupils, but the number increased steadily each term. Officially he was supposed to lecture on the technique of painting, but that was a mere formality imposed on him by the lack of any alternative subject. Dr. Kaesbach, the director of the Academy, was primarily interested in Klee as a stimulus, not only for the students but also for the artistic life of Düsseldorf itself. Klee repaid him by encouraging gifted students and teaching them his own ideas about art. He also actively participated in the artistic activities of the town, which heralded his arrival in the summer of 1931 with a splendid retrospective exhibition of 252 of his works.

Düsseldorf was a large city with a good opera company (Klee heard works by Janacek and Weill), imposing shops, and a great deal of life. Klee adapted himself to this new atmosphere and, fully occupied with his own work, he was prepared to accept his colleagues and the local painters at face value. "There may not be as many geniuses in Düsseldorf as in Dessau, but one feels at home in this art-laden atmosphere. Even the conservative element is prepared to come to terms with progressives, and so it is more honorable and therefore more interesting than the modernist element." Klee's tolerance extended to

the members of the committee and jury of the Deutscher Künstler-
bund with which he exhibited at Stuttgart in 1930, at Essen in 1931,
and at Berlin in 1932. But sometimes he could not prevent his real
feelings from bursting out, and then he remarked that nearly all Ger-
man artists painted disgustingly and that he wished that he could
be far away in a studio on Mount Athos.

Among Klee's colleagues at the Academy at Düsseldorf were
Campendonc (whom he had known twenty years earlier), Oskar Moll,
and the sculptors Alexander Zschokke and Ewald Mataré. Zschokke
made a bust of him, and during the sittings Klee watched the sculptor
at work to see what he could learn.

Klee's studio in Düsseldorf was so large that he said it made him
feel "quite small". He lived alone, doing his own housework and
cooking delicious food, which was one of his chief delights. He wrote
Lily: "The studio has a wonderful smell. Afterwards, a fabulous apple,
and coffee out of the Arabian Nights. Then washing-up with brush
and soap. Tea at 4:45. Love to the others, especially Bim. Yours,
Paul." The thing he missed most was Bimbo, his Angora cat, with
whom he used to have long conversations in a private language.

Monologue of the Kitten p. 86

Klee kept his smaller pictures at home while the "big guns" remained
in the studio. The production of the large pictures took up a great
deal of time because Klee was painting in a mosaic-like style which
he described as "Divisionist". He lived in the Goldsteinstrasse in Düs-
seldorf, in a rented apartment, where he drew and occasionally made
watercolors. He also bought himself a lay figure "so as to be able to
consult nature now and again when working on figure studies. But it
seemed so naked that I lent it a pair of my gloves and bought it a
pair of stockings for sixpence. But now I have got a new worry – it
needs a wig." When in need of practical help or advice, Klee would
go round to see Alexander Vömel, the manager of the Düsseldorf
branch of the Flechtheim Gallery, in the Königsallee. Vömel had a
house with a handsome collection of pictures by Henri Rousseau,
Picasso, Braque, and Klee; he also had a car, and on many accasions
took Klee for long drives through the Rhineland and the Sieben-
gebirge, around Godesberg.

In his spare time Klee read the tragedies of Aeschylus and Sophocles,
and he mentions in a letter that he had read *Antigone* "with as much
excitement as if I myself were concerned". He studied the original

(below) *Demagogy* 1932

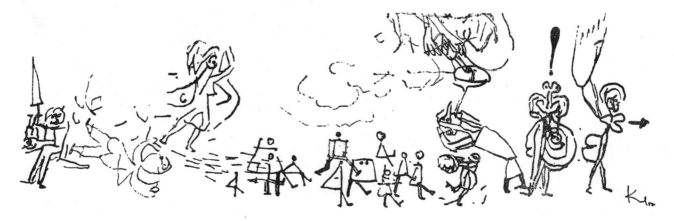

Attacks by the Nazis

Journeys to Sicily, Italy, and France

Parsifal: "There is no modern work as beautiful as the Middle High German epics, and anyone who feels cannot suppress a shiver of delight whenever he recalls them." The statues of the founders of the Naumburg Cathedral represented German classicism at its finest in Klee's eyes. Indian literature, too, interested him and he read *Sawitri* from the Mahabharata epic with the same passionate attention that he had given to Buddha's sermons, the poems of Hafiz, and Chinese poems and tales. Then he turned to Mommsen's *History of Rome* with its glorifications of Caesar: "It does me good to mix a bit with that sort of genius. It is a relief to find that there are people of larger caliber than Hitler and his two lion tamers."

As early as 1933 Klee was violently attacked by the Nazis, who called him a Jew and a foreigner. It never occurred to him to protest. "It would be unworthy of me to become involved in such clumsy mudslinging. Even if it were true that I am a Jew from Galicia, it would not affect in the slightest the value of my personality or my achievement. And I must never of my own accord abandon my personal point of view, which is that a Jew and a foreigner is not *per se* inferior to a home-bred German. Otherwise I shall make a fool of myself forever. I would rather accept any amount of personal discomfort than become a tragicomic figure trying to ingratiate myself with those in power."

So long as it was still possible Klee took a holiday every year in the South. In 1931 he went to Sicily, visiting Syracuse, Ragusa, Agrigento, Palermo, Monreale, and various excavation sites. He thoroughly enjoyed himself, and crossed the island several times in search of scenic beauty and antiquities. In 1932 he traveled via Switzerland to northern Italy and Venice, breaking his journey in Zürich to see the large Picasso exhibition at the Kunsthaus. Picasso's most recent pictures proved "a great surprise. There is something of Matisse ... Here is the great painter of today". In the summer of 1933 Klee was on the

When Will It Quiet Down?
1932

The Tear 1933

southern coast of France – "the only country that keeps its head" –
visiting Hyères, St. Raphael, and the island of Port-Cros. Whenever
possible he tried to incorporate a visit to Paris in these holidays to see
museums and exhibitions – "Paris and Berlin are the two art centers
of the world". Klee never stayed more than a few days in Paris and
avoided doing the round of artists' studios; but Paris was the home of
l'esprit gaulois and French art, and for that reason he loved it.

Quantitatively speaking, roughly half of Klee's total *œuvre* was
produced during the years he taught. When he had arrived at the
Bauhaus, Klee was a romantic with a precise sense of form. Not unlike
Novalis, he regarded art as a kind of science and sought poetic
inspiration in the rigorous discipline of mathematics. His work was
something more than a "cosmic picture-book." He had already pro-
duced *Arctic Thaw,* and the series of rhythmic landscapes with trees,
and he began to discard illustrative content in favor of creative form.
Through his daily contact with architects and with workshops for
stained glass, weaving, and theatrical design, he began to realize the
difference between things one knows and things one experiences or
creates in common. With Klee things always grew naturally, and there
was no abrupt break in his work. There was, however, a rapid
development in the means which he adopted for the realization of his

Works between 1921 and 1933

Arctic Thaw p. 157

Symptom, to be Recognized in Time 1935

intuitive perceptions and ideas. Pictures such as *Tropical Twilight* or *Nocturnal Festival* were still fairy tales, although the splendor of their color range was new. For a while Klee continued to exploit this playful romanticism, although *Scene from a Hoffmann-like Tale* and *The Fateful Hour: 11:45* led to dramatic episodes, often with a malicious twist, chosen from everday life, from the Bauhaus, from opera and ballet. Thus the *Operatic Tenor as a Concert Singer* is shown blasting the pianist to the ground; the ballet *The False Oath* or an imaginary comic opera such as *The Seafarer* are actually performed. The same tendency to dramatize appears in the psychological formulation of specific types of individuals such as *Fool in Christ* or the later *Singer in a Comic Opera*. But the treatment of the figures and the events on stage is more formal and their link with the world of fixed conceptions is less pronounced.

Thus Klee was able to continue at Weimar without being obliged abruptly to alter his course. The construction of *Blue Mountain* of 1919, for example, already points the way to the monumental Egyptian pictures of 1929. With Klee everything was always at hand and merely awaited a particular moment to appear in appropriate artistic form.

Klee had painted architectural pictures before going to the Bauhaus, but after that date the architecture was of his own creation and composed of colored squares and triangles. His first perspective pictures, dreamlike mathematical constructions of disquieting emptiness, date from 1921. The crisscrossed strands of translucent color in more or less regular patterns were inspired by stained glass; over this foundation narrative elements were drawn, or strictly speaking, printed. *Chromatic Triad* (1923) or *Mountain Forms* (1924) are twentieth century stained glass windows with unexpected subject matter. The lace-like façades and church buildings in other pictures derive from weaving.

The sketches produced by the theatrical class at the Bauhaus, the "Mechanical" and the "Triadic" ballet, inspired several of Klee's acrobatic and ballet subjects as well as the group of pictures with marionettes in which the element of improvisation is heightened by the apparently improvised means employed. All the mechanical con-

(page 85) *Woe, Woe!* 1937

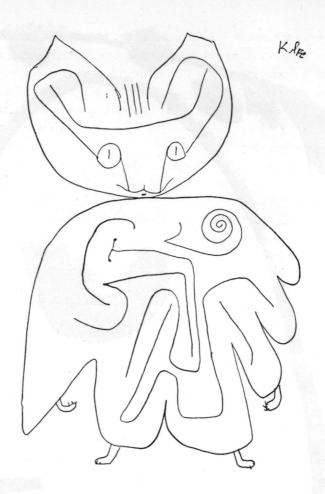

Monologue of the Kitten
1938

The Twittering Machine p. 171

Fugue in Red Cl. Cat. 94
Ceramic-Erotic-Religious
p. 167

Stage Landscape Cl. Cat. 99

Landscape with Yellow Birds
Cl. Cat. 68

traptions which Klee saw in the workshops encouraged him to invent weird apparatus such as a *Twittering Machine* (1922) which would be wound up with a handle to make nightingales sing.

The order of the day at the Bauhaus was construction, an order for which Klee had been waiting. Hitherto he had been guided by Bach's fugues and Mozart's symphonies, *logos* and *eros* in an unusually happy combination. In Weimar the *logos* was encouraged, and pictures such as *Fugue in Red* (1921) or *Ceramic-Erotic-Religious* (1921) represent Klee's first logical attempts at applying the principles of imitation and polyphony to pictorial processes. These are completely integrated pictures, and the subjective elements of vision are apparently overruled in favor of a construction which fills every inch of surface. Klee's rapidly growing feeling for form, hitherto nourished by music, was strengthened at the Bauhaus by examples from very different realms. Suddenly he found that his intuition was correct, and he could see his way clear both in retrospect and in the future. The romanticism of *Stage Landscape* is caught in a system of steps, wings, and elaborate decoration. *Arab Town* (1922) emerges from a network of straight lines which intersect and break off abruptly at right angles. Even *Landscape with Yellow Birds*, a sort of oriental miniature, is so obedient to its structural laws that the birds and the vegetation have become interwoven.

Construction: Yet, as Klee was to write in one of the Bauhaus prospectuses, "construction is not totality," for "intuition still remains

an important element." As Klee's insight into things became more complex, he adopted new techniques and new formulas; and he could use both to produce a poetic atmosphere even in pictures such as *Abstract Trio* (1923) or *The Voice Cloth of Singer Rosa Silber,* which come very near to abstraction. The latter is particularly daring, for it consists simply of the five vowels embedded in a harmony of soprano colors: it is a picture for eyes that have ears. Even in pictures such as *Unstable Equilibrium* or *Intensification of Color from the Static to the Dynamic* which are pure constructions, the important element is the expression of Klee's profound awareness of the world. In some pictures physical factors are decisive; in others a checker-board arrangement of alternating squares of color produces an adagio, as in *Harmony,* or *Gaily Blossoming.*

Klee's first Dessau pictures were based on drawing and consist of parallel lines used fugally and contrapuntally, e. g. *Classical Garden, A Garden for Orpheus,* or *She Sinks into the Grave.* The imitative handling of form and the contrapuntal interweaving in these pictures make them seem as classic as a Haendel opera, but others such as *Mountain Sanctuary* hint at darker and more mysterious realms. As

Unstable Equilibrium
Cl. Cat. 71

Intensification of Color from the Static to the Dynamic
Cl. Cat. 73

A Garden for Orpheus p. 368

View of a Mountain Sanctuary p. 225

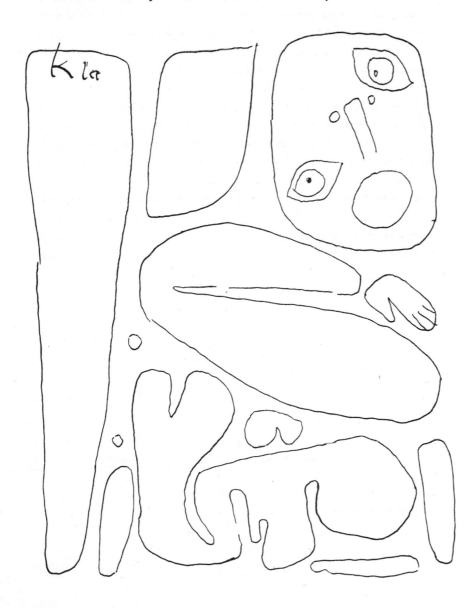
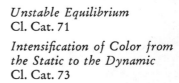

Fear Erupting 1939

always with Klee, a formal discovery becomes an expressive pictorial starting point which could be developed in a number of different directions, serving for *Antigone* as well as for *Golgotha,* for a plant with radiating leaves or a fabulous animal. These configurations of parallel lines should not be confused with the interlaced bands which came four years later (for instance, as in *Complex-Offensive*) – the bands which Klee had seen in the Lombard art of North Italy. Of course, Klee did not take over the ancient, original significance of that stylized art; he merely used a comparable stylization for arabesques, at the dictates of his own fantasy. But his fantasy was unlimited, and he could ever produce new motifs and themes. These could develop into unknown geographical regions, like *Suburb of Beride* (1927); or "musical scores" made up of some novel system of notation, like *A Leaf from the Book of Cities* (1928); or legends made up of geometric entities, like *Family Outing* (1930).

Egypt inspired monumental pictures whose color was lighter and brighter than Klee had ever used before *(Highway and Byways).* The horizontal strips, which are arranged rhythmically in vertical and diagonal groups, create the image and produce a grandiose vision of the landscape. From precise observation and deliberate formal construction there emerges a dream-image. The blending of experience and imagination becomes more and more a matter of course; Klee experiences things real and imaginary as formal images which are at the same time glimpses into the organization of the universe. And so by the end of 1929 we find Klee producing mobile spatial images such as *Atmospheric Group* or *Hovering* (1930). Sometimes these consist of regular, transparent overlapping planes which suggest something spectral or atmospheric; others have floating cubes of space which give a sensation of rising and falling, of soaring and gliding, with mathematical precision. And the planes can differ from each other not only in tonal value and in color but also in texture, for some of them are covered with little dots which look like perforations. The original purpose of the dots was to break down tension, but at a later stage

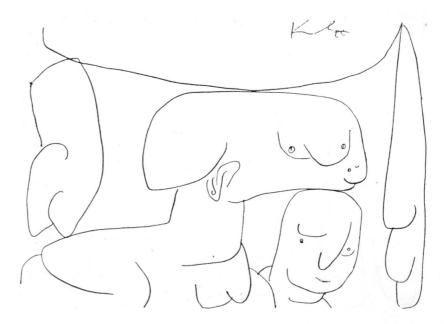

Mother and Son 1939

Burden 1939

they became an independent element which enabled Klee to produce some of the lightest and freest of all his works, e. g. *The Light and So Much Else.* In these he dispensed with drawing, for he could not express what he had in mind graphically by means of dots. Light, which Goethe described as the highest energy imaginable, can be caught by color alone, provided it is used divisionistically. So the solution was to scatter dots of color over receding planes covered with few linear abbreviations.

At no period did Klee ever confine himself to one direction only. There were always exceptional works among his production such as *Snake on a Ladder* (1929) or *The Devil Juggling,* or *Arab Song* (1932).

Disgusted by the Nazi regime in Germany, Klee returned to Switzerland shortly before Christmas 1933. His father and sister still lived in the same little house in Bern, and he contacted Moilliet, Bloesch, and Lotmar (who had also fled from Germany) as well as several

The Light and So Much Else
p. 241

Snake on a Ladder p. 238
The Devil Juggling
Cl. Cat. 143
Arab Song Cl. Cat. 144

Return to Bern

89

A Sick Man Making Plans
1939

Studio in Bern p. 20

collectors. He soon felt at home in Bern and before long had found a modest three-room apartment on the second floor at Kistlerweg 6. He took the largest room for his studio; the grand piano and the violin were housed in another; and the kitchen doubled as dining room. His days were divided between work, music, and walking. Occasionally he would attend a concert, but otherwise he did not go out much. Now and again friends would fetch him in a car and take him to an interesting exhibition in Zürich, Basle, or Lucerne. He felt somewhat lonely, although these outings partially compensated for the international artistic life – the excellent theaters and concerts – which he had known in Germany. In the evening in his spare time Klee read a great deal, notably Racine's tragedies.

When he reached Bern at the end of 1933 Klee stopped work for a while, and not until the following May did he write me that he had started to paint again "with a very reduced orchestra." After thirteen years of teaching in a congenial and productive atmosphere, he did not find it easy to adapt himself to the abrupt change. Rejected by Germany, he had only himself to fall back on, and this was the severest test of all.

At this difficult moment in his life Klee's first exhibition in London opened at the Mayor Gallery in January 1934, and he noted with satisfaction the extension of his sphere of influence in other countries. He was also delighted when I was able to publish in Germany the first of three volumes planned to cover his drawings, entitled *The Drawings of Paul Klee (1921–1930)*. But while the book was still being distributed to booksellers, the entire edition was seized by the Gestapo.

Exhibition in Bern, 1935

A large exhibition of Klee's work undertaken by the Kunsthalle in Bern opened on February 23, 1935, and subsequently traveled to Basle. As result Klee achieved a prominence among Swiss artists such as only Hodler and Amiet had enjoyed before. The Bern Museum bought *Ad Parnassum*, while collectors such as Hanni Bürgi, Hermann Rupf, Maja Sacher, and Richard Doetsch-Benziger acquired new and important examples of his work. During the exhibition in Bern and Basle, Klee received many visitors from Switzerland and abroad.

(page 91) *Come Away* 1939

There were also lectures and discussions which he attended, and many old and new friends invited him to their homes. When these interruptions ceased, Klee was relieved and wrote to me: "The tempo of the last few weeks is gradually slackening and I hope soon to follow a new rhythm."

At once he rushed back to work, not stopping "day or night" (Lily wrote) "but probably he goes on unconsciously working while he is asleep." His last six years in Bern were artistically the most exacting and the most crowded, but at the end he had found the absolute simplicity for which he had searched.

The first signs of the illness which was ultimately to be fatal appeared in the summer of 1935. The first diagnosis was bronchitis with complications of the lungs and heart as a result of measles. From then on, Klee was never well. Subsequently it turned out that he suffered from a little-known but insidious disease (sclerodermia) which causes drying of the mucous membranes. Five years later, when it attacked his heart, he died. Even when his suffering became acute, he never complained or retired from the world. He never lost hope in an ultimate recovery, and until the end he planned paintings, trips abroad, and future books. The present biography was discussed and outlined, and Klee himself supervised the choice of plates. He was not in the least worried by the idea of death, because life, like art, was to him a genesis. He felt that there was no knowing what life in the next world might bring. In fact he did not begin to think of death as a possibility until the last two years of his life. He wrote to me: "Naturally I have not struck the tragic vein without some preparation. Several pictures have pointed the way with their message: The time has come." During the last full year of his life Klee drew and painted twice as many pictures as in any previous year. Many of these were concerned with devils and angels, for he was preparing for death by coming to terms with such things.

Klee seems to have worked without cease during these last years, except in 1936, when he was very ill and his production fell from several hundred to only twenty-five works. In April and again in August of 1936 he prepared to resume painting but each time had to give up. In the summer Hermann Rupf invited Klee to take a cure in Tarasp, after which he went to Montana; but the improvement in his

(below) *Sick Man in a Boat* 1940

physical condition did not last long. Friends tried to distract him by taking him for drives, inviting him to parties, sending him books to read, or doing chores for him. Otherwise, all his energies were devoted to his work and he lived quietly at home seeing very few people and not going out more than necessary. He became more and more serene and otherworldly, to the extent that even people who had no understanding of his art were aware of the aura which surrounded him.

Klee became the master of his condition, however, and the next year in 1937 was again at work. This was a particularly fruitful year, and on many a day he made drawing after drawing until well past midnight. In the summer he visited Ascona, and saw Maria Marc, the painter's widow, who makes pictures in weaving. Kirchner came down from Frauenkirch near Davos to visit and to persuade him to go up to the mountains. But Klee would not interrupt his regular life in Bern except to walk or to take a cure ordered by his doctor. Even the short incline of the Kistlerweg had begun to prove too much, and he remarked half-jokingly one day that he did not have to go far "to find a Matterhorn".

In November Picasso, during a visit to Switzerland, called on Klee and spent some time looking at his paintings and drawings. Klee was most gratified to find that Picasso's reaction was spontaneous and favorable, for he had a tremendous respect for Picasso whom he regarded as the greatest living painter. Indeed, Klee found that Picasso affected him so profoundly that he tended to avoid exhibitions of his work. Strangely enough, this was their first meeting; Klee's visits to Paris had never lasted more than a day or two, and Picasso never went to Germany. On more than one occasion Picasso seems to have been impressed by Klee's "miniatures". When questioned about his visit by François Lachenal in 1951, Picasso summed up his impression of Klee in the cryptic phrase, "Pascal-Napoléon". Presumably he recalled the strange mixture of wisdom and excessive energy, of passionate asceticism and directed intensity, as well as the trace of a Mediterranean origin in his appearance.

The Nazis sequestered 102 pictures by Klee in German museums; of these, seventeen were included in the Exhibition of "Degenerate Art" at Munich in 1937. These events do not seem greatly to have affected Klee, for he was prepared for them and was happy in his Bern retreat. Pictures by Klee were also included in the Bauhaus Exhibition at the Museum of Modern Art in New York in 1938; and during the same year other exhibitions of his work were held at the Buchholz (Curt Valentin) and Nierendorf Galeries in New York, as well as at Kahnweiler's Galerie Simon and the Galerie Balay et Carré in Paris. Klee's contribution to the organization of these exhibitions was small, but their success naturally meant a great deal to him. That summer Klee was afraid to attempt a long journey and went to Beatenberg, near Bern.

In 1938 Klee remained in Bern. He was visited by many friends, but the rest of his life passed without incident. "As a result of this comparative calm, I have given birth to a picture which I have christened *Fama*." Klee's art, like that of Mozart, was not the result

Exhibition "Degenerate Art"
1937

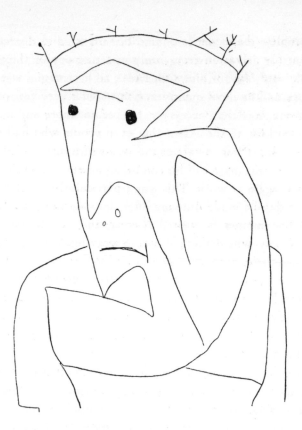

Ecce 1940

Sixtieth birthday

Hurt Cl. Cat. 202
Still Life on Leap Day
Cl. Cat. 195

Death and Fire p. 361

of being in harmony with life, but rather of transposing it. When turbulent people came to see him he still took refuge in humor: "I wish I could invite them all on the same day, to a party in the kitchengarden and then send them away immediately. There is more space downstairs."

During the summer and autumn of 1939 Klee remained in the neighborhood of Bern, at Faoug on the lake of Murten. He visited Lucerne to see an exhibition of his work, and also went to Geneva to see the collection of pictures which had been sent from the Prado. He was tremendously impressed by the paintings of Bosch, Bruegel, and Greco, and above all of Goya. His plan for a trip to Spain in 1905 had never been realized (with the exception of an excursion from the *pays Basque* to San Sebastian and Pamplona in 1925), and he had never seen the works of this artist in such numbers.

On his sixtieth birthday in 1939, Klee received congratulatory letters and telegrams from all corners of the globe. He could not answer all of them personally, but he was immensely gratified by such a spontaneous display of admiration and affection. Naturally he received no communications from Germany, which was deeply involved in war; but, before the end of the first year of hostilities, Klee himself was dead.

In 1940 when his end was near, Klee still had time to jot down some baffling shorthand notes, perhaps meant to point to road he which saw ahead of him (for example, *Hurt*, or *King and Absolute*). *Wood Louse* against a scarlet background suggests hellfire; there is a *Still-Life on Leap Day*, in which Time is out of joint. Then came death itself – an opaque white over a retiring red, a rolling ball, a man striding along: *Death and Fire* is the title. This is Klee's *dies irae;* for, again like Mozart, Klee wrote his own requiem, and many of his last

works complete the sequence of *Credo, Sanctus,* and *Agnus Dei.* The idea of earthly salvation recurs only as a memory of the end in *Bal Champêtre* and *High Watchman.* Klee's final picture was a *Still Life* with a jug, a statue, vases, and some flowers scattered on a table; the background is black, and on a sheet of white paper on the left is an angel of death carrying a cross – this we may take for the signature.

Bal Champêtre Cl. Cat. 162
Still Life p. 363

On May 10, 1940, Klee entered a sanatorium at Orsolina near Locarno, but by June 8 his condition was so much worse that he was transferred to the Clinic of Sant' Agnese at Muralto, where he died at 7:30 a. m. on June 29. His cremation took place at Lugano on July 1, followed by a funeral ceremony at the Bürgerspital in Bern on July 4, with funeral orations by Dr. Georg Schmidt, Hans Bloesch, and the Dean of the Cathedral. His ashes were interred at the Schosshalden Cemetery in September 1942, and on the simple tombstone was engraved the following passage from his journal: "I cannot be understood in purely earthly terms. For I can live as happily with the dead as with the unborn. Somewhat nearer to the heart of all creation than is usual. But still far from being near enough." The cemetery where his ashes have been laid to rest is on the side of a hill looking towards the Bentiger quarry where he made so many drawings in his youth.

Death on June 29, 1940

If Mozart had died before writing *The Magic Flute,* his death would have been illogical, Klee had said in 1917. His own death was as logical as that of the great composer. Death was in him for a long while and everything moved toward its end. It is idle to speculate on what he might have done next. Klee's life was so intimately related to his work that, as his physical powers declined, superhuman powers seemed to be liberated and help him attain his goal. He was convinced of the ambiguity of death, and thus he felt free to glimpse the beginning of a higher form of life.

It has been claimed that as a human being Klee was greater than as an artist. Who can ever be sure of what sort of man he was? His personality remains even more mysterious than his work. Perhaps the best definition of the man was provided by Klee himself in 1916 when he tried to analyze the differences between himself and Marc. With Marc, said Klee, the terrestrial took precedence over the universal; his love was warmer and more earthy, for he belonged to the species and was not a neutral being. Klee, on the other hand, could be entirely absorbed into the cosmos and therefore was not in the least Faustian. "My light burns so white-hot that to most people it seems to lack warmth," he wrote. "So I shall not be loved by them; no sensuous link, however subtle, exists between them and me. I do not belong to the species but am a cosmic point of reference." Nevertheless, the fiercely burning light shone also for "them", even though this did not become apparent until his last years.

The high esteem in which Klee, the human being as well as the artist, was held during his last years in Switzerland was due to his ability to speak indirectly to man. We sensed rather than understood his meaning. It was all there, with no discontinuity; but there was no possibility of grasping from without the connection between the different parts of this complex being. When Klee communicated

something of himself, it was never more than a fragment of the whole. He was a magician, and has remained so after his death through his work.

A series of memorial exhibitions was organized in Switzerland and New York in 1940 and 1941. Neither Klee nor Lily († on September 22, 1946) had ever been granted Swiss citizenship. As Lily lay on her deathbed, four Swiss citizens founded a society, the *Klee-Gesellschaft*. At the time it seemed that the entire contents of Klee's studio might be dispersed at auction in accordance with the Washington Agreement between Switzerland and the Allied Powers concerning German assets in neutral countries. The *Klee-Gesellschaft* controlled the entire contents of Klee's estate until 1952 when Klee's son, Felix, a German national, was recognized by the Swiss government as his father's lawful heir. The Klee Foundation became a reality in 1947 when a number of paintings and drawings from the estate were deposited at the Bern Museum in memory of the artist. In 1952 the *Klee-Gesellschaft* was dissolved. Felix Klee, however, not only agreed to the Foundation but supplemented the material with a private archive containing his father's letters, diaries, early sketchbooks, sculptures, literary contributions, pedagogical and theoretical writings, as well as various personal mementos. The pictures belonging to the Foundation were exhibited in Bern in November 1947, then in Paris, Brussels, Amsterdam, Zürich, and Basle. In 1949 this exhibition was shown in seven American cities–New York, Washington, Detroit, Cincinnati, Portland, St. Louis, and San Francisco – and in a smaller version traveled to in another eight. The collection returned to the Bern Museum in 1950.

Klee Foundation

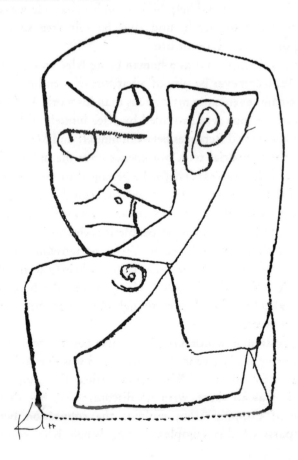

Persevere 1940

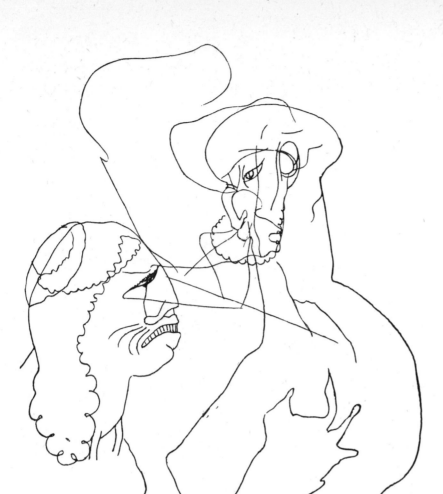

Sootsayers Conversing 1906

"Creative Credo"

"Art does not render the visible; rather, it makes visible. A tendency towards the abstract belongs to the essence of linear expression, hence graphic imagery by its very nature is apt to be both pattern-like and phantastic. It is also capable of great precision. The purer the artist's work (i. e., the more he stresses the formal elements on which linear expression is based), the less well-equipped is he for the realistic rendering of visible things.

"These formal elements are: dot, line, plane, and space – the last three inevitably charged with energy of various sorts. A simple plane, for instance – that is, a plane not made up of other, lesser units – would result if I were to draw a blunt crayon across the paper with constant pressure, thus transferring an energy charge without modulation. A spatial element would be a cloud-like, hazy spot made with a loaded brush and including several shades . . .

"The graphic elements I have mentioned should always be in evidence as the constituent parts of the picture. This does not mean, however, that a picture must consist of nothing but 'elements.' Rather, the elements must produce shapes, yet without sacrificing their own identities in the process.

"It usually takes several elements together to make up a shape or an object or some other secondary entity. Thus planes result from lines related to each other (as in watching a moving stream of water),

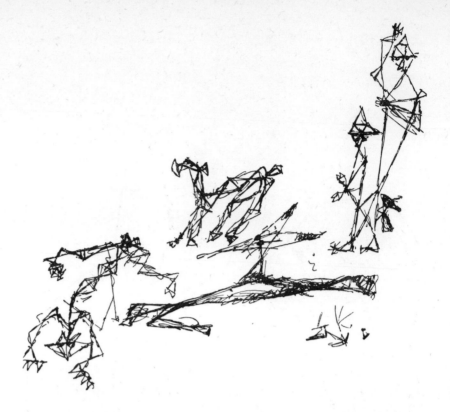

The Exciting Beasts 1912

spatial structures from energy charges within a three-dimensional relationship (as in observing a school of fish in the water).

"In this way, we enrich our formal repertory, and the number of possible variations – an of ideas to be expressed – becomes infinite.

"Action may well be the start of everything, but actions are governed by ideas. And since infinity has no beginning, like a circle, ideas are the primary realm. 'In the beginning was the word,' says St. John.

"Movement is the source of all growth. In Lessing's *Laokoon*, the subject of so much mental exercise in our younger years, there is much ado about the difference between time and space in art. Once we examine it more closely, this is really just a bit of erudite hair-splitting; for space, too, implies the concept of time.

"It takes time for a dot to start moving and to become a line, or for a line to shift its position so that a plane is formed. The same is true of the plane that moves and thus defines a space.

"And the work of art – that is not born all in one moment, either. It has to be constructed bit by bit, just like a house.

"The beholder, of course, all too often spends only a single moment in coping with the work of art.

"It was Feuerbach, I think, who said that a picture cannot be appreciated without a chair. Why the chair?

"So that your tired legs won't distract your mind. Legs get fatigued from standing for so long. What is needed is leisure – time once more.

"Character, too, is movement. Only the single dot, which has no life, no energy, lacks the dimension of time.

"Throughout the universe, movement is the rule. On this earth, rest is no more than a fortuitous clogging of the flow of matter. To accept this chance event as the primary condition is an error.

"The Genesis of Holy Writ is a splendid parable of movement. The work of art, too, is experienced by us first of all as a process of creation, rather than as its passive product. The creative impulse suddenly springs to life, like a flame, passes through the hand on to the canvas, where it spreads further until, like the spark that closes an electric circuit, it returns to its source: the eye and the mind.

"The act of viewing the work of art, too, is in essence a function of time. The beholder focuses on one section after the other; he must leave what he has already viewed in order to be able to center his attention on a new area . . .

"The work of art, then, results from physical movement; it is a record of such movement, and is perceived through movement (of the eye muscles).

"In earlier times, artists liked to show what was actually visible, either the things they liked to look at or things they would like to have seen. Nowadays we are concerned with reality, rather than with the merely visible; we thereby express our belief that the visible realm is no more than a 'special case' in relation to the cosmos, and that other truths have potentially greater weight. In our pictures, the visible appearances of things have a wider and more complex meaning, which often seems to contradict the rational experience of yesterday. We are striving for the essence that hides behind the fortuitous.

"By bringing into play the concepts of Good and Evil, we place our work in an ethical frame of reference. Evil I conceive not as the enemy whose triumph puts us to shame, but as a genetic and evolutionary force. Ethical stability is the equilibrium of the masculine element – evil, passionate, exciting – and the feminine – good, calm, growing and unfolding." . . .

From Klee's essay in "Schöpferische Konfession", 1920 (below) *Love Tide* 1934

Klee was born into a century that strives for integration and wholeness in the arts as well as in the sciences. As Einstein has been searching for a common denominator among all natural forces in his unified field theory, so artists since the turn of the century have striven for a more complex kind of statement within which optical reality is only one case among many. Klee has played a decisive role in this development for forty years. He has pointed roads that will remain fruitful for centuries. Along with Picasso, Braque, and Kandinsky he belongs to the great pioneers who have broadened and re-defined our conception of art.

Klee assumed importance later than Picasso, and at the time of the *Blaue Reiter* he still played a very modest role. It was only the biographies published about 1920 and the great exhibition organized by Hans Goltz that first gained him recognition. Nevertheless, it would be a mistake to view his earlier works as mere preliminaries. We must not be led astray by the small dimensions of his drawings and the miniature quality of his watercolors. Klee knew perfectly well, from the very start, who he was and what he wanted. It was the difficulties that beset his first attempts, not any doubts as to his mission, that made him reserved toward the world around him.

His self-reliance is clearly revealed in his journal and letters; he notes exactly what he thought right and the methods he should employ. At the age of twenty-one he had already realized how hard it is "to work out a pictorial motif which is the exact equivalent" of a poetic one. He also dreamed of the third dimension and how to render it on a flat surface. "In my dream I am my own model, a pictorial projection of myself," he wrote in 1902. "I see myself as a complex but flat configuration, clinging to the canvas. I am my own style." Klee identified himself so completely with his work that subject and object become one. His next move was to determine those elements on which his work should be based: Objective vision, physical qualities, structure, body, and earth – but also the gods of antiquity. Subjective vision, intellectual qualities, spiritual and intellectual vitality – but also the material environment of modern times. These concepts might be an introduction to his lessons at the Bauhaus.

But Klee had not yet produced a single work of which he fully approved. His catalogue includes only six of the sheets executed from 1899 to 1902, none of the ten sketchbooks of his high school years (1892–1898), nor any of the studies done at art school. It would, indeed, be a mistake to overestimate the value of these early works. Those who wish can discover Corot-like traits in the delicate landscapes of Bern and the Elfenau and applaud the meticulousness of the draftsmanship and the gradation of the planes. But similar sheets are produced by novices who keep to the beaten track. The studies of nudes and landscapes done at Munich are routine rather than personal; they are academic works, excellent but without any sign of an aspiration toward an individual style. A few illustrative drawings reveal the indirect influence of *Jugendstil*.

Little has been preserved of Klee's first four years of diligent work; he must have destroyed a very great deal. His letters about his

Sketchbooks p. 36
Studies pp. 38, 39

(page 100) *Up, Away, and Out* 1919

sketches which are lost imply that they were done along the lines of his etchings. "My uncertainty about sexual behavior produces monstrous fantasies – orgies of Amazons and other frightful things," he wrote before starting out on his journey to Italy. He described *The Happy Man* (1901) as "a sort of idiot"; *The Couple* (1902) as "a satire on legitimacy"; another composition, a "monumental female," he describes as distorted in every way but almost finished. However, he also admonishes himself to start with the smallest things, to concentrate on absolute form.

As early as May, 1901, Klee had written to his parents that, for him, etching was a wonderfully expressive medium which he thought he should try. We may assume that he was more drawn to an indirect technique such as etching, with its compulsions and chance effects, than to a direct form of self-expression such as drawing. His technique demanded much patience, and Klee made a large number of preparatory drawings in the spring of 1903. Sometimes he made his corrections directly on to the plate, sometimes he started again. As a rule he etched on zinc plates (a few were copper), and in 1906 he learned the technique of aquatint. Most of his plates were issued in an edition of fifty copies printed by Girardet in Bern.

In the summer of 1903 Klee began to work on his etchings. On June 29 he "composed a drastic figure", but the "form" did not yet please him. His first plate, etched and printed in July of that year, is *Woman and Beast*, dated 1904 in his catalogue because he accepted only the revised version. "A beast, the beast in man, pursues a lady who does not appear altogether unsusceptible. The lady's mentality is easily revealed." He next completed the *Virgin in a Tree* (1903) in which he used different nuances of lines of various weights. "First I drew and etched the contours of the tree, then I modeled them together with the contours of the woman's body, and finally I modeled the body together with the pair of birds." After this he drew sketches for *The Comedian* and *Two Men Meet, Each Believing the Other to be of Higher Rank*. He etched the latter "too soon" and destroyed the plate, only to repeat the work in September. In December he revised *The Comedian*, producing the first version which was followed by a second in January 1904. Although he considered it his "best composition to date," he reworked the same theme for the third time in March 1904.

In the autumn of 1904 Klee etched a monarchist *(A Man Groveling before the Crown)* and a new *Perseus* – with the head of Medusa – *The Triumph of Wit over Misfortune*. Klee gives a very detailed commentary on this sheet in his journal: "The action is depicted physiognomically in the features of Perseus whose face enacts the deed. A laugh is mingled with the deep lines of pain and finally gains the upper hand. It reduces to absurdity the unmixed suffering of the Gorgon's head, added at the side. That face is without nobility – the skull shorn of its serpentine adornment except for one ludicrous remnant." Early in 1905 he did the tragicomic *Hero with a Wing*, "a new antique Don Quixote," in which solemnity contrasts with

Still-Life of Potted Plants and Vases 1908

decay. Then came the *Senile Phoenix* printed on March 20th – a man with clenched fists for antlers, a cross between fable and fact thematically inspired by Ovid's *Metamorphoses*. And as "*finis operis primi*," the *Menacing Head,* which is the last etching done in this severe style, "a sharp negative little demon bending over a hopelessly resigned face," to use his own words. Klee considered the rest of his etchings mainly as experiments and printed only a few proofs.

At his first exhibition in Munich in 1906, Klee included ten "Inventions" in the catalogue. Since he counted the three versions of *The Comedian* as a single Invention, one more should be added to those already mentioned, namely the *Woman Sowing Weeds* (1903).

The word "Invention" and the numbers are found on only seven plates, and the numbering differs from the chronological order of the catalogue. *Woman and Beast* of 1904 is marked 1, while the first version of *The Comedian* of 1903 is marked 4. Besides these ten Inventions there are three other etchings, *Prophet* and *Female Grace* of 1904 and the *Pessimistic Allegory of the Mountains* of the

Senile Phoenix Cl. Cat. 15

Menacing Head p. 105

Woman Sowing Weeds Cl. Cat. 10

Pessimistic Allegory of the Mountains Cl. Cat. 14

Various Nudes 1908

same year, which was not mentioned in the catalogue although the plate is inscribed Invention 11. This brings the total number of works produced between 1903 and 1905 to fifteen.

Klee was well aware that his etchings would create difficulties for art lovers and felt that his idea of art would be considered unnatural. He loved nature, but as he saw it. He did not wish to divorce beauty from art, but intended that it should be referred to the pictorial representation and not to the object. The object is dead, perception takes first place, and only in that way can form become mobile "along the whole scale of temperament." For him a drawing ends by being no longer a drawing but a symbol, and "the higher the dimensions touched by the imaginative projection lines the better."

Perception of the object begins to supplant the object itself; beauty lies in the graphic work; imagination attains to the regions of the world of ideas. Unconsciously, while he is creating, Klee is "not the day-to-day self but the sum-total self, wholly a tool." It is only after he has finished that he takes stock of what he has done.

He turns suffering into song, but the graphic element obtrudes itself upon reality and the melody is fraught with doubt and, at times, with desperation. Some have noted a connection between Klee's etchings and the *Jugendstil;* but what he saw of that movement in Munich is different and has nothing to do with these sheets. *Jugendstil* was a victory over narrative painting and decadence. Klee's etchings are decadent, pessimistic, "soured," as he said of some of his drawings in 1905. Even to the perverse he took no objection: Perverseness widens the field of personal expression, he said. Nonetheless, he refused to accept Beardsley and appreciated William Blake, the apocalyptic Romantic. But he appropriated nothing of

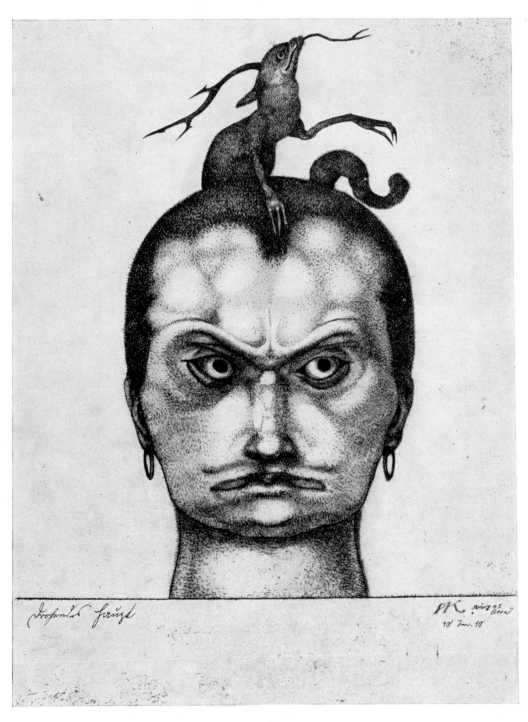

Drohendes Haupt, Radierung (1905) / *Menacing Head*, Etching
Tête menaçante, Gravure

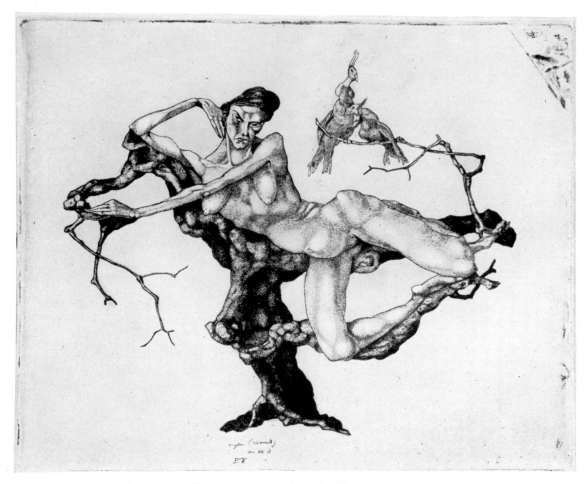

Jungfrau im Baum, Radierung (1903) / *Virgin in a Tree*, Etching
Vierge dans l'arbre, Gravure

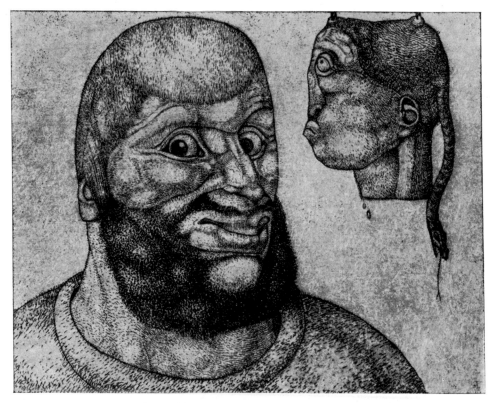

Perseus, der Witz hat über das Leid gesiegt, Radierung (1904)
Perseus, The Triumph of Wit over Misfortune, Etching
Persée, l'esprit a triomphé du malheur, Gravure

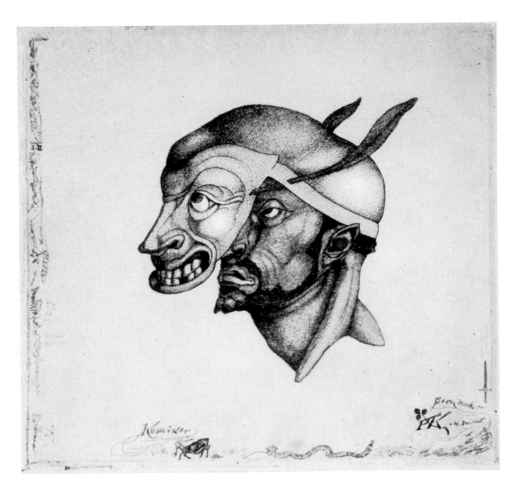

Komiker I, Radierung (1904) / *Comedian I*, Etching / *Comédien I*, Gravure

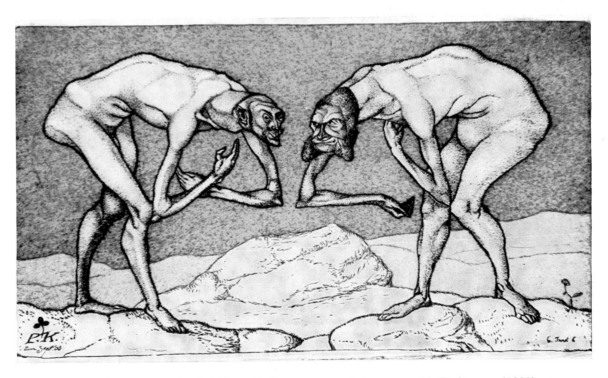

Zwei Männer, einander in höherer Stellung vermutend, begegnen sich, Radierung (1903)
Two Men Meet, Each Supposing the Other to be of Higher Rank, Etching
Rencontre de deux hommes qui se croient moins haut placés l'un que l'autre, Gravure

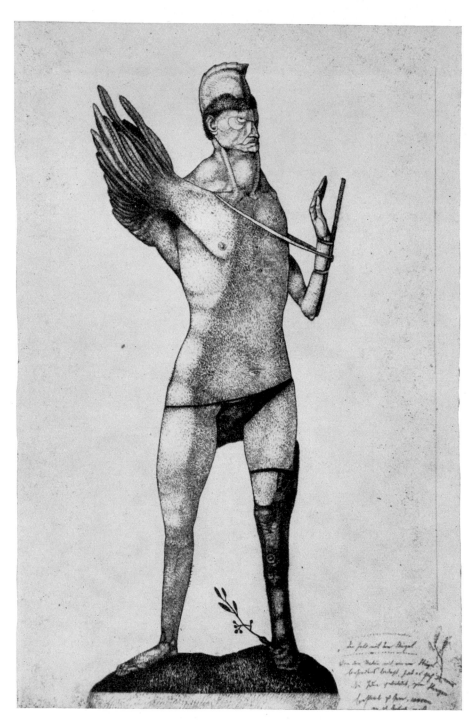

Der Held mit dem Flügel, Radierung (1905) / *Hero with a Wing*, Etching
Le Héros à l'aile, Gravure

Straße mit Fuhrwerk, Hinterglasbild (1907) / *Street with Carriage*,
Glass-painting / *Rue avec char*, Sous-verre

Bestie, ihr Junges säugend, Hinterglasbild (1906) / *Beast Suckling Her Young,*
Glass-painting / *Bête allaitant son petit*, Sous-verre

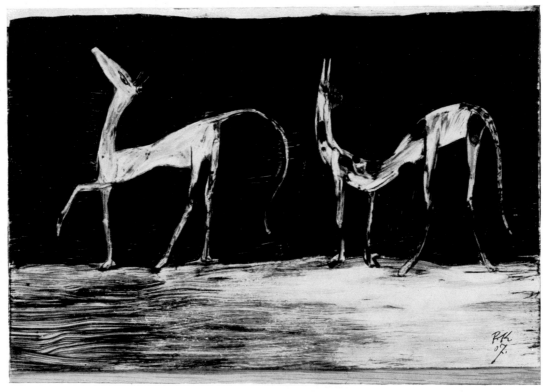

Zwei Langhalshunde, Hinterglasbild (1907) / *Two Long-necked Dogs,*
Glass-painting / *Deux chiens à long cou*, Sous-verre

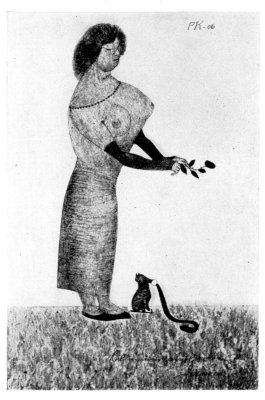

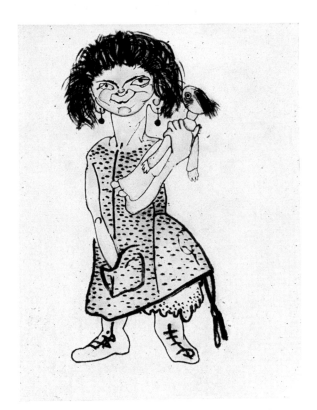

Bildnis einer gefühlvollen Dame, Hinterglasbild (1906) / *Portrait of a Sentimental Lady*, Glass-painting / *Portrait d'une dame pleine de sentiment*, Sous-verre

Mädchen mit Puppe, Hinterglasbild (1905) / *Girl with Doll*, Glass-painting / *Fillette à la poupée*, Sous-verre

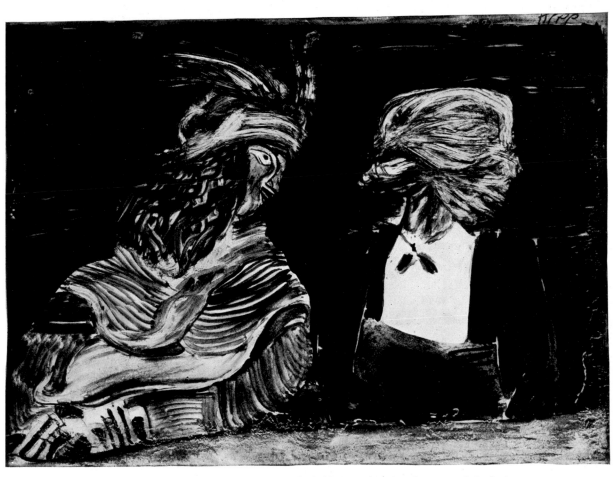

Herr und Dame in der Loge, Hinterglasbild (1908) / *Gentleman and Lady in Front Row*, Glass-painting / *Couple dans la loge*, Sous-verre

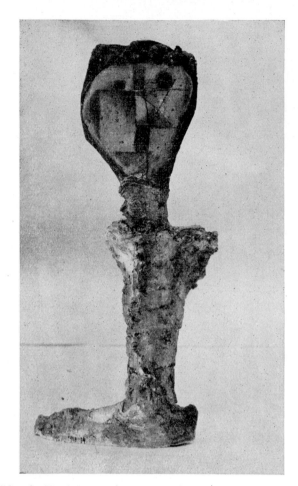

Plastik, *Kopf* (1919) / Sculpture, *Head* / Sculpture, *Tête*

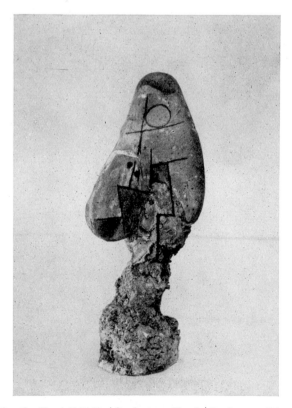

Plastik, *Kopf* (1919) / Sculpture, *Head* / Sculpture, *Tête*

his and, when in the 1930s the Surrealists annexed the English artist's name, Klee had meanwhile proceeded in quite a different direction. He admired Goya, but any connection with him (as, for instance, with *Impaled* in the *Disasters of War* series) is consonance and not dependence.

Were the etchings born of poetic imaginings or of painterly intentions? Art never starts out from a poetic idea, Klee wrote in 1903, but from the construction of one or more figures. On the other hand, figures only enthrall him when they can be utilized as "representatives of my ideas." A contradiction in terms, if these ideas are not linked on the one hand with nature – universal nature – and with the creative possibilities of form on the other. The etchings are neither literature nor free "inventive strolls" of the needle; they are the outcome of a long experience that taught the artist to see the same forces at work in subject and object.

Virgin in a Tree is neither a caricature nor a symbol, but the representation of a social prejudice that denies the right to live. Stretched on a withered tree, as on a Procrustean bed, nature is caricatured as in a distorting mirror. Anatomy is overruled, shape is deformed. The limbs have become branches – a transmutation as in the myth of Daphne; but it is a wintry, deathlike metamorphosis. The frequently alleged resemblance to Pisanello's drawing in the Albertina, *Allegory of Luxury*, does not exist beyond exterior parallels, and the concordances suggest contrasts instead.

Virgin in a Tree p. 106

The *Woman and Beast* resembles the *Virgin in a Tree*. This woman represents "something equally false and true": she is not only more sensual, she is, at the same time, more sculptural as well thanks to the deeply etched background. One is reminded of Klee's sculptural ambitions and his experiments with plasticine. *Comedian II* also produces the effect of a mask in relief, so intensely worked up and related are the actual and make-believe volumes. The "knowledge of the mechanical functions of the body" is tellingly exploited, and the contrast is underlined, objectively and formally, by the juxtaposition of physiognomic expression (man) and mask (art). The transition from masquerade to tragicomedy is progressively intensified in the three versions; the pointed nose and handlebar moustache become a Socratic profile. The needle models more sensitively from state to state and in the last one reproduces the most delicate nuances.

Woman and Beast Cl. Cat. 12

Comedian II Cl. Cat. 13

The brutally crafty *Perseus* most clearly demonstrates how little these etchings have in common with the flowery character of the *Jugendstil*. It was only by wile that Medusa could overcome, and the legendary hero had the "wit to conquer misfortune." Andromeda has been omitted; she has no part in the action, for it is not a myth we have here but the concept of good and evil, of the primeval feminine and the primeval masculine. One lives on the other, and the truth lies in the combination of the two. "Evil must not be a triumphant or confounding enemy, but a constructive force, a co-factor in creation and development," as Klee philosophically remarked. The modeling of the two heads is awe-inspiring; the play of the muscles and sinews

Perseus p. 106

produces tangible monsters, but with purely graphic means which poke fun at the construction of ordinary human anatomy.

At the end of the cycle comes the *Hero with a Wing*, a monument to the borderline man, both physically and spiritually. One wing is obviously insufficient for flight; but his mental equipment is equally insufficient – hence the quixotic quality of the conception. The phenomenon of deficient self-knowledge is demonstrated on a monster, and it was probably not by chance that the artist chose a flying man in the very year when the Wright brothers made their first flight.

Any objections that could be raised against the etchings were already stated by Klee himself. The balance between the painterly and the graphic media as a means of "epigrammatic" expression has not yet been found, and one might say that the sheets present a certain allegorical character. The path runs on in the direction of symbolism where idea and form are conceived simultaneously; Klee's later works do not signify, they exist. Klee first developed the pictorial element and when, about 1906, an inner urge and his encounter with the French Impressionists led him to make experiments in Impressionism, the form grew looser and the allegorical element less apparent. An etching like *Two Nudes in the Lake* (1907) is rather close to nature; the *Bower* (1910), though abstract, is equally unburdened by allegorical meaning. It was during the interval between these two works that his encounter with the work of Van Gogh and Cézanne occurred.

Klee began the year 1905 with a new technique – drawing and painting on glass; and for a while, as in the period of the etchings, all his other work was subordinated to this new effort. Viewed superficially, he may seem to have hit upon the new method by mere chance, by idly scratching on a blackened plate; intrinsically, however, the glass-paintings were the outcome of his desire for a greater freedom, his urge to expand the range of pictorial media, to proceed from line to line and thence to space and light.

He did not want his further development to be the product of a "constructive will"; instead he wanted to let himself drift in order to "allow my new perceptions to take effect in a great variety of ways," to "fix the heightened expression of the soul with the utmost simplicity and painterly freedom." He worked a great deal from nature and tried to translate it directly into his style. "All will be Klee, whether days or only minutes intervene between impression and

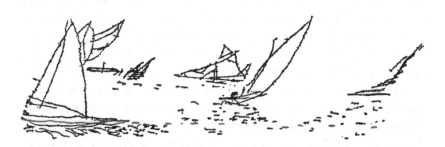

(above) *Sheep in the Fold* 1908

reproduction." After the "classic style of the etchings," he wanted a fresh start.

In his glass-pictures, as in the etchings, Klee proceeded by degrees. The first step was to draw with a needle on a blackened pane of glass. "I begin logically with chaos, that is only natural. Thus I am calm because at first I myself can be chaos . . . Nor is the effect of the first signs of light on this background nearly as vehement as it would be if the lines were black on white, so one's work proceeds in a much more leisurely way. The original blackness works as an opposing force and begins where nature leaves off. The effect created is of rays of the rising sun falling in streaks across the sides of a valley, until the sun rises higher in the sky when its rays gradually penetrate deeper, so that everything which is left black is inchoate. And this stimulates ideas about technique – woodcut and lithography. Is this perhaps the compensation for many a bitter hour?"

Klee soon began to use colors and a whole scale of grays in his paintings on glass; since watercolors are not very durable he tried out oils as well. His medium – not the black lines but the white – seemed to him better suited to nature and to lead to the promised land of tonality.

Tonality – the first step toward the realm of color. Before dealing with the realm of qualities Klee wanted to obtain a firm foothold in the realm of weights, as he said later. The glass-pictures are partly done in black and white, but the "genesis of effect" made him suspect parallels between painting and music as well as the temporality of art. The concept of genesis, of the process of creation, appears.

Klee's twenty-six glass-pictures (most of them conserved in the Klee Foundation because of their fragility) differ thematically from earlier works by their humor, even if it is a grim humor. *Nude with Animal Buttocks* (1905) and *Portrait of a Sentimental Lady* (1906) are forms of a "crumbling" age, and so are the colors – strangely contrasting rusty reds and pale purples against a faded greenish blue. *Beast Suckling Her Young* (1906) is a monstrosity, and some of the eight glass-pictures executed in 1907 are as grotesque as the *Musical Tea Party* (a drawing) with its trunklike and trumpetlike facial deformations. Klee himself felt the "malice and contempt" they contain; he was passing through a period of depression but laid the blame less on circumstances than on his own character.

Portrait of a Sentimental Lady
p. 111

Beast Suckling Her Young
p. 110

115

(above) *Quarrymen I* 1910

Garden Scene p. 117

Sailboats p. 114

(page 117) *Garden Scene* (1905)

Entirely unburdened is the charming *Garden Scene* (1905) with the watering-can, the red chair, and the cat. It reminds one of Matisse both in the color and in the arabesques of the form, although Klee had not yet seen a picture of his. The landscapes done with black water-color on glass in Munich in 1908 are also unburdened.

In Bern, however, Klee returned to philosophy and meaning. He described one of his works to his wife Lily as if he was expounding a program: "This time I have three figures marching across an untilled field on which lie scattered refuse and other disgusting things. But their idealism does not abandon them for a moment; each one carries a rose and therefore everything, especially the unalterable present, is forgotten."

In the autumn of 1906 Klee moved to Munich. At the outset this change of scene had a greater impact on his daily life and general spiritual development than on his art. The first works done there reveal hardly a trace of change. It is only in 1908 that the curve turns upward and we find an abundance of drawings and tonal water-colors of a high order. At the same time, surrounded as he was by the plethora of comparative material that Munich offered, Klee became more clearly aware of his own will with every month that passed. Its roots were too deep for anything to make it swerve. External stimuli did not throw him off his balance but showed him from a new angle who he was. Where a meeting of the ways led to a resemblance to another artist, Klee was quite ready to point it out, as for instance in the Manet-like *Sailboats* (1911).

During those years Klee came to grips with nature and Impressionism once again on a high level. For a time he surrendered himself completely to natural phenomena – for guidance, he declared. "The only difficulty is to catch up with developments that have already taken place." On his thirtieth birthday he made this entry in his journal: "The imperative now is to be as one can. Realism and no more affected fantastication." And looking back in 1911 he said he had been forced to take an interest in Impressionism in order not to miss anything through ignorance and to assimilate what he needed. He went so far as to borrow Zola's essays on Manet from the Bern Library.

(Seite / page 119) *Mädchen mit Krügen* (1910) / *Girl with Jugs* / *Fillette aux cruches*

This process of catching up did not lead Klee to forget his own personal aspiration toward tone and light, line and construction. The realm of tonality and light remained his chief preoccupation. He squinted his eyes spasmodically the better to observe the natural phenomena and applied the diluted black watercolor layer upon layer in order to achieve a mathematical proportion of chiaroscuro. He left white gaps in the high lights, proceeded gradually toward the greatest depths, intensifying "this action by the softly murmuring modulation of the middle tones," and finally found pleasure in the "relativity of values." He was not yet ready to paint but meditated on how he should do so, concentrating on the contents of his paintbox so as to be able at some future time "to improvise freely on the chromatic keyboard of the adjacent watercolor cups." He imagined an offensive against painting and how he could vindicate his skill as a draftsman. For instance thus: a white ground, then large areas of various colors which blend with each other and remain free from the slightest trace of chiaroscuro, and last of all the design, independent and as a substitute for the lack of tonal values; colored bases to forestall any possible weakening. In his journal, Klee mentions a style combining drawing and color. This is a description in anticipation of the watercolors done during the first years in Weimar.

Meanwhile, in 1908, Klee was painting his tonal watercolors on glass and paper – views of the squares and streets of Munich (*Street with Carriage* (1907) and *Balcony* (1908)), fruit in a bowl, flower pieces, and portraits. In 1909 and 1910 he executed landscapes, indoor scenes, and groups of figures. Isolated works of this type are found until 1915. Among the watercolors and oil paintings there are a *Flower Girl* (1909) with touches of glaring color, a *Nude Girl* (1910) in dusky greens and purples, and the *Girl with Jugs* (1910). In this work the perspective treatment is perhaps traceable to Cézanne's influence, the flat composition and the color scheme to Matisse; but the whole is unmistakably Klee.

These tonal and chromatic experiments led Klee to undertake research on light effects. He noticed that light lends movement to forms, bends straight lines, ovalizes parallels and draws circles between them, and he assumed that a painter could intensify this process psychologically. He observed the "expansion of illuminated areas",

Street with Carriage p. 109

Girl with Jugs p. 118

Harlequinade 1912

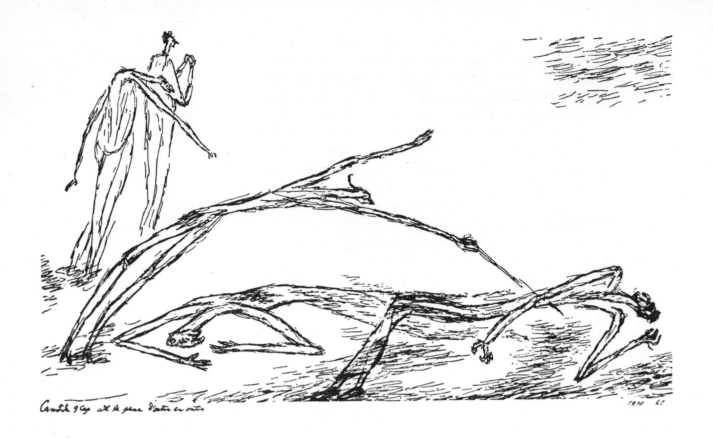

(above) *Candide Chapter 7*
1911

the deformation of shapes due to refraction, and realized the necessity of fixing form by other means than contour. But the phenomenon of deformation also interested him for a different reason – it might give rise to other essential elements of construction. He therefore attempted to obtain rhythmically deformed structures by using a wrongly adjusted pantograph and similar distorted projections.

This method resulted in designs of all sorts and even portraits, which exploit these "light spreadings" and arrangements, and lead away from nature into a region of unpredictable chance. Klee utilized them for his active, painterly experiments. Under the impact of light energy his tonal landscapes become almost free compositions (*Well-Tended Forest Path,* on glass, 1909, and *Drill-Ground*).

Klee now strove to extend the "orientation on the formal level" in all directions in order finally to achieve results governed by laws of their own. For he considered a work of art as an organism to be stabilized. "Like man, a picture too has a skeleton, muscles, and skin. One can speak of a peculiar anatomy of pictures. A picture with a concrete object – a naked man – should be fashioned, not in accordance with human anatomy, but with pictorial anatomy. One constructs a framework of the material to be built. How far one goes beyond the framework is arbitrary; the framework itself can already produce an artistic effect, a deeper one than the surface alone." Klee called this "constructive picture formation." Here too one must proceed by degrees. And in painting as well: One must not from the start aim at a colored pictorial impression but devote oneself entirely to the part in process of formation. The artist must show discipline with regard to the work, purpose with regard to its parts.

This method led once again to the concept of time. Klee planned
to paint figure pictures in two separate phases: first the setting, which
indeed already existed before the action took place, and then the
figure, the action. The process of painting is itself a form of action.
"If I want to 'act' in light colors, then the setting must be kept dark,
and vice versa."

Klee's work in line – the prints and drawings – also benefited from
this preoccupation with time as an aspect of both being and becoming.
In the tonal watercolors there was never much scope for line, and
yet it was still Klee's most personal medium. In Van Gogh he
saw "line in the most advanced sense"; in his own work, too, it
now became firmer and more finished and should "swallow and digest
my little scrawls." Be that as it may, Klee, fortified by his natur-
alistic studies, was able to return to "psychological improvisations"
and depict just what weighed on his soul, "noting experiences which
even in the darkest night could be transmuted into line." Even during
those years drawings are numerically predominant in his artistic
production, but one can see in the woody landscapes, townscapes,
and quarries, in the half-figures and groups, the progress he made
by consistent preoccupation with the problems of structure, tonality,
and light. They display an astonishing airiness, a sensibility and a
psychographic directness not to be found in his earlier work (*Quarry-
men* 1910). When drawing and tonality, pen and brush, are used side
by side in the same sheet, the result is a composition as complete as
Boy in Fur Coat, or the *Young Man* (self-portrait, 1911; p. 51).

Quarrymen p. 116

(below) *Candide Chapter 9*
1911

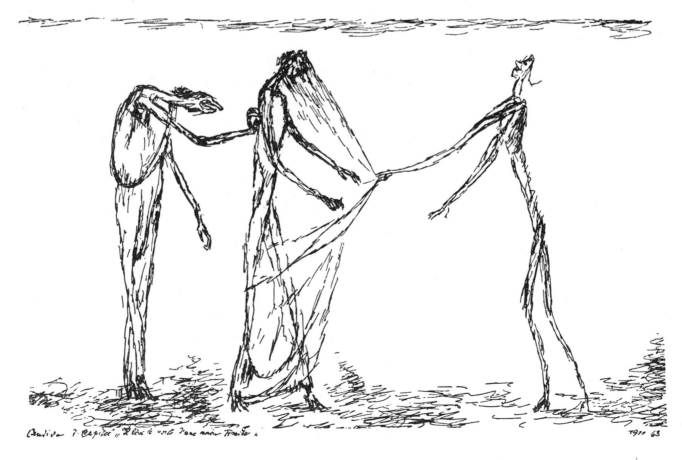

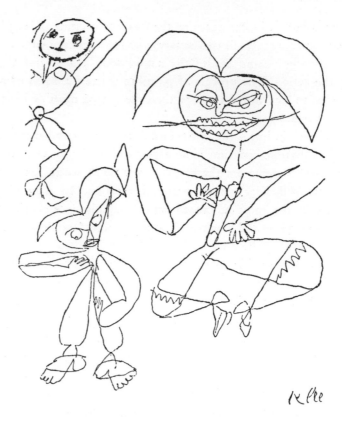

Idols 1913

Illustrative style

(page 125) *Garden in St. Germain, near Tunis* (1914)

How cosmos and art can coincide was Klee's chief concern at that time, for he was unwilling to give up any of the abundance of the outer and inner worlds. Nothing could be easier than to become emancipated and take up an independent stand as an artist. But that would be too simple. "How can I most freely throw a bridge from the inner to the outer?" he asked, and he dreamed of the "enchanting line of the arch of that future bridge." The method is reduction: If one aims at saying more than nature does, one must do so with fewer means, not more. And this is possible because the nothingness of the forms can be read objectively, as Klee read whatever he fancied in the arabesques of the marble-topped tables in his uncle's restaurant.

As far as drawing and graphic art where concerned, Klee had reached his goal. "The calligraphic illustrative style is finished and done with", he wrote to Lily on October 7, 1909. He showed its ultimate perfection in his illustrations for Voltaire's *Candide,* on which he had worked since 1906 but had repeatedly laid aside because he had not yet mastered the task. *Candide,* like Klee, is concerned with extreme gaiety mingled with the deepest pessimism, with facts that annul themselves and give the effect of arabesques – a cross between revolutionary propaganda and stylized narrative: the best of all possible worlds in the perspective of ridicule. Klee's twenty-six pen drawings are done in the same manner as the "psychic improvisations" – notes jotted down in the margin of a text that made a deep impression on him. Spectral shapes move against the neutral background with the vehemence of sudden action, just as Voltaire's characters move against the background of a philosophical order with the abruptness of marionettes. The poet's hand pulls the strings;

1914 / 213 Garten in der Tunesischen Europäer Kolonie St. Germain

(Seite / page 127) *Der Niesen (1915) / The Niesen / Le Niesen*

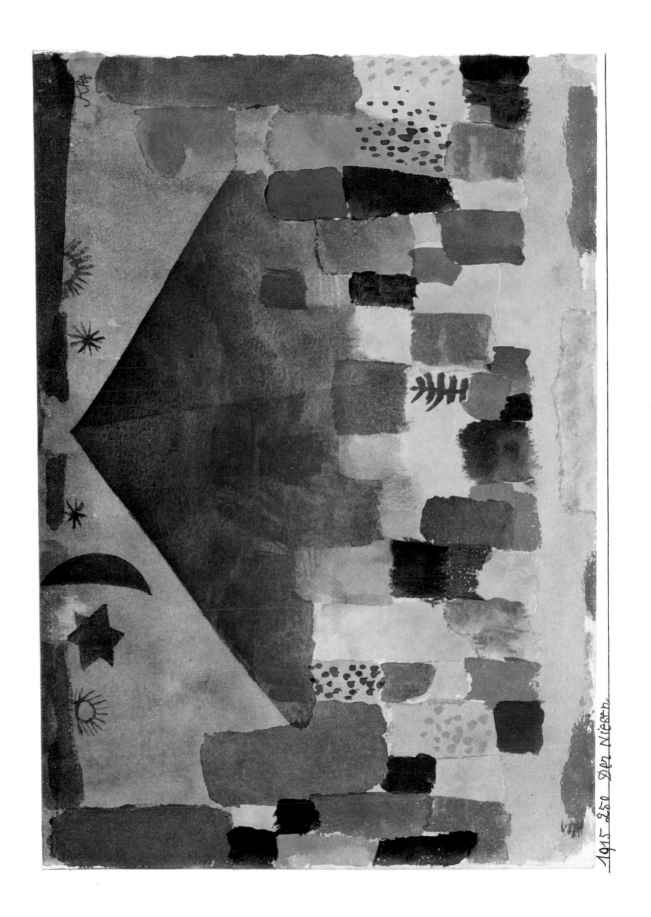

1915 250 Der Niesen.

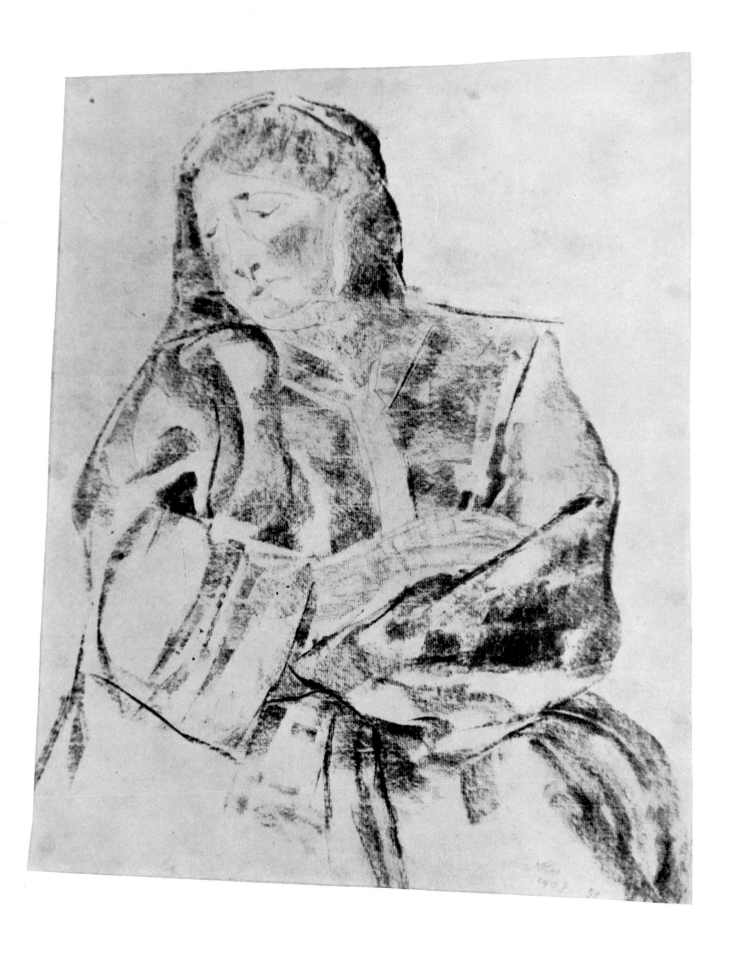

Weibliche Figur mit verschränkten Armen (Lily) 1908 / Female Figure with Arms Folded (Lily) / Femme aux bras croisés (Lily)

129

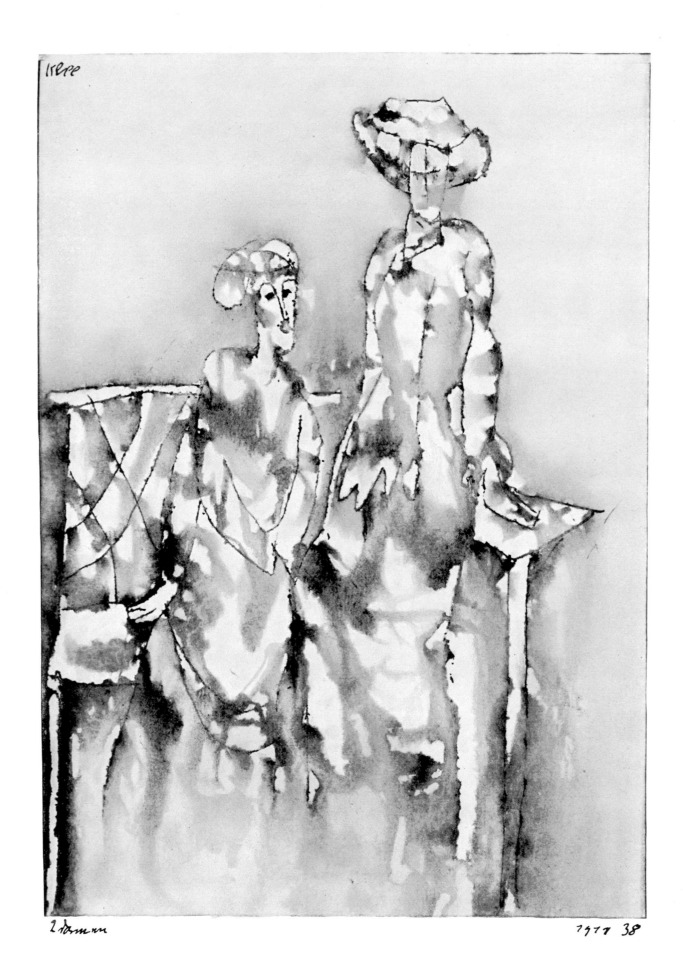

Zwei Damen (1911) / *Two Ladies* / *Deux dames*

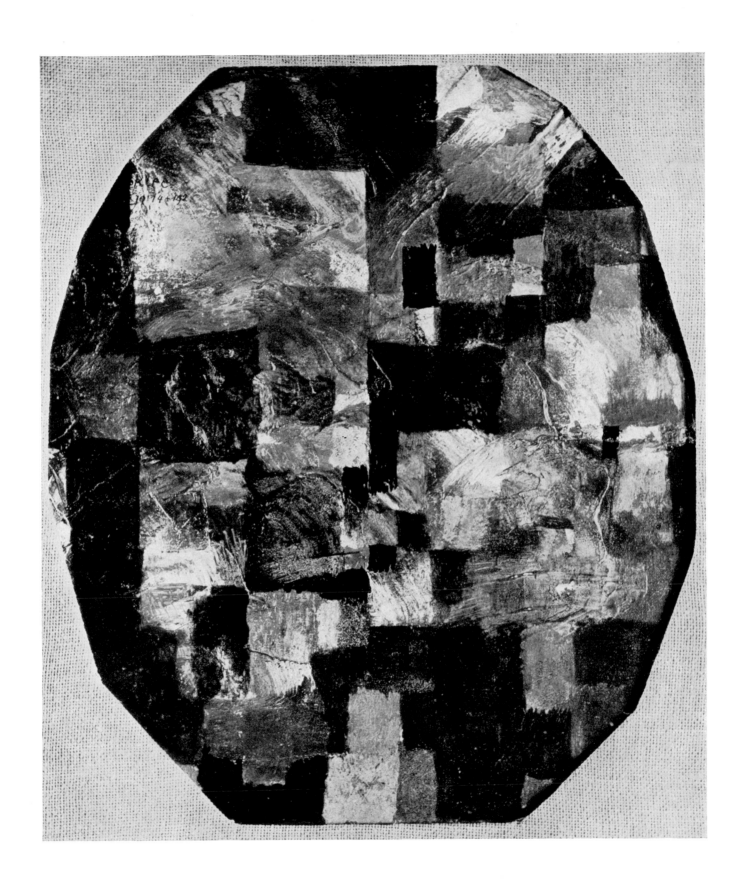

Hommage à Picasso (1914)

131

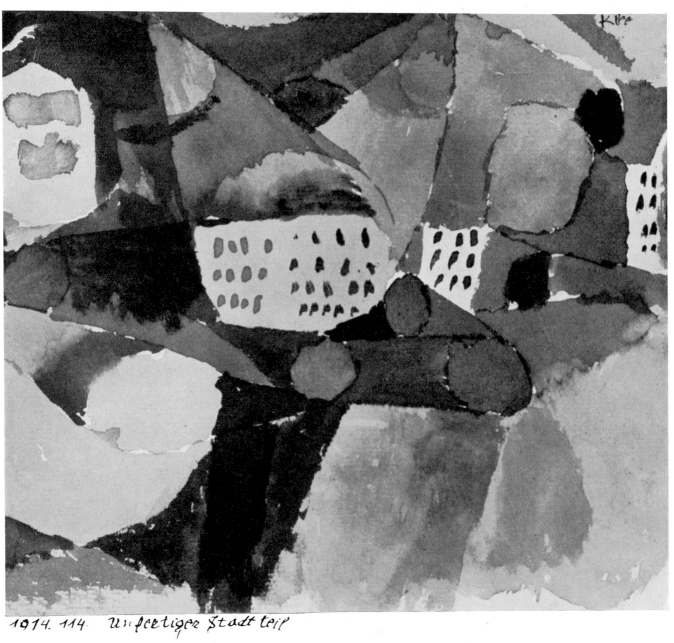

1914. 114. Unfertiger Stadtteil

Unfertiger Stadtteil (1914) / *Unfinished Section of a Town* / *Quartier inachevé*

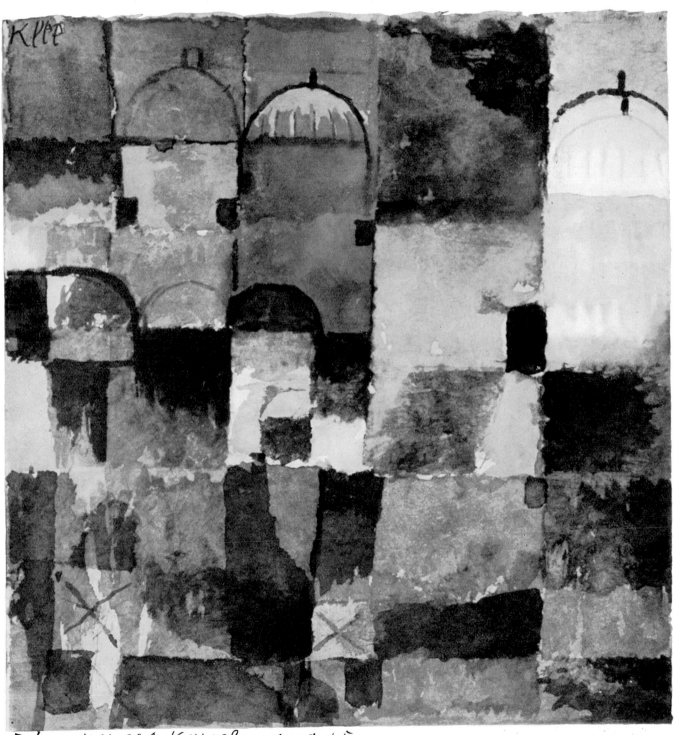

Rote und weiße Kuppeln (1914) / Red and White Domes
Coupoles rouges et blanches

133

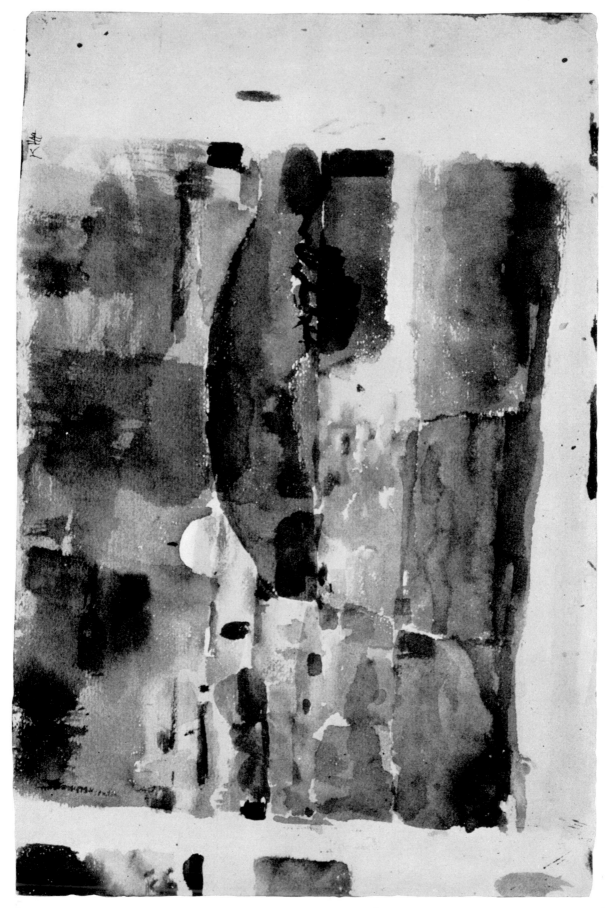

Vor den Toren von Kairuan (1914) / Before the Gates of Kairouan / Devant les portes de Kairouan

134

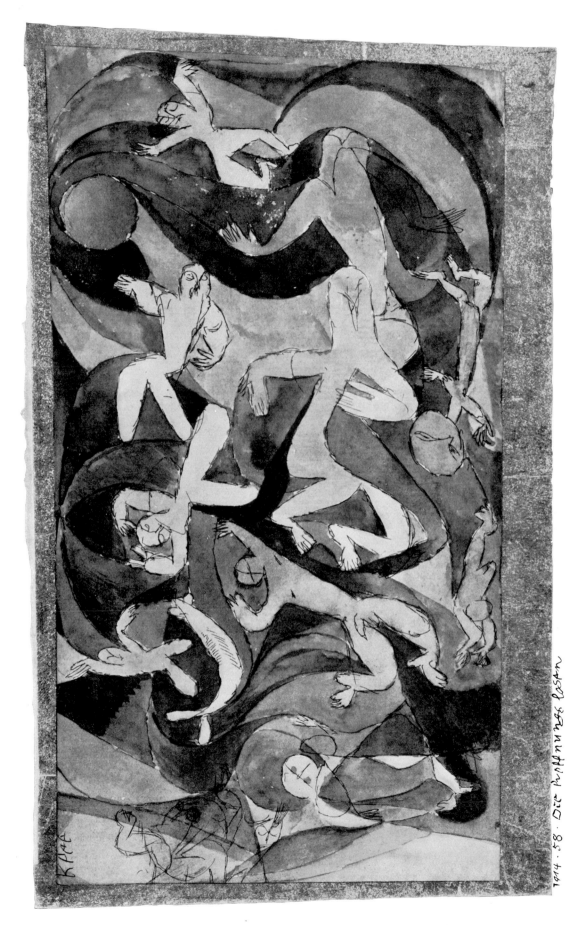

Die Hoffnungslosen (1914) / *The Desperate Ones* / *Les Désespérés*

Mit der herabfliegenden Taube (1918) / The Descent of the Dove / Une Colombe descend du ciel

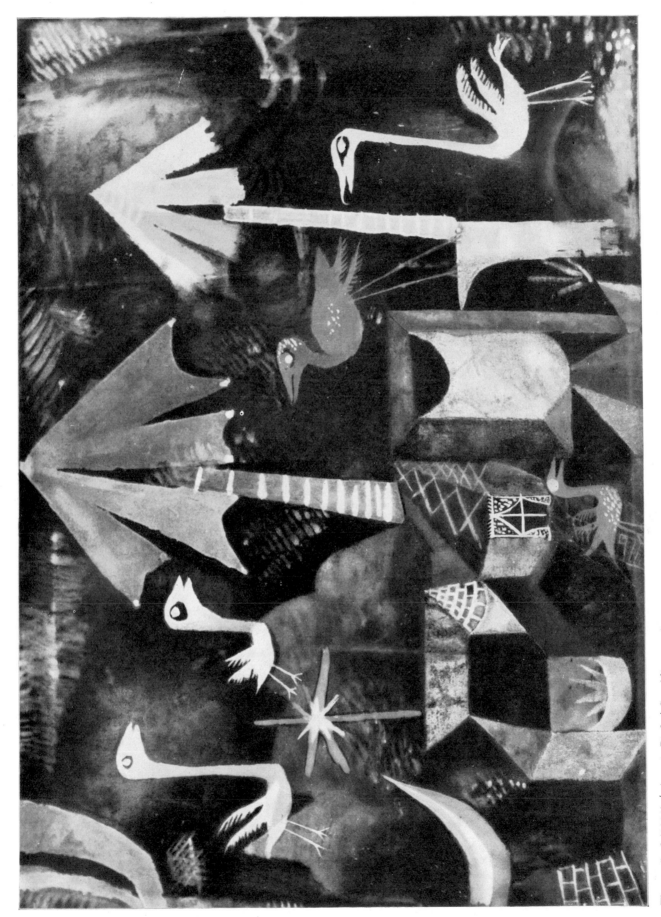

Wasservögel (1919) / *Aquatic Birds* / *Comédie aquatique*

137

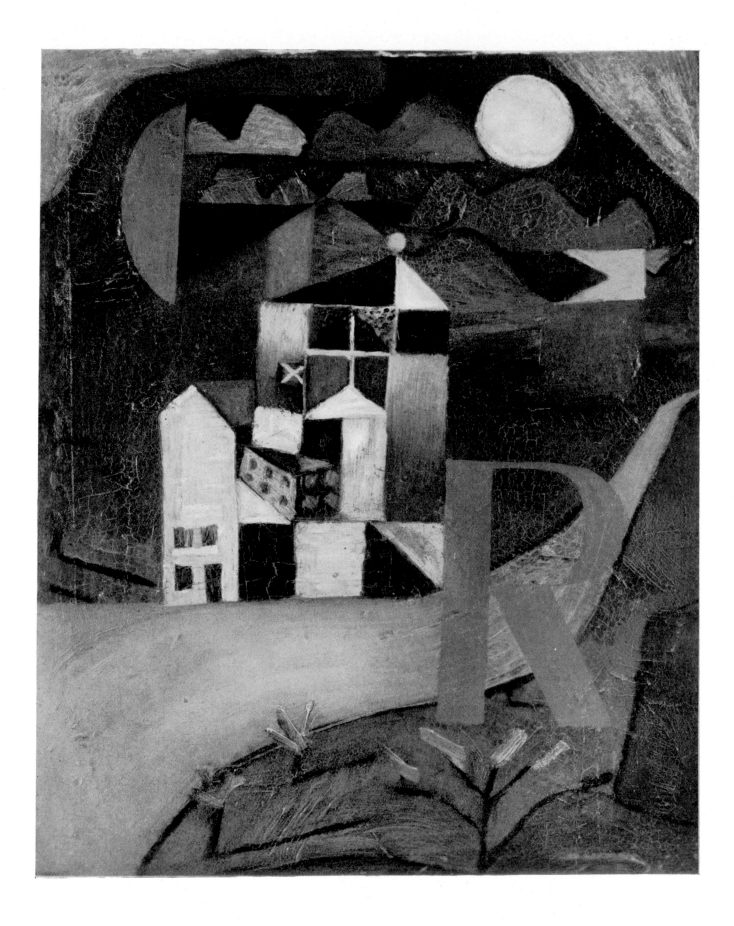

Villa R (1919)

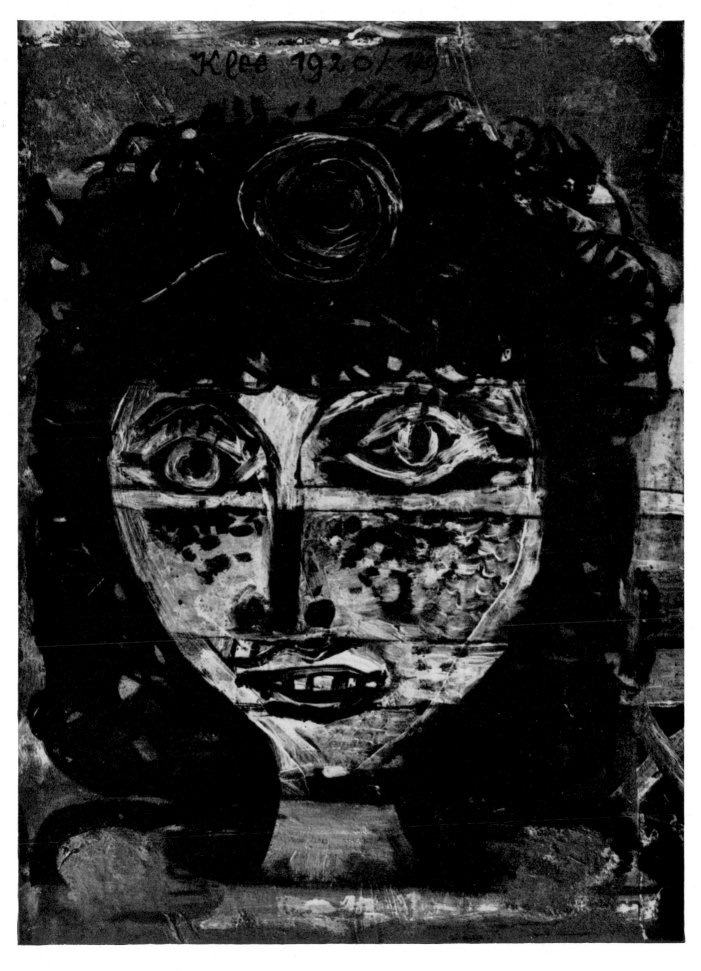

Rosa (1920)

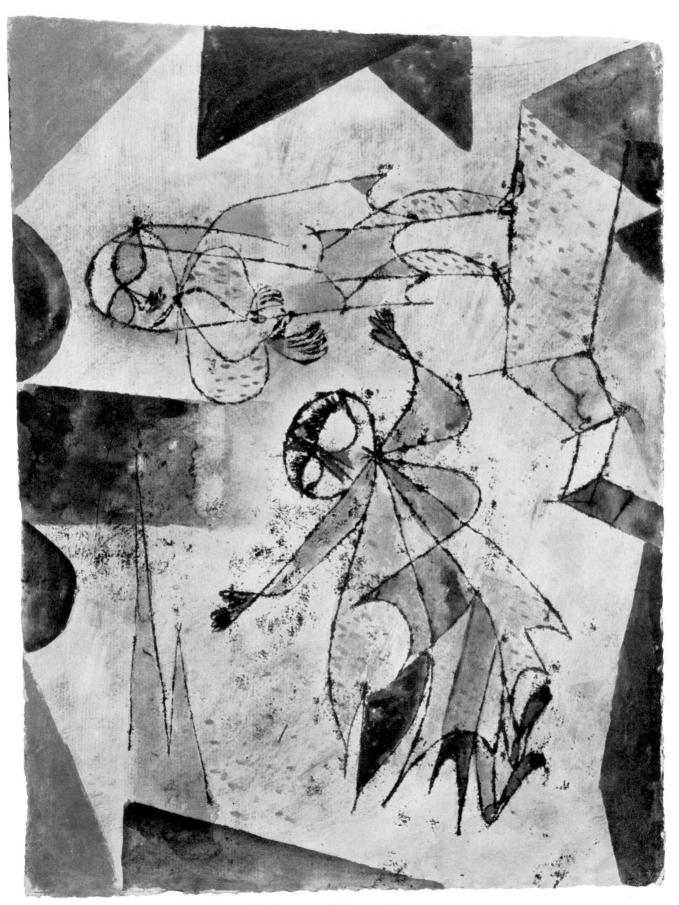

Botschaft des Luftgeistes (1920) / *Message of the Air Spirit* / *Message de l'esprit de l'air*

the draftsman's pen determines their path. "I have found myself again," Klee wrote, in the conciousness of a task well performed, The illustrations for *Candide* occupied part of 1911 and 1912, years of spiritual stress during which Klee emerged from his solitude. It was not a time when people thought in terms of graphic art. Klee was an exception to the rule; Kubin was another exception, but only to a certain extent, for in his illustrated novel *The Other Side* it is the words that strike a chord, not the drawings.

Close to the absurd, like the illustrations for *Candide*, are drawings that present affinities to Christian Morgenstern's poems – for instance *The Exciting Beasts* of 1912, and others that reminded Klee's friends of children's scribbles (*Street Urchins*, 1912). Klee did not deny this relationship; quite the contrary. "Children too can do it, and there is wisdom in the fact that they can. The more helpless they are, the more instructive are the examples they offer us," he wrote in his journal in 1912. All the channels of tradition are silted up, and one must make a fresh start.

The Exciting Beasts p. 98

Next to them there are naive drawings in which Klee added "innocence to innocence," for instance *The Fleeing Policemen, An Angel Handing Over the Object of Desire,* and also purely painterly ones like *Shift to the Right* and *The Garden of Passion* (all of 1913). "True declarations of love to art", Klee called them.

The Fleeing Policemen p. 55

The Garden of Passion
Cl. Cat. 17

Before Klee joined the *Blaue Reiter* group at the end of 1911 he did some watercolors in which tone and color are treated with the utmost freedom. Cézanne's influence had begun to make itself felt. The concept of nature as a sensation related to the visible, the reciprocity of reality and invention, the dependence on a law, must have been easily comprehensible to Klee. But there was also something else – the sensibility with which Cézanne opposed plane to plane and made the colors touch. The lack of contours troubled Klee at first. He managed without them in tonal but not in chromatic painting, so he attempted to overcome the difficulty by transferring the "chiaroscuro time-space process" to painting in such a way that each tonal step corresponds to a different color.

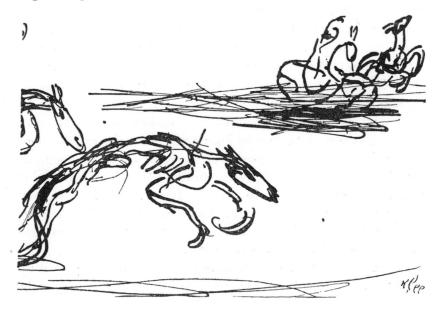

The Hunt 1912

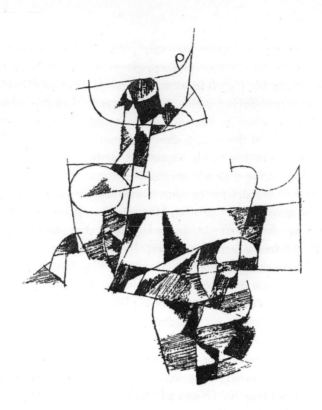

(Untitled Drawing) 1914

In the spring of 1912 came the encounter with Delaunay. Klee became interested in the French artist's investigations of chromatic quantities and qualities, and in the autumn of the same year he translated one of Delaunay's essays on light and color. To introduce the simultaneity of colors into the picture as medium, space, movement, and time, was just what Klee wanted. Delaunay, he said, was one of the most intelligent artists of his day because he avoided in an astonishingly simple way the inconsistency of the Cubists and their destruction of material objects for the sake of construction; he thus created independent pictures which led a totally abstract formal life without taking motifs from nature, plastic structures that are almost as far removed from the repetitive character of the patterning of rugs as one of Bach's fugues. On the other hand, it is a fact that Klee admired the Cubists for thinking of form in fixed dimensions which can be expressed by numbers, in planes, and in masses of light and color. That is more or less how Klee summarized his impressions in his review (1912) of an exhibition. He also said of Expressionism ("the elevating of structural elements to become the instrument of expression"), and of Kandinsky's abstract art: "the strenght of his spirit takes productive form without intermediate steps ... Museums do not illuminate him, but he illuminates them, the greatest there cannot diminish his consciousness of the value of his own spiritual world ... Form adjoins form, constructive ideas are binding but do not predominate. Nothing despotic, free breathing." Even later Klee felt indebted to that painter, although the negation of the concrete was not for him. His own aim was absolute truth, but even so Kandinsky gave him valuable pointers for its realization.

It was only in Tunis that all these stimuli brought forth practical results. For the time being Klee continued to refine still further the

consonance of colors and black-and-white tones with graphic elements, which he utilized sometimes as lines of demarcation and sometimes as independent symbols. In the colored sheet *In the Quarry* and in *Road along the Lake*, there are forebodings of the explosion of 1914.

In the Quarry Cl. Cat. 27
Road along the Lake Cl. Cat. 26

In Tunis Klee experienced color and art in general as an irrational creative process. Delaunay had prepared the way for that experience when he told him how all-pervading light suggests rhythms which obey simultaneous color contrasts, how object and form are built up of light and color, rhythmic in appearance, poetic in feeling. That was how the *Window* pictures were born, on which Delaunay was working when Klee visited him in Paris in 1912. The French artist went on to the abstraction of *formes circulaires*, just as Kandinsky went on to the abstraction of the "inner chords." Klee kept closer to Cézanne (from whom Delaunay also derived), to the modulation of color which, radiating from different centers, gives rise to a structure of honeycomb cells; and to Cézanne's idea of color as the "place where our spirit and the universe meet." These concepts were signposts for Klee when he approached color early in 1914. He first grappled with

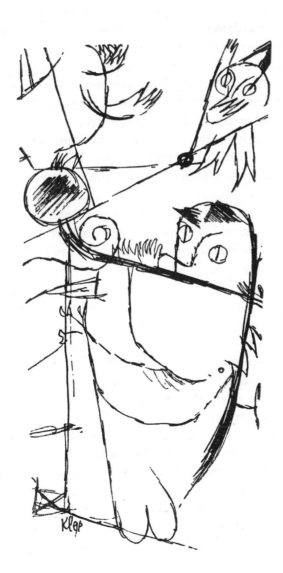

Pastoral 1914

143

"the synthesis of urban architecture and pictorial architecture" and did watercolors "with strong transposition and entire fidelity to nature." When he failed, it was, he said, because the transposition was not sufficiently intense.

Most of the Tunisian watercolors – *Before the Gates of Kairouan, Red and White Domes, Garden in St. Germain* – were painted in Munich after his return. In them the experience of color is combined with a profounder insight into the creative process in general. Klee had come to see a picture as a living organism which advances "from action to perfection." The element of reality recedes more and more into the background. "One leaves the realm of here and now and builds forward into the beyond which must be an absolute Yes." The "chill romanticism of abstraction" begins, the "region in which things fall upward."

In the Tunisian watercolors, for the first time color fashions object and space without the aid of line and, as in Cézanne, the ground does not appear between the colored areas. The modulation of contrasting colors is pushed to the extreme limit, giving rise to rhythmic movement in all directions of the plane as well as vibrations, that is space and time, the assimilation of dream and reality. The rectangles and curve-sided squares form a carpetlike fabric which anticipates the architectonic pictures and magic squares of the 1920s. This had nothing to do with Cubism, for there is no question here of a multiplicity of visual acts balanced in the flat, but rather of an oriental lyricism which evokes memories of visual appearances from the repetition of pictorial elements – Klee begins to grasp the value of association for the further development of his work – or introduces such memories into the structure of form and color. Since a picture is the outcome of a formative process, of nascent colors and forms, one can very well speak, with Klee, of a genesis beneath the surface.

In 1914 Klee painted many watercolors of this type, and in 1915 the *Mount Niesen* and the *Quarry*. But even later he returned to the schema of the Tunisian sheets, as in *Mirage at Sea* (1918) and *Houses by the Sea, after a Tunisian Sketch* (1920).

For other reasons, too, the year 1914 is rich in courageous progress. Klee daringly called an oval painting *Hommage à Picasso* because it seemed to him to be on the same level as the pictures by the Spanish artist he had seen at Wilhelm Uhde's – the level of analytical Cubism. Another oval picture, *Villas for Sale,* is a preliminary to the one just mentioned, even in the restrained gray and brown tints. That they were produced simultaneously with the bright Kairouan watercolors proves that Klee never followed a single track at any one time. He not only worked simultaneously on various pictures, but also in different directions; and one work clarified the other. Whereas Matisse produces many variations on the same theme and demands to be judged by the whole series, Klee often worked along widely divergent lines on one and the same day.

If we have mentioned Cubism in connection with Klee it was only to point out a concordance with the space-time language of the

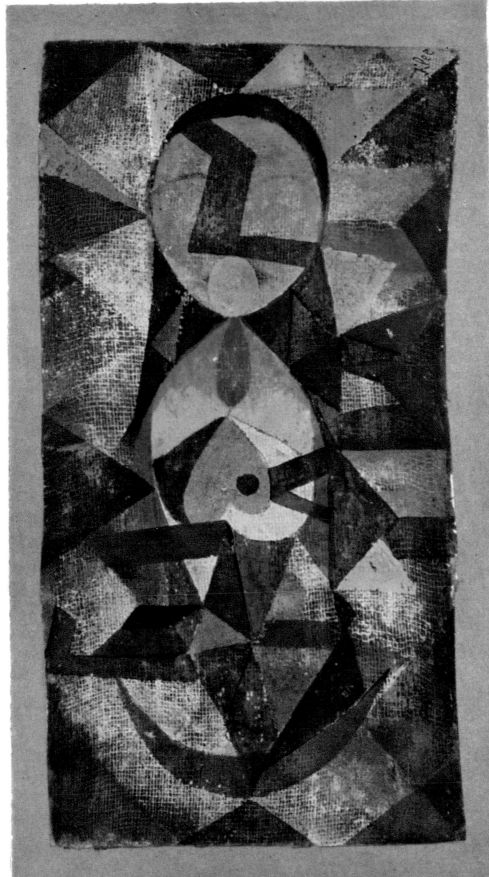

(Seite / page 147) *Invention (mit dem Taubenschlag) (1917) / Invention (with the Dovecote)
Invention (avec le pigeonnier)

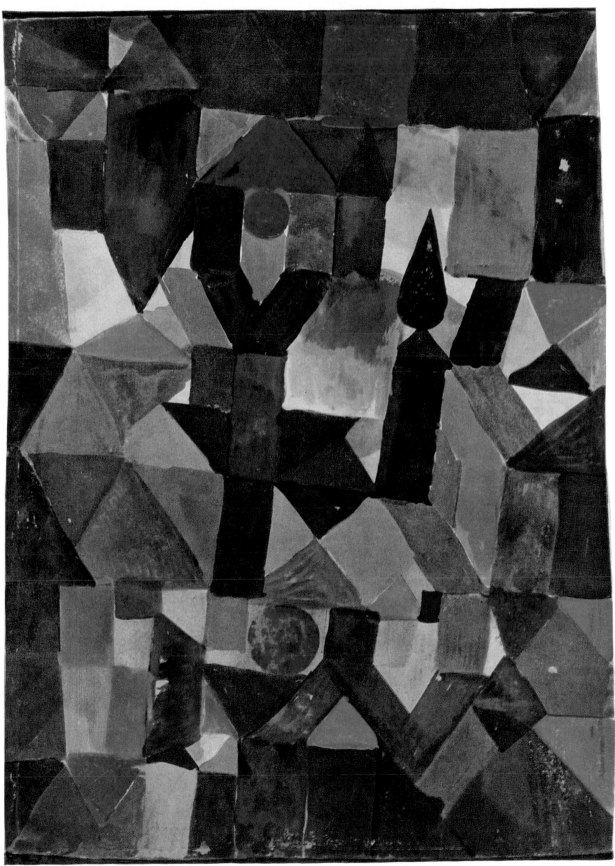

1917 143

Parisian painters. Klee lays less emphasis on the multiplicity of visual acts than on the totality of the image; that is why he can make flowers or architecture grow on deformed planes. He is no less consistent, but his logic lies rather in the adaption of language to theme. He isolates neither object, nor space, nor language, but relates one to the other and discovers the common denominator of the picture in equalizing the claims of representation and independent creation. *Carpet of Memory* (1914) contains not only obvious Cubist reminiscences – art is the theme – but also memories of his journey to Kairouan and its experiences of form. Plunged in a dull, decomposed brown, from which the accents in carmine and emerald green stand out like bright lights, the sheet becomes an elegy.

Delaunay might have stood godfather to *Abstraction-Colored Circles* (1914) and *Movement of Gothic Halls* (1915), but Klee was no fanatic and abandoned the schema after a few experiments. When he painted an *Unfinished Section of a Town* (1914), the houses and mountains tower up one above the other on the surface, as in Picasso, but the concept of "town" involves not only masonry but also details in pink and blue which give the pictures the dramatic quality of a poem. People at the time spoke of Romanticism, but it is not that. It is an imponderable that goes beyond the composition, a sort of radiation of the closed arrangement. Sometimes Klee stresses this added factor and calls a watercolor *Pathetic* (1915); sometimes he gives it no name at all but writes a number on the sheet and leaves to the beholder the task of determining the "meaning." He does this especially when he "constructs" for the purpose of studying problems of weight, deformation, or construction (as in the untitled drawing of 1914), or when he breaks off a work because it has got finished, so to speak, without him.

This happens frequently in drawings that are entirely "an expressive movement of the hand with the recording pencil," with the hand the "tool of a remote will." "I must have friends there, both light and dark. But I find them all extremely kind," he confided to his journal. Drawings of this type are very numerous in those years. Sometimes they may well derive from observation, but just as often they derive from dreams and the subconscious. A sheet like *Sleep* (1914) is merely form in the posture of sleep, another is merely a peal of lines that generate a tension; for such things too are to be found in Klee. When he calls a sheet *Impression of a Woman Playing the Lyre* (1915) he goes still further and, like a seismograph, records almost automatically the psychic effects of musical vibrations.

One is astonished that Klee gave the title *Poems* not to these works but to the more drastic ones he did for the *Sturmbilderbuch – Drama in the Cow World* or *Dead Ones Attracted by a Laid Table* (1915). The drawings accompany his work to the end, because Klee cannot fix the abundance of visions otherwise than in these occasional poems.

Drawings always remained Klee's indispensable "proving ground," and he could not do without them, although he neither exhibited nor sold them. When there are several versions of the same theme the drawing, as a rule, was done first. It rarely served as a subsequent

Dance with Veils p. 367

Script pictures

check. The order of sequence in his catalogue is not always a reliable clue, for Klee often made the entries weeks later. In the case of *Evil Star of the Ships* the drawing was done in 1917, two years before the watercolor, and has a greater wealth of motifs. In the *Dance with Veils* (1920), the watercolor was first; the drawing merely recapitulates the rhythm. The drawing *Love-Death of the Persian Nightingale* (1917) prepares the way for *Mild Tropical Landscape* (1918); both are oriental, but the first is the merest outline while the second has a Tunisian abundance. Occasionally drawing and watercolor are only distinguished by a few watercolor tones, as for instance in the lithograph *Destruction and Hope* (1916). This sheet is characteristic of Klee's attitude toward topical events: violent emotion expressed by the most sublime graphic symbols.

Sublime symbols are also utilized in the watercolor-tinted calligraphic pictures produced from 1916 to 1918, which derived from Klee's experience of Chinese poems and illustrate his attitude toward letters, words, and meaning. Letters of the alphabet first appear in a picture by Braque in 1912. Klee adopted them later, not for the sake of technical contrast or spatial counterpoint, but in the sense of the *ars memorativa* of the Renaissance. Letters stand for words, images of objects for ideas, invented picture signs for symbolical content. The German Romantics tried out something of the kind on a more naturalistic basis and spoke of "plastic symbolism" and "symbols of spiritual intentions." Klee tended toward neither the allegorical representation of the Renaissance nor the sentimental nature symbolism of the Romantics, but toward a cipher language which strengthens the polyphony of the picture like an enigmatical text. Besides the letters in calligraphic pictures, such ciphers include numbers, exclamation marks, points, plummets, pendulums; on a higher level, crosses, flags, eyes, lightning flashes, stars; on a still higher one, fragments of objects or components, which stand as *pars pro toto*. The meaning of a "13" and an arrow pointing downward in *Falling Bird* (1919) is quite clear, but it is more difficult to interpret when the ciphers work on each other, giving rise to allusions or associations which make the object or theme a function of the consciousness that fixes its meaning. In such cases combinations and mutual reactions produce an insight into associations and processes – even mental processes – which were formerly considered impossible to depict and yet are rendered visible in Klee's pictorial enigmas.

Klee's calligraphic pictures are visual interpretations of texts, just as Hindemith's *Marienlieder (Hymns to the Virgin)* are musical interpretations of poems. The text is conceived anew in the spirit of the pictorial medium; the isolated letter loses the banality of the alphabet and is no more legible than other pictorial symbols, as in *High and Radiant Stands the Moon* (1916), and in *Once Emerged From the Gray of Night* (1918). "To read" originally meant "to guess." Letter and word stand again at the beginning and possess a higher reality than the thing they mean; they are representatives of the spirit, not intellectual tools. Intelligent reading is rendered more difficult because

lines and colors become one with the essence of the words. This occurred in the Irish and Carolingian handwriting of the early Middle Ages, and something similar exists in the calligraphic art of Islam, especially the Kufic. Other affinities to Irish and Islamic art can be traced in Klee, in the shape of his arabesques and the invention of pure decorative forms. And also in the textile "lace" pictures which appear at the same time as his calligraphic pictures and recall the ornamental style of Islamic stucco decorations.

The ships, seascapes, and ports of those years assume the character of symbols of movement and fate, for example *Evil Star of the Ships* (drawing 1917, painting 1919) and *R Mi [Marine]* (1917). Birds stand for flight and no-man's land, as in *Trilling Nightingale* (1917) and *The Descent of the Dove* (1918). In these, Klee frees himself from the preponderance of landscape and the human dimension; he surrenders himself to the play of imaginative forces and advances into regions where earthly scale has only a conditional value. Stars, too, are there, predicting good or bad fortune, with flags and crosses, and pointed forms as Capes of Good Hope. Against the deathly black stands a cheerful pink, against a startling green a persistent red. The construction proceeds from the lower or upper edge and often from all sides at once, as in *Naval Review* (1918).

The landscapes are all enveloped in a dreamy atmosphere. *Blue Roof – Orange Moon* (1916) is one of the first. "Many a blond northern moonrise will incite me softly like a muted reflection," Klee wrote in Tunis. It repeats its incitement again and again and in his symphony of the universe plays a more important part than the sun, for like the stars and constellations it possesses magic powers; but in many of his pictures the sun, moon, and stars are placed side by side as portents. Man is missing and his fate is decided *in absentia* as in *Invention* (1917), *With the Eagle* (1918), *Hermitage* (1918).

A picture like *Ab Ovo* (1917) is one of those which, like the Lech landscapes of that period, genetically build up events out of formal events. A system of formal arrangement suggests worlds that do not

Trilling Nightingale Cl. Cat. 36
The Descent of the Dove p. 136

Blue Roof – Orange Moon
Cl. Cat. 35

Invention p. 147
With the Eagle p. 155
Ab Ovo p. 145

(below) *Bird Drama* 1920

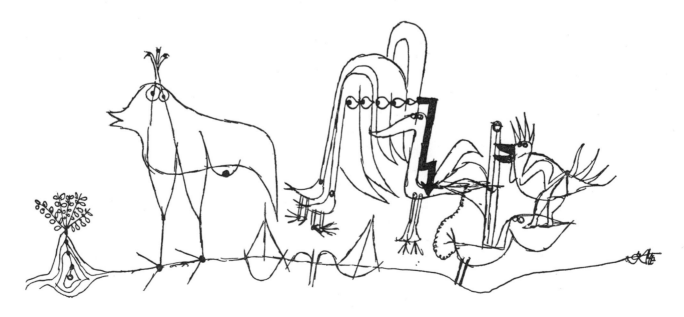

exist but might exist, worlds that are not constructed but sensed and invented in the spirit of *natura naturans*. The artist himself is nature, Klee said; and what he creates cannot be contrary to her spirit. He reverts to that Goethean reason "of which nature consists and in accordance with which she acts." But in Klee reason includes the subconscious which, like a widely ramified system of roots, reaches down to the deepest depths and attracts demonic forces. What is transitory plunges evermore into a deeper realm of being, as Rilke said. Remnants of human memory come to the surface bringing with them archetypal forms which we have known since childhood and even before birth – myth-forming structural elements. The artist creates; man is no longer the center; nature is not anthropocentric; her realms interpenetrate; a complete process of revaluation takes place from within. And form becomes the medium of these new truths. Hence the metaphor and the ambiguous symbol. Consciousness alone no longer determines the connection between the cosmos and the ego; a plurality of layers of consciousness enters the work and gives it the multiplicity of natural and spiritual dimensions. Herein lies the mystery of Klee's art, which becomes greater the more he eliminates, simplifies, and economizes the "conducting channels." He is in fact "no longer comprehensible in terms of this world." *Ab Ovo* depicts just such a creation of life and cosmos: from a pink center, from egg and heart forms, the growth impinges on contrasting pointed forms in purple and black.

On the other hand, the abstract landscapes with their stars and lightning flashes, like *Playing with a Lech River Landscape* (1917), are regions of "cosmic community": man lives on one star among many. A large number of such metaphysical landscapes were produced from 1919 on. They are closely related to *Air Combats* (1919), derived from a system of geometrical lines, and *Three-Part Time* (1919), which is based on planes set in motion round a center. There are numerous musical designations in which the forms free themselves from physical bonds and obey the laws of musical tension.

In the paintings of 1919 and 1920, mostly landscapes, Klee achieves a firmness of form and an objectivity of expression as never before. They comprise the most important works he produced before going to Weimar – *Composition with a B, Architecture with Window, Villa R, Picture with Cock and Grenadier, Landscape with Rocks,* all of 1919, as well as *Arctic Thaw* (1920), and the rhythmic woody landscapes of the same year. Viewed superficially the pictures of 1919 are combinations of planes remotely reminiscent of analytical Cubism. Actually, however, they are based on a translucent network of straight lines which intersect at right or acute angles and produce a structure of planes. The "story," if it exists at all, is worked in and expands the facts by including fate in the composition. Klee's attitude is existentialist in that he repeatedly faces the void, re-creates the universe, and accepts fate. He declines all dogmatism – even a *Dogmatic Composition* (1918) contains windows, a moon, and a heart. All the paintings of 1919 are stigmatized by fate, represented by houses, windows, trees, and stars, rarely by animals or human beings. The associative elements that usually determine the title are

Playing with a Lech-River-Landscape Cl. Cat. 41

Three-Part Time Cl. Cat. 40

Composition with a B Cl. Cat. 45
Villa R p. 138
Camel in a Rhythmic Wooded Landscape Cl. Cat. 47

(page 153) *Once Emerged from the Gray of Night . . .* (1918)

Einst dem Grau der Nacht enttaucht / Dann schwer und teuer / und stark vom Feuer /
Abends voll von Gott und gebeugt // Nun ätherlings vom Blau umschauert, / entschwebt
über Firnen, zu klugen Gestirnen.

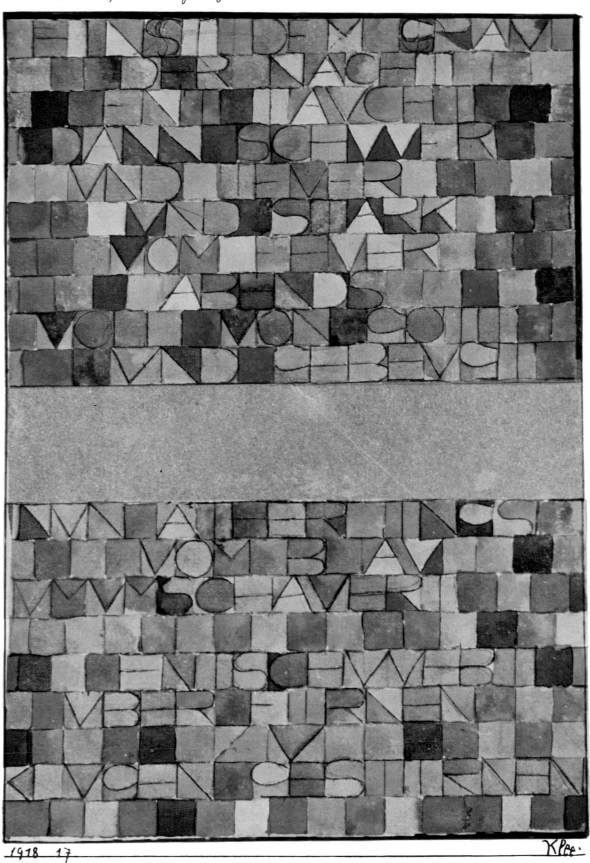

1918 17 Klee.

(Seite / page 155) *Mit dem Adler* (1918) / *With the Eagle* / *Avec l'aigle*

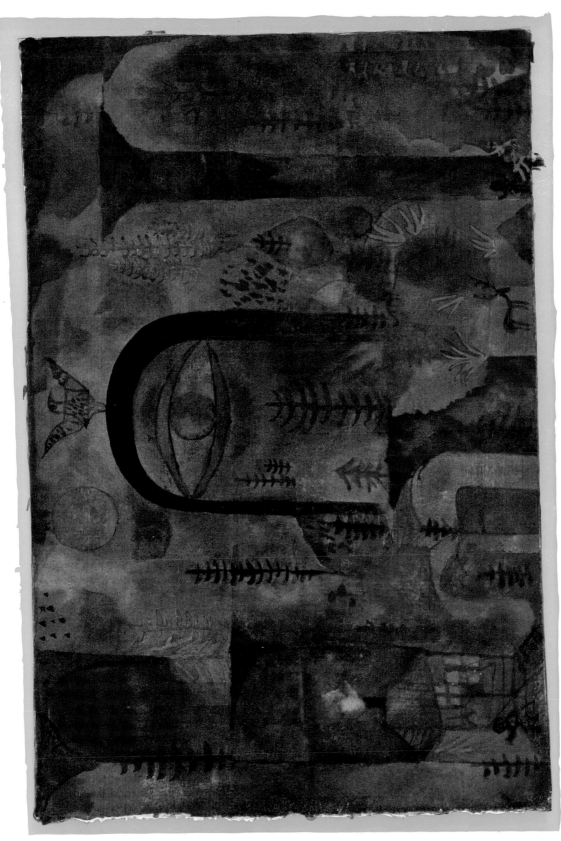

(Seite / page 157) *Arktisches Tauwetter* (1920) / *Arctic Thaw* / *Dégel arctique*

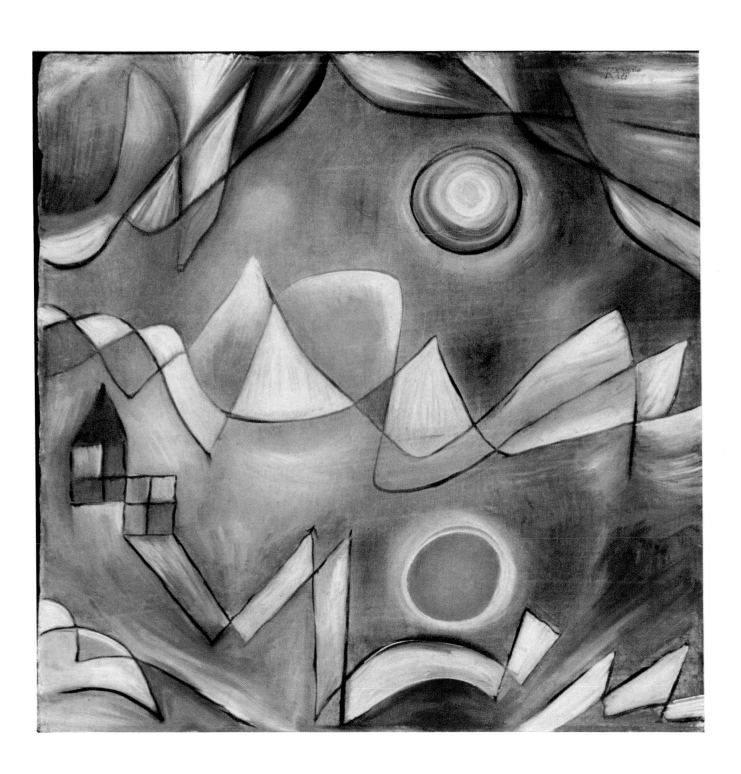

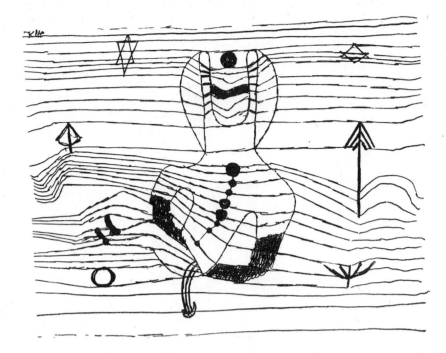

Unhorsed and Bewitched Rider
1920

not the point of departure; nor are the forms, or at least only those that leave room for association. Klee's whole universe is indeed embraced by form, but it is a form filled with the universe, and from this balance springs the fullness and precision of his pictures.

In *Landscape with Rocks* and *Arctic Thaw* the pictorial elements and their expression, the primary color-scheme of purple and ice-blue, become, so to speak, geological-historical. But when Klee employs the same colors and forms in *Tropical Garden* (1919) the medium enhances the non-naturalistic intention. Arctic and tropic are antitheses but Klee renders them in the same key, and even the melodies are akin. This often occurs in Klee, as in Mozart who in his religious music utilized melodies from his operas, though not literally. For Klee it is only a question of "changing the viewpoint like the atmosphere" and seeing the whole in a different perspective.

Arctic Thaw p. 157

In the rhythmic woody landscapes of 1920 we find something of the same kind. *Rhythm of Autumn Trees* is northern, *Rose Garden* is southern. But the rhythm, which partakes of space and time, takes no account of latitude or season and unites antitheses on its own level.

Rose Garden Cl. Cat. 48

During those years Klee also painted and drew figures and events. These works are somewhat closer to actual experience, but not close enough to become biographical. Klee realized the danger of confusing experience with art. In his ghostly visions, like *Canary Magician* (1920) and the cheerful "Intermezzi" – *Drawing for Ideal Household* and *Bird Drama*, both of 1920 – only a fragment of the action is included in the picture. The beholder can fantasticate if he wants to, but he will soon lose his way, for here too the decisive factor is the synthesis of cosmos and form. Despite their occasional humor, the pictures are discordant; the phraseology is basically no different from Klee's other sheets. "These are not comments but poems," Christian Morgenstern would have said. Ha had many a fleeting contact with

Canary Magician Cl. Cat. 46
Drawing for Ideal Household
p. 162
Bird Drama p. 151

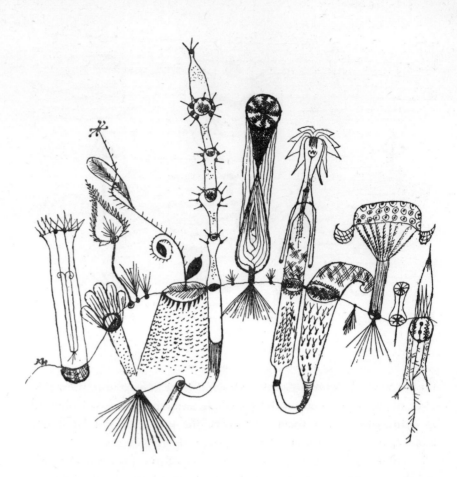

*Drawing for Plants, Soil,
and Air* 1920

Message of the Air Spirit p. 140

New materials

some of these works and his *Nasobem* might have been an idea of Klee's.

Before going to Weimar, Klee also illustrated ideas which gave rise to genuine figurations. *Greeks and Barbarians* (1920) renders a contrast of ideas by a contrast of forms; the *Message of the Air Spirit* is only credible on account of its hieratical form. The figurations also include works like *The Bud* (1920), conceptions of the vegetable kingdom imbued with a very individual and convincing reality.

Whereas Klee, before his trip to Kairouan, had restricted himself to the simplest tools and material, he now began to pay attention to technical values. He employed papers of different grains, rarely hand-made and Japanese papers; he painted on linen, muslin, and shirting, on wood and pasteboard, and even before 1920 on paper stuck on linen. For the sizing or ground, besides the usual materials, he employed chalk and stucco. On the chalk base the pigments occasionally present a mat surface and give an almost fresco effect; on the stucco base, especially when it is thick, weathered effects are obtained which contrast strikingly with the bright glazes. Klee used watercolors, tempera and oils; also watercolors and oils combined, most frequently in a technique in which he imprinted the design in oil paint on a watercolor ground, obtaining a tense, two-layer effect. Sometimes he calks the design on the watercolor ground, as in the printing process, giving rise to enlivening counter-drawn patches and extremely loose and differentiated linework. He adopted spraying as early as 1919. Both in the watercolor and oils Klee washes, brushes, and

rubs when he aims at a certain effect, as in *Carpet of Memory* (1914); indeed he experimented endlessly to achieve the desired effects. Afterwards he varnished watercolors and even pastels, which he drew on damp paper.

Klee prepared his own sizing and pigments, with the result that his studio looked like a chemist's shop. When he undertook a very daring experiment he wrote down the procedure in order to test the durability of the technique employed. Thus in 1918 he made the following note on *Zoo:* "Old, very dry oil paint (thick) rubbed with pumice and water and then glued. On this base applied watercolors and tempera. This layer of tempera was finally coated with linseed oil varnish." It lasted better than he expected, he learned ten years later. Thanks to the care with which he worked his pictures are extremely durable. I can only recall one case of his repeating a work because it did not last.

Until 1930 Klee spoke of drawings, watercolors, and paintings; then later on, of drawings, colored sheets, and panel pictures. It would have been more accurate to apply the new designations even as early as 1918, for a great many of his watercolors are not such at all; and many of the paintings are not done in oils but in watercolors or tempera. It is not always obvious at first glance whether a picture done even before 1920 is a colored sheet or a panel. Klee made very sharp distinctions; he demoted and promoted. When a picture was not capable of living a life of its own on the wall, it was stuck on white pasteboard and became a colored sheet. "On white it sometimes looks all right," Klee said of one such case. On the other hand, when a sheet was sufficiently vigorous, he mounted it on pasteboard or wood and turned it into a panel. Until about 1925 he enclosed his watercolors in a colored border, all around or at the top and bottom: later, frames of this kind rarely occur.

The range of subject matter and artistic media expanded enormously from 1914 to 1920; there is hardly a field accessible to the human intellect that Klee failed to touch. Any subject can become a theme because he was capable of reproducing any analysis, transformation, and penetration of the realm of nature and the strata of consciousness, and even conceptual and metaphysical, musical and temporal elements. The visible world is really only "one instance among many" and often merely the result.

All this was possible because Klee enormously extended the range of artistic media. He renovated or invented by a system of trial and error. Starting from active and passive lines and planes he arrived at perspective and cloudlike spaces, dividual and individual structures, symbols such as arrows and letters and others of a higher order that hint at religious spheres. Even as early as 1920 one is astonished at the multiplicity of his forms and at the skill with which he adapted them to the spirit of the picture. A "schema" – if one may adopt a scientific term for a painterly conception – is never employed wholesale, but only in certain groups of pictures and always with the necessary inflection. Stripes and bands are put to innumerable uses: In *Tree Rhythms* they become staves between which the

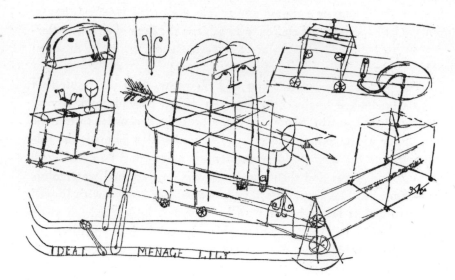

*Drawing for Ideal Household,
Lily* 1920

Woman Awakening Cl. Cat. 43

trees stand like notes; in *Woman Awakening* (1920), fetters; in *The
Lamb* (1920), an antependium; in the architectural pictures, eleva-
tions. The deformed chessboards, the combinations of quadrangles
and triangles give rise to planes which repulse or grip each other,
press forward or back, and occasionally give the effect of a symbolical
pattern. From the window form are derived towns and landscapes,
stage decorations and ghost stories; from the jagged bands and lines,
electrically charged tensions. At times Klee's works are so full of
symbols that they resemble musical scores. In the same way that one
reads musical scores and hears them with the inner ear, one can read
Klee's pictures and see them with the inner eye – not arbitrarily,
but in accordance with the "directions" he gives the eye. Concrete
things are rendered so fluid, so reduced and transfigured that they
can be written down, for not only did Klee achieve complete mastery
of painterly media but he also developed a compositional technique
of his own. Music was more advanced in this respect, he often ob-
served with regret, because it can look back on centuries of tradition.
He was, to say the least, the initiator of a similar tradition in painting
and in his works one finds counterpoint, harmonics, modulation,
tonality, and other musical analogues of the same kind. All the music
that was in him he utilized as a foundation on which to build a science
of artistic form.

His artistic development does not proceed in a straight line but,
as I already observed in 1933 in *The Drawings of Paul Klee,* its stages
constitute concentric circles. As in a tree one growth ring encircles
another, so Klee thrusts out from the center, in different directions,
toward the periphery.

Feeling that he would be misunderstood, Klee jotted down many
of the thoughts that occurred to him while he was working or after-
wards. These notes are among the most instructive contributions to
the literature of modern art. In 1918, while he was still in the army,
he wrote an essay, which was printed two years later in an anthology,
Creative Credo, and which gives a very clear explanation of his idea

(page 163) *Women's Pavilion* (1921)

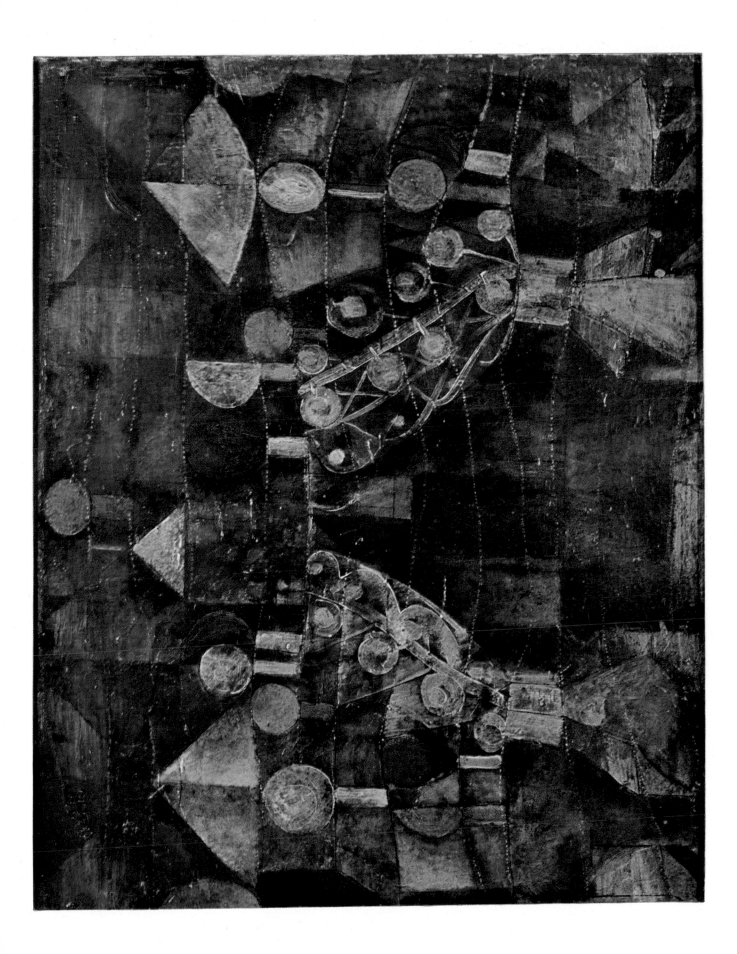

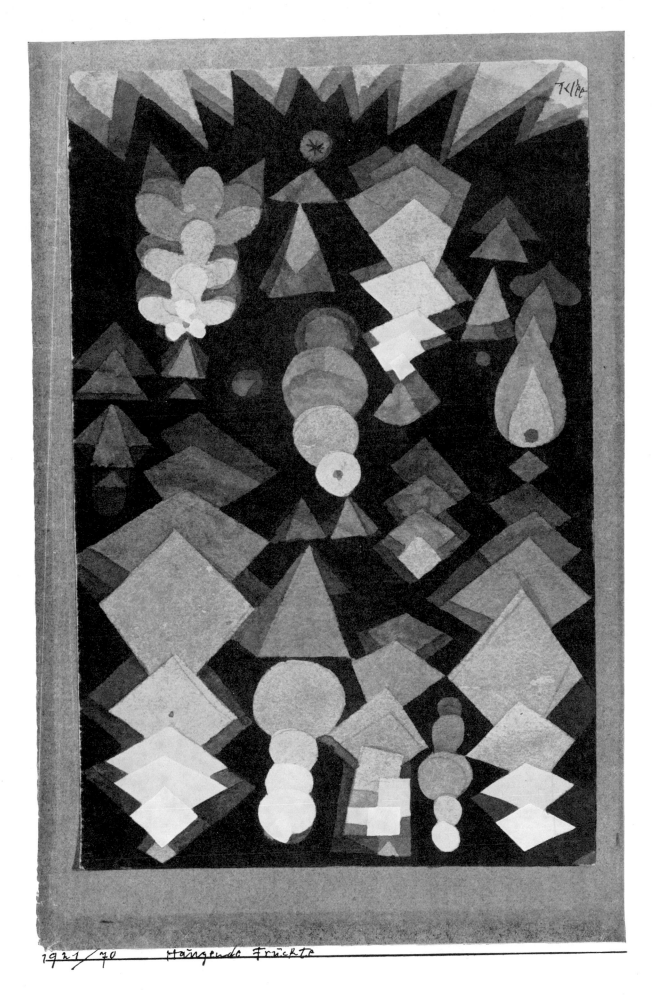

Hängende Früchte (1921) / *Hanging Fruit* / *Fruits suspendus* 165

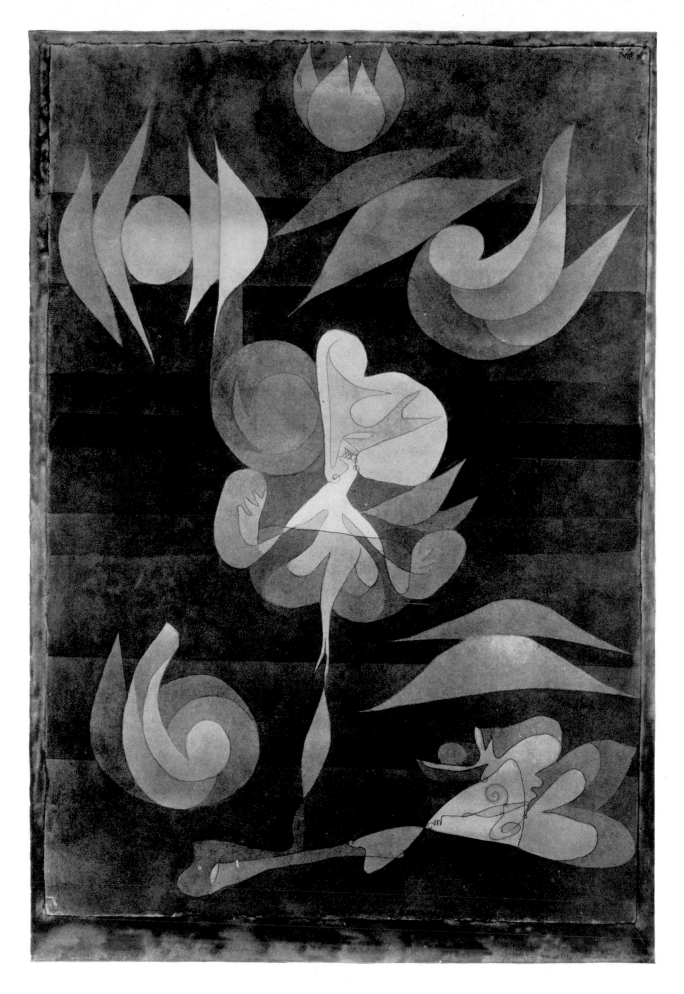

Sterbende Pflanzen (1922) / *Dying Plants* / *Plantes mourantes*

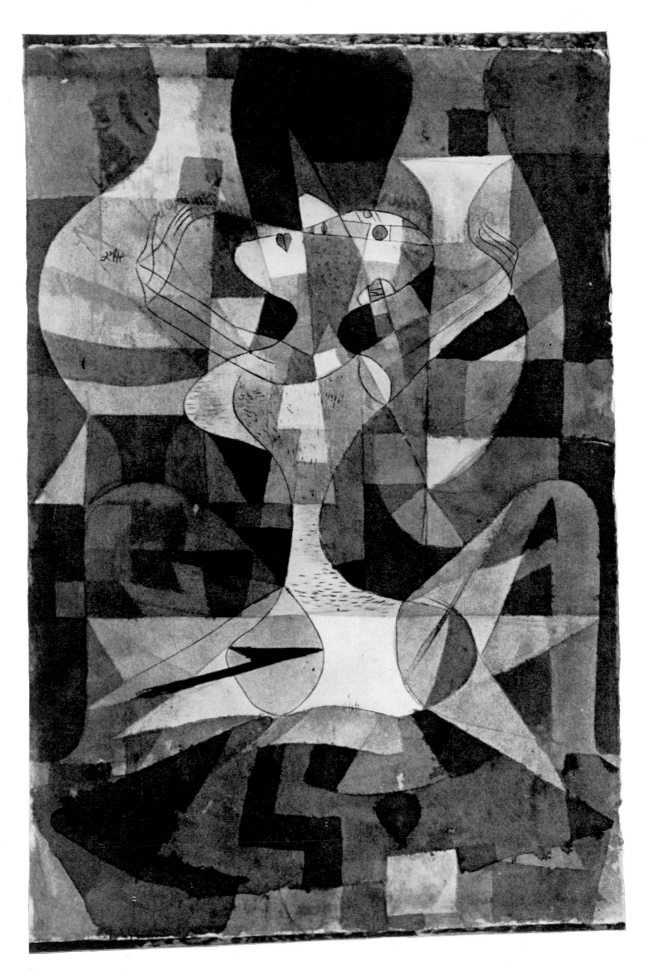

Keramisch-Erotisch-Religiös (Die Gefäße der Aphrodite) 1921 / *Ceramic-Erotic-Religious*
(The Vessels of Aphrodite) / Céramique-érotique-religieux (Les Vases d'Aphrodite) 167

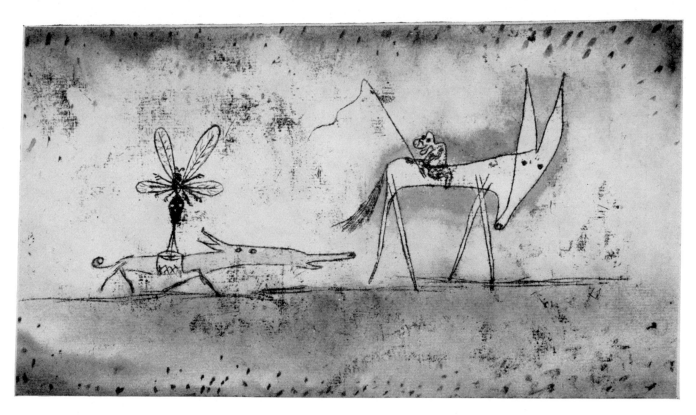

Kunststücke der Tiere (für Florina) 1921 / Performing Animals (for Florina)
Animaux savants (pour Florina)

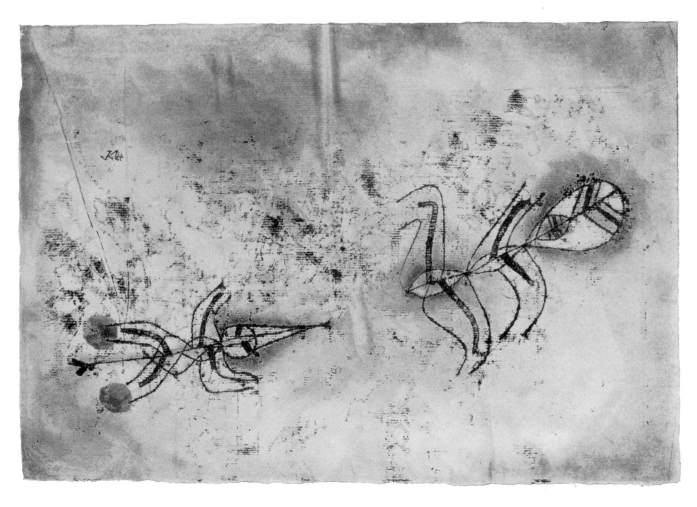

Der Pfeil vor dem Ziel (1921) / Arrow Approaching the Target
La Flèche devant le but

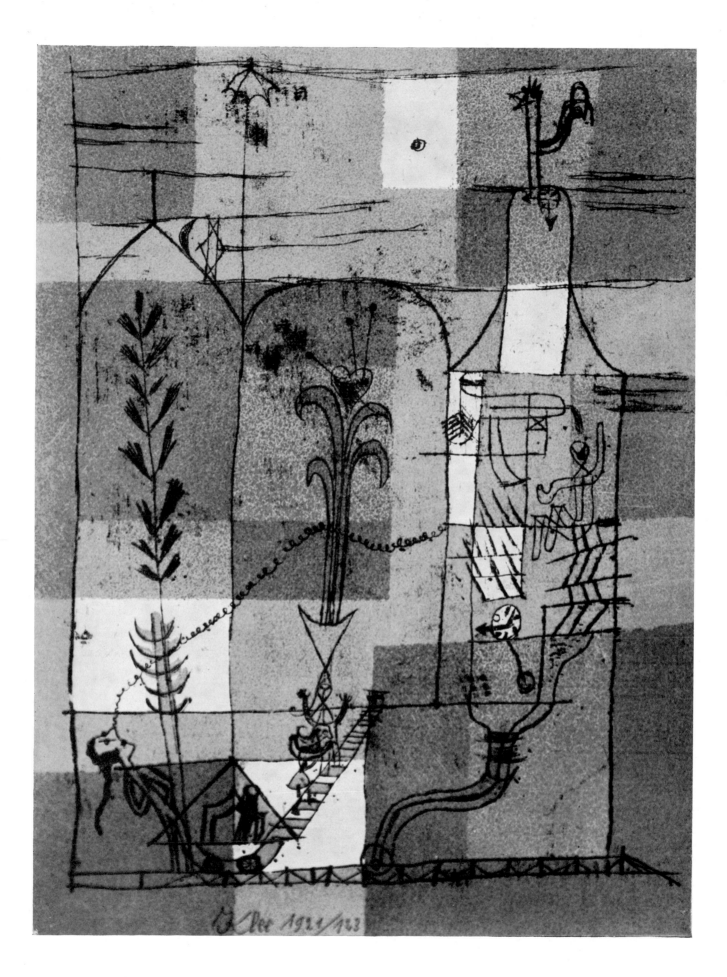

Hoffmanneske Märchenscene (1921) / *Scene from a Hoffmann-like Tale*
A la manière des Contes d'Hoffmann

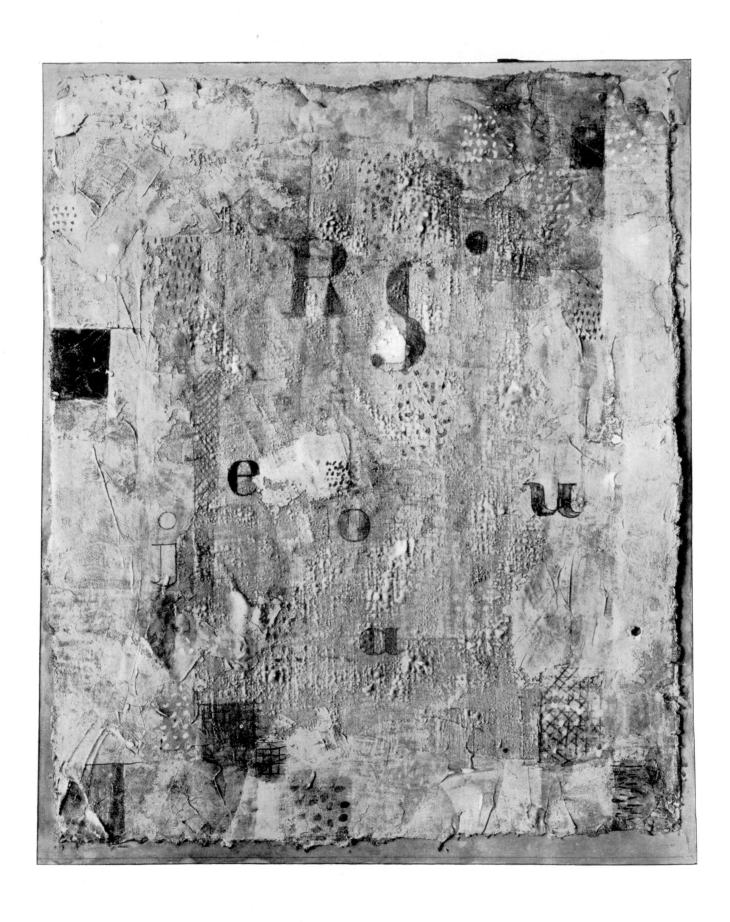

Das Vokaltuch der Kammersängerin Rosa Silber (1922) / *The Voice-Cloth of the Singer Rosa Silber* / *L'Etoffe vocale de la cantatrice Rosa Silber*

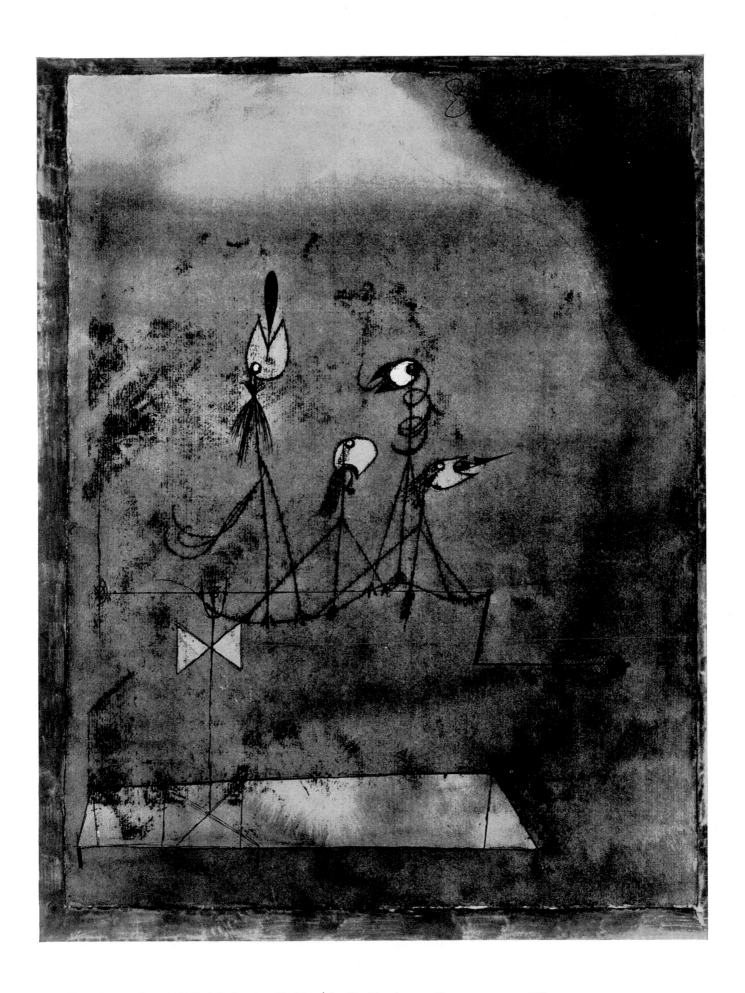

Die Zwitschermaschine (1922) / *Twittering Machine* / *La Machine à gazouiller* 171

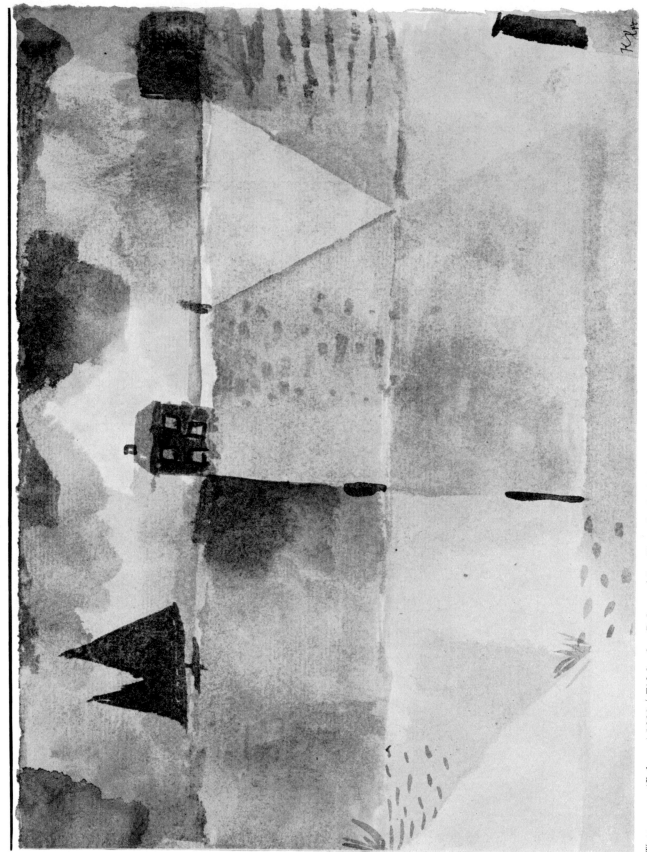

Watenmeer (Baltrum) 1923 / Tideland at Baltrum / Les Hauts-fonds de la mer à Baltrum

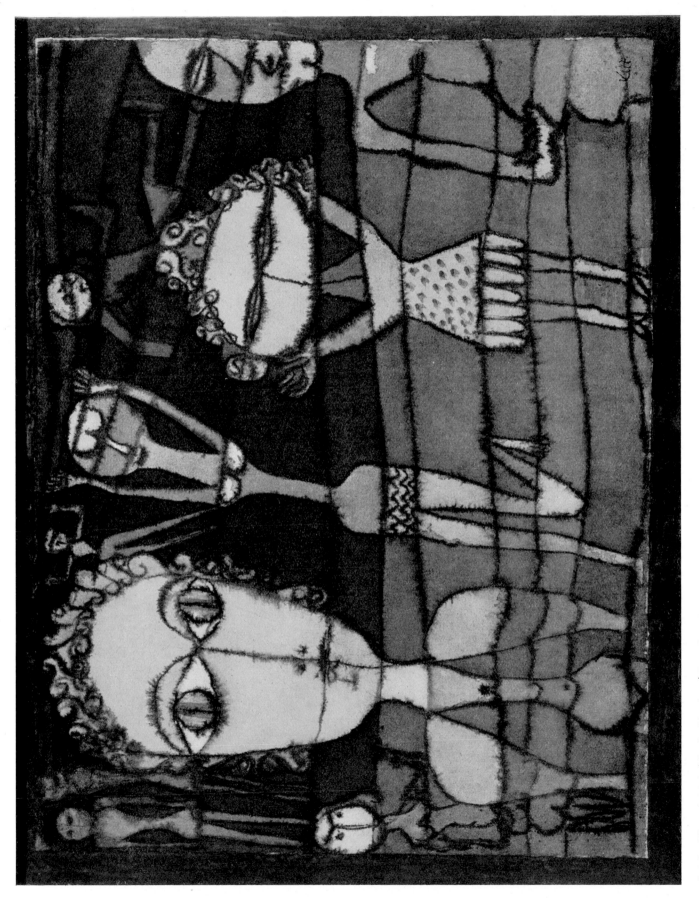

Auf der Wiese (1923) / *In the Meadow* / *Dans le pré*

173

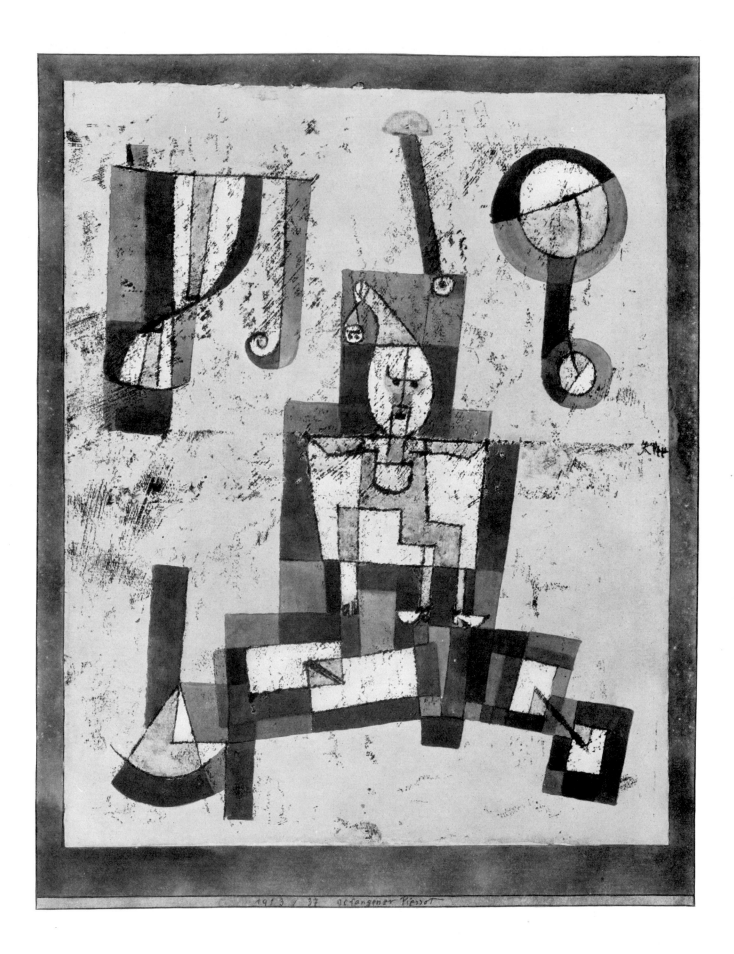

174 *Gefangener Pierrot* (1923) / *Captive Pierrot* / *Pierrot prisonnier*

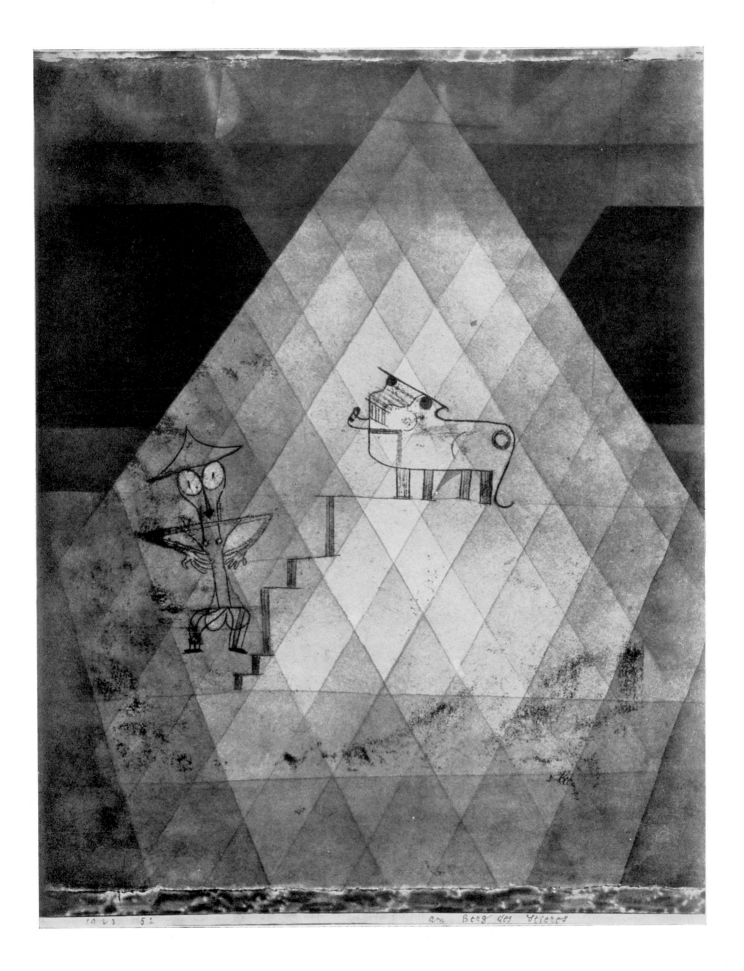

Am Berg des Stieres (1923) / *At the Mountain of the Bull* / *Au Mont du Taureau* 175

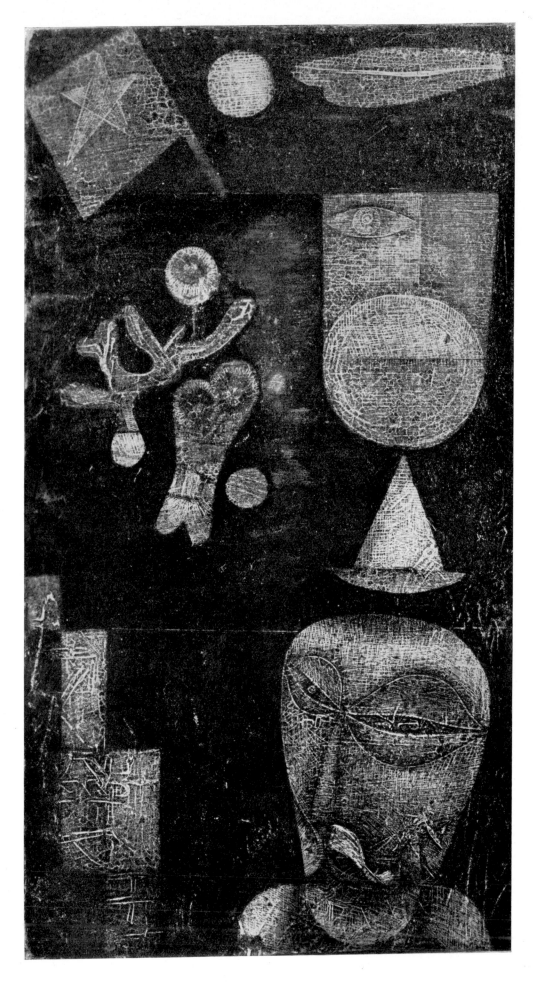

Chinesisch I (1923) / *Chinese I* / *Chinois I*

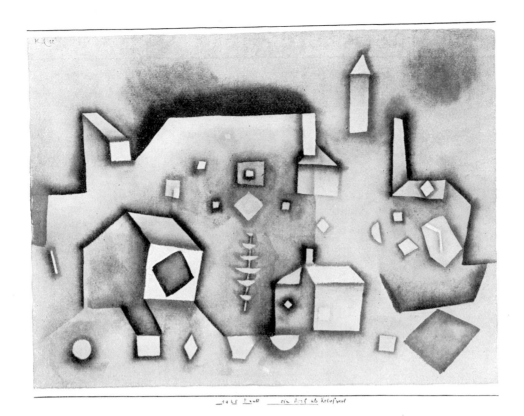

Ein Dorf als Reliefspiel (1925) / *Village in Relief – a Game*
Un Village, jeu de relief

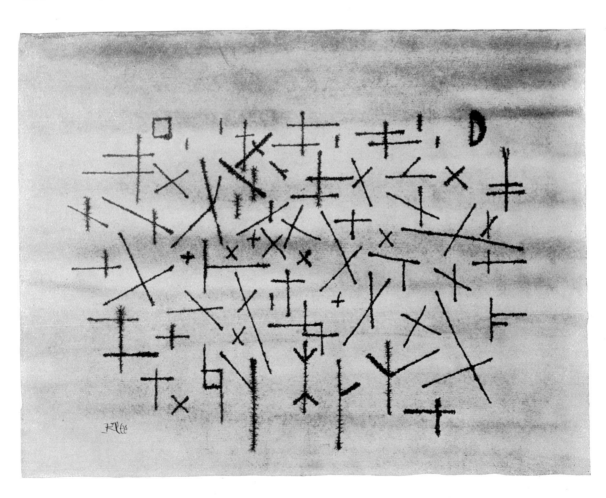

Zeichensammlung (1924) / *Collection of Signs* / *Collection de signes* 177

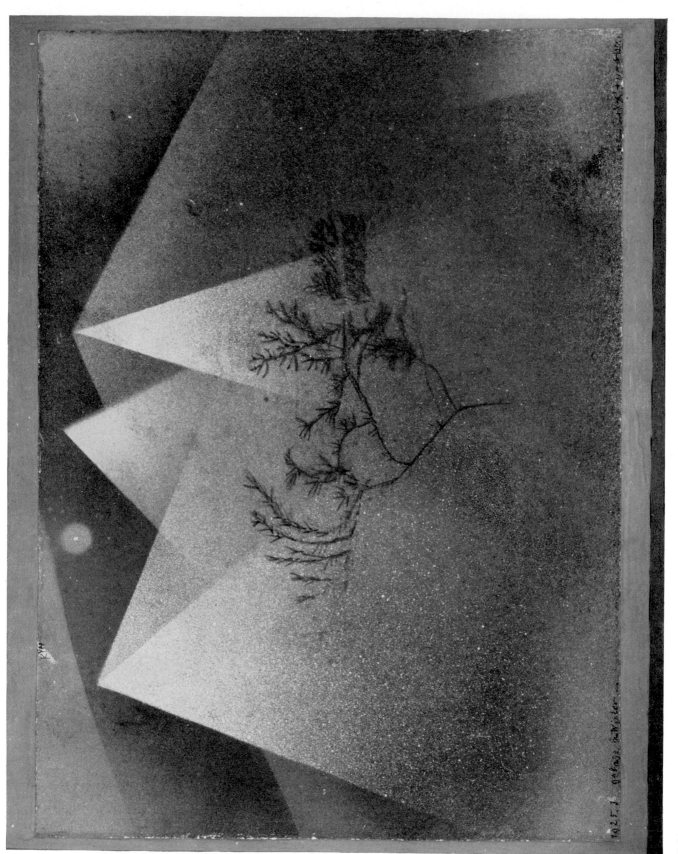

Gebirge im Winter (1925) / *Mountains in Winter* / *Montagnes en hiver*

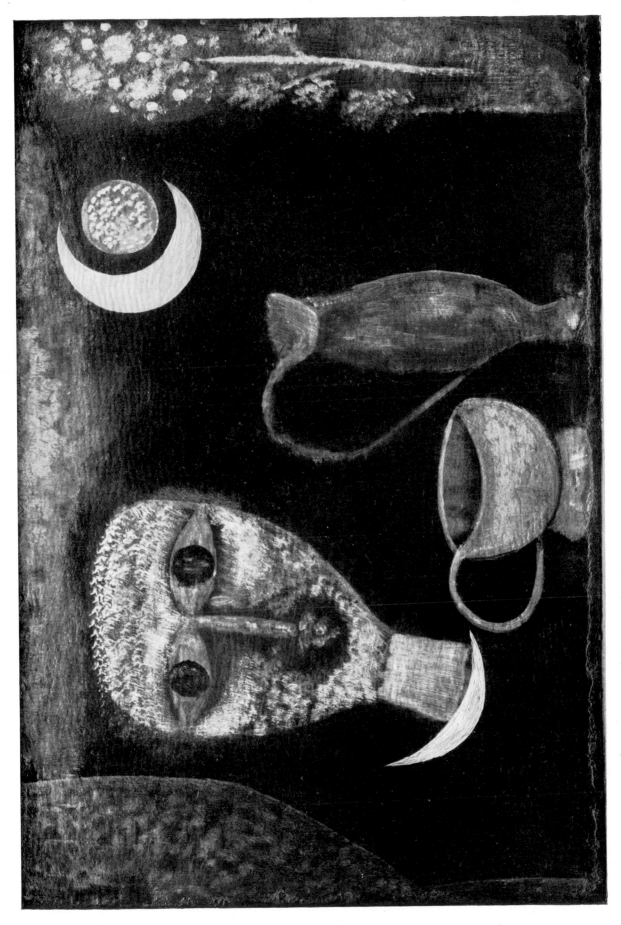

Mystisch-Keramisch (1925) / *Mystic-Ceramic* / *Mystique-céramique*

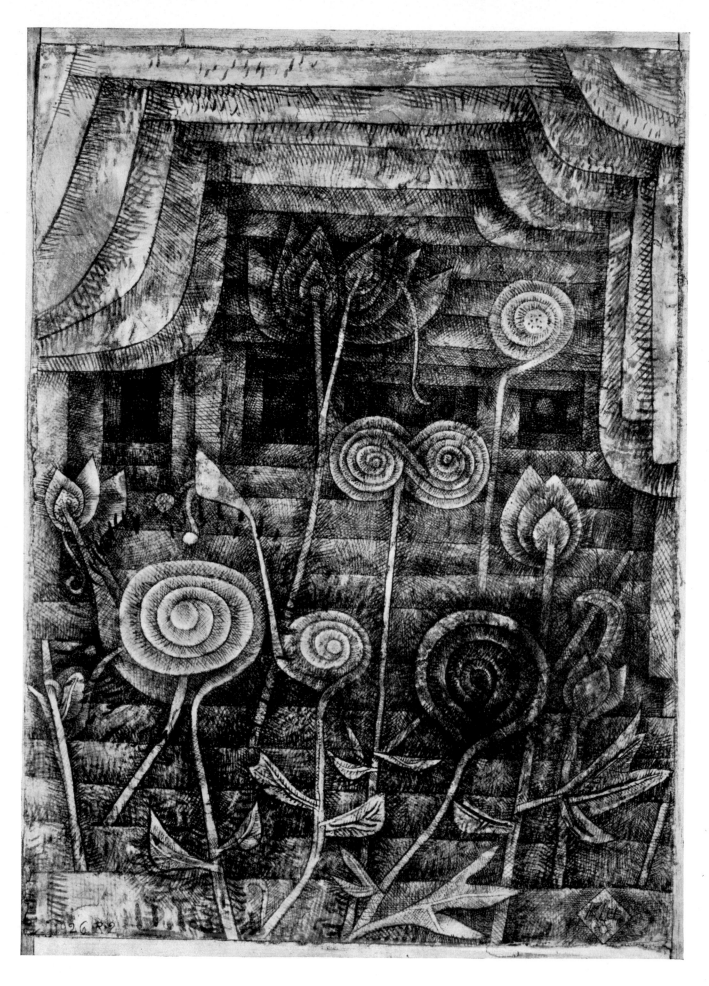

Spiralblüten (1926) / *Spiral Blossoms* / *Fleurs en spirale*

of art. "Art does not render the visible, but makes visible" is his lapidary phrase; and on this premise he builds up to his theory. "We used to represent things visible on earth which we enjoyed seeing or would have liked to see. Now we reveal the reality of visible things, and thereby express the belief that visible reality is merely an isolated phenomenon latently outnumbered by other realities. Things take on a broader and more varied meaning, often in seeming contradiction to the rational experience of yesterday. There is a tendency to stress the essential in the random." And, quoting examples, he goes on to speak very cogently of his "orientation on the formal level" and in particular of the formal elements of graphic art and their combination in objects and spatial structures; of movement, which is the basis of all growth; of the genesis of a work of art and its temporal character. "Pictorial art springs from movement, is itself fixed movement, and is perceived through movements." Out of abstract elements of form (movement, counter-movement, contrasts of divided color), "through their unification in concrete beings or abstract things like numbers and letters, will finally be created a formal cosmos which so closely resembles the Creation that a mere breath suffices to bring to life the expression of religious feelings and religion itself."

Klee then gives examples of pictorial themes and forms: "An apple tree in bloom, its roots, the rising sap, its trunk, the cross section with the annual rings, the blossom, its structure, its sexual functions, the fruit, the core with the seeds. A complex of stages of growth." Or, "A sleeping person, the circulation of the blood, the measured breathing of the lungs, the delicate function of the kidneys; in the head a world of dreams related to the powers of fate. A complex of functions unified in repose." Or, "What a modern man experiences striding across the deck of a steamer: a complex of movements within the universe with the ego on the steamer as the center." And this is how he sums up: "Art is a likeness of the Creation. It is sometimes an example, just as the terrestrial is an example of the cosmic."

In his essay Klee aimed merely at elucidating the essence of graphic art, but once started he went far beyond his original intention. He makes "a journey into the land of greater perception on the basis of a topographical plan," and reveals without restraint the result of his most recent experiences. For instance, a stream and a boat lead to the wave movement; losing one's way in a forest results in the "movement of the running dog"; the starry vault of heaven, in the field of points. Dots, dashes, masonry, and fish-scale patterns, etcetera, express events or accompany them. But he also speaks in cue-words of pictorial monophony and polyphony, of good and evil and their simultaneous existence "as a state of ethical stability," of the ultimate mystery which lies behind ambiguity and "before which the light of the intellect is miserably extinguished." He says that "symbols reassure the spirit that it need not depend exclusively on terrestrial experience with its possible enhancements . . . Art plays an unwitting game with the ultimate things and achieves them nevertheless." In the highest zone it should assist humanity to obtain

Playing with a Lech-River-Landscape Cl. Cat. 41

a fleeting vision of God and "to rejoice in the sacred vigils when the soul sits down to supper."

This little essay should have caused a revolution among artists and art-school circles; instead, it passed almost unnoticed and was read by few.

During those years Klee jotted down in his journal in the shape of aphorisms the ideas he had formulated in the essay – ideas about form, time, and ethics. In 1917, for instance, he says he cannot depict a thin veil of mist before the stars break through because the moment is too fleeting: ". . . it must penetrate into the soul. The formal element must blend with one's philosophy of the universe." In another place he writes that we explore form for the sake of expression and for the insight it can give us into our own soul. Thus form, soul, and cosmos are closely interlaced. That is why Klee can call "completely abstract and completely like Lech country" a watercolor he painted at Gersthofen on the Lech in 1917. Elsewhere he observes that the polyphony of painting is superior to that of music because it brings the concept of simultaneity more clearly to the fore; yesterday and tomorrow coincide.

During a short leave in Munich in 1916 Klee wrote down what distinguished him as a painter from Franz Marc, and his reflections illuminate his artistic position at that time. In contrast to the more human and earthly Marc, he seeks a "more remote source-of-creation point" where he divines a sort of formula "for animals, plants, man, fire, water, air, and all the circulating forces as well . . . I seek a place for myself only with God . . . I am a cosmic point of reference, not species." And he continues: "I cannot be understood in purely earthly terms. For I can live as well with the dead as with the unborn. Somewhat nearer to the heart of all Creation than is usual. But still far from being near enough." This profession of faith is Klee's epitaph; no better one could have been found than these words written twenty-fours years before his death.

All these cognitions and experiences, which Klee started collecting in 1914, make him, as Georg Schmidt said in 1940, the "greatest realist" of our time, "the artist who (in our century) most completely comprehended reality humanly experienced and artistically formed." If we did not know how systematically Klee worked, how consistently he took possession of the universe, and how methodically and gradually he mastered his painterly media, we could not but consider him a clairvoyant. And perhaps, indeed, he was one, for what he termed the "ultimate mystery" cannot be attained by work alone, and what he meant by intuition, which cannot be replaced by any "construction," is inborn. But the supernatural, too, is firmly founded and not arbitrary, even when it is that peculiar sense that musicians and mathematicians sometimes have. Significantly enough, Klee was both a musician and a mathematician.

If Klee, like Marc, had been fated to die young, what he produced before 1920 would still have made him not only one of the most inspiring, but also one of the greatest painters of the twentieth century. The period that preceded the Bauhaus is more than simply the found-

ation for his later work; it is a decisive section of Klee's art and of his century's. In the classification of his works many of the earliest are considered equal to the later ones; they are different but not inferior. What they lack in economy and simplification is compensated for by their vigor and the faith that they reflect in art as an adequate language of a new era.

The Bauhaus enriched Klee's art but did not modify it. All its aspects, even the symbolical and constructive, were already known to him when he wrote his essay for *Creative Credo* in 1918. What he did now was merely to deepen and broaden his knowledge and experience in his written notes and artistic work.

In *Wege des Naturstudiums* (a Bauhaus book of 1923) Klee sketched, long before Heidegger, a quartering of artist and object, earth and cosmos. His relationship to nature had always been very intimate: "The artist is man, nature himself and a piece of nature in nature's space." But the optical-physical approach to nature is outdated. The artist of today expands his knowledge of an object by including its inner being, its cross-sections (anatomy), its vital functions (physiology), the laws that govern its life (biology), and finally its relationship, intuitively conceived and depicted, with the earth and the other planets (terrestrial roots and cosmic unity, statics and dynamics, weight and buoyancy). Hence, a synthesis of outer sight and inner vision, the complete identity of the ego and the cosmos. This method can result in pictures which "differ completely from the optical image of an object and yet, from the standpoint of totality, do not contradict it." Hence, totality and not optics. For the first time in the history of artistic development an artist grappled with this problem. And Klee not only grappled with it but solved it, for all ways "meet in the eye" of the artist; this explains how complex conception is combined with a formal perfection that extends even to the technical details.

Work. "Ways of Studying Nature", 1923

"Wege des Naturstudiums" (Ways of Studying Nature)

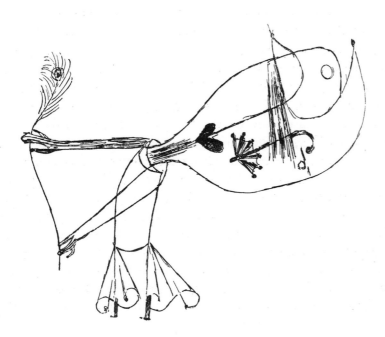

Dance of the Mourning Child 1921

183

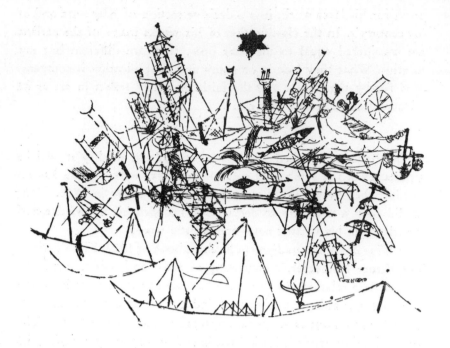

Seascape with Astral Body
1920

"Pedagogical Sketchbook"

The *Pedagogical Sketchbook*, written in 1924, was part of Klee's activity as a teacher. Intended for students, it contains directions for the understanding of pictorial media and practical exercises in their use. Because Klee felt the importance of every detail in relation to the whole, even such a practical textbook has something to tell us of his insight into the essence and development of art. His analysis of the arrow, for instance, is a piece of profound wisdom. "The father of the arrow is the thought: How can I extend my range in that direction? ... The contrast between man's ideal ability to penetrate at will the natural and the supernatural and his physical impotence is the origin of the human tragedy ... Thought as the medium between the earth and the cosmos. The longer the journey, the more poignant the tragedy. One must become movement and not merely be! ... Never quite to reach the point of movement without end! Consolation: a little further than usual! than possible?"

Lecture at the Jena *Kunstverein*
1924

In 1924 Klee delivered a lecture to the *Kunstverein* (Arts Club) at Jena where there was an exhibition of his pictures. He read it from the blue copybook in which he had written it. When the lecture was printed after his death it created a sensation, for in it he speaks, in greater detail than in *Creative Credo,* of the secrets of his work, of formal things, and even more of the creative act itself. He reminds his audience of the orientation on the painterly level and himself of the "orientation in the things of nature and of life." Using the simile of the tree, he compares these things with the root, the artist with the trunk, and the work of art with the crown. But, as the crown is not a mirror-image of the root, so the work of art cannot merely reproduce the ramifications of natural experience. The various functions in various elementary fields necessarily lead to strong deformations. "The work of art is concerned with the need for deformation due to the penetration into the specific dimensions of

(page 185) *Flower-Face* (1922)

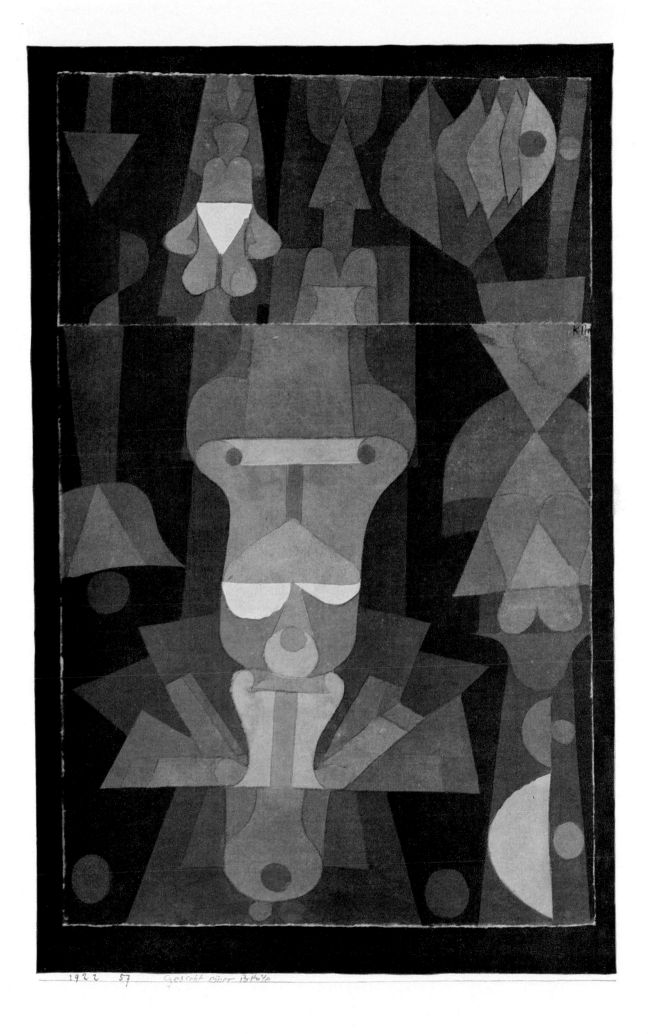

1922 57 Gesicht einer Pflize

(Seite / page 187) *Puppentheater* (1923) / *Puppet-Show* / *Théâtre de marionnettes*

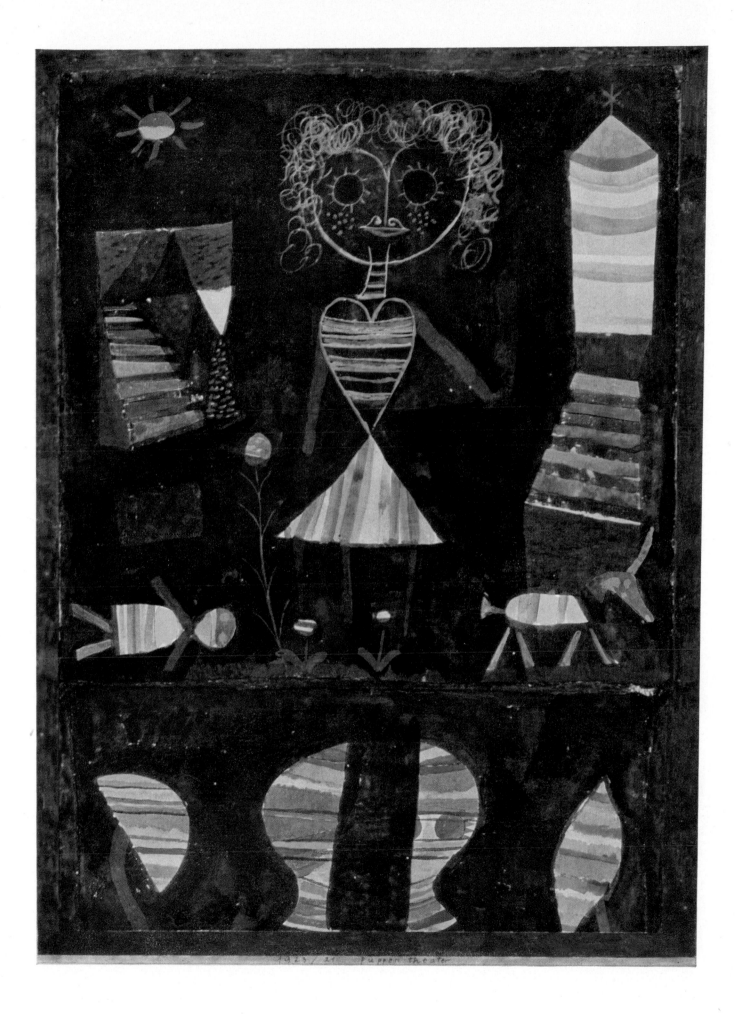

the painterly medium. For there the rebirth of nature takes place."
He goes on to speak of these dimensions – of line, tone, and color,
of mass, weight, and quality, of their occurrence in groups and their
combination in forms which, when abstract, are termed structures
and, when concrete, figures or objects, "depending on the direction
of the attracted comparative associations." He speaks also of the
dimension where content and expression unite, and finally of the
dimension of physiognomy which points to that of style.

Klee says that by the mere mastery of the media one can depict
things so cogently that they can achieve even the more remote
dimensions and result in figures or objects. How is that possible?
"When such a structure expands gradually before our eyes, it is
easily joined by an association which acts as an enticement toward
an objective significance. For every highly organized structure can
with a little fantasy be made comparable with known structures of
nature ... These associative properties have brought about the
passionate misunderstandings between artists and laymen." Whereas
the artist combines structures in absolutely logical groups, the layman
speaks of unlikeness. The artist goes on quietly building but, "sooner
or later, even without a layman's comments, that association can
occur in him and then there is nothing to prevent him from accepting
it if it presents itself under a very apposite name." At this point the
artist can add this or that objective attribute, most happily "at a spot
still formally rather incomplete," and he rejoices when a well-known
face appears, as if spontaneously. "Now it looks at me," Klee used
to say of a work; in that instant the picture passed the test and a few
strokes were often enough to finish it. Out of the construction rises
a figure or a plant, an image or an idea, a *Governess* (1922), or a *Still-
Life with Autumn Flowers* (1925), a *Captive Pierrot* (1923), or a
Chromatic Triad (1923).

Klee's figures have postures, firm, loose or agitated; expression, due
to the line, the tone or the color; gestures and style. Klee leaves off
at this dimension without asserting that it would be the last. He
speaks in this connection, but not as in 1918, of the ultimate things
with which art plays an unwitting game. He leaves it to his listeners
to pursue still further the series of dimension and to make their own
discoveries. He prefers to enlighten them as to the reasons for the
apparently arbitrary deformations. The beholder, Klee says, starts
out from the "terminal form" and not from the creative process,
whereas the artist is "a philosopher without really wanting to be
one." He looks deeper and "instead of a finished image of nature"
he sees "its genesis, the only essential thing" and "thus extends
the creative act from the back forward, endowing genesis with dur-
ation." The world looked different in the past and will look different
again some day; on the other stars there may be quite other forms
and figures. But the artist moves along the natural paths of creation;
that is his school. He considers the optical phenomenon as a peculiar
case, limited in time and space; he prefers to proceed from the model
to the archetype, to the "primary ground of Creation where the secret
key to all knowledge is kept." The universal alphabet, we might

The Governess Cl. Cat. 65
Still-Life with Autumn Flowers
Cl. Cat. 60

Captive Pierrot p. 174
Chromatic Triad Cl. Cat. 91

189

Landscape with Adventurers
1924

say. But the outcome of this process, dream, idea, fantasy must only be taken seriously when they combine completely with the suitable painterly media to produce the image, when the secret vision becomes visible. This is the unification of "world philosophy and genuine artistic practice."

Thus Klee touches on the phases of the creative process, "which during the actual work are consummated mostly in the subconscious." It is with restraint that he speaks of these things, as he is also loath to speak of genius, and when he does so it is not analytically. Klee realized at a rather early stage the unconscious element in his art. Already in 1905 he had written of the inventive strolls of his pencil, in 1912 of the value of primeval origins, and in 1914 of the depths in which he dwelt. It is certain that Klee hardly noticed that the subconscious was also the focal point for other contemporary artists – the Cubists, for instance – as well as for a few scientists, psychologists, and archaeologists. The concordance was natural to the times. Had his attention been called to that fact, he might have referred back to Goethe, with whom he was familiar since his Italian journey and whose works he often reread. In *The Drawings of Paul Klee* (1933) I took as my point of departure Goethe's knowledge that man cannot long remain in a conscious state, that he must take refuge in the unconscious because it is there that he has his roots. I mentioned the "cosmic symbolism and physiognomy" of von Carus, who sees man against the background of the universe and places him in relation to the stages of plant and animal, terrestrial, and cosmic life. I also spoke of a passage in Andre Gide's *Journal* which might have been written for Klee: "A seldom interrupted vigilance binds our future all too logically with the past and hinders growth and development. Only night and sleep produce transfiguration; without the oblivion of the chrysalis the caterpillar could not awaken as a butterfly." In his picture Klee confirms the divinations and insights of the poet and the philosopher.

Many of his psychic energies are reminiscences of the primeval darkness; he dwells "with the dead as with the unborn," he knows where all can derive from all, where lies the course of the pictures that have a striking resemblance to myths and, like them, live on and are endowed with creative powers. They are not equivocal, and their revelational character makes them almost symbols. And a

symbol, as Goethe says, cannot be comprehended or explained; it express truths without itself being the truth; it conceals and reveals and points to the basic phenomena of being and becoming. In so far as much remains open, irony and humor can enter this sphere so that "ethical gravity rules, along with hobgoblin laughter at the learned ones," Klee wrote in 1918.

The combined effect of the symbols results in a fabric of the utmost complexity which embraces all – the thing itself, its origin and growth, its physical meaning and metaphysical import, the interpretation of past, present, and future – so that finally the beholder is himself included in the sublime process of Creation. "Were I a god . . . I should also do a lot of historical theater; the times would be liberated from their age," Klee wrote in his journal on his return from Tunis. The figure that is produced by association in the artistic process is thus no fortuitous analogy to reality but the appearance of the pictures in a different place.

In Klee the beginning projects into the present; physical time becomes ontological time. The beginning occurs again and again and is at the same time development, transmutation, metamorphosis. Inasmuch as the older existence is the deepest and most real – Kant's "condition of the possible" – it is the primary schema of an art that makes beginning and end, time and eternity, coincide. "In the beginning was perhaps the act," Klee wrote, "but above it lies the idea. And since eternity has no certain beginning, but, like a circle, has no beginning, so the idea may be considered primary." And here when Klee says idea, he means εἶδος.

Drawing for "Lieschen" 1924

191

But there is another factor that brings out the form from the "orientation on the painterly level." The painterly orientation and the orientation "in the things of nature and life" correspond, as do the creative forces in the universe and in the artist. An unkown law in the object corresponds to an unkown law in the subject (Goethe); the artist is creature and creator, the world is object and state. We can only grasp one world, that in which we act and suffer; we are what happens to us and what we cause to happen. As "in the smallest leaf analogies to the whole law are exactly reproduced" (Klee), so in the artist are reproduced analogies to the orderly behavior of the universe.

Female Saint Cl. Cat. 52
Fateful Hour Cl. Cat. 66

When a complex of painterly elements gives rise to a *Female Saint* (1921) or to a *Fateful Hour* (1922), it is not because the combined effect of lines and colors offers the possibility of a form, but because Klee derives from the beginnings where all roads remain open until, in the last act of the process of growth and development, all the layers of genesis and action crystallize and produce the picture. How far is Klee aware of these things? "The painter knows a great deal, but he only knows it afterwards," and perhaps even then not with certainty. Goethe collected interpretations of his "fairy tale" from among his friends and even from more distant persons with the idea that they would help him to understand the life of the poem which he had made and yet not made. In the same way Klee, too, sometimes collected interpretations and hoped for a clarifying word. It was seldom spoken, for where nature reveals herself in symbols, words are hard to find.

The inner circle

From Weimar on, Klee's works can be divided into those that lie in the innermost circle of his art and those that are situated near the periphery. In the center are the pictures in which his relationship to the universe is manifested symbolically; each one presents a phenomenon which is inexplicable, or can best be explained by comparison with others or by tracing back the artistic creative process to earlier stages. They are works in which object or theme cannot be separated from their pictorial origin and growth. Most of them are remote from nature, if that expression still applies; one can hardly speak of abstract in connection with Klee, for in his case the conflict revolves "less about the question whether the object exists in reality than about what kind of object it is." These pictures are supra-representational rather than non-representational; one might call them crystalline, as Klee himself did.

The middle circle

In a middle group, form and meaning both spring from pictorial elements and signs which reveal a certain depth but do not become truly symbolic. The outer circle comprises the works in which Klee approaches the processes of life and nature more in the present, from the external situation and not so much from the inner vision, but still under the aspect of totality, of all the pertinent dimensions of the pictorial and creative. Thus the concept of totality has validity for all Klee's works.

(page 193) *Ventriloquist (Caller in the Moor)* (1923)

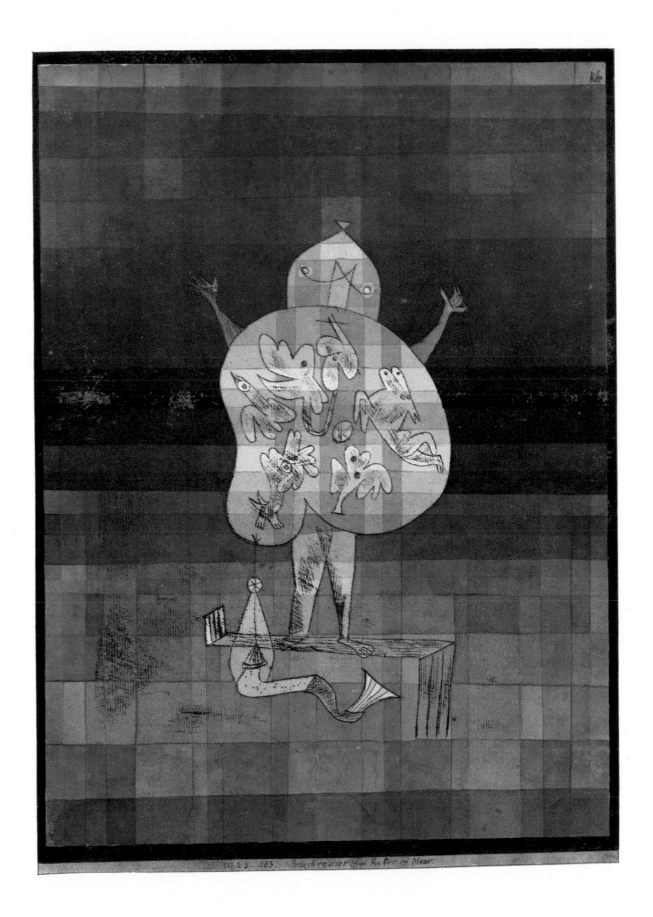

(Seite / page 195) *Kampfscene aus der komisch-phantastischen Oper „Der Seefahrer"* (1923)
Battle-scene from the comic operatic fantasy "The Seafarer"
Scène guerrière de l'opéra comique-fantastique «Le Navigateur»

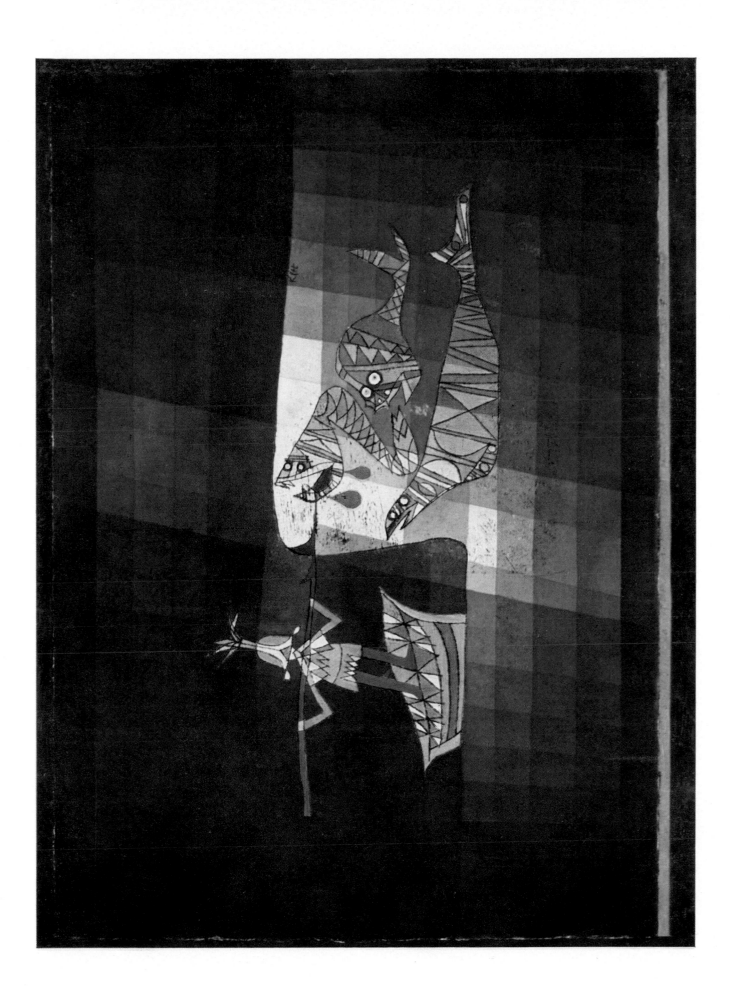

This classification can be maintained for a period of ten years, but already in Dessau pictures of the third group become less numerous; one might even say that they advance into the second. The personal factor – never more than conditionally valid – yields to a detached attitude which projects Klee's own life experience on to the background of general truths. The demarcation is still more fluid and signifies a greater or lesser number of methods and acts, but no scale of values. This outer circle, too, contains masterpieces. They are different but not inferior, just as the autobiographical works of great poets are different from the rest yet are always spirit of their spirit. Where penetration into depth ceases it is compensated for by the strengthening of other forces which give the picture its full weight.

The phenomenon of Klee's art can best be understood by using a number of examples to clarify its breadth and depth. Since Klee is one of the people who gave the word "art" a new meaning in our century, much of his work can as yet hardly be explained today. In many cases we shall have to be content to describe the fabric of the picture and the method employed to produce it. And from the thousands of sheets and pictures we shall have to choose those that are most typical of the whole œuvre.

In the outer zone of the Weimar period are works – mostly watercolors – which revolve around events and figures within the artist's own environment. There are, as before, watercolors which fix the impression of a landscape, after the manner of the Tunisian, ones or more loosely still – *Tideland at Baltrum* (1923), *Near Taormina* (1924), *Mazzaró, Albergo Pagni* (1924). For Klee they were like notes jotted down in a diary, which might one day give rise to something quite different: notes on certain conditions of light and color, effects of the northern or southern sun, colored diagrams raised to a pictorial level, or interplays of forms tending slightly toward a pattern.

On comparing the dune landscapes of 1923 one is inclined to believe that those closest to nature came first. Actually the contrary is true: the earliest is a composition of colored squares, the next a mosaic of built-up rectangles with plant symbols; and it is only after these that we find a genuine landscape with houses, dunes, and plants, more or less on the same formal level as the Kairouan sheets. Klee did not have to fix nature first; he studied it in his head, as he often told his pupils, and he never rejected it, because its forms and atmosphere are an inexhaustible mine of inspiration. In Sicily the same thing happened to him as in the North; there too arabesque-like sheets precede more realistic ones. Those of Mazzaró are so plastically and architectonically correct and so Sicilian in color that one can clearly see how intensely Klee examined things when for once he approached them from without. The surface, too, has its secrets, and here at least he could translate Italian forms into those of the Near East.

Klee strays further from nature when, as an accompaniment to cubes of houses, he invents a music of grasslike brush strokes in red and blue on white, which suggest vegetation and atmosphere, as in *Evening in Bol* (1925). Here the houses are placed in their scenic

The outer circle

Tideland at Baltrum p. 172
Near Taormina Cl. Cat. 58
Mazzaró Cl. Cat. 57

197

element, as the childish ships in *Fishing Smacks* (1924) which steam through water and sky are set in their maritime element. Where the landscape changes into a fairy tale or when fragments promise scenic possibilities, it becomes secondary, as *Landscape with Adventures*, a pen drawing of 1924.

Side by side with these works which are based on external impressions are others that are based on poetic fantasy. They are the most ingratiating productions of a painter who could write, at the very beginning of his career: "I know that fundamentally I am a poet; this knowledge should not be a hindrance in art." The public appreciated them first of all because of their subjects and their humor. They comprise animal fables, occasionally dedicated to children, as *Performing Animals, for Florina* (1921), *Of the Fate of Two Maidens* (1921), *Scene from a Hoffmann-like Tale* (1921), *In the Meadow* (1923). What unites these sheets is their narrative and scenic character, a certain resemblance between the forms in the work of art and those in nature, and above all their humour. That they are closely akin to children's drawings was a matter of course for Klee, for he had to simplify the visible to make room for what really interested him. Too, had he wanted to depict man as he is, he would have required "such a bewildering confusion of lines that there could be no question of a purely basic representation; it would be so opaque as to be almost unrecognizable." The running colors and the design applied by tracing or rubbing, produce a contrast which often serves to enhance the contradiction between reason and circumstance. A picture like *The Fateful Hour: 11:45* (1922) no longer belongs to this series despite the free play with the clock, the menacing bells, the toppling house, and the girl hurrying away. For here the scene includes meaningful symbols that supplement the incident from the abstract point of view, and the colors lead a mysterious life of their own.

When the drama depends on a single figure the structure is still more concentrated; that is, where Klee reduces the drama to a single character he simplifies the picture to an enigmatic minimum. All that remains of *Wild Man* (1922), for instance, is a specter, a puppet-like mechanism of mask and costume, with menacing arrows pointing up and down. Likewise in *Fool in Christ* (1922), which is the essence of Gerhart Hauptmann's novel *Emanuel Quint,* the body is as highly simplified as the expression of the head with its pointed fool's cap. A *Female Saint* (1921) and a *Female Artist* (1924) are reduced to a couple of scroll-like symbols of great tranquility and classic form. It is astonishing how Klee, by adding a couple of abbreviated signs to the object comes very close to its meaning – foolishness, holiness, and so on.

Female Saint Cl. Cat. 52

Fool in Christ Cl. Cat. 53

Frau R Traveling in the South (1924) might be a portrait, though slightly caricatured. *Lomolarm* (1923) is the man with tears in his eyes (l'homme aux larmes), not an individual but a type and therefore considerably schematized. *Actor* (1923) is the pictorial realization of a rôle. In Klee all paths intersect. So daring a construction as *Actor* stands side by side with relatively straightforward descriptions of persons and satirical works like *Ex-Kaiser* (1921). An earlier element never becomes meaningless when a new one is added in the process of development; it remains equally true, though perhaps less obvious. Klee never disowned the works of a previous phase; those produced between 1918 and 1925 held his special sympathy until the end of his life because they were the first fully valid realizations with which he succeeded in convincing the public.

Lomolarm p. 203

Actor Cl. Cat. 100

The Ex-Kaiser Cl. Cat. 61

The middle zone of the Weimar period comprises some works in which Klee heightened the formal element – that is, he employed greater precision and a tauter composition – and others in which he pressed forward into dimensions closely interwoven with nature and history (universal history, that is). Here reality is extended into the infinite; art is carried into the realm of the emblematic.

The middle circle

Semi-narrative representations also continue to occur in this zone; we find a *Steamer Sailing by a Botanical Garden* (1921), an *Operatic Tenor as a Concert Singer* (1922), a *Festive Train on Rails* (1923), theatrical scenes and tomfooleries; but the forms and colors are no longer determined by the subject to the same extent. There is no doubt that this is a ship and that a horse; we see smokestacks and paddle wheels, heads and legs, but also details that might have been taken from a textbook on ship-building or from an anatomical atlas. "Man dissects a thing and visualizes its interior in cross-sections, while the object arranges itself in accordance with the number and kind of the necessary sections" (1923). This leads to new forms, which in turn involve new pictorial elements as well as new contents, for in Klee's work a totality of form is always total experience. In *Dance of the Mourning Child* (1921) there are S-shaped spirals akin to the treble clef. Here one might speak of musical associations, as of religious associations in connection with the scrolls in *Female Saint* (1921), or

Operatic Tenor as a Concert Singer Cl. Cat. 63

Festive Train on Rails Cl. Cat. 64

Dance of the Mourning Child p. 183

The Feast of the Asters
Cl. Cat. 67

Landscape with Yellow Birds
Cl. Cat. 68

Fish Magic p. 211

even of leitmotifs which reappear whenever the artist aims at achieving
a certain musical or religious expression. In these cases the theme gives
rise to the form and expression; but in others the contrary occurs and
the theme is the outcome of the combined effect of curved lines.

The romantic-poetic images and fairy tales of this circle are less
communicative. *The Feast of the Asters* (1921) is a beacon of blossoms;
Nocturnal Festival (1921) is a feast of illuminated roofs and gables
with many stars and shining points in the sky and on the earth, but no
human beings. The central red and emerald green stand out against
a deep black, and toward the edges, brown predominates with a
mysterious gold dust in between. In *Southern Mountain Village* (1923)
a group of houses like a spreading *Tree of Houses* (the title of another
picture) is placed before a phosphorescent mountain peak which stands
out against a black night, so that the picture gives a magical effect.
The word "magic" appears very often alongside of "mystic" in the
picture titles; it is used in the sense of "bewitching," "mysterious."
Magical are the moonlit landscapes and the sunsets of those years, the
gay bird islands and the gloomy crow landscapes.

Tropical Twilight with the Owl (1921) is conceived entirely in
terms of color – a dully glowing carmine – with contrasting tones
refracted toward purple; but the grayish-white owl looks more like
a parrot. Tropical, too, is *Landscape with Yellow Birds* (1923). The
Indo-Persian plant-forms frame a deep black central field that sets off
the metallic brillance of the yellow birds and the whitish tones of the
spreading lianas to which the picture owes its rhythm. A couple of fir
trees are woven into the Persian carpet like Northern motifs in Persian
fairy tales. Klee liberated the world of his imagination from its Western
limitations and introduced Eastern elements of the kind that had
become part of European everyday parlance. He paved the way for
a universal art that extends and intensifies our potential experience.
On visiting an exhibition a Mohammedan who had little sympathy
with modern art was astonished by these and similar pictures by Klee.
Art, he said, had obviously once again become as world-embracing
as it had been in the era of the great migrations before and after the
beginning of the Christian era or during the Hellenistic period.

Altogether dreamlike is *Fish Magic* (1925). "One can, once in a
while, take a picture as a dream," Klee told his pupils; logic is not
always everything. Fish, even more than boats, represent flux and a
transitory realm. This work does not put one in mind of an aquarium,
for out of the darkness shines the face of a clock, inscribed in a fishing-
net whose threads form the outline of a belfry; and this play of lines
is projected on a backdrop which is like a picture within the picture.
A couple of plants grow on the ground; in a vase are real wildflowers;
lower down a two-faced girl and a clown-like figure gesticulate; in
between the dainty fish swim undisturbed and the moons shine. In a
picture such as this everything is possible if its peculiar world is per-
suasive enough to become a credible reality, if things are correct in
themselves and correctly related to each other. Fish and flowers pre-
dominate by their very precision; the human beings are entirely sche-
matic and play the part of visitors; when the clock strikes twelve the

 (page 201) *Architecture* (1923)

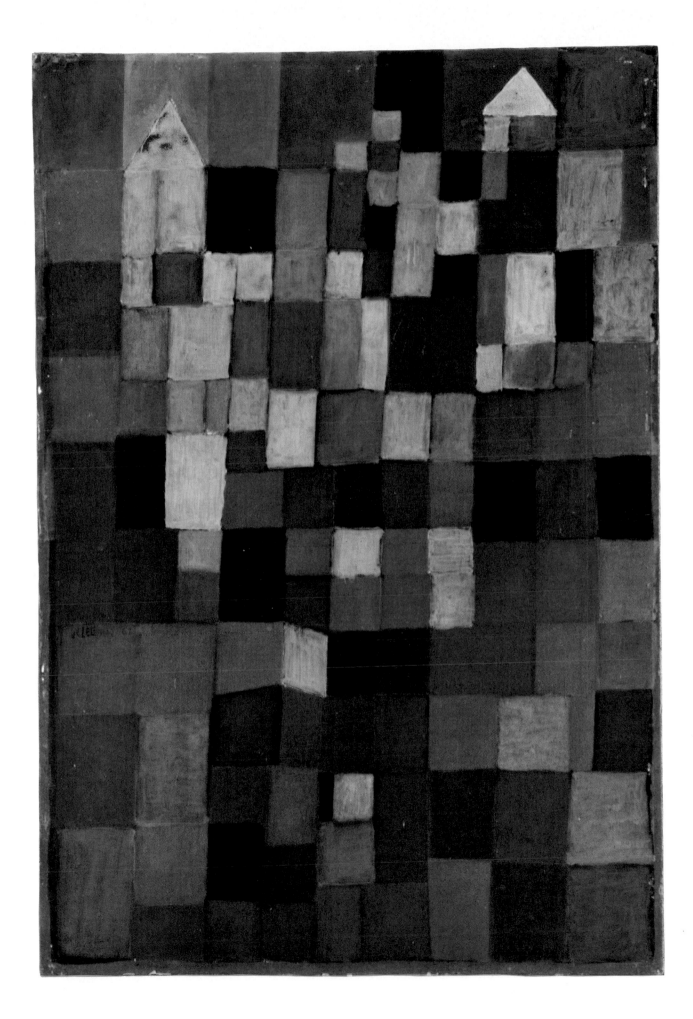

Growth under the Half Moon
1924

spell will be over, the clock will become the moon and the dream will
continue on another planet.

The Bauhaus strengthened Klee's constructive powers. Through con-
tact with his colleagues and the visitors who represented the ideas
of Russian Constructivism and of western "Stijl," in theoretical lessons
and in his weaving and glass-painting classes, Klee came to realize the
value of exact research in the sphere of pictorial art. He did not over-
estimate it, but yet went so far as to see in algebraic, geometric, and
mechanical tasks "didactic steps toward the essential and the func-
tional." They taught one to recognize, lay bare, explain and analyze
the pre-history of the visible. They did not teach formalism but to
despise the formalistic and to avoid the ready-made. They taught
logic and order. Nevertheless, construction was not everything and,
he felt, there was no substitute for intuition. This insight distinguishes
Klee from the painters of the "abstract" and Constructivist schools
even in those of his works that externally are closely akin to theirs.

Klee preferred the word "absolute" to "abstract," for abstract art
could be very concrete and unspiritual; it could look very real, as if
made after a wire model or the like; but the absolute was something "in
itself," like the absolute of a piece of music, psychical not theoretical,
as he told his pupils. We now understand why in Klee a pure
construction like *Unstable Equilibrium* (1922) looks fundamentally
different from a picture by Lissitzky, for instance. The construction
of the layers and directions, of the active and passive elements, the
balance to left and right, up and down, the technical differentiations,
may be the same; but there is more than all this – there are the arrows
that point beyond the construction; they are like living forces and
evoke something like a gesture. And there are also the blue grays that
bring the planes into a supraspatial contact, and the soaring rhythm

Constructed, and absolute
pictures

Unstable Equilibrium
Cl. Cat. 71

205

that tapers upwards in the smaller forms. Or the contrary, as in *Stricken Place* (1922) where the blue-black arrow and the intensification of the stripes (from yellow through red to black) point down at the seaport which is built like a backdrop.

Constructive works of this type are very numerous in the Weimar period and Klee gave them the most diverse interpretations, from a *Dream City* (1921) to a representation of flight *From Gliding to Soaring* (1923). He was seldom satisfied with an analytical title. "Le style c'est le thème" (the theme is the style) was said of James Joyce, meaning that theme and content derive from determined stylistic elements. The same is true of Klee; the more complications result from the coordination of the parts in the whole, the more convincing the theme becomes. "Theory is an aid to clarification," he said in a lecture. "We have rules and the possibility of deviating from them. If one takes the rules too seriously one finishes up in an arid region. One can alter the standpoint or the thing; in either case the liberating movement is, so to say, a moral duty. One can reproduce a thing for the sake of the rule, but that does not make it a work of art. After all, the purpose of a picture is to make us happy."

The absolute works of those years cannot be completely explained. One can analyze their pictorial mechanism from the angles of genesis, form, color and expression, but not their sensibility, their feeling. Klee can dare to make a picture out of an elementary pictorial consideration or task, as in *Under the Spell of the Stars* (1921); out of a progressive movement of steps, a quarry; or out of colored layers, the nautical representation of *Substratum* (1925).

The *Collection of Signs* remains within the runic sphere like many similar calligraphic sheets of 1924; others of this type, like *Mural from the Temple of Desire (Thither)* of 1922, rise to a hieratic significance. Two vertically shifted intersecting meanders, pushing out a few roots downward and hurled upward by the arrows – that is all there is to render the idea of *Temple of Desire*. A poem is made of words alone, as Mallarmé said to Degas, and yet it contains the consonance of the ego with the universe.

Klee succeeded in advancing from the basis of the absolute in various directions: for instance by inventing practicable mechanisms, though with imaginative symbols, or shifting the meaning toward the symbolical. Thus he invents an *Apparatus for Delicate Acrobatics* (1922), and the witty *Twittering Machine* (1922), with its handle like that of a musical box, and four birds in a row which are made to sing by turning the handle. The design is traced by transfer on pink and bluish purple, and its drastic simplification forms a calculated contrast with the evanescent sunset tones of the picture field. The ideal situation, Stravinsky would call it; someone tugs at the bell rope and the resulting sounds are something else again. In 1950 this picture inspired a young composer, Giselher Klebe, to compose a musical "Metamorphosis," which he called *The Twittering Machine*. In the very first bars, with their semiquavers and pauses, it adopts Klee's genetic law of construction. Hans Werner Henze, a musician of about the same age as Klebe, in his *Ballet Scenes* (1950), also makes use of a musical design

of Klee's – the *Voice Cloth of the Singer Rosa Silber* (1922). An *Hommage à Klee* by the composer Sandor Veresz was first performed in Bern in 1951.

The absolute, too, formed the basis of complexes of an architectural character – *The Lofty Aspect* (1923), a design for a Bauhaus postcard; *Arab Town* (1922) and *Castle in the Air* (1922), transfer drawings on a light-colored gesso base – deformed meanders in the one, rising wire-frame forms in the other – heightened dimensions, kakemonos to be read from the bottom up and, like them, full of illusions of space. *Arab Town* is painted in warm pink and yellow with broad, spreading forms; *Castle in the Air*, in cool tones with a pointed, tapering framework. The gauze applied on the stucco base produces a slightly textured surface which at the same time enhances the indirectness of the expression; and the imprinted design seems as if done by a fairy and not by a human hand. Architectural in the wider sense of the term, too, are a snail shell composed of curved lines – *Snail* (1924) – and *Ship II c in Port* (1925) a mixture of harbor and naval architecture.

Snail and *Ship II c* already display contours accompanied by furlike hatchings; this is one of the many technical-formal ideas that Klee utilized at first as a mere experiment and then gradually incorporated in his repertory of expressive devices. The energetic line is given tonal and spatial values by this accompaniment; it becomes prickly or smooth, turned inward or expanding outward, pressing forward or back, depending on the form and direction of the tiny lines and the inclusion of the "grace notes" in the melody. The first work of this type is *Cosmic Flora* (1923) in which Klee renders visible stages of becoming by the varied use of these "flourishes." Growth and expansion, states of change and decay are rendered by this system of flickering main and secondary lines, but in the course of the work other themes also come to the fore. With Klee, technique always was an aid in the realization of his ideas; the vision no longer preceded the picture, seeking an adequate form of expression; it was the creative process itself that pressed forward in a certain direction, producing techniques that look as if they had been the point of departure.

As Klee himself said, the origin of the "grace notes" was the wish to achieve various degrees of white in the design and to differentiate the tonal values; that is why he fancied them particularly in his drawings. In *Growth under the Half Moon* (1924) the hatchings function like antennae between the fragments; in the grotesque *Carnival in the Mountains* (1924) the furry hair-lines and the melting colors render the figurines so unreal that the picture seems like the parody of a spell, as in *The Bird Pep* (1925).

Klee also painted a panel picture in this manner – *Botanical Theater*, one of his masterpieces. It was begun in 1924, when he first invented these "grace notes," and finished in 1934. This does not mean that Klee worked on the picture for ten years; he laid it aside because he did not find the composition clearly balanced on the right-hand edge. In transparent reddish browns and pearly colors he depicted a scene in which the actors are plants – flowers, leaves, and stalks, star-shaped

blossoms such as Klee often drew, and insectivorous plants, along with longitudinal and cross sections. The picture is a nightmare labyrinth with a confusing abundance of mysterious fragments; along the lower edge crawls a shellfish like those we see in pictures by Hieronymus Bosch. The whole work has something of that Dutch artist, who with meticulous details gives an illusion of an inexistent reality, merging the real world and the world of fiction in such a way that one loses one's bearings completely. *Theater,* Klee entitled the picture of his botanical inventions, and the figures on the stage have their drama just as human beings have theirs. Color and hair-line suggest the ambiguous key to the piece in whose center stands the enigmatic plant form like the figure of St. Anthony in Bosch's picture.

Spray process

Another technical innovation is the spray process introduced in 1924; Klee applied the color by means of an atomizer while masking the forms by covering them. It is a simple process also employed for fun by laymen, and it suddenly appears in the works of several masters and pupils of the Bauhaus. Spraying was first used for themes which are rendered most credible in this manner. *Wintry Mask* (1925) seems to be made of minute ice crystals; *Mountains in Winter* (1925) with its truncated pyramid forms seems like the embodiment of polar cold. The leafless tree in the foreground looks like a dried piece of seaweed taken from a herbarium and applied to the picture. In this technique Klee makes use of an expedient which gives the illusion that the work was produced by a non-manual process. In *Horizon, Peak and Atmosphere* (1925) this impersonal quality is pushed to the extreme limit.

Wintry Mask Cl. Cat. 80
Mountains in Winter p. 178

Lacelike fabric

A third method of purely technical origin is the imprint of a lacelike fabric which leads to pictures of an Islamic flavor: façades, cathedrals, imaginary towns, and plant landscapes (*Mural,* 1924, and *Coolness in a Garden of the Torrid Zone,* 1924). Klee's work in the textile department may have contributed to the origin of the idea, but not necessarily; structural experiments may just as well have been the point of departure. For Klee, painting is not merely painting, it is also the invention and discovery of forms that can be utilized for certain purposes, for instance to represent architectonic similes. He now jots down structural elements in outlines that resemble musical notes. In this way Klee extends his means of expression to include all nature. Like a musician he improvises with his stock of tonal material and in so doing learns something he did not know before. Both for the musician and the painter the starting point is experimentation and the desire "to be just as mobile as Nature herself."

Mural Cl. Cat. 81
Coolness in a Garden of the Torrid Zone Cl. Cat. 83

These efforts already point toward the inner circle, and we approach it still more closely in the fragment-pictures of that period. *Chinese I* and *Chinese II* (1923) were originally one picture, but only became "right" on being separated. Klee called them pictures in the sense of Chinese lacquer painting, and the loose arrangement of the objects on the black ground, the brownish glazes, and the fine crackle have in fact a certain Chinese character, quite apart from the slit-eyed Mongol head. The two pictures were executed at the same time as *Assyrian Game* which resembles them closely in technique; objects and expression

(page 209) *Dance of the Red Skirts* (1924)

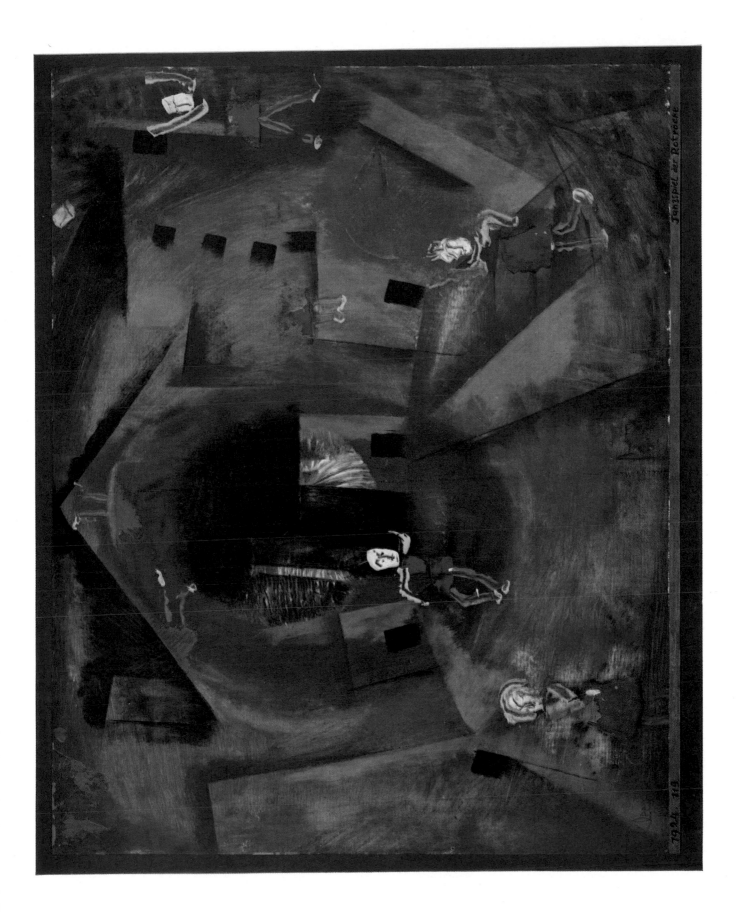

suit the idea of an exotic land without reproducing the actual circumstances. Klee simply imbues the objects and their presentation with his idea of China or Assyria, which he might have derived just as well from Chinese poems or Assyrian texts as from museum visits or reproductions. In *Village in Relief – A Game* (1925) the fragments are replaced by what might be termed "pieces."

Village in Relief – A Game
p. 177

In the Sign of the Snail
Cl. Cat. 75

Fire Wind Cl. Cat. 76

Already on the borderline of the innermost precinct lie *In the Sign of the Snail* (1921) and *Fire Wind* (1922). In the former a pink spiral with bundles of rays (the snail) stands on light blue, while from below sharp, steep forms project upward from the dark brown ground. The general impression is of a star over a mountain. If a sheet is named *In the Sign of Venus* the title gives a clear indication of character and destiny; but when a spiral becomes a snail and the latter becomes a heavenly body, it can only have an ambiguous meaning, namely that the play of forms conceals a destiny that lies beyond the human – a geological one perhaps. In *Fire Wind* tongues of fire with S-shaped edges wave above the brittle structure of the squares. Red arrows nourish the fire, dimmer greens hem it in, the black of night doubles the danger – an exciting action purely in the pictorial realm. A year later Klee painted a replica in which the division of the surface into squares is replaced by a house in a landscape; the curves become a chimney and the arrows press like fire birds against the cube. Here Klee for once followed the path of representational clarification. Did he find the new solution more promising? One is rather inclined to consider the first more forceful. But Klee viewed a problem from all sides and pursued it further when it seemed to offer something for his work as a whole, investigating one or the other of the many dimensions inside and outside the picture.

In the innermost circle of the Weimar period are the groups of pictures that approach the character of archetypes. The first is that of the panel pictures whose colored squares and rectangles resemble stained-glass windows. They seem to be abstract and some of them have abstract designations such as Harmony, Sound, Triads, Architecture, Mosaic. The first example is *Diametric Gradation*, of 1922. In 1923 were produced *Harmony in Blue and Orange; Harmony of Squares; Architecture: Cubes Graded in Red, Yellow, and Blue; Architecture: Cubes Graded from Yellow to Purple; Intensification of Color from Static to Dynamic.* At least one such composition appeared during each of the years that followed. In 1924, *Abstract Color Harmony;* in 1925, *Ancient Sound* and *Abstract with Reference to a Blossoming Tree;* in 1926, *Harmony;* in 1927, *Harmony of the Northern Flora;* in 1930, *Gaily Blossoming;* in 1931, *Portal of a Mosque;* in 1932, *Ancient Citadel K R;* in 1934, *Blossoming;* in 1936, *New Harmony;* in 1937, *Architecture in the Evening;* in 1940, *Glass Façade.* This list excludes all the works that have a representational accent or design. There must be a profound reason for the fact that until his death Klee utilized this principle again and again and remained on such intimate terms with these pictures.

Magic squares

Architecture p. 201
Intensification of Color
Cl. Cat. 86

Portal of a Mosque Cl. Cat. 87

Glass Façade Cl. Cat. 90

When we contemplate them we are reminded of what Klee in 1918 termed "art in the uppermost circle": "Behind the ambiguity lies an ultimate mystery, and the light of the intellect is miserably extinguished." Even at that early date the painter may have had a vague idea of pictures like these; the watercolors from Kairouan, with their colored squares, are perhaps their precursors, and some compositions of 1919 are bypaths. But only in 1922 does the last trace of narrative disappear and, as Goethe said, "the world contemplates itself in us."

The truth that reveals itself to us in Klee's work is a "founded truth," as in Heidegger, where "to found" means "to give," "to establish," "to begin." It can "never be proved or deduced from what already exists"; on the contrary, what already exists is "refuted by the work – it is no longer the only reality." Like Klee, Heidegger places the emphasis on origins, and for him the origin is like a leap, a leap forward beyond all the things to come; even "the end is already latent in the beginning."

Novalis is more akin to Klee, and his *Fragments* are more directly concerned with painting. The painter's hand, he says, has become the seat of an instinct like that of a musician; his art is as independent, as utterly *a priori* as music, but he employs an infinitely more difficult symbolic language. To see is to coin images; the image is a cipher. The artist has aroused the germ of spontaneous life within the members of his own body; he has made them more responsive to the spirit, and is capable of pouring forth ideas through them at will. Cipher, tool, and material are one, and therefore painting is far more difficult than music, more noble and closer to the sacred precincts of the spirit. Thus image-making must be understood as an aspect of the life force that forms itself, spontaneously. The concordance between the poet and the painter becomes still more evident when Novalis acknowledges an artistic instinct in nature, and the artist's unwitting organ as the property of a higher power ("My hand is entirely the tool of a distant will," Klee wrote in his diary in 1918). Hence the correspondence of nature and art, evolution and image-formation, biology and ontology.

Breaking down the barriers between the ego and the cosmos can only mean to "invoke the absolute," to comprehend the universe in symbols, in mute signs. Symbols conceal as well as disclose a deeper meaning and let it appear as through a veil. An "image of squares" like *Harmony* is such a veil. It is meant to be a "key" that unlocks the truth for us, that makes us aware of the archetype. A symbol, Goethe said in his essay on the paintings of Philostratus, is "the thing itself, without being the thing, and yet it is the thing; an image focused in the mirror of the mind and yet identical with the object."

Klee, too, occasionally spoke of these matters in his lectures. In certain pictures one element or another hints at the archetype, often concealed by overlays that have the effect of an alien element. But the "I" is still there and takes care that in every case the threads leading to the archetype remain unbroken even where the connection is no longer visible. Contact with the archetype can occur through hallucination, and what results from that is also recognizable. It can lie far away in the past, and equally well in the future. Thus a new reality is produced

by purely psychic means. The signs that represent it are found immediately, as if one had to act quickly; but that is no defect because such things are quite natural; only the outsider considers them mysterious.

The artist's business is to act, rather than to philosophize (though Klee is often a philosopher) – to form, to create, and also to wait. Much remains on the unconscious level, but for Klee the unconscious is a natural state; he needs it like sleep, as a reservoir of deep psychological experiences, as a counterweight to reason and everyday life. In order to comprehend the continuity of the universe and to find one's place therein – in order to achieve insight – one must be able to let oneself drop, and forget oneself.

Even in these magical pictures Klee proceeds methodically. Like a musician he sets note next to note, develops, particularizes, deepens, visualizes independently of outer reality, until the final form emerges. In this process one or another of his "dimensions" comes to the fore – the tonal value or the color or the rhythm, the harmony or the counterpoint. A pictorial order results which is an analogue of nature. The distribution of color is such that cold hues press from the periphery against warm, bright ones in the center (transition from blue to red through green and brown, from the larger to the smaller form); or the balance between major and minor keys may produce an effect of inner poise. These pictures are painted on a black ground on which, according to Klee, it is particularly difficult to balance the color values; but "we do not have to understand the black, it is the primeval ground." In some of these compositions the sublime lies at a great depth, in others it is contained within the logic of the surface structure.

Only an integrated man like Klee could proceed in this way and reach his goal, a man with ramified and interpenetrating capacities; for here the limits between art and perception, between painting and music, almost disappear. One should read and compare Stravinsky's *Musical Poetics* and see how there, too, intuition, reason, and craftsmanship intermingle, how closely structure is related to feeling, and how mathematical clarity can give rise to a transcendent whole that seems to belie the objective character of the parts.

Klee, who was also a musician, loved music which is not an expression of sentiment – Bach, Mozart, Haydn, Stravinsky, Schönberg, and Hindemith. What he sought was the complete integration that lets the heart remain "in the domain of the head." With all his refined treatment of the pictorial possibilities he must have felt a profound relationship between the expressive means of the two arts. In his work one finds linear configurations that are melodic – rhythmic arpeggios and polyrhythms, tonal compositions based on a keynote and polytonal compositions with several centers, chromatic color scales in major and minor keys. He used such terms himself, for lack of a precise terminology of visual elements, and refused to acknowledge the basic distinction between painting as a spatial art and music as an art in time.

Rhythm is a phenomenon governed by natural and artistic laws; it has a spatial and temporal value and holds the world together. In

works such as *Intensification of Color* (1923) it comes rather clearly to the fore, and helps to determine both the theme and the form. Klee often counted while working; with him, intuition and analytic thought did not stand in each other's way. Once he even wrote down the rhythmic pattern of one of his chessboard compositions, with correlated, discontinuous, reversible series of numbers, in order to calculate the static and dynamic relations. The horizontal and vertical totals are the same, as in a "magic square." Artistic freedom thus finds its fulfillment in the strictest discipline, only to be re-awakened to spontaneous life. In the dialogues in Thomas Mann's *Doctor Faustus*, which are based on Mann's conversations with Schönberg, the magic square, subdivided into smaller squares and provided with numbers, is discussed in a way that also illuminates the rigorous procedure of these compositions of Klee's. It corresponds to the complete integration of all dimensions in Arnold Schönberg's twelve-tone system, which appeared in 1923 simultaneously with Klee's compositions. In both cases the work is developed from a basic scale of twelve half-tones, and each tone is defined by its relation to the given basic scale; it obeys laws of astronomic regularity and complexity, but laws that do not control every detail. Reason and magic meet and become one in what Klee called "wisdom, consecration, faith in stars and numbers."

The other dimension of Klee's magical compositions is that of chromatic harmony. It lies not only between the major and minor keys but also between the irrationality of color as such and the logic of the color intervals in every respect. The same basic material can produce something faded, as in *Ancient Sound,* but also the effect of *Blossoming,* or of an architectonic structure. In every case the result is an "openness" in Rilke's sense of the word. It is as though Klee, like the poet, had for once "penetrated to the other side of nature," and had approached that "pure space" in which all things are open to each other, without barriers or ties.

These pictures lead from apparent nothingness through the veil of the magic square to an ultimate mystery. Already in 1915 Klee had wanted to built a bridge to a region beyond, which "should be all Yes." This goal he now attained. "Spontaneously self-creating life" merges with self-creating art, and the magical compositions represent the relatedness of man and the universe.

Here, too, Klee sometimes adds an explanatory detail; he inserts one or more triangles in the upper third of the picture and evokes a vision of towers, as in *Architecture: Cubes Graded from Yellow to Purple* (1923). Or he loosens the rows, leaves them open at the top and endows them with plant-like qualities, as in *Dune Flora* (1923). Or he slides large transparent squares on top of others and thus fashions structures and spaces in which he inscribes trees and paths; but the whole work preserves a hieratic austerity, and the metaphoric title, *Chorale and Landscape* (1921), stresses the polyphony of the construction as well as the associative element. Or else he leaves the network of the squares light and fills it with variously arranged lines so that it becomes a kind of stick-architecture, as in *Variations* (1927). Klee is an inexhaustible master of the variation; he can grasp all the

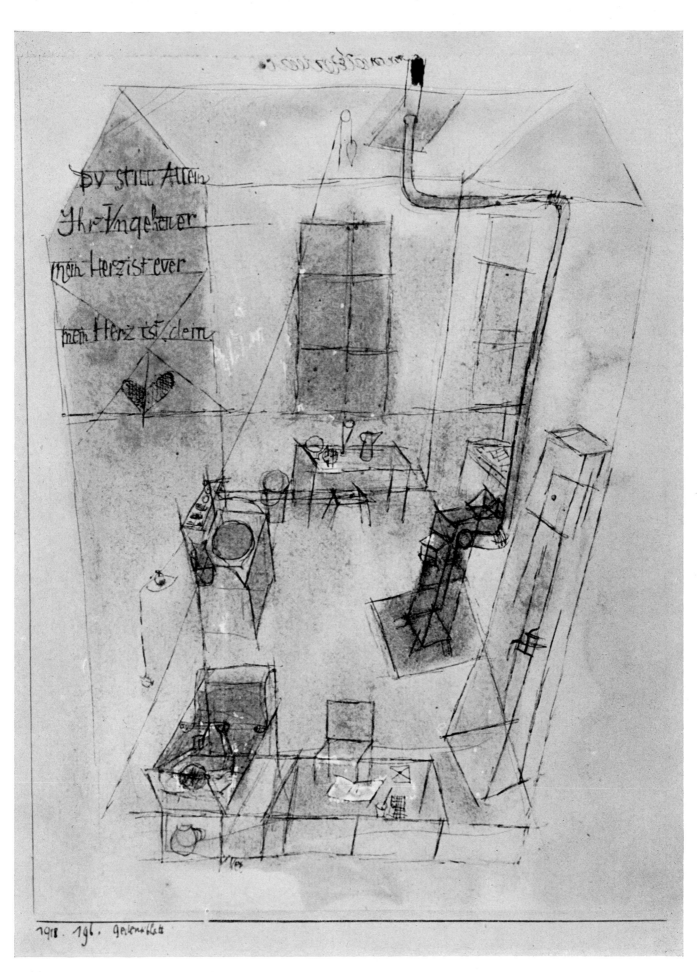

Gedenkblatt an Gersthofen (1918) / *Souvenir of Gersthofen*
Souvenir de Gersthofen

217

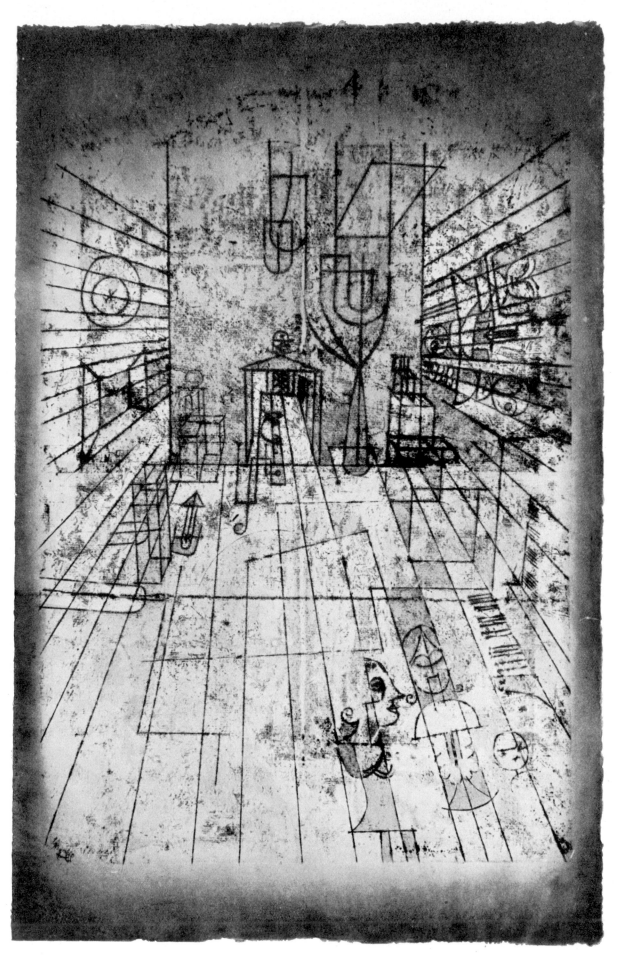

Zimmerperspektive mit Einwohnern (1921) / *Perspective of a Room with Occupants / Chambre avec habitants, vue perspective*

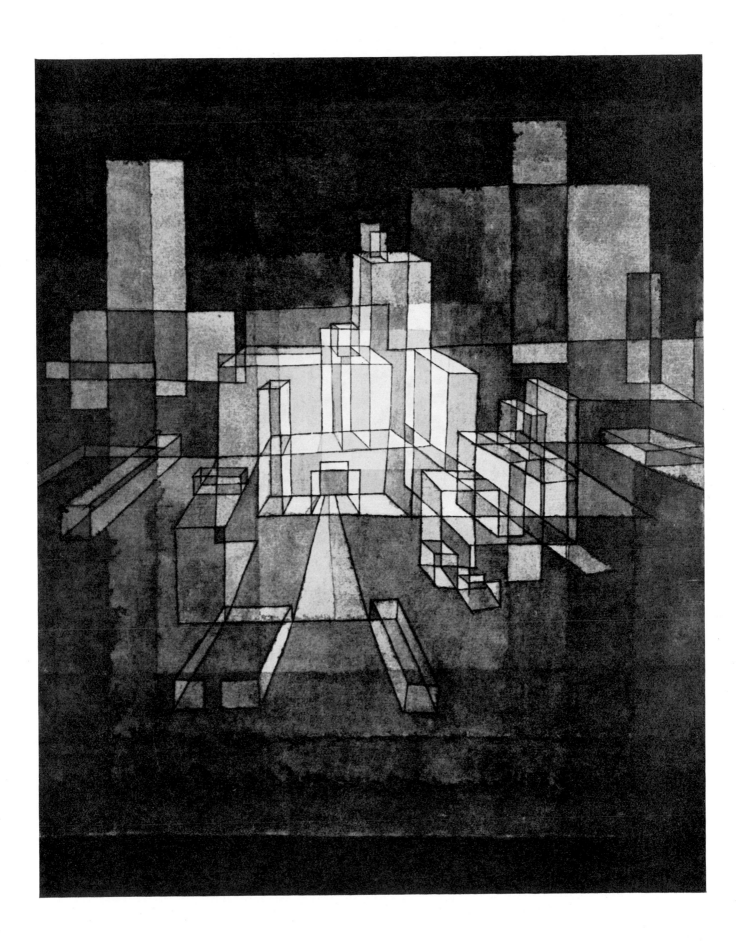

Stadtperspektive (1928) / *Perspective of a City* / *Perspective urbaine* 219

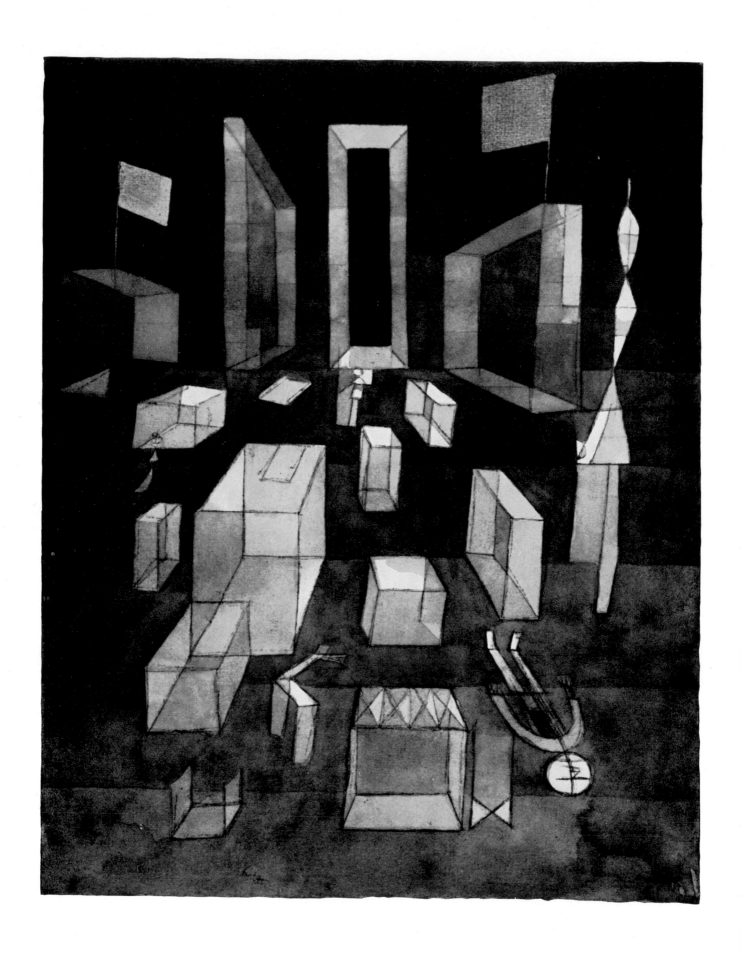

Nichtcomponiertes im Raum (1929) / *Uncomposed Components in Space*
Incomposé dans l'espace

elements of a theme and obtain an infinite variety of new inventions
from the same basic material – as he does, for the last time, in
Superchess (1937).

A group of works closely related to the magic squares are the water-
colors in which Klee superimposes vertical and horizontal stripes so
that they produce a grid of irregular rectangles. These colored net-
works give effects similar to those of the square-compositions of about
the same time, from which some of them differ only by the emphasis
on chiaroscuro values (*Chromatic Triad*, 1923). In most cases, however,
a more legendary or symbolical design is imprinted on the grid by
transfer or rubbing. In *At the Mountain of the Bull* (1923) there is a
glasslike pyramid with a diagonal grid, and a bull and priest so flooded
with light that they are hardly visible at first glance. In *The Mountain
of the Sacred Oat* (1923), a pale pink feline sanctuary with a stairway
and three figurines, the accent lies on the shining façade whose
monochromy and grid pattern give a trancelike feeling. *Mountain
Formations* (1924) remains even graphically in the realm of sym-
bolism; it is a piece of geological history, strata being compressed into
ridges between two opposed arrows, with a pinkish glow toward the
center.

During the Weimar period Klee often combined orderly pattern and
legendary events, thus linking the poetic and the pictorial, as in *Sea-
farer* (1923) and *Ventriloquist* (1923), where he obtains humorous
effects as well. Sometimes he renounces "warp and woof," makes do
with horizontal stripes only, and strings together puppetlike figures in
ballet-like scenes and childish *fêtes champêtres,* suspending them like
notes within the lines of a musical score *(In the Meadow,* 1923, *Group
from a Ballet,* 1923).

Klee, the musician and interpreter of Bach, constantly found new
formal inspiration in the strict pattern of the fugue; he also produced
a group of pictures whose formal structure is based on the principle
of fugal imitation or of contrapuntal polyphony. In the fugue the
same theme is carried through all the voices, each point in the upper
melody corresponding to a point in the lower. The parts enter success-
ively and the theme can be varied or reversed. Thus the theme, the
interweaving, the polyphony, the outward shape and the inner
meaning, all derive from number and order. This mystery was one of
Klee's chief preoccupations during the years he spent at Weimar.

Fugue in Red (1921) is already related by its very title to the
"speculative phenomenon" of music. The four main forms (pot,
kidney, circle, and rectangle) might be considered as the theme,
response, theme in the third voice, and response in the fourth voice.
The changing key would be the changing character of the shapes; the
development of the theme would be the development of the color
(yellowish pink – pink purple). An orderly gradation of the colors is
reflected in the orderly interrelationship of the shapes, and the com-
position must seem alive both to a musician and to a painter, for both
may sense in its harmonious arrangement the echo of a more universal
order.

221

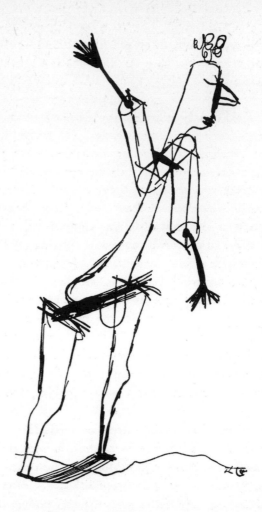

A Performing Puppet 1923

Perspective designs

The same procedure is the basis of *Hanging Fruit* (1921) and *Dying Plants* (1922), *Garden Dry and Cool* (1921), *Dream City* (1921), and the mysterious *Ceramic-Erotic-Religious* 1921). *Dream City* is rather like a double fugue; from the interweaving of themes and keys Klee obtains a spatial picture which, like the analytical pictures of the Cubists, resembles a cryptogram. In *Dying Plants* the exacting pattern yields to representational, associative qualities; in *Garden Dry and Cool* the contrast of dry and cool forms the center of an otherwise two-dimensional landscape. A late reminiscence of these sheets is *Stored Symbols* (1938) in which, as in modern music, the pattern of the fugue has been greatly complicated.

A third group of works within the inner zone comprises the perspective images. As a teacher and as a colleague of the Bauhaus architects, Klee had to grapple with perspective, which is the method used since Giotto's day for rendering space. But Klee only used it for study purposes. Central perspective, which from a fixed viewpoint sees space as infinite, homogeneous, and three-dimensional, was a complete contradiction of his own sense of space; his genetic approach to reality was incompatible with Euclidian geometry.

The "end of scientific perspective" begins with Cézanne. His pictorial structure tends to cling to the surface, and for him the organism of the picture is more important than perspective. The Cubists followed this path to the end with their multiple viewpoints,

their analysis of objects, and their love of planes. Klee chose another path; in his works, space becomes one element among many, a part of integral artistic creation.

The spatial content of a flat plane is always imaginary, Klee insisted in his lectures. The third dimension is not the result of an illusion but of subdividing the surface in various ways. The proper means is the superimposition of shapes, which produces the impression of lesser and greater depths by overlapping and interpenetration, by contour and color. In Klee, space is not premeditated; it grows with the picture and has no function independent of the picture. It has become relative like time and movement; and Klee, who defined the work of art as both temporal and spatial, found himself, without realizing it at first, in agreement with the scientific theorems of his day; they too are images not of the universe but of our mind. Both the physicists and Klee use similes to explain the indefinable quality of spatial relations. *Rope Dancer* (1923), for instance, can be defined neither three-dimensionally nor in terms of its allusion to the fourth dimension. "This is the fault of the inadequacies of language with respect to time concepts. For here we lack the means to make multidimensional, simultaneous events comprehensible," Klee wrote in 1924.

In Weimar from 1921 on there appeared a number of perspective pictures which resemble didactic examples for teaching central perspective. They are drawings, watercolors, and paintings, as *Perspective of a Room with Occupants* (1921), *Block of Houses in Perspective* (1921), *Perspective with Open Door* (1923), *Haunted Room with Tall Door* (1925). They are preceded by *Souvenir of Gersthofen* (1918), the first hint of the whole cycle, and *Perspective Phantom* (1920). Later are *Perspective of a City* (1928) and *Uncomposed Components in Space* (1929). These works seem to be constructed in accordance with the rules given in the *Pedagogical Sketchbook*, with erratic verticals and the measured levels of the horizontals, with views from above and below according to logical or psychological viewpoints. But as Klee said in his lectures, what is logically correct does not have to be accepted; we have the possibility, within the domain of art, of creating

Perspective of a Room p. 218

Souvenir of Gersthofen p. 217

Perspective of a City p. 219
Uncomposed Components in Space p. 220

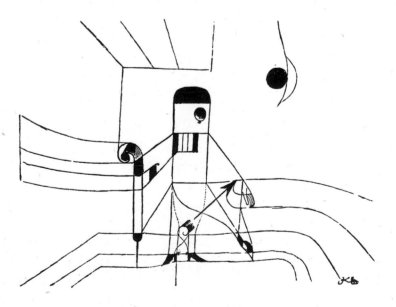

Drawing for Dr. Bartolo
1921

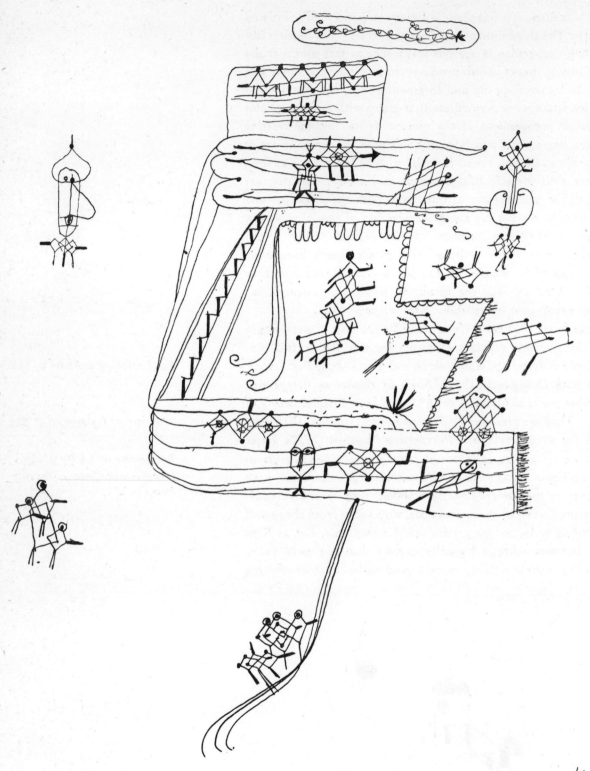

African Village Scene 1925

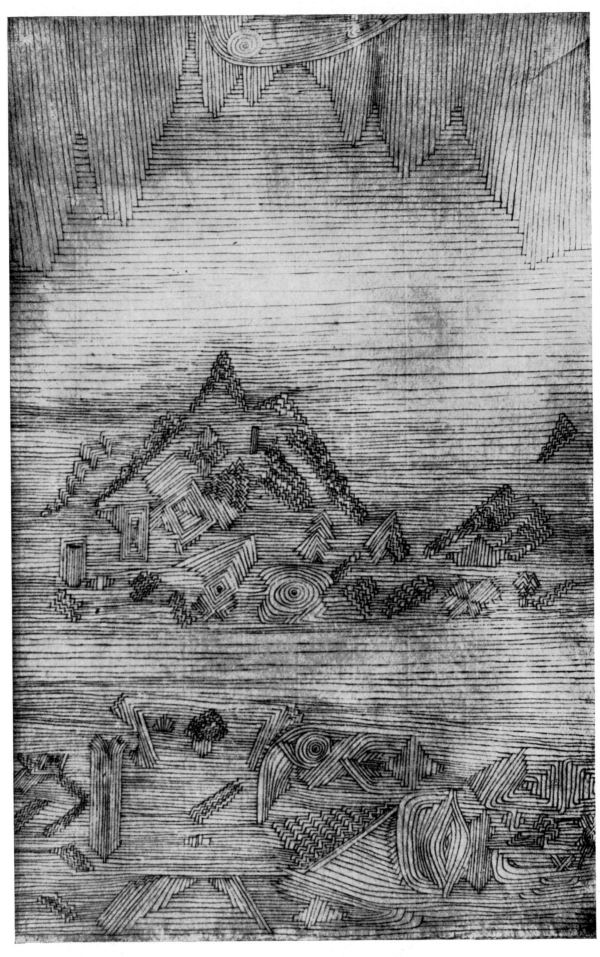

Ansicht eines Bergheiligtums (1926) / *View of a Mountain Sanctuary*
Sanctuaire de montagne

225

Schloß im Walde zu bauen (1926) / Castle To Be Built in a Forest / Château à bâtir dans la forêt

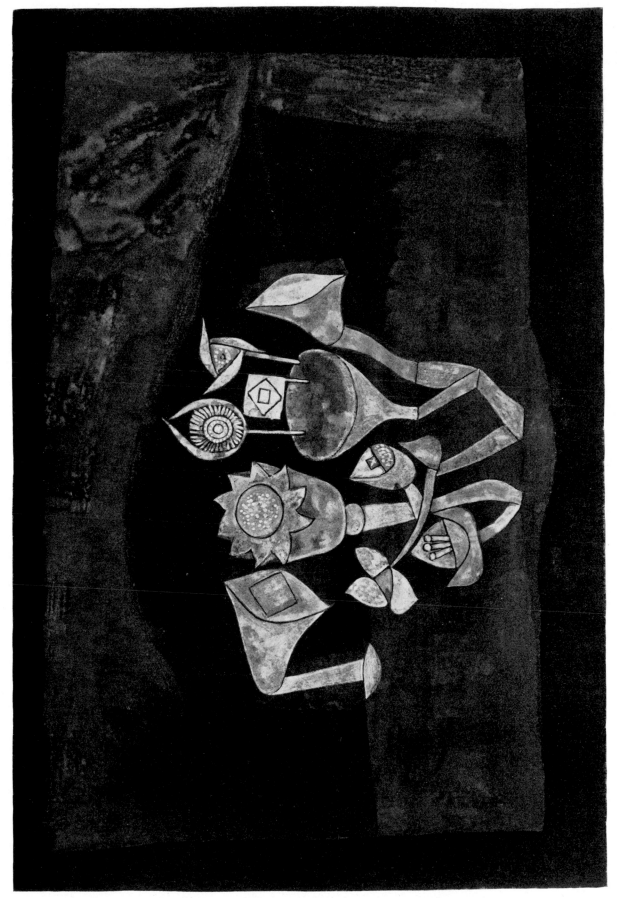

Höhlenblüten (1926) / *Cave Blossoms* / *Fleurs des cavernes*

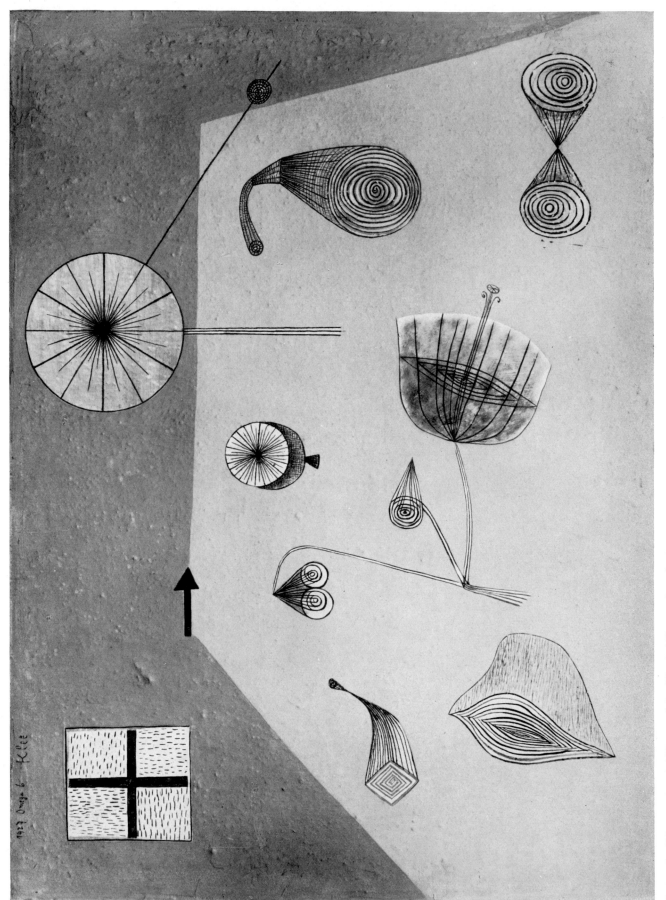

Zeiten der Pflanzen (1927) / *Times of the Plants* / *Temps des plantes*

Um den Fisch (1926) / *Around the Fish* / *Autour du poisson*

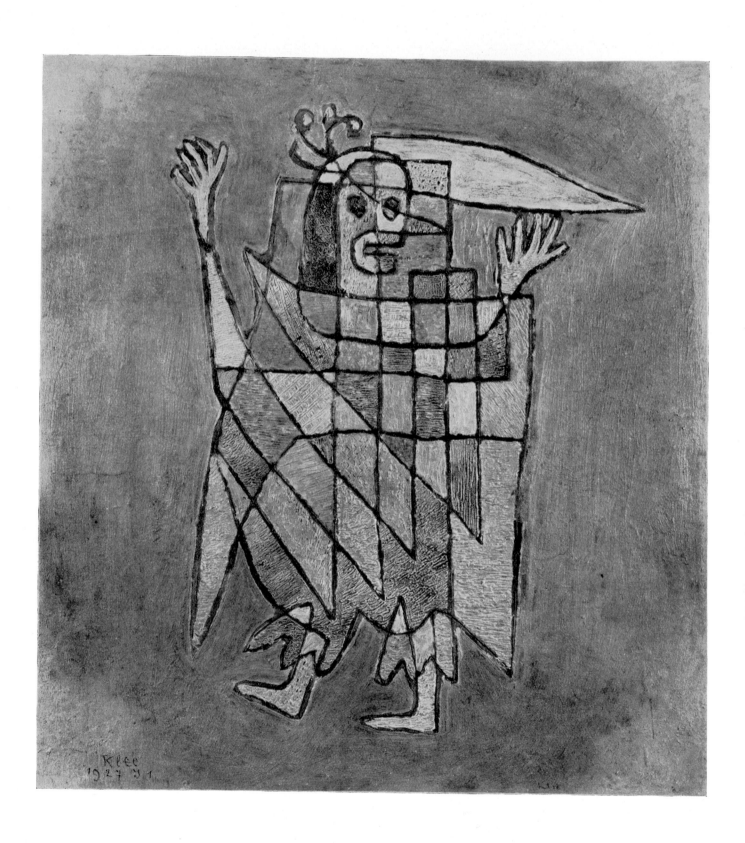

Allegorische Figurine (1927) / *Allegorical Figurine* / *Figure allégorique*

Auserwählte Stätte (1927) / *Chosen Site* / *Lieu d'élection* 231

240 *Schwebendes* (1930) / *Hovering* / *En suspens*

Das Licht und Etliches (1931) / *The Light and Much Else*
La Lumière et d'autres choses

241

Junger Baum (Chloranthemum) 1932 / *Young Tree (Chloranthemum)*
Jeune arbre (Chloranthemum)

242

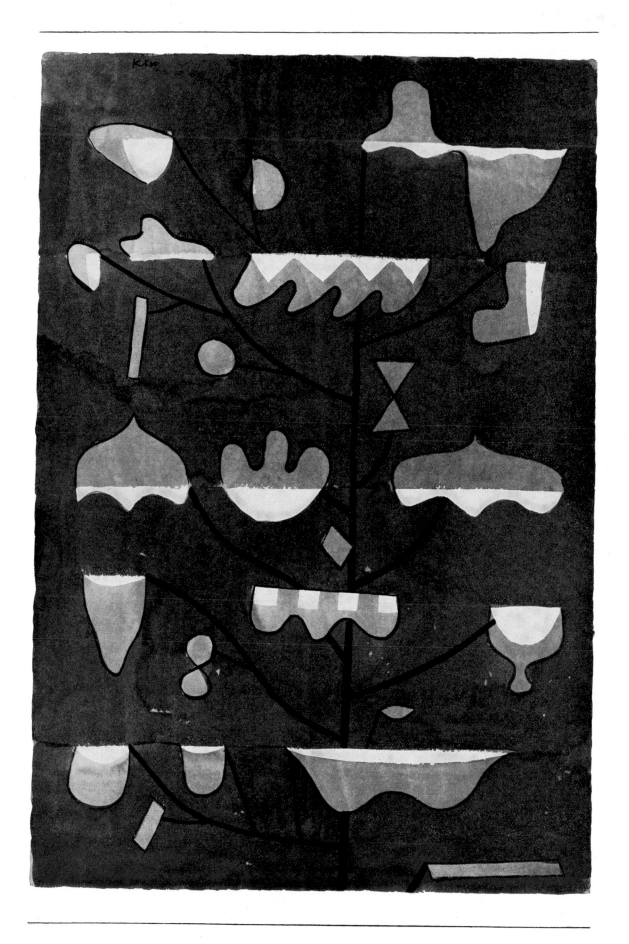

Was alles wächst! (1932) / *The Things that Grow!* / *Tout ce qui pousse!* 243

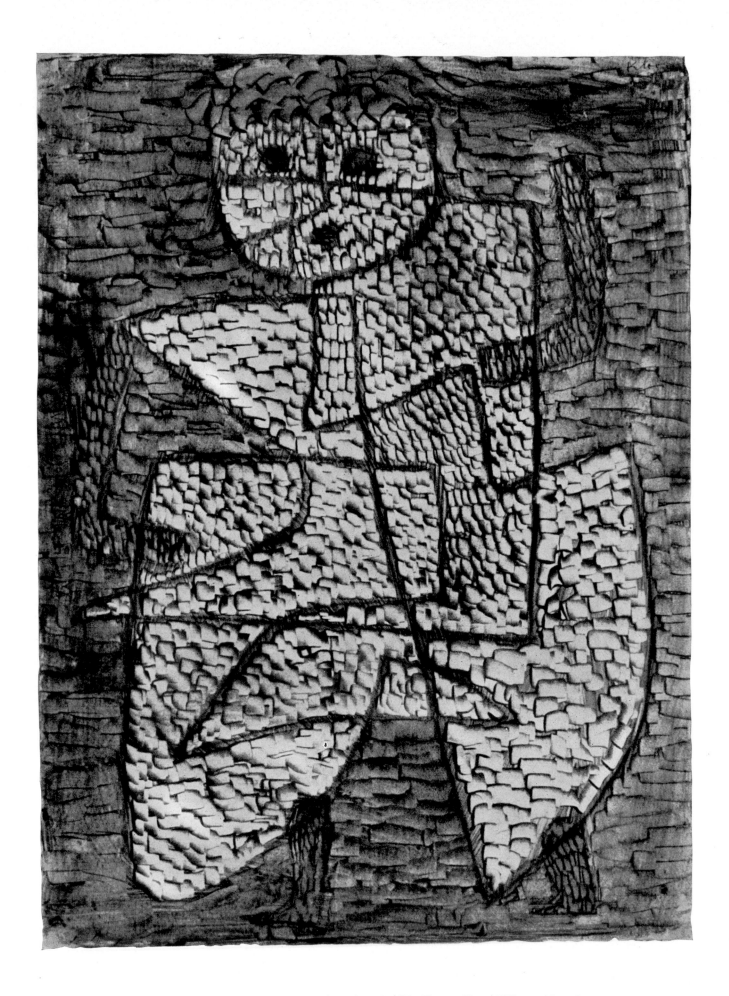

Der Künftige (1933) / *The Future Man* / *L'Homme à venir*

mobility on the basis of the rules and deviations too, for instance by shifting the viewpoint. In the case of mental images, perspective projection is out of place anyway.

In *Perspective of a Room* the view from below is strongly emphasized and the depth exaggerated by the front plane and the view through a door; here the deviation from the rule is the contrast of calculation and appearance. The furniture is realistically constructed, whereas the images of the occupants are projected as flat patterns on the floor and walls. In *Haunted Room*, where one would expect to find them, the occupants are completely lacking; it looks as if they had just gone out, for the ghostly machinery is still moving but the foreshortened lines are wrong. *Perspective with Open Door* shows dynamic and rhythmic displacements, somber superimpositions of ocher, grey, and reddish brown, with the white dial of a grandfather's clock as the chromatic center. Obliquely in the air hovers a specter of harlequin-like shape.

Perspective with Open Door
Cl. Cat. 97

What is the meaning of these pictures? Here again construction and precision are transmuted into their opposites; the greater the accuracy, the more unreal is the effect; the more obvious they seem, the deeper the mystery. And always there is the door leading to another door or opening into a void, as if the perspective space were the vestibule of a world without faith or hope, or at least a world of doubt. One is reminded of Franz Kafka. There are no volumes, despite the stereometry; the furniture is *Spiritistic Furniture* (1923) and intangible; Klee absolutely declines to use plastic effects as a means of rendering space. And the arrows, the contraptions, the clock, the puppet-like ghosts, spooks like those of E. T. A. Hoffmann, but more exact and therefore even less corporeal. The apparently simple perspective formula, like the magic square, becomes a key to reality and spills over into the realm of the transcendental; here, too, the enigmatic quality of the image is a kind of incantation. Peculiarities of style are "modes of thought of a period," hence the concordance we have noted between artistic and scientific events. Klee's own thinking has analogies in Stravinsky's *Musical Poetics* and Gottfried Benn's *Problems of Poetry*.

The last group in the inner circle of the Weimar period comprises the theater pictures. Klee loved the theater and there were times when he went to the opera almost every night. It was not the music alone that attracted him; he had a highly developed sympathy for that world of the contradictory, the illogical, the abstract. Even the most meaningless libretto did not lessen his pleasure; in his opinion the verses of Da Ponte or Schikaneder were raw materials to be transformed into artistic truth by an aria of Mozart or a beautiful voice. Klee could listen again and again to operas like *La Traviata* or *La Bohème* because the musical theater was a world by itself in which he felt at home. Even in Greek tragedy he was less fascinated by the MOIPA (Fate) than by its transformation into opera by the protagonists and chorus.

From those years we have a large number of theater pictures — *Women's Pavilion* (1921), *Stage Landscape* (1922), *Home of Opera-*

Theatrical themes

Home of Opera-Bouffe p. 65

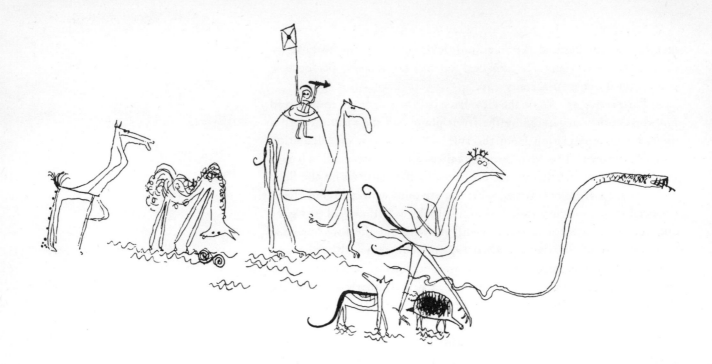

(above) *The Menagerie Goes for a Walk* 1926

Stage Landscape p. 323

Stage Landscape Cl. Cat. 99

Women's Pavilion p. 163

Bouffe (1925); stage scenes like those from the ballet *The False Oath* (1922), *Battle-Scene from the Comic Operatic Fantasy "The Seafarer"* (1923) and *Bartolo: La Vendetta – Oh – La Vendetta;* figurines like *The Order of High C* (1921), *Actor* (1923), *Woman Artist* (1924) and *Female Singer in the Comic Opera* (1925); *Puppet Show* (1923) and *Dance of the Red Skirts* (1924). The same themes occur again in *Stage Building Site* (1928), *Duetto* (1929) and a second *Stage Landscape* (1937). None of these pictures are governed by any definite structural laws bound up with the concept of theater; they adapt themselves rather to nearly all the permutations of Klee's pictorial form. That is where they differ from the magic squares and the fugal pictures; the factor they have in common with them is that they, too, belong to a world that has a logic of its own.

Klee liked the detached quality of operatic action; its human characters represent elementary facts rather than psychological entities like Good and Evil, the Pure and the Demonic, Ugliness and Beauty. The symbolical content is shared among a number of figures, so that the general is embodied in the individual. The abrupt changes, from the adventurous to the devout, from the grotesque to the pleasing, does not disturb the unity of the operatic world because its ensemble depends on contrasts and contradictions, and the most diverse realities result in an unreal world of illusion that veils the indescribable.

Stage Landscape is not a landscape on the stage but a contributing factor, like the cast, the voices, and the instruments; in this picture, figures that allude to the play are just as few as in the bizarre *Women's Pavilion*, or *Home of the Opera-Bouffe*. But whereas in the latter the graphic score is composed of S-shapes and windows, arches and stairs, in *Women's Pavilion* and *Stage Landscape* the whole construction consists of colored, phosphorescent, transparent pieces of scenery, of curtains and fronds. *Home of the Opera-Bouffe* remains two-dimensional, while in *Stage Landscape* the buildings, properties, and drapes

246

swell out as in an enchanted forest and fix the musical action in a
rococo frame. In all three cases Klee may well have thought of Mozart,
in whose mind art and reality were related as they were in Klee. *Home
of the Opera-Bouffe* suggests *Così fan tutti,* the other two, *Don Gio-
vanni,* for which he would have liked to design the sets.

In the stage scenes and figurines Klee consummates his knowledge
of the seraphic and the demonic and their transfiguration in music.
We shall never know exactly which, or how many, of his works allude
to the opera. In Klee, the process of metamorphosis is so intense that
origins are seldom apparent, the more so as in his method of work
the associative elements often enter only after a picture has been started.
The titles alone are not a sufficient clue. Operatic experiences were
undoubtedly the inspiration of many other ballet-like figures – lovers
and mourners, masked and unmasked; and many a landscape with
moons and stars certainly descends from the realm of *The Magic Flute*
and other fairy-tale operas.

Battle-Scene from the Comic Operatic Fantasy "The Seafarer" is a
parody both in form and expression. The tenor decked out in red hose
and plumed helmer resembles a suburban Lohengrin – we have a drawing
of a *Movie Lohengrin* of 1921 – while the three sea monsters are
figures of fun with their gaping jaws and checkered scales. The grid-like
stage is divided into a brown-black and a blue section – into deeper
and higher voices, one might say – but the quasi-sharks are placed,
strangely enough, in the light-blue field of the mermaid. *The False
Oath,* a ballet scene in faded ballet-pink, lampoons in color and
expression the musty, old-fashioned dances that Klee, after seeing

The Seafarer p. 195

The False Oath Cl. Cat. 98

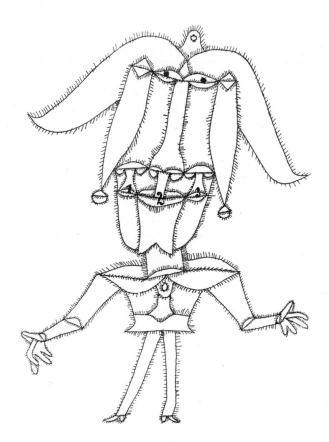

Three Gentle Words from a Fool
1925

Above My House, of Course, the Moon 1927

Dance of the Red Skirts p. 209

Actor Cl. Cat. 100

Puppet-Show p. 187

(page 249) *Bird Pep* (1925)

more up-to-date choreographies, felt were out of place even in Mozart's operas. The *Dance of the Red Skirts* (1924) is an echo of these experiences. Don Bartolo from Rossini's *Barber of Seville* is placed in a dreamy stage perspective, a coloratura world momentarily obstructed by the doctor's aria.

Among the figurines there are ethereal ones like *Singer L. as Fiordiligi* (1923), earthy ones like *Actor*, and satirical ones like *The Order of the High C*, but the former is all grace, bliss, and music, whereas the latter two are vanity and harlequinade.

In Weimar, as previously in Munich, marionette performances were given in Klee's home; Felix shared his father's passion for the stage. The plays were written by father and son together, and Klee himself made the puppets. A sheet like *Puppet-Show* is derived from the perspective of this childish game, with the only difference that Klee the painter could outdo Klee the producer. Before a nocturnal black he places costumes and windows composed of transparent colored stripes, a sun, a unicorn; he is even simpler than the childlike puppet-player. Klee had, indeed, started out with the utterly simple, in an endeavor to "combine objective imagination with pure representation." The contemporaneous *Magic Theater* (1923) suddenly turns complicated, for what is represented here between monstrous beasts and dwarfish puppets, in ghostly greenish-brown with light blue accents, looks like a Bruegelesque hell translated into the twentieth century. Here is an elemental realm which, according to Goethe, means "the primeval in the present," where the phases of time interpenetrate and all phenomena are still fluid. This primeval realm, too, is a veil beyond which lies an ultimate truth, only that here the veil is not a structural pattern but the specific quality of the world of the theater as Klee felt it.

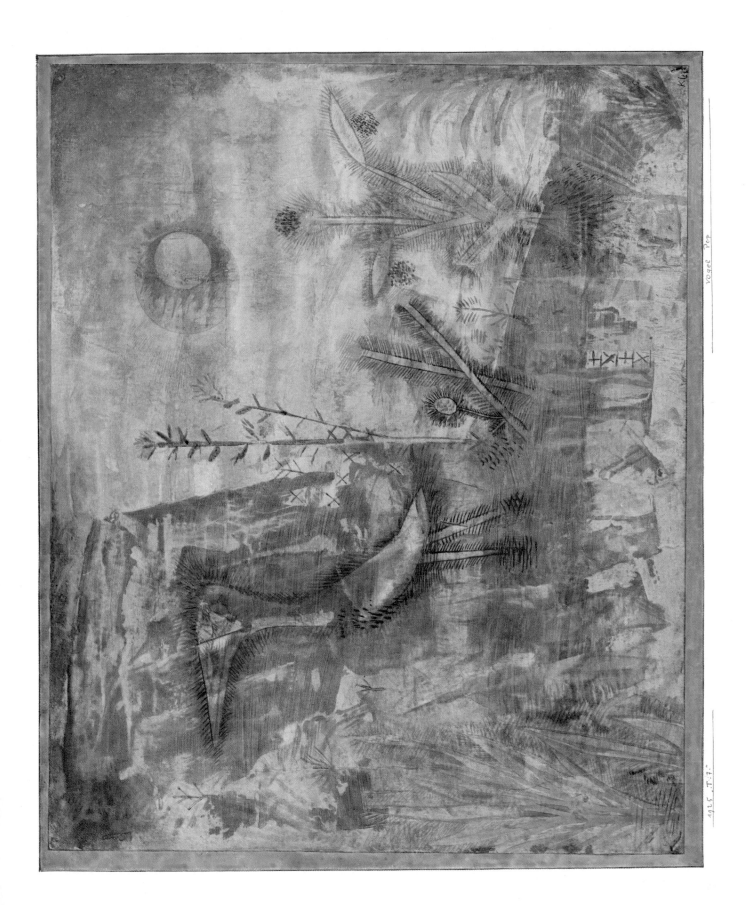

During the five years Klee spent in Dessau, from 1926 to Easter 1931, there appeared a large number of new conceptions whose effects can be felt well into the Bern period. His work gained in range and intensity, and its favorable reception with the public encouraged him to ever greater boldness and directness of pictorial statement. Klee was now one of the few artists in a position to decide the future course of art. Every exhibition of his was eagerly anticipated, and critics measured him by international standards.

Even more than before he painted cycles of pictures and watercolors in which a discovery or an experience is consistently thought through in all its implications. When the ultimate result was achieved, but sometimes even before that, a new sketch started off another cycle. Besides these he executed an increasing number of isolated pictures that deviated from the general direction of his work and in many cases were forerunners of later conceptions. At the same time older themes appear again with their stylistic peculiarities, so that his production in the course of a year and even of a month presents a very diversified appearance. Like the old masters, Klee can take the liberty to paint replicas in which one can see the year when the original was conceived but which, nonetheless, do not interrupt the flow of his contemporary work. This was still true during the last decade of Klee's life; reminiscences of earlier phases repeatedly appear side by side with completely novel designs. He did a great many drawings and tested almost every idea on the graphic level. Sometimes his experiments followed each other as in a diary, and they were often continued even after they had been translated into a definitive work. For Klee, a design was never really exhausted; it merely yielded for a while to other problems that seemed pressing, only to be taken up again later.

(below) *Good bye to You* 1927

Klee's move to Düsseldorf at Easter 1931 did not interrupt the pattern of his work. It is not until 1932 that we find the first signs of a new (and final) phase. A year in advance the artist had a premonition of the catastrophe that was to start in 1933; it isolated him, and threw him back completely upon himself. In March 1932 he called the steel bridge over the Rhine at Mulheim the "legendary achievement of a dying Germany." It was in those very months that he did the first pictures that announce the solitude and wisdom of consummated experience.

Works in the outer circle

At Dessau, and until he abandoned Germany in 1933, Klee carried on many of his former themes and pictorial forms, in all the zones of his artistic production. It would be a mistake, however, to use the simple classifications of landscape, "romantic" action, or theatrical scene as we did for his work of previous years.

We still find landscape reminiscences, but they are less numerous and rarely of the same type as the North Sea watercolors such as *Little Dune Picture* (1926). As a rule a stricter form is in evidence – a cubic

Little Dune Picture p. 255

The Old One 1926

Storm Spirit 1925

space structure or a graphic-stylistic variation or a rhythmical
sectioning. Even when, during a journey, Klee fills a whole notebook
with drawings, they become forms that are "busy throwing off ballast,
in a certain way reactive things . . ." He transmutes natural phenomena
into a schematic pattern; we can observe the beginning of this method
as early as 1927 in the various versions of *Côte de Provence*.

Côte de Provence Cl. Cat. 124

What is true of the landscapes is also true of the anecdotal and
poetic designs; they, too, tend more and more to become formulas and
in Bern they disappear almost completely. Most of the watercolors
and drawings of this group might be classified in accordance with the
formal characters that predominate during the period from 1926 to
1933. Concrete experiences and memories can no doubt still be felt,
but compared with *Zoo* of 1918 a *Zoo* of 1928 looks like a script of
plant and animal "letters." Substance yields to formal expression,
psychographic outline, or tectonic construction. In the later years of
the Dessau period sheets of this type demand to be not only looked
at but "read."

Portraits and single figures also tend toward the middle circle.
Head of a Smoker (1929) might still be taken from life, but next to it
there is a *Clown* (1929) whose oval face, split up into discordant green,
red, and brown zigzags on vermilion, becomes the essence of clowning

Head of a Smoker Cl. Cat. 101
Clown p. 271

An Oriented Person 1927

Negro Glance Cl. Cat. 147

Works in the middle circle

through a few associative touches. Already in 1927 there had appeared a number of heads and half-length figures, for instance *Fool of the Deep*, that conjure up a shred of fate from a fabric of nervous lines. They are intuitive translations of a "conceptual image." Klee painted his freest figure similes in Düsseldorf in 1933. In *Ragged Ghost* he sets a mouth, with the lips stitched together, on a patch of sap-green and attaches two red legs underneath; in *Negro Glance* the piercing white of the eye jumps out from a wide expanse of brown. Nocturnal demons engendered with the spatula from a heavy mass of paint and left as chaotic as they were when they entered his mind – nightmares like these are perhaps born of the fear that people like Klee experienced in the revolutionary year of 1933.

Thus only a little of the work produced during the years in Dessau and the months in Düsseldorf remains in the outer circle of Klee's art; most of it tends more toward the center.

In Weimar the middle circle also comprised the "decorative forms," and the hatchings and lacelike linework were still continued in Dessau. On the other hand, the spray technique was only rarely employed and then only when Klee aimed at removing as little of the drawing as possible. Hatchings are found more frequently in watercolors and

(page 255) *Little Dune Picture* (1926)

Klee 1926 85

panel pictures than in drawings and continue to denote states of becoming and passing away. They occur even later, for instance in *The Soul Departs* (1934) and in the ghostly phantom and fragment pictures. The lacy line patterns remain bound up with the themes of garden and architecture; in *Pastoral* (1927) and *Young Garden* (1927) pattern follows pattern in superimposed rows on a dull green ground like notes in a musical score. This calligraphic technique easily transmutes an architectural structure into a phantasm. *Flag-Decked City* (1927) gives the impression of an enchanted castle out of the Arabian Nights; the silvery moon of Kairouan shines out from a deep blue sky, and the red and yellow flags are just as much astral bodies as festive decorations. Klee employed this formula again in Bern in *Stricken Town* (1936, on gesso ground). But there disaster is at hand; we feel that the down-pointing black arrow will destroy the foundations of the loose framework. To the very end arrows remain symbols of fate, but they are not always menacing. The *Arrow in the Garden* (1929), for instance, glides above the Persian ornament of the ground and signifies the avoidance of disaster.

Whatever else lay in the middle circle now presses into the zone of symbolism; this appears most clearly in the "romantic pictures." In Weimar their fairy-tale aspects had been stressed, but now this happens only rarely. *Snake on a Ladder* (1929) is a symbolical picture with hallucinative details – a sphere, a crystal, an egg shape, some imaginary plants – the contrary of romanticism unless that term is stretched to include the fashioning of myths. Klee found nothing repulsive in the snake, which after his journey to Egypt repeatedly appeared as a theme in his pictures (*The Snake*, 1929, *Snake Paths*, 1934). Here it seems to

Work. Dessau; Works in the Inner Circle

The Soul Departs Cl. Cat. 79

Pastoral Cl. Cat. 82

Works in the inner circle

Snake on a Ladder p. 238

(below) *Family Matters* 1927

be intended in the eschatological sense: coming from the depths it rises up above the planets, while the pure crystal remains aloof from the action like a distant star.

In the same way *Romantic Park* (1930) is a vision of ultimate things. The general impression and the details – the bell form, the black gate, the ruins – recall Bosch, but the key to Bosch's enigmatic pictures cannot explain Klee, whose secret lies in the peculiar amalgamation of juxtaposed strata of conscience. The "dark background of the world" (Heisenberg), which exact science brings to light experimentally, is elucidated by Klee with pictorial symbols that can only be interpreted in their context. Much is incomprehensible. Where, for instance, is the park in this picture, where the plants? Are the petrified forms remnants of a lost culture or indications of another planet, or is the picture perhaps a vision of things to come?

A small group of "initial-landscapes" are really not landscapes at all but dedicatory sheets of many meanings, with letters inserted in the form of a framework that might be a garden gate or a fence, on birthday-pink ground, with spidery contours and delicate colored accents (*Initial-Landscape*, 1932).

The architectural views of the Dessau period – *Perspective of a City* (1928) and *Mechanics of a Part of Town* (1928) – are observed so exactly that they recall not only the architectural models in the Bauhaus but also the mysteries of the preceding perspective images. The latter are continued and attain a new peak in the stage sketches, such as *Stage Building Site* (1928). The wings, structures, stairs and properties offer the widest range of possibilities for the unexpected blending of planes, bodies, and spaces and for the interplay of measurable and immeasurable quantities.

In some sheets Klee combines perspective speculations with cubic constructions. *The Entrance to the Port of P F* (1927) is carried into the imaginary sphere by the transparency of the strongly colored cubes;

so is *View of G* (Corsica, 1927), by the quite terrifying shifts of the verticals. The cubic quality of the countryside in Italy and Southern France, which had impressed Klee during his travels, repeatedly stimulated his fantasy to daring spatial paraphrases and to crosses between Mediterranean order and Northern obscurity. He erects a dream city of sharp-edged, dull-colored blocks and sets the clock at seven (*At Seven above the Roofs*, 1930) – or places a vermilion accent in the

surge of planes und cubes, thus achieving a metaphysical dimension as he does with the number 7 in the roof picture *Fire in the Evening* (1929).

(page 259) *Air-tsu-dni* (1927)

Between cubic plane structure and magic square lie two such hermetic pictures as *Tempo of Three, Quartered* (1930) and *Rhythms* (1930). Klee was fond of them and was loath to let them go; for him they represented the most authentic combination of the pictorial and the musical, the projection of the common spatial element on the common temporal plane, so to say. In superimposed layers, four and six respectively, black, gray, and white tones follow each other, always in the same sequence and number; their horizontal, vertical, and diagonal links produce a multiple rhythm that constitutes the maximum infiltration of music into painting and points to the "absolute" realms that were always in Klee's mind.

Decisive new conceptions in the inner circle of work during the Dessau period are so numerous that they are difficult to classify. There are also many new graphic and pictorial patterns which are more deeply rooted in Klee's intuition and subconscious than the technical inventions (the spray process, the hatchings, and the lacelike effects) of the Weimar period. There are more "ways of the thinking" than techniques. Klee now consciously approached art from two angles, one might say: the systematic, inasmuch as he thoroughly explored every facet of a structural pattern, such as intersecting curves; and by penetrating into the depths of the self and the universe. This method resulted in forms that derive as much from a well-directed impulse to play as from meditation.

The first pattern of this type is the imitative parallel linework which appears in 1925. It was probably a further development of the fugue-like figurations *(Fugue in Red,* 1921) and of the interlacing meanders *(Castle in the Air,* 1922, *Arab Town,* 1922). Be that as it may, imitation, fugue, and parallelism had already played a not unimportant part in the previous years. Now, however, the parallel straight lines and curves achieve independence and by their interlocking and dovetailing, sequence and reverse sequence, rotation and intersection, determine the formal structure, giving rise to flat configurations or to architectonic-scenic ones with occasional suggestions of depth. Moreover, the imitation produces rhythmic qualities and the composition as a whole evokes echoes of classical art. These are reflected in the titles, for instance *A Garden for Orpheus* (1926) and *Classical Garden* (1926). Whether a sheet is entitled *View of a Mountain Sanctuary* (1926), *Botanical Garden, Section for Plants with Star-Shaped Leaves* (1926), or *Castle to be Built in a Forest* (1926), they all convey the flavor of antiquity as a Bach fugue conveys religious feeling – a proof that they are rooted in important areas of experience. These pictures put one in mind of the stringent conventions of ancient tragedies or the musical style of Gluck's Greek operas. The same is true of certain watercolors with figures, such as *She Sinks into the Grave* (1926); and in the quite exceptional *Prelude to Golgotha,* significantly enough, an acropolis with columns rises up behind the Pietà.

Klee started this cycle during the last days of the year 1925, but in the very first drawing – *Storm Spirit* (1925) – he had already mastered the new structural pattern completely. The parallel lines combine to

(page 261) *Place of Discovery* (1927)

(Seite / page 263) *Zweihügel-Stadt (1927) / City on two Hills / Ville aux deux collines*

Klee

1927 V.9 Zwei Hügel Stadt

form stairs and tracks, body and dress, action and expression. Where color is present it is applied with a sprayer and only rarely with a brush.

It is hard to say exactly how the antique flavor is obtained. The horizontal lines of the steps and the vertical lines of the columns in Grecian temples cannot have been the point of departure, but the remote echo of an acropolis vibrates in the strict arrangement and can be felt even in the round and crisscross elements. Even where sheaves of parallel lines become *Plants with Star-Shaped Leaves* one can detect a trace of the "noble simplicity" of the Greeks. As Klee orients himself on the picture plane, testing the effect of parallel lines, the idea of antiquity which was latent in him could come to the fore in the course of the work. He might then add clarifying touches until suddenly a column appears, a stairway becomes a propylaeum, a crisscross design turns into a plant. One image leads to another, as one word leads to another: if the picture represents *A Garden for Orpheus* we find symbols of Orphic mysteries, hexagrams and Orphic cosmogony, Pythagoras and redemption. And from there the road leads to *Golgotha*.

The parallel style was developed and modified until 1934. *Artificial Rock* (1927), in red contours on a black ground, is one of the most compact and authentic works of the cycle and, like *The Creator* (drawing 1930, painting 1934), approaches the religious sphere. *Untamed Waters* (1934), a vortex of light blue and light pink bands, already tends toward the interlacing style, and *Temptation* (1934), with festoons of ribbons and animals, gives the effect of Celtic manuscript illumination. Here Christianity and paganism are merged in a symbolical formula which approaches the style of the Migration Period. Klee hardly knew this style, but the simplicity of his pictorial means produced kindred structures as if by an unconscious regression in time.

That the parallels led to the interlacing style is uncertain. In some drawings of 1926 in which the parallel style is less stringent, one might see a trend in that direction. But it is only in 1930, in drawings like *Complex-Offensive*, that we find reliable evidence of it. This time Klee hit upon ornamental strata which are close to Germanic animal ornament and hardly give a clue to their actual source of inspiration.

The parallels are followed by a number of experiments of a more ephemeral character, mostly derived from drawing techniques. The star-shaped flowers in *Dynamo-Radiolaria* (1926) revolve as if powered by a dynamo; they are just as unreal as the *Spiral Blossoms* (1926) which are not unlike the spiral fibulae of the Bronze Age. In 1927 appear airy, lunar plants made of very fine wire (*Quadrupula Gracilis*) and orchid-like growths with antenna-like stamens (*Hot Blossoming*) that look as if made of spun glass. Another series of drawings is composed of almost parallel and intersecting lines placed at varying distances from each other. Titles like *Overtones* (1928) hint at the musical weightlessness of this technique. Overtones have a certain harmonic relationship to the base tone and determine the timbre. Here

Artificial Rock Cl. Cat. 116

The Creator Cl. Cat. 117

Untamed Waters p. 291

Drawing inventions

Spiral Blossoms p. 180

265

the heavier lines are enclosed in a series of thinner, dynamically graded lines, giving rise to a very attractive maze of "graphic sounds."

Of greater importance is a graphic invention of 1927 which recalls textile designs, embroidery, and fringes. It is embodied in the *Beride* drawings, a cycle of dreamlike travel pictures from the East, perhaps from India. Klee said one must sometimes make a journey in one's mind and on paper. This one might well be to India, for although Egypt already interested him, these towns with their pagodas and temples are not on the Nile but on the Ganges. There is indeed a place called Beride at the very easternmost tip of Africa, in Somaliland, but Klee cannot possibly have alluded to that dreary native settlement; he often invented a use for names that actually exist in some other context. The well-ordered patterns of thin stripes are placed flat alongside and above each other and combine to form net-like, exotic structures *(Beride, The Great Cupola, Suburb of Beride)*. In some cases the stripes are knotted and thickened, as in *Beride, City of Water*. The drawings are executed with the utmost meticulousness, and one, significantly, has the title *Air-tsu-dni* – the Latin word *Industria* (diligence) spelled backwards. This pattern, too, can vary in strictness; the shapes may be frond-like or pointed, as in *Prickly Current* (states I and II) of 1928. Here the flood that washes away cities has become a stream of thorn-like forms. It is hard to say whether the watercolor *Hall of Singers* (1930) has any connection with the *Beride* series. The same honeycombs and domed shapes in various layers on a colored ground occur still more freely in the drawing *Juggler's Festival* (1932), a variant of the color mosaic *Bridged Over*, of 1931.

Thus in the Dessau period Klee made an astonishing number of experimental drawings, not all of which contributed to his development as a painter. Some of the series produced at that time – for instance those of *Beride* – give the effect of cycles of poems in which Klee, like a lyrical poet, sums up a phase of his experience as man and artist. The rhythmic element is always strongly emphasized, the subject becomes a concise theme, but imitation and intensification are more in evidence than thematic development.

The year 1927 also saw the beginning of the melodic line, an invention capable of great modifications. It vibrates alone or in accord with other, often contrasting, lines and expands in the plane or in space into an infinite melody. This invention was so fruitful that Klee utilized it for both representational and abstract compositions; in both cases he started at a single point and jotted down an impulse or a reaction without a break. The essential feature is not the rhythm or the repetition, but the flow and the interlacing. This can result in very specific images like *Mother Dog with Three Litters* (1927) or in less comprehensible ones like the nervous *Magicians Disputing* (1928). But the line can also remain symbolic and abstract, and either terminate *staccato*, as in *Stakim* (1931), or vibrate freely and softly as in *Dramatic Landscape* (1928). Even after the Dessau period these contrasting modes yield a variety of large configurations that blend with other types of design, such as the divisionist ones.

Suburb of Beride p. 73

Hall of Singers Cl. Cat. 85

Melodic line

Mother Dog with Three Litters p. 258

Decay 1927

Among the staccato pictures are the ideograms *The Will* (1933) and
Uprising (1933), as well as many of the mathematical pedagogic
study sheets that Klee drew in connection with his activity as a teacher.
The "soft" group is more numerous: the vibrating line with its inter-
sections gives birth to heads and figures, to landscapes and metamor-
phoses, and even to abstract pictures like *Shame* (1933). By introducing
color associations and technical differentiations in the areas defined
by the intersecting lines, Klee produced pictures that vary greatly in
character – gay and sad, labyrinthine and crystalline, with reflections
and reversions.

Shame p. 288

Also born of the unbroken line is a series of sheets in which inter-
woven triangles become sails and sailboats *(Four Sailboats,* and *The
Ships Depart,* 1927), or inverted triangles become figurines like *Alle-
gorical Figurine* (1927) and the *Fool in a Trance* (drawing, 1927,
painting, 1929). Whereas in the allegory of death the grating formed
by the intersecting lines represents Hades, in the *Fool* it is the path of
his ecstatic dance. When he explained his pictures to his pupils, Klee
called *Fool in a Trance* an "example of instantaneously fixed move-
ments superimposed on each other." Thus one can see a thing simul-
taneously from the front and from above. And in the triangular
sailboats there may well be an allusion to the action of tacking into
the wind. As nature has many purposes, so has art. A picture can be
many different things at the same time, and *Fool in a Trance* is at once
fool, choreography, and trance.

The Ships Depart Cl. Cat. 120
Allegorical Figurine p. 230

Fool in a Trance Cl. Cat. 119

The last series of graphic inventions that started in 1927 is that of
free, discontinuous lines. These works reveal the greatest sensibility,

Free, discontinuous lines

and might well have been named *Imponderable* or *So to Say* — titles Klee actually did use, but only in 1933.

The sheet *Static-Dynamic Tension* (1927) is perhaps an example taken from the chapter on *Formal Pathology* compiled by Klee in 1927 for his lectures. The drawing *Dreamlike* which follows in 1930 is completely rooted in the subconscious. In 1929 and especially in 1931 Klee produced a quantity of drawings in which he grappled with mathematical-artistic problems, for instance — *Dynamics of Neighboring Groups* (1929) and *Reflected Course of a Broken Straight Line through Four Planes* (1931). They serve as exercises in the absolute and constitute one of the most salient contributions to the mathematical style of today.

In 1933 Klee mastered free expression so completely that his shapes become legible and visible symbols *(Snow Thoughts, One of the Finest Parables)*. The relativity of existence extends from these works to images that have a topical purpose. *Arrows of the Vanguard* and *The Second Wave Attacks* are "drawings of lines that are meant to be outrageously straight," as he wrote to me in 1933. They are Klee's contribution to contemporary history; his image-making power enabled him to translate Nazism into visual irony. These veiled meanings were understood only by the initiated. What Klee had to say directly he had already said, and "closed the book" on the subject, when the Nazi flag was hoisted over the Düsseldorf Academy.

The Second Wave Attacks
p. 286

The color

While he was engaged in Dessau in his numerous graphic experiments Klee did not neglect color. It was "the most irrational element in painting," he said, and he prized its spiritual and symbolical value more than its psychological effect. Since art is creation, there can be nothing fixed about colors beyond their purely optical and physical properties. With Klee the very meaning of cold and warm colors, of brightness and darkness, reaches deep down into the sphere of artistic intuition. He was not satisfied with clear-cut relationships; so long as everything is "in order" there can be no tension, creation only begins "with willful acts of over-emphasis". For Klee colors are actors; he is the stage director; but he does not too severely restrict the independence of his cast, their basic character and their mutual relationship, their attitude toward repose and movement and toward certain shapes such as pointed and round. A picture can look green without containing any green. The way color is applied has its importance; glazes give a sense of remoteness, body color brings things close. All means are permitted that help to achieve the desired goal.

In Klee the symbolism of color cannot be divorced from the symbolism of design. Therefore one can approach him equally well from the angle of color as from that of form, or from the conception as a whole. By and large he proceeded from light (Kairouan) to dark (late Munich period) and back again, from sensuous impact to relative calm to sensibility, from psychology to poetry to symbolism. But just as there are throwbacks and anticipations in his graphic work, so in his painting too the periods tend to overlap.

(page 269) *View of G.* (1927)

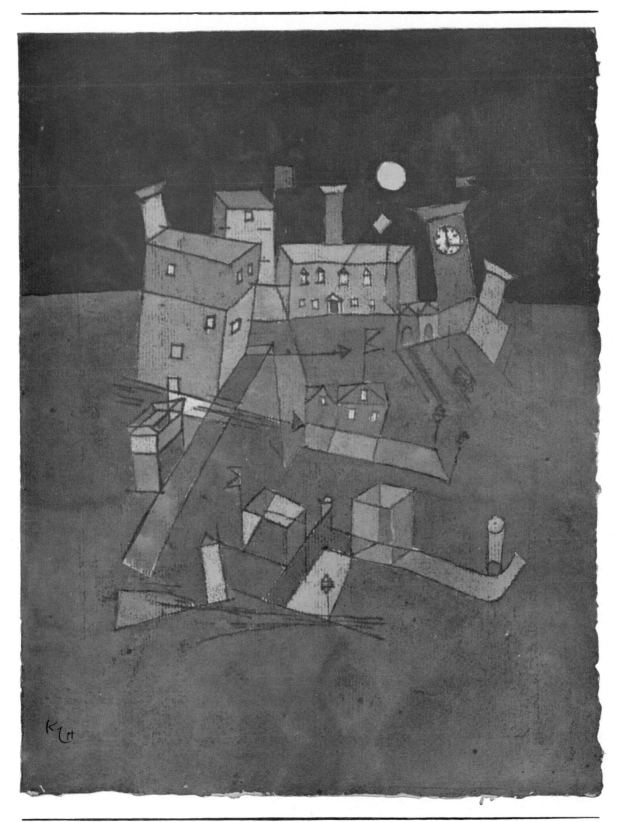

1927 Y5 Partie aus G.

(Seite / page 271) *Clown* (1929)

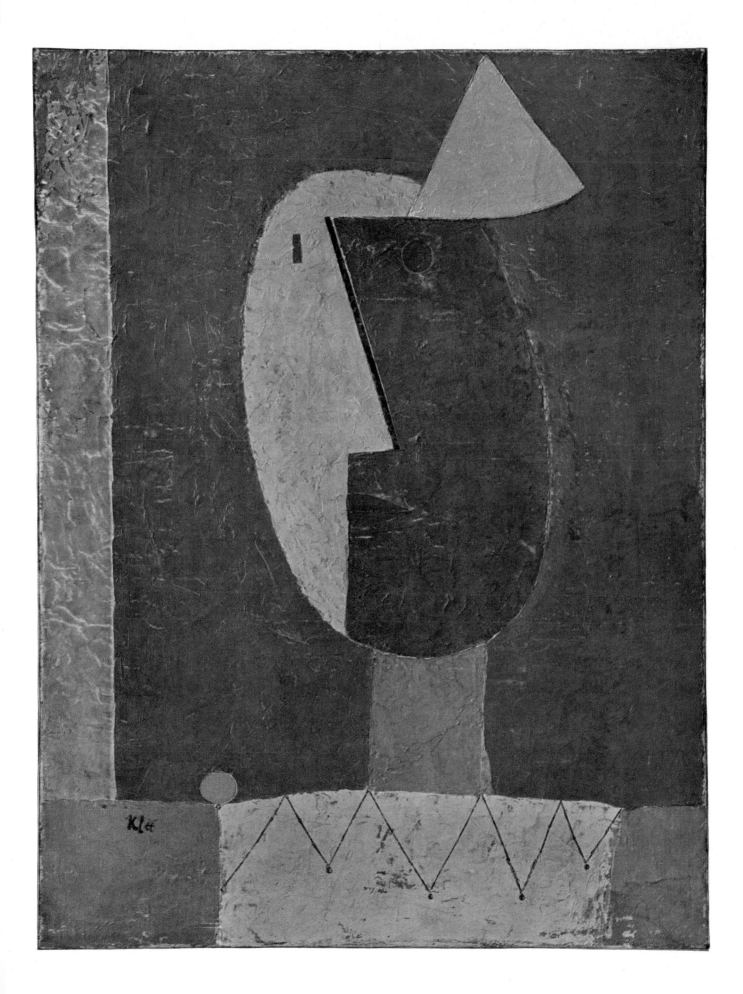

Klee's intense preoccupation with graphic problems in Dessau – he wrote in 1927 that he had once again thrown himself into drawing with "barbaric fury" – brought about a simultaneous intensification of color. Occasionally there is a desire to suppress the linear element altogether and to build a picture entirely on color and pictorial technique. *Young Park* (1926) is an interplay of thick, heavy strokes of color into which the lines are scratched; in *Trees in October* (1931) a very expressive color scheme is based on pink and purple. The graphic element is completely eliminated in the gouaches, where color and brushwork are so predominant that the representational element enters only as if by chance (*Necropolis*, 1930, for example). In Düsseldorf Klee went still further and scooped out the design from the heavy mass of pigments with a small palette knife, obtaining a scaly and even ribbon-like surface with a shimmering contour along the edges of the grooves (*The Future One*, 1933).

Necropolis p. 235

The Future One p. 244
A Village in Relief p. 177

This is where the pictorial "relief-games" fit in. The first is *A Village in Relief* (1925), with suggestions of houses and landscape, all brought out, like pieces on a gaming board, by deeply shaded contours and lightly modeled planes. Klee painted a number of archaeological subjects in this manner – *Reconstruction* (1926), and *Place of Discovery* (1927); also, with the aid of angular stencils, *Vase of Flowers in Sculpture* (1930). While a drastic technique imbues the place of discovery with something of the surprise of treasures suddenly unearthed, the *Vase of Flowers* is rendered intangible by the stencils, the rubbing, and the dotting, as if light itself were the material to be molded. In Klee every medium is ambivalent and the result is a disturbing "confusion of sentiments." Precision and ambiguity are not opposites, so that even a constructed picture retains the quality of living things.

Place of Discovery p. 261
Vase of Flowers in Sculpture p. 236

Klee was stimulated by his trip to Egypt at the end of 1928 to produce a second series of important pictures on his return to Dessau. They are the Egyptian landscapes in which the flavor of that age-old cultural soil has been caught as in the focus of a lens. Already on his way there, at Syracuse, he felt that "the combination of historical stimulus and nature was the right thing" for him, and in Egypt this simultaneous view of time and space became the basis of his vision and his work. All this is evident in his pictures, even though his verbal comments on Egypt are rather sparse. When he was painting *Monument in Fertile Country* he wrote to Lily (April 17, 1929): "I am painting a landscape somewhat like the view of the fertile country from the distant mountains of the Valley of the Kings. The polyphonic interplay between earth and atmosphere has been kept as fluid as possible." The pictures do hold something of the shimmer of the air in the hot sun, but this atmospheric quality is merely one aspect of the statement.

Egyptian pictures

Monument in Fertile Country
Cl. Cat. 130

Klee can hardly have hit upon the colored stripe patterns of his Egyptian pictures as a result of direct observation. With him it always happens this way: a latent expectation is fulfilled and is brought to light in the picture. Klee's longing for Egypt came from the same depths as Goethe's longing for Italy; he had an instinctive bond with

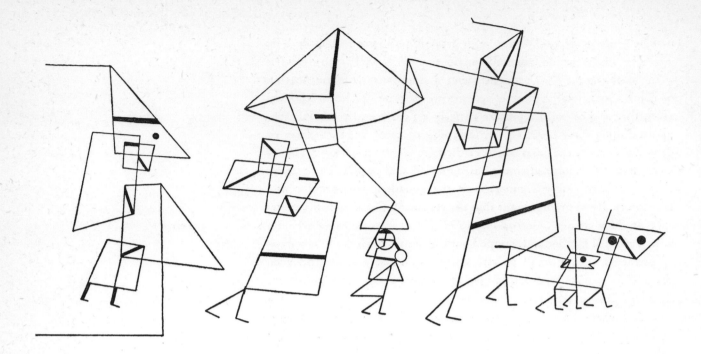

(above) *Family Outing* 1930

View of a Mountain Sanctuary
p. 225

Legend of the Nile Cl. Cat. 167
On the Nile Cl. Cat. 191

the Near East that was as strong as Goethe's with classical antiquity. Klee's previous knowledge of Egypt was no greater than his knowledge of Tunis, but on arrival he felt as though he had been there before. "Where are we going? Always home," as Novalis said. Klee had of course seen reproductions of Egyptian art; he had read fragments of ancient Egyptian literature and was attuned to its picture-language and hidden meaning. And this slight knowledge held the promise of a penetration into something primeval that could not have been dead but was merely dormant until someone would come and give it a new life.

Klee was not disappointed to find that Egypt was different from what he had imagined, nor was he disappointed in the motley colors of Cairo and the baroque flavor of the mosques. He had not gone there for their sake; they did not intrude on his vision and did not even constitute a superficial reality; they were mere haphazard marginal aspects of his experience.

Egypt as a theme or a problem is hinted at several years earlier, and the name of the country appears in the titles of two watercolors done in 1924. But more significant are the many artistic portents. The bright, stripy nature of the North Sea Pictures of 1923 points in that direction, as undoubtedly do some works in the "fugal parallel" style of 1925. In *View of a Mountain Sanctuary* the vertical stripes cut into the horizontal planes in a rhythmic way that makes us think of the Egyptian pictures. It is a puzzle how Klee ten years earlier could have painted a picture – *Blue Mountain (1919)* – that contains nearly all the features of the Egyptian style. Perhaps he had already been there once in spirit, but without entirely grasping its message, for it faded away like a mirage. On the other hand, after the spell of Egypt was broken he painted richer and more naturalistic works like *Reminiscence of Assouan* (1930) and, later still, pictures like *Legend of the Nile* (1937) and the large panel *On the Nile* (1939), though the latter is set in the context of Hades and Death.

274

Klee's first encounter with Egypt was shy and hesitant. On arriving in Cairo he made an on-the-spot silhouette drawing of a part of the city in continuous line (*Reminiscence of Cairo* 1928), and on reaching Luxor he drew the rather different *Desert Mountains* (1929). These two sketches are like those he often jotted down on his journeys, and the real work began after he had returned home. The most important pictures of the series are *Monument on the Edge of the Fertile Country*, *Monument in Fertile Country*, *Highway and Byways*, *Orpheus*, and *Necropolis*, executed in 1929; in 1930 a large number of watercolors such as *Individualized Measurement of Strata*, as well as drawings. *City on a Lagoon* follows in 1932.

Klee overlaid the surface with bright-colored horizontal stripes of varying width which seldom extend from one edge of the picture to the other but are intersected by vertical or diagonal lines according to the requirements of the design in each particular case. The horizontal organization of the picture is offset to a certain extent by its ascending rhythm, and a second system of stripes, generally of greater width and contrasting colors, is formed within the verticals; the result is a formal framework which appears at first to express no more than an underlying order, perhaps that of a landscape or of an architectural view. Even without the titles, the structure of the pictures, the pyramid forms and cubes, the layout and colors would suggest the Orient to anyone familiar with Klee's work, and the cycle as a whole would point to Egypt, though for no apparent concrete reason.

The pictorial scheme was ready, but to produce the Egyptian pictures Klee needed a direct contact with the country and its history. It would be absurd to assume that this had no bearing on their realization, for nowhere do history and landscape intermingle so closely as in Egypt. The past of 5000 years ago is still present there, and the agricultural pattern of the Nile Valley has hardly changed since the days of the Pharaohs. The pyramids and monuments, temples and tombs of the ancient dynasties are still standing and, with the areas of tilled and untilled land, produce a network of horizontal, vertical, and oblique lines out of which the responsive mind can read man's destiny in time and space.

Klee, then, brought with him the necessary flexibility of pictorial means; what Egypt gave him was the possibility of utilizing them to

Desert Mountains Cl. Cat. 107

Orpheus Cl. Cat. 131

Individualized Measurement of Strata p. 277
City on a Lagoon Cl. Cat. 132

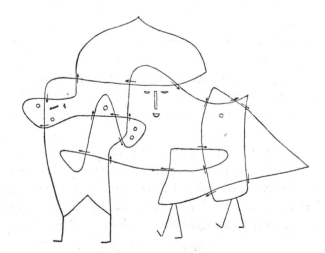

Laced into a Group 1930

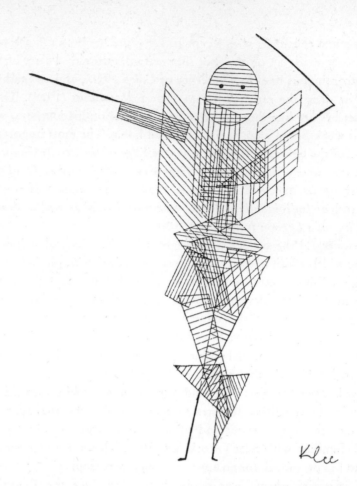

Dancing Master 1930

Highway and Byways p. 234

Monument in Fertile Country
Cl. Cat. 130

produce a complete image of what he experienced there, a picture not of present appearances but of origins and changes in time – the "ka," the genius of the land. What he absorbed there sank gradually into his soul, where it became a latent force, and though he was unconscious of it, it came to the fore in his pictures. Since Klee, as always, handled forms and colors very freely, mindful only of their interdependence, relations arose between the internal and the external factors, between his imagination and his experience of Egypt. The rhythmical sequences and fugal dovetailings of 1926 are transmuted into a fabric of contrapuntally interwoven colored motifs which expand into larger themes – into fields and paths, pyramids and monuments. Thus his image of Egypt was born of both imagination and observation, of the concordance of art and nature.

Highway and Byways does not share the horizontal or vertical flatness of Egyptian art, though it has analogies with it. In intermittent surges the fields run like paths toward the Nile, represented by the horizontal stripes on the upper edge of the picture. The colors are laid on very subtly in the palest pink, green, and blue, and numerous intermediate tones; they render the African sun, spring, and fertility, and at the same time the independent creative power of the painter himself. *Monument in Fertile Country* suggests temples and light with its bright yellows and pinks, *Measurement of Strata* the geological layers of the earth from primeval times. *Necropolis* piles pyramid on pyramid, the red half-moon illuminates a scene of muted colors ranging from dull

(page 277) Individualized Measurement of Strata (1930)

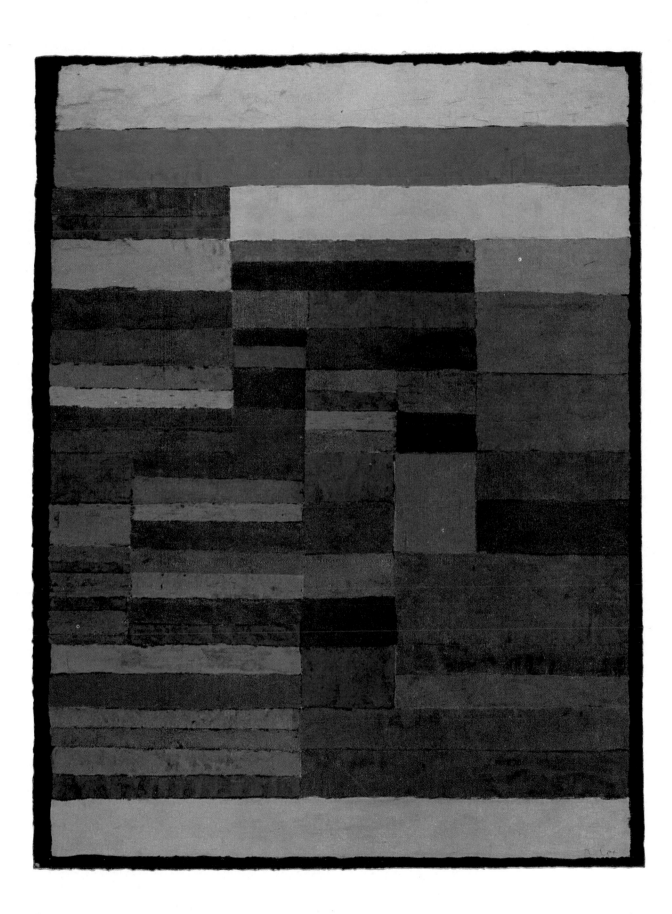

(Seite / page 279) *Diana* (1931) / *Diana* / *Diane*

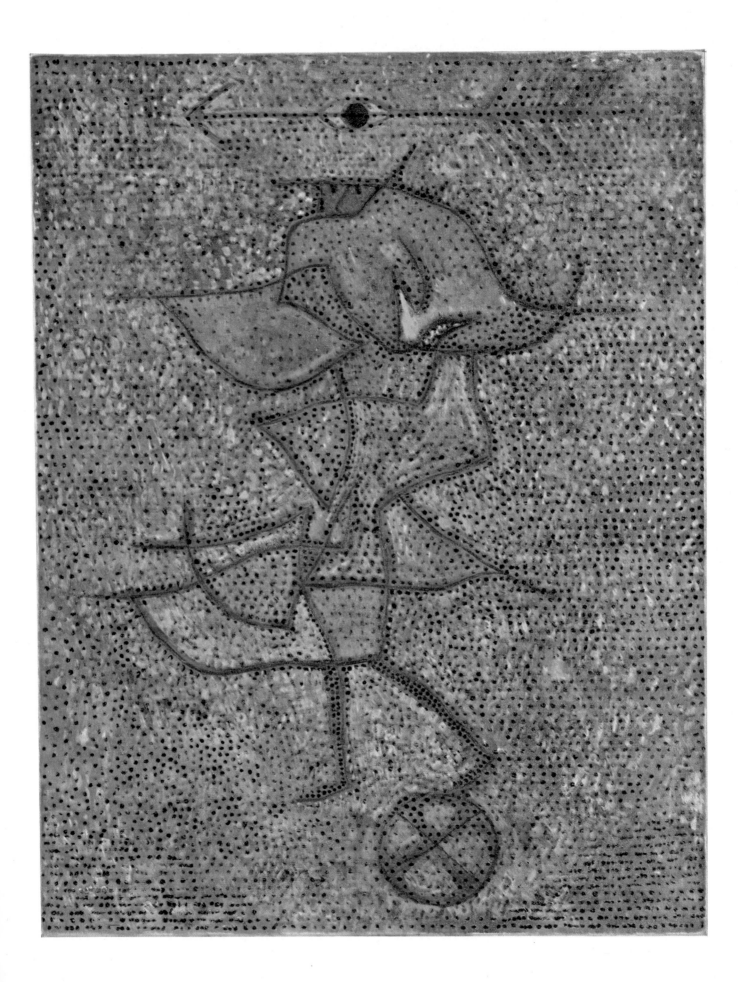

pink through purple and gray to deep brown. *Fishing Trawler in Distress* (1929, same pattern) seems to be endangered by the violent movement of the framework and the spatial overlappings and is like an intruder in this dream of time and eternity.

Yet the construction could become looser, the severity of the layers could be softened, the upward forces could abate. *Light Touches the Planes* (1929) approaches the imponderable; *Evening in Egypt* (1929) is hardly more than a hint. Figurative elements also may enter into the design: *The Clown Pyramidal* (1929) is like a parody on a sphinx irradiated by an evening glow. *City on a Lagoon* (1932) partakes of both the Egyptian scheme and parallel patterns, but the architecture of the horizontal bands broken at right angles is closer to the style of the *Fertile Country* than to that of the *Garden of Orpheus*. On the other hand, *Dead Cataract* (1930), despite Assouan and the serpent, belongs to the following cycle.

Two closely related groups of works appeared almost simultaneously in the summer of 1929. The first and more important one is based on the scheme of simple planes, superimposed or interlocked, the second on irregular, cloudlike planes, overlapping and transparent. This first group begins somewhat earlier and extends over several years, while the second is confined almost entirely to a few weeks' time.

Both are concerned with the problem of space, which occupied Klee more much insistently in 1929. After many experiments Klee wrote in April 1930 of his hope that "what I have achieved in the three-dimensional realm" would become lastingly fruitful for his work. He was not alluding to perspective or illusionistic space but to the "flow" of space; "the goal is inward, the problem mysterious," he said. This does not mean that Klee had ignored the problem of space until then. During the first world war he had hit upon solutions parallel to Cubism after coming very close to Cézanne in Tunis. After 1918 space had been a symbolic function in his art; and finally, by giving a stronger rhythm to the pictorial elements he achieved a more musical, and less expressive spatial structure; for his parallel configurations have a spatial effect somewhat like that of a fugue. The final stage is reached in the tonal polyphony of interwoven bands in the Egyptian landscapes.

The year 1929 led Klee to new formulations of space. Their forerunners are pictures like *Côte de Provence* (seven versions, 1927) with its intersecting quadrangles and triangles set against the horizon. In the spring of 1929 he did a number of drawings in which irregular

Côte de Provence Cl. Cat. 124

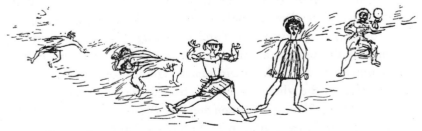

Last Hope 1929

quadrangles are placed alongside and above each other, with a triangle or arc added here and there. *Exit* is to some extent a preliminary stage of these new designs. It was followed after a brief interval by the panel *Dispute* (1929) in which the interpenetration of the colored planes clearly produces a spatial effect. Three very bright squares plumb the deepest point from which the space is measured.

At the beginning of 1930 Klee did a number of three-dimensional studies which are mathematical in their precision. They constitute the basis of the following pictures in which, however, the construction is concealed by concentrating on a few fulcrums – *Surfaces in Tension*, *Hovering*, *Sailing City*, *Cabins*, and *Dancer*. As always one finds later specimens of the same style, even very intensive ones like *Upsurge and Road* (1932). The structural pattern recalls those folded cartons that can be assembled and dismantled. Colored quadrangles, foil-like or dotted – one might even say perforated – intersect and interpenetrate in such a way that the stronger charge of energy gains the upper hand. The corners of the planes are linked together, giving rise to a second system of relationship which is coordinated with the first or at times superior to it. One is reminded of biplanes with connecting struts. The colors are very bright (in *Hovering* light Naples yellow on pink) and enhance the impression of soaring and flight.

Here again the structural pattern is primary; the construction results in a three-dimensional body in space; the system of struts, the transparency, and perforation render these bodies mobile and changeable, while the absence of a fixed reference point transmutes the whole system into a hovering constellation. Here too Klee pushes the scheme to a point where intuition intervenes and transforms the theorem into an exciting vision. In *Upsurge and Road* arrows and stars render palpable the simile of "finite infinity" as we conceive it today.

Far removed from earthly reality as these works are, Klee occasionally relates them to man by the addition of associative elements. To one spatial framework he gives hands and feet and makes it a *Dancer* (1930). The torn piece of silk on which it is painted represents the ground, the landscape setting.

Association can also encroach on the structural forms themselves. Although *Twins* (1930) is constructed like *Sailing City*, its metamorphic features (eyes and nose) have forced a modification of the intersecting quadrangles, a rounding of the corners, and a curving of the contours. Entire human figures may emerge from the schematic pattern, as in *Brothers and Sisters* and *Loaded Children* (1930). While the interplay of space and associative elements may be modified in various ways, it never produces volume – not even through added limbs or shaded edges. Any discrepancy between the structural system and the associative elements only serves to make the relationship of the two more expressive. In *Family Outing* (1930) and similar drawings of the same year, the precise, unadorned geometry of the shapes appears to contradict their human significance to such a degree that the effect of the whole is comic – a comedy based on form.

In *Atmospheric Group in Motion* and *The Place of the Twins* (1929) the very titles indicate kinship with *Sailing City* and *Twins*, however

Surfaces in Tension Cl. Cat. 125
Hovering p. 240

Twins Cl. Cat. 126

Atmospheric Group in Motion
Cl. Cat. 127

much they may differ from the latter in appearance. Here the drama of action-in-space has abated into pure lyricism. These watercolors were produced in the fall of 1929 and constitute a small independent group. What little there is of definable shapes results from the interpenetration and superposition of delicately colored screens, of nebulous yet somehow bounded strata. Aerostatic and aerodynamic elements are charged with associative values so as to produce weather forecasts *Before the Snow*, or a *Wandering Soul* (1929). No matter how far Klee may travel from this earth, he never loses touch with human life and destiny, with spirits, souls, and demons. Perhaps he alludes here to the transience and evanescence of man's life: "We merely drift past everything like a current of air," Rilke said. The space in these pictures is something like the "inside space of the universe" of which Rilke spoke; the inner and outer events coincide, and the tree in *Before the Snow* is no alien thing. "Oh I who want to grow, I look out the window and the tree grows within me."

Very close to the "atmospheric" group in effect are some pictures composed of continuous lines that intersect and form planes, as *Connection* (1930), and structures of superimposed surfaces like *Hat, Lady, and Small Table* (1932). The latter is a preliminary state of *Lady Demon* (1935) left unfinished for several years. In these works the element of airy mobility and translucence is directed toward the demonic. *Lady Demon* is a fearful gray-blue double face weighed down by a mountainous hat; *Poison* is a nocturnal, black shape that embraces and strangles a white one, a face.

A third important group of works conceived during the Dessau period comprises the pictures that Klee called Divisionist. They are panels and watercolors (but no drawings); here Klee, in his own way, makes use of colored light as Van Gogh and Seurat had done before him. On a slightly differentiated ground he places dots of varying

Work. Dessau; Atmospheric Group

Before the Snow Cl. Cat. 129
Wandering Soul Cl. Cat. 128

Poison Cl. Cat. 123

Divisionist pictures

Downward 1932

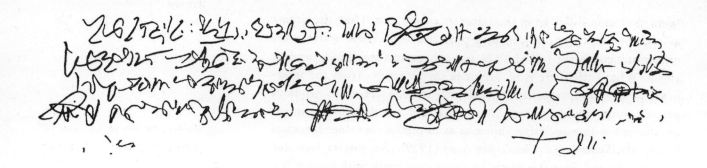

(above) *Abstract Script* 1931

Mosaik from Prhun Cl. Cat. 134

Sunset Cl. Cat. 133

Steamer and Sailboats
Cl. Cat. 135

color and intensity in closely-set rows and organizes this "field of dots" by the use of intervals, through relations between colors and planes, or by graphic accents and symbols. Klee differs from the Pointillists in that he does not "split" his colors to achieve an effect of greater luminosity nor does he arrange them according to the law of "simultaneous contrasts," but works with rows of dots of the same color. A connection with Seurat exists only to the extent that the latter was concerned with metaphor and symbol, with analogies of color, tone, and line. The designs of the preceding series had led Klee to ask himself whether space could be rendered with color alone, whether color could be made an instrument for the conquest of that "infinity within the finite" which was his goal. Was it possible, he wondered, to "humanize" the spatial functions of color?

This style, too, had its forerunners. In *Child in the Aster Garden* (a black-and-white watercolor of 1925) he already suggests in certain places the system of division into colored particles. In *Garden in Pot* (1926) Klee employs small round colored dots, though still with a certain representational intent; in *West-Easterly Buildings* (1928) he uses rows of small squares as he does later in the "mosaic" pictures, which are akin to the Divisionist ones (cf. *Mosaic from Prhun*, 1931). The process of "division" had already preoccupied Klee for quite some time before it gave rise to a new manner.

The first picture of the cycle – *Sunset* (1930) – was painted at the same time as *Twins* (1930); *Polyphony* (1932), on the other hand, was done simultaneously with *City on a Lagoon*. The contrast between these works illustrates Klee's remarkable ability to pursue several different paths at the same time. His powers radiate from a common center in various directions, and a new beginning is thus more than the start of a new growth ring. *Sunset* is such a beginning; on an earth-colored ground lies a dragonlike form composed of four polygons in light blue and purple; above it are two cloudlike but sharply defined shapes, the upper one with vermilion and the lower one with dull blue dots (evening and night). A red circle with an arrow pointing downward may be the sun; a second circle above it, enclosing a weeping eye, may represent man or the moon: emotions at sunset. Here the Divisionist areas are only parts of the whole and serve to complete its message.

Next come the chief pictures of the group: in 1931 *The Light and So Much Else, Classic Coast, Bridged, Steamer and Sailboats* (in three versions: early morning, noon, and evening), and *Diana;* in 1932

Work. Dessau and Düsseldorf;
Divisionist Pictures
Landscape Uol Cl. Cat. 136
At Anchor p. 313

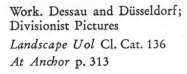

Fermata, Polyphony, Ad Parnassum, Landscape Uol, North Room, At Anchor, As If Infinite, and *Female Dancer.*

As soon as Klee, in the course of his explorations, discovered the structural pattern of Divisionism he found a flood of images which had been waiting for this very discovery; whose matrix was the new light-filled space itself. The pattern does not restrict his means of expression but expands them; for with Klee, imagination is always in tune with observation. Thus he could paint light in his pictures both in terms of its own internal harmonies – its polyphony, as it were – and with the exactitude of a mathematician balancing the terms of an equation.

In those two years there is no apparent development in Klee's handling of Divisionism save perhaps, in *Ad Parnassum,* a gradual loosening of the pattern due to greater stress on the image within the structural system. That the possibilities of the scheme were not exhausted is proved by *Polyphony,* which was painted simultaneously with *Ad Parnassum;* and even *Light on the Past* (1933) – an echo of the Egyptian trip – shows no trace of slackening.

Ad Parnassum Cl. Cat. 137

Some of these pictures such as *Polyphony* have no representational subject at all; others, like *Steamer and Sailboats* or *Female Dancer,* are as fully recognizable as those of other phases of Klee's work.

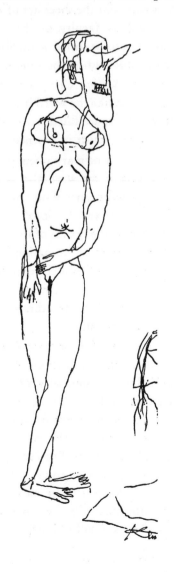

Masked-Naked 1932

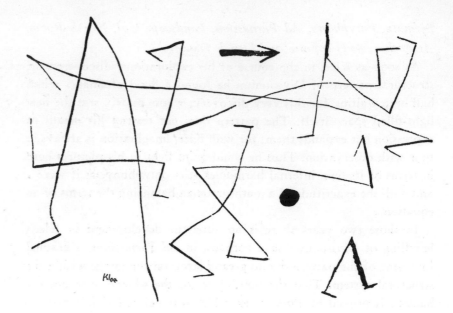

The Second Waves Attacks
1933

Diana p. 279

Divisionism is as applicable to the absolute as to the metaphorical, if indeed the two can be separated, for to Klee *Fermata* means something just as definite as *Diana*. What matters is not the bodily shape of a goddess – or a coastline – but the truth concealed behind the veil of Divisionism. Klee was aware that the sheer act of drawing or painting will fertilize the image-making faculty of the mind – a faculty he regarded as sovereign and not to be trifled with. Sometimes the result is an "image contracted and focused in the mirror of the spirit," like *Highway and Byways* and *Sailing City*. The pictorial medium is indeed finite like the word, but like the word it has a magic power.

In the pictures of this cycle, space filled with colored light takes the place of "constructed space," which in essence does not depend on color. Goethe regarded light as a primary phenomenon, both in nature and in art, for to him works of art were also "the highest works of nature, produced by men in accordance with true, natural laws." And in the colors he saw the "actions and passions" of light. Novalis went still further; for him, light was "the breath of life itself, simultaneously decaying and being formed anew ... an action of the universe ... a divining agent." For Klee, too, the colored light-space was more of a spiritual than a physical phenomenon; it mirrors his own inner world and does not presuppose any other. He acknowledges no distinction between the within and the without.

The Light and So Much Else
p. 241

One of the most intense works of the series is *The Light and So Much Else*. A surface like enamel; the small, brightly varnished squares of iridescent color are applied on a ground of white oil lacquer, and their green and blue hues are sensitively graded. The straight lines give the effect of measuring devices; but there is also a small flag, and suddenly the whole thing might just as well be the image of a harbor, though projected onto a very unearthly plane. For even the fixed points have no greater reality than the digits in an equation with many unknown quantities. What indeed can *So much Else* mean, next to *Light*? The red circle in the upper center might be the sun, but the light does not proceed from it. It is, rather, a wholly "independent action," as Klee

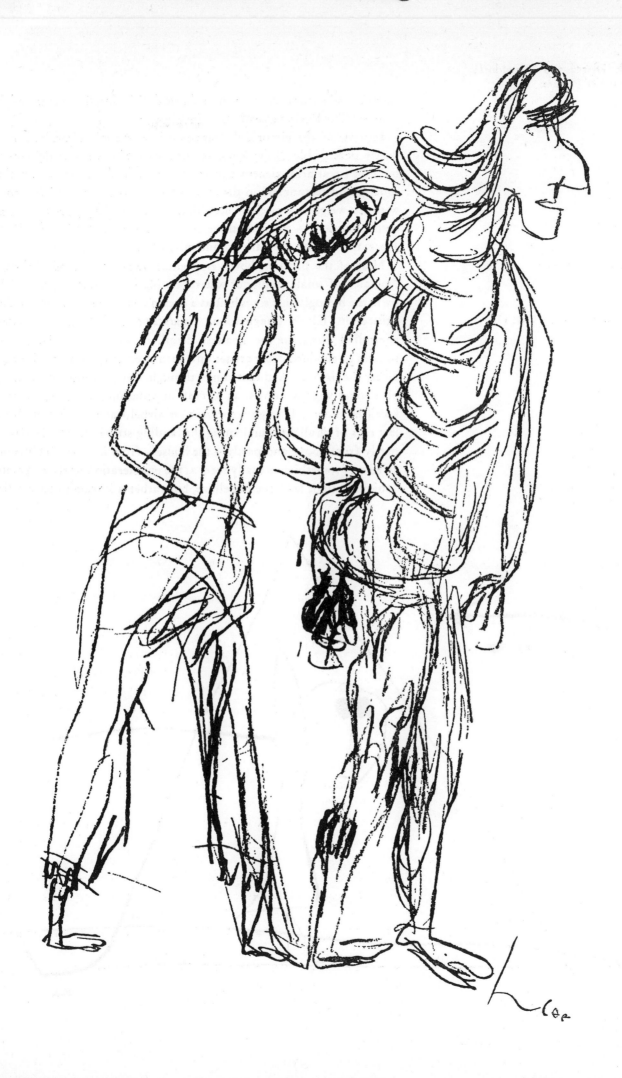

said in his lectures. A more metaphorical title for the picture might well be "The Divine Eye of Day" (Sophocles).

In some of the pictures the metaphoric element is either absent or barely perceptible. *Polyphony*, the strongest of these, is a light-space built on fugal arrangement and counterpoint and, in the overlapping squares and rectangles, on the effect of the "magic square." *Fermata*, with its weightless circle – according to Klee, the "purest form of cosmic motion" – has something of the nocturnal sky in *The Magic Flute;* the dots on the dark ground might be stars.

Most of the pictures, however, contain explicit symbols. *Prhun*, a "mosaic" of small, luminous squares on black, occupies a place of its own; the hieroglyphic signs hint at a dream city – one of the many that existed in Klee's imagination. *Landscape Uol* (1932), precisely controlled down to the smallest detail, is an evening vision. The squares of subdued color are set on a saturated gray ground with gaps where the light-colored base comes through. One can discern the shape of a house with windows, an aircraft approaching, and, higher up, a face (the moon). It might represent an airfield at nightfall, with the last rays of daylight illuminating the landing strips, the whole viewed partly from above and partly – the house – from in front. This is not an echo of something actually seen, as the enumeration of the enigmatic "objects" might lead one to believe, but rather a station in interstellar

Mosaic from Prhun
Cl. Cat. 134

Landscape Uol Cl. Cat. 136

(below) *Shame* 1933

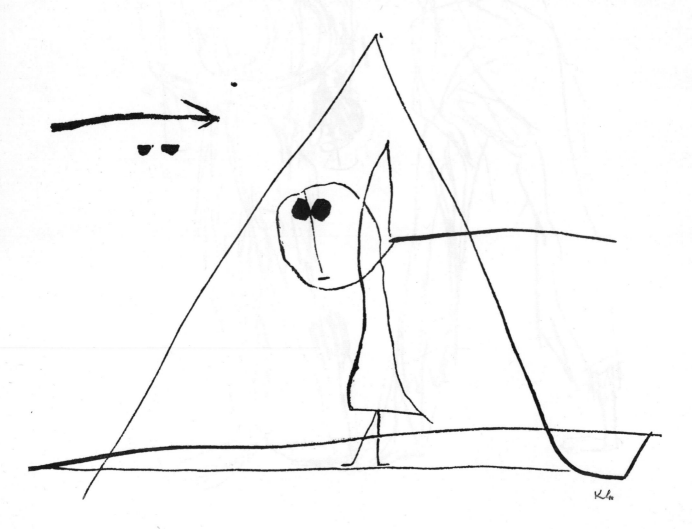

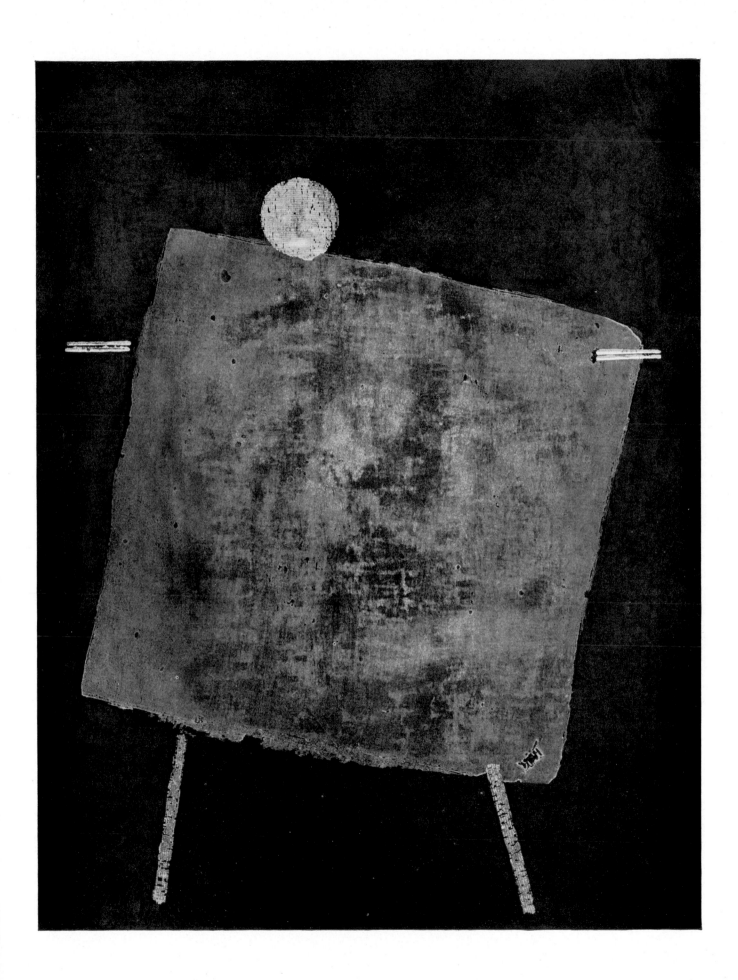

Vogelscheuche (1935) / *Scarecrow* / *Epouvantail* 289

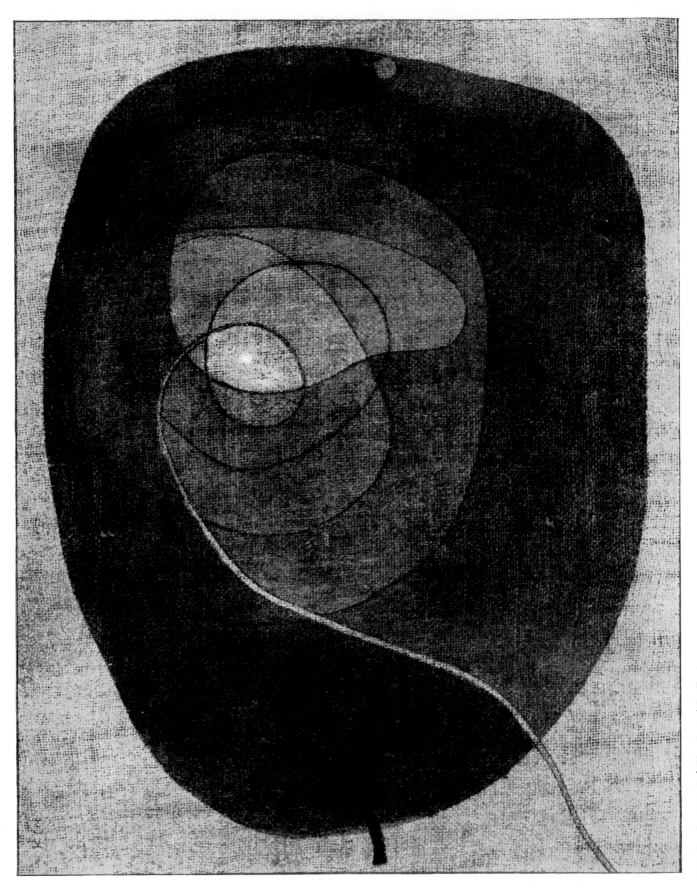

Die Frucht (1932) / The Fruit / Le Fruit

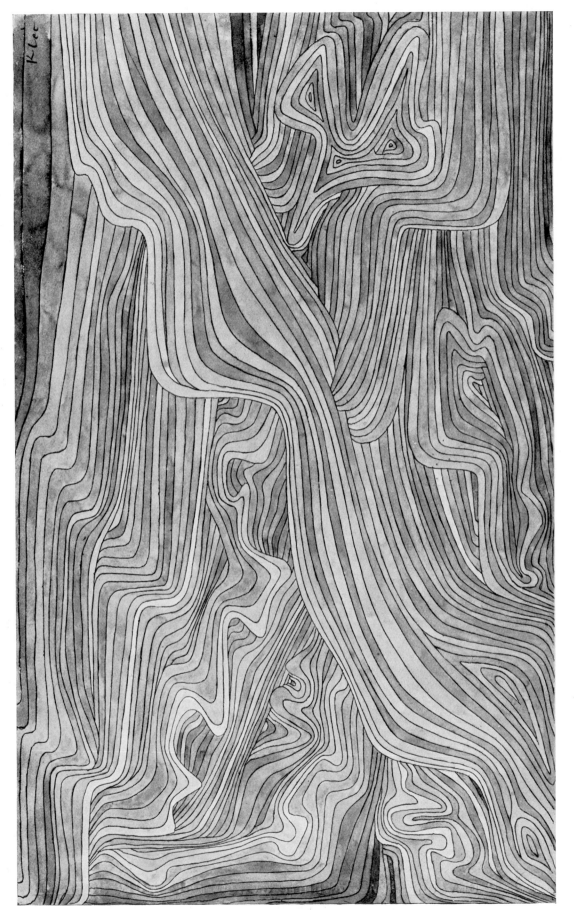

Wildwasser (1934) / Untamed Waters / Torrent

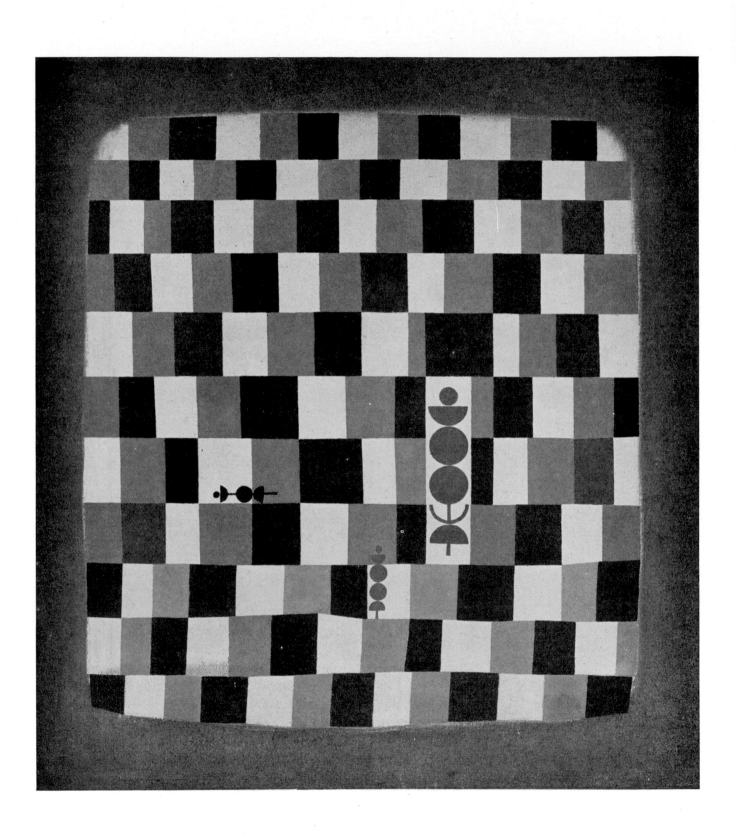

Überschach (1937) / *Super-Chess* / *Sur-échec*

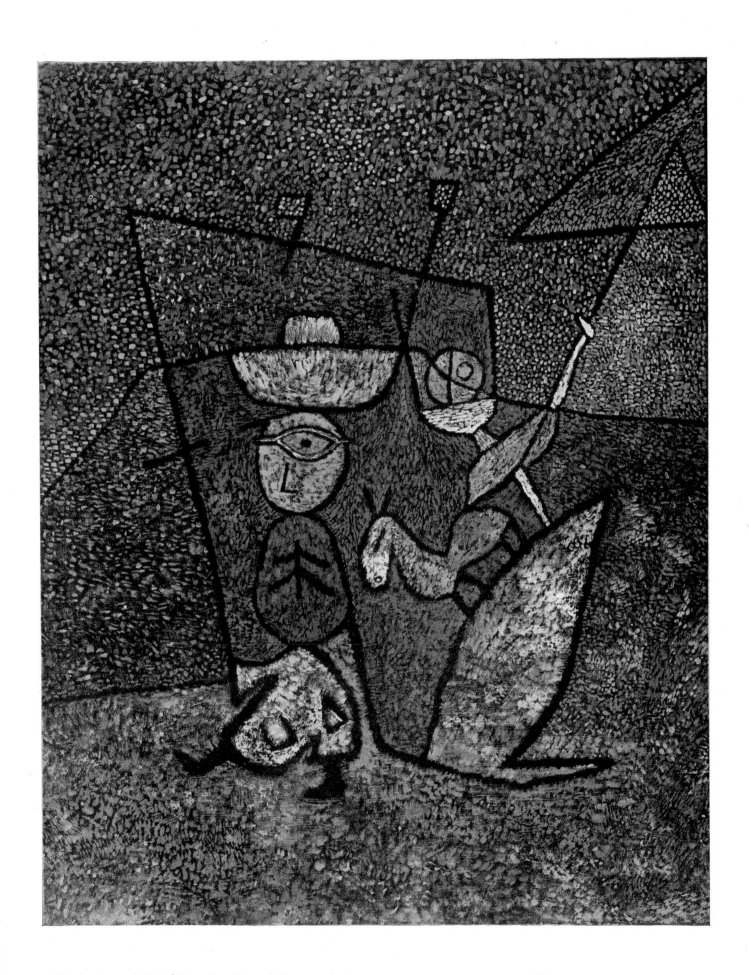

Wandercircus (1937) / *Traveling Circus* / *Cirque ambulant* 293

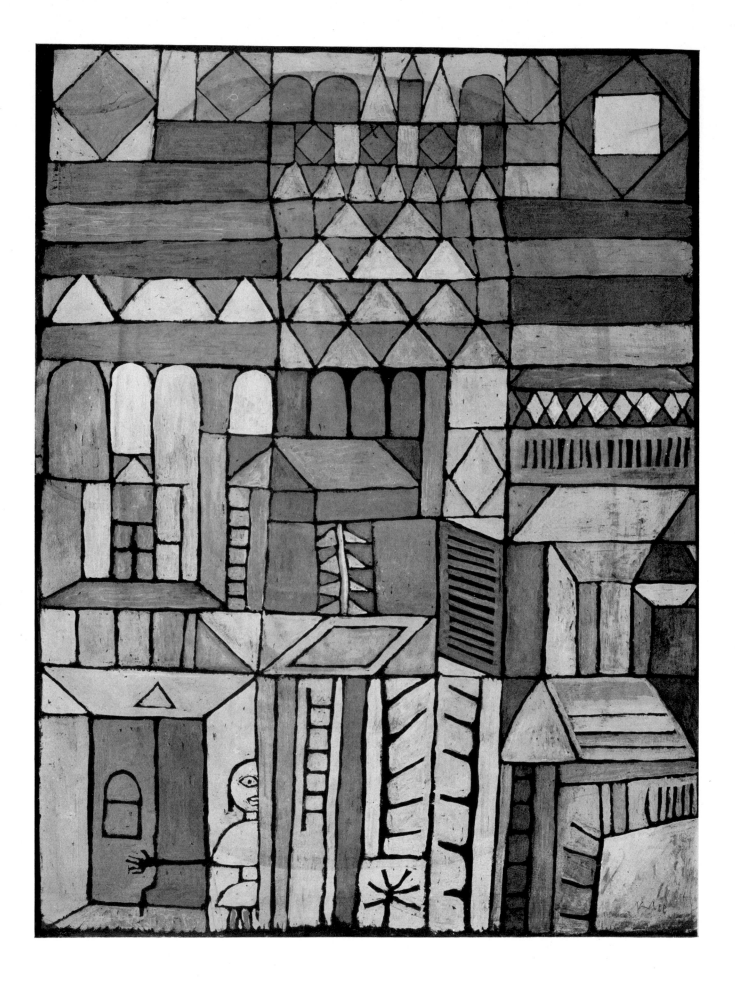

Beginnende Kühle (1937) / *Early Chill* / *Première fraîcheur*

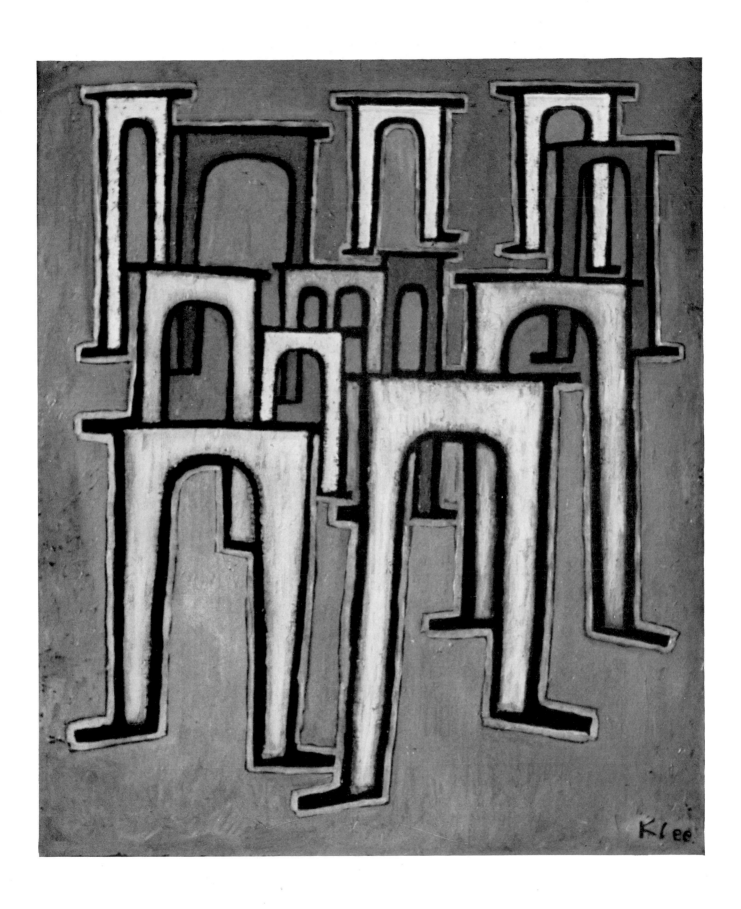

Revolution des Viaduktes (1937) / *Revolution of the Viaduct*
Révolution du viaduc 295

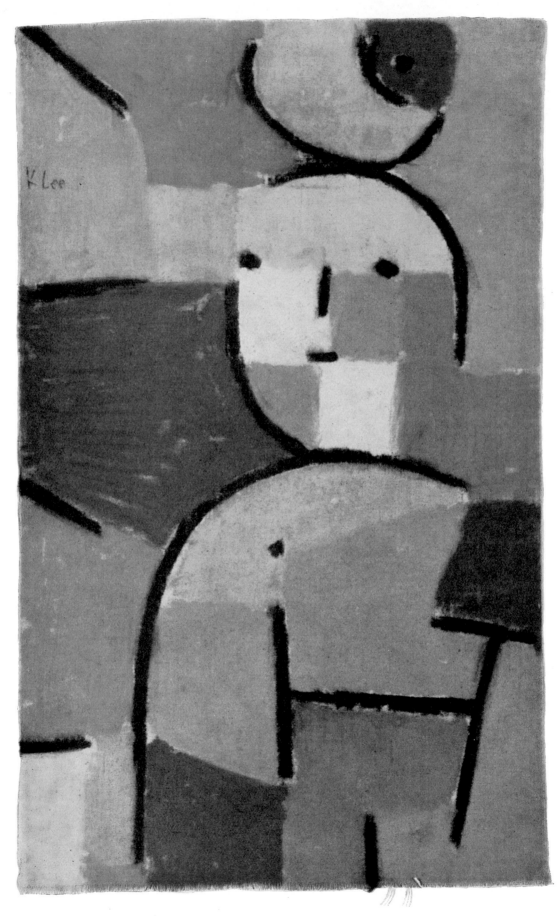

1937 S.6. Kind in Rot

Kind in Rot (1937) / *Child in Red* / *Enfant en rouge*

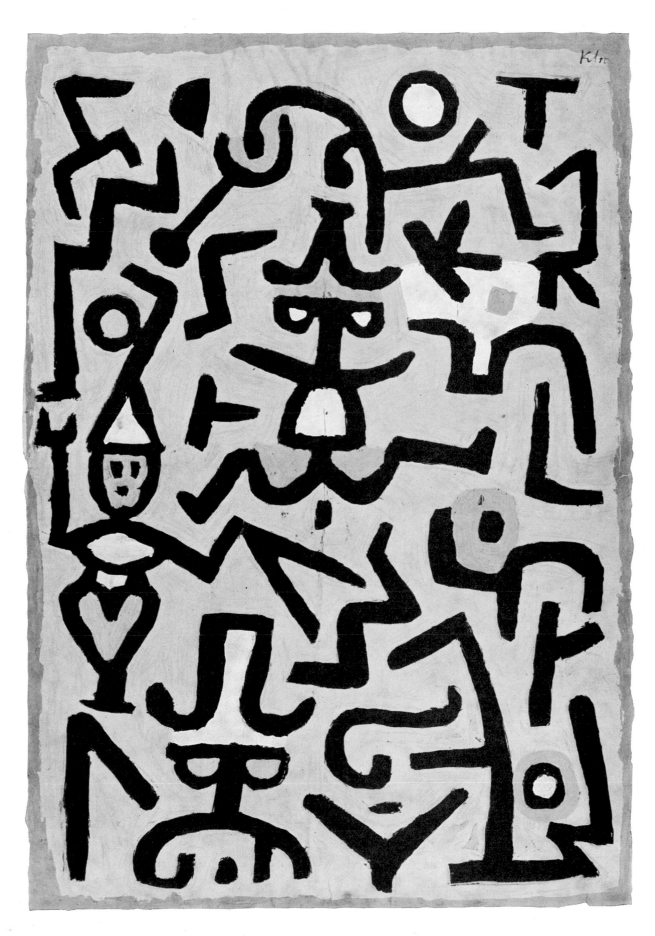

1938 E2

Werbeblatt der Komiker (1938) / *Poster for Comedians* / *Affiche des comédiens* 297

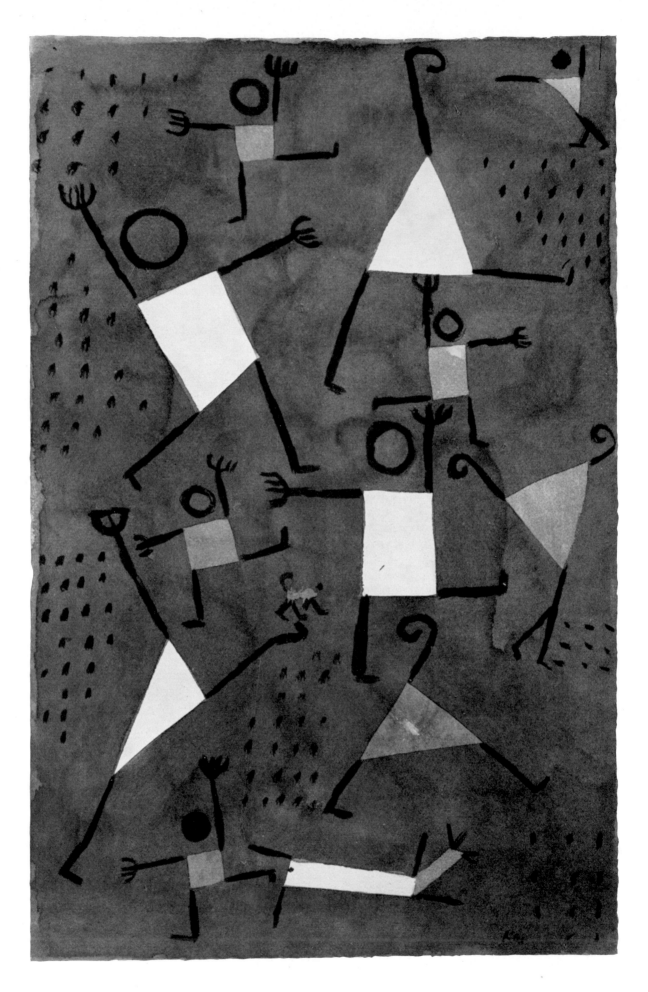

Tänze vor Angst (1938) / *Dancing for Fear* / *Ils dansent de peur*

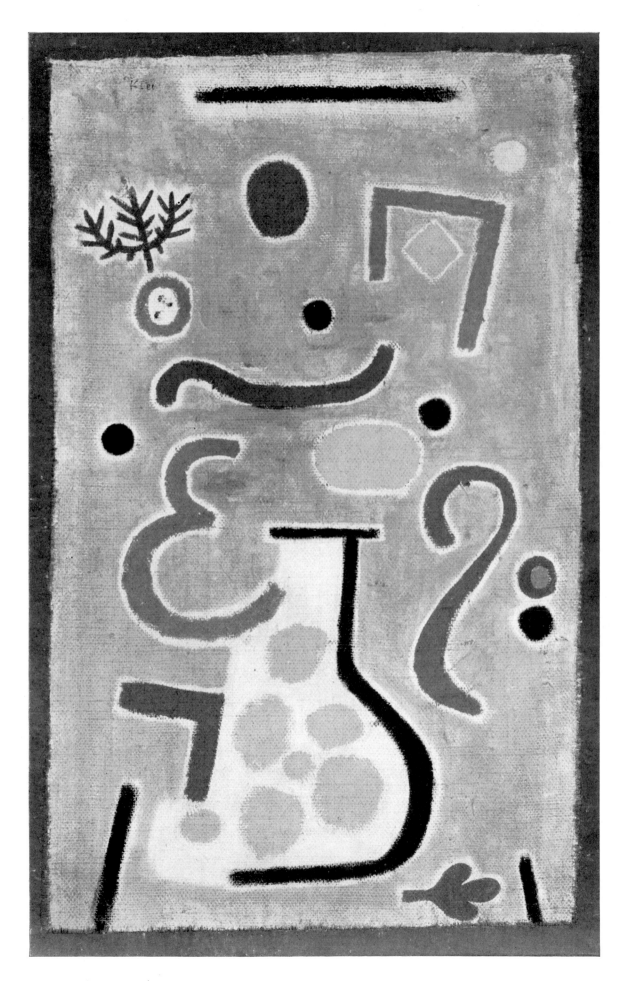

Die Vase (1938) / *The Vase* / *Le Vase* 299

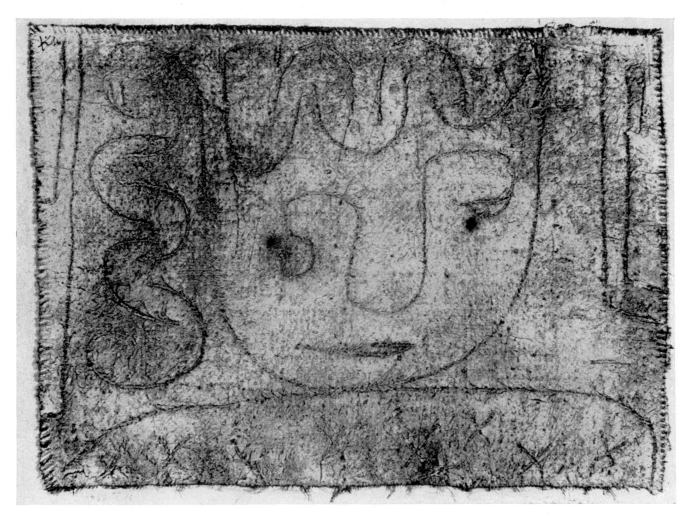

Frühes Leid (1938) / *Early Sorrow* / *Douleur précoce*

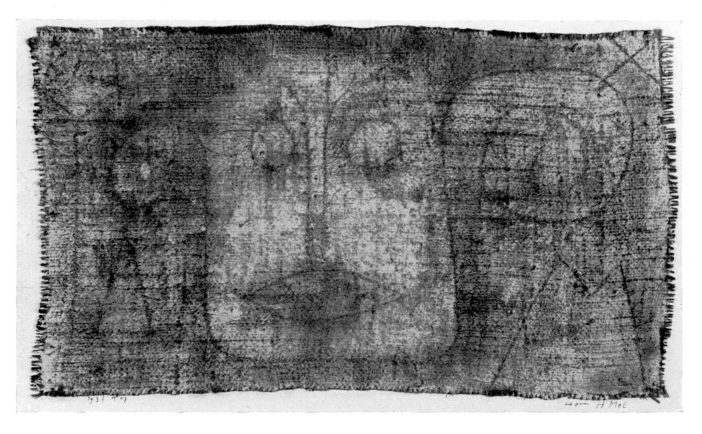

Herr H. Mel (1938) / *Mr. H. Mel* / *Monsieur H. Mel*

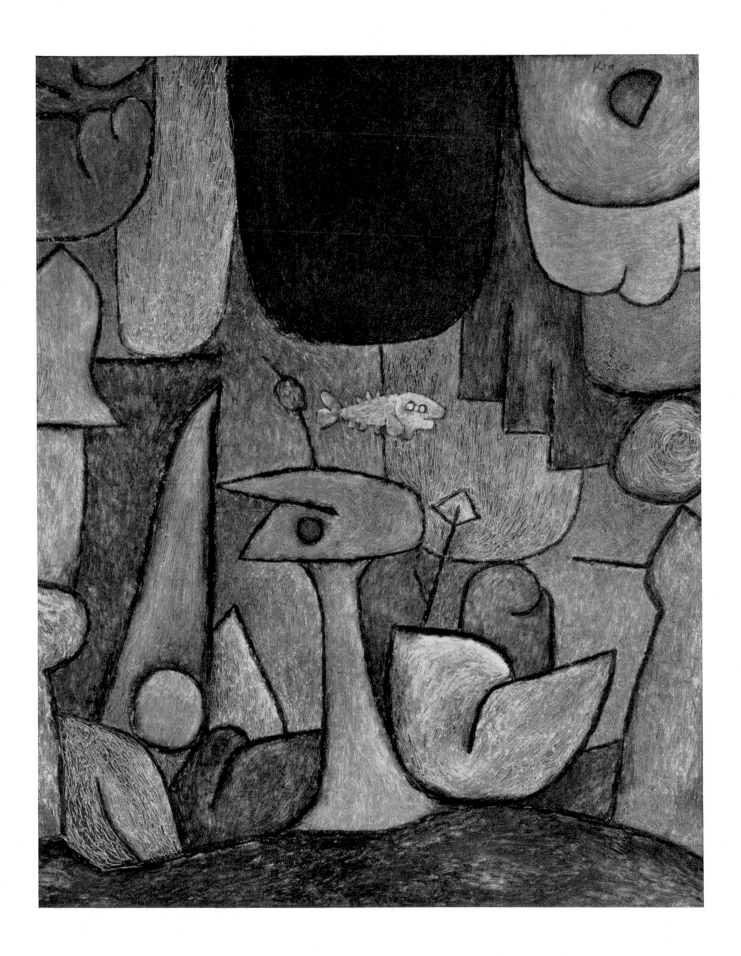

Unterwassergarten (1939) / *Underwater Garden* / *Jardin sous-marin* 301

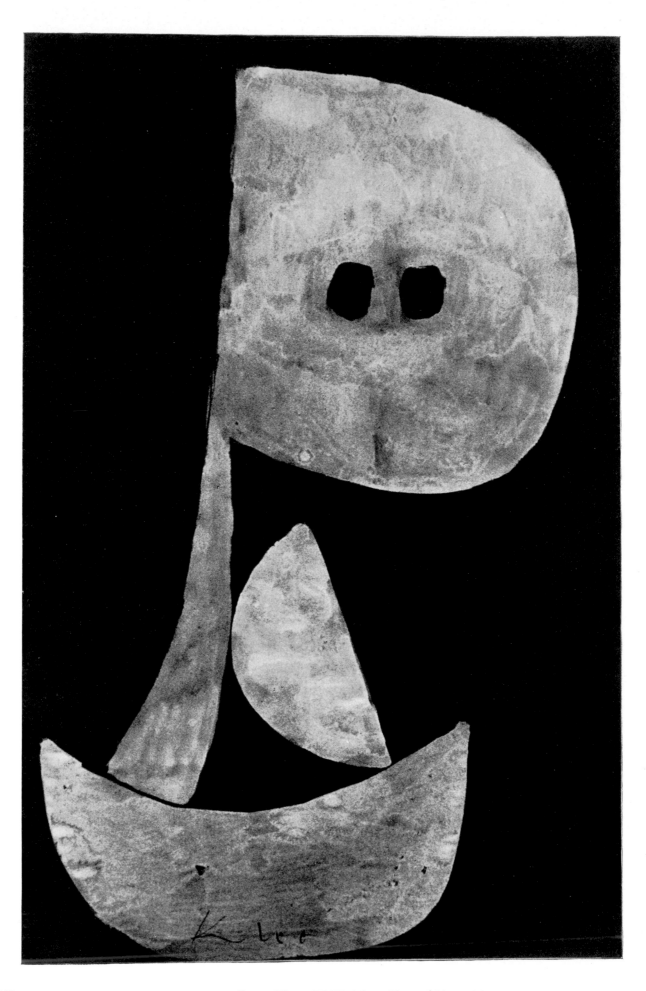

302 *Ernste Miene* (1939) / *Stern Visage* / *Mine sévère*

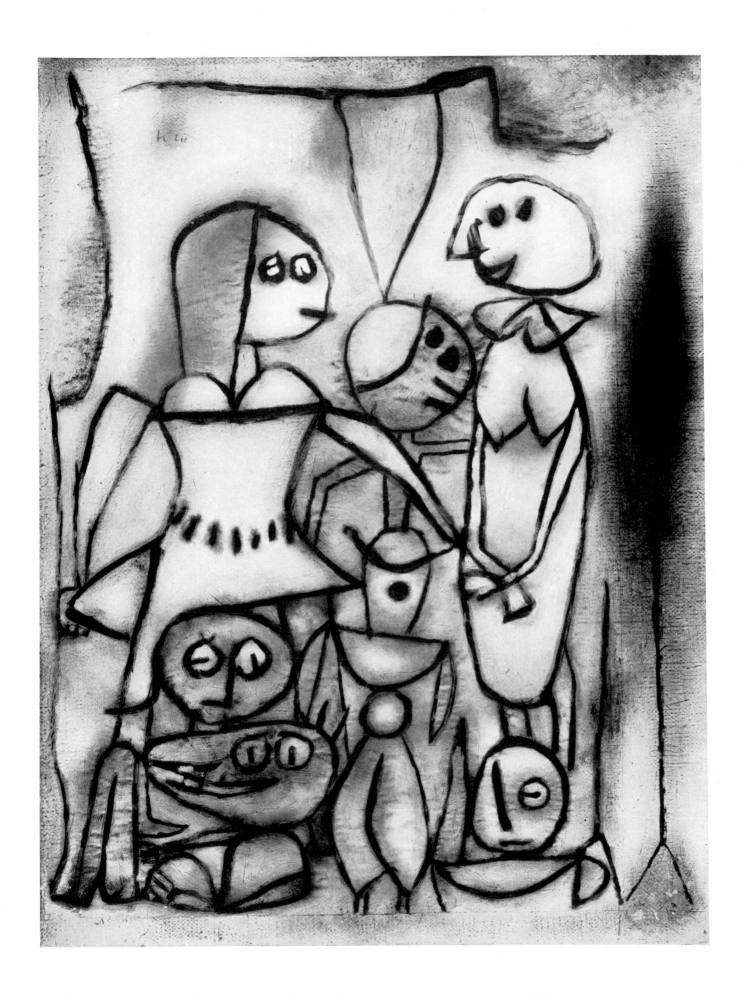

Gruppe der Masken (1939) / *Group of Masks* / *Groupe des masques* 303

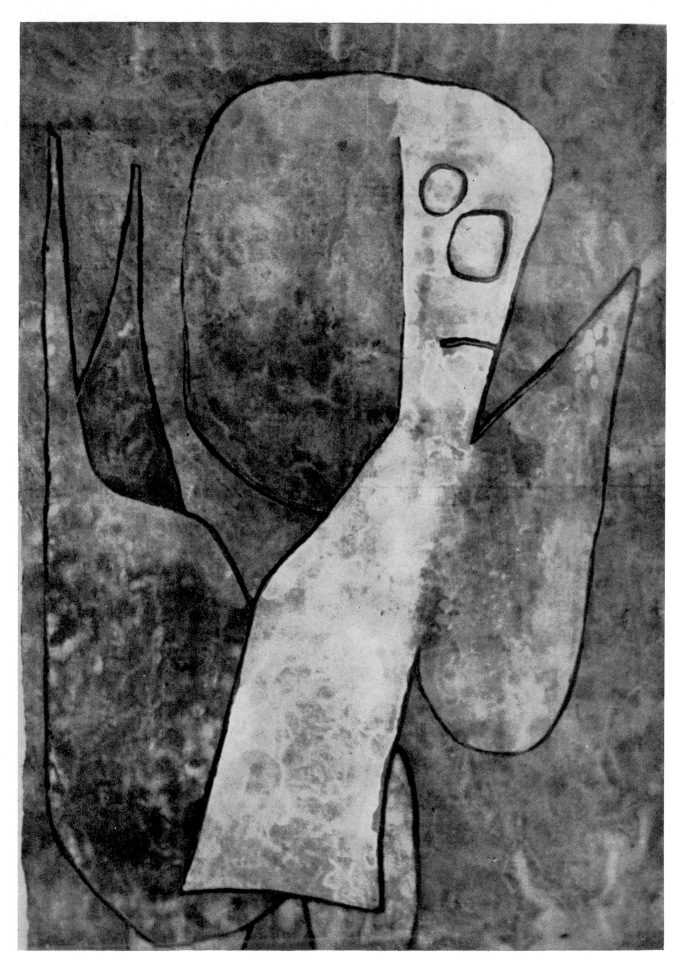

Armer Engel (1939) / *Poor Angel* / *Pauvre ange*

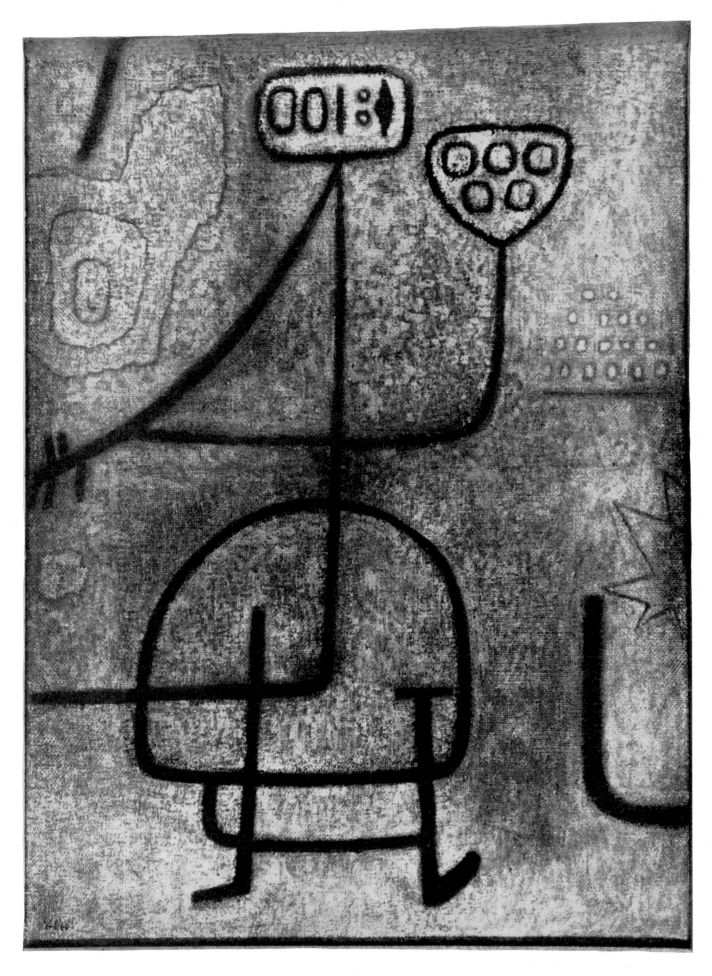

La Belle Jardinière (1939)

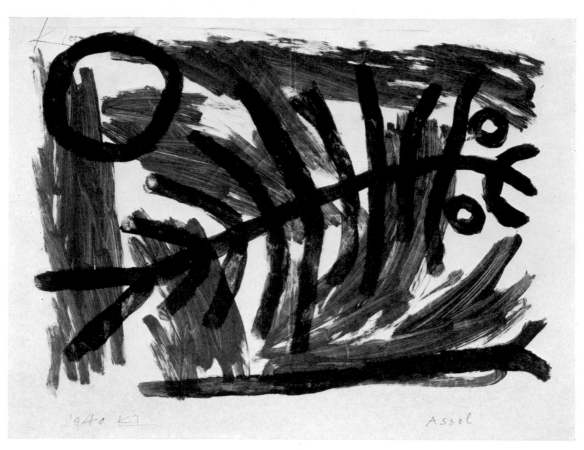

Assel (1940) / *Wood Louse* / *Cloporte*

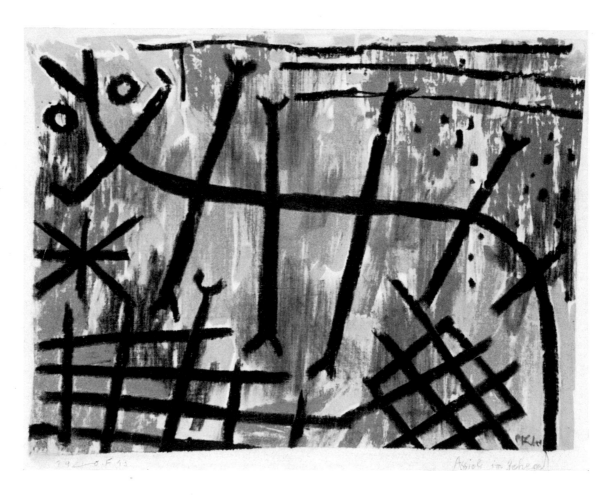

Assiel im Gehege (1940) / *Wood Louse in Enclosure* / *Cloporte enclos*

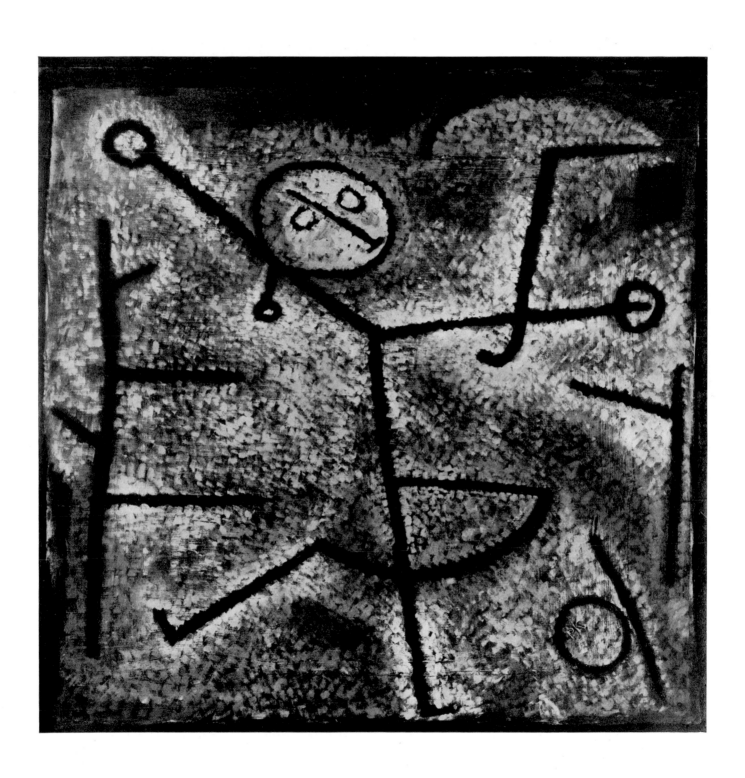

Tänzerin (1940) / *Female Dancer* / *Danseuse* 307

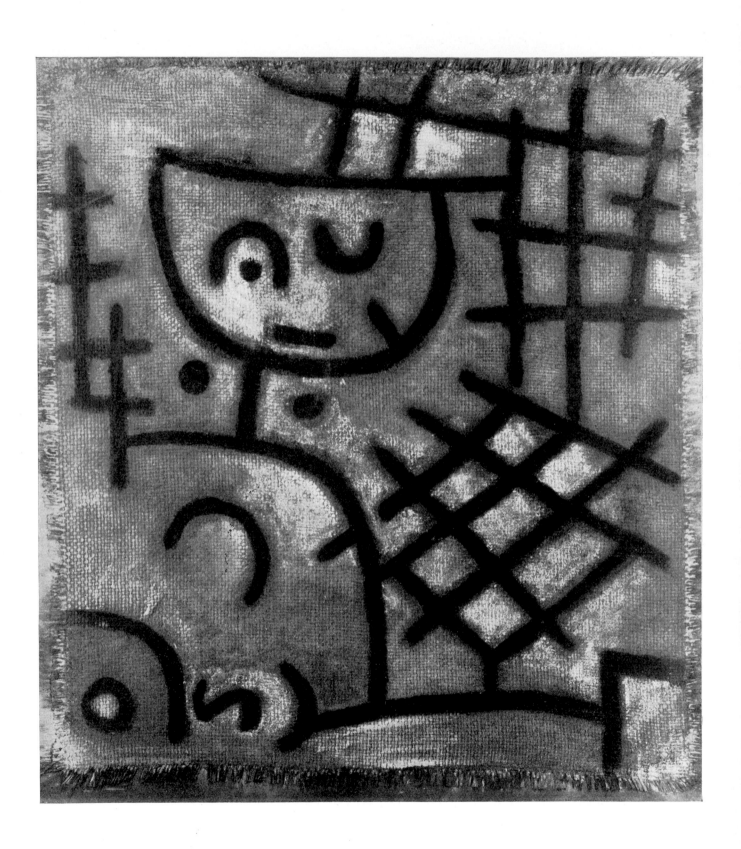

Gefangen (1940) / *Captive* / *Captif*

space, depicted by a hand "guided by remote forces" (Klee). The association "airfield" probably intruded itself upon the painter while he was working on the picture and suggested the more realistic reference points.

At the end of the series are pictures which no longer depend on light-space to the same extent. *Ad Parnassum* is so firm in structure that the Divisionist pattern looks superimposed. In *At Anchor* (1932) the pattern actually disappears toward the edges of the picture; while in *Regulated Fertility* (1933), a gardener's or grocer's display with fruit, the design is so representational that it hardly belongs to the series at all.

Ad Parnassum Cl. Cat. 137
At Anchor p. 313

The Dessau and Düsseldorf periods produced a large number of pictures that are difficult to classify. They are either quite isolated specimens or combine to form small groups. Some are thematically related to larger cycles, differing from them, however, in formal character; others may be linked to one expressive pattern or another without conforming to it. Klee at this time was about fifty years old and had achieved such a degree of freedom that he could afford to obey impulse. He was receptive to everything and penetrated into ever more distant regions of time and space. For him the most remote was also the nearest, and past and future were equally present. The creative process came to be ever more concentrated as his reach increased.

Miscellaneous pictures

In 1925, while still at Weimar, Klee painted *Flowers in Glasses* — expiring carmine, orange accents on a black ground, nocturnal blues. The picture was one of those that he always kept in his home. Its Franciscan simplicity recalls the Douanier Rousseau. If his attention had been called to this resemblance he might well have answered: "I had to have a Rousseau, too!" Still life is perhaps not the correct term for a picture of this kind, for in Klee it is not so important whether the shapes turn into flowers or something totally different. In the representational elements of his pictures he saw nothing more than the coincidence of his own creative process with the creative impulse of nature. Sometimes it is the process that predominates; sometimes, the result, the "re-presentation" of nature. Here, too, his flexibility as a maker

Flowers in Glasses Cl. Cat. 59

Animals in Enclosure 1938

A Sailor Feels the End Is Near
1938

Around the Fish p. 229

*Plants in Still-Life with
Window* Cl. Cat. 148

Colorful Repast Cl. Cat. 149

of images corresponds to his "mobility on the paths of natural creation."

Klee's phosphorescent *Goldfish* (1925), which hung in the Berlin National Gallery until 1936, is a sort of submarine garden, very neatly and properly embroidered, and the wavy lines of the water are in perfect harmony with the blossom and leaf forms. *Around the Fish* (1926) is still more enigmatic – a real carp on a dish, but surrounded by symbols, stars, a cross, an arrow, little flags, two vases with star-shaped blossoms, a cut lemon. The arrow joins the fish with a flower that ends in a mask. What does it mean? Fate, perhaps, or guilt? Is the fish something else as well, a symbol of Christ, for example? One thing is certain, however; the word "around" in the title was not chosen haphazardly. The same applies to *Plants in Still Life with Window* (1927). The tablet of hieroglyphics on the wall – if only we knew how to read it – might perhaps explain the strong tension of the black and red on the cold green ground, the connection between the silvery moon, the exotic plants, and the head of the negro child. A disquieting story from the Orient disguised as a "still life." *Colorful Repast* (1928) is quite *Neighborly-By-Chance*, which is the title of a similar sheet of 1929. The objects play-act as if they were living creatures. The tomcat and the figurines – are they actors or ceramic vases? It really makes no difference, for they are symbols in any event, and a tomcat (a German *Kater*, which also means "hang-over") is quite at home in the tipsily rotating pattern with the brandy bottle and the tilted glass. Even *Still Life with the Dove* (1931) is really not a still

life at all but rather an elegy, with a very delicate musical accompaniment in green and pink.

But what might *Time and the Plants* (1927) be? Blossoms and cut fruits built up of spirals and circles, a sunflower with radii like those on the face of a clock, and a swinging pendulum: hence sundial, sun, growth – the principle of transience visually demonstrated with elements of the vegetable kingdom. *Time and the Plants* is followed in the same year by *Limits of the Intellect*, another scientific-magical picture with complicated interlockings that suggest a face and continue upward in ladders to the heavenly body crowning the intricate framework. The ascent is definitely more dangerous than on the sheet dedicated to Leon-Paul Fargue *(Ascent,* 1925).

To the category of "script pictures" belongs *A Leaf from the Book of Cities* (1928) – a musical score, its staves inscribed with honeycomb-shaped, house-like "notes," little flags, and stars; at the top, between a red and a green beam, the moon – a precious miniature framed by a wide dark-green margin. *Ad Marginem* (1930), too, looks like an old document, with the dominant red planet in the center on a field of weathered green. The ghostly writing is scattered along the margins as in a child's drawing; included are plantlike hieroglyphics, a bird, fragments of figures, and letters of the alphabet – a diploma from the realm of nature. Even the script picture proper, which had interested Klee from 1916 to 1918, reappears in a different form, for instance in *Abstract Script* and in *Plant Script Picture* (1932). The curved forms of the latter in opaque topaz-blue and pink, are not unlike Arabic characters. Many other such plant script pictures were produced in 1932.

In 1930 we find three demonic images – *The Devil Juggling, Conqueror*, and *Refuge*. Stylistically they have nothing in common. In *The Devil* Klee exploits his knowledge of precise construction, which, in this case, serves to deepen the disquieting mystery of the dancing Siva-like figure with its many limbs. The agile arms are hinged rods, the eyes are circles, the left hand grows out of the rust-brown body – a terrifying shape that could never be consciously invented but only "discovered" in the process of artistic creation. In comparison *Overloaded Devil* (1932) looks like a carnival figure. The Mongol *Conqueror*, on the other hand, is on a par with the juggling *Devil;* the strange, oversized flag and the aggressive colors portend misfortune. In *Refuge* the demonic element is transposed into the passive voice; the spirit, a head with arms and legs, its eyes staring, issues forth from the shelter of its own world toward the beholder, more terrified than terrible.

The first picture Klee painted in 1930 is *A New Game Starts* – an oblique rectangle set in a horizontal one and, modestly added on the right-hand, edge, the painter as helmsman. An exceptional sheet, it is an anticipation of later things like some others executed since 1930, including the cool and calculated *Staging* and *Open Book* (1930). It may be a reminiscence of the rock tombs of Egypt.

From 1932 on Klee approached closer and closer to unconditional statements; instead of combining many different symbols he now tends to employ a single one that contains them all. *The Fruit* (1932) and

Time and the Plants p. 228

Limits of the Intellect p. 232

A Leaf from the Book of Cities p. 233

Ad Marginem p. 237

Plant Script Picture Cl. Cat. 138

The Devil Juggling Cl. Cat. 143
Refuge Cl. Cat. 141

Conqueror Cl. Cat. 142

Staging Cl. Cat. 110

The Fruit p. 290

Arab Song Cl. Cat. 144

A Small Room in Venice
Cl. Cat. 122

Female Mask (1933) are composed of continuous twisted threads that remind one of umbilical cords. *Glance of Silence* (1932) might just as well be a death's head as a landscape with the moon. The contours are applied in thin paint on absorbent rough-textured linen in so simple a manner that one feels almost as if faced with the work of a primitive. *Arab Song* (1932) is nothing but a veil, large as a stage curtain, out of which gaze two fascinating eyes and a lightly curved line with a heart-shaped leaf pointing toward the heart. In Tunis the Arab song had been an "eternal rhythm"; now it is both melodic and deeply melancholy.

Shortly before leaving Germany, Klee did a number of very fine pastels such as *Blossom in the Night* (1933) and *A Small Room in Venice* (1933). They had been preceded in 1932 by a couple of other works in the same medium, such as *Gaiety by the Inner Lake*. The translucency of Klee's pictures at that time demanded this new technique. The coarse absorbent linen had subdued the impact of color and shape to the point where they looked like the lowest layer beneath many that were left unpainted. Pastel colors recede still further into the surface, so that their radiance seems to enter the picture as if from behind. *A Small Room in Venice* is like a painted window admitting the luminous night into the room. Perhaps the red triangles are the curtains of a window through which one can look out into the blue. The red circles on the blue ground might be eyes, but like the stars they gaze in, not out. The whole may be the memory of a night spent in that improbable city whose streets are waterways and whose houses are stage sets. The intense dark blue of the paper ground shows even through the bright red but is rather warm than cold, for how could Venice be cold? This is not, however, the city marked on the map, but a dream city out of the Arabian Nights, very oriental in tone, color, and form. The poet Theodor Däubler had the same impression of Venice and praised it with similar metaphors. Had he and Klee collaborated – as they planned to do at one point – they might have achieved a unique cross-fertilizing of poetic and visual imagery.

Thus even the move from Düsseldorf to Bern did not mean a break in Klee's artistic development. His final phase had been prepared since 1932, and after the inevitable interruptions due to the change of residence and the search for a place to live, it was easy for him to continue the "unifinished work," as he called such beginnings.

Bern 1933–1940

Klee stayed in Bern until his death six and a half years later. The years 1934 and 1935 are like a new start which was then interrupted by illness for nearly twelve months. In 1936 he produced practically nothing; it was a year of rest and also a period of preparation for his last works. Klee utilized this time of enforced inactivity and solitude to meditate and achieve an ultimate maturity.

His first task was to make himself at home again in Bern and all his old friends did their best to help him do so. There were invitations, musical evenings, concerts, visits to exhibitions, and the preparations for his own comprehensive show in February 1935. This took a lot of

(page 313) *At Anchor* (1932)

(Seite / page 315) *Figur im Garten* (1937) / *Figure in a Garden* / *Figure au jardin*

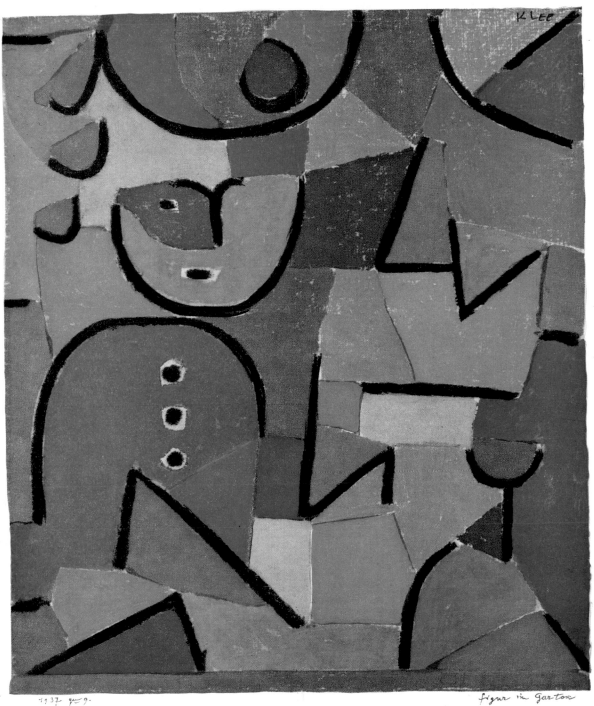

1937 y=9. figur in Garten

time, and in the weeks before and during the exhibition Klee hardly managed to work at all; nonetheless, before he fell ill in 1935, he produced a quantity of works that reveal him at the height of his powers. But it is only in 1937 that the "late style" begins.

Klee thought over what he had done during the last few years and found much that needed to be supplemented and clarified. That was perhaps the purpose of *Figure of the Oriental Theater* (1934). The artistic and teaching activities of the years previous to 1933 were now so far behind him that he felt free to speak more frequently and with less constraint about his works and to drop helpful hints about them to visitors. Of *Mixed Siesta* (1934) he said that the associative elements (eyes, etc.) were not unimportant; the Constructivists avoided them intentionally and left everything open, which was no advantage, he thought. *Low Tide* (1934) elicited the explanatory remark that the first time he saw an ebb tide on the North Sea coast he felt as if he were going down into a cellar. In *Ruins of the Barbaric Temple* (1934) he had imagined the ancient American civilizations, which did not appeal to him very much. He also provided some clues to the comprehension of his metaphorical titles. Thus in *Furnished Arctic* (1935) he had thought of the restaurant on the Jungfraujoch; in *Album Sheet for Y*

Figure of the Oriental Theater
Cl. Cat. 151

Low Tide p. 99

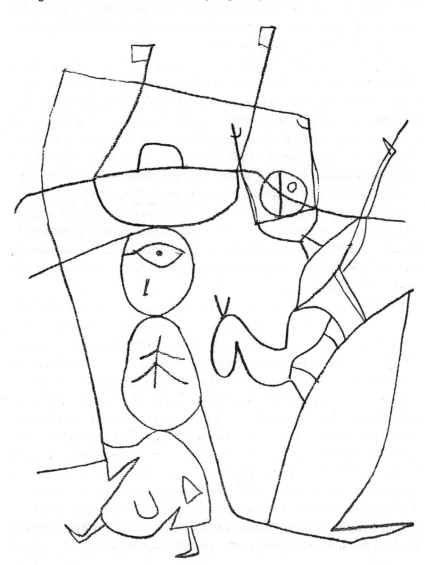

Drawing for Traveling Circus
1937

317

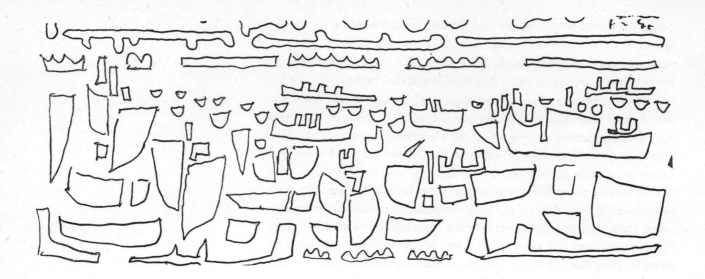

(above) *Harbor of K.* 1939

Equation Cl. Cat. 185

(1937), of a vegetable garden over which winter had passed. *Silting* (1935) was, he said, the reminiscence of a trip to Montana in the Rhône Valley and the swollen mountain torrents he had seen there; the same applied to *After the Flood* (1936). When such references to actual experience are not immediately evident in pictures such as these, the reason is that even where external elements are included, Klee received his main impulses from within himself.

In 1935 he painted a *Speckled Landscape* which he felt was like a Munch, and it does indeed have something of the Norwegian painter's style. That, however, was certainly not the point of departure; rather, Klee here resumed his earlier experiments with diffused light. But now he was not interested in the effect of the sun, as he had been in 1909, but in achieving a flat style based on design elements that suggest large-sized mosaic stones or inlays. A great many works of this type were produced in 1935, among them *Day in the Forest* and *Red Trunks*. The colored light-space of previous years is now replaced by a space effect based on juxtaposed flat areas in colors that respond to each other (orange and purple, green und blue). The broad beam-like strokes, or bars, of the "trunks" are the first hint at the heavy contours of the artist's last years.

Klee's periods of meditation awakened memories of earlier works but did not lead him to resume such previous efforts directly. The mosaics developed into jewelry-like forms with semi-precious stones like those of early Germanic jewelry. In *Arrogant Arms* (1935) and *Growing Weapons* (1935) even the coloring recalls the enameled ornaments of the Migration Period. These effects were probably suggested by the idea of the "barbaric" as a component of pictorial expression, rather than by a museum experience. Of *Growing Weapons* Klee said they were like cactus plants, which means that he had botanical elements in mind. The free straight lines of an earlier period turn into *A War Formula* (1936); lightning zigzags, into a *Diagram of Redemption* (1934); continuous, plane-defining lines, into *Equation* (1936) with its imaginary mathematical symbols. Everywhere the path leads in the direction of definitive, precise statement.

In some isolated cases Klee does variants of earlier patterns. To the rhythmically interwoven parallels of 1926 he may add a series of triangular and quadratic forms, as in *Eastern Classic Coast* (1936), or overlapping U-shaped lines, as in *Organ Mountain* (1934). The cloud-like structures of *Atmospheric Group* (1929) he now places alongside each other but leaves them opaque, and thus produces a *Double Portrait* (1934). He detaches the spirals from their vegetable context and obtains *Gourd Bottle* (1934); spirals are beautiful, he said, and astronomical spirals the most beautiful of all.

Figures and heads occur as if spontaneously at all stages of Klee's artistic development. On one occasion his hand jots down almost automatically a *Dance Posture* (1935); on another it may turn out a *Roughhewn Head* (1935) or a *Headdress* (1935). The psychological interest gives way completely to the coinage of symbols; a little head like *Early Sorrow* (1938) is exceptional in this respect. The *Child Consecrated to Woe* (1935) with its exotic headdress is an idol, the "W" on its brow might just as well signify an unknown divinity as woe, and the leathery mask of the face differs only slightly from the rubbed *Cushioned Seat* of the same period. *Mr. Z* (1934) and *Mr. Gibbon* (1935) have as if by chance become types of Anglo-Saxon aristocrats and are almost caricatures; the "Z" and the nebulous circle in the upright oval of the head have been transformed into the empty face of decayed nobility.

A few heads form a transition from earlier years to the Bern period. They are composed of patches, and only a few dots and dashes identify them as faces (*Bust of a Child*, 1933 and *The Name is "Parents' Image"*, 1933). The latter title is a metaphor for duplicate features (two pairs of eyes, two mouths), for the head is not the image of two people. Similar in flavor are *A Reasonable Man* and *Magic Mirror-Image*

Atmospheric Group
Cl. Cat. 127

Roughhewn Head Cl. Cat. 152

Early Sorrow p. 300
Child Consecrated to Woe
Cl. Cat. 155

(below) *Poem in Pictoral Script* 1939

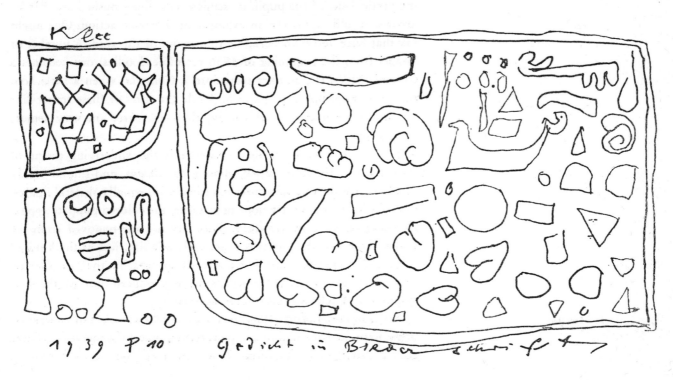

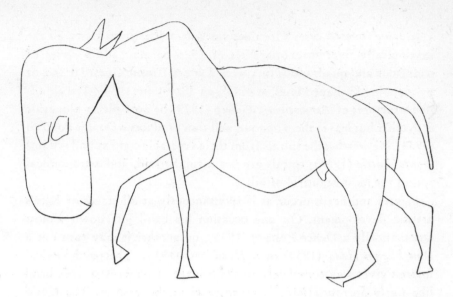

Grandchild of Rosinante 1939

Figur of the Oriental Theater
Cl. Cat. 151

Scarecrow p. 289

Fear Cl. Cat. 183

Still-Life on Leap Day
Cl. Cat. 195

Angel in the Making
Cl. Cat. 197

(both 1934) in which the truth is brought to light as in a distorting mirror. It was probably the magic quality of the mirror that inspired these works – its link with double identity and protective spells, with divination and self-enchantment. Such things were not alien to Klee, and *Still Life with the Dead Mirror* (1935) leads still further into the realm of magic which the mirror reflects.

Otherwise in those years Klee was less preoccupied with magic and witchcraft. *Figure of the Oriental Theater* (1934) is only mildly demonic, the blood-red blots on the earth-green apparition are rather an exhilarating quality. And the figure of the conquered dragon in *St. George* (1936), with its patched wattle forms, looks more clumsy than fearsome. *Scarecrow* (1935), a simple brown framework seemingly embroidered on the cobalt blue ground, is not really terrifying; more frightening is the barely recognizable vision of *Fear* (1934). Without the vertical slit of the pupil, its semicircular lines, pushed asunder by arrows, would be merely an example of dynamic action. One might say that Klee derives his graphic similes out of the void. A number of images from the beginning of 1936 resemble doodles; one becomes a *Ceramic Still Life*, another turns into a *Caligula*, when a little boot suddenly crops up in the pattern. While the titles of these trance-like pictures are not chosen arbitrarily, they are based on very remote associations.

The uncertainty of earthly existence is the underlying theme of *Two Reds in the Framework*, *Among the Beams*, and similar works of 1935 with skeletal structures inscribed with equally skeletal figures. On a dark ground, partly done in gouache, the colored puppets appear like denizens of a netherworld. They are not far removed from the Hades figures of the last two years of Klee's life, just as the kindred picture *Blossoms in Their Place* already approaches the *Still Life on Leap Day* of 1940. These works were produced just as the first symptoms of Klee's fatal disease appeared.

Angel in the Making (1934) is not an angel but an act of generation or perhaps, as Klee said of the picture, the place of generation. Three curves that intersect to form planes, three red symbols – a cross, a

(page 321) *A Sheet of Pictures* (1937)

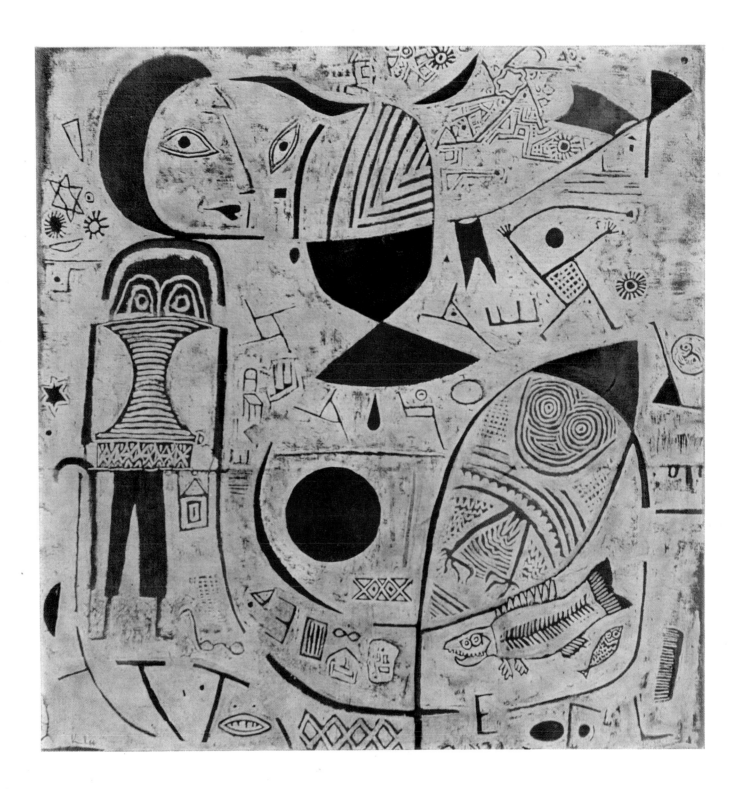

322

(Seite / page 323) *Bühnenlandschaft (1937) / Stage Landscape / Paysage de théâtre*

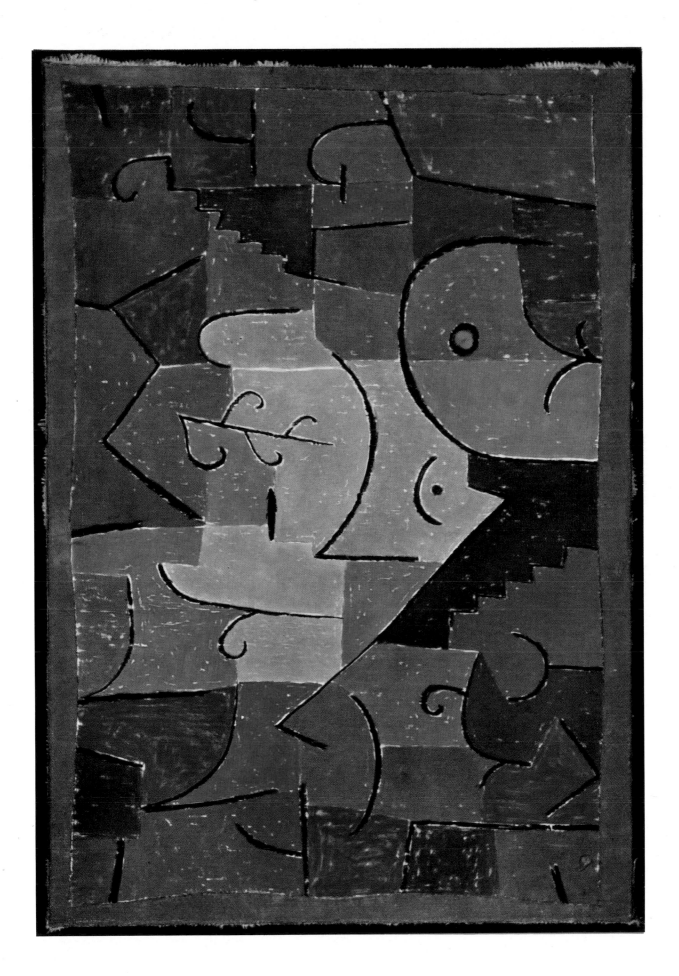

circle, and a triangle – that is all. A little more would have turned
the free forms into a wing or a head, but instead we remain in the
intermediate sphere between spirit and substance where angels have
their place. *Destroyed Country* (1934) is situated in a similar no-man's
land between the here and the beyond. A scrap of damask pasted on
linen, a threadbare ground in blue, green, and white daubed with red
and blue dots, together with a few intersecting lines, evokes dying and
flowering, the spark of life in the midst of ruin.

The last three and a half years of Klee's life form a single period.
Despite some resumptions and continuations of earlier concepts, the
last act of the drama opens clearly and portentously now, as with a
roll of drums. It would be a mistake, however, to see everything in
terms of the artist's impending death; like all sick people, Klee hoped
to the last for a turn for the better, though he was equally ready for
the end.

At the conclusion of most artists' lives we find a concentration on
a few themes and forms of expression. With Klee, on the contrary,
there is a broadening of the flow, even in 1939 and 1940 when he was
most insistently concerned with the ultimate mysteries. There are a
great many new conceptions and advances in many directions, but
gay and ironical works are almost completely lacking. Klee's humor,
which had always been musical and Mozartian, becomes still more
detached and philosophical and approaches the tragic. In a picture
like *Capriccio in February* (1938) it is so deeply embedded in the
pictorial structure that it can be sensed only by those receptive to the
most finely graded expressive values of line and color. *Donkey Eating
out of the Hand* (1937), with its Midsummer Night's Dream atmo-
sphere, is a relapse; like *Animals Play-Acting* (1937) – toylike creatures
painted on a pink, patterned tablecloth – it is a friendly reminiscence.
Klee's kindliness remains unchanged, and even what is most imperfect
seems to him to be an indispensable part of the whole; but, as in *The
Magic Flute*, it all advances into the sphere of ethics.

Among his last heads and figures tragic ones predominate. In 1937
he painted *Sick Girl*, the moving *Vision from Egypt*, and *Penitent*,
a monkish figure with his own features. *Clown in Bed* is anything
but a harlequinade. *Black Mask* (1938) and *Fire Mask* (1939) are the
offspring of fear. The *Flower Girl* (1940) is Persephone, the wife of
Hades the god of the nether world; the figures of Flora and Pomona
are creatures of a realm of shadows rather than of the world of the
living.

The panel pictures of the year 1937 have only a slight relationship
to earlier ones. *Traveling Circus*, with its figurines and animals, houses
and trees, is no longer embedded in seductive pinks and greens and
an amiable if slightly ironical humor; it is monosyllabic and ashen.
Resignation and concentration on the essentials. Still more starkly
reduced to the necessary minimum is *Revolt of the Viaduct*. Twelve
arches have grown feet and advance with heavy tread like men
conscious of their strength. On the intense purple ground the yellow

Capriccio in February
Cl. Cat. 157

Donkey Eating out of the Hand
p. 384

Clown in Bed Cl. Cat. 153

Flower Girl Cl. Cat. 196

Traveling Circus p. 293

Revolt of the Viaduct p. 295

of the foremost arch and the carmine and pink of the hindmost are like a threat and a challenge, while the black contours enhance the tension. These bridge-men end at the hip; they have neither trunk nor head and are "the marching ones" and nothing more. It is not impossible that when Klee painted this picture he was thinking of Nazi Germany. It is a cruel image of which he did four versions; one of these – *Strange Hunt* – tends toward the burlesque.

A Sheet of Pictures (1937), with its abundance of details that are not easy to view simultaneously, is like a strange illuminated manuscript, but all the different forms – the stars, the tiny figurines, the little flags, the letters, and the petrified fish – are Klee's. It is a curious jumble distributed in an upper and a lower zone. On the left, occupying almost the whole height of the picture, is a moon-woman whose stare conjures up this nocturnal spell. Or is it perhaps an old excavation site around which life goes merrily on? Such groups of pictures usually tell stories, and so does Klee, but he uses hieroglyphics whose factual context is hard to decipher. Are the E-forms letters or something else? Some of the shapes are the same as those found in the script pictures of 1937 and 1938, but do the latter still contain written characters? Standing in front of *ABC for Muralists* (1938) Klee remarked: "Everything really started with those three letters." This is a useful hint at the origin and significance of his ciphers. The older he grew the more letter-minded he became. In 1938 he wrote *Beginning of a Poem* in letters, *A Light and Dry Poem* in symbolic signs; the effect of both is almost the same. But Klee's remark also explains the recurrence of the same symbolic shapes over a span of many years (e. g. $\triangle \, \circlearrowright \, \boxminus$) and the unitary formal character of the pictures produced during his different periods. At one time angular characters predominate, at another round ones; and in either case they determine to a great extent the formal repertory of the period in question.

There is no fundamental difference between the output of 1937 and 1938, but the latter year is richer because it saw the production of many important works of comparatively large size. In 1937 Klee had already adopted the technical processes that suited his artistic impulse of those years. His desire for directness, which was the outcome of a last detour around the tangible aspects of the natural and spiritual world, led him to use very simple shapes. Often bar-like strokes are the main features and the pictorial values are reduced to a supplementary function, or the colors lead an independent life of their own within a sparse linear framework. Klee now returned to gouache, which he had already used before on occasion. He employs it as a thick impasto or thinned out, and he likes to combine with oil, tempera, and watercolor, so that it is not easy to see just how the surfaces obtained in this way were produced, especially when he uses the gouache only for the first coat and goes over it with other media, or when he mixes gouache and gesso for the first coat. He also paints on unusual materials such as wrapping paper or sacking; or he coats jute or linen with newsprint, which is absorbed into the fabric and yields a surface that is both rough and smooth. Sometimes the printed type shows through, which gives this ground a certain haphazard quality.

Klee also continued to work with earlier techniques, such as painting
in oils either alone or combined with tempera or watercolor, on linen
or gesso. But he also uses watercolor on linen and then applies a coat
of wax, and he employs crayons and pastels more than before.

The cipher-like pictures painted with these techniques in 1937 and
1938 can be classified in three groups. In the first the symbols, mostly
embedded in a bright gouache ground, maintain their former size and
degree of emphasis; in the second they are black, heavy as bars, and
considerably larger than before; in the third they have brightly colored
halos, a pictorial effect that lends them a special emphasis. These
distinctions may seem superficial but they really go beyond mere
technicalities because the meaning of the symbols varies with their
character.

In the first group, that of the "lesser bar-like symbols," the signs
have a rather lyrical quality. *Instruments for Play-Music* (charcoal
on chalk ground, 1937) gives the impression of a sample card of
abbreviated object forms. *Port with Sailboats* (1937), with its sailing
digits, has an extraordinary suggestive power; beyond doubt we are
looking at a yacht basin, yet we cannot identify the objects themselves
in the slightest. The same is true of *Temple Festival* (1937) with its
columnar verticals and stilt-legged dancing triangles and squares.
Comments on a Region (charcoal and watercolor on gouache ground,
1937) already approaches the exclamatory, heavy bars of the second
group but retains a lyrical flavor thanks to the delicately colored fields
into which the surface has been subdivided. What is the meaning of
this procedure? For Klee it consisted in the extreme abbreviation of

Three groups of cipher-like
pictures

Sign images with thin bars

Temple Festival Cl. Cat. 168

Comments on a Region
Cl. Cat. 169

(below) *Monolog of Tree and
Men* 1939

all his imaginative or actual experiences; since only essentials are admitted into the picture, it is left to the beholder to find his way back to Klee's starting point. But this becomes more and more difficult, for the bridge that links the sign and its meaning is not easy to find. The artistic means that Klee now employs are themselves a primary experience. In other words, the gap between the "impulse of the hand" and the "impulse of nature" approaches zero; the painter makes pictorial statements about himself but this self reaches deep down into the world of myths and origins.

One must not be tempted by the title to see what is not there. *Comments on a Region* may lie in a sphere that has little to do with landscape. When two pictures display the same interpenetrating U-shaped curves and one is called *Landscape with Rocks* (1937) and the other *Fertility* (1937), we are tempted to think in the first case of the undulating lines of a mountain range and in the second of a gushing spring. Both assumptions may be wrong; perhaps in *Landscape with Rocks* Klee was thinking of the origin of rock, and in *Fertility* of womanly ripeness. The meaning of the work can only be derived from the entire fabric. But even within these ciphers Klee can utilize associations; a couple of eye symbols transforms into *Child and Aunt* (1937) what otherwise might well have turned into a landscape; *German Dryad* owes its physiognomy to a single last detail, and even so it remains a tree.

In 1937, too, Klee adopted the heavy, bar-like strokes of the second of our three groups. They seem endowed with a certain violence; *Boats in the Flood* (blue gouache on wrapping paper) gives an almost prehistoric effect; the firm, thick contours, the obstinate brushwork, and the technique (the intermittence of the color due to its dry application, the casualness of the boundaries between the colored areas) are the typical features of the process. Here there is no possibility of modeling and differentiation; the impetus is all. That this impetus is capable of numerous variations may be seen in other works of the same type and date, like the sensitive *Alas! Oh Alas!* and the monumental *Sentry* which suggests the Pillars of Hercules somewhere at the end of the world.

Works of this type led to ever more forceful formulations in the next two years. *Dancing for Fear* (1938) and *Threatening Signs* (1938) convey their gloomy meaning directly; the letter-like symbols of *Law* (1938) know no pity, while those of *Poster for Comedians* (1938) radiate the coarse, gay atmosphere of the circus. How close these works come to "automatic writing" in a state of trance is shown by the sheet *Hurry* (1938); two E-forms and two vertical strokes meet in such a way that they can be read as *Eile* (hurry), and that was the title Klee gave the design, which is otherwise quite unhurried.

In such cases the titles are little more than convenient labels to distinguish one work from another. *Northeastern* (1938) may be either landscape or physiognomy; the picture got its name from the yellowish green note in the old rose of the ground. The archetypes on which Klee relies here are unspecific so that they may manifest themselves in a variety of meanings. The same broken spirals can become either *Heroic*

Sign images with heavy bars

Alas! Oh Alas! p. 85
Sentry Cl. Cat. 184

Dancing for Fear p. 298

Poster for Comedians p. 297

Hurry Cl. Cat. 172

(page 329) *Fruit* (1938)

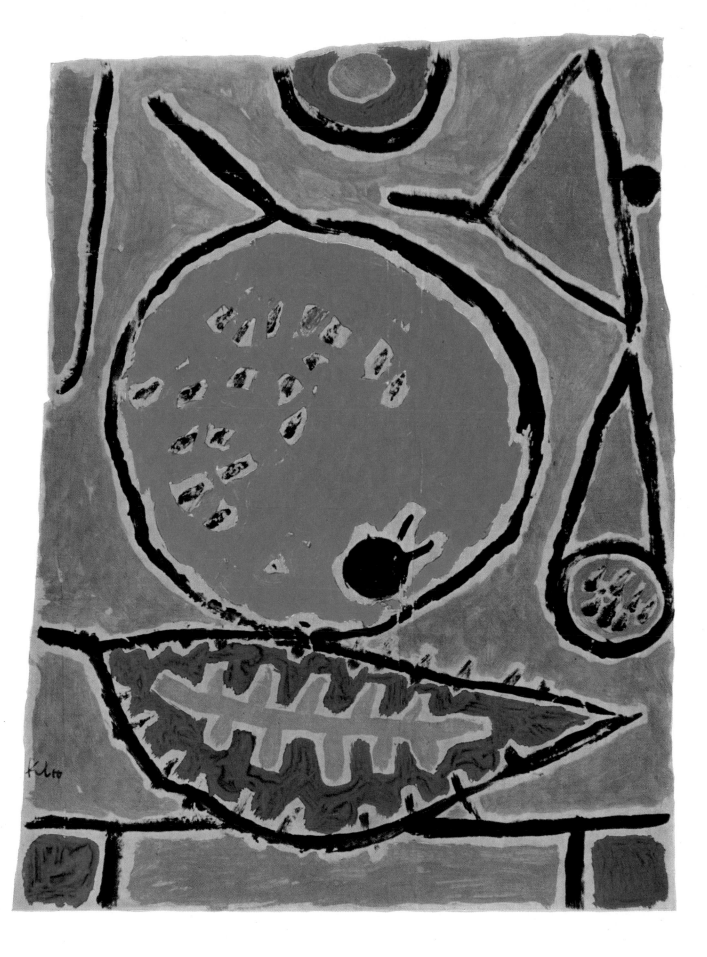

330

(Seite / page 331) *Östlich-süß* (1938) / *Oriental-Sweet / Douceur d'Orient*

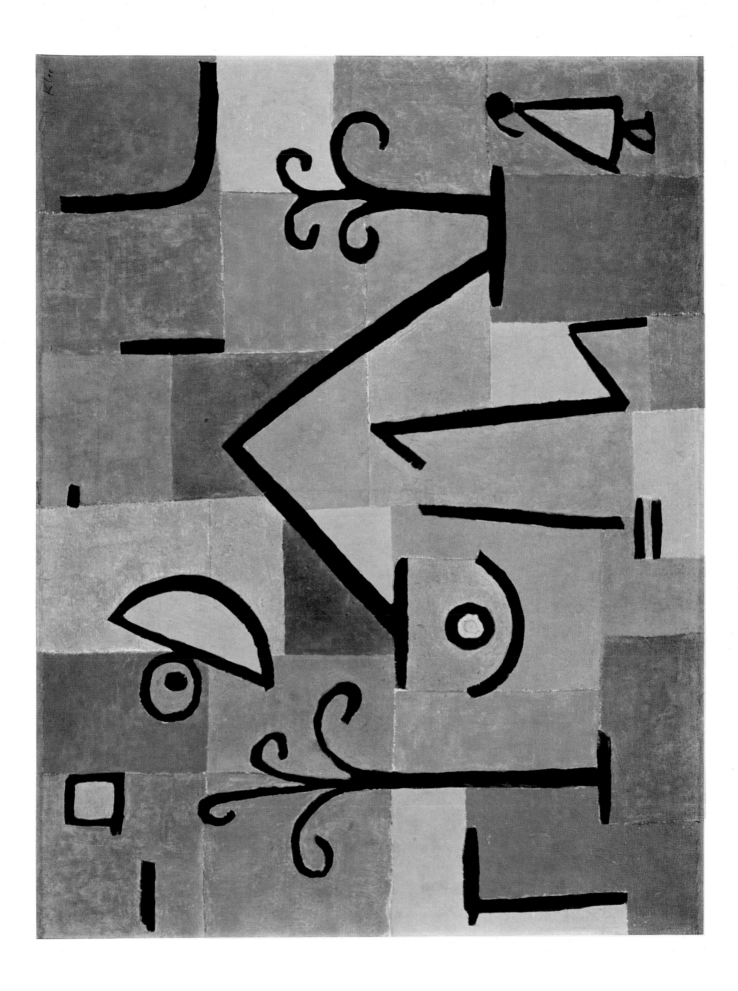

Roses or a *Cunctator* (1938). The same succession of violent curves means in one case *Heroic Fiddling*, in the other *The Gray One and the Coastline* (1938) – a definite proof of the expressive versatility of the forms, for in the former the curved strokes represent violin playing, bowing technique and musical dynamic, in the latter coastal formation. *Coast* was originally intended to be *Fiddling II*, and Klee thought of dedicating it to Adolf Busch; it was transformed into a seacoast by the addition of a few small details when it was almost finished.

A very similar process occurs in the manikin-like *Lady and Fashion* (1938) and the closely related *Group Staring*. Of these Klee said: "I must have learned that from Schlemmer," and the pictures do indeed have something of that artist's marionette-like ballet figures. It is possible that the *Groups* of 1939 *(Group of Eleven, Group of Masks)* are bound up with recollections of Oscar Schlemmer's Bauhaus stage settings and his *Triadic Ballet*.

A further intensification may be seen in the panel pictures of 1938, such as *Aeolian, Three Young Exotics, Broken Key,* and *Oriental-Sweet*. By giving color a greater weight and in one case inscribing the

Work. Bern; Sign Images with Heavy Bars

Heroic Fiddling Cl. Cat. 171

Group of Masks p. 303

Aeolian Cl. Cat. 173
Broken Key Cl. Cat. 174

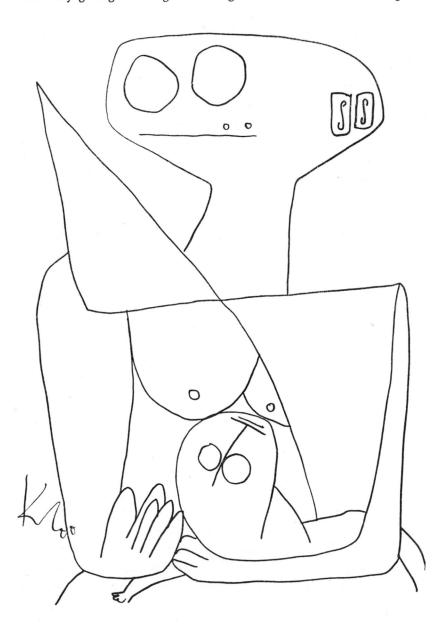

Maternity 1939

symbols into a system of regular planes like that of the magic square, and in the other linking the individual ciphers closely with the color, Klee varies and intensifies the expressive power of the bar structure. Its force combines with the harmoniously graded planes of color to produce an austere beauty. In *Oriental-Sweet* the silvery moon of Kairouan has lost its tenderness, but pyramid and palm tree have become the words of a quatrain of the most concise form and all-embracing significance. *Aeolian*, with its ceramic colors, might be a homage to Sappho's native land, a summer noon on an Aeolian Isle like those sung by the Greek poetess. In *Broken Key* the title contains as many riddles as the picture itself. Did the shape suggest the words or vice versa? Without doubt the key shape was there from the start and in combination with the colors and the linear symbols gave rise to a story which probably conceals yet another and different one. The ciphers on the left represent a woman and therefore the broken key might signify "no entry"; but the key symbol may also be charged with other meanings. As in a dream the apparent meaning is accompanied by latent ideas, and the artist reacts evasively to the questions of whence and why.

In 1937 and 1938 Klee painted an equal number of pictures in which the heavy contours are edged either with bright colors or with strips of the blank painting surface. These constitute the third group. Here the black symbols seem to be bathed in light and thus more closely tied to their pictorial background. This type first appears at the end of 1937, in *Miss Bin*, and is fully developed in 1938. In this amplified version of the bar pattern, figural subjects are more numerous than landscapes and symbolic signs. *Red Waistcoat* (1938) is a sort of circus act with a sweepingly interlaced form that suggests conjuring tricks and animals; *Capriccio in February* (1938) is a burlesque play of forms on the theme of the Basle carnival; *Sportive Young Lady* (1938), with its exaggerated gestures, derides the mania for athletics. In the two finest works of this group Klee deviates from the pattern. In *The Vase* (1938) the black bar is replaced by colored ones (yellow, green, bluish purple); in *Park near L* (Lucerne, 1938) the contours are edged in white and surrounded by zones of color, with vibrantly colored planes in between (green, yellow, red, and purple). The two pictures owe their gaiety almost entirely to their melodious color, attractively combined with the rhythm of the graphic objects. *Vase* and *Park near L* are masterpieces of chromatics and modulation; their melancholy beauty, like that of Mozart's *Don Giovanni Overture*, lies chiefly in the chromatic passages.

Among the more than forty panel pictures painted in 1938 there are seven large oblong ones measuring up to 65 inches in width, all of them showing bar-like contours combined with vigorous color schemes. They are *Rusting Ships, Rich Harbor, Intention, Legacy of an Artiste, Fruits on Blue Ground, Insula Dulcamara,* and *Spring of Fire. Ships* is the most realistic, with its rust-red hulls, the smokestacks and hatches, a lapis lazuli sea, and the sky-blue strip of horizon; but

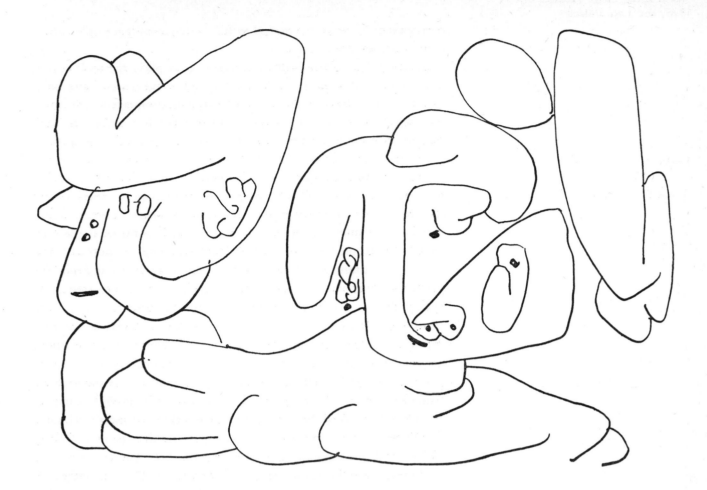

that is not what Klee was aiming at. With him ships are symbols of mobility, adventure, journeys into the unknown; they are nearly always sailing vessels, not unlike seagulls. Here for once they are warships waiting to be scrapped; their power is a mere illusion – an allegory of death, as *Rich Harbor* is an allegory of activity. In the latter the symbols are placed on a white ground which is divided by colored islands into zones of water, of vegetation, and of buildings. Here, too, one cannot be sure whether the ciphers signify merely landscape elements or figures as well; the shape on red ground, at least, recalls the *Dark Messenger*, and the creeperlike shrubs and the cupolas give an oriental effect. Klee had seen many ports; this one is southern. Perhaps it is the fulfillment of a dream, an armchair journey to the South, the Orient. In *Intention* the black symbols lie on a vermilion ground on the right-hand side and on an olive green ground on the left-hand side of the picture; they are edged respectively with white and red. The smaller section on the left, with the figures and animals, the little flags and trees, seems to represent the past; the project is centered on the brighter right-hand side, which is dominated by the large shape that divides the picture in two. The past is clear, the future full of riddles. It is only from a synopsis of Klee's entire output that the various ciphers will gradually become comprehensible; some recur again and again – trees, houses, keys, eyes – but their meaning varies according to the context. They are a means for noting unconscious impulses and reach down into long forgotten regions of the artist's

personality. We must be satisfied to follow the monologue only to the extent that we can at present.

Legacy of an Artiste is really a legacy; it displays the tools of the circus performer's trade – a racket (the key shape), a cup and ball, gymnastic apparatus, on the easel his portrait (or his image in a mirror); the ground is painted in gloomy colors – (olive green, rust red, and purple). Not much is left when an artiste dies, was Klee's comment.

Fruits on Blue Ground
Cl. Cat. 179

Insula Dulcamara Cl. Cat. 182

Fruits on Blue Ground (paste-coulours) and *Insula Dulcamara* are the products of a happier mood. This does not mean that Klee's health was better, for that had little bearing on the gloom or gaiety of his pictures. In periods of the greatest relaxation strongly demonic figures could appear among his work, and vice versa. It is rather the law of contrasts that ruled in these matters, and so exciting a picture as *Fama* (1939), for instance, was "the result of relative calm." The *Fruits* represent summer warmth and fertility; their bright colors stand out against the lapis lazuli ground; they are flat yet precious and heavy. *Insula Dulcamara* is Mediterranean, the island of Calypso perhaps, springlike in its pink, light green, and blue. The curving black contours are coasts; the looming head stands for the realm of myth; a steamer passes along the horizon. The sun (or is it the moon?) is shown both rising and setting. What is space here, and what is time? As early as 1918 Klee had called the distinction between them a pundit's delusion. The Homeric epics exist in the present and the myth lives on. In *Spring of Fire* the black stream of fire – what a paradox! – gushes forth from the blue circle and spreads over the whole surface ($27^5/8 \times 59$ inches) of the picture. The center is accentuated with orange; at the upper left is the emerald green speck of a little tree. The fury of the fire's meandering path does not destroy life. But is the stream really fire?

In all these pictures the preliminary drawing was done with charcoal on sheets of newspaper pasted alongside each other on jute. After the first coat of paint was applied the drawing and the newspaper ground were still just barely visible.

Late pastels

A last group of works of the same period and type are the mysterious pastels on white cotton or jute, sometimes on paper. The colored chalks are frequently applied on a damp ground that absorbs them so that the colors disappear behind the surface. Klee liked the luminosity of pastels, their capacity for rendering sunny brightness and nocturnal dark. They maintain their radiance over the full range of the scale and on every level of intensity, and admit of monochromatic combinations of greens und blues which in a strange way suggest the whole spectrum, even the refractions that our eye cannot catch.

Child in Red p. 296

Sextet of Spirits Cl. Cat. 166

The pastels display the same heavy contours as the other works of these years, and treat the same themes. In the figure subjects such as *Child in Red* (1937) and *Sextet of Spirits* (1937), the contours and colored planes are strongly linked together; depending on where the main emphasis is placed, they produce effects that recall stained glass windows with heavy leading, or tapestry-like fabrics with a few scattered linear accents. In the landscapes the method is similar but the link between contours and color areas is less close, as in *Oriental*

(page 337) *Park near L(ucerne)* (1938)

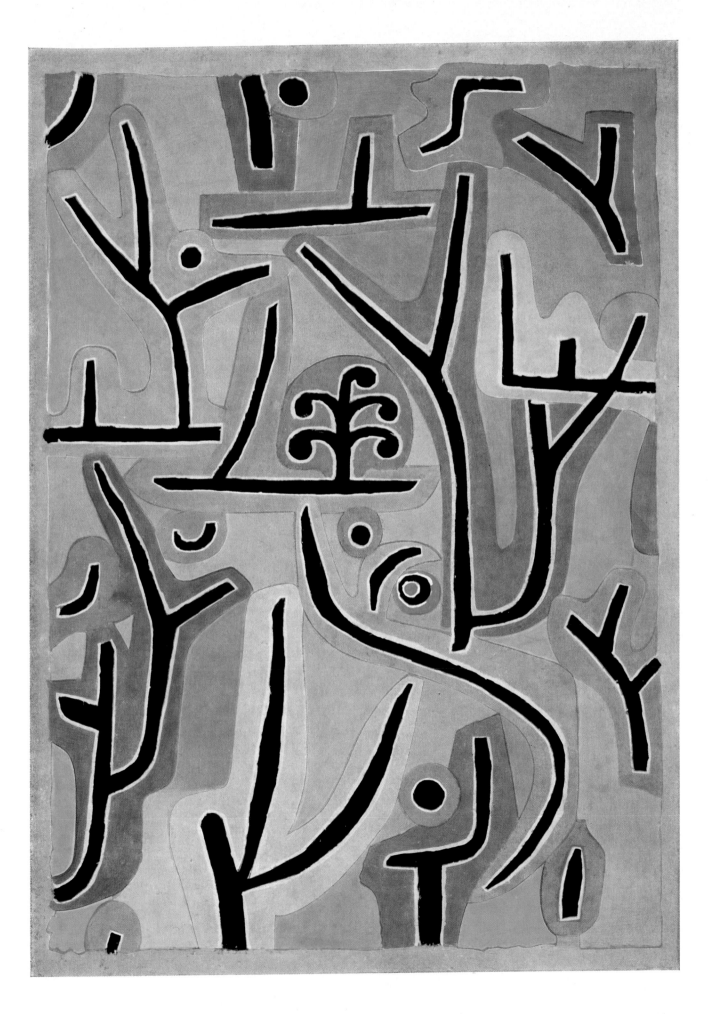

(Seite / page 339) *Rote Weste* (1938) / *Red Waistcoat* / *Gilet rouge*

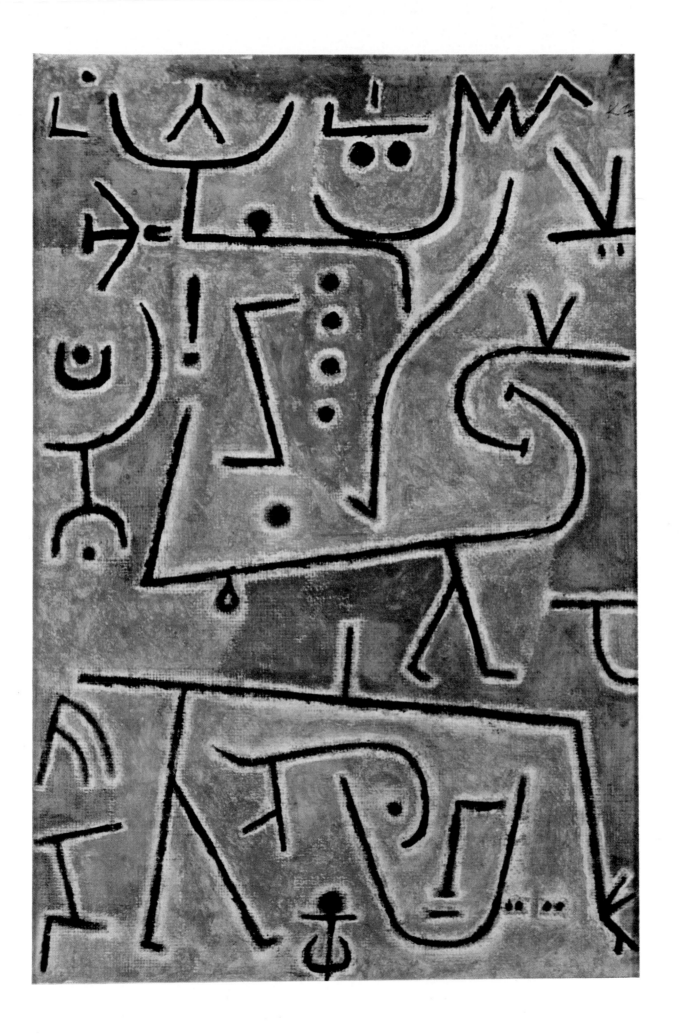

Garden (1937), *Legend of the Nile* (1937) and *Stage Landscape* (1937). The Egyptian legend is told in brown hieroglyphics on a blue ground divided into fields, as if it were the wall of a tomb or the third millennium. *Stage Landscape* is a backdrop, perhaps, for *The Magic Flute,* in yellow and red with green and purple accents. Colors and contour correspond like music and text; the little tree in the center might be the dance of the little bells, and the dark powers dwell in the depths of the purple, brown, and green. It is the colors that carry the tune; the next is an accessory.

Klee proceeds further and further beyond the limits of what can be put into words. In *Jewels* (1937) he did not think of jewelry, as one might assume, but of the song of exotic birds in an aviary. The ciphers are the feathered singers, the pastel colors their song. As always, the title is a poetic metaphor, but more than one word would be needed to explain its meaning. *Indian* (1937) might be Klee's dream of the country in which Montezuma's tragedy took place. *Blue Night* (1937) might be an *hommage à Novalis* whose *Hymns to Night* Klee had read many times.

While he was at work Klee listened only to his inner voice; afterwards he tried to find a verbal simile for what he had produced, but he often adopted an objective title referring merely to the color or the general impression. The pictures were then simply called *Yellow Signs* (1937) or *Green in Green* (1937). They are not more abstract but "more absolute" and fraught with meaning like the magic squares of earlier years. They might be the final utterances of a sage who now

(below)
A Trio Conversing (1939)

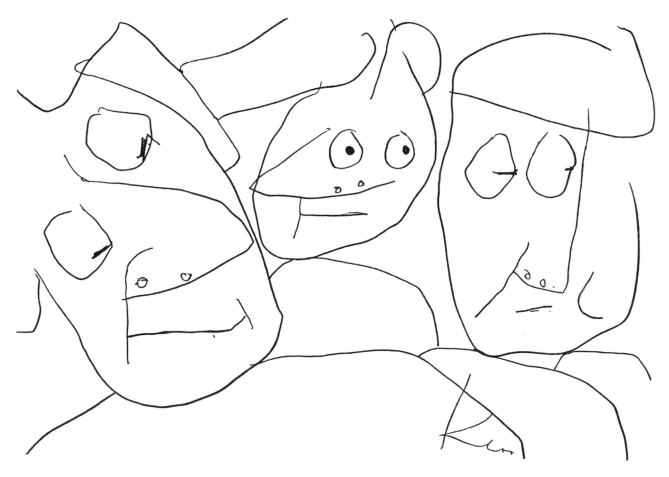

views things from the landscape aspect, and their symbols are as meaningful as those in the Chinese *Book of Transformations,* concordances of the corporeal and spiritual factors. A well is a well, but also life, storage, inexhaustibility; a mountain is a mountain and at the same time a pause, the point where life and earth meet. Where is the dividing line between within and without? In Klee's work the symbols recur like the characters in Chinese script; the colored fields combine them into phrases and stanzas. But who could write the poem that would convey the meaning of these pastels? The title *Green in Green* is not very revealing, and we can only assume that Klee in a moment of euphoria had a vision of a world that he could paint but could not name. In themselves the symbols and colored planes are sufficient justification for a picture, but in Klee their polyphonic interplay always tends to project beyond reality into the sphere of the universal. These pictures achieve a serene harmony that is unrivaled.

Intimations of Death

The end of the drama is foreshadowed in some works produced in 1938. Not only do they bear such titles as *Figure from Hades, Grave Tidings,* or *Another Dark Messenger,* but the shapes and colors become opaque and incalculable, the details give the impression of casual gestures, and the sheet as a whole is like a page torn out of some portentous tome. The humor is bitter (*A Sailor Feels His End is Near*), the action often fragmentary and as if composed of remnants (*From a Collection of Masks);* the figures become idols (*A Wife for the Gods*). They are premonitions of departure that become more and more frequent and strange until they gradually monopolize the stage.

A Sailor Feels His End is Near
p. 310

From a Collection of Masks
Cl. Cat. 188

In many pictures the color, which now becomes more material and yet more unreal, determines form and expression. The pictures have the look of colored masonry, but their substance and structure have no foundation. In *Rosebush* (1938) the bluish green and vermilion gouache colors spread like a viscous, fluid mass and produce configurations that look as if they could not have been made by human hands. Even figures and faces can emerge in this way, but the anthropomorphic elements are as if written in mud, destined to remain visible only for a few moments. *Dusk Falls* (1939) is in fact a twilight scene; from various tints of blue there arise symbols that give a glimmering of landscape, and perhaps of heads as well. The ambivalence of nature and creature becomes disquieting but the unity of nature and spirit becomes ever more complete.

In 1939 colors and forms sometimes look as if they were undergoing a process of fermentation. *Fruit-Bearing Blossoms* suggest a state halfway between bursting and putrefaction, between embryo and corpse. *Emotional Germination* is a sickly swelling. *The Poorest Man at Easter,* with its decomposed forms and withered colors, lies beyond the Christian message of Salvation; this is the poorest of the poor because the Easter tidings are not for him.

Emotional Germination
Cl. Cat. 193

Whitish pearly colors on a similar or darker ground give an effect of decay in sheets like *Fruit Bowl* (1939) and *Baroque Centaur* (1939). The word "baroque" turns up repeatedly in the title now and indicates

(page 343) *Group with the Fleeing Scold* 1940

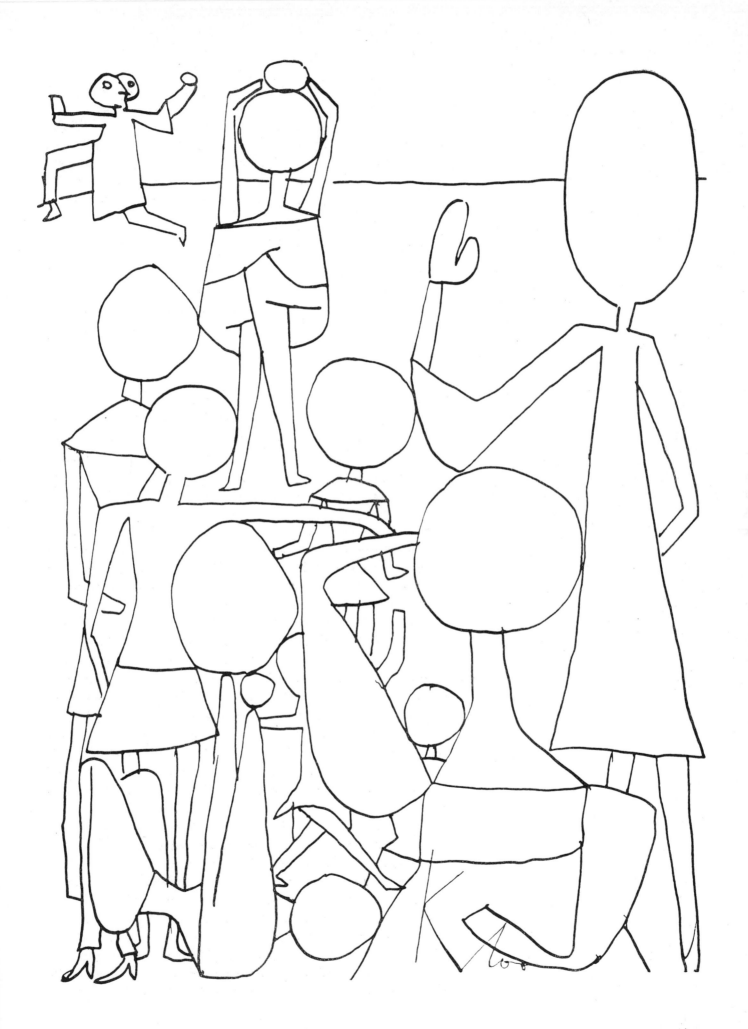

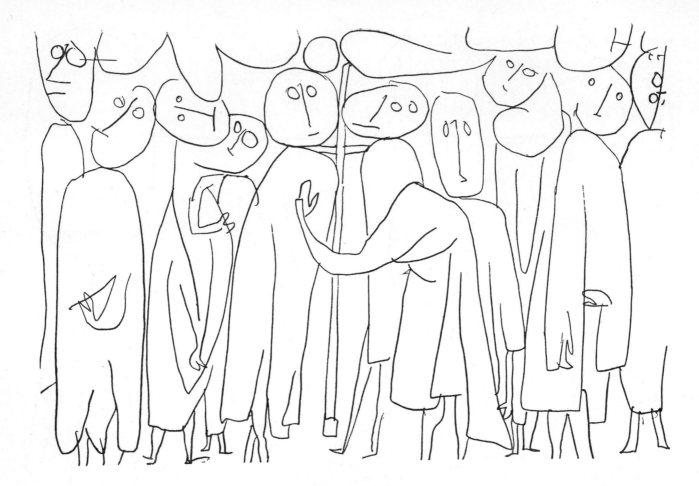

(above) *Brotherhood* 1939
Mephistopheles as Pallas
Cl. Cat. 190

Fear Erupting p. 87

(page 345) *Intoxication* (1939)

a tendency toward conscious exaggeration and sudden turns to the opposite extreme. *Mephistopheles as Pallas* is a work of this type; *Luna of the Barbarians* another. The titles clarify the inner contradictions here.

Luna is one of the pictures composed of fragments to which Klee resorted with increasing frequency after 1938 and for increasingly demonic utterances. The subjects are apparently ecstatic visions (*Fear Erupting*, 1939) and gruesome legends (*In Memory of a Crime*, 1939). The shock ruptures the connection between objects and events, but not in the same way as in the early works of Chagall, with their naturalistic details, and the fragmentary shapes are the symbols of events that remain detached from them. *Red Glove (1938)* where the base of red bunting is still visible through the white gouache ground, is not merely a tale of blood, and *Tragic Metamorphosis* (1939) is not one of Kafka's "transformations." Here Klee is in a world where the fragments have an independent existence, like living beings in ours. Glove, breasts, head and limbs are – if we interpret them correctly – the actors on a stage whose significance is not in the philosophico-literary sphere. The other-worldly plane of these pictures is revealed still more clearly in *Intoxication* (1939) where the details vaguely recall a head, an ear, an animal, seeds, flowers, a twig, a sail, but make no sense if we try to add them up to make a story. And the vermilion colors and green accents on the whitish ground are anything but intoxicated. The title does not describe the picture. The "imperfection of language" which Klee already regretted in 1924 makes it difficult

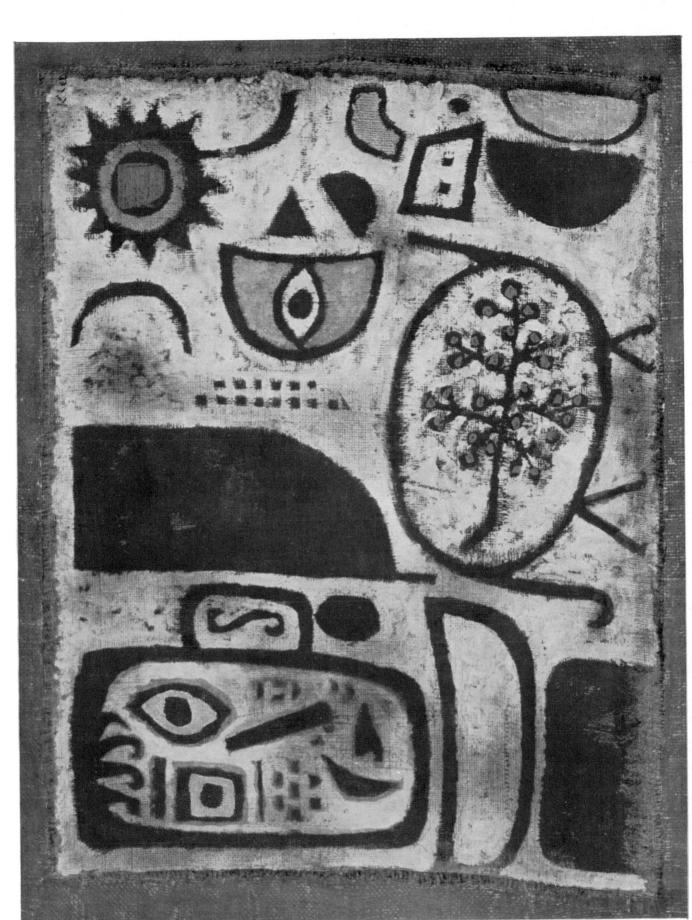

to say what the picture means, and for Klee the word "Rausch" (intoxication) probably had a meaning different from the usual one. It may also involve substitutions such as occur in *Man of Mistaken Identity* (1939). The enigmatic element predominates; as Klee said in a lecture, "The immaterial needs no fixed base, it hovers. No simile is possible for it."

At the same time as *Intoxication* Klee painted *Love Song by the New Moon*. The colors are dirty except for a few yellow, blue, and green accents; the song is despair; the new moon is not new; the whole picture dreams of a dark earthbound world. The *Earth-Witches* (1939) "really come out of the earth," as Klee himself said. *Bust of Gea* (1939), with its earthy tones (brown, red ochre, and brownish green) and its proliferating forms, is a symbol of earth in the literal sense.

Love Song by the New Moon
Cl. Cat. 189

Earth-Witches Cl. Cat. 187

Gea is not one of the fragment pictures; it continues the series of figures that begins in 1938 with *A Wife for the Gods* and ends with the overpowering visions Klee painted during the last months of his life.

A Wife for the Gods, dated 18/12/1938 (gouache on wrapping paper), is a figure from the most ancient mysteries in which heaven, earth, and man are not yet separated and the supernatural is visible as a matter of course. Here Klee is almost a seer, except that his insight – to quote Kleist's *Marionettentheater* – has passed, as it were, through infinity, and having reached the state of infinite knowledge he relapses again into the state of innocence. According to Kleist, that would be the last chapter in the history of the universe.

Similar in character are the physiognomic mountain range of *Fama*, the menacing star of *Stern Visage* (1939) and finally *Omphalo-Centric Lecture* (1939). This title is not easy to understand. Klee's attention had been repeatedly attracted to James Joyce, and he had read parts of *Ulysses*. It is striking that in Klee's picture, too, the navel is the seat of divine light and prophetic inspiration, the symbol at once of birth and reincarnation, of the endless chain of the generations. The nearness of death projects birth and eternity into Klee's field of vision, and the visionary female figure that seems to hold its navel in its hand is not really a human figure; rather it embodies a metaphysical position. Here philosophy cuts into Klee's art as it does into Joyce's in *Finnegan's Wake*.

Stern Visage p. 302
Omphalo-Centric Lecture
Cl. Cat. 192

In 1939 and 1940 we also find some works which show no sign of Klee's approaching end and in which he indulges in a grave gaiety. *Sleeping Animals* (1939), *The Torso and His Own* (1939), and the many animals in general are carefree and sometimes slightly grotesque (*Grandchild of Rosinante*, 1939). Even in the last months one occasionally finds charming ideas like *Three Fours Sailing* (1940), where the numerals form the sail; or *They All Run After* (1940), a delightful little poem of child-like directness. *Bal Champêtre* (1940) may be somewhat ghostly but it has some comic details as well and loose greens and pinks that belong to a summery picture.

The Torso and His Own
Cl. Cat. 158

Grandchild of Rosinante p. 320

They All Run After Cl. Cat. 161
Bal Champêtre Cl. Cat. 162

Some panel pictures of 1939 lie exactly on the borderline of the beyond. *On the Nile* suggests Hades more than it does Egypt. The heavy contours of the mule, well-wheel, river bank, boats, etcetera, and the gouache colors thickly applied on wrapping paper pasted on

On the Nil Cl. Cat. 191

jute, do not give an impression of the "fertile country" but rather of Acheron and Pluto, whose wealth also comprised grain. *High Spirits* is, viewed superficially, a dare-devil acrobatic turn, but in reality it is a life-and-death gamble. In *Oh! the Rumors!* even the formula of "false" straight lines and curves and the mildewed quality of the color are a distortion and a negation of the facts.

La Belle Jardinière (1939) Klee himself described as a "Biedermeier ghost." The head is set awry on a frame made of bent wires in reddish brown and blue-black; the greenish ground is stained like a garden bed. "Ghost" suits it better than "pretty gardener" and one shudders at the thought of Raphael's classical pictures of the same title, for this "jardinière" is illuminated by the rays of a lethal dawn. Klee's landscape is now an *Infernal Park* (1939). Inferno means the nether world, and its flora are *Twilight Blossoms* (1940). *Still Life on Leap Day* (1940) is the vegetation of a realm of shadows. The curious flowers and leaves bare and stonelike stand against the gray-green and brown gouache ground; their purples are as faded as the tones of the swelling sail-like shapes which make the picture something like a ship of death. The play of forces is reduced to a minimum here, to the barest residue of polarity; the conflict has ceased, all is rest. Klee's thoughts now admit but little of the outer world. They are focused, rather, on a realm of universals where distinction and contrasts are barely perceptible. *Submarine Garden* (1939) is a *Music Beneath the Day* (the title of a sheet of 1940): a red fish swims like a remembered theme in the deep blue; the red lacks all earthly gaiety and makes the garden beneath the day look like the Elysian fields.

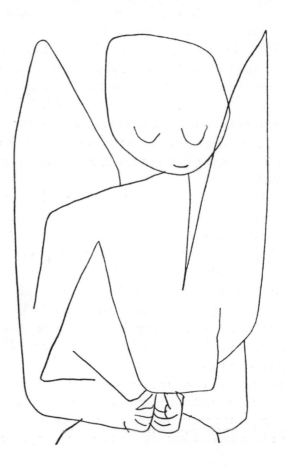

Forgetful Angel 1939

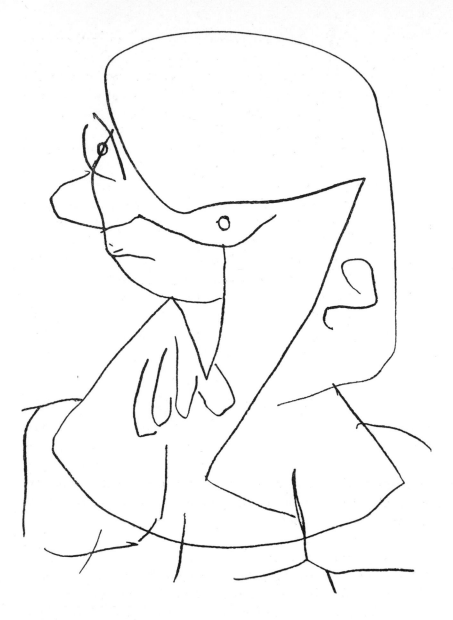

Dürer's Mother, Too (Passion)
1940

The works Klee produced during the last months before his death
include two series of drawings – the *Eidola* and the *Passion in Detail.*
"Eidos" signifies idea, archetype, and in these sheets Klee has fixed the
essentials of specific human types – the general, the *opera-bouffe*
singer, the philosopher. *Knaueros, former Kettledrummer* recalls the
dead musician Knauer, whose supreme art as a kettledrummer Klee
had admired at the Dresden Opera. The *Kettledrummer* (1940) who
strikes his instrument with two bones, reappears in the last year of
Klee's life as a hieroglyph of the most vigorous dynamic, and I
remember him saying that one evening in the excitement of drawing
he had the feeling that he was striking a kettledrum. They are indeed
like kettledrum strokes, these heavy, rapidly sketched signs; like
percussive sounds, they are restricted in their "tonal" range but all the
more emphatic for that.

*Knaueros, former
Kettledrummer* p. 359

Kettledrummer p. 355

Among the drawings of the *Passion*, the sufferings of mankind, there
are a *Galley Slave*, an *Old Maid*, an *Image-Maker*, and a sheet entitled
Dürer's Mother, Too. Dürer's moving portrait of a woman marked by
death has here become a homage to Dürer in the sparse, pensive

Dürer's Mother, Too (above)

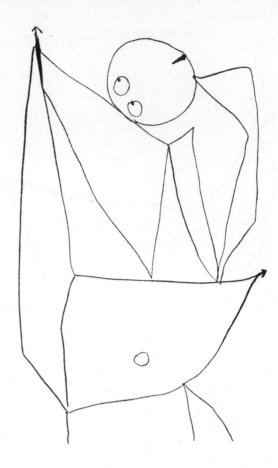

Angelus Militans 1939

The series of angels

language of Klee's last period. The archetype "mother" may have occurred to him even though the portrait has rather the features of Lily than those of his mother.

The series of *Angels* is a very long one; it stretches through twenty-five years and comprises fifty sheets, twenty-eight of which were done in 1939 and four in 1940. One could even expand the series still further, for it undoubtedly includes drawings like *God Be Blamed* (1940). Are these the angels to which Rilke referred in his *Duino Elegies* – superior beings who in their majesty are fatal to man? According to Rilke, they reach out beyond life and death and are at home neither in this world nor in the next but in the supreme union of the two. They have already consummated the transmutation of the visible into the invisible and recognize in the invisible a higher reality.

Klee and Rilke had met in Munich. Rilke then had the soothing conviction that everything was "good" for him, that everything would be all right again "hereafter," and that Klee would not be able to share his feeling. The elision of the subject in Klee's work and the inter-penetration of music and design, "this short-circuit of art behind the back of nature and even of the imagination," had worried Rilke (*Lettres à Merline*, Paris, 1950). That was in 1920, six years before his death. Would he have recognized in Klee's angels of 1939 the kith and kin of the "deadly birds of the soul," the "spoilt children of Creation," the "limbs of light," the "spaces made of beings"? Rilke's angels had "being, nothing but being, a superabundance of being"; men, on the contrary, were "transient" and still attached to the visible

 (page 351) *Woman in Native Costume* (1940)

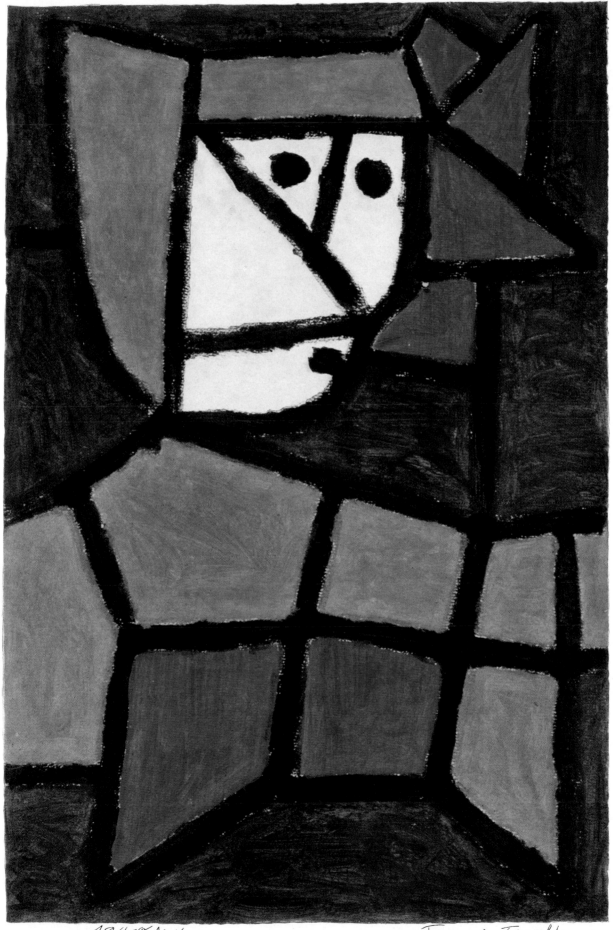

1940.M14 Frau in Tracht

(Seite / page 353) *Doppel* (1940) / *Double / Double*

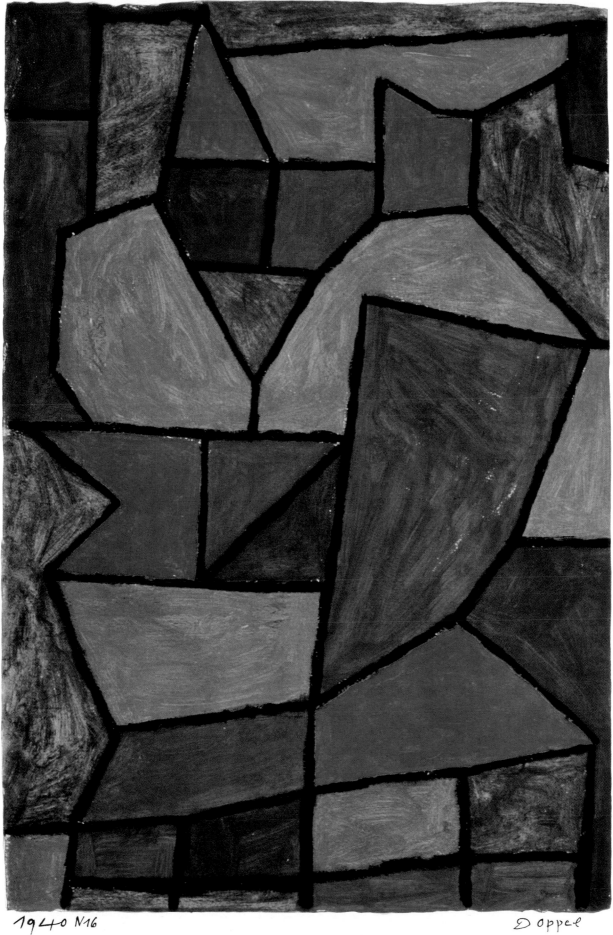

1940 N16 Doppel

(Seite / page 355) *Paukenspieler* (1940) / *Drummer* / *Timbalier*

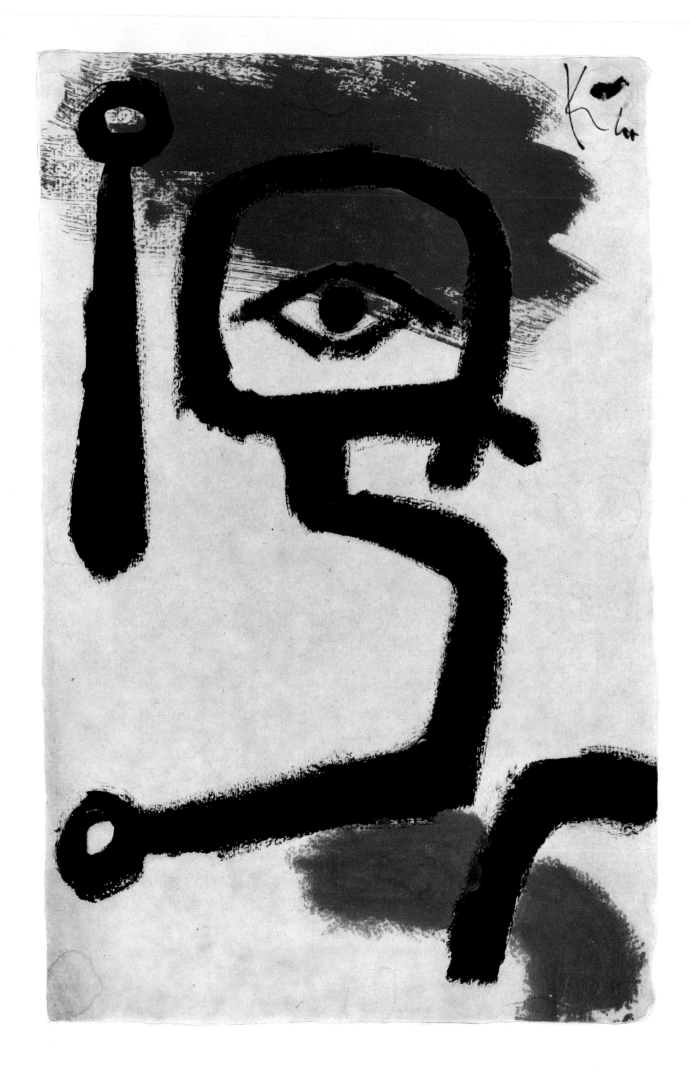

world. His angels threw man back on his own reality; nonetheless Rilke left him the chance of transmuting visible things into invisible, spiritual forms. "Earth, is it not this that you want, to arise invisible in us?" is the question he asks.

Klee's angels, too, live in the supreme unity that embraces life and death and see in the invisible a higher reality; but for him that was equally true of mankind, at least toward the end. This world and the next interpenetrate, and man partakes of both. Klee dwelt "somewhat closer than usual to the heart of Creation." Did the angels dwell closer to it still? Certainly not as the "spoilt children of Creation", else how could Klee have invented an "unfinished," a "poor," an "ugly" or a "forgetful" angel? Others of the series are "brimful," "vigilant," "hopeful," and there is one *Angelus Militans*. But what might be the meaning of *Not Yet Been Taught to Walk* or *Angel Still Female* (1939)? Is there still good and evil among the angels, and the "coincidence of the primeval male and the primeval female" (Klee, 1918)? In that case "still female" would mean still growing. Klee's angels are not the opposite to men, they are transitions and symbols of the last mutation, creatures neither "terrible" nor "deadly in their majesty." In them the hieroglyph of man merely assumes a broader significance; that is why the degree of their mutability varies, so that beside very enigmatic specimens such as *Angelus Dubiosus* (1939) there are more comprehensible ones like *Poor Angel* (1939). Beside menacing ones like *Angelus Militans* (1940) there are such gravely solemn ones as *Watchful Angel* (1939), – beside child-like ones like *Angel Still Groping* (1939) such fully formed ones as *Angel from a Star* (1939). The series has no goal; the last angel is a "doubting" one (1940), and the "groping" angel, too, is among the last. It is a set of variations on a theme that obtrudes itself upon the artist whenever the proximity of death brings him to an ultimate clarity of vision and the creative process produces the final metamorphoses. The concept of growth and self-transformation becomes apocalyptic at the angel stage and passes beyond itself. *Angel Still Female* (1939) and the other "still" imperfect ones refer to the gradual process of formation and transformation of every living thing, even of those that are beyond our ken. *Watchful Angel* (1939), with its white contours on a black ground, is not the guardian of a grave but the "wakeful self." Klee had no reason to change his position in the face of the last things, for in him the end was rooted in the beginning.

The colors correspond to this conception of the nature of angels; they are subdued but their range extends from sonorous to "cracking" and "dubious" tones. They differ from those of the kindred hieratical images, as *High Watchman* (1940) in which severe but confident chords harmonize with the concise, sure linear structure. *High Watchman* and *Double* have something of a *cantus firmus* about them; they tend toward the liturgical. "A breath is enough to evoke the realm of religions experience," as Klee said in 1918.

Now his works revolve round the theme of "the end." Klee had painted saints before, but *Female Saint, from a Window* (1940) is like a stained-glass window, and the old rose, purple, and blue colors glow

Forgetful Angel p. 348
Angelus Militans p. 350

Poor Angel p. 304

Angel from a Star Cl. Cat. 199

Double p. 353

357

Former Harpist 1940

Graveyard Cl. Cat. 194

Sick Man in a Boat p. 92

between the framework of leading as if the light shone through them from behind the temporal world. *Graveyard* (1939), with its crosses and cypresses, means "bygone," but goes on in the sky-blue and green fields. Klee forestalls any misunderstanding that might result from superimposing Christian doctrine of final things on his own last metamorphoses. *Gloomy Cruise* (1940) clearly refers to Hades; *Charon* and *Sick Man in a Boat* (1940) signify crossing the river into the realm of the dead. Their colors and shapes are of soul-shattering monotony; black, grey, brown, and ochre predominate; the rhythm seems cut from some larger context and can only be grasped if we carry it both forwards and backwards thus completing the fragmentary pattern in our minds. Is the meaning of these sheets "consummated" or "passed away"?

The answer to this question may be found in the pictures of death – Klee's *Requiem*. Their symbolism cannot be comprehended from the viewpoint of established philosophy or religion but only from the works themselves, like everything that Klee experienced and produced. He had already said in Dessau im 1930 that death was "not an evil." "For does one know which is more important, life now or the life that is to come?" But in a creative artist the work surpasses the individual, and the ultimate meaning of his pictures he himself may have known only in rare moments. He had felt from the start that death was another state, a passage to the "other side," an "opening." The less attached he grew to life and the nearer he approached to death, the less this "state of absolute mystery" troubled him. The more he renounced his self and yielded himself up to the flow of actions and events, the more life became a "passing beyond," a transcendence. That was Klee's most typical trait since Kairouan, this need to surpass himself which urged him on from stage to stage, made every achievement a transition and

every work a step that already contained the next. Four weeks before his death he sketched *Ecce*, a token of this passage to the ultimate "openess."

The works produced in March, April, and May 1940 fall into three distinct groups. May 10th is the latest date we find among them; a few remain unsigned and untitled. To the first group belong the symbolic signs, prepared since 1938 and set down with a heavy brush, *Alea Jacta, Hurt, King and Absolute, Locksmith, Traveling Artiste*. In them the physical world has undergone a process of "artistic combustion." What does a *Locksmith* mean here, or a *King*? Are they emblems of the Absolute? What is affirmed in these images no longer depends on the things of this earth. Klee here responded to the few calls that still concerned him; that explains the extreme economy of means, the silence of these signs. Might not *Locksmith* be Pascal's coincidence of machine and spirit? For the last time the visible form is a veil that both conceals and reveals.

In the second group are the gratings, enclosures, and railings built of heavy frets – *Enclosure, The Snake Goddess and Her Foe*, and the unnamed apparitions of figures hedged in by gratings on red or blue. They suggest both stricture and free passage, threat and hope – a borderline situation more fluid than stable, where the breath of time and fate can be felt among the shapes.

Only the *Wood Lice* partake of a more real life. In the last three months of Klee's career we find a *Wood Louse*, a *Mud-Louse-Fish* involving a pun on "*Schlamm-Assel*," and "*Schlammassel*" (a German slang term for "confusion", and a *Wood Louse in Enclosure*. They themselves are black gratings, fishbone gratings, backed by a reddish glow, suggesting fire, combustion, transmutation. "If our bodily life is a process of combustion, so is our spiritual life (or perhaps the opposite?)

Death and Fire p. 361

Thus death means a change of potential." (Novalis). Goethe said: "Organic life is a trick of Nature." Klee, the magician, made the trick his own and his pictorial statements are so commanding because they concern not the What or How, but the Whither. He answers: towards death.

And now in the third group of works Klee paints death itself as well. *Death and Fire*, a whitish blue skeleton with heavy dark brown contours against a smouldering red. He holds a sphere but it does not roll, it floats above his flat palm. From the right a man with a staff approaches towards the ball; is he the ferryman we know already, or the man to be ferried across in the boat? The red and whitish blue are fire and water, an evocation of the elements, of pure nature, not a triumph of death. If this death has a face it signifies doubt, but the forward stride of the man with the staff signifies an advance, a passage beyond death. The unity of life and death is attained at last.

Still Life p. 363

Klee's last picture, unsigned and unnamed, is a large *Still Life* on a black ground. It is as powerful as the other late works, whose ascetic character implies no slackening of creative or technical mastery. In 1940 Klee still did drawings of the utmost structural delicacy, such as *Through Poseidon*, and his handwriting remained fully controlled and finely differentiated to the very end. In the right foreground of the still life is a round table with an orange cloth strewn with a flower pattern, and on it a grass-green coffee pot and a grayish-purple piece of sculpture, modeled in bulging forms. At the upper left, on a red circle, are three vases of different shades of green and a blue vessel with a purple appendage that looks like an arm. Between the two groups is the disk of the moon, yellow as the yolk of an egg. At the lower left, as if stuck into the frame, a large white sheet of paper with a vigorously striding angel whom two heavy hands seem to restrain – *Jacob Wrestling with the Angel*. The domestic interior, already disturbed by the black background combined with the sharp colors and the nocturnal moon, becomes even more disquieting if we look at the rigid shapes of the cut flowers which suddenly look as if strewn on a grave. Thus the still life is transmuted into a ghostly nocturne. But Jacob was among the chosen ones, and the flowers at the upper left-hand edge have roots; the picture hints at the "fullness of time" which also embraces the future.

Mozart bequeathed to us a world of music which moves even those who do not grasp its association with the world of symbols. Klee left us a world of pictures which is alive even to those who do not comprehend their penetration into the absolute.

(page 361) *Death and Fire* (1940)

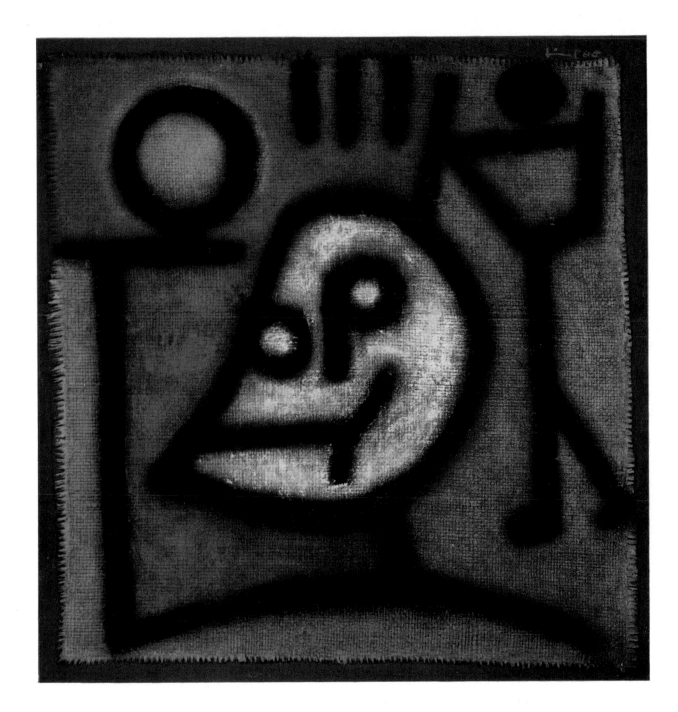

(Seite / page 363) *Stilleben* (Klees letztes Bild) / *Still-Life* (Klee's last painting)
Nature morte (dernier tableau de Klee)

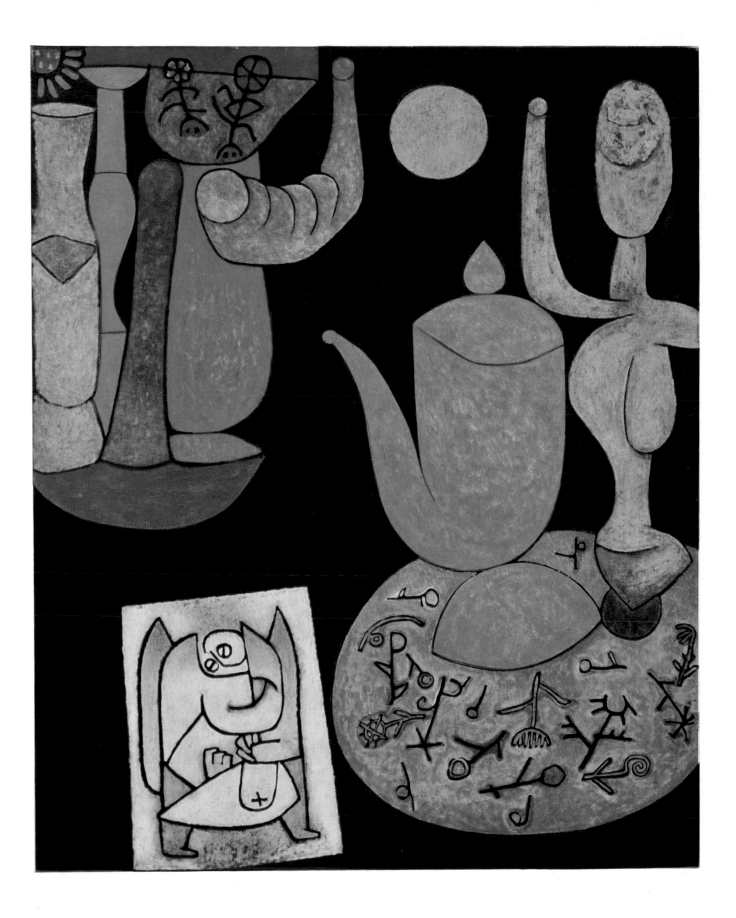

From Klee's Jena Lecture, 1924

"In order to avoid the well-known injunction that artists should be doers, not talkers, I should like to center my remarks on that part of the creative process which takes place mainly on the unconscious level. In that way, talking about my own work may be justified, at least from my personal point of view. What I should like to do is to shift the focus of discussion by looking at the subject from a new angle; to put more emphasis on content, rather than on the formal aspect of art, which usually carries the main burden of the argument.

To achieve some sort of balance between these two is a task that appeals to me. It encourages me to try to clarify my own thoughts on the verbal and conceptual level.

I am probably thinking too much of myself, however; to most of you, I am sure, content is more familiar than form. I shall, then, have to tell you something about these formal matters as well.

Let me give you a glimpse into the painter's workshop; for the rest, I am sure we shall get along.

There must be some common ground somewhere, after all, where artist and layman can meet; once we have reached it, you will no longer think of the artist and his work as something peculiar and out-of-the-way.

You will realize then that the artist is someone who, like yourself, has been plunged into this confusing world without his consent; someone who, like yourself, must find his way willy-nilly among the welter of things here below.

The only difference is in the way the artist copes with this task; he does it by using his own special endowment, and at times he may be better off than those without the artistic impulse, who do not find release in creative activity.

This limited advantage you will have to grant the artist, for in other respects he has a hard enough time as it is.

Let me use a simile; the artist, you might say, is like a tree. He has coped with this bewildering world – reasonably well, we shall assume – in his own quiet way. He knows how to find his way in it well enough to bring some order into the stream of impressions and experiences impinging on him. This orientation among the phenomena of nature and human life, this order in all its ramifications, that's like the root part of our tree.

From there the artist – who is the trunk of the tree – receives the sap that flows through him and through his eye.

Under the pressure of this mighty flow, he transmits what he has seen to his work.

His work, then, is like the crown of the tree, spreading in time and space for all to see.

Now, nobody would expect the crown of a tree to have exactly the same shape as the roots. We all know that the one cannot be a mirror-image of the other. Clearly, their very different functions, the fact that they belong to different realms – air and earth – must of necessity produce important differences in structure.

Why, then, do people deny the artist's right (which is not so much a right as a necessity) to depart from the appearance of his models?

365

(above) *Thoughts* 1917

Some even go so far as to question both his competence and his sincerity.

After all, in his capacity as the trunk he only gathers and transmits what comes to him from below. He is neither master nor servant but only a mediator.

His position, then, is a modest one indeed; and the beauty of the crown, that's not the artist himself – it has only passed through him.

... While the artist is thus concentrating on the problem of how to relate all the forms to each other as cleanly and logically as possible, so that every one of them is put in the exact spot where it is needed but without detracting from its neighbors, some layman onlooker will devastate him with the remark: "But this still doesn't look like uncle!" If he has steady nerves, the painter will say to himself, "Uncle go hang! I've got to keep on building ... This block I've just added, seems a bit heavy and pulls things down too much on the left; I shall have to put some sort of counterweight on the right to restore the balance."

So he shifts his weights back and forth, adding or taking away a bit here and there, until he reaches the equilibrium he wants.

And as he does so, he thanks his stars if he manages not to strain his basic construction any more than he has to; he cannot, after all, hope to avoid such strains entirely, since the structure he is building is part of life, which is full of contrasts and contradictions.

Yet sooner or later he himself may come to associate his structure with something like "uncle", with or without laymen's help; and if the name seems to fit, there is nothing to prevent him from accepting the notion.

Once he affirms the representational aspect of his design, he is apt to add some things, or shapes, that further identify the subject he has fixed in his mind. If he is lucky, he will manage to place these representational elements in such a way that they look as if they had always been part of the basic structure, rather than mere appendages to it.

The question is thus not so much whether or not there should be a subject but what kind of subject it is, how it looks, in any given case.

I hope that the type of layman who does nothing but hunt for his favorite subject among pictures, may gradually become extinct in my particular domain, so that he will haunt me only as a ghost who can't help doing it. When it comes to subjects in painting, we know only own private enthusiasms. And, of course, once in a while it may give us great pleasure to see a familiar face suddenly emerge from a picture.

. . . From prototype to archetype!

The artist who gets stuck along this road, becomes pretentious. Only they have the true call who succeed nowadays in approaching that secret realm where all growth is nourished by the same universal law.

What artist does not yearn to dwell near the mind, or heart, of creation itself, that prime mover of events in time and space?

In nature's own womb, the soil whence all creation springs, which holds the key to every riddle?

But not all of us are destined to go there. Each must obey the command within him, wherever it may lead.

Thus the Impressionists, our adversaries of yesteryear, were quite right, in their time, to dwell among the underbrush of everyday appearances.

Our own heart, however, urges us to go deeper, down to bedrock.

What comes of this impulse – however you call it: dream, idea, imagination – is not to be taken seriously until it has been given bodily shape in the work of art, through the creative procedure that is suited to it.

Only then do these oddments become realities – artistic realities that widen the horizon of our life beyond its ordinary limits.

Because they don't simply reproduce, more or less idiosyncratically, what our eye has seen, but cast into visible form our secret visions and insights."

Dance with Veils 1920

367

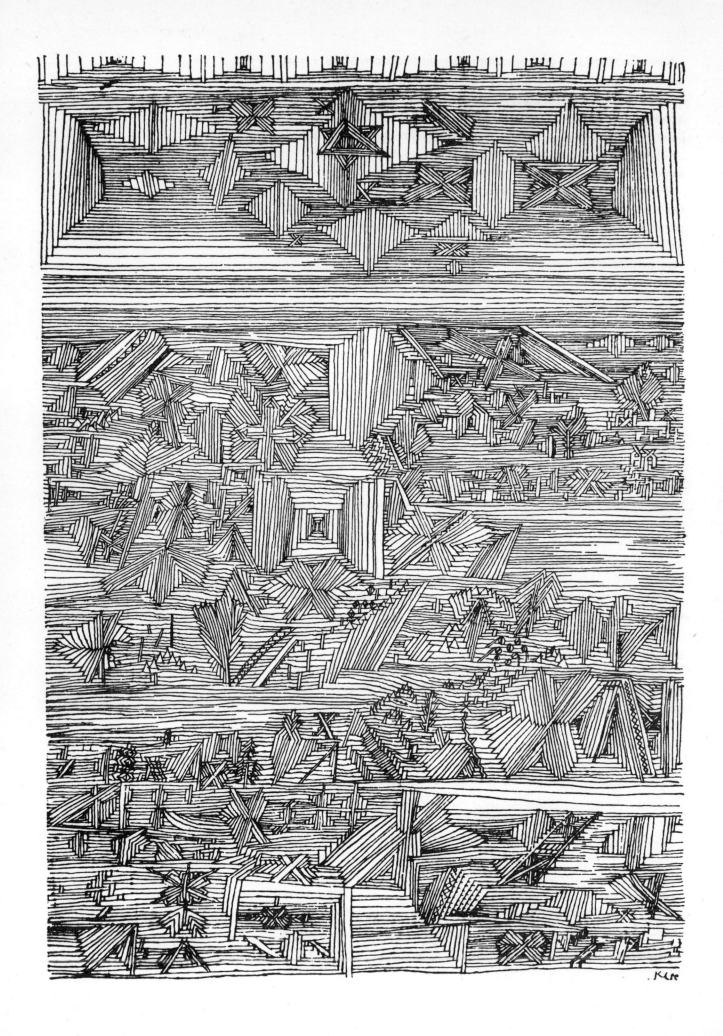

From the very outset of his career Klee tirelessly probed into both the manual and the intellectual aspects of art. His letters to his fiancée prove as much, and his preoccupation with these things continues as a monologue in his *Diary* up to 1918. In that same year he wrote an essay (published in 1920) that contains in a nutshell his whole conception of the artist's mission. In 1924 he gave a lecture at Jena (published in 1945; excerpts are printed here on pages 365–367) that is nothing less than a detailed, step-by-step account of the creative process as he had experienced it, one of the most profound analyses – indeed, perhaps the most exhaustive – any modern artist has given us of how the work of art takes form. During his years as a teacher he published an essay, *Ways of Studying Nature* (in the Bauhaus-Buch, 1923), and *Exact Experiments in the Field of Art* (*Bauhaus-Zeitschrift*, II, 2–3, 1928). In 1925 there appeared his *Pedagogical Sketchbook* (another *Bauhaus-Buch*), which he intended to continue in later years. After his death a whole suitcase of manuscripts was found, containing articles, notes, and drawings relating to teaching; these were written down between the years 1920 and 1930 and, like the *Diary*, are as yet unpublished. Part of this pedagogical material is due to appear shortly. What his students have recorded of Klee's talks and conversations remains unpublished.

The creative work of Klee links up indirectly with his teaching activities, since it served to enrich the educational methods of the Bauhaus and other schools of that period. In the course of his lectures Klee often analyzed his own pictures, and they proved a particularly fruitful source of instruction.

In the second section of this book – *Work* – we have had to refer frequently to Klee's attitude towards nature and the outer world, towards color and graphic expression, as well as to many other points bearing directly on his teaching activities. Teaching for Klee was so intimately connected with his own creative work that we may say he simply taught what he himself had experienced as a practicing artist, while at the same time he continually learned from his own pupils, just as he always did from everything and everybody that crossed his path. At Dessau he once dropped the remark, with a smile, that it was he, not the students, who should be paying tuition, so much did he learn from them. For Klee there was no end to learning; his teaching activities simply became part of his own inner growth. This, of course, must not be taken to mean that he confined his lectures to the problems occupying him at the moment personally, or that he improvised, following the whim of his students; on the contrary, he proceeded systematically, "prepared up to the last word" (letter to Lily, 1921). He took teaching so seriously that after ten years of it he no longer felt able to sacrifice so much of his time and left the Bauhaus for a less burdensome position at Düsseldorf.

For twelve years the Nazi regime, with its program of ruthless Philistinism in art, tried to undo Klee's teaching as much as possible. Many of the seeds he planted failed to sprout, some of his pupils were compelled to abandon art altogether, and a few made concessions. But the essence of his message came through intact, and art schools the

(page 368) *A Garden for Orpheus* 1926

world over, particularly in America, have taken his doctrines to heart and studied them in his works.

No final judgment on Klee's art doctrines is possible until the main body of his pedagogical writings has been published. This, however, will be of considerably more interest to specialists than to art-lovers, since the essays intended for the public at large are already available in print.

To Klee the teachable aspects of painting and drawing were inseparable from the conception of the world; his every creative act, however modest or tentative, had its counterpart in an actual experience of life and reality. "Our conception of form," he wrote in 1917, "is our conception of the world." He began his course of lectures on *The Theory of Plastic Form* (winter term, 1921–1922) by laying down the following program: "We shall investigate the path covered by the artist in the creation of a given work. We mean to cover that path ourselves and thus to guard against hasty conclusions. We shall analyze the genesis of the picture, stage by stage. Its history begins in fact even before the first brush stroke, with the desire for self-expression, with a particular outlook on things. But even the best intention in the world is not enough without the actual tools." Klee then touches on points and lines – lines with a life of their own that "take a walk," lines wedded to forms, lines whose movement changes them into planes, so that they lose their active character and become medial or passive. Then he illustrates his meaning with a simile: I fell a tree, the tree falls (medial), the tree lies where it has fallen.

Having explained at length the three concepts – active, medial, passive – Klee approaches the matter in terms of actual experience, illustrating their interrelations with such examples as the motor mechanism of the body (bones – passive, muscles – medial, brain – active); the mill-wheel and hammer (water power – active, transmitting machinery – medial, hammer – passive); plant reproduction (stamen – active, insect – medial, pistil – passive); or the circulation of the blood (heart – active, lungs – medial, blood – passive). In this way students were sure to remain in touch with nature, and its life-processes, which are no less important for them than art training properly so called. The point was to familiarize them with art and nature concomitantly. Klee posited the creative self as a mirror of the universe. For him the laws governing nature and man tallied perfectly – and in the classroom he always emphasized this credo, axiomatic for his own understanding of the world of forms.

In *Ways of Studying Nature* he laid down, in his quartering, the concepts on which this teaching was based: I and Thou, the Earth and the Universe, or Artist and Subject, Earthbound (static) and Cosmic (dynamic). "The artist is a man, and thus part of nature – a fragment of nature within the natural world." Thus the man or thing opposite you merges with yourself, into a single, fully integrated relation. The *Pedagogical Sketchbook* omits this and much else, giving no more than excerpts from Klee's theoretical teachings. Klee here proceeds from the motor mechanism directly to an analysis of dimensions, to "operations in three dimensions," to the vertical as the "true, upright path on the

plane," to the horizontal as representing the beholder's position in space, his eye-level; and he explains the difference between logical and psychological perspective.

All of Klee's other writings should be studied as a complement to the *Pedagogical Sketchbook,* a good example being the 1918 essay on line, a very straight-forward interpretation of the graphic elements and what lies behind them – for behind everything there lies something else, as Klee used to say. His description of how lines act is like a tale of adventure: "Breaking away from dead center (i. e., from the single point), that is our first act of motion (the line). After a moment it stops short to catch its breath (broken or articulated line). Then a backward glance to see how far we have come (counter-movement). Tentative starts in several directions (cluster of lines). A river lies in our way, so we take to a boat (wave movement), though there may be a bridge farther upstream (series of arches) . . . We cut across a ploughed field (plane traced with lines), then through dense woods . . . meeting basket-makers on their way home with their cart (the wheel, a circle). They have a child with the funniest curls (spiral movement). Later on the atmosphere grows sultry and night falls (spatial element). A flash of lightning on the horizon (zigzag line), though stars still twinkle overhead (scattered points) . . . How eventful our little journey is! The happy, even pace of the first stretch, then the obstacles, the nervous strain! Fear and trembling, the caress of auspicious breezes. Before the storm a swarm of gadflies comes at us. Fury and killing. Our good cause is our guide, even in the woods and darkness. The flash of lightning brings to mind a fever-chart. A sick child . . . long ago." Long ago? Not so long, for we know that when little Felix fell seriously ill, Klee entered the fever chart in his *Diary* every day until the danger was past. Such things as this were the "realities" of which he spoke. Behind everything lies something else, as behind the sum total of things lies a final configuration – pure form. When Klee wrote this essay, he had developed his means of expression to the point where he was able to communicate experience that had hitherto been reserved for the poet and musician. Perhaps this whole pictorial journey, sketched out in 1918, was somehow provoked by the shock of Felix's illness.

After touching on perspective, on the vertical as symbolizing the upright position of man's body and the horizontal as representing the horizon-line, the *Sketchbook* goes on to equilibrium, to the plummet and the balance. Here, again using a familiar image to make his point, he starts with the example of the tightrope-walker and his balancing pole. "I catch myself wavering to the left and throw out my right hand so as not to fall." The painter can restore balance in many different ways, according to the dimension he occupies at the moment: he can manipulate the measure (size), the weight (chiaroscuro), and the quality (color) of shapes. If the result is to be precise and clean-cut, these various factors must be kept distinct from one another. In his Jena lecture Klee had gone into these matters at length; in the *Sketchbook* he merely alludes to them, moving from the "symbols of the static realm" (plummet and balance) by way of the intermediate domain of

371

water and air, to the "symbols of motive impulses" (dynamics), the
spinning top and the pendulum; from the walker, whose equilibrium
must be restored with every step he takes, from the swimmer with his
more loosely articulated rhythm, to cosmic movement, serenely free
of earthly constraints. And again Klee resorts to an image: "A balance
that rests on a single point of support, will tip over, sooner or later . . .
Set the thing turning horizontally and the danger of its tipping over
is averted – we have a spinning top before us. A plumb-line set in
motion becomes a pendulum . . . This form of movement may be made
more complex by imparting motion to the swinging pendulum as a
whole." If we do away with the force of gravity, the movement of
the swinging pendulum describes a circle, or, if we vary its radius, a
spiral. Thus we get the following simile: extend the radius and the
movement gathers life force, shorten it and the movement dies away –
life on the one hand, death on the other. Much the same applies to
the arrow, whose father is "thought, mediating between the earth and
the universe. The farther the journey, the more poignant its ultimate
failure: never to reach the goal where movement is never-ending."

The flight of the arrow may be "in the line of the action" from
white through gray to black, or the other way. This leads Klee to the
problem of how to "create compositional motor mechanisms," first
in the field of tonality, then in that of color. The arrow flies from
minimal red to maximal red, or from water to fire, or from fire to ice,
or from green to red, or from red to green. However, the composition
itself is a higher concept, a dynamic, organic unit, and demands "the
coordination of every element into a self-sufficient whole." The goal
is achieved only "when movement is met by counter-movement, or
when the movement becomes continuous, endless." In the latter case
the direction of the movement no longer matters; opposites (e. g. warm-
cold) unite, "pathos is changed into ethos, force and counter-force are
merged into one." This ideal of continuous movement is symbolized
by the spectrum, "where each arrow becomes superfluous, for we no
longer speak of this or that direction; there is only an 'everywhere',
i. e. also a 'here'."

What Klee hardly mentions in the *Sketchbook* is how to solve, in
terms of weight and quality (tonality and color), the problems he has
dealt with in the field of measure. How, for example, to render per-
spective through gradations of chiaroscuro or color. He went into this
more fully in the classroom, and in his Jena lecture he added further
remarks. There he spoke in detail of the "specific dimensions" of line
and measure, tonality and weight, and especially of color and quality:
"the ruler and scales will show no difference between pure yellow and
pure red, if both cover equal areas and are of the same degree of
brightness; yet an essential difference between them remains, and this
we express with the words "yellow" and "red." Thus we learn that
color equals quality, weight, and measure; chiaroscuro (tonal values)
is weight and measure; line is measure alone.

Out of the elements that constitute these three categories the picture
is built up. "Here is the center of gravity of our conscious creative
efforts. Here we get to the substance of our professional activity. Here

is the critical point, from which, having once mastered the material, we may be assured of building up structures that endure, that reach out into realms remote from our conscious perceptions...Here too is where we most easily go wrong, missing the mark sadly and getting nowhere, squandering the most exceptional gifts. The reason being inadequate command of form." But this building-up is only one step; the image is on a higher level than form, and expression is on a higher one still. Klee then launches into a discussion of the possible variations of expression in terms of color: red in red, transitions between opposites; from red to green, transitions between adjoining hues, as from yellow through orange to red, and so on. Each variation has a physiognomy of its own, and this becomes a matter of style. The artist must be aware of the appropriate means at his disposal; "this is what determines whether a picture will come into being or something else in its stead."

But what of the role of genius? "The school should keep silent on this point and prudently turn away . . . this is a mystery locked in a self-contained space of its own . . . Genius is genius, a state of grace with neither beginning nor end, it is generation itself" *(Bauhaus-Zeitschrift*, 1928). The school teaches only what can be learned: "There is plenty of room left for exact experiment in art, and the gate has been open for some time. What had been accomplished in music by the end of the eighteenth century has only begun in the fine arts. Mathematics and physics have given us a clue in the form of rules to be strictly observed or departed from, as the case may be. Here salutary discipline is to come to grips first of all with the function of forms, and not with form as the final result . . . In this way we learn how to look beyond the surface and get to the roots of things." Yet, for all that, "nothing takes the place of intuition", for without it the totality, the wholeness of things remains outside of our reach. Klee's meaning is clear; we know that in 1924 he was dreaming of "a work of quite exceptional breadth covering the entire realm of subject, content, and style." And he added: "It is a good idea, from time to time, to imagine the possibility of such an achievement, vague as it may seem today."

Among the teaching materials Klee left behind we find, besides many fragmentary notes and sketches, drafts for lecture courses on such subjects as "Principles of the Theory of Form," "The Approach to Form," "The Mechanics of Plastic Form," "Principles of Order" (winter semester 1923–24), and "Style," together with more detailed notes on "Design Based on Structural Patterns," "Design without Structural Pattern," "Compound Form," "Special Classifications of the Plastic Means," and "Theory of Articulated Structures." Some of these theoretical notes run to two or three hundred pages. But there is more besides. Klee left whole bundles of papers, studies of "Irregular Forms" and "Abnormal Changes in Basic Forms" (a pathology of form), studies of "Form and Frame" and "The Relations between Measure and Weight," and lastly a draft for a "Theory of Projective Space." Still other writings and sketches relate to "The Internal Patterns of Basic Forms," "Secondary Aspects of the Square" (progressions, angular movement, etc.), "Secondary Aspects of the Circle"

Gleanings of teaching materials

(the ellipse, parabola, hyperbola, spiral, etc. – 426 pages). Other sheaves of pages contain problems illustrated with examples, some of them worked out by students; single sheets deal with hexahedrons, octahedrons, pyramids, spherical forms, and cyclical figures. Klee delved into the most difficult mathematical and geometrical problems, taking a particular interest in the theory of functions, analytical geometry, and spherical trigonometry, as well as many other problems that arose from his creative efforts, such as thrust, gyration, reflection, and inversion, "mediating forms," "irregular forms," and "subjective perceptions of space." Beside this wealth of manuscript material the *Pedagogical Sketchbook* looks tiny indeed, and despite the occasional repetitions they contain, these papers cover an enormous range of problems in both art theory and art teaching.

A few quotations from the most important manuscripts will serve to give some idea of the way Klee's mind worked. In *Principles of the Theory of Form* he speaks, among other things, of the ways leading to form, "of ways, not of ends to which nothing leads. Form arises out of natural, vital functions; it is, we might say, a function of those functions themselves." Finishing his course at the end of the term in March 1927, he summed it up in the following stages: means at rest, basic principles of growth, pathways to form, relations of form and space, organization of the pictorial whole, principles of representation, construction in detail and as a whole, questions of style and composition, dimensions. Anxious to avoid being misunderstood by his pupils, Klee thus carefully recapitulated the whole sequence, in order to keep alive the idea that there is a connection between all creative elements.

In *Principles of Order* he defines the exact limits of his share in Bauhaus theory, and sums it up in this way: "The initial impulse in ourselves, the actual progressive carrying out of the work itself, and then getting the work across to others, to the beholders – these are the chief stages of the creative act: conceiving, creating, imposing the creation. But there are no cut-and-dried rules. As the way taken and the work in view become identified, the work takes form; a regular rate of progress at the start gives way to a varied pace, and the different stages form a coherent whole." In the same manuscript Klee embarks on a thoroughgoing inquiry into color. Making his way round the equator of the color-sphere whose axis is the black-white plumb-line, with gray as its mid-point, he fellows each color from pole to pole; the long curve from pole to pole, he states, imparts a kind of deep, even breathing to color, while the shortest distance from pole to pole, through the center of the sphere, constricts the breathing to a bare sign. "Around the gray there is only a whispering; we either rise above it to the violins (greater brightness) or sink below it to the cellos (darkness)." He distinguishes between equilibrium existing on a plane and equilibrium in space; the former is limited to meaningful arrangement within the plane of the spectrum (a horizontal, circular plane), the latter arises out of the meaningful analysis of the whole realm of color and chiaroscuro (i. e. the color-sphere).

In his *Theory of Articulated Structures* Klee deals, among other things, with the connection between the theory of composition as a

structure and questions of style (static-dynamic, classic-romantic); in
The Mechanics of Plastic Form he discusses equilibrium as a passive
and an active state. "Movement is the normal condition. Passive
equilibrium can be no more than a basis and a conclusion, the
foundation of action and its aftermath, just as sleep is the foundation
of the day's activities and death the aftermath of everything. A truly
dynamic style is still a remote prospect." The styles of the past he
explains entirely in terms of the different attitudes towards life that
are reflected in them.

The astonishing thing is that Klee reached his major conclusions so
early; he felt the necessity of "purebred (i. e. rigidly selected) artistic
means" as early as 1910, and wrote of "genesis as a movement of
forms" in 1914. Even then he had reached out to the very limits of
art. "Art carries beyond the last outpost of verifiable truth," he wrote
in *The Mechanics of Plastic Forms,* thus clearly setting the world of
art apart from the world of science and its related activities.

Those who took part in his painting classes at the Bauhaus, in his own
home, or at the Düsseldorf Academy, can recall many a wise word of
advice or criticism that fell from Klee's mouth in the course of
analyzing and judging the work of his students. On these occasions he
also used to show pictures of his own, as often as not his very latest,
and discussed their good and bad points as impartially as he would
anybody else's work. His sole desire was in every case to get as close
as possible to the limits of the mystery behind the work. Even at
exhibitions, particularly those of his students, he commented on the
nature and qualities of works of art with such insight that those who
were privileged to hear him at once felt a little more intimately
initiated into the creative process. Our picture of Klee as a teacher
of art may be rounded out by the following extracts from such dis-
cussions.

To begin with the simplest factor, technique: For four decades Klee Technique
ceaselessly probed into the technical side of painting, always laying
the greatest stress on the proper use of materials and the physical
stability and durability of pictures. "Everything, down to the last
detail, must be accounted for." When trying out risky technical proce-
dures, he recorded every step on the back of the picture itself (e. g.
Refuge, 1930) or noted them down on a slip of paper; after considerable
time had passed he returned to the picture, checking up on its condition.
Here, as always, he began at the beginning, with the priming of his
canvas, to which he attached such importance that when his students
at Düsseldorf put their heads together to choose a birthday present for
him they decided on a set of meticulously prepared blank canvases.
But even in technical matters Klee never lost sight of the sense and
utility of the methods employed, holding technique to exist not for
its own sake but as the servant of the artist's purpose. It makes a
difference in the treatment of a theme whether a coarse impasto or
a fine glaze is put on, although "in its place a coarse coat of paint
may be the ultimate in refinement," and may be as precise and jewel-

like as any connoisseur could desire, for "pictures are not mere ex-
hibits." Thus here, too, starting from the material side of things, Klee
moves on to the spiritual and the aesthetic.

Handwriting

After technique comes the artist's "handwriting." "Keep your hand
in practice," he was fond of saying, "or better both hands, for the left
works differently from the right. It is not so deft, and for that reason
sometimes of more use to you. The right hand writes more naturally,
the left more hieroglyphically. Good handwriting, however, is not
mere accuracy, but expression (keep the Chinese in mind) and with
exercise it will grow more sensitive, more intuitive, more spiritual."
Klee himself, let us note, habitually drew with his left hand, and
often with both hands at once.

Sketching

To sketch is to seize on the wing what the eye (or mind) sees, and
a sketch is a good one when it can be carried further by additional
studies. Of an easel-painting we expect a great deal more than that. For
one thing, it must always have something new to impart to us; it must
have a certain intensity (Klee always thought intensity in a work of
art more important than monumentality). The day when the work
has reached the right degree of intensity is a matter the artist must
judge for himself. If he goes too far the picture gets over-complicated
and the life is wrung out of it. The watchword is simplicity, i. e., the
art of saying much but saying it as simply as possible.

Color

The handling of color is almost inexplicable and at any rate so
highly personal a matter, Klee maintained, that every artist must
settle it for himself. His own preference went to orange, red, yellow,
graded to green and to brown. He cared less for blue, at least until 1930;
after that there was a change. Laws governing the order and combinations
of colors mean little or nothing; everything depends on the sensitivity
of the man who is handling them. Each color has a personality of its
own that must be respected; each color has its likes and dislikes, and
with these the artist must familiarize himself. White and yellow, for
instance, are fond of each other and both press forward. The problem
grows more complex when color is grafted onto form; for color and
form have a profound effect on each other, producing either harmony
or tension.

Space

As mysterious as the workings of color are those of space. The
painter sets to work on a flat surface; yet every freely drawn line
almost inevitably suggests the third dimension, as does any intersection
of lines and planes and any juxtaposition of colors. Each color, by its
very nature, is inclined either to push forward or to draw back, so
that adjacent squares of color, alike in size and intensity, produce an
impression of space. Klee refused to introduce space in flux, i. e., the
fourth, imaginary dimension, in his teaching; he felt that it only made
things more difficult for the student without promising any plausible
solution – at least for the time being. Here he stands in complete
agreement with Albert Einstein, who does not believe in mingling the
fourth dimension with art. However, Klee welcomed the time element,
for all evolution, all growth extends in time, and "space, too, is to be
understood in terms of time."

Glance 1940

Both as a man and as a painter Klee held aloof from the conflicts and controversies raging around him. Of all twentieth-century masters he was the least exposed to attack, as he issued no challenge for hostile spirits to seize on. The fact that the Nazi government proscribed his work must be viewed on a strictly political plane and need not detain us here.

What kind of man Klee really was is not easy to say in retrospect. He held the world at arm's length, so to speak, was extremely reticent, and there is no judging him by the stand he took in human or artistic matters, as he hardly ever committed himself. If he was looked up to by all as the final arbiter in conflicts and quarrels – and not only at the Bauhaus – the reason was his absolute integrity, recognized even by those who lost suit in his judgments. But he took no pride in this; on the contrary, it pained him to feel that his associates at times questioned the depth of his sympathies and put him down as a "neutral observer." This is exactly what he was, of course, but only for the sake of his art. A "cosmic viewpoint" – and this was the position he chose for himself – was hardly calculated to cement his ties with other men; in everyday life it amounted to a renunciation, and over this he came to ponder deeply towards the end of his life. Did his work suffer from the exclusion of *Eros?* The elemental and cosmogonic *Eros* surely was not missing in his work, ranging through space and time, linking all forms of being. But the direct, personal *Eros* cannot be found in Klee's work any more than in all the art of the twentieth century, which is peculiarly "self-less" and free of private passions. Klee was not incapable of loving or responding to love, but as "nothing lasts in this world," love to him was an ever incomplete thing, a mere part of the eternal flux of things. An artist cannot attain to this "crystalline" state without paying the price of "abandoning the self in his work." Genius, having once tasted of the tree of knowledge, may no longer taste of the tree of life, wrote Jean Paul.

It would be a mistake, however, to think of Klee as living cut off from the world. He knew the world for what it is. He was acquainted with evil but regarded it not as an isolated phenomenon, but as part and parcel of the whole. Good and evil for him made up the "moral sphere," and evil "has its share in generation and growth." When the "radically evil" makes its appearance in his work, as it does every once

in a while, it is compensated for in such a way that a one-sided picture is rarely produced. Good men only dream what evil men do; not that Klee's works are dreams, though sometimes they are; more often he reacts consciously to the world as it impinges on him and "copes with it using his own special endowment" (as he put it in his Jena lecture), so that in the end he achieves a balanced, harmonious view.

The artist has knowledge of everything, and with Klee the link between the inner self and the outer world is more complete than with any of his contemporaries. He has been called the greatest realist of our time, and that describes him well, although his realism is concerned with the essence of things, rather than with their surface appearance. Group his themes together and they encompass the universe, not only the plenitude of things but the secrets of their birth and growth, the mystery of their innumerable sublunar and cosmic linkages. His art mirrors almost every area of human thought; he visualizes the rise, evolution, and fate of human, plant, and animal life, as well as their transformation into primeval and potential states. The world of art itself becomes his subject, as do the world of music and poetry, the whole realm of the exact sciences, physics and mathematics, geology and cosmology, the vistas of history, and the intricacies of pure invention. Thus he could give us a *Bud* as well as a *Vocal Cloth,* a *Cloister Garden* as well as the *Limits of Reason* and *Coolness in a Garden of the Torrid Zone.* He gave us daydreams and shocks, ghostly apparitions and buffoonery, definitions and equations. Whoever follows the trail blazed by Klee is in for new experiences, new unsuspected truths. He leads the way through microcosm and macrocosm, pointing out the stars, fraught as they are with the possibility of other lives, other destinies, other truths.

Surely Klee was a painter, but he was also a naturalist, a philosopher, a poet; as early as 1911 he had demanded these things of himself. His insight into nature was at times more penetrating than that of specialists, and his "intuitive discernment" rivaled that of Goethe. Philosophy for him was not just a branch of learning but a method of investigating the interaction of phenomena. Poetry and music, however, were as much part of his own being as painting.

Poetry and Humor

The titles he gave his pictures are like small metaphorical poems whose intense suggestive power enhances the themes he drew and painted. In coining them he coined many a new word and, linguistically speaking, created new lands and cities, new plants and living things. Best of all, and richest in invention, are the short phrases with which he sent his creatures and creations on their way. Klee invented close to nine thousand such titles and phrases, hardly ever repeating himself. (His total *oeuvre* numbers 8926 items.)

Many of the titles sparkle with wit, and the point of many pictures only becomes clear when they are taken in conjunction with their titles. For it is not always easy to get the drift of certain works from their forms alone, which playfully mask the meaning. "Humor," wrote Goethe, "results from an imbalance between reason and the world of facts"; and he recognized gay humor wherever reason abandons its

rights and in good grace lends itself to the jest. Such was Klee's brand of humor. Very often picture and title so complement each other that the latter adds a further nuance to the work, stressing particular elements in it. Occasionally the title does not quite succeed in suggesting the scope and depth of the pictorial experience. *A Light and Dry Poem* (1938) adds an extra note to the picture itself, while *Right, Left* (1938) detracts a little from it. Though the titles are only secondary, they betoken a highly suggestive intermingling of painting and poetry. And Klee's linguistic resources, the accuracy, the carrying power of his words and phrases, and the startling combinations in which he puts them, are an essential feature of his art.

A Light and Dry Poem
Cl. Cat. 170
Right, Left Cl. Cat. 176

The subtle imagery of Klee's wit lies in the theme, in the design, or in both. When he paints a *Christian Sectarian* (1920), he slightly over-does every trait commonly attributed to such men: the emaciated body, long flowing hair, watery eyes, spidery fingers, the cross he wears round his neck. In *Acrobatic Animals* (1921) it is the direct, childlike imagery and the primitive quality of the forms that delights us. Even in early works, however, we find another type of humor, based on "tension between forms." Thus *Dr. Bartolo* (1921) is a puffed-up composition, while *The Chair-Animal* (1922) is a creature that behaves like a piece of furniture. The delightful drawing, *What Does It Matter to Me?* (1928), though dominated by several mathematical and spatial components, show a small animal on a stand in the foreground, looking for all the world like a doll in a child's crib; the presence of the tiny creature, comically out of place here, throws a veil of good humor over the grave complex of forms on which the picture as a whole is built. Thus a single detail holds the entire work in balance. About 1930 Klee's sense of humor began to express itself even more strongly in formal terms. Not that the wordly-wise humanity of his earlier work went entirely by the board; in *Halves, the Clown* (1938), *Poster for Comedians* (1938), or *X-let* (1938) a gay sense of contrast still pervades the picture, but the power of expression and the keen intelligence with which lines and colors are interwoven are more strikingly in evidence than before. We also have such drawings as *Manageable Grandfather* (1930) or *Family Outing* (1930), where pure geometry rises to its most eloquent pitch and at the same time produces those "playful, innocent flashes" that are the essence of humor.

Acrobatic Animals p. 168

Dr. Bartolo p. 223

Poster for Comedians p. 297
X-let p. 10

Family Outing p. 274

Still more significant than this interaction of painting and poetry is the way Klee mingled painting and music. He was an excellent musician himself, often playing for his own enjoyment, and never at a loss to read and interpret a score. Though he did not compose, he thoroughly understood the process of musical composition and was as much at home with Igor Stravinsky's musical system as with Arnold Schönberg's twelve-tone scale. Bach, Mozart, and Haydn were as familiar to him as the poems of Goethe to poetry lovers, and he knew practically every one of their works, some of them by heart. It was his way always to go back to the underlying elements of things; he could profit as much from the study of music as he did from painting, perhaps even more so; for where, in painting, could he find the

Music

exemplars that might have helped him to solve the problems he had
set himself? The analysis of graphic representation in his *Creative
Credo,* not only gives us an outline of his methods as a painter,
but those of the creative artist in general, including the musician. The
fact is that Klee's procedure is no different from that of the composer
as he sets down note after note, goes on from motif to theme, introduces
a second theme, combines the two, and so on. His art being unique of
its kind, the musician is often described as a man with a sixth sense.
But every artist worthy of the name is gifted with a sixth sense, and
his creations are just as unique of their kind. This is true of Klee, as
it is of the old masters. The deeper we go into his work, the more we
realize how rich it is in unique, inexplicable forms of beauty –
phenomena analogous to those that lead us to attribute a sixth sense to
the musician.

Figure in Red Cl. Cat. 94
Pastoral Cl. Cat. 82

Music runs through the whole of Klee's work, not merely in such
works with musical titles as *Fugue in Red* (1921) or *Pastoral* (1927).
Obvious musical features of his pictures are their rising or falling
rhythms, brief or broadly arching melodies, subdued or cheerful keys,
polyphonic or harmonic phrases, tonal and atonal counterpoint; we
might even speak of fugues and sonatas, chamber music, solo pieces,
and so on. Despite his keen interest in modern music, Klee's enduring
fondness for Mozart was only nature in view of the deep
temperamental affinity between the two artists; the life of each, in
fact, was so busily employed with painting in the one case and music
in the other that neither had any time left for the things that fill other
people's daily lives.

Analogies are often drawn between Picasso and Stravinsky, and
certainly each reflects the climate of the times. Reservations must be
made, however, for Picasso's classical period of about 1920 is not nearly
so inevitable as that of Stravinsky. With Klee we are less inclined
to look for such parallels; he stands as an exceptional case in this
respect as well. Music was so intimate a part of his being, transmuted
into visual qualities whenever he stood before his easel or drawing-
board, that it seems to flood through all his work. The effect of many
of his pictures is like a phrase or passage out of a symphonic whole;
and there are sets of pictures – those painted in Egypt, for example –
whose over-all effect is comparable to that of a symphony.

If in the 'twenties Klee stirred up far less controversy than did the
vanguard composers of the day, the reason is, perhaps, that painting
is a less "public" art than music and does not impinge upon the
consciousness of so large an audience. In the 'thirties, when the challenge
of his pictures might have been at its most provocative, Klee himself,
almost imperceptibly, had reached an unassailable degree of maturity,
with a body of work behind him that disarmed his detractors.

The Near East

After music and poetry comes a third determining factor in his
work; the spirit of the Near East. His trips to Tunis and Egypt are not
the cause of this influence; they were the natural outcome of his
partiality for Near Eastern countries and Mohammedan culture in
general. Whether or not there are actual blood ties behind it, Klee's

affinity with the Orient is obvious. Without ever being on really familiar terms with life in these countries, Klee felt at home there. Their echoes in his work ring true, like deep-seated reminiscences of the remote past. There are compositions of his in which trees, ladders, and jugs at once bring to mind the archaic characters of Babylonian writing tablets of the third millenium B.C. One of his sketches from Kairouan resembles a *sgraffito* wall picture in the Parthian city of Dura-Europos representing a caravan wending its way across the desert. Many of his still lifes in the 1920s are built up of flowers, fish, and symbolic signs like the Alexandrian mosaics at Tripoli (second century A.D). His "sign-pictures" and "plant-script-pictures" have striking affinities with Kufic inscriptions and manuscripts of the Koran. Going through Klee's paintings and sketches, one is continually brought up short by such analogies with the remains of ancient cultures, far too frequent to be the product of chance. Klee's way of combining fountains, trees, mountains, birds, fish and so on corresponds to the Persian Hvarenah pictures and to the symbolic landscape elements on the façade of the Omayyad palace of Mschatta, while his frequent use of broad curves on plane surfaces harks back to the arabesques of Islamic art. His interlacing of figures, plants, animals, signs, and script, his alternation of ground and design, the way many of his forms seem to have neither beginning nor end, thus inducing a kind of hypnotic spell – all these procedures have their counterparts in the art of the Near East. The point here is not simply his continual use of Oriental themes, but rather the thoroughgoing interpenetration of two different ways of thinking. And this we find not only in a picture such as *Arab Song* (1932), but in many others whose titles betray no inkling of it, in festive scenes and pavilions decked out with flags, in exotic figures and animals, in the actors and dancers of his theater-pictures.

Arab Song Cl. Cat. 144

The invisible spiritual core of the Mohammedan religion, the eloquent symbol of the void, appears in Klee's pictures as a state of self-fulfillment, and also as the very reverse: the supra-personal, the magical. The angels and genii of Islam are more akin to the "messengers" of Klee's world than Christian angels are. Above all, however, Klee, like the Moslem, retains the fullness of worldly experience while overcoming the world, armed with serenity and seriousness, faith and irony, knowledge of nature and belief in myths. The love of analogy and parable, the revelation of the fundamental oneness of all things through the metamorphosis of forms, the kaleidoscopic interplay of nature, man, and eternity – all this we find in Klee as we find it in the East. And the imagery, the approach to man and nature of the Persian poet Hafiz is reflected in Klee's art just as it is in Goethe's *West-East Divan.*

"All art is a memory of age-old things, dark things, whose fragments live on in the artist." Hence the archaic note struck in so much contemporary art, which gives free rein to the uprush of the unconscious. So it is with Klee, whose work is rich in archaic forms and overtones. Not that the conscious mind is by any means denied its due; Klee drew simultaneously on many levels of experience, and this fact

Archaic forms and ciphers

in large part accounts for his complex, many-faceted links with remote times and peoples throughout the world, for the basic psychic patterns are the same nearly everywhere. But in his work even the elements he could not assimilate play their part and lead to unexpected tensions and schisms. At such times the world of the moment, the here-and-now, falls away, all that seemed certain and solid comes to look extremely relative, and the plastic means employed hitherto no longer suffice, but give way to a new vocabulary whose message is couched in ciphers and strange formulas.

It has been said that pictures of this kind are as exact as Einstein's equations. These, too, are made up of ciphers; for the physicist their meaning is symbolic, they stand for far more than mere mathematical certainty. Klee's pictures, despite their multitude of implications, are indeed exact; to establish his world, the painter drew his materials and means from many sources — from nature study and intuition, from reality and dream, from mathematics and music. Had he sought only the most comprehensive formula instead of the most exact, why is it that in literally thousands of sketches — many of which have the character of blueprints or mathematical constructions — he labored to find the most sparing, most economical form of expression? As Goethe's *Theory of Color* took its place beside the symbols of the second part of *Faust,* so Klee's exact formal experiments, his pedagogical-scientific studies and literary formulations, stand beside the symbolism of what I have termed his "central" creations. This then is the fourth instance of a fruitful interpenetration of his painting with an external factor, based on his gift of both scientific and intuitive insight.

What at present may strike us as inexplicable in Klee's art will yield a rich harvest of enjoyment to later ages. The course of the plastic arts will merge with that of music and poetry, to the enrichment of each. This has come about already in isolated cases; thus James Joyce, Léon-Paul Fargue, Stravinsky, and Hindemith throw light on Klee as Klee illuminates them. Here, too, science has a part to play, just as Klee's painting will in time be recognized as an important contribution to human knowledge, for his art is not only a picture of our world but also a diagnosis of its problems.

Klee's greatness lies in his unswerving single-mindedness, in the way he kept faith with himself. He spared no effort and unflinchingly made the sacrifices called for at every stage of his artistic evolution. Outward success meant nothing to him; he worked on as always, heedless of the fame he had acquired, intent only on finding ever better solutions to his artistic problems. His singleness of purpose, however, went hand in hand with serenity. He accepted everything with composure, with complete self-possession, with good sense. Never in better humor than when hard at work, never surer of himself than when immersed in the mysteries of creation — such was Paul Klee.

Note

This excerpt from the catalogue of Klee's *œuvre* has been grouped according to class of pictures or, rather, classes of conceptions. To the extent that they can be fitted into these groupings, it also contains page references to the color plates, the black-and-white plates, and the illustrations in the text. I have also added page references to the discussion of these groupings in the text.

The chronological sequence of Klee's work has been retained as far as possible, but each grouping includes former and later formulations of the same idea, as well.

□ = Color plate O = Black-and-white plate △ = Text illustration

Donkey Eating out of Hand
1937

384

1: Selbstbildnisse
Self-Portraits / Autoportraits

○ = 24

△ = 16, 27, 51, 59, 63

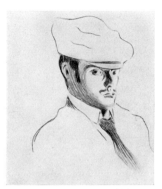

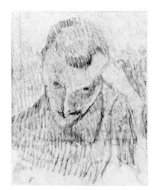

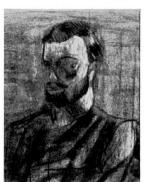

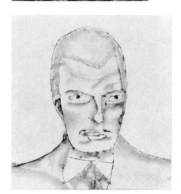

1 *Selbstporträt mit der weißen*
 Sportmütze (1899)
 Self-Portrait with White Cap
 Autoportrait à la casquette
 blanche

 2 *Junger männlicher Kopf mit*
 Spitzbart (1908)
 Head of Young Man with
 Pointed Beard
 Tête de jeune homme à
 barbe de bouc

3 *Skizze eines Selbstbildnisses*
 (1908)
 Sketch for a Self-Portrait
 Esquisse d'un autoportrait

 4 *Selbstporträt en face, in die*
 Hand gestützt (1909)
 Self-Portrait, Full Face,
 Head Resting in His Hand
 Autoportrait de face, le
 menton dans la main

5 *Jugendliches Selbstporträt*
 (1910)
 Youthful Self-Portrait
 Autoportrait de jeunesse

 6 *Bildnis-Skizze* (1913)
 Sketch for a Self-Portrait
 Esquisse d'un portrait

7 *Abwägender Künstler* (1919)
 Artist Meditating
 L'Artiste méditant

 8 *Formender Künstler* (1919)
 Artist at Work
 L'Artiste au travail

9 *Komiker (Versuch)*
 (1903)
 Comedian (Sketch)
 Comédien (Essai)

2: Radierungen 1903–1905
 Etchings / Gravures à l'eau-forte

 S. / pp. 43–45, 102–104, 113

 ○ = 105, 106, 107, 108

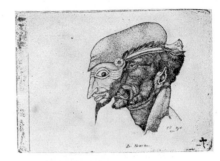

10 *Ein Weib, Unkraut säend*
 (1903)
 Woman Sowing Weeds
 Femme semant de l'ivraie

 11 *Ein Mann versinkt vor*
 der Krone (1904)
 A Man Groveling before
 the Crown
 Un Homme s'abîme
 devant la couronne

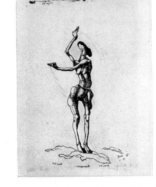
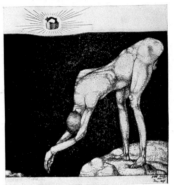

12 *Weib und Tier (1904)*
 Woman and Beast
 Femme et Animal

 13 *Komiker II (1904)*
 Comedian II
 Comédien II

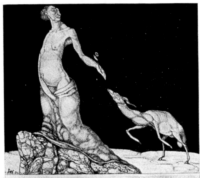

14 *Pessimistische Allegorie des*
 Gebirges (1904)
 Pessimistic Allegory of the
 Mountains
 Allégorie pessimiste de la
 montagne

 15 *Greiser Phönix (1905)*
 Senile Phoenix
 Phénix sénile

16 *Zwei Akte im See (1907)*
 Two Nudes in the Lake
 Deux nus au bain

 17 *Der Garten der Leiden-*
 schaft (1913)
 The Garden of Passion
 Le Jardin de la passion

3: Hinterglasbilder 1905–1908
Glass-Paintings / Sous-verres

S. / pp. 45, 46, 113–116

□ = 117
○ = 109, 110, 111

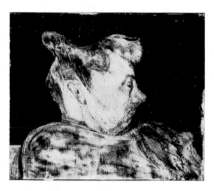

München 1906–1920

4: Arbeiten 1906–1913

S. / pp. 46–54, 115, 116, 121–124

□ = 119

○ = 22, 23, 129, 130

△ = 28, 29, 31, 42, 43, 44, 47,
49, 55, 97, 98, 103, 104,
114, 115, 116, 121, 122,
123, 124, 141

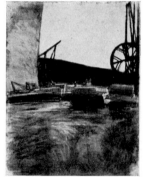

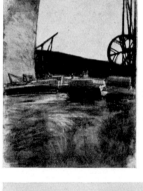

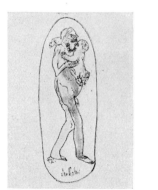

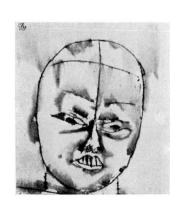

18 *Bildnis meines Vaters*
(1906)
Portrait of My Father
Portrait de mon père

19 *Bildnis einer schwangeren*
Frau (Lily) (1907)
Portrait of a Pregnant
Woman (Lily)
Portrait d'une femme
enceinte (Lily)

20 *Bern, Matte, industrieller*
Teil (1909)
Bern, Matte, Industrial
District
Berne, Matte, partie
industrielle

21 *Im Ostermundigen Stein-*
bruch (1907)
In the Quarry at Oster-
mundigen
Dans la carrière d'Oster-
mundigen

22 *Der Vater, zwei Akte* (Paul
Klee mit Sohn Felix) (1908)
The Father: Two Nudes (Paul
Klee with His Son Felix)
Le Père, deux nus (Paul Klee
avec son fils Félix)

23 *Bern, der industrielle*
Teil der Matte (1909)
Bern, the Industrial
District of Matte
Berne, la partie
industrielle de la Matte

24 *Hannah I* (1910)

25 *Kopf eines jungen Pierrot*
(1912)
Head of a Young Pierrot
Tête d'un jeune pierrot

387

26 *Straße am See* (1913)
Road along the Lake
Route au bord du lac

27 *Im Steinbruch* (1913)
In the Quarry
Dans la carrière

28 *Motiv aus Hamammet*
(1914)
Motif from Hamammet
Motif d'Hamammet

5: Kubismus
und Kairuan 1914–1915
Cubism; Kairouan
Cubisme et Kairouan

S. / pp. 54, 55, 124, 141–143

□ = 125, 127

○ = 131, 132, 133, 134, 135

△ = 52, 142, 143

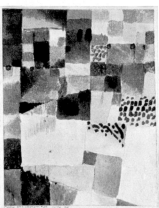

29 *Teppich der Erinnerung*
(1914) Carpet of Memory
Tapis du souvenir

30 *Abstrakt, farbige Kreise*
durch Farbbänder ver-
bunden (1914)
Abstract-Colored Circles
with Colored Bands
Abstrait, cercles colorés
que relient des rubans de
couleur

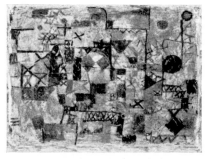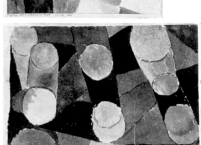

31 *Bewegung gotischer Hallen*
(1915)
Movement of Gothic Halls
Mouvement de salles
gothiques

32 *Steinbruch Ostermun-*
digen (1915)
The Quarry at Oster-
mundigen
La Carrière d'Ostermun-
digen

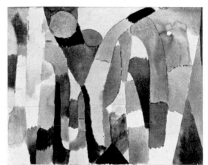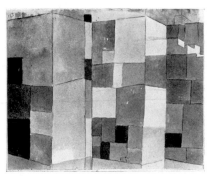

33 *Fata Morgana zur See*
(1918)
Mirage at Sea
Fata Morgana en haute mer

34 *Dünenflora* (1923)
Dune Flora
Flore des dunes

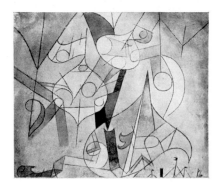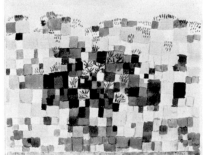

6: Kosmisches Bilder-
buch 1916–1920
Cosmic Picture Album
Imagerie cosmique
 S. / pp. 60, 144, 149
 □ = 147, 153, 155
 ○ = 136, 137, 140
 △ = 100, 151, 160, 184, 366,
 367

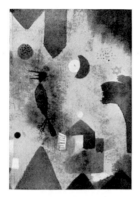

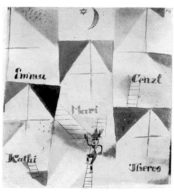

7: Formereignisse
1915–1920 / Formal Experiments
Formes nouvelles

 S. / pp. 149, 150

 □ = 145
 △ = 159, 162

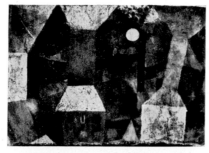

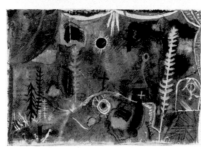

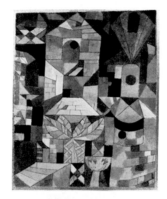

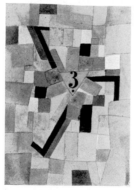

35 Blaues Dach, orange
 Mond (1916)
 Blue Roof, Orange Moon
 Toit bleu – lune orangée

36 Schlagende Nachtigall (1917)
 Trilling Nightingale
 Rossignol chantant

37 Einsiedelei (1918)
 Hermitage
 Ermitage

38 Der bayerische Don Giovanni
 (1919)
 The Bavarian Don Giovanni
 Le Don Juan bavarois

39 Burggarten (1919)
 Castle Garden
 Jardin de château

40 Dreitakt, mit der Drei
 (1919)
 Three-Part Time
 A trois temps, avec un
 trois

41 Spiel der Kräfte einer Lech-
 landschaft (1917)
 Playing with a
 Lech-River-Landscape
 Jeu des Forces d'un paysage
 de la Lech

42 Festungsneubau (1919)
 New Fortress
 Forteresse nouvelle

43 *Erwachende* (1920)
 Woman Awakening
 Femme s'éveillant

 44 *Fesselung* (1920)
 Fettering
 Dans les liens

45 *Composition mit dem B*
 (1919)
 Composition with a B
 Composition à la lettre B

8: Ölbilder 1919–1920
 Oils / Peintures à l'huile

 S. / pp. 60, 150, 151

 □ = 157
 ○ = 138, 139

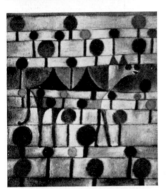

46 *Der Kanari-Magier* (1920)
 Canary Magician
 Le Magicien canari

 47 *Kamel in rhythmischer*
 Baumlandschaft (1920)
 Camel in a Rhythmic
 Wooded Landscape
 Chameau dans un rythme
 d'arbres

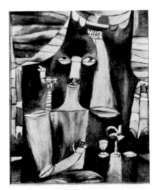

48 *Rosengarten* (1920)
 Rose Garden
 Roseraie

 49 *Legende vom Tod im*
 Garten (1919)
 Legend of Death in a
 Garden
 Légende de la mort au
 jardin

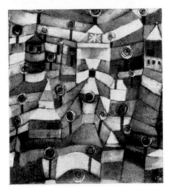

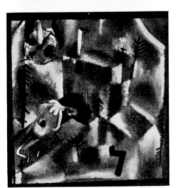

50 *Parkbild bei Regen* (1920)
 Park in the Rain
 Parc sous la pluie

 51 *Zerstörtes Dorf* (1920)
 Destroyed Village
 Village détruit

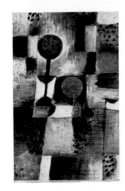

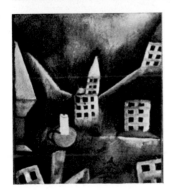

Weimar 1921–1925
Arbeiten im äußeren Kreis
Works of the Outer Circle
Travaux du domaine extérieur

9: Köpfe und Gestalten,
Landschaften und Stilleben
Heads and Figures, Landscapes,
and Still Lifes / Têtes et figures,
paysages et natures mortes
S. /pp. 190–192
□ = 203 / ○ = 172
△ = 66, 191

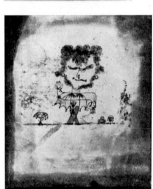

52 *Die Heilige* (1921)
Female Saint
La Sainte

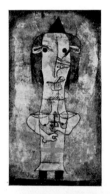

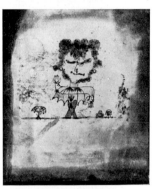

53 *Narr in Christo* (1922)
Fool in Christ
Fou in Christo

54 *Sganarelle* (1922)

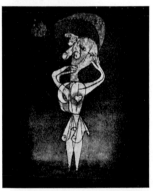

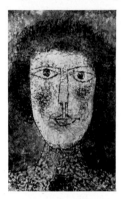

55 *Die Künstlerin* (1924)
Female Artist
L'Artiste

56 *Bildnis eines blonden
Fräuleins* (1925)
Portrait of a Blonde Girl
*Portrait d'une demoiselle
blonde*

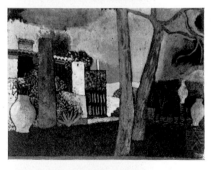

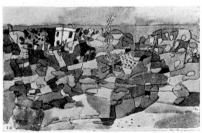

57 *Mazzaró (Albergo Pagni)*
(1924)

58 *Bei Taormina (Scirocco)*
(1924)
Near Taormina (Sirocco)
*Près de Taormina
(Sirocco)*

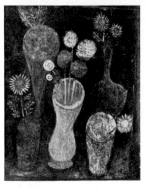

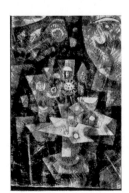

59 *Blumen in Gläsern* (1925)
Flowers in Glasses
Vases de fleurs

60 *Herbstblumen-Stilleben*
(1925)
*Still Life of Autumn
Flowers*
*Nature morte aux fleurs
d'automne*

61 *Der Ex-Kaiser* (1921)
 The Ex-Kaiser
 L'Ex-Kaiser

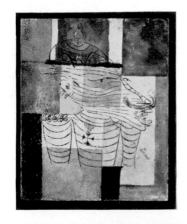

62 *Vom Schicksal zweier*
 Mädchen (1921)
 Of the Fate of Two Maidens
 Du destin de deux jeunes filles

63 *Der Heldentenor als*
 Konzertsänger (1922)
 Operatic Tenor as a
 Concert Singer
 Le Ténor de grand opéra
 se produit au concert

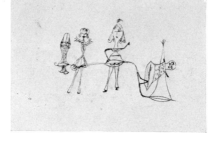

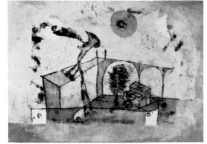

64 *Festzug auf Schienen* (1923)
 Festive Train on Rails
 Cortège sur rails

65 *Das Kinderfräulein*
 (1924)
 The Governess
 La Gouvernante

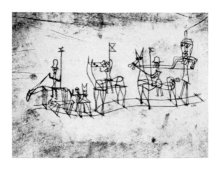

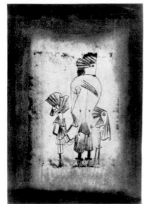

66 *Schicksalsstunde um*
 dreiviertel zwölf (1922)
 The Fateful Hour: 11.45
 Heure fatidique à 11.45

67 *Das Fest der Astern* (1921)
 The Feast of the Asters
 La Fête des asters

68 *Landschaft mit gelben*
 Vögeln (1923)
 Landscape with Yellow
 Birds
 Paysage aux oiseaux
 jaunes

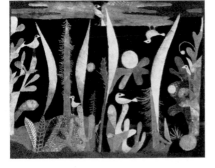

12: Konstruktive
und absolute Bilder

Constructed and Absolute
Images / Constructions et
tableaux absolus

S. / pp. 198-200

○ = 170, 171, 174, 177
△ = 198, 224

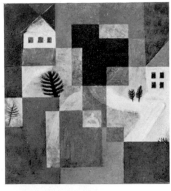

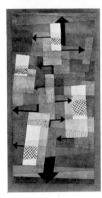

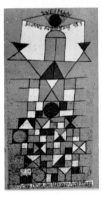

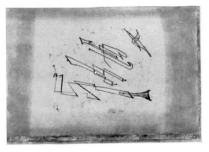

13: Dem Sinnbild
sich nähernde Bilder

Pictures Approaching the
Symbolic

A proximité du symbole

S. / pp. 206, 207

○ = 176, 179

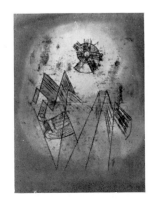

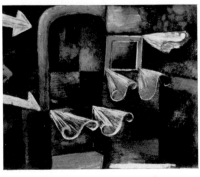

69 *Choral und Landschaft*
(1921)
Chorale and Landscape
Choral et paysage

70 *Betroffener Ort* (1922)
Stricken Place
Lieu interdit

71 *Schwankendes Gleich-*
gewicht (1922)
Unstable Equilibrium
Equilibre instable

72 *Postkarte zur Bauhaus-Aus-*
stellung: Die Erhabene Seite
(1923)
Postcard for Bauhaus Exhi-
bition. The Lofty Aspect
Carte postale pour l'exposi-
tion du Bauhaus. La Partie
éminente

73 *Von Gleiten zu Steigen*
(1923)
From Sliding to Climbing
Glisser puis monter

74 *Im Banne des Gestirns*
(1921)
Under the Spell of the
Star
Le Charme de l'astre
opère

75 *Im Zeichen der Schnecke*
(1921)
In the Sign of the Snail
Sous le signe de l'escargot

76 *Feuerwind* (1922)
Fire Wind
Vent de feu

77 *Kosmische Flora* (1923)
Cosmic Flora
Flore cosmique

78 *Karneval im Gebirge* (1924)
Carnival in the Mountains
Carnaval en montagne

79 *Entseelung* (1934)
The Soul Departs
Dés-animation

80 *Winterliche Maske*
(1925)
Wintry Mask
Masque hivernal

81 *Wandbild* (1924)
Mural
Peinture murale

82 *Pastorale* (1927)
Pastoral
Pastorale

83 *Kühlung in einem Garten
der heißen Zone* (1924)
*Coolness in a Garden of
the Torrid Zone*
*Brise fraîche dans un
jardin de la zone torride*

84 *Wald bei M.* (1925)
Forest Near M.
Forêt près de M.

85 *Sängerhalle* (1930)
Hall of Singers
Salle des chanteurs

14: Technische Erfindungen
Technical Inventions
Inventions techniques

a: Begleitschraffuren
Hatched Effects / Hachures
S. / pp. 200, 205
☐ = 249 / ○ = 180, 239
△ = 205, 247

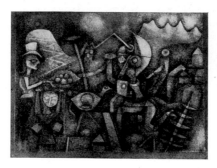

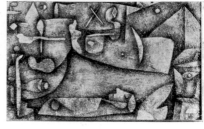

b: Spritzverfahren
Sprayed Effects / Pulvérisations
S. / pp. 205, 206
○ = 178

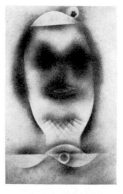

c: Spitzenartige Gewebe
Lace Effects / Effets de dentelle
S. / p. 206

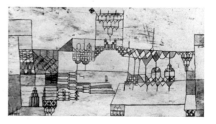

Arbeiten im inneren Kreis
Works of the Inner Circle
Travaux du domaine intérieur

15: Magische Quadrate 1923 ff.

Magic Squares / Carrés magiques

S. / pp. 207, 208, 213, 214

□ = 201
○ = 292

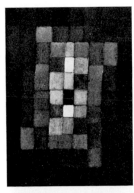

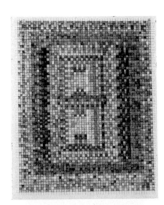

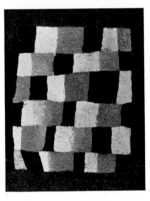

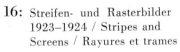

16: Streifen- und Rasterbilder
1923–1924 / Stripes and
Screens / Rayures et trames

S. / pp. 79, 214

□ = 193, 195
○ = 173, 175
△ = 75, 367

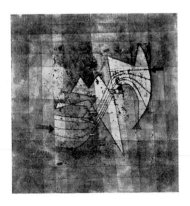

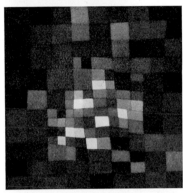

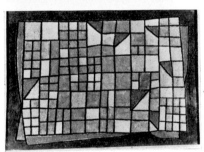

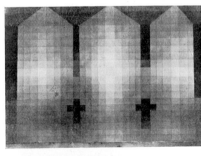

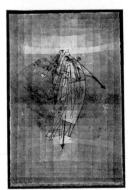

86 *Farbsteigerung vom Sta-*
tischen ins Dynamische
(1923)
Intensification of Color
from the Static to the
Dynamic
Gradation de couleurs du
statique au dynamique

87 *Portal einer Moschee* (1931)
Portal of a Mosque
Portail d'une mosquée

88 *Blühendes* (1934)
Flowering
En fleur

89 *Rhythmisches* (1930)
Rhythms
Rythmique

90 *Glasfassade* (1940)
Glass Façade
Façade de verre

91 *Farbige Dreigliederung*
(1923)
Chromatic Triad
Trinômie chromatique

92 *Gebirgsbildung* (1924)
Mountain Formation
Formation de montagnes

93 *Nachtfaltertanz* (1923)
Dance of the Moth
Danse de phalène

94 *Fuge in Rot* (1921)
Fugue in Red
Fugue en rouge

17: Fugenbilder 1921–1922
Fugal Images / Fugues

S. / pp. 80, 214, 215

□ = 185
○ = 165, 166, 167

95 *Trocken-kühler Garten*
(1921)
Garden Dry and Cool
Jardin sec et frais

96 *Traumstadt* (1921)
Dream City
Ville de rêve

97 *Perspektive mit offener*
Türe (1923)
Perspective with Open
Door
Perspective à la porte
ouverte

18: Perspektivische
Figurationen 1921 ff.

Perspective Structures

Perspectives

S. / pp. 215, 216, 221

○ = 217, 218, 219, 220
△ = 72, 77

98 *Hauptscene aus dem*
Ballett "Der falsche
Schwur" (1922)
Main Scene from the
Ballet "The False Oath"
Scène principale du ballet
«Le Faux serment»

19: Oper und Theater
1921–1925

Opera and Theater

Opéra et Théâtre

S. / pp. 80, 221–223

□ = 163, 187, 209
△ = 65, 222, 223

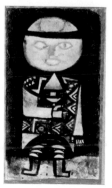

99 *Bühnenlandschaft* (1922)
Stage Landscape
Paysage de théâtre

100 *Schauspieler* (1923)
Actor
Acteur

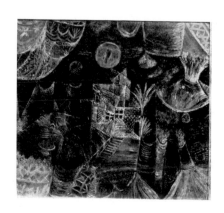

Dessau 1926–1930,
Düsseldorf 1931–1933

Arbeiten im äußeren Kreis
Works of the Outer Circle
Travaux du domaine extérieur

20: Gestalten, Landschaften und
Stilleben / Figures, Landscapes
and Still Lifes / Figures,
paysages et natures mortes
S. / pp 72, 245, 246
□ = 255, 261 ○ = 227, 242
△ = 71, 80, 81, 82, 246, 248,
 251, 281, 282, 285, 287

Arbeiten im mittleren Kreis
Works of the Middle Circle
Travaux intermédiaires

21: Konstruktive Arbeiten
Constructions
S. / pp. 246, 247
□ = 269 / ○ = 236, 243
△ = 254, 276, 283

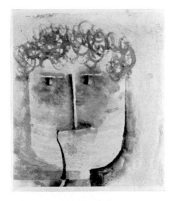

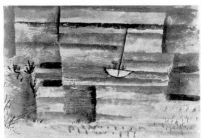

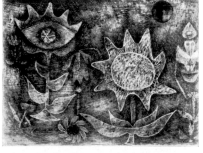

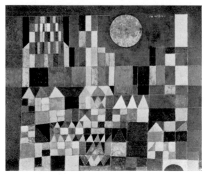

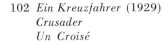

101 *Kopf eines Rauchers*
 (1929)
 Head of a Smoker
 Tête de Fumeur

102 *Ein Kreuzfahrer (1929)*
 Crusader
 Un Croisé

103 *Landendes Boot (1929)*
 Boat Approaching the
 Shore
 Bateau abordant

104 *Landschaft mit dem Fischer*
 (1929)
 Landscape with Fisherman
 Paysage au pêcheur

105 *Blüten in der Nacht*
 (1930)
 Night Blossoms
 Fleurs dans la nuit

106 *Burg und Sonne (1928)*
 Castle and Sun
 Château et soleil

107 *Wüstengebirge (1929)*
 Desert Mountains
 Montagnes du désert

108 *Burghügel (1929)*
 Castle Hill
 Colline fortifiée

397

109 *Märchen* (1929)
Fairy Tale
Conte

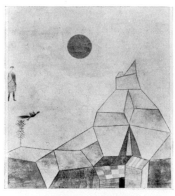

110 *Regie* (1930)
Staging
Régie

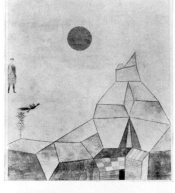

111 *Um sieben über Dächern*
(1930)
At Seven above the Roofs
A sept heures au-dessus des
toits

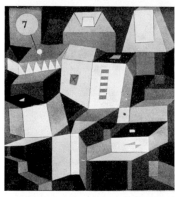

112 *Die Paukenorgel*
(1930)
Kettledrum-Organ
L'Orgue à timbales

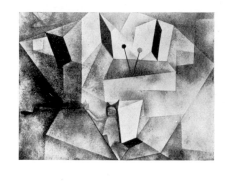

113 *Kleine Felsenstadt* (1932)
Small Town among the
Rocks
Petite ville dans les rochers

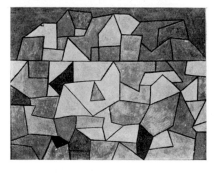

114 *Neugeordneter Ort*
(1940)
Newly Arranged Place
Lieu de l'ordre nouveau

115 *Ein Vorspiel zu*
Golgatha (1926)
A Prelude to
Golgotha
Un Prélude à
Golgatha

Arbeiten im inneren Kreis
Works of the Inner Circle
Travaux du domaine inférieur

22: Parallelfigurationen 1926–1927
Configurations of Parallels
Parallèles

S. / pp. 252–254, 257

○ = 225, 226, 291
△ = 69, 80, 252, 253, 368

116 *Künstlicher Fels* (1927)
Artificial Rock
Rocher artificiel

117 *Der Schöpfer* (1934)
The Creator
Le Créateur

23: Arbeiten graphischen
Ursprungs 1926 ff.

Works Suggestive of Engravings

Travaux rappelant la gravure

S. / p. 257

△ = 73, 78, 257, 259, 267

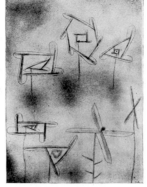

118 *Sieben Blüten* (1926)
 Seven Blossoms
 Sept fleurs

24: Kontinuierliche und sich
schneidende Lineamente 1927 ff.

Continuous Intersecting Lines

Linéaments ininterompus et se
croisant

S. / pp. 257, 258, 260

▭ = 263
○ = 230, 231, 290
△ = 76, 79, 83, 258, 286

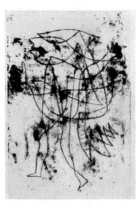

119 *Kleiner Narr in Trance*
 (1927)
 Small Fool in a Trance
 Petit Fou en transe

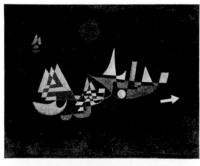

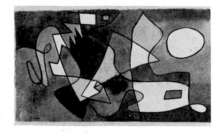

120 *Abfahrt der Schiffe* (1927)
 The Ships Depart
 Départ des bateaux

121 *Dramatische Landschaft*
 (1928)
 Dramatic Landscape
 Paysage dramatique

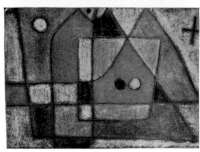

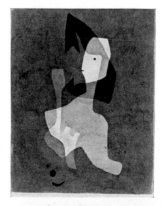

122 *Ein Stübchen in Venedig*
 (1933)
 Small Room in Venice
 Une Chambrette à Venise

123 *Gift* (1932)
 Poison
 Poison

25: Verspannte Flächen und
bewegte Raumkörper 1930

Surfaces Held in Tension;
Objects Moving in Space

Surfaces distendues et corps
mobiles dans l'espace

S. / pp. 268, 273–275

○ = 240 / △ = 274, 275

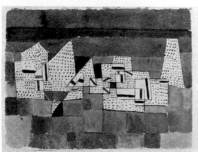

124 *Côte de Provence I*
 (1927)

125 *Verspannte Flächen* (1930)
Surfaces in Tension
Surfaces distendues

126 *Zwillinge* (1930)
Twins
Jumeaux

127 *AtmosphärischeGruppe*
in Bewegung (1929)
Atmospheric Grouping
in Motion
Groupe atmosphérique
en mouvement

26: Atmosphärische Gebilde 1929
Atmospheric Compositions
Compositions atmosphériques

S. / pp. 274, 275

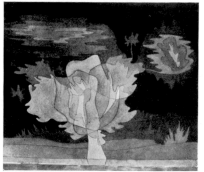

128 *Irrende Seele* (1929)
Wandering Soul
Ame errante

129 *Vor dem Schnee*
(1929)
Before the Snow
Avant la neige

130 *Monument im Frucht-*
land (1929)
Monument in Fertile
Country
Monument en pays
fertile

27: Bilder aus Ägypten
1929–1930
Pictures of Egypt
Tableaux d'Egypte

S. / pp. 72–74, 266–268

□ = 277
○ = 234

131 *Orpheus* (1929)
Orpheus
Orphée

132 *Lagunenstadt* (1932)
City on a Lagoon
Ville de lagunes

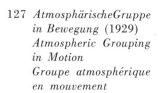

28: Divisionistische Bilder
1930–1932
Divisionist Pictures
Tableaux divisionnistes

S. / pp. 275, 276, 281–283

□ = 279, 313
○ = 241

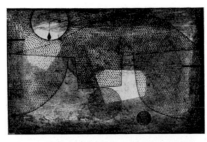

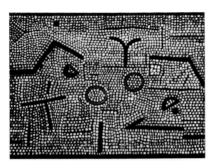

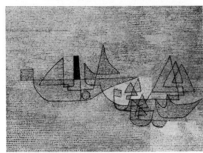

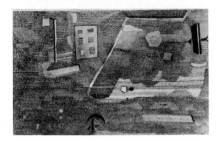

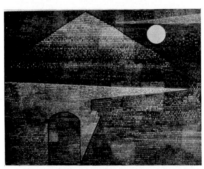

29: Schriftbilder 1928 ff.
Script Pictures
Tableaux en signes graphiques

S. / p. 285

○ = 233, 237
△ = 284, 319

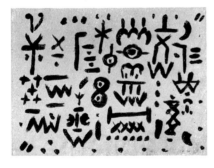

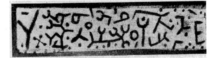

30: Gestalten strengerer Form

Figures in Stricter Form

Figures d'une forme plus
rigoureuse

S. / pp. 285, 286

□ = 271
○ = 244

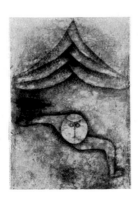

133 *Sonnenuntergang*
 (1930)
 Sunset
 Coucher de soleil

134 *Mosaik aus Prhun* (1931)
 Mosaic from Prhun
 Mosaïque de Prhun

135 *Dampfer und Segel-*
 boote gegen Abend
 (1931)
 Steamer and Sailboats
 towards Evening
 Vapeur et voiliers
 vers le soir

136 *Landschaft Uol* (1932)
 Landscape Uol
 Paysage, Uol

137 *Ad Parnassum* (1932)

138 *Pflanzenschriftbild*
 (1932)
 Plant Script Picture
 Ecriture végétale

139 *Geheimschriftbild* (1934)
 Secret Script Picture
 Ecriture secrète

140 *Schrift* (1940)
 Script
 Ecriture

141 *Zuflucht* (1930)
 Refuge
 Refuge

142 *Eroberer* (1930)
 Conqueror
 Le Conquérant

 143 *Der Teufel jongliert*
 (1930)
 The Devil Juggling
 Le Diable jongle

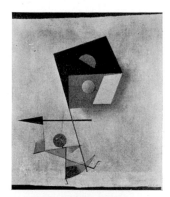 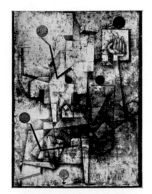

144 *Arabisches Lied* (1932)
 Arab Song
 Chant arabe

 145 *Gelehrter* (1933)
 Scholar
 Le Savant

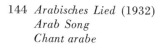 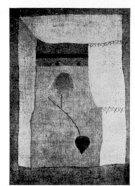 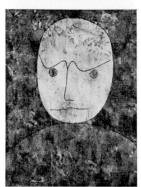

146 *Namens Elternspiegel*
 (1933)
 The Name is "Parents'
 Image"
 Le Nommé Mireparents

 147 *Negerblick* (1933)
 Negro Glance
 Regard de nègre

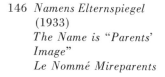 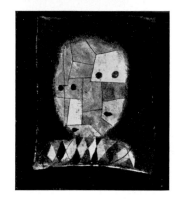 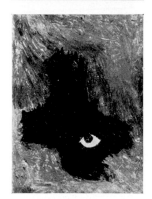

 148 *Pflanze auf Fenster-*
 stilleben (1927)
 Plant in Still Life
 with Window
 Plante sur une nature
 morte avec fenêtre

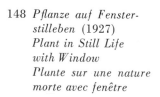

31: Metaphysische Bilder
 Metaphysical Images
 Tableaux métaphysiques

 S. / p. 284

 ◯ = 228, 229, 232, 235, 238

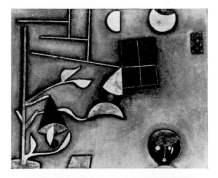

149 *Bunte Mahlzeit* (1928)
 Colorful Repast
 Repas bigarré

 150 *Romantischer Park*
 (1930)
 Romantic Park
 Parc romantique

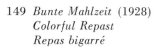 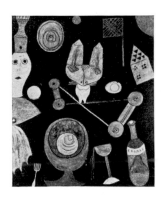 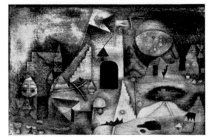

Bern, Berne 1934–1940

32: Nachträge und Neuanfänge
Postscripts and New Beginnings
Compléments et renouvellements

S. / pp. 309-312

☐ = 329
◯ = 289
△ = 99

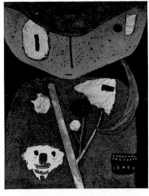

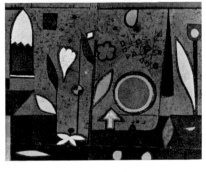

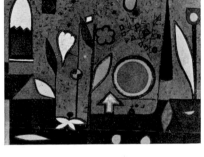

33: Später Humor
Humor of the Late Years
Humour tardif

S. / pp. 312, 317

◯ = 293, 297
△ = 86, 88, 310, 311, 317, 320,
327, 328, 334, 335, 336,
341, 342, 343, 384

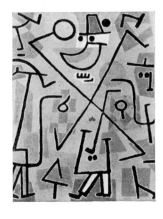

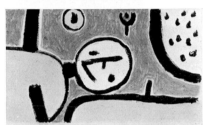

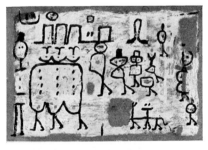

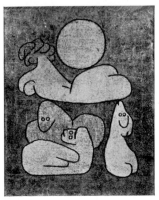

151 *Figur des östlichen*
Theaters (1934)
Figure of the Oriental
Theater
Figure du théâtre
oriental

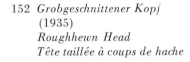

152 *Grobgeschnittener Kopf*
(1935)
Roughhewn Head
Tête taillée à coups de hache

153 *Clown im Bett* (1937)
Clown in Bed
Clown alité

154 *Vollmond im Garten* (1934)
Garden in Full Moonlight
Pleine lune au jardin

155 *W-geweihtes Kind*
(1935)
Child Consecrated to
W (Woe)
Enfant voué au malheur

156 *Der Boulevard der*
Abnormen (1938)
The Boulevard of the
Abnormal Ones
Le Boulevard des
anormaux

157 *Capriccio im Februar*
(1938)
Capriccio in February
Capriccio en février

158 *Der Torso und die*
Seinen bei Vollmond
(1939)
The Torso and His
Own in Full Moonlight
Le Torse et les siens
par pleine lune

159 *Übermut* (1939)
High Spirits
Bravoure

160 *Regie bei Sturm*
(1938)
*Stage Direction in a
Storm*
Régie par la tempête

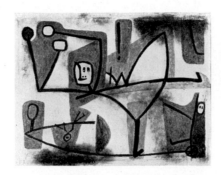

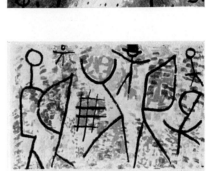

161 *Alles läuft nach!* (1940)
They All Run After!
Tout le monde court après!

162 *Bal champêtre* (1940)

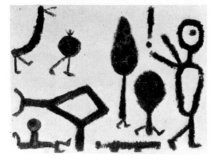

163 *Garten im Orient*
(1937)
Oriental Garden
Jardin d'Orient

34: Späte Pastelle 1937
Late Pastels
Pastels de la fin

S. / pp. 328, 333–335

□ = 315, 323
○ = 296

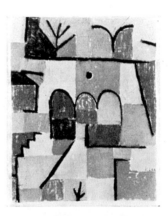

164 *Zeichen in Gelb* (1937)
Signs Yellow
Signes en jaune

165 *Zweige im Herbst*
(1937)
Branches in Autumn
Branches d'automne

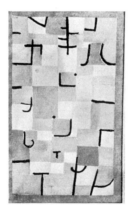

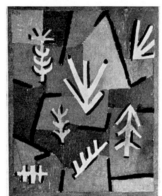

166 *Sextett der Genien* (1937)
Sextet of Spirits
Sextuor des génies

167 *Legende vom Nil*
(1937)
Legend of the Nile
Légende du Nil

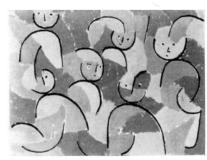

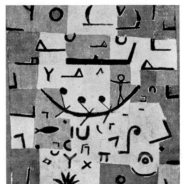

35: Zeichenbilder 1937 ff.
Sign Images / Barres

a: Dünne Balken-Zeichen
Sign Images with Thin Bars
Barres minces
S. / pp. 319, 320

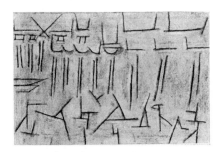

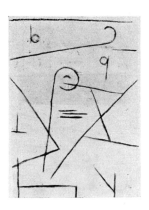

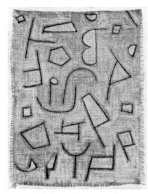

b: Dicke Balken-Zeichen
Sign Images with Heavy Bars
Barres épaisses (No. 171–174)
S. / pp. 325, 326
□ = 331 / ○ = 298
△ = 10, 309, 373

c: Umrandete Balken-Zeichen
Sign Images with Outlined Bars
Barres cernées (No. 175–177)
S. / p. 326
⊓ = 337, 339 ○ = 299

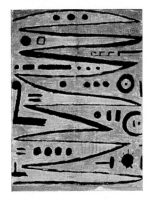

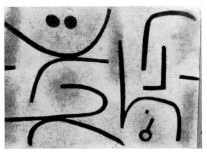

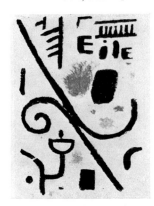

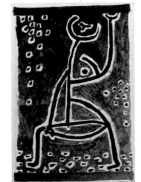

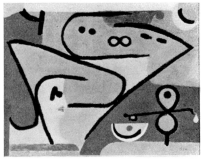

168 *Tempelfest (1937)*
Temple Festival
Fête au temple

169 *Bemerkungen zu einer*
Gegend (1937)
Comments on a Region
Notes sur une contrée

170 *Leicht-trockenes*
Gedicht (1938)
A Light and Dry Poem
Poème plutôt sec

171 *Heroische Bogenstriche*
(1938)
Heroic Fiddling
Coups d'archet
héroïques

172 *Eile (1938)*
Hurry
Hâte

173 *Aeolisches (1938)*
Aeolian
Eolien

174 *Zerbrochener Schlüssel*
(1938)
Broken Key
Clef brisée

175 *Fräulein vom Sport*
(1938)
Sportive Young Lady
Mlle du Sport

176 *Nach rechts, nach links*
 (1938)
 Right, Left
 A droite, à gauche

177 *Masken im Zwielicht*
 (1938)
 Masks at Twilight
 Masques dans la
 pénombre

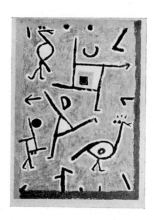
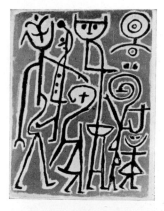

178 *Vorhaben* (1938)
 Intention
 Projet

36: Große Tafelbilder von 1938
Large Pictures of 1938
Grands tableaux de 1938

S. / pp. 92, 326–328

△ = 318

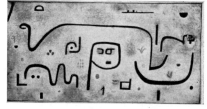

179 *Früchte auf Blau* (1938)
 Fruit on Blue Ground
 Fruits sur du bleu

180 *Feuerquelle* (1938)
 Spring of Fire
 Source de feu

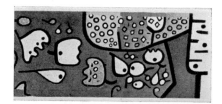
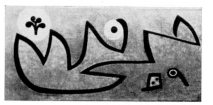

181 *Reicher Hafen* (1938)
 Rich Harbor
 Port florissant

182 *Insula Dulcamara*
 (1938)

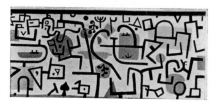
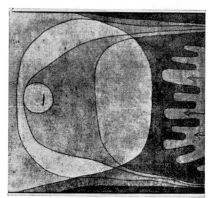

183 *Angst* (1934)
 Fear
 La Peur

37: Begriffsbilder
Images of Ideas
Tableaux d'idées

○ = 294
△ = 84, 288, 333, 344, 347, 382

184 *Wache* (1937)
 Sentry
 La Garde

185 *Gleichung* (1936)
 Equation
 Equation

38: Tragik, Dämonie
und Todesahnung 1937 ff.
The Tragic and the Demonic;
Forebodings of Death
Le tragique, le démoniaque
et le pressentiment de la mort

S. / pp. 93, 335, 336, 341–347

□ = 321, 345, 351, 353
○ = 295, 300, 301, 302, 303,
 305, 307
△ = 3, 85, 87, 89, 90, 91, 92,
 96, 357, 360

186 *Unter dem Viadukt*
 (1937)
 Under the Viaduct
 Sous le viaduc

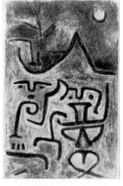

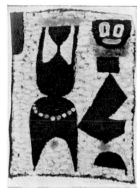

187 *Erdhexen (1938)*
 Witches of the Earth
 Sorcières

188 *Aus einer Masken-*
 sammlung (1938)
 From a Collection of
 Masks
 D'une collection de
 masques

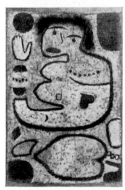

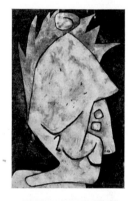

189 *Liebeslied bei Neumond*
 (1939)
 Love Song by the New Moon
 Chant d'amour par nouvelle
 lune

190 *Mephisto als Pallas*
 (1939)
 Mephistopheles as
 Pallas
 Méphisto en Pallas

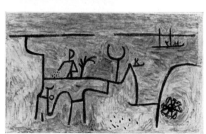

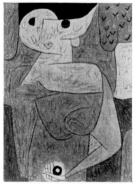

191 *Am Nil (1939)*
 On the Nile
 Au bord du Nil

192 *Omphalo-Centrischer*
 Vortrag (1939)
 Omphalo-Centric
 Lecture
 Discours omphalo-
 centrique

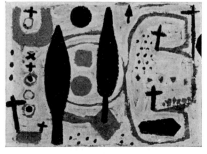

193 *Pathetisches Keimen (1939)*
 Emotionel Germination
 Germination pathétique

194 *Friedhof (1939)*
 Graveyard
 Cimetière

195 *Stilleben am Schalttag*
 (1940)
 Still Life on Leap Day
 Nature morte le jour
 intercalaire

196 *Blumenmädchen*
 (1940)
 Flower Girl
 Bouquetière

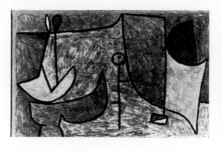

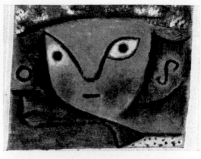

197 *Engel im Werden*
 (1934)
 Angel in the Making
 Ange en devenir

39: Die Reihe der Engel
 The Angel Series
 La série des anges

 S. / pp. 348–350

 ○ = 304
 △ = 93, 348, 350
 Einband / Binding / Reliure

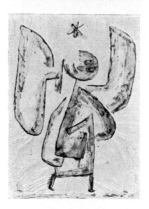

198 *Erzengel* (1938)
 Archangel
 Archange

199 *Engel vom Stern*
 (1939)
 Angel from a Star
 Ange de l'étoile

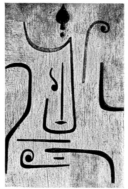

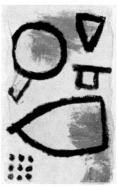

200 *Alea jacta* (1940)

40: Requiem 1940

 S. / pp. 94, 357–360

 ▭ = 355, 361, 363
 ○ = 306, 308
 △ = 94, 95, 349, 358, 359
 377

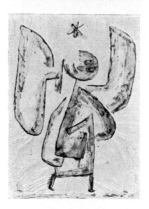

201 *Schlosser* (1940)
 Locksmith
 Serrurier

202 *Verletzt* (1940)
 Hurt
 Blessé

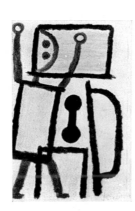

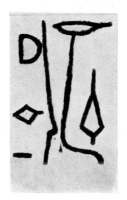

Informations given in the following order: title, signature; dimensions; technique; owner, page where shown. The bold numbers refer to color plates.

1 Childhood Drawing: *Christmas Tree with Christ Child and Toy Train,* 3; 5 : 3¹/₄″; Colored crayon; Klee Foundation, Bern, page 33.

2 Childhood Drawing: *Picture with Hare,* 18; 5¹/₈ : 7″; Colored crayon; Klee Foundation, Bern, page 33.

3 Childhood Drawing: *Christ Child with Yellow Wings,* 2; 3¹/₈ : 2¹/₈″; Colored crayon; Klee Foundation, Bern, page 33.

4 From Sketchbook I: *Clock Tower in Bern,* not catalogued; 6 : 4⁸/₈″; Pencil; Klee Foundation, Bern, page 36.

5 School Copybooks: *Hoopoes,* not catalogued; Ink; Felix Klee, Bern, page 34.

6 From Sketchbook VI, not catalogued; 4⁸/₄ : 4″; Pencil; Klee Foundation, Bern, page 36.

7 From Sketchbook VIII, not catalogued; 6⁸/₄ : 4⁸/₄″; Pencil; Klee Foundation, Bern, page 37.

8 From Sketchbook VIII, *Basle,* not catalogued; 4⁸/₄ : 7¹/₈″; Pencil; Klee Foundation, Bern, page 37.

9 *My Room,* not catalogued; 2³/₄ : 8¹/₂″; Pencil; Klee Foundation, Bern, page 35.

10 Drawing in a Volume of Hölty's Poems, not catalogued; 6¹/₄ : 3¹/₈″; Pen; Klee Foundation, Bern, page 36.

11 School Copybook: *Winter Journey through the Harz Mountains,* not catalogued; Pen; Felix Klee, Bern, page 34.

12 *Elfenau, Bern,* not catalogued; 3¹/₂ : 13″; Pencil; Klee Foundation, Bern, page 37.

13 Sketchbooks, Munich Academy; not catalogued; 12⁵/₈ : 8¹/₄″; Pencil; Klee Foundation, Bern, page 38.

14 Sketchbooks, Munich Academy; not catalogued; 12⁵/₈ : 8¹/₄″; Pencil; Klee Foundation, Bern, page 39.

15 *Self-Portrait with White Cap,* 1; 5¹/₄ : 4³/₄″; Pencil; Felix Klee, Bern, Cat. 1.

16 *The Artist's Sisters,* not catalogued; 11³/₈ : 12⁵/₈″; Oil; Klee Foundation, Bern, page 40.

17 *Virgin in a Tree* (Invention 2), 2; 9¹/₄ : 11⁵/₈″; Etching; Several proofs, page 106.

18 *Comedian* (sketch) (Invention 4), 3; 4³/₄ : 6¹/₄″; Etching; 2–3 proofs, Cat. 9.

19 *Woman Sowing Weeds,* 4; 6 : 3¹/₈″; Etching; 2–3 proofs, Cat. 10.

20 *Two Men Meet, Each Believing the Other to be of Higher Rank* (Invention 6), 6; 4³/₈ : 7¹/₈″; Etching; Several proofs, page 107.

21 *Comedian I,* 10; 5³/₄ : 6¹/₄″; Etching; 2 proofs, plate destroyed, page 107.

22 *A Man Groveling Before the Crown* (Invention 7), 11; 6¹/₄ : 6¹/₄″; Etching; Several proofs, Cat. 11.

23 *Perseus: The Triumph of Wit over Misfortune* (Invention 8), 12; 4 : 5″; Etching; Several proofs, page 106.

24 *Woman and Beast* (Invention 1), 13; 7³/₄ : 8³/₄″; Etching; Several proofs, Cat. 12.

25 *Comedian II* (Invention 4), 14; 5 : 5³/₈″; Etching; Several proofs, Cat. 13.

26 *Pessimistic Allegory of the Mountains* (Invention 11), not catalogued; 5¹/₈ : 2³/₄″; Etching; 2–3 proofs, Cat. 14.

27 *Girl with Doll,* 17; 7³/₈ : 5″; Watercolor, glass-painting; Felix Klee, Bern, page 111.

28 *Garden Scene with a Watering Can,* 24; 5¹/₈ : 7¹/₈″; Watercolor, glass-painting; Felix Klee, Bern, page 117.

29 *Lily,* 24; 11³/₈ : 8⁵/₈″; Pencil with Watercolor; Felix Klee, Bern, page 23.

30 *Senile Phoenix,* 32; 9¹/₂ : 7¹/₂″; Etching; Several proofs, Cat. 15.

31 *Menacing Head* (Invention 10), 37; 7¹/₂ : 5¹/₈″; Etching; 10 proofs, plate destroyed, page 105.

32 *Hero with a Wing* (Invention 3), 38; 9¹/₈ : 6¹/₄″; Etching; Several proofs, page 108.

1884

1885

1892

1895

1896

1897

1899

1903

1904

1905

1918

107 *Hermitage*, 61; 7¹/₄ : 10″; Watercolor on gesso ground; Klee Foundation, Bern, Cat. 37.

108 *With the Eagle*, 85; 6³/₄ : 9³/₄″; Watercolor on gesso ground; Klee Foundation, Bern, page 155.

109 *The Descent of the Dove*, 118; 7¹/₈ : 9³/₄″; Watercolor on gesso ground; Ida Bienert, München, page 136.

110 *Souvenir of Gersthofen*, 196; 10⁵/₈ : 8¹/₄″; Pen and wash; Felix Klee, Bern, page 217.

1919

111 *Up, Away, and Out. The Ascension of Termadeus* (from Corrinth "Potsdamer Platz"), 17; 10¹/₄ : 8⁵/₈″; Pen; Klee Foundation, Bern, page 100.

112 *Statuette in the Manner of a Herma*, 33; 6³/₄″; Painted tile; Klee Foundation, Bern, page 112.

113 *Head*, Sculpture, 34; 12″; Painted tile; Klee Foundation, Bern, page 112.

114 *Three-Part Time*, 68; 12 : 8⁵/₈″; Watercolor; Private collection, Italy, Cat. 40.

115 *Artist Meditating* (Self-Portrait), 73; 7³/₄ : 6³/₄″; Transfer picture; Felix Klee, Bern, Cat. 7.

116 *Artist at Work* (Self-Portrait), 74; 10⁵/₈ : 7³/₄″; Pencil; Felix Klee, Bern, Cat. 8.

117 *Lost in Thought* (Self-Portrait), 113; 10¹/₂ : 7¹/₈″; Lithography; Several proofs, page 16.

118 *The Bavarian Don Giovanni*, 116; 9 : 8¹/₄″; Watercolor and Pen; The Solomon R. Guggenheim Museum, New York, Cat. 38.

119 *Villa R*, 153; 10¹/₂ : 8⁵/₈″; Oil; Museum, Basle, page 138.

120 *Compositon with a B*, 156; 20 : 15³/₄″; Oil; Klee Foundation, Bern, Cat. 45.

121 *Castle Garden*, 188; 8¹/₄ : 6¹/₂″; Watercolor; R. Doetsch-Benziger, Basle, Cat. 39.

122 *New Fortress*, 193; 6¹/₂ : 5⁷/₈″; Watercolor; Private collection, USA, Cat. 42.

123 *Aquatic Birds*, 195; Watercolor; Private collection, USA, page 137.

124 *Legend of Death in a Garden*, 244; Oil; Collection unknown, Cat. 49.

125 *An Artist* (Self-Portrait), 260; 9 : 5¹/₄″; Pen and wash; The Pasadena Art Institute, California, page 59.

1920

126 *Message of the Air Spirit*, 7; 9¹/₄ : 12⁵/₈″; Watercolor and oil on gesso ground; Max Fischer, Stuttgart, page 140.

127 *Canary Magician*, 24; 19⁵/₈ : 16¹/₄″; Oil; Clifford Odets, New York, Cat. 46.

128 *Dance with Veils*, 34; 7¹/₄ : 11″; Oil and watercolor; Ibach collection, Barmen, Germany, page 367.

129 *Camel in a Rhythmic Wooded Landscape*, 43; 19¹/₄ : 15³/₄″; Oil; Ida Bienert, Munich, Cat. 47.

130 *Rose Garden*, 47; 19¹/₄ : 16³/₄″ Oil; Private collection, Berlin, Cat. 48.

131 *Woman Awakening*, 49; 8⁵/₈ : 11″; Watercolor; Private collection, USA, Cat. 43.

132 *Unhorsed and Bewitched Rider*, 62; 7¹/₂ : 8¹/₄″; Pen; Private collection, USA, page 159.

133 *Bird Drama*, 93; 7¹/₄ : 11″; Colored drawing; The Solomon R. Guggenheim Museum, New York, page 151.

134 *Rooster and Pig*, 119; 2³/₄ : 8¹/₈″; Pen; Frederick Zimmermann, New York, page 60.

135 *Park in the Rain*, 123; 12 : 8¹/₄″; Oil; Ida Bienert, Munich, Cat. 50.

136 *Arctic Thaw* (Polar-Landscape), 128; 20³/₄ : 20¹/₈″; Oil; Hans Meyer, Bern, page 157.

137 *Rosa*, 129; 7¹/₂ : 5¹/₂″; Oil; Ida Bienert, Munich (destroyed), page 139.

138 *Destroyed Village*, 130; 12 : 9¹/₈″; Oil; Private collection, Bern, Cat. 51.

139 *Seascape with Astral Body*, 166; 5¹/₈ : 11″; Pen; Klee Foundation, Bern, page 184.

140 *Fettering*, 168; 12¹/₂ : 9¹/₂″; Watercolor and oil; Klee Foundation, Bern, Cat. 44.

141 Drawing for *Ideal Household*, Lily, 191; 7¹/₄ : 11¹/₄″; Pen; Felix Klee, Bern, page 162.

142 Drawing for *Plants, Soil, and Air*, 205; 8¹/₈ : 7¹/₂″; Pen; Klee Foundation, Bern, page 160.

143 *The Angry Kaiser*, 206; 7¹/₄ : 8″; Pen; Felix Klee, Bern, page 58.

1921

144 *Performing Animals* (for Florina), 7; 5⁷/₈ : 10¹/₂″; Watercolor and oil; Private collection, USA, page 168.

145 *Arrow Approaching the Target*, 8; 10 : 12¹/₄″; Watercolor and oil; John S. Newberry, Grosse Pointe, Michigan, page 168.

146 *The Ex-Kaiser*, 14; 12⁵/₈ : 8¹/₂″; Watercolor; Ward Cheney, New York, Cat. 61.
147 *Under the Spell of the Star*, 21; 12⁵/₈ : 16¹/₈″; Watercolor and oil; Mrs. Edward Pelton Green, Reseda, California, Cat. 74.
148 *In the Sign of the Snail*, 27; 15 : 10⁵/₈″; Watercolor and oil; F. C. Schang, New York, Cat. 75.
149 Drawing for *Dr. Bartolo*, 40; 7¹/₄ : 11″; Pen; Klee Foundation, Bern, page 223.
150 *Fugue in Red*, 69; 9 : 13″; Watercolor; Felix Klee, Bern, Cat. 94.
151 *Hanging Fruit*, 70; 10³/₄ : 7″; Watercolor; Clifford Odets, New York, page 165.
152 *Garden Dry and Cool*, 83; 9¹/₂ : 12″; Watercolor; R. Doetsch-Benziger, Basle, Cat. 95.
153 *Ceramic-Erotic-Religious (The Vessels of Aphrodite)*, 97; 17³/₄ : 12″; Watercolor; Klee Foundation, Bern, page 167.
154 *Dream City*, 106; 18⁷/₈ : 12¹/₄″; Watercolor; Miss Betty Chamberlain, New York, Cat. 96.
155 *Female Saint*, 107; 17³/₈ : 12″; Watercolor; The Pasadena Art Institute, California, Cat. 52.
156 *Of the Fate of Two Maidens*, 112; 11³/₄ : 17³/₄″; Oil; The Solomon R. Guggenheim Museum, New York, Cat. 62.
157 *Scene from a Hoffman-like Tale*, 123; 12¹/₂ : 9″; Color lithograph; Fairly large edition, page 169.
158 *Chorale and Landscape*, 125; 13³/₈ : 12″; Oil; W. Allenbach, Bern, Cat. 69.
159 *Perspective of a Room with Occupants*, 168; 13³/₄ : 9⁷/₈″; Pen; Klee Foundation, Bern, page 218.
160 *Dance of the Mourning Child*, 186; 7⁵/₈ : 8⁵/₈″; Pen; Klee Foundation, Bern, page 183.
161 *Women's Pavilion*, 191; 7³/₄ : 8⁵/₈″; Oil; Ralph Collin, New York, page 163.
162 *The Feast of the Asters*, 206; 12⁵/₈ : 16″; Oil; Hans Meyer, Bern, Cat. 67.

163 *Fire Wind*, 17; 14¹/₄ : 20″; Oil; W. Allenbach, Bern, Cat. 76.
164 *Sganarelle*, 25; 18³/₄ : 14⁵/₈″; Watercolor; David Thompson, Pittsburg, Cat. 54.
165 *Flower-Face*, 57; 15 : 18″; Watercolor; Edgar Kaufmann, New York, page 185.
166 *Dying Plants*, 82; 18¹/₈ : 12⁵/₈″; Watercolor and pen; Philip Goodwin, New York, page 166.
167 *Fool in Christ*, 92; 17³/₄ : 9¹/₂″; Watercolor and oil on gesso ground; Walter Zivi, Chicago, Cat. 53.
168 *Stricken Place*, 109; 13 : 9″; Watercolor and oil; Klee Foundation, Bern, Cat. 70.
169 *The Voice Cloth of the Singer Rosa Silber*, 126; 20¹/₂ : 16¹/₂″; Watercolor on gesso ground; Mrs. Stanley Resor, New York, page 170.
170 *Operatic Tenor as a Concert Singer*, 144; 11 : 15³/₈″; Watercolor; Ida Bienert, Munich, Cat. 63.
171 *Twittering Machine*, 151; 16 : 11³/₄″; Watercolor and oil; The Museum of Modern Art, New York, page 171.
172 *Main Scene from the Ballet "The False Oath"*, 155; 18 : 11³/₄″; Watercolor and pen; Curt Valentin Gallery, New York, Cat. 98.
173 *Unstable Equilibrium*, 159; 12¹/₂ : 6″; Watercolor; Klee Foundation, Bern, Cat. 71.
174 *Stage Landscape*, 178; 18¹/₈ : 20¹/₂″; Oil; Hans Meyer, Bern, Cat. 99.
175 *The Fateful Hour*, 184; 11 : 45″; Oil; Whereabouts unknown, Cat. 66.
176 First Sketch for the *Spectre of a Genius* (Self-Portrait), 192; 14¹/₈ : 7³/₄″; Pen; The Pasadena Art Institute, California, page 63.
177 *Apparatus for Delicate Acrobatics*, 234; 11 : 8¹/₄″; Pencil; Private collection, USA, page 198.

178 *Puppet-Show*, 21; 20¹/₄ : 14⁵/₈″; Watercolor on gesso ground; Klee Foundation, Bern, page 187.
179 *Actor*, 27; 17³/₄ : 9¹/₈″; Oil; Felix Klee, Bern, Cat. 100.
180 *Landscape with Yellow Birds*, 32; 14 : 17³/₈″; Watercolor and oil; R. Doetsch-Benziger, Basle, Cat. 68.
181 *Captive Pierrot*, 37; 15³/₄ : 11³/₄″; Watercolor and oil; Robert H. Tannahill, Detroit, Michigan, page 174.
182 Postcard for Bauhaus Exhibition – *The Lofty Aspect*, 47; 5³/₄ : 7″; Lithography; Fairly large edition, Cat. 72.

1923

183 *Architecture (Yellow-Violet Stepped Cubes)*, 62; 22¹/₄ : 14¹/₂″; Oil; Hermann Rupf, Bern, page 201.

184 *Intensification of Color from the Static to the Dynamic*, 67; 15 : 10¹/₄″; Oil; Private collection, Berlin, Cat. 86.

185 *Festive Train on Rails*, 77; 12⁵/₈ : 15³/₄″; Oil; Clifford Odets, New York, Cat. 64.

186 *From Sliding to Climbing*, 89; 13³/₄ : 20¹/₂″; Watercolor and oil; Frederick Deknatel, Cambridge, Mass., Cat. 73.

187 *In the Meadow*, 93; 8³/₄ : 11³/₄″; Watercolor and pen; Mrs. Marian Willard Johnson, Locust Valley, New York, page 173.

188 *Chromatic Triad*, 102; Watercolor; Whereabouts unknown, Cat. 91.

189 *Ventriloquist (Caller in the Moor)*, 103; 15³/₈ : 11³/₈″; Watercolor; Douglas Cooper, Argilliers, France, page 193.

190 *Battle-Scene from the comic operatic fantasy "The Seafarer"*, 123; 15:20¹/₄″; Watercolor and oil; Trix Dürst-Haass, Basle, page 195.

191 *Dance of the Moth*, 124; 8¹/₄ : 5¹/₂″; Watercolor and oil; Private collection, Japan, Cat. 93.

192 *Perspective with Open Door*, 143; 10¹/₄ : 10⁵/₈″; Watercolor and oil; Hans Meyer, Bern, Cat. 97.

193 *At the Mountain of the Bull*, 152; 18¹/₈ : 13³/₈″; Watercolor and oil; Private collection, Berlin, page 175.

194 *Lomolarm (L'Homme aux Larmes i. e., Man in Tears)*, 172; 13 : 9″; Watercolor on wax base; F. C. Schang, New York, page 203.

195 *Cosmic Flora*, 176; 9¹/₈ : 13³/₄″; Watercolor; Klee Foundation, Bern, Cat. 77.

196 *Dune Flora*, 184; 9⁷/₈ : 11¹/₂″; Watercolor, Private collection, USA, Cat. 34.

197 *Chinese I*, 235; 12¹/₄ : 6³/₄″ Watercolor and oil; Private collection, USA, page 176.

198 *A Performing Puppet*, 253; 7¹/₈ : 3¹/₂″; Pen; Klee Foundation, Bern, page 222.

199 *Tideland at Baltrum*, 263; 6 : 8¹/₂″; Watercolor; Mrs. Marian Willard Johnson, Locust Valley, New York, page 172.

1924

200 *Growth under the Half Moon*, 59; 9 : 6¹/₄″; Pen; Private collection, USA, page 205.

201 *The Governess*, 71; 20¹/₈ : 13³/₈″; Watercolor and oil; Klee Foundation, Bern, Cat. 65.

202 *Landscape with Adventurers*, 94; 6¹/₄ : 11″; Pen; Private collection, USA, page 190.

203 *Carnival in the Mountains*, 114; 9¹/₂ : 12¹/₂″; Watercolor; Klee Foundation, Bern, Cat. 78.

204 *Dance of the Red Skirts*, 119; 13¹/₂ : 17″; Oil; Private collection, Bern, page 209.

205 *Mountain Formation*, 123; 16¹/₂ : 15″; Watercolor; Private collection, Berlin, Cat. 92.

206 *Mural*, 128; 7¹/₂ : 21¹/₄″; Watercolor; Klee Foundation, Bern, Cat. 81.

207 *Female Artist*, 139; 16¹/₈ : 11″; Watercolor and pen; Private collection, Stuttgart, Cat. 55.

208 *Coolness in a Garden of the Torrid Zone*, 186; 11³/₈ : 8¹/₄″; Watercolor and pen; R. Doetsch-Benziger, Basle, Cat. 83.

209 *Collection of Signes*, 189; 9¹/₂ : 11³/₄″; Watercolor and drawing; Private collection, USA, page 177.

210 *Mazzaró (Albergo Pagni)*, 218; 9 : 12¹/₄″; Watercolor; Clifford Odets, New York, Cat. 57.

211 *Near Taormina (Scirocco)*, 220; 5¹/₈ : 9¹/₄″; Watercolor; Klee Foundation, Bern, Cat. 58.

212 *Drawing for Lieschen*, 264; 10⁵/₈ : 7¹/₄″; Pen; Private collection, USA, page 191.

213 *Fishing Smacks*, 288; 5¹/₈ : 10⁵/₈″; Pen; Saidenberg Gallery, New York.

1925

214 *Mountains in Winter*, 3; 11 : 14¹/₄″; Sprayed watercolor and brush; Hermann Rupf, Bern, page 178.

215 *Flowers in Glasses*, K null; 20³/₄ : 16¹/₄″; Oil; Hans Meyer, Bern, Cat. 59.

216 House of the Opera-Bouffe, M 6; 8¹/₂ : 11″; Watercolor; Mrs. Charlotte Purcell, Chicago, page 65.

217 *Fish Magic (Large Fish Picture)*, R 5; 30¹/₄ : 38⁵/₈″; Oil and watercolor; The Philadelphia Museum of Art, Philadelphia, page 211.

218 *Mystic-Ceramic*, B 8; 12¹/₄ : 18¹/₈″; Oil; R. Doetsch-Benziger, Basle, page 179.

219 *Migratory Bird*, C 6; Pen; Private collection, USA, page 67.

220 *Portrait of a Blond Girl*, D 3; 12⁵/₈ : 7¹/₂″; Oil; F. C. Schang, New York, Cat. 56.

221 *Forest near M*, D 7; 5 : 11³/₄″; Watercolor and pen; Eleanor Saidenberg Gallery, New York, Cat. 84.

222 *Village in Relief – A Game*, E null; 11³/₄ : 15³/₄″; Watercolor; Morton Neumann, Chicago, page 177.

223 *African Village Scene*, F 7; 11 : 8⁵/₈″; Pen; Private collection, USA, page 224.

224 *Three Gentle Words from a Fool*, G 3; 10⁵/₈ : 8⁵/₈″; Pen; Curt Valentin, New York, page 247.

225 *Still Life of Autumn Flowers*, J 2; 21⁵/₈ : 14⁷/₈″; Watercolor; Morton Neumann, Chicago, Cat. 60.

226 *The Bird Pep*, T 7; 12¹/₂ : 15³/₈″; Oil and watercolor; Rolf Bürgi, Bern, page 249.

227 *Wintry Mask*, V 3; 21¹/₄ : 13³/₈″; Watercolor; Ida Bienert, Munich, Cat. 80.

228 *Storm Spirit*, Y 4; 9 : 11³/₈″; Pen; Klee Foundation, Bern, page 253.

229 *Castle to be Built in a Forest*, 2; 10¹/₂ : 15¹/₂″; Watercolor; Private collection, Berlin, page 226.

230 *A Garden for Orpheus*, 3; 18¹/₂ : 12⁵/₈″; Pen; Klee Foundation, Bern, page 368.

231 *View of a Mountain Sanctuary*, K 8; 18¹/₂ : 11³/₄″; Watercolor and pen; Ida Bienert, Munich, page 225.

232 *"A Prelude to Golgotha"*, M 1; 18¹/₈ : 12¹/₈″; Watercolor and pen; Mrs. Katharine Warren, New York, Cat. 115.

233 *Christ*, Q 1; 6¹/₄ : 6¹/₄″; Pen; Klee Foundation, Bern, page 69.

234 *Spiral Blossoms*, R 2; 16¹/₄ : 12¹/₄″; Watercolor and pen; R. Doetsch-Benziger, Basle, page 180.

235 *The Menagerie Goes for a Walk*, R 3; 7 : 12″; Pen; Private collection, Bern, page 246.

236 *Little Dune Picture*, B 5; 12 : 9¹/₂″; Oil on casein ground; F. C. Schang, New York, page 255.

237 *Around the Fish*, C 4; 18¹/₄ : 25¹/₄″; Tempera and oil; The Museum of Modern Art, New York, page 229.

238 *Seven Blossoms*, D 6; 21⁵/₈ : 15″; Watercolor; I. B. Neumann, New York, Cat. 118.

239 *The Old One*, G 1; 13¹/₈ : 9³/₄″; Pencil; Frederick Zimmermann, New York, page 252.

240 *Cave Blossoms*, Y 1; 14⁵/₈ : 21″; Watercolor; Galerie O. Stangl, Munich, page 227.

241 *Plants in Still Life with Window*, K 9; 18³/₄ : 21″; Oil; Private collection, Bern, Cat. 148.

242 *Pastoral*, K 10; 27¹/₈ : 20¹/₂″; Oil; The Museum of Modern Art, New York, Cat. 82.

243 *Artificial Rock*, L 1; 27⁵/₈ : 19¹/₄″; Oil; Victor Surbeck, Bern, Cat. 116.

244 *Place of Discovery*, L 7; 18⁷/₈ : 13⁷/₈″; Oil; Philippe Dotremont, Brussels, page 261.

245 *"Air-tsu-dni"*, N 2; 11³/₄ : 11″; Pen; Hans Meyer, Bern, page 259.

246 *Suburb of Beride*, O 4; 11³/₄ : 12¹/₄″; Pen; Klee Foundation, Bern, page 73.

247 *Porto Ferraio*, Q 9; 11³/₄ : 18¹/₈″; Pen; Phil Hart, USA, page 72.

248 *An Oriented Person*, B 6; 12¹/₄ : 9¹/₄; Pen; Private collection, USA, page 254.

249 *The Ships Depart*, D 10; 19⁵/₈ : 23⁵/₈″; Oil; Edward M. Warburg, New York, Cat. 120.

250 *Decay*, F 5; 8¹/₄ : 7¹/₂″; Pen; Private collection, USA, page 267.

251 *Mother Dog with Three Litters*, F 7; 13³/₄ : 18″; Pen; Curt Valentin, New York, page 258.

252 *Fool in a Trance*, H 1; 18¹/₄ : 12″; Oil; Klee Foundation, Bern, Cat. 119.

253 *Allegorical Figurine*, J 2; 18¹/₂ : 16⁷/₈″; Oil; Frau Werner Vowinckel, Munich, page 230.

254 *Côte de Provence*, W 9; 9 : 12¹/₄″; Watercolor; F. C. Schang, New York, Cat. 127.

255 *Chosen Site*, X 8; 18¹/₈ : 12″; Watercolor and pen; Theodor Werner, Berlin, page 231.

256 *City on Two Hills*, Y 4; 10 : 14¹/₄″; Watercolor and pen drawing; Max Fischer, Stuttgart, page 263.

1927 257 *View of G. (Corsica),* Y 5; 12¹/₂ : 9¹/₂″; Watercolor and oil; James Gilvary, New York, page 269.

258 *Good-bye to You,* Z 6; 5⁷/₈ : 7¹/₈″; Pen; Klee Foundation, Bern, page 251.

259 *Above My House, of Course, the Moon,* Ae 3; 12 : 9¹/₄″; Pen; Curt Valentin, New York, page 248.

260 *Family Matters,* OE 7; 11³/₄ : 17³/₄″; Pen; Miss Jane Wade, New York, page 257.

261 *Time and the Plants,* Om 6; 15³/₈ : 20³/₄″; Oil and watercolor; David Thompson, Pittsburg, page 228.

262 *Limits of the Intellect,* Om 8; 21⁵/₈ : 16¹/₈″; Oil and watercolor; Theodor Werner, Berlin, page 232.

1928 263 *Colorful Repast,* L 9; 32⁵/₈ : 27¹/₈″; Oil; Mrs. Stanley Resor, New York, Cat. 149.

264 *A Leaf from the Book of Cities,* N 6; 6³/₄ : 12¹/₂″; Oil; Museum Basle, page 233.

265 *Countercurrent by Full Moon,* B 9; 12 : 10¹/₂″; Pen; Curt Valentin, New York, page 78.

266 *Perspective of a City,* D 7; 18¹/₈ : 13³/₄″; Watercolor and pen; Ida Bienert, Munich, page 219.

267 *Dramatic Landscape,* F 4; 7 : 12″; Watercolor and pen drawing; Private collection, USA, Cat. 121.

268 *Mechanics of a Part of Town,* G 4; 5¹/₄ : 10¹/₄″; Pen; Private collection, USA, page 76.

269 *Castle and Sun,* U 1; 21¹/₄ : 24³/₈″; Oil; Rolant Penrose, London, Cat. 106.

1929 270 *Head of a Smoker,* 10; 20 : 12³/₈″; Watercolor; Richard Sisson, New York, Cat. 101.

271 *Desert Mountains,* K 3; 12 : 8¹/₄″; Pencil; Klee Foundation, Bern, Cat. 107.

272 *Monument in Fertile Country,* N 1; 18¹/₈ : 12″; Watercolor; Klee Foundation, Bern, Cat. 130.

273 *Afraid on the Beach,* P 4; 8⁵/₈ : 7⁷/₈″; Pen; Klee Foundation, Bern, page 75.

274 *Highway and Byways,* R 10; 32⁵/₈ : 26³/₈″; Oil; Frau Werner Vowinckel, Munich, page 234.

275 *Castle Hill,* S 6; 16⁷/₈ : 20¹/₂″; Watercolor; Private collection, Basle, Cat. 108.

276 *Child and Dog,* A 5; 8¹/₄ : 8″; Pen; Mrs. Robert T. Gage, Milford, Conn., page 71.

277 *Last Hope,* B 3; 6³/₄ : 17⁷/₈″; Pen; Curt Valentin Gallery, New York, page 281.

278 *Uncomposed Components in Space,* C 4; 12⁵/₈ : 9⁷/₈″; Watercolor and pen; Private collection, Bern, page 220.

279 *Boat Approaching the Shore,* C 10; 13³/₈ : 19⁵/₈″; Watercolor on gesso ground; Mrs. Lois Dailey, Pomfret Center, Conn., Cat. 103.

280 *Clown,* D 3; 26³/₄ : 19⁵/₈″; Oil with challe; Curt Valentin, New York, page 271.

281 *Fairy Tale,* D 2; 20¹/₂ : 16⁷/₈″; Watercolor; Douglas Cooper, Argilliers, France, Cat. 109.

282 *Saint A in B,* G 10; 8¹/₄ : 13³/₈″; Pen; Klee Foundation, Bern, page 77.

283 *Crusader,* T 12; 17 : 11″; Watercolor; F. C. Schang, New York, Cat. 102.

284 *Landscape with Fisherman,* X 1; 12¹/₄ : 17³/₄″; Watercolor and pen; Alfred Saretzky, New York, Cat. 104.

285 *Orpheus,* Z 7; 19¹/₄ : 9″; Watercolor; James Speyer, Chicago, Cat. 131.

286 *Atmospheric Group,* OE 6; 8⁷/₈ : 11³/₄″; Watercolor and pen; Felix Klee, Bern, Cat. 127.

287 *Wandering Soul,* 3h 11; 9¹/₂ : 14¹/₈″; Watercolor and pen; Privat collection, Bern, Cat. 128.

288 *Before the Snow,* 3h 19; 13¹/₂ : 15³/₈″; Watercolor; Private collection, Bern, Cat. 129.

289 *The Snake on the Ladder,* 3h 40; 11¹/₂ : 17¹/₈″; Oil and watercolor; Peter Watson, London, page 238.

1930 290 *Refuge,* L 1; 31¹/₈ : 13³/₄″; Oil and watercolor; The Pasadena Art Institute, California, Cat. 141.

291 *Necropolis,* O 7; 32⁵/₈ : 26³/₈″; Gouache; David Thompson, Pittsburg, page 235.

292 *Individualized Measurement of Strata,* R 2; 19⁵/₈ : 15³/₈″; Pastel; Klee Foundation, Bern, page 277.

293 *Surfaces in Tension*, W 5; 19⁵/₈ : 23⁵/₈″; Oil; Hans Meyer, Bern, Cat. 125.

294 *Twins*, W 8; 23⁵/₈ : 19⁵/₈″; Oil; Henry T. Kneeland, Hartford, Conn., Cat. 126.

295 *Conqueror*, W 10; 16¹/₈ : 17³/₈″; Watercolor; Klee Foundation, Bern, Cat. 142.

296 *Dancing Master*, A 9; 17¹/₂ : 12⁵/₈″; Pen; Privat collection, USA, page 276.

297 *Vase of Flowers in Sculpture*, B 9; 13³/₈ : 8¹/₄″; Oil, stenciled; Hermann Rupf, Bern, page 236.

298 *Hall of Singers*, C 9; 10⁵/₈ : 18⁷/₈″; Watercolor on gesso ground; Rolf Bürgi, Bern, Cat. 85.

299 *Staging*, E 1; 11³/₈ : 16⁷/₈″; Watercolor and gesso ground; F. C. Schang, New York, Cat. 110.

300 *Rhythms*, E 3; 27¹/₈ : 19⁵/₈″; Oil; Hans Meyer, Bern, Cat. 89.

301 *Night Blossoms*, E 7; 10 : 12⁵/₈″; Watercolor; Mrs. Charlotte Shack, San Francisco, Cat. 105.

302 *Sunset*, E 9; 18¹/₂ : 27⁵/₈″; Oil; Private collection, Berlin, Cat. 133.

303 *Ad Marginem*, E 10; 18¹/₄ : 14¹/₈″; Watercolor; R. Doetsch-Benziger, Basle, page 237.

304 *At Seven above the Roof*, S 1; 21⁵/₈ : 19⁵/₈″; Watercolor; Galerie Louise Leiris, Paris, Cat. 111.

305 *Drum Organ*, S 2; 12⁵/₈ : 16¹/₈″; Oil and watercolor; Oberlin College, Oberlin, Ohio, Cat. 112.

306 *The Devil Juggling*, S 3; 27¹/₈ : 19⁵/₈″; Oil; Maja Sacher, Basle, Cat. 143.

307 *Hovering, Before the Ascent*, S 10; 33¹/₈ : 33¹/₈″; Oil; Klee Foundation, Bern, page 240.

308 *Laced into a Group*, J 7; 11 : 18¹/₈″; Pen; Klee Foundation, Bern, page 275.

309 *Family Outing*, J 10; 16 : 22³/₄″; Ruling pen; Klee Foundation, Bern, page 274.

310 *Romantic Park*, OE 10; 13 : 19⁵/₈″; Oil; E. M. Warburg, New York, Cat. 150.

311 *Portal of a Mosque*, S 1; 15 : 11³/₈″; Watercolor; Ralph Colin, New York, Cat. 87.

312 *Mosaic from Prhun*, S 18; 13 : 18″; Watercolor; Rolf Bürgi, Bern, Cat. 134.

313 *Steamer and Sailboats Toward Evening*, T 16; 19 : 24″; Watercolor; Private collection, USA, Cat. 135.

314 *The Light and Much Else*, V 8; 37³/₈ : 38¹/₈″; Watercolor, varnished; Ida Bienert, Munich, page 241.

315 *Abstract Script*, Y 4; 3¹/₄ : 8⁷/₈″; Ruling pen; Klee Foundation, Bern, page 284.

316 *Diana*, Y 7; 31¹/₂ : 23⁵/₈″; Oil; Curt Valentin, New York, page 279.

317 *Poison*, 13; 24 : 19″; Watercolor; Klee Foundation, Bern, Cat. 123.

318 *Landscape Uol*, 15; 11³/₄ : 18⁷/₈″; Watercolor; Hermann Rupf, Bern, Cat. 136.

319 *At Anchor*, K 2; 34⁵/₈ : 37″; Oil; Joseph Pulitzer, Tr., St. Louis, page 313.

320 *Masked – Naked*, K 14; 19 : 11⁵/₈″; Pen; Klee Foundation, Bern, page 285.

321 *Plant Script Picture*, M 1; 10 : 20³/₄″; Watercolor; Klee Foundation, Bern, Cat. 138.

322 *City on a Lagoon*, M 3; 19 : 11⁵/₈″; Watercolor; Private collection, Bern, Cat. 132.

323 *Please!*, M 19; 7⁷/₈ : 14⁵/₈″; Pen; Klee Foundation, Bern, page 79.

324 *Downward*, M 20; 9¹/₂ : 13⁵/₈″; Pen; Private collection, USA, page 283.

325 *Young Tree (Chloranthemum)*, P 13; 18¹/₂ : 14¹/₈″; Watercolor; Rolf Bürgi, Bern, page 242.

326 *Revolt in the Plains*, S 13; 7³/₄ : 12″; Pen; Curt Valentin, New York, page 80.

327 *Demagogy*, S 15; 5¹/₂ : 7¹/₄″; Pen; Klee Foundation, Bern, page 81.

328 *When Will It Quiet Down?*, U 5; 7¹/₈ : 9¹/₄″; Pen; Klee Foundation, Bern, page 82.

329 *The Things That Grow!*, V 13; 18⁷/₈ : 12¹/₂″; Watercolor; Klee Foundation, Bern, page 243.

330 *Ad Parnassum*, X 14; 39³/₈ : 49⁵/₈″; Oil; Museum, Bern, Cat. 137.

331 *Small Town among the Rocks*, X 16; 17³/₈ : 22; Oil; Klee Foundation, Bern, Cat. 113.

332 *Arab Song*, Y 3; 35⁷/₈ : 25¹/₄″; Oil; The Phillips Collection, Washington, Cat. 144.

333 *The Fruit*, Y 17; 21⁵/₈ : 27⁵/₈″; Oil; Mies van der Rohe, Chicago, page 290.

1933

334 *Shame*, K 15; 18$^{1}/_{2}$: 25″; Brush; Klee Foundation, Bern, page 288.
335 *The Tear*, M 7; 24 : 18$^{7}/_{8}$″; Pen; Mrs. Walter Paepcke, Chicago, page 83.
336 *Emigrating*, U 1; 13 : 8$^{1}/_{4}$″; Pencil; Klee Foundation, Bern, page 287.
337 *The Second Wave Attacks*, V 18; 18$^{3}/_{4}$: 26$^{3}/_{4}$″; Brush; Curt Valentin, New York, page 286.
338 *The Future One*, Y 5; 24$^{3}/_{8}$: 18$^{1}/_{8}$″; Watercolor; Klee Foundation, page 244.
339 *Scholar*, Z 6; 13$^{3}/_{4}$: 10$^{1}/_{2}$″; Watercolor; Private collection, Bern, Cat. 145.
340 *The Name Is "Parents' Image"*, C 17; 17$^{3}/_{4}$: 14$^{5}/_{8}$″; Watercolor wash; Mrs. Marian Willard Johnson, Locust Valley, Cat. 146.
341 *Small Room in Venice*, H 7; 8$^{1}/_{4}$: 12″; Pastel; R. Doetsch-Benziger, Basle, page 122.
342 *Negro Glance*, T 2; 19$^{1}/_{2}$: 14$^{5}/_{8}$″; Gouache; Klee Foundation, Bern, Cat. 147.

1934

343 *Untamed Waters*, 16; 11$^{5}/_{8}$: 19$^{1}/_{4}$″; Watercolor and pen; Private collection, Bern, page 291.
344 *Low Tide*, P 3; 12 : 17$^{5}/_{8}$″; Pen; Klee Foundation, Bern, page 99.
345 *Secret Script Picture*, P 5; 19$^{7}/_{8}$: 24$^{3}/_{4}$″; Gouache; Klee Foundation, Bern, Cat. 139.
346 *Flowering*, T 19; 31$^{7}/_{8}$: 31$^{5}/_{8}$″; Oil; E. Friedrich, Zurich, Cat. 88.
347 *Fear*, U 2; 19$^{5}/_{8}$: 23$^{5}/_{8}$″; Watercolor wash; Nelson A. Rockefeller, New York, Cat. 183.
348 *Angel in the Making*, U 4; 20$^{1}/_{8}$: 20$^{1}/_{8}$″; Oil; Nelson A. Rockefeller, New York, Cat. 197.
349 *The Soul Departs*, U 11; 12 : 19$^{1}/_{4}$″; Watercolor; Klee Foundation, Bern, Cat. 79.
350 *The Creator*, U 13; 16$^{1}/_{2}$: 20$^{7}/_{8}$″; Oil; Klee Foundation, Bern, Cat. 117.
351 *Garten by the Full Moon*, U 14; 19$^{5}/_{8}$: 23$^{5}/_{8}$″; Oil; Hermann Rupf, Bern, Cat. 154.
352 *Figure of the Oriental Theater*, U 18; 20$^{1}/_{2}$: 15$^{1}/_{2}$″; Oil; The Phillips collection, Washington, Cat. 151.
353 *Botanical Theater*, U 19; 19$^{5}/_{8}$: 26$^{3}/_{8}$″; Oil and watercolor; Rolf Bürgi, Bern, page 239.

1935

354 *Symptom, to be Recognized in Time*, 17; 7$^{1}/_{8}$: 11″; Pencil; Klee Foundation, Bern, page 84.
355 *Rough-Hewn Head*, K 2; 13 : 8$^{1}/_{4}$″; Watercolor; F. C. Schang, New York, Cat. 152.
356 *Child Consecrated to Woe*, K 11; 5$^{1}/_{8}$: 9″; Oil and watercolor; Albright Art Gallery, Buffalo, Cat. 155.
357 *Scarecrow*, R 5; 28 : 23$^{5}/_{8}$″; Oil; W. Allenbach, Bern, page 289.

1936

358 *Equation*, 1; 11$^{3}/_{4}$: 18$^{1}/_{4}$″; Watercolor; Mrs. Marian Willard Johnson, Locust Valley, New York, Cat. 185.

1937

359 *Donkey Eating out of Hand*, 7; 11 : 7$^{1}/_{8}$″; Charcoal; Klee Foundation, Bern, page 384.
360 *Drawing for Traveling Circus*, L 1; 6$^{3}/_{4}$: 13$^{1}/_{2}$″; Pencil; Private collection, USA, page 317.
361 *Under the Viaduct*, M 17; 20$^{3}/_{4}$: 12″; Charcoal and gouache; David Thompson, Pittsburgh, Cat. 186.
362 *Comments on a Region*, Q 7; 18$^{7}/_{8}$: 12$^{5}/_{8}$″; Watercolor and charcoal on gesso ground; Curt Valentin, New York, Cat. 169.
363 *Figure in a Garden*, Q 9; 31$^{7}/_{8}$: 24″; Pastel; Felix Klee, Bern, page 315.
364 *A Sheet of Pictures*, Q 13; 23$^{1}/_{4}$: 22″; Oil; The Phillips collection, Washington, page 321.
365 *Early Chill*, Q 16; 28$^{3}/_{4}$: 20$^{7}/_{8}$″; Oil; Bernard H. Friedman, New York, page 294.
366 *Traveling Circus*, Q 19; 25$^{5}/_{8}$: 19$^{5}/_{8}$″; Oil; Baltimore Museum of Art, Baltimore, page 292.
367 *Superchess*, R 1; 47$^{1}/_{4}$: 43$^{1}/_{4}$″; Oil; Kunsthaus, Zurich, page 293.
368 *Temple Festival*, R 2; 13$^{3}/_{8}$: 19$^{1}/_{4}$″; Watercolor wash; Private collection, USA, Cat. 168.
369 *Revolution of the Viaduct*, R 13; 23$^{5}/_{8}$: 19$^{5}/_{8}$″; Oil; Kunsthalle Hamburg, page 295.
370 *Child in Red*, S 6; 13$^{3}/_{8}$: 7$^{7}/_{8}$″; Pastel; I. B. Neumann, New York, page 296.
371 *Oriental Garden*, S 7; 14 : 10$^{3}/_{4}$″; Pastel; F. C. Schang, New York, Cat. 163.
372 *Sextet of Spirits*, T 9; 13$^{3}/_{4}$: 18$^{1}/_{2}$″; Pastel; John S. Newberry, Grosse Pointe, Mich., Cat. 166.

373 *Sentry*, T 6; 12¹/₂ : 18¹/₂″; Watercolor and gouache; Hanns Swarzenski, Boston, Mass., Cat. 184.

374 *"Woe, Woe!"*, U 1; 7¹/₈ : 11³/₈″; Black gouache; Rolf Bürgi, Bern, page 85.

375 *Yellow Signs*, U 10; 32⁵/₈ : 19⁵/₈″; Pastel; Private collection, Bern, Cat. 186.

376 *Stage Landscape*, U 12; 22⁷/₈ : 33⁷/₈″; Pastel; Hermann Rupf, Bern, page 323.

377 *Legend of the Nile*, U 15; 27¹/₈ : 24″; Pastel; Hermann Rupf, Bern, Cat. 167.

378 *Branches in Autumn*, U 16; 7¹/₂ : 15¹/₂″; Pastel; David Thompson, Pittsburg, Cat. 165.

379 *Clown in Bed*, W 14; 9¹/₂ : 19″; Gouache-tempera; Klee Foundation, Bern, Cat. 153.

380 *Heroic Fiddling*, 1; 26³/₈ : 19¹/₄″; Gouache; Nelson A. Rockefeller, New York, Cat. 174.

381 *Animals in Enclosure*, 8; 9 : 11³/₄″; Gouache; F. C. Schang, New York, page 309.

382 *Fruit*, D 8; 10⁵/₈ : 14″; Gouache; Klee Foundation, Bern, page 329.

383 *Sportive Young Lady*, D 9; 21¹/₄ : 13⁵/₈″; Gouache; Felix Klee, Bern, Cat. 175.

384 *Poster for Comedians*, E 2; 18⁷/₈ : 12⁷/₈″; Gouache; Galerie Louise Leiris, Paris, page 297.

385 *The Boulevard of the Abnormal Ones*, E 6; 12⁷/₈ : 18⁷/₈″; Gouache; David Thompson, Pittsburg, Cat. 156.

386 *Stage Direction in a Storm*, E 7; 11 : 15¹/₄″; Gouache; Private collection, USA, Cat. 160.

387 *Right, Left*, E 11; 18⁷/₈ : 12³/₄″; Gouache; F. C. Schang, New York, Cat. 176.

388 *X-let*, F 3; 11 : 7¹/₈″; Black gouache; Angela Rosengart, Lucern, page 10.

389 *Hurry*, F 17; 13 : 15¹/₈″; Gouache; Klee Foundation, Bern, Cat. 172.

390 *Archangel*, G 2; 39⁵/₈ : 25⁵/₈″; Oil; Private collection, USA, Cat. 198.

391 *Dancing for Fear*, G 10; 18⁷/₈ : 12¹/₂″; Watercolor; Klee Foundation, Bern, page 298.

392 *Witches of the Earth*, H 8; 19 : 12¹/₄″; Oil and watercolor; Klee Foundation, Bern, Cat. 187.

393 *Oriental-Sweet*, H 20; 19⁵/₈ : 26″; Oil; Curt Valentin, New York, page 331.

394 *The Vase*, J 2; 34⁵/₈ : 21¹/₄″; Gouache; Mrs. Gertrude Lennart, New York, page 299.

395 *Intention (sketch)*, J 6; 29¹/₂ : 44¹/₈″; Gouache; Klee Foundation, Bern, page 299.

396 *Capriccio in February*, J 8; 39³/₈ : 29¹/₈″; Oil; Morton Neumann, Chicago, Cat. 157.

397 *Park near L(ucerne)*, J 9; 39³/₈ : 27⁵/₈″; Oil; Klee Foundation, Bern, page 337.

398 *Fruit on Blue Ground*, J 10; 21⁵/₈ : 53¹/₂″; Gouache; Klee Foundation, Bern, Cat. 179.

399 *Spring of Fire*, J 12; 27⁵/₈ : 59″; Oil; Rolf Bürgi, Bern, Cat. 180.

400 *From a Collection of Masks*, J 14; 11⁵/₈ : 8⁵/₈″; Oil and watercolor on gesso ground; Private collection, Bern, Cat. 188.

401 *Broken Key*, J 16; 21⁵/₈ : 24″; Oil; Private Collection, Bern, Cat. 171.

402 *Aeolian*, J 17; 20¹/₂ : 26³/₄″; Oil; Hermann Rupf, Bern, Cat. 173.

403 *Red Waistcoat*, K 3; 25⁵/₈ : 16³/₄″; Gouache, waxed; F. C. Schang, New York, page 339.

404 *Rich Harbor*, K 7; 29¹/₂ : 65″; Oil; Museum, Basle, Cat. 181.

405 *A Light and Dry Poem*, T 12; 19¹/₄ : 17³/₈″; Pastel; Rolf Bürgi, Bern, Cat. 170.

406 *Mr. H. Mel*, T 17; 11³/₄ : 20¹/₂″; Oil and watercolor on gesso ground; Klee Foundation, Bern, page 300.

407 *Early Sorrow*, T 18; 13¹/₈ : 17⁵/₈″; Oil and watercolor on gesso ground; Klee Foundation, Bern, page 300.

408 *A Sailor Feels the End Is Near*, Y 4; 11⁵/₈ : 8¹/₂″; Black gouache; Felix Klee, Bern, page 310.

409 *Monologue of the Kitten*, Z 6; 11³/₄ : 8¹/₂″; Pencil; Felix Klee, Bern, page 86.

410 *Insula Dulcamara*, C 1; 34⁵/₈ : 68¹/₂″; Oil; Klee Foundation, Bern, Cat. 182.

411 *Masks at Twilight*, C 6; 18⁷/₈ : 13¹/₈″; Gouache; Paul Rand, New York, Cat. 177.

412 *Fear Erupting*, G 7; 10⁵/₈ : 8¹/₂″; Pen; Klee Foundation, Bern, page 87.

413 *Harbor of K.*, G 12; 4⁵/₈ : 11³/₈″; Pen; Klee Foundation, Bern, page 318.

414 *Poem in Pictorial Script*, P 10; 3⁷/₈ : 8¹/₄″; Ruling pen; Felix Klee, Bern, page 319.

415 *The Torso and His Own by the Full Moon*, T 16; 25⁵/₈ : 19⁵/₈″; 1939; Watercolor wash; Klee Foundation, Bern, Cat. 158.

1939

416 *Emotional Germination*, V 1; 10 : 19″; Gouache; Klee Foundation, Bern, Cat. 193.

417 *Intoxication*, Y 1; 31¹/₂ : 25⁵/₈″; Oil and watercolor; Hans Meyer, Bern, page 345.

418 *Love Song by the New Moon*, Y 2; 39³/₈ : 27⁵/₈″; Watercolor; Klee Foundation, Bern, Cat. 189.

419 *Dialogue of Tree and Man*, B 3; 8¹/₄ : 11⁵/₈″; Pencil; Felix Klee, Bern, page 327.

420 *Mother and Son*, DD 2; 8¹/₄ : 11¹/₂″; Pencil; Klee Foundation, Bern, page 88.

421 *Maturing Separation*, DD 13; 8¹/₄ : 11¹/₂″; Pen; Felix Klee, Bern, page 335.

422 *A Sick Man Making Plans*, FF 11; 8¹/₄ : 11¹/₂″; Pencil; Felix Klee, Bern, page 90.

423 *Omphalo-Centric Lecture*, KK 10; 27⁵/₈ : 19⁵/₈″; Gouache; Bernard H. Friedman, New York, Cat. 192.

424 *Graveyard*, KK 13; 14⁵/₈ : 19⁵/₈″; Gouache; Klee Foundation, Bern, Cat. 194.

425 *Submarine Garden*, NN 6; 39³/₈ : 31¹/₂″; Oil; Private collection, Bern, page 301.

426 *Grandchild of Rosinante*, RR 20; 11³/₄ : 16¹/₄″; Pencil; Felix Klee, Bern, page 320.

427 *Burden*, TT 17; 11¹/₂ : 8¹/₄″; Pencil; Felix Klee, Bern, page 89.

428 *Come Away*, TT 18; 11¹/₂ : 8¹/₄″; Pencil; Klee Foundation, Bern, page 91.

429 *Maternity*, UU 9; 11¹/₂ : 8¹/₄″; Pencil; Felix Klee, Bern, page 333.

430 *On the Nile*, UU 11; 29¹/₂ : 49¹/₄″; Gouache; Curt Valentin, New York, Cat. 191.

431 *Poor Angel*, UU 14; 7¹/₄ : 12⁷/₈″; Watercolor and tempera; Private collection, Bern, page 304.

432 *Mephistopheles as Pallas*, UU 15; 18¹/₂ : 14⁵/₈; Watercolor and tempera; Douglas Cooper, Argilliers, France, Cat. 190.

433 *Stern Visage*, UU 17; 13 : 8¹/₄″; Watercolor and tempera; Klee Foundation, Bern, page 302.

434 *Watchful Angel*, UU 19; 18⁷/₈ : 12⁵/₈″; Pen and tempera; Private collection, Bern, Binding.

435 *Exotic Temple Maid*, VV 5; 13 : 8¹/₄″; Ruling pen; Klee Foundation, Bern, Binding.

436 *Forgetful Angel*, VV 20; 11¹/₂ : 8¹/₄″; Pencil; Klee Foundation, Bern, page 348.

437 *A Trio Conversing*, ZZ 10; 8¹/₄ : 11¹/₂″; Pencil; Felix Klee, Bern, page 341.

438 *Brotherhood*, ZZ 12; 11¹/₂ : 8¹/₄″; Pencil; Klee Foundation, Bern, page 344.

439 *Angelus Militans*, DE 8; 17³/₈ : 15³/₄″; Pencil; Klee Foundation, Bern, page 350.

440 *Angel from a Star*, EF 10; 24 : 18¹/₈″; Gouache; Klee Foundation, Bern, Cat. 199.

441 *Fertilized*, EF 20; 3¹/₈ : 23⁵/₈″; Pencil; Felix Klee, Bern, page 382.

442 *La Belle Jardinière*, OP 17; 37³/₈ : 27⁵/₈″; Oil and tempera; Klee Foundation, Bern, page 305.

443 *Group of Masks*, OP 18; 37³/₈ : 27⁵/₈″; Oil and gouache; Mrs. Alma Morgenthau, New York, page 33.

444 *High Spirits*, PQ 11; 39³/₈ : 51¹/₈″; Oil and gouache; Klee Foundation, Bern, Cat. 159.

1940

445 *Newly Arranged Place*, Z 10; 8 : 11¹/₂″; Encaustic; Private collection, USA, Cat. 114.

446 *Group with the Fleeing Scold*, Y 16; 11¹/₂ : 8¹/₄″; Pen; Klee Foundation, Bern, page 343.

447 *Sick Man in a Boat*, W 6; 8¹/₄ : 16⁷/₈″; Crayon; Klee Foundation, Bern, page 92.

448 *Former Harpist*, V 20; 11¹/₂ : 8¹/₄″; Pencil; Klee Foundation, Bern, page 358.

449 *Knaueros, Former Drummer*, U 2; 11³/₄ : 8¹/₄″; Crayon; Klee Foundation, Bern, page 359.

450 *Fir-Tree*, T 6; 11¹/₂ : 8¹/₄″; Pen; Felix Klee, Bern, page 1.

451 *Ecce*, T 18; 11¹/₂ : 8¹/₄″; Pencil; Felix Klee, Bern, page 94.

452 *Flower Girl*, R 5; 14³/₄ : 16³/₄″; Watercolor wash; Rufus Stillman, Litchfield, Conn., Cat. 196.

453 *Dürer's Mother, Too (Passion)*, R 18; 11¹/₂ : 8¹/₄″; Pencil; Klee Foundation, Bern, page 349.

454 *Still Life on Leap Day*, N 13; 29¹/₈ : 43¹/₄″; Gouache; Klee Foundation, Bern, page 195.

455 *Double*, N 16; 20¹/₂ : 13¹/₂″; Gouache; Klee Foundation, Bern, page 353.

456 *Woman in Native Costume*, M 14; 18⁷/₈ : 12¹/₂″; Gouache; Klee Foundation, Bern, page 351.
457 *Drummer*, L 10; 13¹/₂ : 8⁵/₈″; Gouache; Klee Foundation, Bern, page 355.
458 *Alea Jacta*, L 11; 13¹/₂ : 8¹/₂″; Gouache; F. C. Schang, New York, page 200.
459 *The Locksmith*, L 14; 18⁷/₈ : 12¹/₄″; Gouache; Museum, Basle, Cat. 201.
460 *Wood Louse*, K 7; 11³/₈ : 16¹/₄″; Gouache; Private collection, Bern, page 306.
461 *Glass Facade*, K 8; 27⁵/₈ : 37³/₈″; Encaustic; Klee Foundation, Bern, Cat. 90.
462 *Hurt*, H 16; 16¹/₂ : 11⁵/₈″; Black gouache; Klee Foundation, Bern, page 202.
463 *The Snake Goddes and Her Foe*, H 17; Gouache; Private collection, Bern, page 3.
464 *They All Run After*, G 5; 12⁵/₈ : 16³/₄″; Gouache; Klee Foundation, Bern, Cat. 161.
465 *Death and Fire*, G 12; 18¹/₈ : 17³/₈″; Oil; Klee Foundation, Bern, page 361.
466 *Persevere!* G 17; 11¹/₂ : 8¹/₄″; Black pastel; Klee Foundation, Bern, page 96.
467 *Wood Louse in Enclosure*, F 13; 12¹/₂ : 16¹/₈″; Pastel; Klee Foundation, Bern, page 306.
468 *Bal Champêtre*, F 14; 15¹/₂ : 24³/₈″; Pastel; Frederick Zimmermann, New York, Cat. 162.
469 *Female Dancer*; 20¹/₈ : 20¹/₈″; Oil; Mrs. Lynne Thompson, New York, page 307.
470 *Captive*; 18⁷/₈ : 17³/₈″; Oil; Frederick Zimmermann, New York, page 308.
471 *Script*; 5³/₄ : 24¹/₂″; Oil; David Thompson, Pittsburg, Cat. 140.
472 *Glance*; 7³/₄ : 9³/₄″; Brush; Klee Foundation, Bern, page 377.
473 *Still Life* (Klee's last painting); 39⁵/₈ : 3¹/₂″; Oil; Felix Klee, Bern, page 363.

Biography

1879 Born December 18 at Münchenbuchsee near Bern, to Hans Klee (1849–1940) and Ida Marie Frick Klee (1855–1921).

1886 Primary school, 1890 *Progymnasium*, in Bern.

1898 Graduates from the *Literarschule*, Bern.

1898–1900 Munich, studies with Knirr and, at the Academy, with Stuck. Attends lectures on anatomy and the history of art, learns the technique of etching, and experiments with sculpture.

1901–1902 Travels to Italy with the Sculptor Hermann Haller: on June 30 from Munich via Bern to Milan and Genoa; in Rome October 27; Naples at Easter, 1902; returns to Bern May 7, 1902.

1902 Engaged to the pianist Lily Stumpf in Munich.

1902–1906 Bern; in addition to painting and drawing, reads widely and shows much interest in music.

1903–1905 Ten etched "Inventions."

1904 Visit to Munich; studies Beardsley, Blake, and Goya in the print room of the Pinakothek. Sees paintings by Corot in Geneva.

1905 Trip to Paris with Bloesch and Moilliet, May 31–June 13; much impressed with Leonardo da Vinci. Starts work on glass-paintings.

1906 Brief visit to Berlin in April, views the *Jahrhundertausstellung* and the Kaiser-Friedrich Museum. His etchings shown in the Munich *Sezession*. In September marries Lily Stumpf and moves to munich; preoccupied with defining his attitude towards nature and towards Impressionism.

1907 Birth of his son Felix. Discovers the graphic work of Ensor.

1908 Exhibits in the group shows of the Munich and Berlin *Sezession* and in the Munich *Glaspalast*. Much impressed by the Van Gogh exhibitions at the Zimmermann and Brake galleries and by the Marées exhibition at the Munich *Sezession*. Produces glass-paintings, watercolors, and drawings. Preoccupied with the concept of time as a genetic force.

1909 Views Cézanne exhibition at the *Sezession* and Matisse exhibition at the Thannhauser Gallery.

1910 Fifty-six of his works shown at the Bern Museum and subsequently in Basel, Zurich, and Winterthur.

1911 First major exhibition of his work at the Thannhauser Gallery, Munich. Contact with the *Blaue Reiter* group. Begins his illustrations for Voltaire's *Candide* (published 1920). Etablishes a catalogue of his own works, going back to 1899. Meets Kubin, then Macke, Kandinsky, Marc, Campendonk, Jawlensky, Werefkin, Münter, Arp.

1912 Contact with Eliasberg, Meyer-Gräfe, Wolfskehl, Piper, Thannhauser, Walden, Carossa, Rilke in Munich. Exhibits at the *Sonderbund*, Cologne (four drawings), the Kunsthaus, Zurich (as a member of *Die Walze*, an association of Swiss graphic artists), at the

Moderne Bund shwo, Zurich, and at the second *Blaue Reiter* exhibition. Views the Futurist exhibition at the Thannhauser Gallery. Second trip to Paris, April 2–18; visits Delaunay, Kahnweiler, Uhde, and sees pictures by Picasso, Braque, Rousseau. Translates an essay by Delaunay.

1913 Exhibits in the *Sturm* show, Berlin, and in the *Erste Deutsche Herbstsalon*.

1914 Helps to found the *Neue Münchner Sezession*. Trip to Tunis and Kairouan, April 5–22, with Moilliet and Macke. New awareness of color, works largely in watercolor; defines his attitude toward Cubism.

1915 Trip to Switzerland.

1916–1918 Sercive in the German army, behind the lines. "Script pictures"; *Cosmic Picture Album;* rhythmic tree landscapes.

1918 Fifteen drawings by Klee published in the *Sturm-Bilderbuch*.

1919 Contract with the dealer Goltz for three years, later extended to 1925.

1920 Long sojourn in Switzerland (the first since 1910). Many small oils. 362 works shown at the Goltz Gallery (the illustrated catalogue issued as a special number of the journal *Ararat*). Erich Reiss publishes *Schöpferische Konfession*, including Klee's own "creative credo." Monographs on Klee by Wedderkop (in the series *Junge Kunst*) and L. Zahn (G. Kiepenheuer). *Candide,* with Klee's illustrations, published by Kurt Wolff. Appointed to the faculty of the Weimar Bauhaus by Gropius on November 25.

1921 Moves to Weimar. W. Hausensteins *Kairuan oder eine Geschichte vom Maler Klee und von der Kunst dieses Zeitalters* (Kairouan; or An Account of Klee and of The Art of Our Time) is published.

1923 Bauhaus exhibition and festival. Klee exhibition at the Kronprinzen-Palais, Berlin. His *Wege des Naturstudiums (Ways of Studying Nature)* published in the *Bauhaus-Buch*. Summer vacation on the island of Baltrum. "Poetic works" and "constructions", "technical inventions," "magic squares," "screen pictures," "perspectives," "theater pictures."

1924 First Klee exhibition in America (Societé Anonyme, New York). Founding of *Die Blaue Vier:* Kandinsky, Klee, Feininger, Jawlensky. Klee visited by Léon-Paul Fargue. Trip to Sicily. Lecture at Jena. In December Klee gives up his activity at the Weimar Bauhaus.

1925 The Bauhaus moves to Dessau. The *Pädagogisches Skizzenbuch (Pedagogical Sketchbook)* published in the series, *Bauhaus-Bücher*. Participates in the Surrealist exhibition, Paris. First major showing of Klee's work in Paris (Galérie Vavin-Raspail).

1926 Moves to Dessau. Summer trip to Italy (Elba, Florence, Pisa, Ravenna). "Configurations of parallels."

1927 Summer trip to Corsica and to the Isle de Porquerolles.

1928 Summer trip to Brittany. Visit to Egypt, December 17–January 17, 1929.

1929 Klee's fiftieth birthday marked by large one-man show at the Flechtheim Gallery, Berlin. Monograph by Will Grohmann (*Cahiers d'Art*, Paris).

1930 The Klee exhibition of the Flechtheim Gallery shown at the Museum of Modern Art, New York. Other Klee exhibitions in Dresden, Düsseldorf, Saarbrücken. Summer trip to the Engadin and Viareggio. First Divisionist pictures.

1931 On the faculty of the Düsseldorf *Akademie* since April 1. Large exhibition at the Düsseldorf *Kunstverein*. Becomes a member of the jury of the *Deutscher Künstlerbund*. Summer trip to the Gulf of Biscay.

1932 Summer trip to Northern Italy and Venice.

1933 Summer trip to south of France. Dismissed by the Nazis. Moves to Bern in December.

1934 First Klee exhibition in England (Mayer Gallery, London). Book on Klee's drawings, 1920–30, edited by Will Grohmann, confiscated by the Gestapo. Kahnweiler becomes Klee's dealer.

1935 Large Klee exhibition at the Kunsthalle, Bern, and in Basel. First signs of fatal illness.

1936 Summer spent at Tarasp and Montana. Klee exhibition in Lucerne.

1937 Klee is visited in Bern by Picasso, Braque, and Kirchner. Summer spent in Ascona. Klee represented by 17 pictures in the Nazi Exhibition of "Degenerate Art" in Munich; 102 of his works confiscated from public collections in Germany. Beginning of his late style.

1938 Summer spent in Beatenberg. Bauhaus exhibition in New York. Klee exhibitions at the Buchholz (Curt Valentin) and Nierendorf galleries, New York, and at the Simon (Kahnweiler) and Carré galleries, Paris. Seven large panel pictures, late pastels.

1939 Visits the Prado exhibition in Geneva. On the Murten lake during fall. Sixtieth birthday. "Angel" series, premonitions of death.

1940 Large exhibition of Klee's work, 1935–1940, at the Zurich Kunsthaus. Trip to Orselina-Locarno, May 10. Dies at Muralto-Locarno, June 29. Klee memorial service in Bern, July 4. Memorial exhibitions in Bern and New York, and (in 1941) in Basel and Zurich. Klee's ashes interred at the Schlosshalden cemetry, Bern, September 1942.

Bibliographie
Bibliography

Paul Klee: Bibliographie, zusammengestellt von Hannah Muller-Applebaum, Bibliothekarin am Museum of Modern Art, New York.

Paul Klee: A Bibliography, compiled by Hannah Muller Applebaum, Assistant Librarian, The Museum of Modern Art, New York.

Paul Klee: Bibliographie établie par Hannah Muller-Applebaum, Bibliothécaire au Musée d'Art moderne, New-York.

Schriften von Klee
Writings by Klee
Ecrits de Klee

1. "Die Ausstellung des Modernen Bundes im Kunsthaus Zürich", *Die Alpen*, Berne, v. 6, no. 12, Aug. 1912, pp. 696–704.
 Klee was a regular contributor to *Die Alpen* from Nov. 1911, v. 6, no. 3 to Dec. 1912, v. 7, no. 4. His critical comments from Munich included in the section "Literatur und Kunst des Auslandes" dealt with Renoir, Munch, Cubism, Futurism, Kandinsky, music, the opera and the theater.

2. Translation of essay by Robert Delaunay. "Über das Licht", *Der Sturm*, Berlin, v. 3, no. 144–145, Jan. 1913, p. 255–256.

3. *Schöpferische Konfession*, Berlin, E. Reiss, 1920, pp. 28–40. (Tribüne der Kunst und Zeit, hrsg. v. Kasimir Edschmid, 13).

4. "Antwort auf eine Rundfrage an die Künstler: Über den Wert der Kritik", *Der Ararat*, Munich, v. 2, 1921, p. 130.

5. "Wege des Naturstudiums". In *Staatliches Bauhaus in Weimar, 1919–1923*, Weimar-München, Bauhausverlag, 1923, pp. 24–25, illus.
 Reprinted in exhibition catalog 1950, Munich, Haus der Kunst; 1950, Frankfurt am Main, Galerie Buchheim-Militon.

6. *Pädagogisches Skizzenbuch*, München, Langen, 1925, 51 pp., illus. (Bauhausbücher 2).
 Translated into English under title: *Pedagogical Sketchbook*, New York, Nierendorf Gallery, 1944, 67 pp., illus. Also published under title: *Paul Klee: Pedagogical Sketchbook*. Introduction and translation by Sibyl Moholy-Nagy, New York, Praeger, 1953, 64 pp., illus. The 1944 translation is reviewed in *College Art Journal*, New York, v. 4, May 1945, pp. 232–235.

7. "Kandinsky". In *Katalog Jubiläumsausstellung zum 60. Geburtstag*, Dresden, Galerie Arnold, 1926.

8. "Emil Nolde". In *Festschrift für Emil Nolde anläßlich seines 60. Geburtstages*, Dresden, Neue Kunst Fides, 1927.

9. "Exakter Versuch im Bereich der Kunst", *Bauhaus; Zeitschrift für Gestaltung*, Dessau, v. 2, no. 2–3, 1928, p. 17.
 Reprinted in Bauhaus prospectus 1929, and in Robert Goldwater and Marco Treves. *Artists on Art*, New York, Pantheon Books, 1945, pp. 441–444 along with quotations from Klee's Journal. Also published in *Abstrakt-Konkret: Bulletin der Galerie des Eaux Vives*, Zurich, no. 7, 1945, pp. 7–9.

10. *Über die moderne Kunst*, Bern-Bümplitz, Benteli, 1945, 53 pp., illus.
 Prepared as the basis for a lecture delivered at the opening of an exhibition at the Museum in Jena, 1924. Excerpts are reprinted in exhibition catalog, 1949, Freiburg. Translated into English under title: *On Modern Art*, with introduction by Herbert Read, London, Faber and Faber, 1947, 55 pp., illus. Excerpts, translated into Spanish, reprinted with note by Mathias Goeritz in *Cobalto*, Barcelona, no. 2, 1949. Reviewed in bibl. 127, 161.

11. Poems. In Carola Giedion-Welcker. *Poèmes à l'écart*, Bern-Bümplitz, Benteli, 1946, pp. 105–110, illus.

See also 62, 65, 80, 135, 177, 178, 230; exhibition catalog 1941, San Francisco; 1950, Munich, Haus der Kunst; 1950, Frankfurt am Main; 1952, Hannover; 1953, New York.

Graphiken und Zeichnungen Klees in Veröffentlichungen
Illustrations by Klee
Ouvrages illustrés par Klee

12. "Sema" Vereinigung, Munich. Portfolio of 15 original lithographs, München, Delphin Verlag, 1913. Contains one lithograph by Klee: *Flußlandschaft*.

13. *Zeit-Echo: ein Kriegstagebuch der Künstler*, Band 1, München, 1914–15, p. 93. Contains one lithograph by Klee.

14. *Der Sturm*, Berlin. Issues from 1913 to 1923 contain frequent reproductions of drawings by Klee.

15. Walden, Herwarth, ed. *Expressionismus: die Kunstwende*, Berlin, Verlag Der Sturm, 1918. A museum edition of 50 copies, each containing an original, signed, numbered etching.

16. *Das Kestnerbuch*, Hannover, Heinrich Böhme, 1919, plate 9. An original lithograph by Klee: *Auslöschendes Licht*.

17. *Münchner Blätter für Dichtung und Graphik*, Munich, v. 1, 1919, no. 1, p. 10; no. 3, p. 38; no. 9, p. 142, 143; no. 11–12, p. 185.
Lithographs by Klee. Special edition of no. 9 contains also a color lithograph.

18. *Die Schaffenden*. Hrsg. von Paul Westheim, Weimar, Kiepenheuer, 1919, v. 1, portfolio 1, no. 3.
Contains a signed etching by Klee: *Kleinwelt*, and short biographical note.

19. *Die Freude*, Burg Lauenstein, v. 1, 1920.
50 copies contain an original hand-colored lithograph by Klee.

20. Pfister, Kurt. *Deutsche Graphiker der Gegenwart*, Leipzig, Klinkhardt & Biermann, 1920, plate 10.
An original lithograph by Klee: *Die Riesenblattlaus*.

21. Voltaire, F. M. A. de. *Kandide; oder, Die beste Welt*, München, Kurt Wolff, 1920.
Contains 26 drawings by Klee completed in 1911. English edition published by Pantheon Books, New York, 1944.

22. Staatliches Bauhaus in Weimar. *Neue europäische Graphik . . . erste Mappe: Meister des Staatlichen Bauhauses in Weimar*, Weimar, 1921.
Portfolio including one original lithograph by Klee.

23. Corrinth, Curt. *Potsdamer Platz, oder die Nächte des neuen Messias*, München, G. Müller, 1920.
Contains 10 lithographs by Klee.

24. Tzara, Tristan. *L'Homme approximatif*, Paris, Denoël et Steele, 1931.
10 copies contain original signed etching by Klee.

25. Hardenberg, Friedrich von (Novalis). *The Novices of Saïs*, New York, Curt Valentin, 1949.
Contains reproductions of 60 drawings by Klee. Preface by Stephen Spender.

Bücher und Aufsätze über Klee
Books and articles on Klee
Livres et articles sur Klee

26. Adler, Jankel. "Memories of Paul Klee", *Horizon*, London, v. 6, no. 34, Oct. 1942, pp. 264–267, illus.
Also published in *Kroniek van Kunst en Kultuur*, Amsterdam, v. 8, no. 7/8, 1947, pp. 213–214 under title: Herinneringen aan Paul Klee.

27. Alfieri, Bruno, *Paul Klee*, Venezia, Istituto Tipografico Editoriale, 1948, 25 pp., illus.
Reviewed in *Werk*, Zurich, v. 36, April 1949, supplementary p. 50.

Aragon, Louis. See bibl. 93; exhibition catalog 1926, Paris.

28. Arland, Marcel. *Chronique de la peinture moderne*, Paris, Corrêa, 1949.
Occasioned by the exhibition held at the Musée National d'Art Moderne, Paris, 1948.

29. Armitage, Merle. *5 Essays on Klee*, New York, Duell, Sloan & Pearce, 1950, 121 pp., illus.
Includes contributions by Merle Armitage, Clement Greenberg, Howard Devree, Nancy Wilson Ross, James Johnson Sweeney.

30. Arnheim, Rudolf. "Klee für Kinder", *Die Weltbühne*, Berlin, v. 26, Jan. 28, 1930, pp. 170–173. See also bibl. 132.

31. Arnostava, Z. N., "Paul Klee", *Blok P*, Brno, v. 2, no. 8, 1948, pp. 110–111, illus.

Artigas, José Llorens. See 119.

32. "Aspects of the Art of Paul Klee", *Museum of Modern Art Bulletin*, New York, v. 17, no. 4, 1950, pp. 3–9, illus.
Papers by Marcel Breuer and Ben Shahn read at symposium held at the Museum of Modern Art, Feb. 2, 1950.

33. "Aus Stuttgart wird uns geschrieben", *Kunstchronik und Kunstmarkt*, Leipzig, v. 55, 1919/20, p. 145.
A letter from a reader protesting the suggestion of Klee's appointment as director of the art school in Stuttgart.

Bach, Otto Karl. See exhibition catalog 1946, Denver.

34. Ball, Hugo. *Die Flucht aus der Zeit*, 2d ed., Luzern, 1945, pp. 15, 151, 155–156, 169.
First published in 1927, München-Leipzig, Duneker & Humblot.

Barr, Alfred H., Jr. See exhibition catalog, 1930, N. Y., Museum of Modern Art; 1941, N. Y., Museum of Modern Art.

Bataille, Georges. See 49.

35. *Bauhaus; Zeitschrift für Gestaltung*, Dessau, December 1931, 9 pp., illus.
Special Klee number, with contributions by Kandinsky, Grohmann, Hertel.

36. Baynes, H. G. *Mythology of the Soul: A Research into the Unconscious from Schizophrenic Dreams and Drawings*, Baltimore, Williams & Wilkins, 1940, pp. 515, 563, 607–609, 678–679, illus.

37. Beenken, H. "Nachkriegsliteratur über Klee und Picasso", *Zeitschrift für Kunst*, Leipzig, v. 4, no. 1, 1950, pp. 84–85.
Comments on bibl. 10, 55, 78, 95, 193 et. al.

38. Behne, Adolf. "Paul Klee", *Die Weißen Blätter*, Munich, v. 4, no. 5, May 1917, pp. 167–169.

39. Berggruen & Cie., Paris. *Paul Klee, aquarelles et dessins*, Paris, 1953, 21 pp., illus. (some col.).
Text in English, French, German by Will Grohmann.

40. Bernoulli, Rudolf. *Mein Weg zu Klee. Randbemerkungen zu einer Ausstellung seines graphischen Werkes in der Eidg. graphischen Sammlung in Zürich*, 1940, Bern, Benteli, 1940.

41. Bill, Max. "Paul Klee", *Das Werk*, Zurich, v. 27, Aug. 1940, pp. 209–216, illus.

42. Bille, Ejler. *Picasso, surréalisme, abstrakt Kunst*, København, Forlaget Helios, 1945, pp. 129–148, illus. (1 col.).

43. Bloesch, Hans. "*Ein moderner Grafiker Paul Klee*", *Die Alpen*, Berne, v. 6, no. 5, Jan. 1912.

44. Bloesch, Hans & Schmidt, Georg. *Paul Klee: Reden zu seinem Todestag, 29. Juni 1940*, Bern, Benteli, 1940, 18 pp., illus.
Talk by Schmidt reprinted in exhibition catalog

1950, Basel; excerpts in exhibition catalog 1948, Amsterdam.

Bolliger, Hans. See 84.

45. Bosman, Anthony. *Paul Klee in Memoriam.* 's Gravenhage, D. de Jong, 1945, 18 pp.

Bousquet, Joe. See 49.

Breuer, Marcel. See 32.

46. Bruhl, Rodolfo G. "Paul Klee y sun ideas sobre el arte moderno", *Ver y Estimar*, Buenos Aires, v. 1, no. 4, July 1948, pp. 17–32, illus.

47. Bruhl, Rodolfo G.: "Nuevos aportes sobre el arte de Paul Klee", *Ver y Estimar*, Buenos Aires, no. 25, Sept. 1951, pp. 16–32.
In part, a review of Werner Haftman's *Paul Klee* (bibl. 103).

48. Bulliet, C. J. *The Significant Moderns and Their Pictures*, New York, Covici-Friede, 1936, pp. 172–174, illus.

Bürgi, Rolf. See 65; exhibition catalog 1945, London.

49. *Cahiers d'Art*, Paris, v. 20–21, 1945–1946, pp. 9–74, illus.
Includes articles by Christian Zervos, Georges Duthuit, Pierre Mabille, Tristan Tzara, Joe Bousquet, Georges Bataille, Roger Vitrac, Will Grohmann, Valentine Hugo; poems by René Char and Jacques Prévert.

50. Caro, E. "Klee", in Carl Brun, ed. *Schweizerisches Künstlerlexikon*, Frauenfeld, Huber, 1917, v. 4: supplement, p. 261.

51. Cassou, Jean. "Paul Klee", *Feuilles Libres*, Paris, v. 9, no. 48, May-June 1928, pp. 131–132, illus.

52. Cassou, Jean. "Paul Klee", *Architecture d'Aujourd'hui*, Boulogne, special no. 2, 1949, pp. 50–64, illus. (some col.).

Char, René. See 49.

53. Charpier, Jacques. "La Merveille concrète; note sur Paul Klee", *Empédocle*, Paris, Mar.-Apr. 1950, pp. 40–45.

54. Cheney, Sheldon. *The Story of Modern Art*, New York, Viking Press, 1941, passim.

55. Cooper, Douglas. *Paul Klee.* Harmondsworth, Middlesex, Eng., Penguin Books, 1949, 16 pp. and 32 illus. (some col.) *(The Penguin Modern Painters).*
Reviewed in *Art Quarterly*, Detroit, v. 12, no. 3, 1949, p. 286. Two of the color reproductions: *Landscape with Yellow Birds* and *Ad Marginem* each issued in portfolio with brief introductory note as *Penguin Prints* 2 and 5.

56. Cossio del Pomar, Felipe. *Nuevo arte*, Buenos Aires, "La Facultad", 1934, pp. 201–202.

57. Courthion, Pierre. *Klee*, Paris, Fernand Hazan, 1953, 14 pp. and col. plates. *(Bibliothèque Aldine des arts, 27).*

Courthion, Pierre. See also 118.

58. Crevel, René. *Paul Klee,* Paris, Gallimard, 1930, 63 pp., illus. (Peintres nouveaux.)
Biographical note, pp. 13–16, for the most part, a translation of information given in *Der Ararat*, special no. 2, 1920.

Crevel, René. See also 93; exhibition catalogs 1928, Berlin; 1929, Paris; 1931, Hannover.

59. Däubler, Theodor. "Paul Klee", *Das Kunstblatt*, Weimar, v. 2, Jan. 1918, pp. 24–27.

60. Däubler, Theodor. "Paul Klee", *Neue Blätter für Kunst und Dichtung*, v. 1, May 1918, p. 11, illus. Reprinted in exhibition catalog 1919, Frankfurt.

61. Däubler, Theodor. "Paul Klee", *Das Junge Deutschland*, v. 2, 1919, p. 101.

62. Debrunner, Hugo. *Paul Klee: Flugsamen, Gartentor, Landschaft mit der Heiligen. Drei Faksimile ... mit einem Geleitwort*, Zürich, Verlagsgemeinschaft der Brunnenhof, 194? *(Brunnenhof Druck Blatt 3, 4, 5).* Includes brief excerpts from writings by Klee.

63. Degand, Léon. "Klee", *Art d'Aujourd'hui*, Paris, no. 7/8, Mar. 1950, illus.

Devree, Howard. See 29.

64. Dorfles, Gillo. *Klee*, Milano, Edizioni del Milione, 1950, 6 col. plates.

Dorival, Bernard. See 182.

65. *Du*, Zurich, v. 8, no. 10, Oct. 1948, 52 pp., illus. (some col.).
Special Klee number, with contributions by Arnold Kübler, Max Huggler, Felix Klee, Rolf Bürgi, Alexander Zschokke, Camilla Halter, Walter Überwasser, René Thiessing, Marguerite Frey-Surbek, and excerpts from writings by Klee, compiled by Carola Giedion-Welcker.

Duchamp, Marcel. See 228.

Duthuit, Georges. See 49.

Eichhorn, Alfred. See 133.

66. Einstein, Carl. *Die Kunst des 20. Jahrhunderts*, 2nd ed., Berlin, Propyläen Verlag, 1926, pp. 153–157, illus. (1 col.). *(Propyläen Kunstgeschichte, 16.)*

67. Eluard, Paul. "Paul Klee", In the author's *Capitale de la douleur*, Paris, Gallimard, 1926, p. 110.
A poem. Reprinted in the author's *Donner à voir*, 5th ed., Paris, Gallimard, 1939; and in his *Voir*, Genève-Paris, Editions des Trois Collines, 1948, pp. 45–47, illus. and in bibl. 93. First published in catalog, Paris, Galerie Vavin Raspail, Paris, 1925.

68. Eluard, Paul. "Paul Klee", In the author's *Thorns of Thunder*, London, Europa Press and Stanley Nott, 1936, p. 17.
A poem.

69. Faldi, Italo. "Paul Klee", *Habitat*, São Paolo, no. 3, 1951, p. 79, illus.

70. Fasola, Giusta Nicco. *Ragione dell' arte astratta*, Milano, Istituto Editoriale Italiano, 1951, plate 20. Brief analysis of a single work: *Il Passo*.

Feininger, Julia & Lyonel. See exhibition catalog, 1940, N. Y., Buchholz & Willard Gallery, 1941, N. Y., Museum of Modern Art.

Ferrant, Angel. See 119.

71. Flanagan, George A. *How to Understand Modern Art*, New York and London, Studio Publications, 1951, pp. 273–276, illus.
Brief summary of Klee's life and style.

Flechtheim, Alfred. See exhibition catalog 1928, Berlin.

72. Forge, A. *Paul Klee*, London, Faber and Faber, 24 pp., col. illus. 1954, col. illus.

73. Fosca, François. *Histoire de la peinture suisse*, Genève, Éditions de Rhône, 1945.

74. Frey-Surbek, Margaret. "Bern, Switzerland, 1904. With the Klee Family", *Right Angle*, Washington, D. C., v. 2, no. 9, Dec. 1948, p. 2, illus.
Brief personal reminiscences of the Klee family by a pupil of Paul Klee and his father. Reprinted from bibl. 65.

75. Frost, Rosamund. "Klee: Pigeons Come Home to Roost", *Art News*, New York, v. 41, June 1942, pp. 24–25, illus.

76. Gaunt, William. *The March of the Moderns*, London, Jonathan Cape, 1949, pp. 122–126.

77. Geist, Hans Friedrich. "Kinder über Paul Klee", *Das Kunstblatt*, Berlin, v. 14, Jan. 1930, pp. 21–26, illus.

78. Geist, Hans Friedrich. "*Paul Klee*", Hamburg, Hauswedell, 1948, 46 pp., illus. (some col.).
Includes bibliography. Reviewed in *Werk*, Zurich, v. 36, Oct. 1949, supplementary p. 147.

79. Geist, Hans Friedrich. "Paul Klee", *Rheinischer Merkur*, Coblenz, no. 6, 1949, p. 5.

80. Geist, Hans Friedrich. "Paul Klee und die Welt des Kindes", *Werk*, Zurich, v. 37, no. 6, June 1950, pp. 186–192, illus.
An account of a meeting with Klee in 1930, with expressions of the artist's opinions quoted.

81. Giedion, Siegfried. "Klee". In the author's *Mechanization Takes Command*, New York, Oxford University Press, 1948, pp. 109–113, illus.

82. Giedion-Welcker, Carola. "Bildinhalte und Ausdrucksmittel bei Paul Klee", *Werk*, Zurich, v. 35, no. 3, Mar. 1948, pp. 81–89, illus.

83. Giedion-Welcker, Carola. "[Review of] Paul-Klee-Mappe, eingeleitet von G. Schmidt", *Die Weltwoche*, Zurich, v. 17, no. 799, Mar. 4, 1949, p. 5.

84. Giedion-Welcker, Carola. *Paul Klee*, New York, The Viking Press, 1952, 156 pp., illus. (some col., incl. ports.).
Includes biographical data by Hans Bolliger and a selected bibliography, chronologically, arranged, by Hannah B. Muller. Reviewed in *Art News and Review*, London, v. 4, no. 25, Jan. 10, 1953, p. 3; *Studio*, New York, v. 145, May 1953, p. 176; *Werk*, Zurich, v. 40, Mar. 1953, sup. pp. 38–39; *Apollo*, London, v. 58, July 1953, p. 23; *Everyday Art Quarterly*, pp. 391–394; *Burlington Magazine*, London, v. 95, Sept. 1953. pp. 312–313; *Canadian Art*, Ottawa, v. 11, 1954, p. 81.

Giedion-Welcker, Carola. See also 11, 65.

Goeritz, Mathias. See 10, 119.

85. Goldwater, Robert J. *Primitivism in Modern Painting*, New York, Harper, 1938, pp. 153–161, illus.

Goldwater, Robert J. See also 9.

86. Grebe, Karl. "Paul Klee als Musiker", *Tages-Anzeiger*, Zürich, no. 14, Jan. 17, 1953, p. 13.

87. Greenberg, Clement. "On Paul Klee (1879—1940)", *Partisan Review*, New York, v. 8, no. 3, May-June 1941, pp. 224–229.

Greenberg, Clement. See also 29.

88. Grigson, Geoffrey. "Paul Klee", *The Bookman*, London, v. 85, Jan. 1934, pp. 390–391, illus.
Occasioned by exhibition held at the Mayor Gallery, London.

89. Grigson, Geoffrey. *The Arts To-day*, London, John Lane, 1935, pp. 90–92, illus.

90. Grohmann, Will. "Paul Klee, 1923–1924", *Der Cicerone*, Berlin, v. 16, no. 17. Aug. 1924, pp. 786–798, illus. (1 col.).
Reprinted in *Jahrbuch der Jungen Kunst*, Leipzig, 1924, pp. 143–154, illus.

91. Grohmann, Will. "Handzeichnungen von Paul Klee", *Monatshefte für Bücherfreunde u. Graphiksammler*, Leipzig, v. 1, no. 5, v. 1, no. 5, 1925, pp. 216–226, illus.

92. Grohmann, Will. "Paul Klee", *Cahiers d'Art*, Paris, v. 3, no. 7, 1928, pp. 295–302, illus.

93. Grohmann, Will. *Paul Klee*, Paris, Éditions "Cahiers d'Art", 1929, 27 pp. and 91 illus.
Includes biographical information and tributes to Paul Klee by Louis Aragon and Paul Eluard (reprinted from exhibition catalog, 1926, Paris, Galerie Vavin-Raspail); René Crevel (reprinted from exhibition catalog, 1928, Berlin, Galerie Flechtheim); Lurçat (reprinted in *Omnibus*, Berlin, 1932, pp. 55–57); Philippe Soupault, Tristan Tzara, Roger Vitrac.

94. Grohmann, Will. *Die Sammlung Ida Bienert*, Potsdam, Müller & I. Kiepenheuer 1933, pp. 14–15, 21–22, illus. (Privatsammlungen neuer Kunst, Band 1.)

95. Grohmann, Will. *Handzeichnungen, 1921–1930*, Potsdam, Berlin, Müller & I. Kiepenheuer, 1934, 30 pp. and 74 illus.
Includes definitive catalog. The plates are reissued and the text translated into English, but with definitive catalog omitted, under title: *The Drawings of Paul Klee*, New York, Curt Valentin, 1944, 20 pp. and 73 illus. American edition reviewed in *College Art Journal*, New York, v. 4, May 1945, pp. 234–235; in *Magazine of Art*, Washington, D. C., v. 38, Oct. 1945, p. 242; in *Studio*, London, v. 132, July 1946, p. 30. German edition reissued by Müller & Kiepenheuer, Bergen, 1948.

96. Grohmann, Will. "Klee at Berne", *Axis*, London, no. 2, April 1935, pp. 12–13, illus.
Occasioned by exhibition held at Kunsthalle, Berne.

97. Grohmann, Will. "Abschied von Klee", *Werk*, Zurich, v. 22, May 1935, p. 160–161.
Article signed: W. G.

98. Grohmann, Will. "L'Art contemporain en Allemagne", *Cahiers d'Art*, Paris, v. 13, no. 1–2, 1938, p. 9, illus.

99. Grohmann, Will. *Paul Klee: Handzeichnungen*, Wiesbaden, Insel-Verlag, 1951, 13 pp. plus 40 plates.

Grohmann, Will. See also 35, 39, 49, 121, exhibition

catalog 1931, Düsseldorf, Kunstverein; 1950, Frankfurt am Main; 1953, London.

Gropius, Walter. See exhibition catalog 1950, Munich, Haus der Kunst; 1950, Frankfurt am Main.

Grote, Günter. See exhibition catalog 1948, Düsseldorf.

Grote, Ludwig. See exhibition catalog 1950, Munich, Haus der Kunst.

100. Guggenheim, Peggy. *Art of This Century*, New York, Art of This Century, 1942, pp. 47–50, illus.
Includes reprint of bibl. 67 and excerpt from essay by Julia and Lyonel Feininger (exhibition catalog Buchholz & Willard Gallery, N. Y., 1940).

101. Gurlitt, Fritz. *Das graphische Jahr*, Berlin, 1921, p. 77.
Biographical essay.

102. Haftmann, Werner. "Über das 'humanistische' bei Paul Klee", *Prisma*, Munich, no. 17, 1948, pp. 31–32, illus.

103. Haftmann, Werner. *Paul Klee: Wege bildnerischen Denkens*, München, Prestel Verlag, 1950, 175 pp., illus. (some col.).
Includes bibliography. Reviewed in *Die Zeit*, Hamburg, v. 6, no. 6, Feb. 8, 1951, p. 5 and in bibl. 113, 192.

104. Halle, Fannina W. "Dessau: Burgkuhnauer Allee 6–7 (Kandinsky und Klee)", *Das Kunstblatt*, Berlin, v. 13, July 1929, pp. 203–210, illus.

Halter, Camilla. See 65.

105. Hanson, Kenneth O. "Dance You Monster to My Sweet Song", *Tiger's Eye*, New York, no. 7, March 1949, pp. 69–71, illus.
A poem.

106. H[artlaub], G[ustav F.] "Wie ich Klee sehe", *Feuer*, Weimar, v. 2, pt. 1, 1920/21, pp. 239–240.

107. Hartlaub, Gustav F. *Die Graphik des Expressionismus in Deutschland*, Stuttgart und Calw, Gerd Hatje, 1947, p. 60, illus.
Brief biographical summary.

108. Hausenstein, Wilhelm. *Kairuan, oder eine Geschichte vom Maler Klee und von der Kunst dieses Zeitalters*, München, Kurt Wolff, 1921, 134 pp., illus. (some col.).
Reviewed in *Feuer*, Weimar, v. 2, no. 11, Aug. 1921, p. 654.

109. — *Über Expressionismus in der Malerei*, Berlin, Reiss, 1919, p. 34–35.
Brief reference to Klee.

110. Hauth-Trachsler, Dora. "Zum Kopfschütteln über Paul Klee", *WBK* (Wirtschaftsbund Bildender Künstler) *Mitteilungen*, Zurich, no. 1, 1949.

111. Hayter, Stanley William. "Apostic of Empathy", *Magazine of Art*, Washington, D. C., v. 39, April 1946, pp. 126–130, illus.

112. Heintz, M. H. "Paul Klee zum 70. Geburtstag", *Der Kunsthandel*, Heidelberg, no. 1, 1950, p. 7.

113. Hentzen, Alfred. "[Review of] Werner Haftmann: *Paul Klee: Wege bildnerischen Denkens*", *Kunstchronik*, Nürnberg, v. 4, Nov. 1951, pp. 298–301.

Hentzen, Alfred. See also exhibition catalog 1952, Hannover; 1954, Hannover.

Hertel. See 35.

114. Herzog, Thomas. *Einführung in die moderne Kunst*, Zürich, Werner Classen, 1948, pp. 135–136.
Brief mention of Klee's style.

115. Hess, Walter. *Die Farbe in der modernen Malerei*, München, Universität, 1950, pp. 192–197.

116. Hildebrandt, Hans. "Paul Klees magische Welt", *Wirtschaftszeitung*, Stuttgart, no. 37, 1950, p. 11.

117. *History of Modern Painting from Picasso to Surrealism*, Geneva, Albert Skira, 1950, pp. 162–169, 197–198, col. illus.
Includes bibliography.

118. "Homage to Paul Klee", *XXe Siècle*, Paris, no. 4, Dec. 1938, pp. 30–36, illus.
Articles by Herbert Read and Pierre Courthion.

119. *Homenaje a Paul Klee*, Madrid, 1948, 29 pp., illus.
Brief statements by Angel Ferrant, Mathias Goeritz, Jose Llorens Artigas, Sigurd Nyberg, Pablo Palazuelo, Benjamin Palencias, and drawings dedicated to Klee by these artists.

Hoppenot, Henri. See exhibition catalog 1948, Paris, Musée National d'Art Moderne.

120. Huggler, Max. "Paul Klee. Auszug aus der Ansprache . . . zur Eröffnung der Ausstellung der Paul Klee Stiftung, 22. November im Kunstmuseum, Bern", *Kunst und Volk*, Zurich, v. 10, no. 1, Jan. 1948, p. 15, illus.
English summary, p. 17. Also published in *Figur*, Genf, no. 3, 1948, p. 1–2, 5.

Huggler, Max. See also 65, exhibition catalog 1948, Venice.

Hugo, Valentine. See 49.

121. Huyghe, René. *Histoire de l'art contemporain; la peinture*, Paris, Alcan, 1935, passim, illus.
Biographical and bibliographical note by Will Grohmann, p. 439. First published in *Amour de l'Art*, Paris, 1934.

122. Ironside, Robin. "Paul Klee", *Horizon*, London, v. 12, no. 72, Dec. 1945, pp. 413–417, illus. (1 col.).

123. Jäggi, W. "Paul Klee: Wort, Bild, Ton", *Die Bunte Maske*, v. 4, Dec. 10, 1948, pp. 4, 6–9, illus.

Joel, Hans T. See 155.

124. Jollos, Waldemar. "Paul Klee", *Das Kunstblatt*, Potsdam, v. 3, Aug. 1919, pp. 225–234, illus.

125. Justi, Ludwig. *Von Corinth bis Klee*, Berlin, Bard, 1931, pp. 193–197, illus.

126. Kadow, Gerhard. "Paul Klee and Dessau in 1929", *College Art Journal*, New York, v. 9, no. 1, 1949, pp. 34–36, illus.
Reminiscences of instruction by Klee. Reprinted from catalog issued in connection with exhibition, Dusseldorf, 1948.

127. Kahnweiler, Daniel Henry. "Apropos ett föredrag av Paul Klee", *Konstrevy*, Stockholm, v. 24. no. 1, 1948, pp. 7–12, illus.
In part, a review of bibl. 10.

128. Kahnweiler, Daniel Henry. *Klee*, Paris, Braun; New York, E. S. Hermann, 1950, 32 pp. and 24 col. illus. (Collection Palettes). Text in German, French, English. Reviewed in bibl. 203.

129. Kaiser, Hans. "Paul Klee", *Hohe Ufer*, Hannover, v. 2, 1920, p. 14.
For commentary on this article, see bibl. 139.

130. Kallen, Horace M. *Art and Freedom*, New York, Duell, Sloan and Pearce, 1942, v. 2, pp. 728–729.

Kandinsky, Wassily. See 35.

131. Keyes, Sidney. "Paul Klee", In the author's *Collected Poems*, London, Routledge, 1945, pp. 21–22.
A poem, dated 1941.

132. Kirchner, Ernst Ludwig. "Randglossen zum Aufsatz: Klee für Kinder", *Das Kunstblatt*, Berlin, v. 14, May 1930, pp. 154–156.

133. Klee, Felix. *Paul Klee: 22 Zeichnungen*; Stuttgart, Eidos Presse, 1948, 4 pp. and 22 illus.
Introduction by Felix Klee. Plates selected by Alfred Eichhorn.

134. K[lee], F[elix]. "Der Musiker Paul Klee", *Schweizer Radio Zeitung*, Bern, v. 29, no. 9, Mar. 2, 1952.
Comment on music in Klee's life and art on occasion of presentation of composition for two pianos by Sandor Veress based on 7 paintings by Klee.

Klee, Felix. See also 65; exhibition catalog 1945, Munich.

135. Klee-Gesellschaft, Bern. *Paul Klee, 1. Teil: Dokumente und Bilder aus den Jahren 1896–1930*, Bern, Benteli, 1949, 15 pp. and illus. (some col.)
Includes writings by Klee.

Klee-Gesellschaft, Bern. See also exhibition catalog 1947, Bern; 1945, Paris, Brussels, Amsterdam, Basel, Zurich; 1949, N. Y., etc.

136. Klein, Jerome. "Line of Introversion", *New Freeman*, New York, v. 1, no. 4, April 5, 1930, pp. 88–89.

137. Klumpp, Hermann. *Abstraktion in der Malerei, Kandinsky, Feininger, Klee*, Berlin, Deutscher Kunstverlag, 1932, passim, illus. (Kunstwissenschaftliche Studien, Band 12).

138. Knolle, H. "Malerei des Unbewußten. Paul Klee zum Gedächtnis", *Aufbau*, Berlin, v. 4, no. 11, 1948, pp. 991–992.

139. Kolle, Helmud. "Paul Klee", *Der Ararat*, Munich, v. 2, 1921, pp. 112—114, illus.
Criticism of bibl. 129.

140. Kolle, Helmud. "Über Klee, den Spieltrieb und das Bauhaus", *Das Kunstblatt*, Potsdam, v. 6, May 1922, pp. 200–205, illus.

Kübler, Arnold. See 65.

141. Küppers, Paul Erich. "Die Sammlung Max Leon Flemming in Hamburg", *Der Cicerone*, Leipzig, v. 14, no. 1, Jan. 1922, pp. 3–12.
Klee, pp. 11–12.

Küppers, Paul Erich. See also exhibition catalog, 1919, Hannover.

142. Lang, Willy. "Die Walze", *Die Schweiz*, Zurich, 1908, pp. 418, 421.

Review of a traveling exhibition shown in Aarau, St. Gallen and Zurich from Sept.–Nov. 1908, sponsored by a Swiss art organization of which Klee was a member.

143. Leepa, Allen. *The Challenge of Modern Art*, New York, Beechhurst Press, 1949, passim.
Brief references to Klee, with quotations from his writings.

144. Lhote, André. "L'exposition Klee", *Nouvelle Revue Française*, Paris, v. 26, Feb. 1926, pp. 247–249.
Occasioned by exhibition held at Galerie Vavin-Raspail, Paris, 1925. Reprinted in the author's *La Peinture*, Paris, Denoël et Steele, 1933, p. 199–202.

145. Limbour, Georges. "Paul Klee", *Documents*, Paris, v. 1, April 1929, pp. 53–54, illus.

Limbour, Georges. See also exhibition catalog 1948, Brussels.

Lurçat, Jean. See 93.

146. M., E. "Autour de Paul Klee", *Labyrinthe*, Geneva, no. 11, Aug. 15, 1945, p. 11, illus.
Occasioned by exhibition held at Galerie Rosengart, Lucerne, 1945.

Mabille, Pierre. See 49.

147. Marchiori, Giuseppe. *Pittura moderna in Europa*, Venezia, Neri Pozza, 1950, pp. 141–145, illus.

148. Marlier, Georges. "Paul Klee", *Cahiers de Belgique*, Brussels, v. 2, Feb. 1929, pp. 76–78, illus.
Occasioned by exhibition held at Galerie Le Centaure, Brussels.

149. Marwitz, H. "Paul Klee, Maler zwischen den Zeiten", *Der Ruf*, Munich, no. 9, 1948, pp. 13–14.

150. Masson, André. "Éloge de Paul Klee", *Fontaine*, Paris, no. 53, June 1946, pp. 105–108.
Translated into English in *Partisan Review*, New York, v. 14, no. 1, 1947, pp. 59–61.

151. Meier-Graefe, Julius. *Entwicklungsgeschichte der modernen Kunst*, 2nd ed., München, Piper, 1915, v. 3, pp. 669–671, illus.

152. Meyer-Benteli, Hans. "Omaggio a Klee", *Domus*, Milan, no. 218, Apr. 1947, pp. 10–15, illus. (some col.).

153. Meyer-Benteli, Hans. "Paul Klee, zu zwei Bildern", *Werk*, Winterthur, v. 30, no. 7, July 1943, pp. 201–202, illus.
Discussion of *Blumen in Gläsern* and *Rhythmisches*.

Meyer-Benteli, Hans. See also exhibition catalog 1940, Bern.

154. Michel, Wilhelm. *Das Teuflische und Groteske in der Kunst*, München, R. Piper, 1917, p. 33.

155. Michel, Wilhelm. "Paul Klee", In *Das graphische Jahrbuch*, hrsg. von Hans T. Joel, Darmstadt, Karl Lang, 1919, p. 48.

156. Miller Company, Meriden, Conn. *Painting Toward Architecture*, New York, Duell, Sloan and Pearce, 1948, pp. 72–73, col. illus.

Mills, Clark. See exhibition catalog 1941, New York, Nierendorf Gallery.

157. Milo, Jean. "Paul Klee", *Cahiers de Belgique*, Brussels, v. 1, 1928, pp. 196–198, illus.

Morley, Grace. McCann. See exhibition catalog 1941, San Francisco.

Muller, Hannah B. See 84.

158. Morello, Augusto. "Paul Klee", *Commentari*, Roma, v. 3, July-Sept. 1952, pp. 211–223.

159. Muraro, Michelangelo. "Paul Klee, color y fabula", *Ver y Estimar*, Buenos Aires, no. 25, Sept. 1951, pp. 1–7, illus.

160. Nemitz, Fritz. "Paul Klee", In the author's *Deutsche Malerei der Gegenwart*, München, R. Piper, 1948, pp. 36–40, illus. (1 col.).

Neumann, J. B. See 165.

161. Newton, Eric. "Paul Klee on Art", In the author's *In My View*, London, Longmans Green, 1950.
Text dated 1948. In part, a review of bibl. 10.

162. Nierendorf, Karl, ed. *Paul Klee, Paintings, Watercolors, 1913 to 1939*, New York, Oxford University Press, 1941, 35 pp. and illus. (some col.).
Introduction by James Johnson Sweeney. Includes bibliography. Reviewed in *Art in America*, Springfield, Mass., v. 30, Apr. 1942, p. 135; in *Art News*, New York, v. 40, Dec. 1, 1941, p. 4; in *College Art Journal*, New York, v. 1, Mar. 1942, p. 78.

Nonne-Schmidt, H. See exhibition catalog 1950, Munich, Haus der Kunst.

Nyberg, Sigurd. See 119.

163. Oeri, Georgine. "W. K. Wiemken und Paul Klee", *Werk*, Winterthur, v. 28, no. 11, Nov. 1941, pp. 310–312.

Palazuelo, Pablo. See 119.

Palencias, Benjamin. See 119.

164. *Paul Klee*, Berlin, 1918. (Sturm Bilderbücher 3).
First monograph on Klee.

165. "Paul Klee", *Artlover*, ed. by J. B. Neumann, New York, v. 3, no. 1, 1936, pp. 3–7, illus.
Reprinted from exhibition catalog 1935.

166. Pearson, Ralph M. *Experiencing American Pictures*, New York, Harper, 1943, pp. 33–36, illus.

167. Pedersen, Carl H. "Paul Klee", *Helhesten*, Copenhagen, v. 1, no. 1, n. d., pp. 2–5, illus.
Brief comment supplemented by excerpts from *Schöpferische Konfession* (bibl. 3) and a biographical note.

168. Penzoldt, Ernst. "Zu einem Aquarell von Paul Klee", *Das Kunstwerk*, Baden-Baden, v. 2, no. 8, 1948, pp. 26–28, illus. (1 col.).
Analysis of *Reiseerinnerung*.

169. Pfister, Kurt. *Deutsche Graphiker der Gegenwart*, Leipzig, Klinkhardt & Biermann, 1920, pp. 27–28, illus.

Phillips, Duncan. See exhibition catalog 1942, Washington, D. C.

170. Podesta, Attilio. "Situazione critica di Klee", *Emporium*, Bergamo, v. 101, no. 662, Feb. 1950, pp. 67–79, illus.

171. "Polyphonic Architecture", *St. Louis Museum Bulletin*, St. Louis, v. 27, Dec. 1942, pp. 26–27, illus.
Description of new acquisition.

Prévert, Jacques. See 49.

Probst, Rudolf. See exhibition catalog 1929, Dresden.

172. Pulver, Max. "Erinnerungen an Paul Klee", *Das Kunstwerk*, Baden-Baden, v. 3, no. 4, 1949, pp. 28–32, illus.

173. Rabe, Martin. "Rhythmus der Bäume: Erläuterungen zu dem Werk Paul Klees", *Die Zeit*, Hamburg, v. 4, no. 4, Jan. 27, 1949, p. 5, illus.
Occasioned by exhibition of Klee's work held in Hamburg.

Rathbone, Perry. See exhibition catalog 1938, N. Y., Nierendorf Galeries.

174. Rave, Paul O. *Kunstdiktatur im 3. Reich*, Hamburg, 1949, passim.

175. Raynal, Maurice. *Modern Painting*, Geneva, Skira, 1953, pp. 233–241, col. illus.

176. Read, Herbert. *The Anatomy of Art*, New York, Dodd, Mead, 1932, pp. 181–185, illus.
Published in England under title: *The Meaning of Art*, 1931; 1948.

177. Read, Herbert. *Art Now*, New York, Harcourt, Brace, 1934, pp. 140–143, illus. Reprinted with changes in illustrations in revised and enlarged edition, London, Faber and Faber, 1948, pp. 123–125. Includes excerpts, translated into English, from the artist's writings.

178. Read, Herbert. *Klee (1879–1940)*, London, Faber and Faber, 1948, 24 pp., col. illus. (The Faber Gallery).
Includes excerpts, translated into English, from the artists writings. Reprinted in 1948 by Pitman Publishing, New York.

Read, Herbert. See also 10, 118, exhibition catalog 1941, London.

179. Reynolds, Graham. *Twentieth Century Drawings*, London, Pleiades Books, 1946, pp. 42–43, illus. (some col.).

180. Rilke, Rainer Maria. *Lettres françaises à Merline*, Paris, Editions du Seuil, 1950, pp. 89–98.
A letter from Rilke to Klossowska discussing Klee. In French and German. Reprinted in German in *Das Kunstwerk*, Baden-Baden, v. 5, no. 4, 1951, p. 55.

181. Robb, David M. *The Harper History of Painting: The Occidental Tradition*, New York, Harper, 1951, p. 819, 821, illus.
Brief mention of Klee's work.

Ross, Nancy Wilson. See 29.

182. Rotzler, Willy. "Klee", in Bernard Dorival, ed. *Les Peintres célèbres*, Genève, Mazenod, 1948, p. 342, illus.

183. Rudikoff, Sonya. "Notes on Paul Klee", *Hudson Review*, New York, v. 3, no. 1, Spring 1950, pp. 132–134.

184. San Lazzaro, G. di. *Cinquant' anni di pittura moderna in Francia*, Roma, Danesi, 1945, pp. 115–116.
Translated into English in the author's *Painting in France, 1895–1949*, New York, Philosophical Library, 1949, pp. 97–98.

185. Schacht, Roland. "Paul Klee", *Freie Deutsche Bühne*, Berlin, v. 1, no. 30/31, March 28, 1920, pp. 728–730.

Schang, F. C. See exhibition catalog 1951, Palm Beach.

186. Schardt, Alois J. "Das Übersinnliche bei Paul Klee", *Museum der Gegenwart*, Berlin, v. 1, 1930, pp. 36–46, illus.

187. Schardt, Alois J. "Paul Klee", *California Arts & Architecture*, San Francisco, v. 58, June 1941. pp. 20–21, 40, illus.

188. Scheck, H. "Ein Maler des echten Spielens", *Die Kommenden*, Freiburg, no. 12, 1950, p. 5.

189. Scheewe, L. "Klee", In Ulrich Thieme and Felix Becker. *Allgemeines Lexikon der bildenden Künstler*, Leipzig, Seemann, 1927, v. 20, pp. 424–426. Includes bibliography.

190. Scheffler, Karl. "Paul Klee: Ausstellung in der Galerie Alfred Flechtheim", *Kunst und Künstler*, Berlin, v. 28, Dec. 1929, pp. 112–114, illus.

191. Schiess, Hans. "Notes sur Klee à propos de son exposition à la Galerie Simon", *Cahiers d'Art*, Paris, v. 9, no. 5–8, 1934, pp. 178–184, illus.

192. Schmeller, Alfred. "Romantischer Paul Klee", *Wort und Wahrheit*, Vienna, v. 6, Nov. 1951, p. 861. Review of Haftmann's *Paul Klee* (bibl. 103).

193. Schmidt, Georg. *Ten Reproductions in Facsimile of Paintings by Paul Klee*, New York, Wittenborn, 1946, 10 pp. and col. illus. First published by Holbein Verlag, Basle, 1946.

194. Schmidt, Georg. *Paul Klee: Ten Facsimile Reproductions of Works in Watercolour and Tempera*, Basle, Holbein Publishing Co., 1948, 14 pp. and col. illus. Reviewed in bibl. 83.

Schmidt, Georg. See also 44, exhibition catalog 1945, Lucerne.

195. Schmidt, Paul Ferdinand. *Geschichte der modernen Malerei*, Zurich, Fretz & Wasmuth, 1952, pp. 216–223 et passim, illus. (some col.).

196. Schön, Gerhard. "Ein Magier kreuzt den Weg. Zu Bildern von Paul Klee", *Rheinischer Merkur*, Coblenz, no. 8, 1951, p. 8.

197. Schwetzov, Hyman. "Poems to Two Paintings by Paul Klee: *The School Girl, Actor's Mask*", *Accent*, New York, v. 5, no. 2, Winter 1945, pp. 95–96.

198. Scialoja, Tati. "Apparizione di Klee", *Letteratura: Arte Contemporanea*, Florence, v. 1, no. 5, Sept.–Oct. 1950, pp. 34–44, illus.

199. Seize, Marc. "Paul Klee", *Art d'Aujourd'hui*, Paris, v. 6, no. 22, Summer 1929, p. 18, illus.

Shan, Ben. See 32.

200. Shipley, Sylvia. "Travelling Circus", *Baltimore Museum of Art News*, Baltimore, v. 7, no. 7, April 1945, pp. 4–6, illus.

201. Soby, James Thrall. *The Prints of Paul Klee*, New York, Curt Valentin, 1945, 26 pp. and illus. Second edition published by the Museum of Modern Art, New York, 1947, 26 pp. and illus. Reviewed in *Art Digest*, New York, v. 20, Dec. 15, 1945, p. 24; *Art News*, New York, v. 45, Apr. 1946, p. 67, *Journal of Aesthetics and Art Criticism*, New York, v. 5, Sept. 1946, p. 72.

202. Soby, James Thrall. *Contemporary Painters*, New York, The Museum of Modern Art, 1948, pp. 99–100, illus.

Soby, James Thrall. See also exhibition catalog 1949, N. Y., Museum of Modern Art.

Soupault, Philippe. See 93.

Spender, Stephen. See 25.

203. Stabile, Blanca. "Paul Klee y Juan Gris", *Ver y Estimar*, Buenos Aires, no. 25, Sept. 1951, pp. 8–15, illus.

In part, a review of Kahnweiler's *Klee* (bibl. 128).

204. Stern, Lisbeth. "Klee", *Sozialistische Monatshefte*, Berlin, v. 52, 1919, p. 294. Comment occasioned by Klee works seen at a Sturm Galerie exhibition.

Sweeney, James Johnson. See 29, 162, exhibition catalog 1940, N. Y., Buchholz & Willard Gallery; 1941, Chicago; 1941, N. Y., Museum of Modern Art.

205. Sydow, Eckart von. "Paul Klee", *Münchner Blätter für Dichtung und Graphik*, Munich, v. 1, no. 9, pp. 141–144, 1919, illus. Reprinted in the author's *Die deutsche expressionistische Kultur und Malerei*.

206. Sydow, Eckart von. *Die deutsche expressionistische Kultur und Malerei*, Berlin, Furche Verlag, 1920, pp. 124–126, illus.

Thieme, Ulrich. See 189.

Thiessing, Renc. See 65.

207. Thoene, Peter. *Modern German Art*, Harmondsworth, Middlesex, Engl., Penguin Books, 1938, pp. 69–75, illus.

208. Thwaites, John A. "Paul Klee and the Object", *Parnassus*, New York, v. 9, no. 6, Nov. 1937, pp. 9–11, illus.; v. 9, no. 7, Dec. 1937, pp. 7–9, 33–34, illus.

209. Thwaites, John A. "Blaue Reiter, a Milestone in Europe", *Art Quarterly*, Detroit, v. 13, no. 1, 1950, pp. 12–21, illus. Klee, p. 16, 19. Occasioned by Blaue Reiter exhibition, Munich, 1950.

210. Todd, Ruthven. "Paul Klee", *London Bulletin*, London, no. 12, Mar. 1939, p. 18. A poem. Reprinted in the author's *The Planet in My Hand*, London, Grey Walls Press, 1946.

211. Todd, Ruthven. "Paul Klee, 1879–1940", *Horizon*, London, v. 2, no. 12, Dec. 1940, pp. 340, 342, 344, illus.

212. Todd, Ruthven. "The Man in the Paul Klee Mask", *Art News*, New York, v. 48, Jan. 1950, pp. 28–29, illus.

Tzara, Tristan. See 49, 93.

Überwasser, Walter. See 65.

213. Uhde, Wilhelm. "Brief [an Edwin Sauermondt]", *Die Freude*, Burg Lauenstein, v. 1, 1920, pp. 155–156. The author tells of his reactions to paintings seen at Galerie Goltz, Munich.

214. Uhde, Wilhelm. *Picasso and the French Tradition*, Paris, Editions des Quatre Chemins, New York, E. Weyhe, 1929, pp. 85–86.
Translation of the author's *Picasso et la tradition française*.

215. Vaughan, Keith. "At the Klee Exhibition", *New Writing and Daylight*, London, Lehmann, 1946, pp. 117–121, illus.
Occasioned by Klee exhibition, Tate Gallery, London.

216. Venturi, Lionello. *Pittura contemporanea*, Milano, Hoepli, 1947, pp. 40–41, illus. (some col.).

217. Veress, Sandor. *Hommage à Paul Klee*, Bern, 1952.
A musical composition for two pianos based on paintings by Klee: *Zeichen in Gelb, Feuerwind, Alter Klan, Unten und oben, Steinsammlung, Grün in Grün, Kleiner Blauteufel*. Performed by Enid Mary Blake and Sandor Veress orchestra under the direction of Hermann Müller on Radio Beromünster, March 6, 1952 at 10:20 p. m.

218. Veronesi, Giulia. "Paul Klee", *Emporium*, Bergamo, v. 108, no. 613–614, July-Aug. 1948, pp. 49–52, illus.
Occasioned by 25th Biennale, Venice, 1948.

219. Vitrac, Roger. "A propos des oeuvres récentes de Paul Klee", *Cahiers d'Art*, Paris, v. 5, 1930, pp. 300–306, illus.
Vitrac, Roger. See also 49, 93.

220. Walden, Herwarth, ed. *Expressionismus: die Kunstwende*, Berlin, Verlag der Sturm, 1918, pp. 82–87, illus.

221. Walden, Herwarth. *Einblick in Kunst*, Berlin, Verlag der Sturm, 1924, pp. 73–77, illus.
3 reproductions of works by Klee.
Wartmann, W. See exhibition catalog 1940, Zurich; 1948, Zurich.

222. Wedderkop, H. von. *Paul Klee*, Leipzig, Klinkhardt & Biermann, 1920, 16 pp. and 33 illus. (*Junge Kunst*, Band 13).
Major portion of text and plates reprinted in *Der Cicerone*, Berlin, v. 12, no. 14, July 1920, pp. 527–538, and in *Jahrbuch der Jungen Kunst*, Berlin, 1920, pp. 225–236.

223. Westheim, Paul. *Helden und Abenteurer: Welt und Leben des Künstlers*, Berlin, Reckendorf, 1931, pp. 224–227, illus.

224. Wild, Doris. *Moderne Malerei: ihre Entwicklung seit dem Impressionismus*, Zurich, Europa Verlag, 1950, pp. 217–220 et passim, illus.
Willemson, Ernst. See exhibition catalog, 1948, Düsseldorf.

225. Willrich, Wolfgang. *Säuberung des Kunsttempels: eine kunstpolitische Kampfschrift zur Gesundung deutscher Kunst im Geiste nordischer Art*, München, Berlin, Lehmanns Verlag, 1937, passim, illus.

226. Winkler, Walter. *Psychologie der modernen Kunst*, Tübingen, Alma Mater Verlag, 1949, pp. 128–131 et passim, illus.

227. Wolfradt, Willi. "Der Fall Klee", *Freie Deutsche Bühne*, Berlin, v. 1, no. 52, Aug. 22, 1920, pp. 2123–2127.

228. Yale University Art Gallery, New Haven, Conn. *Collection of the Société Anonyme: Museum of Modern Art 1920*, New Haven, 1950, pp. 141–142, illus.
Statement by Marcel Duchamp. 9 works by Klee are included in the collection.

229. Zahn, Leopold. "Paul Klee", *Valori Plastici*, Rome, v. 2, no. 7–8, 1920, pp. 88–89.

230. Zahn, Leopold. *Paul Klee: Leben, Werk, Geist*, Potsdam, Kiepenheuer, 1920, 87 pp., illus.
Includes excerpts from Klee's Journal, 1902–1905, and facsimile of his handwriting. Reviewed in *Der Cicerone*, Berlin, v. 13, no. 20, Oct. 1921, p. 599, and in *Kunstchronik und Kunstmarkt*, Leipzig, v. 56, no. 48, Aug. 26, 1921, p. 866–867, in *Feuer*, Weimar, v. 3, 1921/22, sup. p. 34.

231. Zahn, Leopold. Paul Klee: "*In the Land Called Precious Stone*", Baden-Baden, Woldemar Klein, 1953, 12 pp. and 12 col. plates. (*Der Silberne Quell*. 9). First published in German under title: *Paul Klee: "Im Lande Edelstein"*.

232. Zervos, Christian. *Histoire de l'art contemporain*, Paris, Editions Cahiers d'Art, 1938, pp. 393–406, illus.
Zervos, Christian. See also 49.
Zschokke, Alexander. See 65.

Ausstellungen: Kataloge und Besprechungen

Exhibitions: Catalogues and Commentary

Expositions: Catalogues et Commentaires

1906 Munich. Secession.
Showed etchings. Reviewed in *Berner Rundschau*, no. 7, 1906.

1908 Zurich. Participated in traveling exhibition sponsored by group: *Die Walze*. For review of exhibition, see bibl. 142.

1910 Zurich. Kunsthaus. 55 works.
Later shown in Berne and Basle.

1911 Munich. Thannhauser Gallery.

1912 Munich. Participated in Second Blue Rider exhibition.

1912 Cologne. Participated in Sonderbund exhibition, May 25-Sept. 30. 1 work.

1912 Zurich. Participated in second exhibition of Der Moderne Bund. For Klee's own comments on exhibition, see bibl. 1.

1913 Berlin. Der Sturm.

1913 Berlin. Participated in Erster Deutscher Herbstsalon held at Der Sturm Gallery. 22 works.

1917 Zurich. Galerie Dada.

1919 Zurich. Salon Wolfsberg.

1919 Frankfurt. Zinglers Kabinett. 35 works.
Catalog: [*Zur Eröffnung unserer Buch- und Kunsthandlung*] p. 13–14, 21–22, illus. Includes note by Theodor Däubler, reprinted

from *Neue Blätter für Kunst und Dichtung,* May 1918.

1919 Berlin. Galerie Fritz Gurlitt.
Reviewed in *Kunst und Künstler,* v. 18, 1919–1920, p. 341.

1919 Hannover. Kestner Gesellschaft. Nov. 30–Jan. 1, 1920. 122 works.
Catalog: *Paul Klee,* pp. 1–12, illus. Introduction by Paul Erich Küppers.

1920 Dusseldorf. Galerie Flechtheim, Mar. 17 – Apr. 4.
Catalog with introduction by Däubler.

1920 Munich. Galerie Hans Goltz. 356 works.
Catalog issued in *Der Ararat,* Munich, special no. 2; pp. 1–25, 1920, including biographical essay based on information supplied by the artist. Reviewed in *Der Ararat,* Munich, v. 1, no. 8, July 1920, p. 80; no. 9–10, Oct. 1920, p. 123, and in *Die Bildenden Künste,* Vienna, v. 3, 1920, p. XIII, *Kunstchronik und Kunstmarkt,* Leipzig, v. 31, 1920, p. 725.

1921 Cologne. Kunstverein.
Reviewed in *Kunstchronik und Kunstmarkt,* Leipzig v. 56, 1921, p. 468.

1921 Vienna. Galerie Wurthle.
Reviewed in *Kunstchronik und Kunstmarkt,* Leipzig, v. 56, no. 27, Apr. 1, 1921, p. 527.

1921 Hannover. Galerie von Garvens.
Catalog, with excerpts from Klee's Journal, and Hausenstein's *Kairuan* (bibl. 108). Mentioned in *Der Cicerone,* Berlin, v. 14, no. 2, Jan. 1922, p. 88.

1921 Frankfurt. Zinglers Kabinett.
Mentioned in *Kunstchronik und Kunstmarkt,* Leipzig, v. 56, 1921, p. 731.

1921 Munich. Neue Secession.
Mentioned in *Feuer,* Weimar, v. 2, no. 12, Sept. 1921, p. 715.

1922 Wiesbaden. Nassauischer Kunstverein.
Mentioned in *Der Cicerone,* Berlin, v. 14, no. 11, June 1922, p. 488; and in *Kunstchronik und Kunstmarkt,* Leipzig, v. 57, 1922, p. 668.

1922 Berlin. Goldschmidt & Wallerstein.
Mentioned in *Der Cicerone,* Berlin, v. 14, no. 24, Dec. 1922, p. 984.

1923 Berlin. Kronprinzenpalais.
Reviewed in *Der Cicerone,* Berlin, v. 15, no. 4, Feb. 1923, p. 194.

1923 Munich. Galerie Thannhauser
Mentioned in *Der Cicerone,* Berlin, v. 15, no. 18, Sept. 1923, p. 852.

1924 Braunschweig. Landesmuseum.
Mentioned in *Der Cicerone,* Berlin, v. 16, no. 8, Apr. 1924, p. 378.

1924 Dresden. Galerie Fides.
Mentioned in *Der Cicerone,* Berlin, v. 16, no. 11, June 1924, p. 519.

1924 New York. Société Anonyme. Jan. 7–Feb. 7. 26 paintings.
First American showing.

1925 Munich. Galerie Hans Goltz. 214 works.
Catalog: *Paul Klee, 2. Gesamtausstellung, 1920/1925,* 4 pp. and illus. Reviewed in *Kunst-chronik und Kunstmarkt,* Leipzig, v. 59, no. 11, June 13, 1925, p. 201.

1925 Paris. Galerie Vavin Raspail. Oct. 21–Nov. 14. 39 works.
Catalog: *39 aquarelles de Paul Klee* ... 8 pp., illus. Includes poem by Paul Eluard, (reprinted in bibl. 67) and introduction by Louis Aragon. For comment, see bibl. 144.

1926 Dresden. Galerie Fides .
Reviewed in *Der Cicerone,* Leipzig, v. 18, no. 12, June 1926, p. 441.

1926 Berlin. Goldschmidt & Wallerstein.
Reviewed in *Der Cicerone,* Berlin, v. 18, no. 6, Mar. 1926, p. 201; in *Kunst und Künstler,* v. 24, 1926, p. 294.

1926 Prague. Kunstverein.
Mentioned in *Der Cicerone,* Berlin, v. 18, no. 9, May 1926, p. 302.

1926 Zurich. Kunsthaus.
Mentioned in *Der Cicerone,* Berlin, v. 18, no. 11, June 1926, p. 365.

1926 Hannover. Kestner Gesellschaft.

1927 Dusseldorf. Galerie Alfred Flechtheim. Apr. 1. 50 works.

1928 Berlin. Galerie Alfred Flechtheim. Mar. 18– Easter. 56 works.
Catalog: *Paul Klee,* 12 pp., illus. Preface by Alfred Flechtheim, and "Merci, Paul Klee", by René Crevel.

1928 Brussels. Galerie Le Centaure. Dec. 22–30. 42 works.
Catalog: *Exposition P. Klee,* 4 pp. For review, see bibl. 148.

1929 Berlin. Galerie Alfred Flechtheim. Oct. 20– Nov. 15. 150 works.
Catalog: *Paul Klee,* 18 pp., illus. Reviewed in *Musaion,* Prague, 1929/1930, p. 208, and in bibl. 190.

1929 Paris. Galerie Georges Bernheim. Feb. 1–15. 40 works.
Catalog: *Exposition Paul Klee,* 7 pp., illus. Introduction by René Crevel, as in catalog, Galerie Alfred Flechtheim, Berlin, 1928; also translated into German.

1929 Dresden. Galerie Fides. Feb. 105 works.
Catalog: *Paul Klee,* 12 pp., illus. Introduction by Rudolf Probst reprinted, in part, in *Kunst und Künstler,* Berlin, v. 28, April 1930, p. 308. Reviewed in *Der Cicerone,* Berlin, v. 22, no. 5, Mar. 1930, p. 142.

1930 Berlin. Galerie Alfred Flechtheim. Feb. 15– Mar. 10. 160 works.
Catalog: *Paul Klee,* 8 pp., illus. Introduction by Louis Aragon (reprinted from exhibition catalog 1925, Paris).

1930 Berlin. Nationalgalerie.
Reviewed in *Art News,* New York, v. 28, May 3, 1930, p. 14.

1930 New York. Museum of Modern Art. Mar. 12– Apr. 2. 63 works.
Catalog: *Paul Klee,* 17 pp. and illus. Introduction by Alfred H. Barr, Jr., reprinted in *Omnibus,* Berlin, 1931, pp. 206–209, and,

with revisions, in catalog, Museum of Modern Art, New York, 1941. Reviewed in *Arts*, New York, v. 16, April 1930, pp. 567–568; and in *Art News*, New York, v. 28, Mar. 15, 1930, pp. 11–12.

1931 Dusseldorf. Kunstverein für die Rheinlande und Westphalen. June 14–July 6. 252 works. Catalog: *Paul Klee*, 29 pp. Introduction by Will Grohmann.

1931 Hannover. Kestner Gesellschaft. Catalog: *Paul Klee*, 6 pp., illus. Includes excerpt from René Crevel's "Merci, Paul Klee."

1931 Berlin. Galerie Alfred Flechtheim. Nov. 5–Dec. 10. 40 works. Catalog: *Paul Klee, neue Bilder und Aquarelle*, 3 pp., illus. Reviewed in *Art News*, New York, v. 30, Dec. 12, 1931, p. 24.

1934 London. Mayor Gallery. Reviewed in *Apollo*, London, v. 19, Feb. 1934, p. 109; and in bibl. 88.

1934 Paris. Galerie Simon. June 12–25. Reviewed in bibl. 191.

1935 New York. Contempora Art Circle. March. Catalog: *Paul Klee at Neumann's*, 4 pp. Note by J. B. Neumann, reprinted in *Artlover* (bibl. 165). Reviewed in *Art Digest*, New York, v. 9, Mar. 15, 1935, p. 13; in *Art News*, New York, v. 33, Mar. 9, 1935, p. 12.

1935 Bern. Kunsthalle. Feb. 17–Mar. 17. Reviewed in bibl. 96.

1935 London. Mayor Gallery. Reviewed in *Apollo*, London, v. 22, Aug. 1935, p. 111.

1935 Oakland, Cal. Oakland Art Gallery. October. Reviewed in *Art Digest*, New York, v. 10, Nov. 1, 1935, p. 19.

1936 Hartford. Wadsworth Atheneum. Jan. 21–Feb. 11. Catalog: *Paul Klee*, 1 pp.

1937 San Francisco. San Francisco Museum of Art. Jan. 12–Feb. 26, 69 works. No catalog.

1937 Munich. Included in exhibition of degenerate art.

1938 Paris. Galerie Simon. Jan. 24–Feb. 5. 40 works. Catalog: *Paul Klee: œuvres récentes*, 3 pp., illus.

1938 New York. Buchholz Gallery, Curt Valentin. Mar. 23–April 23. 75 works. Catalog: *Paul Klee*, 4 pp., illus. Reviewed in *Art News*, New York, v. 36, Apr. 9, 1938, p. 15.

1938 Paris. Ballay et Carré July 7–28. 23 works. Catalog: *Paul Klee: tableaux et aquarelles de 1917 à 1937*, 4 pp., illus. Reviewed in *Beaux Arts*, Paris, July 15, 1938, p. 6.

1938 New York. Nierendorf Galleries. Oct. 24–Nov. 62 works. Catalog: *Exhibition Paul Klee*, 7 pp., illus. Introduction by Perry Rathbone.

1938 New York. Buchholz Gallery, Curt Valentin, Nov. 1–26. 37 works. Catalog: *Paul Klee*, 3 pp. Reviewed in *Art News*, New York, v. 37, Nov. 5, 1938, p. 17;

in *Parnassus*, New York, v. 10, Dec. 1938, p. 15.

1938 New York. Museum of Modern Art. Bauhaus exhibition. Dec. 7–Jan. 30, 1939. Catalog: *Bauhaus, 1919–1928*, pp. 39, 172 et passim, illus. Includes statement by Klee, p. 172, partial translation of bibl. 9.

1939 London. London Gallery. Mar. 3–16. 12 works Catalog in *London Bulletin*, no. 11, Mar. 1939, p. 4.

1939 New York. Neumann-Willard Gallery. May 1–June 10. 27 works. Catalog: *Paul Klee*, 2 pp. Reviewed in *Art News*, New York, May 20, 1939, p. 12.

1939 Chicago. Katharine Kuh Gallery. December.

1940 New York. Nierendorf Gallery. February. 44 works. Catalog: *Paul Klee*, 5 pp. Reviewed in *Art News*, New York, v. 38, Feb. 3, 1940, p. 16.

1940 Cambridge, Mass. Germanic Museum, Harvard University. Feb. 28–Mar. 27. 37 works. No catalog.

1940 Los Angeles. Stendahl Gallery. No catalog.

1940 Bern. Kunsthalle. Nov. 9–Dec. 8. 233 works. Catalog: *Gedächtnisausstellung Paul Klee*, 16 pp., illus. Introduction by H. Meyer-Benteli.

1940 Zurich. Kunsthaus. Feb. 16–Mar. 25. 213 works. Catalog: *Klee*, 24 pp. and illus. Introduction by W. Wartmann. Reviewed in *Werk*, Zurich, v. 27, no. 3/4, Mar.-Apr. 1940, supplementary p. 30.

1940 New York. Buchholz & Willard Gallery. Oct. 9–Nov. 2. 100 works. Catalog: *Paul Klee*, 32 pp., illus. Essays by James J. Sweeney, Julia and Lyonel Feininger. Reviewed in *Parnassus*, New York, v. 12, Nov. 1940 p. 37; *Art News*, New York, v. 39, Oct. 12, 1940, p. 12; *Art Digest*, New York, v. 15, Oct. 15, 1940, p. 12.

1940 Zurich. Graphische Sammlung der E. T. H. Oct. 19–Dec. 21. For comment, see bibl. 40.

1940 Chicago. Katharine Kuh Gallery. December.

1941 New York. Nierendorf Gallery. Arranged by Art Students League. Jan.-Feb. 10. 42 works. Catalog: *Paul Klee*, 7 pp., illus. Introduction by Clark Mills. Reviewed in *Art News*, New York, v. 39, Jan. 25, 1941, p. 17.

1941 Chicago. Arts Club. Jan. 31–Feb. 28. 83 works. Catalog: *Paul Klee: Memorial Exhibition*, 8 pp., illus. Essay by James J. Sweeney, reprinted from catalog of Buchholz Gallery, New York, 1940. 64 of the 83 works were circulated by the Museum of Modern Art, New York. Reviewed in *Art Digest*, New York, v. 15, Jan. 15, 1941, p. 15.

1941 London. Leicester Galleries. Mar. 4–25. Catalog: *Catalogue of an Exhibition of Paintings and Watercolors by Paul Klee*, 12 pp., illus. Introduction by Herbert Read, also re-

printed in the author's *A Coat of Many Colours*, London, Routledge, 1946, pp. 16–19.

1941 Basel. Kunsthalle. Feb. 15–Mar. 23. Reviewed in *Werk*, Zurich, v. 28, no. 4, Apr. 1941, pp. 109–110.

1941 San Francisco. Museum of Art. Apr. 14–May 5. Catalog: *Paul Klee Memorial Exhibition. Addenda to the Exhibition of the Museum of Modern Art*, 8 pp., illus. Introduction by Grace Morley and excerpts from Klee's letters. Also shown at Stendahl Art Galleries, Los Angeles, May 8–18. Reviewed in *Arts & Architecture*, San Francisco, v. 58, May 1941, p. 4.

1941 New York. Museum of Modern Art. June 30–July 27. 66 works. Catalog: *Paul Klee*, 12 pp. and illus. Essays by Alfred H. Barr, Jr., reprinted from catalog, Museum of Modern Art, New York, 1930; James Johnson Sweeney, and Julia and Lyonel Feininger, reprinted from catalog, Buchholz Gallery, New York, 1940. This exhibition was circulated during 1941 to Smith College, Northampton, Mass.; Arts Club of Chicago; Portland Art Museum; Stendahl Gallery, Los Angeles; City Art Museum, St. Louis; Wellesley College, Wellesley, Mass.

1941 New York. Nierendorf Gallery. November. 44 works. Catalog: *Paul Klee*, 3 pp. Reviewed in *Art News*, New York, v. 40, Nov. 15, 1941, p. 25; in *Art Digest*, New York, v. 16, Nov. 15, 1941, p. 16.

1942 New York. Nierendorf Gallery. March–Oct. 10. 37 works. Catalog: *Fifth Selection of Works by Paul Klee*, 1 p.

1942 Cincinnati. Art Museum. Apr. 7–May 3. 43 works. Catalog: *Paintings by Paul Klee ... Assembled by the Cincinnati Modern Art Society*, p. 1–7, illus.

1942 Washington, D. C. Phillips Memorial Gallery. June 2–Oct. 4. 30 works. Catalog: *Paul Klee, a Memorial Exhibition*, 4 pp. Essay by Duncan Phillips.

1943 New York. Buchholz Gallery, Curt Valentin. Feb. 23–Mar. 20. 27 works. Catalog: *Paul Klee*, p. 1–15. Reviewed in *Art News*, New York, v. 42, Mar. 1, 1943, p. 23; in *Art Digest*, New York, v. 17, Mar. 1, 1943, p. 12.

1943 Baltimore. Museum of Art. Mar. 16–Apr. 25. Reviewed in *Baltimore Museum News*, v. 5, Mar. 1943, p. 7.

1943 New York. New Art Circle, J. B. Neumann. Oct. 4–30. 24 works. Catalog: *Paul Klee Exhibition*, 3 pp. Reviewed in *Art Digest*, New York, v. 18, Nov. 1, 1943, p. 20.

1944 Philadelphia. Art Alliance. Mar. 14–Apr. 9. 97 works. Catalog: *Paul Klee, Paintings, Drawings,*

Prints, 15 pp., illus. Reviewed in *Art Digest*, New York, v. 18, Mar. 15, 1944, p. 17.

1945 New York. Nierendorf Gallery. Mar. 8–Apr. 8. 59 works. Catalog: *Works by Klee*, 4 pp., illus. Reviewed in *Art Digest*, New York, v. 19, Mar. 15, 1945, p. 14.

1945 Lucerne. Galerie Rosengart. July 15–Sept. 15. 45 works. Catalog: *Paul Klee zum Gedächtnis*, 13 pp., illus. Essay by Georg Schmidt. Reviewed in *Emporium*, Bergamo, v. 102, Nov. 1945, p. 120–121; in *Werk*, Winterthur, v. 32, no. 9, Sept. 1945, supplementary p. 103; and in bibl. 146.

1945 Basel. Galerie d'Art Moderne. November.

1945 London. National Gallery. December. 137 works. Catalog: *Paul Klee*, 9 pp., illus. Foreword by Rolf Bürgi. Reviewed in *Arts*, Paris, no. 50, Jan. 11, 1946, p. 1, 3; in *Apollo*, London, v. 43, Feb. 1946, p. 28; in *Museums Journal*, v. 45, Feb. 1946, p. 196; in *Studio*, London, v. 131, Apr. 1946, p. 125; in *Labyrinthe*, Geneva, no. 16, Jan. 15, 1946, p. 2; in bibl. 215. A selection (51) of the works was circulated by the Arts Council of Great Britain, 1946: Catalog, 6 pp., illus.

1945–1946 Prints by Paul Klee. 34 works circulated by the Museum of Modern Art to Vassar College, Poughkeepsie, N. Y.; Addison Gallery of American Art, Andover, Mass.; Baltimore Museum of Art, Hamline University, St. Paul, Minn.; Denver Art Museum, Cranbrook Academy of Art, Bloomfield Hills; Renaissance Society of the University of Chicago.

1946 Denver. Art Museum. Mar. 1–Apr. 13. 69 works. Catalog: *A New Way to Paul Klee*, 19 pp., illus. Text by Otto Karl Bach.

1946 Chicago. Renaissance Society. June 5–24. 50 works. Catalog: *Paul Klee Exhibition*, 4 pp.

1947 New York. Nierendorf Gallery. June–July. Drawings. Reviewed in *Art News*, New York, v. 46, July 1947, p. 34; in *Art Digest*, v. 21, July 1947, p. 14.

1947 New York. Nierendorf Gallery. October. 29 works. Reviewed in *Art Digest*, New York, v. 22, Oct. 15, 1947, p. 13; *Art News*, New York, v. 46, Oct. 1947, p. 45.

1947 Bern. Kunstmuseum. Nov. 22–Dec. 31. 365 works. Catalog: *Ausstellung der Paul Klee-Stiftung*, 40 pp., illus. Introduction by Klee-Gesellschaft. Reviewed in *Werk*, Zurich, v. 35, no. 1, Jan. 1948, supplementary p. 3. For talk given at opening of exhibition, see bibl. 118.

1948 Paris. Galerie Colette Allendy. Feb. 1–26. Reviewed in *Arts*, Paris, no. 153, Feb. 13, 1948, p. 4.

1948 Paris. Musée National d'Art Moderne. Feb. 4–
Mar. 1. 365 works.
Catalog: *Paul Klee*, 24 pp., illus. Introduction
by Henri Hoppenot. Klee-Gesellschaft collec-
tion. Reviewed in *Musées de France*, Paris,
Mar. 1948, pp. 38–42; in *Le Musée Vivant*,
Paris, v. 12, no. 35, Apr. 1948, p. 7; in *Kro-
niek van Kunst en Kultuur*, Amsterdam, v. 9,
no. 5, May 1948, p. 15; v. 9, no. 6, June 1948,
p. 186; in *Arts*, Paris, no. 153, Feb. 13, 1948,
p. 4, and in bibl. 28.

1948 New York. Buchholz Gallery, Curt Valentin.
Apr. 20–May 15, 40 works.
Catalog: 24 pp., illus. Reviewed in *Art Digest*,
New York, v. 22, May 1, 1948, p. 14; in *Art
News*, New York, v. 47, May 1948, p. 38.

1948 Brussels. Palais des Beaux-Arts. March.
365 works.
Catalog: *Paul Klee*, 44 pp., illus. Preface by
Georges Limbour. Klee-Gesellschaft collection.

1948 Munich. Moderne Galerie Otto Stangl. April–
May 1948. 46 works.
Catalog: *Paul Klee*, 16 pp., illus. Introduction
by Felix Klee.

1948 Amsterdam. Stedelijk Museum.
Catalog: *Paul Klee*, 32 pp., illus. Klee-Gesell-
schaft collection. Reviewed in *Emporium*,
Bergamo, v. 107, June 1948, p. 275–276.

1948 Venice. 24th Biennale. May 29–Sept. 30.
18 works.
One room devoted to Klee. Catalog note by
Max Huggler.

1948 Lucerne. Galerie Rosengart. Aug.–Sept.
Reviewed in *Werk*, Zurich, v. 35, Sept. 1948,
supplementary p. 121.

1948 Beverly Hills, Calif. Modern Institute of Art.
Sept. 3–Oct. 6. 101 works.
Catalog: *Exhibition Klee, 30 Years of Paint-
ings, Water Colors, Drawings and Lithographs*,
14 pp., illus.

1948 Zurich. Kunsthaus. Sept. 22–Oct. 17. 300 works.
Catalog: *Ausstellung Paul Klee - Stiftung*,
42 pp., illus. Introduction by W. Wartmann.
Biographical information supplied by the
artist. Reviewed in *Werk*, Zurich, v. 35, no. 11,
Nov. 1948, supplementary p. 148–149.

1948 Basel. Kunsthalle. Oct. 27–Nov. 21. 196 works.
Catalog: *Aus der Stiftung Paul Klee*, 31 pp.
and illus. Introduction by Klee-Gesellschaft.

1948 New York. Buchholz Gallery, Curt Valentin.
Oct. 26–Nov. 13. 50 works.
Catalog: *Paul Klee: Fifty Drawings*, 14 pp.,
illus. Includes excerpts in English translation
from bibl. 10, 178, reprinted from bibl. 176.
Reviewed in *Art Digest*, New York, v. 23,
Nov. 1, 1948, p. 11.

1948 Dusseldorf. Hetjens-Museum. Nov.–Dec.
30 works. (From Klee Gesellschaft.)
Catalog: *Späte Werke von Paul Klee*, 12 pp.,
illus. Includes articles by Gerhard Kadow
(reprinted in bibl. 126), Ernst Willemsen and
Günter Grote.

1949 Freiburg-Breisgau. Kunstverein. May 9–June 8.
30 works. (From Klee Gesellschaft.)
Catalog: *Späte Werke von Paul Klee*, 11 pp.,
illus. Includes extracts from Klee's *Über die
moderne Kunst.*

1949 Mannheim. Städtische Kunsthalle.
Apr. 2 – May 1.

1949 Freiburg-Breisgau. Kunstverein. May 9–June 8.
30 works.

1949 Basel. Galerie d'Art Moderne. Sept. 24.
Reviewed in *Werk*, Zurich, v. 36, Nov. 1949,
supplementary p. 154.

1949 Munich. Haus der Kunst. Sept.–Oct. 50 works.
Catalog: *Der Blaue Reiter*, pp. 10–11, 17,
20–21, 30–34, illus. Includes excerpts from
Klee's diary. For article occasioned by exhibi-
tion, see bibl. 209.

1949 Hamburg. Kunstverein.
Reviewed in *Das Kunstwerk*, Baden-Baden,
v. 3, no. 4, 1949, p. 44, and in bibl. 173.

1949 New York. Museum of Modern Art. Dec. 20–
Feb. 14, 1950.
Catalog: *Paintings, Drawings and Prints by
Paul Klee from the Klee Foundation, Berne,
Switzerland, with Additions from American
Collections*, 59 pp., illus. (some col.). Introduc-
tion by James Thrall Soby.
Also shown at San Francisco Museum of Art,
Mar. 24–May 2, 1949; Portland Art Museum,
May 16–June 21, 1949; Detroit Institute of
Arts, Sept. 15–Oct. 19, 1949; City Art Museum,
St. Louis, Nov. 3–Dec. 5, 1949; Phillips Art
Gallery, Washington, D. C., Mar. 4–Apr. 10,
1950; Cincinnati Art Museum, Apr. 26–May 24,
1950. Reviewed in *Art News* (New York, v. 48,
April 1949, pp. 42–43; in *Art Digest*, New
York, v. 24, Feb. 15, 1950, p. 16; *Art Digest*,
New York, v. 24, Jan. 1, 1950, p. 10.

1949 Braunschweig. Galerie Otto Ralfs.
Dec. 3–Jan. 8, 1950.

1950 Braunschweig. Kunstverein. February.

1950 Cambridge, Mass. Harvard University. Ger-
manic Museum. Mar. 8–April 3.

1950 New York. New Art Circle, J. B. Neumann,
May 1–31.
Reviewed in *Art Digest*, New York, v. 24,
May 15, 1950, p. 19; in *Art News*, New York,
v. 49, May 1950, p. 47.

1950 New York. Buchholz Gallery, Curt Valentin.
May 2–May 27. 60 works.
Catalog: *Paul Klee*, 23 pp., illus. Includes
translations of statements by Klee from bibl.
135. Reviewed in *Art Digest*, New York, v. 24,
May 15, 1950, p. 19; *Art News*, New York,
v. 49, May 1950, p. 47.

1950 Munich. Galerie Günther Franke.
May 12–June.

1950 Munich. Haus der Kunst. May–June. 59 works.
Catalog: *Die Maler am Bauhaus*, München,
Prestel Verlag, pp. 11, 15–17, 30, 32, 36–39,
42–45, 52, illus. (1 col.). Includes extract from

letter from Klee to Hans Hildebrandt, statement by Walter Gropius, Klee's "Wege des Naturstudiums", and essay by Helene Nonne-Schmidt: "Klee's Unterricht"; essay by Ludwig Grote.

1950 London. Mayor Gallery, June. 48 works. Catalog: *Paul Klee Exhibition*, 4 pp. Reviewed in *Art News and Review*, London, v. 2, June 17, 1950, p. 5.

1950 Basel. Kunstmuseum, June 29–Aug. 15. 102 works. Catalog: *Paul Klee, 1879–1940: Ausstellung aus Schweizer Privatsammlungen zum 10. Todestag, 29. Juni 1950*, 35 pp., illus. Includes reprint of speech by Georg Schmidt (bibl. 44), and revised version of his introduction (bibl. 194). Reviewed in *Werk*, Zurich, v. 37, Aug. 1950, supplementary p. 99.

1950 Paris. Galerie Bucher. June 20–July 13. Reviewed in *Arts*, Paris, no. 270, July 7, 1950, p. 4.

1950 Frankfurt am Main. Galerie Buchheim-Militon. Opening Nov. 11. 36 works. Catalog: *Paul Klee: Gemälde, Aquarelle, Zeichnungen, Graphik*, 16 pp., illus. Introduction by Will Grohmann; statement by Walter Gropius; reprint of Klee's "Wege des Naturstudiums"; extracts from letters from Klee to Hans Hildebrandt.

1950 Guadalajara, Mexico. Galeria Arquitac. Dec. 7–23.

1951 New York. Buchholz Gallery, Curt Valentin. Jan. 16–Feb. 3. 60 works. Catalog: *Klee: Sixty Unknown Drawings*, 12 pp., illus.

1951 Bremen. Kunsthalle. Jan. 21–Feb. 18. 36 works.

1951 Cologne. Kunstverein. March. 36 works.

1951 Palm Beach. Society of the Four Arts. March 9–April 1. 76 works. Catalog: *Paintings by Paul Klee*, 16 pp., illus. Introduction by F. C. Schang, from whose collection 29 of the exhibited works were borrowed.

1951 Buffalo. Albright Art Gallery. Oct. 20–Nov. 25.

1952 Paris. Bergguren & cie. Feb. 14–Mar. 8. 30 works. Catalog: *Paul Klee: gravures*, 24 pp., illus. (some col.). Reviewed in *Studio*, London, v. 143, May 1952, p. 156; *Art d'Aujourd'hui*, Boulogne, ser. 3, no. 3–4, Feb.–Mar. 1952, p. 62.

1952 New York. New Art Circle. Apr. 13–May 30. 31 works. Catalog: *Klee*, folder, illus. Reviewed in *Art News*, New York, v. 51, Apr. 1952, p. 44; in *Art Digest*, New York, v. 26, May 1, 1952, p. 17.

1952 Hannover. Kestner-Gesellschaft. May 20–June 22. 88 works. Catalog: *Paul Klee*, 18 pp., illus. Includes introduction by Alfred Hentzen and quotations from the artist's writings.

1952 Winterthur. Kunstmuseum. Sept. 14–Nov. 2. 99 works. Catalog: *Paul Klee*, 16 pp. Reviewed in *Werk*, Zurich, v. 39, Nov. 1952, sup. p. 164.

1952 Louisville, Kentucky. J. B. Speed Art Museum. October. 40 drawings from the collection of Curt Valentin. 1952–1954: exhibition circulated to University of Miami, Vassar College, University of Michigan, Washington University, Smith College, Currier Gallery of Art, Minneapolis Institute of Arts.

1952 Dusseldorf. Galerie Alex Vömel. Oct. 1–31.

1952 Boston. Margaret Brown Gallery. Oct. 27–Nov. 15.

1953 Paris. Berggruen & cie. May 22–June 20. Reviewed in *Art d'Aujord'hui*, Paris, ser. 4, no. 5, July 1953, p. 26; *Arts*, Paris, no. 414, June 5, 1953, p. 7; *Cahiers d'Art*, Paris, v. 28, no. 1, 1953, p. 153–155.

1953 London. Institute of Contemporary Arts. November 18–December 1953. Fifty Drawings by Paul Klee, from the collection of Curt Valentin, 24 pp., illus. Introduction by Will Grohmann. Exhibition circulated to Hannover, Berlin and Dublin.

1953 New York. Curt Valentin Gallery. Sept. 29–Oct. 24. 57 works. Catalog: *Paul Klee*, 16 pp., illus. Includes unpublished excerpts from Klee's *Journal*. Reviewed in *Art Digest*, New York, v. 28, Oct. 1, 1953, p. 19; *Arts and Architecture*, San Francisco, v. 70, Nov. 1953, pp. 8–9.

1953 São Paulo. Museu de Arte Moderna. Nov. 1953–Feb. 1954. 65 works. Catalog: *Paul Klee*, Munique, Prestel Verlag, 1953, 53 pp., illus., port. Issued by German Section at 2d Bienal de São Paulo.

1954 Hannover. Kestner Gesellschaft. Jan. 17–Feb. 21. 50 works. Catalog: *Paul Klee, Max Beckmann*, pp. 1–12, illus. Introduction by Alfred Hentzen.

1954 New York. Saidenberg Gallery. Mar. 8–Apr. 26. 49 works. Catalog: *Paul Klee*, 6 pp., illus. Reviewed in *Art Digest*, New York, v. 29, Mar. 1, 1954, p. 21; *Art News*, New York, v. 53, Mar. 1954, p. 41.